LOOKING BEYOND

Visions, Dreams, and Insights in
Medieval Art & History

Index of Christian Art

Occasional Papers · XI

LOOKING BEYOND

*Visions, Dreams, and Insights in
Medieval Art & History*

EDITED BY

COLUM HOURIHANE

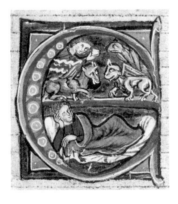

INDEX OF CHRISTIAN ART

DEPARTMENT OF ART & ARCHÆOLOGY

PRINCETON UNIVERSITY

in association with

PENN STATE UNIVERSITY PRESS

MM · X

DISTRIBUTED BY
PENNSYLVANIA STATE UNIVERSITY PRESS
820 NORTH UNIVERSITY DRIVE, USB I, SUITE C
UNIVERSITY PARK, PENNSYLVANIA 16802

*

Library of Congress Cataloging-in-Publication Data

LOOKING BEYOND: VISIONS, DREAMS AND INSIGHTS IN MEDIEVAL
ART AND HISTORY / EDITED BY COLUM HOURIHANE.

P. CM. — (THE INDEX OF CHRISTIAN ART: OCCASIONAL PAPERS; II)
INCLUDES BIBLIOGRAPHICAL REFERENCES AND INDEX.

ISBN 978—0—9768202—8—4 (PBK. : ALK. PAPER)

I. DREAMS IN ART. 2. VISIONS IN ART. 3. ART, MEDIEVAL—
THEMES, MOTIVES. 4. PHILOSOPHY, MEDIEVAL.

I. HOURIHANE, COLUM, 1955—

N8217.D74L66 2010 704.9'4820902—DC22

2010002853

TITLE-PAGE IMAGE:

*Ezekiel in the Vision of Shekinah, showing Ezekiel
reclining with the Beasts of the Apocalypse above. A
detail of the initial E from a mid-thirteenth-century
bible, French, possibly from Paris. Morgan Library
and Museum, New York, M. 269, fol. 287ʳ*

BOOKS PUBLISHED BY THE INDEX OF CHRISTIAN ART,
PRINCETON UNIVERSITY, ARE PRINTED ON ACID-FREE PAPER
AND MEET THE GUIDELINES FOR
PERMANENCE AND DURABILITY OF THE
COMMITTEE ON PRODUCTION
GUIDELINES FOR BOOK LONGEVITY OF THE
COUNCIL ON LIBRARY RESOURCES

CONTENTS

viii Contents

PREFACE

THE CONFERENCE that took place at Princeton in March 2008 was the second in a series of symposia devoted to visions that started at the University of Southern California in 2007.[1] If the California conference was more interdisciplinary, while having a strongly focused anthropological slant, and being more wide-ranging in the historical periods examined, the Princeton conference could be portrayed as focusing exclusively on the medieval period (albeit also in relation to twenty-first-century visions and visionaries in a number of essays), and as having a disciplinary emphasis on history and art history in particular.

The subject of visions is a huge one, and, no matter how inclusive we attempted to be, some of the better-known exemplars—such as the dreams of Dante, Hildegard of Bingen, the Magi, Mordecai, Nebuchadnezzar, Pharaoh, or Pilate's wife, or the visions of Constantine, Daniel, Zechariah, Eustace, Stephen, or Ursula, to name just a few from the files of the Index of Christian Art—could not be included. Moreover, despite the fact that attempts to categorize and define ways of seeing beyond the physical world can be traced to Augustine himself, and in the face of an ever-increasing bibliography on the subject, we remain in many respects no closer to defining the basic differences between such general concepts as dreams, visions, and insights, or to understanding their purpose. Thus, although the essays in this volume range over several centuries and continents, we have simply touched the tip of a very big iceberg. Some of the essays are general and far-reaching in their scope, while others are specific case studies; all, I hope, will provide insights for future research, and in each instance, I am grateful to all the authors for working so conscientiously.

With one or two exceptions, all of the speakers at the conference decided to include their essays in this volume and I am grateful to them for meeting my rigorous deadlines. I am also grateful to those authors whose essays are in this volume but were not presented at the conference. The papers in the collection will undoubtedly lose some of the excitement that was generated in the live interchange of ideas and opinions at the conference itself, but they all attest to the scholarship and interest in the subject.

1. The conference that was held in 2007 at the University of Southern California was called "Visionaries and Vision-Hunters" and some of the papers have subsequently been published as a special issue of the journal *Visual Resources*, see Lisa Bitel, ed., *Visualizing the Invisible: Visionary Technologies in Religious and Cultural Contexts*, a special issue of *Visual Resources: An International Journal of Documentation* 25:1 (March 2009).

It is indeed gratifying to be able to provide a forum for new research, as has been the role of the Index for the last ninety-five years.

My thanks are extended to the moderators at the conference who ensured good scheduling and lively discussions, namely, Anne Marie Luijendijk and Michael Curschmann from Princeton University, as well as Lisa Bitel from the University of Southern California. William Christian Jr., one of the foremost scholars of visions was present at the conference and my thanks are extended for his help. The event could not have been held without the assistance of the Center for Religion and Civic Culture at the University of Southern California and Jon Miller in particular. Closer to home, the Council of the Humanities in Princeton provided very generous financial support for the conference and I wish to thank especially Carol Rigolot for her valuable help.

All of my colleagues in the Index of Christian Art gave of their time, energy, and scholarship to ensure a successful conference and publication. Specifically, Robin Dunham deserves to be acknowledged for giving so enthusiastically towards organizing a successful event and I am particularly grateful to her. My thanks also go to Mark Syp and Mini Ott, interns in the Index of Christian Art, as well as Michelle Horgan from the Conference and Events Service in Princeton University for their help. I wish to thank Marilyn Gazillo for providing excellent and reliable media support for the two days of the event.

This work could not have been published were it not for the expertise, advice, and guidance of Mark Argetsinger, who has worked on many Index volumes over the years. The design and shape of this work, the copy-editing, and the index are truly a credit to his skills and knowledge. He has endured my many requests over the years with admirable charm.

COLUM HOURIHANE
Director, Index of Christian Art

NOTES ON
THE CONTRIBUTORS

HANS BELTING is Professor of Art History and Media Theory at the Hochschule für Gestaltung, Karlsruhe in Germany, where he has been based since 1992. He studied art history, archaeology, and history at the universities of Mainz and Rome before receiving his Ph.D. in Art History in 1959. He has taught at the universities of Hamburg (1966), Heidelberg (1970–80), and Munich (1980), as well as being visiting professor at Columbia University (1989–90). A member of the Medieval Academy of America, the American Academy of Arts and Sciences, the Institute for Advanced Study (in Berlin), he has received numerous honors and awards in his distinguished career. Amongst his many publications are *Likeness and Presence: A History of the Image before the Era of Art* (1994); *The Germans and their Art: A Troublesome Relationship* (1998); *Hieronymus Bosch, Garden of Earthly Delights* (2002); and *Szenarien der Moderne: Kunst und ihre offenen Grenzen* (2005).

ALISON I. BEACH is Associate Professor of Religious Studies at the College of William and Mary and director of William and Mary's Program in Medieval and Renaissance Studies, where she has been based since 2001. She received her Ph.D. in Religion from Columbia University in 1996 and has published widely in the field of medieval studies with a particular emphasis on Germany. Her primary field of scholarly interest is in medieval European religious history with a focus on spirituality and intellectual life in twelfth-century monastic communities. As well as writing *Women as Scribes: Book Production and Monastic Reform in Twelfth-Century Bavaria* (2004), she has also edited *Manuscripts and Monastic Culture: Reform and Renewal in Twelfth-Century Germany*, Medieval Church Studies 13 (2007).

LISA M. BITEL is Professor of History, Religion, and Gender Studies in the University of Southern California where she has been based since 2001. Professor Bitel studies the social, cultural, and religious history of medieval Europe. She is the director and editor of *Monastic Matrix* and sits on the advisory boards of *History Compass* (for Medieval Ireland) as well as *Feminae* (Medieval Feminist Index). She has published articles on sex, dreams, architecture, and Christianity, among other topics. She is currently researching two books about religious vision as well as a book on the material history of medieval visions and a collaborative book on a modern-day vision in the Mojave desert. She is the author of *Isle of Saints: Monastic Settlement and Christian Community in Early Ireland* (1990); *Land of Women: Tales of Sex and Gender from Early Ireland* (1996); and *Women in Early Medieval Europe, 300–1100* (2002).

LUIS CORTEGUERA is Associate Professor in the History Department in the University of Kansas. He received his Ph.D. from Princeton in 1992. He is particularly interested in sixteenth- and seventeenth-century Spain as well as popular politics in Early Modern Europe and the political and religious uses of images in the Spanish monarchy. He has written two books, *Artisans and Politics in Barcelona, 1550–1650* (1992) and *For the Common Good: Popular Politics in Barcelona, 1580–1640* (2002), and has edited a third volume with Marta V. Vicente entitled *Women, Texts, and Authority in the Early Modern Spanish World* (2003).

RICHARD K. EMMERSON is Professor in English and Dean of the School of Arts in Manhattan College, New York. He received his Ph.D. in English from Stanford University and was Executive Director of

the Medieval Academy of America. His research has always focused on the interdisciplinary nature of medieval art, literature, and religion. He has numerous publications, including *Antichrist in the Middle Ages: A Study of Medieval Apocalypticism, Art, and Literature* (1981); *The Apocalypse in the Middle Ages* (co-edited with Bernard McGinn) (1992); *The Apocalyptic Imagination in Medieval Literature* (with Ronald B. Herzman) (1992); and *Key Figures in Medieval Europe: An Encyclopedia* (with Sandra Clayton-Emmerson, associate editor) (2006).

GEORGIA FRANK is Associate Professor of Religion at Colgate University, where she has been since 1994. She received her Ph.D. from Harvard University and taught there and at the College of the Holy Cross before joining Colgate University. Her particular interests include women in antiquity, pilgrimage, relics, and monasticism. She is the author of numerous articles, the most recent of which is "'Taste and See': The Eucharist and the Eyes of Faith in the Fourth Century," *Church History* 70 (2001), 619–43, as well as the monograph *The Memory of the Eyes: Pilgrims to Living Saints in Christian Late Antiquity* (2000).

MATT GAINER is Director of Digital Imaging in the University of Southern California Libraries. Prior to taking on this post he taught at various colleges including Marymount College (1997–1998), California State University, San Bernardino (2001–2002), and The University of California, School of Policy, Planning, and Development (2006–2008). He has exhibited in *The Vision Identification Project* (University of Southern California, 2007), *Images of Dissent* (Pacifica Radio, Los Angeles, 2003), *As real as angels: dot.coms after the fall* (Angels Gate Cultural Center, Palos Verdes, Calif., 2002). He has also collaborated with Elizabeth McMillian on the publication of *California Colonial* (2002).

MICHELLE GARCEAU received her doctorate in History from Princeton University where she studied under William Chester Jordan. This was for a thesis titled "God and His Saints in Medieval Catalunya: A Social History." She holds two Masters in History, one from University College London (2003) and the other from Princeton University (2005). She has written entries in the *Dictionary of Medical Biography* (ed. W. F. Bynum, 2007) on Guy de Chauliac and William of Saliceto, as well as two articles in *The Journal of Pharmaceutical and Biomedical Analysis*. She is currently an Assistant Professor in History at the College of Charleston.

PETER JEFFERY was the Scheide Professor of Music History in Princeton University until 2009 when he joined the faculty of the University of Notre Dame. He received his Ph.D. in Music History from Princeton University in 1980 for a study entitled *The Autograph Manuscripts of Francesco Cavalli (1602–1676)*. He taught at the University of Delaware before arriving in Princeton in 1993. He received a MacArthur Fellowship in 1987, as well as numerous other honors and grants throughout his distinguished career. He sits on the editorial board of numerous publications, including *Religion and the Arts*, and is the editor of *Liturgical Chant Newsletter*. The author of numerous volumes, his two most recent studies are *Cum mortuis in lingua mortua: Death and the Requiem Mass in the Nineteenth Century* (2002) and *The Secret Gospel of Mark Unveiled: Imagined Rituals of Sex, Death, and Madness in a Biblical Forgery* (2007).

JACQUELINE JUNG is Assistant Professor in the History of Art Department at Yale University, which she joined in 2006. She received her Ph.D. from Columbia University in 2002 for a dissertation on the ritual, spatial, and iconographic dimensions of the thirteenth-century choir screen at Naumburg Cathedral, which is now being prepared for publication. She sits on the Board of Directors of the International Center of Medieval Art. Amongst her most recent publications are "Crystalline Women and Pregnant Hearts: The Exuberant Bodies of the Katharinenthal Visitation Group" in *Medieval History in the Comic Mode* (eds. Rachel Fulton and Bruce Holsinger)

(2007) and "The Passion, the Jews, and the Crisis of the Individual on the Naumburg West Choir Screen," in *Beyond the Yellow Badge: Anti-Judaism and Anti-Semitism in Medieval and Early Modern Visual Culture* (ed. Mitchell Merback) (2008).

PETER KLEIN is Professor in Art History at the Eberhard Karls Universität in Tübingen. His particular studies have ranged from Spanish medieval art to apocalyptic studies to Romanesque sculpture, as well as to modern material, including Goya. He is the author of or contributor to over fourteen monographs, amongst which the most recent are *Der Mittelalterliche Kreuzgang: Architektur, Funktion und Programm* (2004) and *Beato de Liébana: Codice del Monasterio de San Mamede de Lorvão* (2003).

DAVID MORGAN was the Phyllis and Richard Duesenberg Professor of Christianity and the Arts and Professor of Humanities and Art History in Christ College at Valparaiso University, where he was based from 1990 to 2008, before moving to Duke University as Professor of Religion. He received his Ph.D. from the University of Chicago in 1990 for a study entitled "Concepts of Abstraction in German Art Theory, 1750–1914." His studies have focused on the history of religious visual and print culture as well as American religious and cultural history. He has written several monographs, including *The Sacred Gaze: Religious Visual Culture in Theory and Practice* (2005) and *The Lure of Images: A History of Religion and Visual Media in America* (2007).

ERIC PALAZZO is Professor in the History of Art at the University of Poitiers where he has been since 1999. He was also director of the Centre d'Etudes Supérieures de Civilisation Médiévale in Poitiers from 2000 to 2007. He has taught at the universities of Lausanne, Geneva, and Barcelona, to name just three in a distinguished career that has focused on art and liturgy. He has published widely, including *Les Sacramentaires de Fulda: étude sur l'iconographie et la liturgie à l'époque ottonienne* (1994); *A History of Liturgical Books from the Beginning to the Thirteenth Century* (1998); and *L'évêque et son image: l'illustration du pontifical au Moyen Age* (1999).

GLENN PEERS is Professor in the Department of Art History at the University of Texas at Austin. He received his Ph.D. in art history from Johns Hopkins University and a Licentiate in medieval studies from the Pontifical Institute of Medieval Studies in the University of Toronto. He has served on the boards of the Canadian Archaeological Institute at Athens, the American School of Classical Studies at Athens, and the Byzantine Studies Conference. He is the author of two monographs, *Subtle Bodies: Representing Angels in Byzantium* (2001) and *Sacred Shock: Framing Visual Experience in Byzantium* (2004). He is currently working on Christian-Muslim interaction in medieval Egypt, philhellenism in Renaissance France, and Byzantium and Modernism.

ANN MARIE YASIN is Assistant Professor of Classics and Art History in the University of Southern California where she has been since 2005. Prior to that she taught for three years at Northwestern University. She received her Ph.D. from the University of Chicago in 2002 for a study entitled "Commemorating the Dead—Constructing Community: Church, Space, Funerary Monuments and Saints' Cults in Late Antiquity." She received a Fellowship in Byzantine Studies from Dumbarton Oaks in 2006. She specializes in Roman and Late Antique art and material culture and is presently completing a monograph entitled *Martyrium Revisited: Churches, Saints and Communities in Late Antiquity*.

NINO ZCHOMELIDSE is Assistant Professor in the Department of Art and Archaeology at Princeton University. Before coming there in 2006, she was a research fellow in the Royal Danish Academy of Fine Arts. She received her Ph.D. from the University of Bern in 1992 for a thesis entitled "Die Mittelalterlichen Fresken en Santa Maria dell'Immacolata Concezione in Ceri bei Rom," which was subsequently

published as Vol. 5 in *Storia e Arte* (1996). Her research has focused on the concepts of civic identity and ecclesiastical power in southern Italy and lay patronage. She has co-edited two books entitled *Fictions of Isolation: Artistic and Intellectual Exchange in Rome During the First Half of the Nineteenth Century* (with Lorenz Enderlein) (2006) and *Die Sichbarkeit des Unsichbaren: Zur Korrelation von Text im Wirkungskreis der Bibel* (with Bernd Janowski) (2003).

INTRODUCTION

COLUM HOURIHANE

THE TITLE of the conference that inspired these studies, and indeed of this collection of essays as well, is "Looking Beyond," and there seems to be no need to actually specify what the "beyond" is intended to convey! Lest there be any doubt, however, it is "beyond the self" or "beyond the physical," as the concept of dreams or visions implies. We aim to look at the ability to see beyond the visible or physical. Dreams and Visions are concepts whose meaning has remained consistent over time, despite a less-than-comprehensive understanding of all that is entailed in those terms. Even though it appears to be a simple descriptor, the term vision is impossible to fully understand, and, despite the efforts by Augustine and successive theologians to determine or categorize the various types of visions, it is still an unfathomable subject. How do we try or hope to understand the invisible through the represented and visible, be that a word, an image, or any other possible means? Visions and dreams cut across many boundaries and this volume focuses largely on the spiritual and religious. Much to our regret, the secular dream, which has been the subject of considerable research, was not included in any of the essays, although it can be argued that many of the same precepts and principles can be applied from one subject to the other.

We may enumerate a few salient points regarding visions and dreams. The concept of visions or being able to see beyond the physical implies a special sight that is or was not widely available to others. More often than not, the vision is a highly personal experience that was usually given for a particular reason. Visions are not simply given to everybody, and they are never given without a reason—and this purpose or significance is usually determined only in retrospect. Very rarely can the person who is given the vision determine its importance while it is happen-

ing. Moreover, the reason why individuals are chosen to receive these special gifts is similarly unclear, but it seems to relate to their standing or importance. Kings and other rulers, for example, are clearly a chosen group who have received countless visions in the Middle Ages. As many of these essays show, however, other visionaries come from far more humble backgrounds. As shown in David Morgan's essay in this volume, visions have been given to ordinary people whose importance is rarely equal to the gift they have received. The children at Fatima or at Lourdes spring to mind as typical examples of the more modern recipients of visions. It is also clear that those chosen to receive visions can rarely return to their existence as it was before they received them. Visions add status to those who receive them, usually amongst believers. The recipients are clearly chosen and visions are not given randomly. Yet, why they are chosen remains a mystery.

Visions are sometimes given at moments of importance and especially when a decision needs to be made. Throughout history they have been used to guide mankind in moments of indecision. They are symptomatic of cause and effect between the heavenly and earthly realms.

Certainty about the origins of visions is lacking, but they are usually believed to come from the Divine, or at the very least from some supernatural source. Notwithstanding, visions as well as dreams can come from evil as well as good, and from personal as well as extra-personal sources, and it is sometimes difficult to determine their origin. Pilate's wife's dream, for example, could equally have come from the Devil as from the Lord. If Pilate's wife had succeeded in preventing Jesus' crucifixion, then mankind would not have been saved and the Devil's wishes would have succeeded. On the other hand, as she was a believer in

Jesus it may have been her own personal wish to save him that made her intervene. As such, the origins and reasons for her dream are unclear.

Visions come from outside the body, but may be physically manifest upon it. Sometimes the person who is receiving the vision can see its manifestations and this is usually not visible to others—it is the status of the recipient that allows them to have this privilege. Visions are frequently accompanied or induced by prayer and especially powerful prayers are shown to heighten the vision. The surrounding space is also a powerful factor in inducing visions and sacred space is usually a factor in their cause. Visions are heightened by these factors as well as, especially, by the faith and willingness to believe. Another common element is the gaze or look of the recipient and their power to focus on some material object to induce the state of seeing.

Of course dreams are slightly different from visions and in many ways their status is lower. Everyone can and does dream, but it is usually those dreams of importance that are related to others. Dreams are clinically defined as the thoughts, feelings, and emotions experienced by a person when they are asleep. It is the ability to recall, recount, and interpret those feelings while awake, especially if they are of importance, that separates the everyday dream from those that are special. Whether dreams come from the conscious or the unconscious has been a matter of much debate in recent times, and despite the speculations of Freud or Jung, their origin in the Middle Ages was usually seen as coming from a higher power than the self and usually from the Divine.

The case studies in this volume look at how visions and dreams have been represented both textually and artistically in the medieval period. Such representations range from the diagrammatic to the personal and imaginative. The ways in which such ethereal events have been represented in word and image is as interesting as the actual visions and dreams themselves. Artists have used different ways to depict these, but there are certain general principles that pertain. The most uniform of these are the ways in which dreams (as distinct from visions) are shown. In most cases the recipient is shown recumbent and in bed or else lying on some bed-like furniture, usually with their eyes closed and removed from this world. More often than not an angel or some other heavenly element, such as a hand or finger, interrupts the scene from above and points to the recumbent figure as if in conversation. The unification of the physical and the ethereal is undertaken or signified by the mental activity of this supine figure—but nothing is shown of the other world, apart from the messenger who imparts the message to the figure. It is a one-way conversation whose importance will only be revealed once the figure has awoken.

The angel is frequently found in images of visions as well, and has the same role of representing the heavenly. or other world. The person who is having the vision does not necessarily have to be recumbent in these representations, unlike dreams where it is usually the norm. Instead, the recipient may be standing or involved in some action, and whereas dreams rarely show the nature of the message, in visions it may sometimes be concretely conveyed, as for example in Saint Eustace's vision, where he looks at Christ between the horns of a stag, or Jeremiah's vision of the seething pot in which a cauldron is usually shown.

When it came to representing visions, the medieval artist appears to have been far more inclined to include elements of what was being seen. The inherent difficulty for the artist as well as the viewer lies in representing and seeing the invisible and how this could be conveyed as something other than the physical. Of course, this lies at the very core of medieval iconography, but the need in such representation was to show the concept of physically seeing. Visions carried with them the concept of seeing and this was a two-way picture—not only for the person who had the vision, but also for the viewer of such medieval works in which the deed was represented. A variety of devices were used in the medieval period, as these essays will show, ranging from rays, to the use of different shades of color, to light, to gesticulating figures.

The problem facing the artist when it came to showing vision is dealt with in the first essay in this collection. This benchmark study builds on the exist-

ing scholarly framework, but at the same time shows us what we have missed and just how complex the whole interpretation of visions or dreams can be. In its strictest sense, Saint Francis did not have a vision when he received the stigmata, which has traditionally been shown as a series of rays emanating from the seraphic entity in the sky. With all the hallmarks of linking the physical with the heavenly, it has traditionally been included in the category of visions. In a revelatory and insightful essay, Hans Belting shows how complex was the task before the artist when given the responsibility of representing this moment and how the recipient, in this case Saint Francis, became the canvas for the message. Using Giotto as a case study, he demonstrates beautifully how tactile visions could be and how minor details could play the most significant purposes. It is an essay that will undoubtedly pave the way for future study in this field and make all of us look anew at spatial, textual, and physical relationships in the medieval image.

Elements of this study are gently and reflectively found in many of the succeeding studies in this volume, but not so in the second essay, which brings us into the inter-relationship of the liturgy and visions. Eric Palazzo is one of the foremost scholars on the liturgy of the Middle Ages and in this finely crafted essay he provides us with an encyclopedic analysis of visions and the liturgy in the early-medieval period. In a series of case studies he shows the efficacy of prayer in generating visions and the common characteristics found in descriptions of such events. As the author points out, very little research has been undertaken by historians of the liturgy on this subject and this work is pioneering in many respects. Although it is difficult to reconstruct the environments and conditions that induced these visions, the author's efforts are valiant in this regard and they clearly show certain common and powerful characteristics. These include the devotional nature of the prayer and the immediate environment, which is usually a sacred space. Ritual was clearly important in these visions, but even more revelatory was the use of such media as a statue or image, which allowed the recipient to focus on the vision. He also highlights the central role of the gaze

in the whole process. Of course all of these visions as described by Eric are similar to others described elsewhere in the volume, but it is the focus on elements such as the gaze (and its relationship to liturgical gazing) in these particular case studies that classifies them as liturgical. His essay shows the role that art could play in these visions, which is essentially one of support after the vision had been induced by prayer and ritual.

There are many echoes of Eric's paper in the third essay in this collection which was written by Lisa Bitel. This study moves the reader back to a critical and formative period in northern European history, that is, to fourth and fifth century Ireland where she takes the case study of Saint Patrick's visions to examine how they came to be defined. She provides us with a history of the visions and their development for an area that was far removed from the more southerly and practiced area of seeing around the Mediterranean. Looking at the collective and the individual, the personal and the communal, she examines the way visions, or revelations as they are sometimes called, came to be legitimized and accepted through many of the props defined in the liturgical study of Eric Palazzo. She shows us how the visual environments changed over time in response to visions, but more significantly how the visions came to reflect strength in Christianity. Context was important for the development of the vision on a communal scale and enabled the worshipper to go beyond their immediate environment into the realm of the unseen. The unseen came to define the beliefs of the individual as well as the larger group but as she demonstrates that was not something that happened immediately.

The fourth paper marks the beginning of a series of case studies in which particular themes are discussed in relation to seeing and visions. This study by Ann Marie Yasin looks anew at apse mosaics from the fourth to the sixth centuries from the holistic perspective of iconography, inscription, and context, and attempts to explain some of the unusual features from the approach of the late antique viewer. Her focus, in this encyclopedic article that synthesizes much of the existing scholarship, is on the presence of donor fig-

ures who accompany saintly portraits in the later mosaics. These monumental programs go well beyond the saintly effigies and enable the viewer to see or envisage the heavenly rewards that await them. They present the viewer with a readily available and literal vision of the heavenly as well as the present, and, for Ann Marie, location is a significant feature wherein the apse unites present and past through the liturgy in an unbroken linkage that ends with the vision above but also focuses on the present space below.

The complexity of the apse mosaic is also underlined in Peter Jeffery's paper in the collection that looks at the cult surrounding Ravenna's first bishop, martyr, and confessor, St. Apollinaris. Apollinaris' life is recounted in the *Passio sancti Apollinaris*, which is studied in this paper, and forms, along with other material drawn from textual sources, hagiography, ritual, architecture, and iconography, an encyclopedic and riveting study of the cult of this saint. In a finely paced study the author considers the links between the saint and his namesake Apollo and focuses on the sun and the architecture of his shrine from all perspectives. The daily worship of the saint is reconstructed and hitherto undiscovered and un-researched insights into his cult are brought to light.

Georgia Frank's essay is similarly located in the late antique period and looks from an inter-disciplinary perspective on the personification of death. She postulates the "ritualized visibility of death" in the Middle Ages. Her detailed study focuses in particular on the visions of two early Christian poets on the subject of death and his interactions with Satan or the Evil One. In looking at the works of two authors from fourth- to sixth-century Syria, Ephrem and Romanos the Melodist, she looks at the way their words were used to describe Death and the descent into Hell. This really is the focus of the study—the Harrowing of Hell—that moment between Christ's death and his resurrection. Her study examines the way these two poets' dialogues looked at personifications that acted as "figures of speech." The study of these two poets, with all the trappings of the underworld, gives us an unrivalled and insightful understanding of death in the underworld in the late antique and Byzantine world.

The slightly later topic of visions in the time of reformation and liturgical expansion is examined by Alison Beach. The study looks at the Hirsau reforms, which marked a period of change and uncertainty in eleventh- and twelfth-century Germany. These changes naturally influenced how the religious community, which in this instance was the Benedictine Abbey of Petershausen, perceived itself. These perceptions are recounted in a twelfth-century chronicle authored by an anonymous monk. This riveting text also recounts visions that interestingly only happened in this period of uncertainty. The core of this paper are the visions that are examined against a small drawing at the bottom of one of the pages in the chronicle—it is the only vision to be so illustrated. It shows the monk Bernhard climbing a ladder to see and be part of the Last Judgment. More like a plan or map, it is an earthly and in many ways personal guide to the Last Judgment and differs drastically from the standard iconography of the scene. Its importance is belied by its small scale and less than accomplished finish, in that it provides us with a unique insight into the way the personal could extend to the communal and how the world beyond was used for earthly benefit.

All of these essays look at individual studies or works and then attempt to move the reader into broader more general applications in an effort to understand the process of visions and gazing, and such is the case with Nino Zchomelidse's study of what at first appears to be a simple tympanum in a twelfth-century church in the north of Spain. Using this carving, she deftly shows how text and image could be unified and, through the use of conflation in the imagery, how different layers of typological meaning and relationships could be conveyed and used to engage the viewer and move them beyond the temporal and physical. It is a study that highlights the use of the physical as a means to access the invisible, showing how art supports the theological. This essay brings to the fore the complexity of such works and our need to relate them to text and seeing.

Glenn Peers proposes a slightly different reading to the term "Looking Beyond" in the next case study in this collection. He takes as his subject the underground oratory of the Forty Martyrs in Syracuse, a little-known monument of imprecise date. In a revelatory study he examines the monument in a holistic perspective dealing with the material remains, the archaeology of the site, the iconography and style of the frescoes, as well as the cultural, historical, and religious background in Sicily from the ninth to the eleventh centuries. His arguments propose a re-dating of the monument and all that this entails. If his new dating is accepted, then it suggests an entirely new context and background in which these works should be viewed—a setting which is still very much bridged to both Rome and Byzantium but which is also placed at the center of the Muslim world. He analyses the life of a Christian as represented in the fragmentary frescoes in the oratory and shows the struggle for accommodation and acceptance. For this author "Looking Beyond" implies the use of the visual in helping the worshipper to see and believe, in times of trouble, in the eternal, which of course also underpins several of the other studies in this volume.

In her innovative article Jacqueline Jung adopts a different approach and advises us "to look at" so that we can "look beyond." Her focus is on the beholder or viewer and what can be used to help or aid the visionary experience. How should we as viewers approach the work to see beyond it and in this respect she looks with considerable skill and benefit into the tactility of late medieval sculpture and examines how the paradigm of "looking" changed over the entire Middle Ages. Touch allowed a physical sense of communion that was far more real than any of the other means of sensing. While this essay builds on existing theories, it also proposes new ways of looking at what has traditionally been seen as innocuous details. Movement, animation, gesture, touch, space, material, iconography, and design could all be used to involve and move the beholder into the vision, as this essay convincingly shows.

Viewing or seeing in the visionary experience is also the subject of Luis Corteguera's fine essay in this volume. The specific subject of his work is the seventeenth-century painting by Alonso Cano showing Saint Teresa of Ávila's vision. In a pivotal study Luis looks at the relationship of "artistic imagery" and "mystical imagining" where the visual and the verbal are beautifully combined in this painting. This essay shows how different visions from the intellectual to the emotional are influenced by many factors, all of which have the ultimate aim of achieving perfection. Much of this essay details the power of images in influencing the vision and the soul and beautifully extends the concept of seeing raised in other studies.

A related essay and yet more specific case study is that by Michelle Garceau, who looks at visions and miracles in northeastern Spain in the late twelfth and thirteenth century. Focusing more on the historical background, this study shows how visions decreased in Cataluña in this period. Interactions with the other world continued through saintly intervention, but visions decreased—or at least were not recorded with the same frequency. Her explanation for this centers on "a story of changing causality." From being visible and understood in the twelfth century, the role of the saint in the thirteenth and fourteenth centuries changed in terms of being differently evaluated and described. This, the author concludes, may have been caused by over familiarity with these events, which ultimately lead to their being recorded differently. Although not presented at the actual conference, it forms a valuable addition to the corpus of studies in this volume.

No collection of essays on visions could be undertaken without a study on the Apocalypse of Saint John or Book of Revelation, the last book of the Bible. This records how John while on the island of Patmos received his first (of many) visions, which were to be subsequently represented in illuminated Apocalypses spanning the medieval period. If Christ is the origin of these visions, it is John who is more often than not the focus of much study, and the two essays in this collection are no exception. The first study looks at

John as the "seeing, hearing, and recording witness who participates in his apocalyptic visions, serves as their authorized intermediary, and provides a model for the medieval reader/viewer of these spectacular manuscripts." Richard Emmerson, renowned scholar of these manuscripts, provides us with another benchmark study in his survey of this body of work. Looking at the many Apocalypses made between the tenth and fifteenth centuries, this essay examines how John is represented in them and how the medieval viewer would have understood the iconography. In a finely structured essay, this study shows the many roles that this imagery encompassed from visionary witness to participant and intermediary, uniting the eternal and the viewer.

The second essay to look at Saint John is again by a renowned scholar of the Apocalypse, Peter Klein. It is a return for him to a subject he first examined some years ago. After an introduction that explains the nature of visions, he identifies John's visions as belonging to Augustine's second type, that of the spiritual, in which the spirit sees and not the intellect. The problems facing the artist in showing such a type are reconstructed and the solutions examined in an essay reminiscent of Hans Belting's study at the start of this volume. It forms a beautiful extension of the first study and details one unique figure: the "external witness" as represented in the Metz group of English thirteenth-century Apocalypses. This detailed study focuses on this single figure, especially its function against *comparanda*, and concludes that they are guides for both reader and viewer.

Visions are not restricted to the medieval period, and the final essays in this volume move the reader into the modern period. The first of these studies is by David Morgan, one of the foremost experts in the study of post-medieval religions. In this revealing article he examines the modern concept of visions and how new technology has perhaps given us different platforms to see. His article shows that the world or mankind has not changed since the medieval period and that our need to see is still as strong as ever. He looks at the role of the image in modern visions and that of the artist in particular, and their ability or susceptibility to perhaps see "better" because of their greater powers to behold visions. Images still play a pivotal role in modern visions and, using a series of modern apparitions of the Virgin, David examines these as forms of visual culture and sees how they "collaborate" with communal imagination. The potential for capturing or recording visions, and for seeing more and beyond, is also extended with new technology. Here, the use of Polaroids—as opposed to digital images, which may be potentially altered—is examined, and the process of how these work in the context of vision forms a conclusion to the study.

If this encyclopedic study covers many areas, the final essay is a specific case study that deals with the visions of the Virgin given to a Californian named Maria Paula, which first started in 1989. This photographic essay recounts the development of a cult similar to that of the medieval period, but this time based in the Mojave Desert outside of California City. Objectively described by Lisa Bitel and illustrated with clarity and the eye of an artist by Matt Gainer, this essay does indeed show us that very little has changed in mankind, as recounted in the first essay in this collection. We strive to depict, in word and image, that which is beyond.

This collection of studies does not offer any finite conclusions, but hopefully it will provide the platform for future research into the subject.

LOOKING BEYOND

Visions, Dreams, and Insights in
Medieval Art & History

HANS BELTING

Saint Francis and the Body as Image:
An Anthropological Approach

THIS PAPER, although not a current research project of mine, illustrates issues in a debate that in Germany takes place under the heading "Bildwissenschaft." Anthropology in Europe means historical and cultural anthropology in the Kantian sense.[1] In my case, it serves as a method to explain images not by themselves but in relation to body and medium. Images need such media as canvas, print, or television to become visible. But they also need our bodies, bodies with a given size and an ever-changing range of perception. Images, in my view, always result from an interaction: a body interacts with artificial media, resulting in the transmission of images.

In 2000, I founded a research group of twenty-four pre- and post-doctoral fellows from seven disciplines, including historians and philosophers. Their common concern was images, not just as works of art, but images in texts and public media, both mental and physical. The participants of this Karlsruhe research group have since their foundation published three volumes of collected studies, one on the history and significance of technical images in the sciences and beyond, another on cross-cultural relations of pictorial practice and theory, including Asia, and, finally, a third volume on "Image and Body in the Middle Ages," edited by the medievalists in the same group.[2] When they asked me to contribute a short paper to the last volume, I initially declined, but when they showed me the cover of the book representing St. Francis of Assisi receiving the likeness of Christ as an image in his physical body, I was inspired to write the paper that follows.

I.

A few days after the death of Saint Francis, who died in his hometown on the fourth of October 1226 at the age of about forty-two years, the Franciscan minister-general Elias spread the news in a circular letter that "an incredible miracle" had been discovered when Francis' corpse had been examined. "Never before had one heard that such a miracle happened, except that of the Son of God, whose name is Christ."[3] Francis looked like "a Crucified Christ, because the five wounds which actually are those from the Crucifixion of Christ, appeared on his body." Some forty years later, and after endless disputes that nearly disrupted the Franciscan Order, the Franciscan minister-general Bonaventure was commissioned to write a new biography, wherein he coined the following formula: "The true love of Christ turned him into that image" (*in eandem imaginem transformavit*), when the saint had "on his body the physical effigy (*effigiem*) of the Crucified Christ, but not the one, as artists have it in stone and wooden panels. Instead, it was written in his limbs of flesh and blood by the hands of the

1. I contributed to this debate with a book on iconic anthropology. An English translation is due to appear with Columbia University Press as *Pictures and Bodies: Toward an Anthropology of Images*. Before its appearance two short summaries have been published, one in a volume of the Clark Institute Papers, the other as "Image, Medium, Body: A New Approach to Iconology" in *Critical Inquiry* (2005).

2. This paper is a translation of the original German essay "Franziskus, Der Körper als Bild" published in *Bild und Körper*

im Mittelalter, ed. by Kristen Marek, Raphaèle Presinger, Marius Rimmele, and Katrin Kärcher (Munich, 2006), 21–36..

3. *Helias Epistola encyclica*, in *Analecta Franciscana*, Vol. X (1926), 523. Cf. Chiara Frugoni, *Vita di un uomo: Francesco d'Assisi* (Turin, 1995), 119 to the beginning of the chapter on the stigmata. For a general review of the sources, see Chiara Frugoni, *Francesco e l'invenzione delle stimmate: una storia per parole e immagini fino a Bonaventura e Giotto* (Il problema delle fonti francescane) (Turin, 1993), 10 ff.

living God (*in carneis membris descriptum*)."[4] The saint's body had turned into the image of the Son of God and had therefore crossed the barrier that separated all the other pictures of Christ from the original. The Son of God, who in turn had been born as a *bodily* image of the *bodiless* God, was re-embodied in a contemporary body, even though in a very specific likeness. Francis had traces of Christ's suffering on his body, the wounds of the cross' nails on his feet and hands as well as the wound of the lance that had been driven into Christ's side.

Bonaventure's text was a masterpiece from both a theological point of view and that of the religious order's political agenda. In the meantime there had been a lot of cause for conflict. The stigmata had first been discovered on the corpse, and the Franciscan minister-general Elias immediately made this known (he also could have kept silent). However, rumors had already spread among Franciscans. Two years before his death, St. Francis had stayed on the mountain known as La Verna during a forty-day-long fast in honor of the Archangel Michael. His fellow monk and confessor Leo, who accompanied him, noted on an autograph by the Saint, which is still preserved at Assisi, that Francis had written this text at La Verna "after he received the impression of Christ's stigmata (*impressionem stigmatum*) on his body."[5]

These two inconsistent versions, that of Elias and that of Leo, were carefully combined in the first official biography of the saint, which a beleaguered Pope Gregory IX commissioned from the monk Thomas of Celano immediately after Francis' canonization in 1228. After this, Thomas wrote several more versions, but they did not put an end to the conflicts within the Order and neither did they appease the worried Official Church. It was only with the text that the Order in the Paris Chapter of 1266 commissioned Bonaventure to write, that an official version of this incredible biography was finally established. All other texts about the saint that had been written up to then were not only forbidden but were destroyed throughout Europe (*omnes legendae de beato Francisco olim factae deleantur*). There were some 1,500 monasteries in Europe around this time.[6] The problem of the stigmata was surely of an explosive nature.

If the miracle was at all to be believed, the stigmata lent themselves to two explanations that in principle excluded one another, although the Order tried hard to link them. Either the saint had stood under the *pressure of mimesis* through an extraordinary act of imagination, which he managed to make visible on his body, or else he had received the stigmata from an external source by divine *intervention* and therefore in a passive way. Different meanings apply in each case. In the first case, his "excessive imagination"[7] created empathy with the sufferings of Christ, to which all Christians were called. In the second case, however, a unique miracle had occurred that would exclude his fellow monks forever, although the desire for a union with the object of contemplation had been on the minds of many mystics who had not achieved this goal. The saint kept quiet about the condition of his body throughout his lifetime and even protected himself against curious eyes. He must have known that he had crossed a border that left everyone else behind.

2.

As a result, Franciscan texts were at a loss to explain the unexplainable. The same problem applied to pictorial renderings, from which one expected clarity about the condition of Francis' body. The question no longer was whether to depict (or to neglect) the stigmata or whether to represent them red, bloody, or in black.[8] Instead, the issue of representation had become an issue of the body as pictorial medium, as against panel painting or other pictorial media. A body on

4. S. Bonaventure, *Legenda Maior*, Ch. XIII in *Analecta Franciscana*, Vol. X (1941), 109

5. Frugoni 1993 (as in note 3), 137ff. and Frugoni 1995 (as in note 3), 125f.

6. Frugoni 1993 (as in note 3), 25.

7. See note 19.

8. Klaus Krüger, *Der Frühe Bildkult des Franziskus in Italien* (Berlin, 1992), *passim*, esp. 101ff. and 149ff. See also Dieter Blume, *Wandmalerei als Ordenspropaganda* (Worms, 1983) 13ff. on the Bardi life-panel, and 37ff. on the cycle of Assisi; see also Hans Belting, *Bild und Kult: Eine Geschichte des Bildes vor dem Zeitalter der Kunst* (Munich, 1990), 427ff. on the festive images of the Order.

which Christ's wounds had been imprinted, a transformed and marked body, could no longer be regarded as a trivial matter whenever the saint was to be represented. Rather, painters had to embrace the body's physical reality and individuality as an indispensable task, a new task at the time. They had to prove how Francis physically looked in his lifetime, instead of having him look like all the other saints in heaven. Another challenge facing the artists was the ambivalence, or dualism, in a body that simultaneously looked like Christ's body during the Passion, while still remaining a contemporary and living body. This dual perspective led to questions for which answers were still lacking. In tribal cultures, one would have dealt with a possessed body. Here, however, St. Francis was still himself while looking like someone else.

The body miracle upset the pictorial practice in that it forced the painters to render a body as a pictorial medium. But the visual arts of the time were not yet ready for the double and contradictory task of rendering a physical body lifelike and, at the same time, transforming it into an authentic representation of Christ. They had to deal with a "real picture" of St. Francis and, at the same time, with a picture of Christ that had surfaced in the body of the saint.[9] As artificial media, painting and sculpture here had to compete with the body as a natural or living medium for representation, a medium superior to their art. The triangular constellation of *image, body, and medium*, which I use in my theory of image anthropology, here appears in an unusual and yet exemplary way.[10]

The question of the body of Francis, in this instance, is a question of medium as well as image. In the case of this miracle, either a mental image emerged visibly on the body, or a human body had been chosen as the pictorial medium for a supernatural image. There are two ways in which our own bodies may be involved as medium: either as a medium for producing the mental images of imagination and memory, or as the focus of external images, when we perform or mask our bodies as pictures for whatever role; we are all, in that respect, voluntarily or involuntarily actors of ourselves. Usually, the one excludes the other. We can either abandon ourselves to inner images or make our body a visible picture, by means of posture, clothing, or facial expression. But in the case of St. Francis, external and internal are equated: the mental becoming visible.

The painters of the second generation solved this problem in a remarkable manner. The stigmata event had, until then, always been a narrative episode in Francis' life, but Giotto turned it into the official portrait of the saint. On his Pisan altarpiece in the Louvre (Fig. 1), as well as on the replica in the Fogg Art Museum in Cambridge (Fig. 2), the picture, instead of being a mere narrative, catches the moment in which Francis' body is changed. In the process of its becoming a picture, the saint's body, as in a double photographic exposure, reveals a picture of the suffering Christ. The angel of the vision, to whom I shall return, had already turned into a picture of Christ. Five rays of light indicate the transfer of the five wounds of Christ—who is represented in the six-winged angel—to the kneeling visionary. In this way, the representation visualizes picturing as incorporation. What Francis sees becomes part of his body. In this way the representation fills a gap still persisting in the texts on the miracle: it makes the visualization of an image (*Bildwerdung*) a visible embodiment (*Einkörperung*).

By the temporal aspect, an essentially *timeless* religious image includes us as witnesses of a metamorphosis, which seems to take place in front of our eyes: the event and the picture become inseparable. But a sharp line was kept in the assimilation with Christ: Francis looked like Christ only because he embodied his sufferings. He received the wounds that Christ had suffered on the cross on his own body. Francis himself, while looking at a picture, turns into that at which he looks. Through this much-debated miracle, a picture has become or obtained a living body. The question of the image, through this event, which was on everybody's mind, became a question of body. As such, the iconography of the saint transformed an image into a

9. On this issue, see Hans Belting, *Das Echte Bild: Bildfragen als Glaubensfragen* (Munich, 2005).
10. Hans Belting, *Bild-Anthropologie: Entwürfe für eine Bildwissenschaft* (Munich, 2001), 22ff.

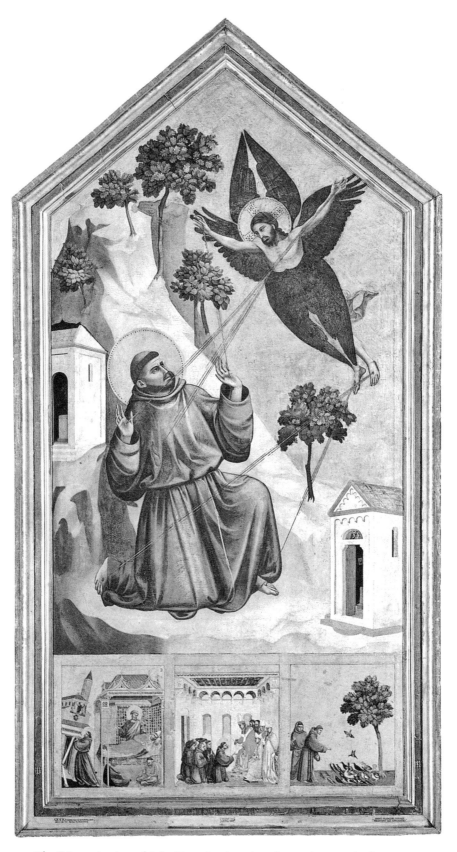

FIG. I. The Stigmatization of Saint Francis, altarpiece from Pisa. Musée du Louvre, Paris.

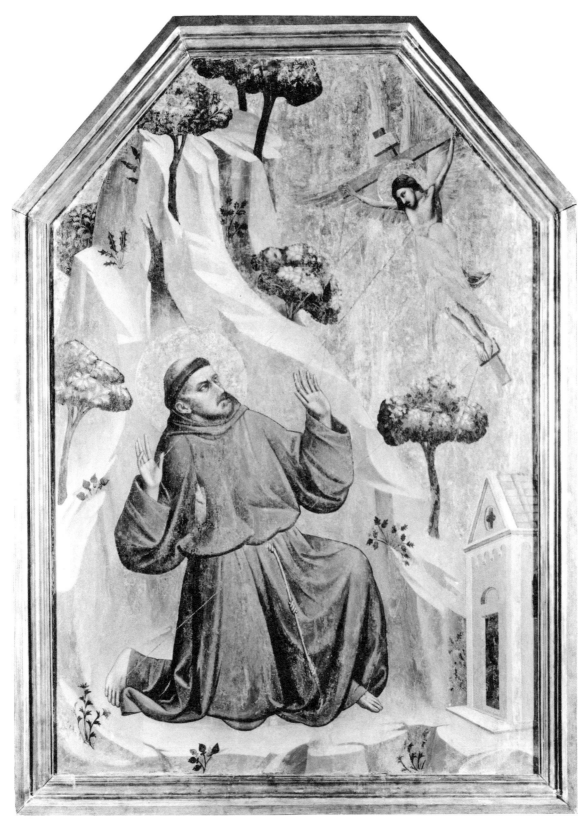

FIG. 2. The Stigmatization of Saint Francis, replica of the altarpiece from Pisa. Fogg Art Museum, Cambridge, Mass.

physical body. Giotto reacted to this miracle by super-imposing a physical (bodily) vision with a trans-physical (trans-bodily) view: the saint of Assisi remains in his own physical condition, while simultaneously turning into a pictorial medium of heavenly origin. And yet texts at the time strictly regulated the meaning (and the visual invention). The links to Bonaventure's text are obvious already in the fresco cycle at Assisi, where Giotto introduced the composition of the Louvre altarpiece for the first time (Fig. 3).[11]

3.

The miracle of La Verna put potentially dangerous psychological pressure on Francis' followers. If the saint had produced the stigmata himself through *mimesis* of the Crucified Christ, it would have been hopeless for his fellow monks to follow him in this prodigious effort. To defuse this conflict, Bonaventure could do no better than to declare Francis to be inimitable in that regard, and thus remove a threatening role model.[12] If Francis had succeeded in imitating Christ to such a degree, it would not be possible for anybody else to equal him.

But there was equal danger in idolizing the saint. In order to avoid it, the meaning of the reproduced stigmata had to be considered in more detail. In Christ's case, the New Testament mentions the stigmata only once, namely as branded signs that marked slaves in Antiquity, i.e., not as the wounds caused by the cross. In his letter to the Galatians quoted by Bonaventure, St. Paul identifies himself as one who carried such a sign with the words "I bear the marks (*stigmata* also in the Greek original) of my Lord Jesus on my body" (6:17). Here, he argues that Christians will be released from slavery of the senses and also from physical death. That is why the metaphor also means the prospect of eternal life. Bonaventure still remembers this meaning when, in his *Legenda maior* (LM), he calls the stigmatized Francis the chosen "servant of Christ"

(*servus Christi*) (13.4) and, in another passage, also speaks of the "bulla" or God's "seal," which imprinted itself as a promise on his body (4.11).

The "long legend" (*Legenda maior*), beside which Bonaventure also wrote a short biography for use at the service hours,[13] is interspersed with quotations from earlier texts that had been declared invalid in the meantime. The quotations from the Bible reach their highest density in the header about the "holy stigmata." It was with the stigmata that the author secured his bold exegesis with theological portents and predictions, in the way the Old Testament was used as the mirror of the New Testament. By speaking of the "angel-like man," he prepared us for the vision of the angel, who carried the picture of the crucified on him and would transfer it to St. Francis' body. The vision, as the author explains, was no transgression and no attempt to sinful curiosity. Instead, it prepared Christ's "faithful and wise servant," Francis, for God's will to choose him as his own simile (LM 13.1).

When the saint asked his brethren three times to open the Bible and to consult it like an oracle, they opened to the story of the Passion every time. Thus, he was prepared for his own death, which he wanted to suffer following Christ's example (13.2). The meeting with the angel consciously arouses an association with the Mount of Olives, in which an angel, on the eve of the Passion, fortified the fearful Jesus. Further on in the same chapter, the biblical association re-orients itself in the direction of Mount Golgotha—and therefore toward the crucifixion. The vision did not happen by pure chance on the Feast of the Cross (*exaltatio crucis*), which the church celebrated on the 14th of September. The text then says that Francis "saw an angel, descending from heaven, a seraph with six wings gleaming like fire." When coming closer, "the physical effigy (*effigies*) of a crucified man, whose hands and feet were stretched as a cross (*in modum crucis*) and were fastened to a cross, appeared between the wings."

11. Hans Belting, *Die Oberkirche von San Francesco in Assisi* (Berlin, 1976), 80 ff. and 234 ff.; as well as Blume (as in note 8), 37 ff.

12. Frugoni 1993 (as in note 3), 25 f.

13. Both versions can be found in the publication cited in note 4.

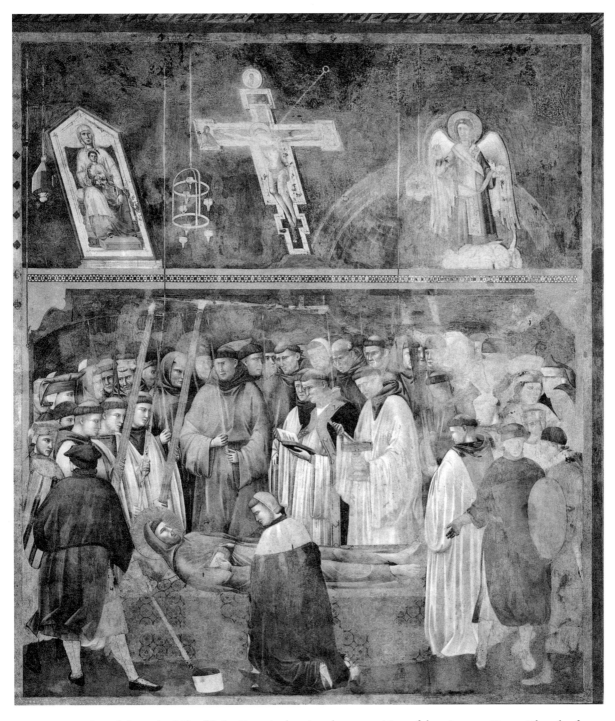

FIG. 3. Detail from the Life of Saint Francis showing the recognition of the stigmata. Upper Church of Saint Francis, Assisi.

Here, every word is carefully chosen, hence also the reference to the picture of a human carried by an angel (13.4).

Bonaventure's explanation of this event puts questions that the doubting reader will ask in the mouth of the saint. Francis was torn between joy and fright. With joy he saw himself "watched by Christ in the figure (*sub specie*) of a seraphic angel," but he was also filled with the pain of the suffering of Christ. The human "weakness of passion in this obscure vision did not match with the immortality of the seraphic spiritual being." The saint takes this as a hint that "the transformation into the likeness (*similitudinem*) of the crucified Christ would not happen in himself through the martyrdom of the flesh, but by the fire of the mind."

At that stage, the author emphasizes the enormous imagination of the Saint, which alone could produce such an incredible image. But, already in the next sentence, he warns us to question the supernatural personification of Christ. The vision he describes as "inconsistent," "left in his heart (of Francis) not only a wonderful ardor, but also imprinted the wonderful likeness (*effigiem*) of the signs (*signorum*) in his flesh" (13.3). The die was cast with this formulation. The stigmata were transferred to this body from the outside, but not entirely so, as we shall see. After this caution, Bonaventure begins to describe St. Francis carrying the nails of the cross, without hiding the fact that the affected parts of his body were bleeding. The wounds caused by the cross had, so to speak, become physical "signs," and as such they transformed this body into a picture of Christ.

The marks caused by the cross were indeed images of the wounds that Christ had suffered on the cross, but they still caused physical wounds on St. Francis. Every time the author talks about the body, he immediately applies it to pictures, and each time he speaks about pictures, he mentions the body. This ambivalence is a concerted program. Francis' wounds are images in two respects, because they are products of his *imagination* and appear on his body as *representation*. The author never cuts this knot between inside and outside imagery. The act of viewing and representing became one. Francis looked at the seraph's picture of Christ the same way he always looked at painted crosses (Fig. 4), and while looking he became an image himself. There emerges a mirror-like situation between angel and human viewer, who both bear the picture of a third person on themselves. The bodiless angel bears the image of a body, and the human Francis the image of another body. So they both become pictorial media, although of an unexpected type. Picture and body had never before identified in such way in Christian culture.

Further on in the chapter dealing with the stigmata, Bonaventure collects every available eyewitness account, as well as reports of the dream that endowed the miracle with heavenly authority. While describing how the saint was converted (*conversio*), he also introduced an argument of his own in order to explain the miracle as the highest achievement in the practice of the empathy of the gaze. In doing so, he turned to the dead saint and said directly to him, as if he wanted him to agree, that the "first vision you have experienced" already announced the miracle of La Verna. In the small, decayed chapel of San Damiano on the outskirts of his home town, the young Francis had suddenly felt literally spoken to by the painted crucifix—the same cross still found in Assisi today (Fig. 4). He experienced the image as a "talking image," through which the Crucified Christ became alive. This image, as Bonaventure explains, "consumed him with the sword of a compassionate pain," which was, through the "voice on the cross," deemed worthy of an answer (13.10).

"Within the seven visions of Christ's cross" during Francis' lifetime, Bonaventure considered the miracle of La Verna as the "peak of evangelic perfection" by which Francis became the perfect copy of Christ. He even brought the "secret book of Revelations" into play, which announced the signs of the living God (7:2) to identify Francis with the prophecy of the Apocalypse. With emphatic certainty, the last paragraph of the same chapter states that at the end of the life "the sublime likeness (*sublimis similitudo*) of the seraphic angel and the humble image (*humilis effigies*) of the crucified Christ were shown to you at the

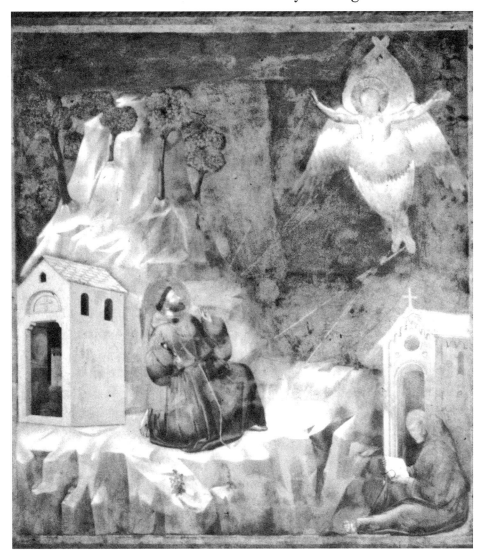

FIG. 4. Detail from the Life of Saint Francis showing the stigmatization. Upper Church of
Saint Francis, Assisi.

same time. It was the same image that lit you internally and that decorated you on the outside, like *the other* of the angel ascending to the sunrise, that marked on you the signs of the living God" (13.10).

4.

Here it is possible to speak of an *iconization of the body* as well as of the *incorporation of an image*. Two complementary aspects catch the eye: the body turns into the medium for an image, and we do not see an *image of the body*, but an *embodiment of an image*. The saint's transformation does not merely depict a human body (if not the human in Jesus), but in a human condition depicts the Crucified in his Passion. There is an anthropocentric shift in the idea of "body," as it was later to be accepted in the Renaissance, although the theological idea still prevails.

St. Francis' body became *a medium* (for an image) through the miracle. As such, he is defined *through an image*, while still remaining *a mortal body* in flesh. The stigmata are expressions of the fight of death in a living body and turn him into a *living icon*. While the Crucifix

represents the double nature of Life in Death, Francis represents in a mirror-image Death while still alive.[14] The iconography of the crucified Christ had changed significantly in the arts of Francis' lifetime. The suffering body had replaced the crowned victor over death.[15] The saint of Assisi followed this iconography. The reciprocal relationship of picture and body is a topic in the saint's biography. It starts in the moment of conversion, which happened in the ruined chapel of San Damiano. Here, the young patrician fell down in prayer "before the image (*ante imaginem*), when a voice, speaking to him from the cross, was heard from his bodily ears" (LM 2.1). In the respective scene in the fresco cycle at Assisi, a pendant cross, typical of its time and used to deepen the live effect, leans forward in such a way as if talking directly to the praying youth (Fig. 4).[16] In the same cycle, a citizen of Assisi convinces himself of the authenticity of Christ's wounds on St. Francis in the funeral ceremony.[17] It is impossible not to see the analogy between the physical (that of Francis) and the painted image (that of the cross above him), the body and the cross on the choir's beam that bends towards the viewer. Bonaventure spoke of this encounter when he says that Francis "had the marks of the future glory on himself and indicated his own resurrection, after his holiest flesh was imprinted by the image (*effigies*) of the passion of the Christ" (15.1). *Effigies* is usually a term used for a physical likeness, while *imago* is the term for a representation, or in other words, for a painted likeness.

5.

The narrative of the stigmata, which at Assisi immediately precedes the saint's death, offers a new, groundbreaking iconography, which is linked to Giotto's name (Fig. 3). The same iconography appears on the altarpiece at the Louvre, which Giotto signed (Fig. 1), as well as on the Fogg Art Museum panel (Fig. 2).[18] Both versions depict the miracle as an ongoing event. The metamorphosis of the earthly body takes place, so to speak, in front of our eyes. The saint in the event turns into a picture. The ruined dwelling, in which he spent forty days, nestles into the steep slopes of the mountain.

The new iconography is highlighted in two important changes that are inter-related. Instead of the beautiful angel's head, which had been customary in most depictions of the vision, the crucified Christ appears between the wings of the seraph. The angel has turned into an image of Christ, who shows the wound on his naked torso. The visibility of the hands and feet of the crucified Christ (which on the altarpiece is expanded by the loincloth in the storm of the heavenly vision) reveals a new idea of the event. The second change consists in connecting by rays Christ's five wounds with the same number of wounds on the saint's body. White rays on the fresco at Assisi and golden ones on the Louvre panel disclose the manner of creating the stigmata. Rays had already been used before, but now they suddenly have a function. Like tracks or channels they transmit the wounds between the heavenly source and the earthly recipient, whose body thus mirrors the original.

With these changes, new questions arise. What was transferred here, real wounds or mere pictures of them? Did the wounds hurt when they touched a body of flesh and blood? The answers to these questions lie in the rays' course, which transmit the angel's likeness to the earthly body. They run mirror-like in Giotto's early works in such a way that the left hand of Christ is connected with St. Francis' right hand, and vice

14. Belting 2005 (as in note 10), 93 ff. (The two natures on the cross).

15. Belting 1990 (as in note 8), 398 ff.

16. Joachim Poeschke, *Die Kirche San Francesco in Assisi und ihre Wandmalerei*, (Munich, 1985), Pl. 147, and Blume (as in note 8), 32 ff., 37 ff., and 64.

17. Poeschke (as in note 13), Pl. 184, and Blume (as in note 6), Fig. 82.

18. See J. Gardner, "The Louvre Stigmatization and the Problem of the Narrative Altarpiece" in *Zeitschrift für Kunstgeschichte* 45 (1982), 217 ff.; Krüger (as in note 8), 173 ff.; Frugoni 1995 (as in note 3), 145 f. and Frugoni 1993 (as in note 3), 210 ff.; Philippe Faure, "Corps de l'Homme et Corps du Christ: l'iconographie de la stigmatisation de S. François en France et Angleterre (XIVᵉ et XVᵉ siècles)," in *Micrologus* I (*I Discorsi dei Corpi*), (Paris and Turnhout, 1993), 327–346.

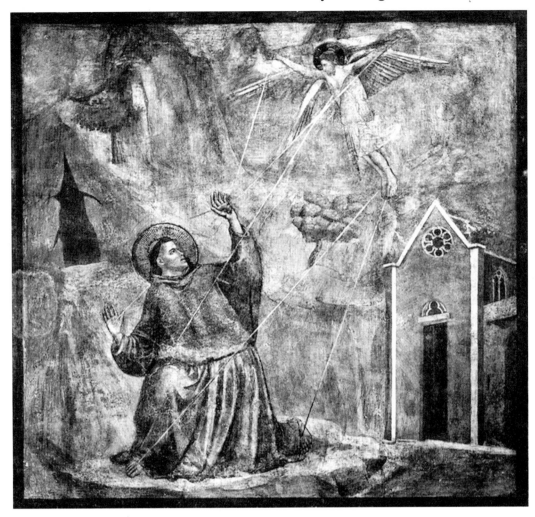

FIG. 5. The Stigmatization of Saint Francis. Santa Croce, Bardi Chapel, Florence.

versa. Giotto corrects this concept only at the Bardi Chapel of Santa Croce at Florence, where he gives the mirror correspondence up for the benefit of a direct one-to-one correspondence of body to body (Fig. 5).

Such subtle differences reveal debates that, at that time, still continued to question the miracle. Contemporary texts set out to prove "that the stigmatization, as a real event, was not a result of powerful imagination (*vehemens imaginatio*), but the outcome of a miracle which only could be performed by the power of God." [19] Such an explanation still follows Bonaventure's line, but Chiara Frugoni, who was the first to investigate the rays, comes to another conclusion. Prior to Giotto's Florentine version (Fig. 4), as she maintains, the Assisi type does not aim at a bodily transfer of wounds, but indicates a vision. "While the saint is painted as a body in the flesh, Christ-Seraph remains an immaterial and ethereal vision." So Giotto may have indicated an inner "image of the saint, which he found reflected in the mirror in which he looked at himself." [20] In other words, he "was reflected in the picture which had been created by his ardent love." The mimetic force in his look materialized in his physical body. Thus the mystic vision as a mirror experience would completely eliminate the distance between the Crucified Christ and the viewer.

19. Krüger (as in note 8), 176f. 20. See note 18 with the citation.

Bonaventure speaks in fact about the ardor of imagination, but he quickly and somewhat desperately adds that physical likeness (*effigies*) of the Crucified, as a result of an unceasing meditation, imprinted itself into the saint's flesh. The two versions, which differ significantly from each other, may be two different readings of the same event. On the one hand, they emphasize the mirror experience of imagination and, on the other, a physical intervention from above. The contemporary debate, as expressed in Giotto's two variants, revolved around the *body as picture*. It is obvious that interpretations diverged. The body, to sum up, represents a pictorial medium in a double sense. It served, on the one hand, as a medium for mental images that finally surfaced on its skin. On the other hand, it carried a physical picture that was projected on it from Heaven. The *iconization* of the body, much as the *incorporation* of an image, is the same transformation in reverse direction. It involves image, body, and medium in changing configurations.

But the rays also have another reference, which I should like to add by way of speculation. In Giotto's times, the visual rays, which supplied the visual appearance (*species*) of everything we see in perception, caused a hot debate. The so-called "perspectivists" among scholastics, such as Roger Bacon, discussed visual rays as responsible for the transmittance of everything visible to the eye.[21] Thus, did Giotto link a supernatural vision with the discussion of perception? Does the point-by-point transmission of the wounds transform the body of the saint into a giant eye? It is daring to connect the religious event with the optical theories of the day. St. Francis' rays do not link material surfaces with the eye's surface. But the debate on visual perception may have found a religious echo. I have recently studied the controversies around perception that arose from the translation of an Arab text by Alhazen, alias Ibn al-Haytam, which carried the Latin title *Perspectiva*. One controversy concerned the correspondence between points on an object seen with points in the eye of the spectator. Giotto certainly was well aware of the difference between objects as they are and as they appear (*species*). He did not invent the Renaissance perspective, but he introduced, in my view, the act of visual perception into his art. In this respect, visual rays would connect the visible world to the physical organ of vision that would "suffer" from the force of the incoming light. My speculation would be confirmed by the power of St. Francis' gaze, which at the same was a passive respondent of an image that imprinted itself not only on his eye but on his whole body. The reciprocal symmetry between wounds of the subject seen and wounds of the one who is looking, connected as they were by rays in a corresponding number, invites us to give this speculation a certain credence. Roger Bacon's optical treatises in fact relate the working of God's power on the faithful with the direction on the central visual ray arriving in the eye without refraction.

But it is clear that, if my speculation has any value, it rests on the basic distinction between theology and art. Giotto's project was different from Bonaventure's task. He had to visualize an event and, to do so, he was on his own. Much as he had to follow the theological line, it would not solve his own problems as a painter. Iconography, in my view, is not just applied content and even less the transfer of pre-existing texts, but remained to a considerable extent the domain of the visual intelligence of the artists. Powerful artists were, and still remain, visionaries in their own right.

21. Katherine Tachau, "Vision and Certification in the Age of Ockham," in *Optics, Epistemology and the Foundation of Semantics*, (Leiden, 1988), 3 ff. and 113 ff.; Michael Camille, "Before the Gaze. The Internal Senses and Late Medieval Practices of Seeing" in *Visuality Before and Beyond the Renaissance: Seeing as Others Saw*, ed. by Robert S. Nelson, (Cambridge, 2000), 197–223.

ERIC PALAZZO

Visions and Liturgical Experience in the Early Middle Ages

(for Herbert L. Kessler)

THE THEME of the conference at which this paper was presented focused on the phenomenon of visions in the Middle Ages, and as such it opened up numerous research avenues for the historian of the liturgy, as well as for the art historian who wished to extend his inquiry to materials normally investigated by liturgical historians. Recently, several important publications have contributed to our understanding of the history of visions and the visionary experience in medieval Christianity, particularly in the period between the thirteenth and the fifteenth centuries. There is no need to stress the importance of Peter Dinzelbacher's work on visionary literature or that of Barbara Newman's, which have proven to be seminal in many respects.[1] In a recently published synthesis, this last author significantly outlined the principal historical, anthropological, and epistemological dimensions of visionary culture in the medieval West.[2] Her work provides an ideal theoretical framework in which to carry out research on visions in the Middle Ages, as

well as providing a synthetic bibliographic and historiographic overview.

In art history, many authors have investigated the complex relationships between medieval images and visions, and more generally, between images and dreams in the culture of the medieval West.[3] One can refer here in particular to Jeffrey Hamburger's work on religious art produced in female monastic circles in the second half of the Middle Ages,[4] or to some of Herbert Kessler's publications in which he clearly establishes and demonstrates the links that existed between the theology of images and visions.[5] In art history, specific iconographic themes such as images and dreams,[6] or the Mass of St. Gregory, have attracted the attention of scholars such as Carolyn Walker Bynum, who has recently provided fresh interpretations.[7] Generally speaking, these art historical studies have emphasized the richness of women's visions in the context of female monastic circles in the second half of the Middle Ages.[8] Hans Belting, for his part, has underlined

1. I should like to thank Marie-Pierre Gélin for translating this article. Among the important studies by Peter Dinzelbacher, see *Vision und Visionsliteratur im Mittelalter* (Stuttgart, 1981); B. Newman, *God and the Godesse: Vision, Poetry and Belief in the Middle Ages* (Philadelphia, 2003); *Micrologus*, Vols. v and vi, "La visione e la sguardo nel Medio Evo," and "View and Vision in the Middle Ages," (1997–1998).

2. B. Newman, "What Did It Mean to Say 'I Saw'? The Clash between Theory and Practice in Medieval Visionary Culture," *Speculum* 80 (2005), 1–43.

3. P. Dinzelbacher, *Himmel, Hölle, Heilige: Visionen und Kunst im Mittelalter* (Darmstadt, 2002).

4. J. Hamburger, *Peindre au couvent: la culture visuelle d'un couvent médiéval* (Paris, 1997).

5. H. L. Kessler, *Spiritual Seeing: Picturing God's Invisibility in Medieval Art* (Philadelphia, 2000), especially "Real Absence:

Early Medieval Art and the Metamorphosis of Vision," 104–148. See also C. Hahn, "*Visio Dei*: Changes in Medieval Visuality," in *Visuality Before and Beyond the Renaissance: Seeing as Others Saw* (Cambridge, 2000), 169–196 (I should like to thank Cynthia Hahn for giving me this reference and for sharing her ideas on medieval visions with me).

6. See *Träume im Mittelalter, Ikonologische Studien* (Stuttgart-Zürich, 1989).

7. C. Walker Bynum, "Seeing and Seeing Beyond: The Mass of St. Gregory in the Fifteenth Century," in *The Mind's Eye: Art and Theological Argument in the Middle Ages*, ed. by J. Hamburger and A. M. Bouche (Princeton, 2006), 208–240, and her recent study, *Wonderful Blood: Theology and Practice in Late Medieval Northern Germany and Beyond* (Philadelphia, 2007).

8. C. Walker Bynum, *Jeûnes et festins sacrés: les femmes et la nourriture dans la spiritualité médiévale* (Paris, 1994).

the conflict that exists between images and visions, because of the way in which both were used by Church authorities throughout the Middle Ages and beyond.[9]

It may be noted that the history of the liturgy is not completely absent from research carried out on visions, images, and dreams and, more generally, on visionary experience in the medieval period. Jeffrey Hamburger, for example, has undertaken an in-depth study on certain artistic works in relation to the history of visions and the liturgical and devotional practices of nuns of the later Middle Ages.[10] Historians of the liturgy, however, have paid virtually no attention to the relationship between visions, the visionary experience, or even dreams, on the one hand, and the liturgy and its ritual practices, on the other. This essay does not pretend to fill that gap, but wishes to address it by taking an interdisciplinary look at the links between visions and the liturgical experience in the early Middle Ages. It must be acknowledged that the history of the liturgy provides only limited material for a deeper reflection on visions and the ritual practices of the medieval Church. There are, for instance, very few references to visions, or even allusions to the theme in general, in sacred texts of the liturgy, such as the prayers of the Mass.[11] Similarly, there is a quasi-systematic absence of reference to visions in texts that describe liturgical rituals—*ordines*, pontificals, customaries, or ordinaries—which is hardly surprising, since these are normative liturgical texts. There are, however, a few exceptions, such as a passage from the eleventh-century customary from Fruttuaria, which mentions a statue of Christ that started moving during a Good Friday ceremony, animated by the faith and devotion in the monks' gazes.[12]

The choice of the early medieval period in this essay, between the eighth and the eleventh centuries is justified by the creation and development—in particular during the Carolingian period—of a more emotional, affective liturgy that gave rise to ritual practices of a devotional type.[13] An important connection can be seen between these new liturgical practices and the occurrence of visions that result more or less from this new devotional liturgy. It is also possible to see how the theological content of this devotional liturgy, which was centered on emotions and affectivity,[14] could be used to explain its close links to the visionary experience. In the first part of this essay I shall look at the efficacy of liturgical rituals, and in particular devotional practices, on the visionary experience. Here I shall draw on a variety of texts where reference is made to liturgical practices that in turn gave rise to, or provoked, a vision. In the second part, I shall examine the liturgical contextualization of some accounts of visions, and their theological and anthropological meaning in relation to visions. In the conclusion, I shall outline the importance of liturgical aids, that is to say, objects used in the liturgy or closely associated with it, and the role they could play as mediators, as liturgical and theological "signs," in the realization of a vision. And, finally, I shall look at the nature of the liturgy, taken here as a "sign" in the theological sense, a sign that allowed the visionary phenomenon to take place.[15]

Ritual Efficacy and the Visionary Experience

Here I shall attempt to define how the ritual practice could provoke and generate a vision and, in order to do so, I shall briefly present a few accounts of individual liturgical practices and their links to visions.

9. H. Belting, *Pour une anthropologie des images* (Paris, 2004), 100–101.

10. As in note 4.

11. A. Blaise, *Le vocabulaire latin des principaux thèmes liturgiques* (Turnhout, 1966).

12. H. L. Kessler, "Turning a Blind Eye: Medieval Art and the Dynamics of Contemplation," in *The Mind's Eye* (as in note 6), 413–439, 413.

13. E. Palazzo, "Les pratiques liturgiques et dévotionnelles et le décor monumental dans les églises du Moyen Age," L'emplace-

ment et la fonction des images dans la peinture murale du Moyen Age, "Actes du 5e séminaire international d'art mural," *Cahier* 2 (Saint-Savin, 1993), 45–56.

14. See P. Nagy, *Le don des larmes au Moyen Age* (Paris, 2000) and E. Palazzo, "Foi et croyance au Moyen Age: Les médiations liturgiques," *Annales HSS* (1998), 1131–1154. On emotions in the early Middle Ages, see B. Rosenwein, *Emotional Communities in the Early Middle Ages* (Ithaca, London, 2006).

15. Prophetic visions will not be included here, see P. Strinemann, "L'illustration du commentaire d'Haymon sur Ezéchiel.

Inspired by the models of saints' lives, some texts establish a direct link between liturgical practices (mostly of a devotional nature and very often limited to reciting prayers or meditating on psalms) and visionary experiences. These texts emphasize the strength of an individual's faith, which is usually expressed through a "liturgical" or devotional exercise, and this, in turn, allows a vision to take place. In a long poem written in 826 in honor of Louis the Pious, Ermoldus Nigellus recorded how Theutrammus, custodian of the church of Notre-Dame in Strasbourg, used to spend day and night in prayer at the altar of the Virgin. "This is why," he says, "favored by divine grace, this holy man often deserved to catch a sight of angels," and many other similar visions followed.[16]

One night, after singing the psalms and the hymns, as he was about to lie down on his bed, he saw the whole church lit up by a sudden brightness, like the rays of sunshine on a beautiful day. He got up from his bed, in order to look for the source of this light radiating from the sanctuary. The wings of a bird resembling an eagle covered the altar ... its beak was made of gold, its talons were made of a material more precious than gemstones, its wings were the color of the sky; from its eyes shone forth such a bright light that the priest, dazzled, could not look at it. He admired the bird, its wings, its body, and above all its eyes. The eagle stayed there a long time, until the cock crowed for the third time, calling the priests to the office. Then it took its flight, and the window facing him opened miraculously, allowing it to fly out.

After it had disappeared in the sky, the light also disappeared, thus signaling that it was a divine bird. Another time, the same priest had another vision, the miracle of which was related to me by the clerks of the church. He was, as was his custom, singing the psalms in front of the altar of the church, spending the night praying to God. The clerks who were that night responsible for the vigil were keeping the hours of the divine office nearby. But suddenly the rooftop of the church was shaken by thunder and by a violent wind. The clerks fell to the ground, prostrating themselves in the nave, overcome with terror. But the priest, calmly, extended his hands towards heaven and tried to discover the meaning of this commotion. He saw the vault of the holy house open and three men, bathed in light, descend from it majestically.

A passage from the Life of St. Hariolfus, founder of the monastery of Ellwangen in Germany (around 764) is similar. It was composed in the middle of the ninth century at the monastery by the monk Ermenrich and deals with the efficacy of the prayer offered by the monk Grimold, who was the custodian of the abbey church, and of the vision that he experienced as a result. One night, while he was praying at the back of the church, Grimold saw the two martyrs, Sulpicius and Servilianus, whose relics had been transferred to the abbey of Ellwangen, appear in front of the main altar. The martyrs dragged a monk who had wronged the monastery to the front of the altar. They forced him to prostrate himself, and the Virgin, who was sitting enthroned at the base of the altar, ordered the

Paris, BN, lat. 12302," *L'Ecole carolingienne d'Auxerre. De Muretach à Remi, 830–908* (Paris, 1991), 93–117.

16. "Ermold le Noir, Poème sur Louis le Pieux et épîtres au roi Pépin," in *Les classiques de l'histoire de France au Moyen Age*, édités et traduits par E. Faral (Paris, 1964), 193–195. The original reads: Idcirco meruit, caelesti munere fretus, angelicos cives cernere saepe sacer. Nocte quidem quadam, psalmis hymnisque peractis, cum cuperet membra fusa locare thoro, templum namque videt subita clarescere luce, ut solet accendi sole serena dies. Surgit ab usque thoro, causam cognoscere mavult, lumine quo tanto fulgeat alma domus. Forte aquilae similis pennis praetexerat aram, non tamen in terris gignitur haec volucris; rostrum erat ex auro, gemma preciosior unguis, et color in pennis aethere fusus adest, ast oculis lux ipsa micat. Stupet ipse sacerdos, nec valet obtutus tendere contra suos. Miratur volucrem, pariter miratur et alas, lumina praecipue, corpus et omne simul. Tamque diu residet, cum galli garrula terna vox resonat, fratres excitat officio. Inde levans, miranda fides, se sponte fenestra obvia recludit, laxat et ire foras. Ipsa abeunte polos, pariter lux ipsa recessit; apparet civem inde fuisse Dei. Tempore nempe alio crevit didascalus idem, mira satis cecinit quae mihi turba fratrum. Psalleret ut solito praefatae sedis ad aram, expendens tenebras, corde petendo Deum, discipuli secum, quorum custodia noctis, servabant signi tempora pervigiles, ecce repente sonus tonitrus, ventusque perurguens. Concutit instanter ardua tecta domus. Discipuli cedidere solo, trepidique per aulam corpora prosternunt mensque timore fugit, intrepidusque sacer palmis ad sidera pansis scire cupit, causae quid sonus ille ferat. Aspicit alma aperire domus mox tecta sacratae, intrantesque videt tres quoque honore viros.

bad monk to be flogged. In his analysis of this vision and of another one that the same monk, Grimold, had later, Jean-Marie Sansterre, proposed that this vision referred to a material image of the Virgin.[17] I believe that it was the efficacy of Grimold's intense devotional prayer that provoked the visions in the choir—the same space where the official liturgy took place. These texts convey the belief that the person who prays with fervor and devotion will see his faith increase and thereby experience visions and sometimes even witness miracles. The efficacy of the ritual act has to be seen here as the source, and at the same time the way to experience visions. In the Carolingian period, the most relevant text to examine the power of devotional liturgical prayer on visions (where such material images as statues play a part) is undoubtedly the description in St. Maure of Troyes' prayer, which is found in a sermon by Prudentius of Troyes (who died in 861), composed probably between 843/45 and 861.[18] Although many doubts still remain about the date and authenticity of this text,[19] it clearly describes a type of devotional prayer and a resultant vision that is very much in the general spirit of the Carolingian period. In this text, the author describes three images (a Madonna and Child, a Crucifixion, and a representation of God in Majesty), which were found in the crypt in the Troyes cathedral, and which were venerated by the saint. The saint's ceaseless prayer in front of these images during solitary devotional practices generated visions of a miraculous nature: "I have often heard," said the saint, "the child crying on his mother's knee and the

young man moaning on the cross and the king thundering on his throne, but who would yet extend a gold sceptre to me in a friendly way." Trying to account for these "cries," she goes on, "It is not to the realm of nature, but to that of the miraculous that one can attribute the fact that a piece of dry wood should wail or moan in order to remind to our faith the awe-inspiring sacraments and to strengthen them in the minds of the faithful." The message is straightforward: faith in the sacraments must increase in each of us through devotional practice and, if they do, then visions may ensue.

In the eleventh century, Peter Damian records the story of a clerk who, to satisfy his own personal devotion, recited the *Ave Maria* daily in front of the altar of the Virgin. Following this diligent practice, the Virgin appeared to the clerk, and asked him to have several special Masses said according to a very precise weekly rhythm. These were to be in her honor as well as that of all the angels and saints.[20] The additions to the Life of St. Ives, which was written at the end of the eleventh century, record how the relics of the English saint's three companions were brought to Slepe.[21] According to the hagiographical narrative, a soldier suffering from a mortal fever went into that church with a friend. Having prayed, he fell asleep in front of the altar and was cured during a dream, which he then recounted to his friend. He saw himself, fully armed, alongside his companions, fighting a large army:

> eventually, in my vision, the *iconia* of the most holy Ives, which you can see standing on this altar, came to me and threw all my weapons to the ground with

17. J.-M. Sansterre, "Attitudes occidentales à l'égard des miracles d'images dans le haut Moyen Age," *Annales HSS* (1998), 1219–1241, 1232–1233.

18. A. Castes, "La dévotion privée et l'art à l'époque carolingienne: le cas de sainte Maure de Troyes," *Cahiers de civilisation médiévale 33* (1990), 3–18 (translation from Castes). The original reads: ... frequenter audivi, et puerum in matris gremio vagientem, et juvenem in cruce gementem, et regem in solio terribiliter intonantem, sed mihi virgam auream amicabiliter donantem ... Non naturae, sed miraculis ascribendum est, si ad recolenda fidei nostrae mirifica sacramenta, et ea in mentibus fidelium roboranda lignum aridum, gemitum edidit aut vagitum.

19. See Sansterre, "Attitudes occidentales" (as in note 17), 1231.

20. Migne PL 145:564–565, see Palazzo, "Les pratiques liturgiques" (as in note 14), 1145.

21. Jean-Marie Sansterre, "*Omnes qui coram hac imagine genua flexerint* ... La vénération d'images de saints et de la Vierge d'après les textes écrits en Angleterre du milieu du XIe aux premières décennies du XIIIe siècle" *Cahiers de civilisation médiévale 49* (2006), 257–294, 265 (translation by Sansterre). The original reads: ... Postremo autem veniens ad me, sicut visione videbam, sacratissimi Yvonis iconia, illa videlicet quam super altare illud stare conspicares, uno impetu arma mea dejecit ... Quum vero de occipite meo loricam iconia tulisset, proculdubio omnem a me pariter per beati Yvonis merita, quod fatendum est, medendi satis perita tulit infirmitatem ... Sit igitur nomen Domini benedicendum in secula, qui talem tantamque beato Yvoni contulit gratiam, ut per suam suo nomini dicatam iconiam tam inopinatam queat restituere sospitatem.

a single blow ... by removing the hauberk from my head, the *iconia* certainly also removed the whole disease through the merits of the blessed Ives, which, it must be proclaimed, are most skilled at healing ... Therefore let the name of the Lord be blessed in all eternity, for he has granted the blessed Ives such grace, and in so plentiful a manner, that he can unexpectedly restore health through an *iconia* consecrated in his name.

Also in the eleventh century, Gauzlinus, abbot of Fleury, ill and feeling close to death, had himself transported into the crypt of the church of Châtillon, when he was on his travels. There, in front of the altar, he lay down on the floor, prayed, and confessed himself in the presence of several images (statues, mural paintings):

As he felt himself already called to Christ, he had himself carried into the crypt of the Mother of God, where the image of the Mother of the Lord can be seen, sculpted in wood, on a very fine altar alongside the representation of the Assumption of our Savior, and there, as if he was already appearing before the tribunal of the stern judge, lying on the floor, he entrusted by his prayers to Jesus Christ, not only himself but also the flock he had, by the grace of God, ruled until his dying day.

In this narrative of Gauzlinus' last moments, no vision is mentioned, but it seems interesting to note how the author of the text is careful to emphasize the same ritual contextualization of the scene, where the power of prayer, which can generate visions, is associated with material images.[22] A passage from a poem by Hrosvitha of Gandersheim about the origins of the monastery of the same name, allows us to assess how the liturgy and its associated ritual practices, such as private prayer, influenced the visionary experience.[23] Composed, between 968 and 975, Hrosvitha's poem about the convent monastery of Gandersheim testifies to the strength of the female monastic vocation, its aptitude for efficacious liturgical prayer, and its capacity to receive visions. Twice, at least, Hrosvitha's text mentions the liturgy, or certain devotional practices. These are found at the heart of the poem, and are clearly related to a vision. Oda, the founder of Gandersheim, convinced her husband to have the monastery built in a rural setting. Abbess Hathumoda started building the church, which unfortunately had to stop because of a shortage of stones. Hathumoda then increased her pious efforts in order to attract the Lord's grace and to allow work to start again. With that in mind, the abbess directed the power of her prayer to God, and this illustrates the devotion of a woman who was ready to increase the intensity of her prayer so that the church could be completed:

And surrounded by the daughters entrusted to her

22. André de Fleury, *Vie de Gauzlin, abbé de Fleury*, texte édité et traduit par R.-H. Bautier et G. Labory (Paris, 1969), 145. The original reads: Jamque sese sentiens ad Christum vocari, in criptam Dei genitricis se deferri precepit, in qua idea ipsius matris Domini ex ligno honestissime are supereminet insculpta, cum ipsius nostri Redemptoris humane assumptionis forma, quo ac si jam positus ante tribunal districti judicis, humi prostratus, se suosque quos usque in ultimum diem, Deo disponente, gubernaverat, sub obtentu orationis Jesu Christo commendat.

23. Hrotsvita de Gandersheim, *Oeuvres poétiques, Xᵉ siècle*, édition et traduction par M. Goullet (Grenoble, 2000), 205–227. The original reads: Et subiectarum multis illi sociatis, coelitus auxilii petiit solamina ferri, ne non perfectum remaneret opus bene coeptum. Nec mora, caelestem quam quaerebat pietatem sensit adesse sui votis promptam misereri. Nam Ieiunando sacris precibusque vacando cum prostrata die quadam iacuit secus aram, vocis mansuetae iussu compellitur ire atque sequi volucrem, quem iam progressa sendentem cerneret in saxi cuiusdam vertice magni. Ipsaque complectens animo praecepta parato egreditur, dictis credens ex corde iubentis; ac cementariis secum sumptis bene gnaris perrexit citius, quo duxit spiritus almus, doncee ad coeptum pervenit nobile templum. Illic candidulam vidit residere columbam in designati praecelso vertice saxi. Quae mox expansis volitans praecesserat alis, temperat atque suum non sueto more volatum, posset ut aereos directo tramite sulcos cum sociis grandiendo sequi virguncula Christi. Cumque columba locum volitans venisset ad illum, quem nunc non sterilem magnis scimus fore petris, descendens terram rostro percussat illam, sub cuius lapides latuerunt aggere plures. Quo certe viso Christi dignissima virgo emundare locum socios praeceperat ipsum, et molem terrae circumfodiendo secare, tellurisque gravem fodiendo scindere molem. Quo facto, praestante pia bonitate superna, copia magnarum monstratur multa petrarum, unde monasterii cum templo moenia coepti omnia materiam possent traxisse petrinam. Hinc magis atque magis toto conamine mentis factores templi domini sub honore sacrandi instabant operi mox nocte dieque recenti. See E. Palazzo, "La liturgie de l'Occident médiéval autour de l'an mil. Etat de la question," *Cahiers de civilisation médiévale* 43 (2000), 371–394, 393–394.

care, she beseeched heavenly assistance, so that the building which had been begun should not remain unfinished. Immediately she felt the divine kindness she was calling upon was granting her wish. One day, during her fasts and holy prayers, as she was prostrated in front of the altar, she heard a gentle voice ordering her to stand up and to follow the bird she would see perched on a large rock on the path outside. And she, wholeheartedly accepting this order, went away with a deep belief in the words she had heard; taking with her skilled stone cutters, she hurried where the Holy Spirit was leading her, to the site where the noble church had been begun. There, she saw a white dove, perched on top of the rock; spreading its wings, the bird flew ahead of her, adjusting its flight in an unusual way so that the young virgin of Christ and her companions were able to follow its path in the air in a straight line. When the dove flew down in the place where great rocks are still today to be found in abundance, as it landed, it struck with its beak the ground under which was hidden a quarry. Seeing this, the very illustrious virgin of Christ ordered her companions to clear the bushes and to dig to reveal the abundance of huge stones that would furnish the required material to complete the monastery and the church. Then, with growing ardor, the workmen of the temple dedicated to the Lord applied themselves to their task night and day.

All of these texts, which vary in origin and nature, underline the strength and effectiveness of liturgical prayer and devotional practice, which can provoke visions and generate the visionary experience. In the majority of these cases, the emphasis on a strong liturgical contextualization can be noted, as well as the use of solitary prayer, usually at night and in front of the main altar in the church, during sleep, or at times of illness or closeness to death. The importance given to the props, which are generally liturgical objects and

images, and which act as vehicles for the vision, must also be noted.

As Jean-Marie Sansterre has shown in his exploration of images of the saints and the Virgin in England of the tenth and eleventh centuries, these objects are also associated in one of St. Godric's (d. 1170) many visions.[24] The Life of this saint, which was composed in Durham by Reginald of Coldingham, records that Godric had a vision while chanting the psalms in front of the crucifix. He saw Christ and the cross bending forward and bowing down several times, in a quasi-liturgical gesture. Following this, a child issued from Christ's mouth and went over to the wooden image of the Virgin, which extended her hands to him and kissed him before taking him onto her lap to warm him. Several hours later, the child re-entered Christ's mouth. When told of a similar vision by a friend, Godric concluded:

> human faith cannot doubt that the Son of God, who underwent death for us, can instil the breath of life into whatever he chooses. Indeed, he who just now instilled the vital breath into the wood obviously demonstrates through the wonderful mystery of such a great sign that he still lives and that he sees everything.

The animation of the crucifix after what was clearly an efficacious, to say the least, liturgical and devotional exercise by Godric and his friend brings to mind other miraculous visions involving crucifixes or other images of Christ and of the Virgin.[25] In these examples, it may happen that this type of vision did not necessarily occur after devotional rituals that required long prayers or intense psalmody. This is the case in the vision recorded by Adhemar in his chronicle:[26]

> And the aforementioned monk Adhemar, who lived in Limoges, at the monastery of St-Martial, with his

24. Sansterre, "Omnes qui coram" (as in note 21), 280–281. The original reads: … nec fides humana potest diffidere quod Dei filius, qui pro nobis mortem subiit, cui voluerit spiritum vitae possit infundere. Qui enim ligno infudit nunc vitalem spiritum, ipse semper se vivere et cuncta se videre, manifeste ostendit per tanti signi prodigiale mysterium….

25. See the liturgical devotional prayers against anxiety, A. Wilmart, "L'office du crucifix contre l'angoisse," *Ephemerides Li-*

turgicae 46 (1932), 421–434. On the Iconography of the Crucifix and the Crucifixion in the early Middle Ages, see L. Nees, "On the Image of Christ Crucified in Early Medieval Art," *Il Volto Santo in Europa: Culto e immagini del Crocifisso nel Medievo, Atti del Convegno internazionale di Engelberg* (13–16 settembre 2000), Istituto Storico Lucchese (2005), 345–385

26. *Adémar de Chabannes, Chronique*, introduction et traduction par Y. Chauvin et G. Pon (Turnhout, 2003), 257–258. See also,

uncle, the famous Roger, having woken up in the middle of the night, as he was looking up to the stars outside, saw a great cross in the south, high in the heavens, as if planted in the sky, with the image of the Lord hanging from the cross and weeping into a great river. But the one who saw this vision, utterly astounded, could do nothing but shed abundant tears from his eyes. Thus he saw, for half of the hour of the night, the cross with the image of Christ, all bloodied and the color of fire, until the vision disappeared from the sky. This vision he has always hidden in his heart until writing these lines, and the Lord is his witness that he did see these things.

Even though this happens outside a strictly liturgical context, this type of vision, like the others mentioned here, relies on the medium of the image. In this case it is the crucifix; this is used to highlight the complex relationship between the material image and the deeper nature of what it "represents."[27] This type of narrative also calls to mind the miracles that took place around the statue of St. Foy at Conques (Fig. 1). Jean-Claude Schmitt has shown how such miracles place the object at the center of a complex relationship between vision narratives and image rituals.[28] Several authors

J.-M. Sansterre, "L'image blessée, l'image souffrante: quelques récits de miracles entre Orient et Occident (VIᵉ–XIIᵉ siècle)," Les images dans les sociétés médiévales: pour une histoire comparée. *Bulletin de l'Institut historique belge de Rome* 69 (1999), 113–130, 126–127; Jean-Marie Sansterre, "Visions et miracles en relation avec le crucifix dans les récits des Xᵉ–XIᵉ siècles," *Il Volto Santo in Europa: Culto e immagini del Crocifisso nel Medioevo*. Atti des Convegno internazionale di Engelberg (13–16 settembre 2000), Lucca, 2005, 387–406; and S. Lipton, "'The Sweet Lean of His Head': Writing about Looking at the Crucifix in the High Middle Ages," *Speculum* 80 (2005), 1172–1203. On the two natures of the crucified Christ, which was based on the theological ideas of such Carolingians as Amalarius of Metz and Hrabanus Maurus, see H. L. Kessler, *Neither God nor Man: Words, Images, and the Medieval Anxiety about Art* (Freiburg i.Br/Berlin/Vienna, 2007), 34–35: "In that meditation fire inflames if you ponder these simply according to the letter. Here therefore scrupulously understand the face of your Creator and Redeemer, look into the face of your Christ, and with the entire gaze of your heart and body, with your entire mind and emotion, and especially with a humbled spirit concentrate upon that image as if Christ were right now dying on the cross and ponder in you heart him whose image and whose titulus this is, because he is God and Man," Hrabanus Maurus, Migne PL 112: 1425 (translation by Kessler). The original in *Ademarii Cabannensis Chronico, Corpus Christianorum—Continuatio Mediaevalis* CXXIX, ed. by P. Bourgain (Turnhout, 1999), 165–166, reads: "Et supradictus monachus Ademarus, qui tunc cum avunculo suo inclito Rotgerio Lemovicas degebat in monasterio Sancti Marcialis, experrectus in tempesta noctis, dum foris astra suspiceret, vidit in austrum in altitudine celi magnum crucifixum quasi confixum in celo et Domini pendentem figuram in cruce, multo flumine lacrimarum plorantem. Qui autem haec vidit, attonitus, nichil aliude potuit agere quam lacrimas ab oculis profundere. Vidit vero tam ipsam crucem quam figuram crucifixi colore igneo et nimis sanguineo totam per dimidiam noctis horam, quousque celo sese clauderet. Et quod vidit semper in corde celavit, quousque hic scripsit, testisque est Dominus quod haec vidit."

FIG. 1. Reliquary Statue of St. Foy of Conques. Gold repousse, Carolingian, late 9th or start of the 10th century. Treasury of the Church of Ste-Foy, Conques (photo: Photothèque du CESCM, Poitiers).

27. Sansterre, "L'image blessée" (as in note 26).

28. J.-C. Schmitt, "La légitimation des images autour de l'an mil," *Le corps des images: Essais sur la culture visuelle au Moyen Age* (Paris, 2002), 167–198. See also T. Dale, "Romanesque Sculpted Portraits: Convention, Vision and Real Presence," *Gesta* 46/2 (2007), 101–119, 109–111.

have highlighted the fact that these different situations, which do not necessarily relate to liturgical practices, put the individual's gaze at the heart of the visionary experience. Thomas Lentes, for instance, has shown the central role played in the ritual of gazing in liturgical piety, where a medium such as a crucifix or other images is used.[29] This merging of images of a liturgical nature and the ritual practice of a devotional type is characteristic of the narratives I have mentioned and analyzed here, and tends to back up the idea that art sustains the vision.[30] Artistic supports appear as elements of mediation that allow the vision, on condition that the latter should be first generated by an act of faith through prayer. This can also, on occasion, be accompanied by a "gazing ritual," thus demonstrating the influence and the consequences of liturgical efficacy on the visionary experience.[31]

The Different Forms of Contextualization in Vision Narratives

In the second part of this paper, I shall focus on what I call the liturgical contextualization of vision narratives in the Middle Ages. In the many accounts of visionary experiences and the practice of the liturgy, several aspects of liturgical contextualization appear frequently. Alongside references to the actual forms taken by rituals, which specify for instance whether the person is chanting the psalms or reciting prayers, details such as the liturgical time and space are also found. These details recur with some frequency in the vision narratives and raise the question of the liturgical *mise-en-scène*, which is necessary to describe the visionary experience. They also suggest that, in order to allow the vision to take place, it seems necessary that it should take place in a liturgical context, both in terms of time and space, which encourages ritual practices.

Liturgical contextualization in vision narratives thus seems to be a relatively indispensable feature for the occurrence and fulfillment of visions. This always follows devotional practice, usually by a saint, whose prayers and faith provoke the vision. Beyond the efficacy of prayer, it seems to be required for the person who experiences the vision to be located in an appropriate and favorable spatio-temporal liturgical context. In a limited number of visions, the liturgical contextualization is at the center of the vision narrative. This is for instance the case for Robert, a monk of Mozac, who, in the tenth century, had a vision of the cathedral of Clermont-Ferrand built by Bishop Etienne II. As both Monique Gallet and Dominique Iogna-Prat have pointed out, the *Visio monachi Roberti* describes an ideal church, straight out of a biblical dream rather than an apocalyptic vision. In this account, the liturgical space does more than simply create a liturgical context for the visionary experience. It is the main object of the narrative, and it constitutes its core.[32]

Peter the Venerable's *De miraculis*, written in the twelfth century, teems with vision narratives, some of which emphasize the liturgical context. In Book I, the miraculous apparition of Stephen, nicknamed "the White," is recounted. At the abbey of Cluny, the monk Bernard Savinelle left the night office and found himself on the stairs leading up to the dormitory, where he had a vision:

> One night, while they were celebrating the night vigils in the church in honor of God, he left the choir where he was chanting with the others and headed for the dormitory. As he was climbing up the stairs, he suddenly found himself facing Stephen—commonly known as "the White"—a former abbot of the monastery of St-Gilles who had passed away from this life a few days before.[33]

29. T. Lentes, "As far as the eye can see …: Rituals of Gazing in the Late Middle Ages," *The Mind's Eye* (as in note 6), 360–373. On the importance of the expression of vision on medieval art, see recently, Thomas Dale, "Romanesque Sculpted Portraits: Convention, Vision and Real Presence," *Gesta* 46/2 (2008), 101–119.

30. Kessler, "Real Absence" (as in note 5) and, *idem, Seeing Medieval Art* (Peterborough, 2004), 165–180.

31. Newman, "What Did It" (as in note 2), 15. See also the spe-

cific case of the *libelli precum*, J. Hamburger, "A Liber Precum in Sélestat and the Development of the Illustrated Prayer Book in Germany," *The Art Bulletin* 73 (1991), 209–236.

32. M. Goullet et D. Iogna-Prat, "La Vierge en majesté de Clermont-Ferrand," in *Marie: Le culte de la Vierge dans la société médiévale* (Paris, 1996), 383–405.

33. *Pierre le Vénérable: Les merveilles de Dieu*, présenté et traduit par J.-P. Torrell et D. Bouthillier (Fribourg, 1992), 111–112.

The liturgical contextualization of the vision clearly concentrates here on the time and space of the ritual, which is interrupted by the spatial and temporal wanderings of Bernard Savinelle. In Peter the Venerable's text, liturgical contextualization can refer to specific elements of the liturgy, such as processions. This is the case of a monk of this monastery who saw demons advancing in a procession:

> Thus a brother told me that he had seen a vast crowd of demons go through the building called the *cella* of the novices. One night, before matins, he was lying on his bed meditating on some verse from the psalms. While everybody was sleeping, he saw this abominable college enter through the door located next to his bed. Dressed up as monks and with their hoods up, mimicking the outward forms of religion, they were advancing in a single file with much apparent solemnity.[34]

Another monk, Benedict, saw a crowd dressed in white as he was about to die. Once again, the narrative includes important elements of liturgical contextualization:

> He would chant the psalms ceaselessly and, night and day, would meditate on the Sacred Scriptures. For this reason, he always had a glossed Psalter with him, for he would chant with extreme attention and devotion, and not superficially as some do.... He would spend the whole day chanting and meditating, and

the night in prayers and vigils.... Even then, he was not inactive, for his eyes seldom stopped crying and his tongue never stopped chanting. During almost all his life, his habit was to exhaust further his body, already broken by countless austerities, by wearing very rough hair shirts.... Having thus spent his life in the constant practice of virtue, he came to his last days after a short illness. It happened during Eastertide.... He was lying on his bed, with his lamp full of oil, that is to say with his conscience full of the witness of his virtues, and he was waiting for the Bridegroom, ... And then he saw a multitude of beings clad in white coming forward and filling the whole space of the house little by little.[35]

Brother Enguizo's vision, as related by Peter the Venerable, takes place in the church at night, while the monk was sleeping in the space consecrated for the liturgy:

> A noble knight, named Enguizo, came to Cluny during my time to take the monastic habit and, during his early days, so that he would get used more easily to the practice of divine things, he was given for his service in the church a place where he could rest in the church itself. One night, while he was sleeping there, he saw one of his former comrades-in-arms, named Peter de la Roche, after a castle located in the Geneva diocese. This knight had died some time before on his way to Jerusalem, but the brother here mentioned knew nothing of his passing away. He had not even

The original in *Petri Cluniacensis Abbatis: De Miraculo libri duo*, Corpus Christianorum—Continuatio Mediaevalis LXXXIII, D. Bouthillier ed., (Turnhout, 1988), 37–38, reads: "Is nocte quadam dum fratres in ecclesia nocturnas vigilias et Deo laudes decantarent, de choro ubi cum aliis psallebat egressus, dormitorium petiit. Cuius gradus cum conscenderet, repente Stephanum, qui vulgo Blancus vocabatur, olim monasterii Sancti Egidii abbatem, qui ante paucos dies de vita excesserat, obvium habuit."

34. *Ibid.*, 130–131. The original reads: "Unde fuit illud quod frater quidam michi retulit, vidisse se innumerabilem demonum turbam per domum illam que cella novitiorum dicitur transeuntem. Iacebat autem nocte quadam ante matutinos in lecto, et nescio quid de psalmis secum meditabatur, cum ecce dormientibus cunctis, conspicit nefandum illud collegium in monachorum spetiem commutatum, ab ostio quod capiti suo imminebat procedere. Qui capitiis indutis, religionis scema simulantes, seriatim, et quasi cum multa gravitate incedebant."

35. *Ibid.*, 140–144. The original reads: "Psalmodia indeficiens,

scripturarum sanctarum nocte dieque meditatio. Propter quod et psalterium glosatum semper circumferebat, quoniam psalmos non perfunctorie, ut quibusdam moris est, set summa cum intentione, atque devotione cantabat.... Diem totam psallendo, meditando, noctem vigilando et orando, peragebat.... Sed erat etiam ipsa sessio non ociosa, quando rare oculi a lacrimis, numquam vero lingua a psalmodia cessabat. Innumeris confectum suppliciis corpus, toto pene vite sue tempore ciliciis asperrimis exasperare conserveverat.... Is igitur in omni virtutum exercitatione vite sue cursu peracto, corporis incommoditate brevi ad extrema deductus est. Fuit autem tempus illud paschale, quo transacta ieiuniorum quadragesima purgatiorem gregem suum, et velud maturiorem segetem Christus inveniens.... Iacebat vero in lecto, et lampadem plenam oleo, id est conscientiam plenam virtutum, testimonio habens, Sponsum expectabat, et ut arbitror, cum Apostolo dicebat.... Respiciens ergo vidit infinitam multitudinem albatorum advenire, et paulatim omne domus illius spatium complere."

received a hint of this death yet. As he was already asleep, as I was saying, this comrade appeared to him under the appearance he had had in the world. [36]

In this instance, the liturgical contextualization specifies the spatial location of the vision, as is the case in this other vision recounted by Peter the Venerable about an experience he himself witnessed while traveling in Rome:

> Early in the pontificate of the Lord Pope Eugenius, I went to Rome to visit him, and to visit our common mother the Roman Church. Once there, I received the hospitality of the cardinal see of Santa Maria Novella, which is built near the antique temple of Romulus. There, one night while I was resting, Lord William, a man of venerable life who had left this world recently, appeared to me in a dream, standing next to me while I was sleeping. And since it is necessary for the following account, let me tell briefly who he was, what his life was, and furthermore how he left this life. [37]

As Jean-Claude Schmitt has reminded us, antique tradition liked to locate and record carefully visions that occurred during offices. [38] As I have just shown with some of the passages from Peter the Venerable's *Book of Miracles*, visions acquired an importance and a significance that was much greater when they took place in a liturgical context.

In the eleventh century, Otloh, a monk from St-Emeramm in Ratisbon, composed a *Liber visionum*, which records twenty-three visions, the first four of which are personal. [39] Born in Bavaria around 1010, Otloh first became a monk at the monastery of Tegernsee, then moved to Hersfeld before coming to

St-Emeramm in Ratisbon. According to Jean-Claude Schmitt, Otloh represents an example of spiritual conversion that follows the model of St. Jerome by abandoning the reading of classical authors to embrace fully instead the reading and meditation of scripture, following the Christian path. Otloh had a significant influence in his time, especially over his brethren at the monastery of Ratisbon, where he was master of the novices. He was also in charge for a while of the monastery's necrology, and, most importantly, he developed and reinforced the links between St-Emeramm and the movement of monastic reform from Gorze. All the visions recorded by Otloh were received from witnesses he judged reliable, sometimes the beneficiaries of the visions themselves. The four personal visions of the Ratisbon monk are all dreams, which guarantee the authenticity of his own authority. In one of his dream-visions, Otloh had fallen asleep in the choir of the abbey church of Tegernsee and there he saw Christ appear to him and praise him for his chanting of the psalms. Christ encouraged him along the path of spiritual perfection, through liturgical practice, and in particular the recitation of the psalms and the quality of chanting. In another dream, dated to 1025 and which also occurred in Tegernsee, Otloh had fallen asleep in the church choir. Once again, the importance of the "liturgical" localization of the vision, the sacred space *par excellence*, is clear. In this particular location and liturgical context, the monk has a vision of an old man, God or rather Christ, coming out of a corner of the altar just as the monk was about to incense it. In this story of Otloh's visionary experience, the liturgical contextualization does not concern only time and

36. *Ibid.*, 258–260. The original reads: "Venerat Cluniacum meo tempore conversionis causa nobilis vir Enguizo nomine, et ut primordiis suis erga divina magis exerceri assuesceret, locum quiescendi ad serviendum ecclesiae, in ecclesia suscepit. Ubi dum quadam nocte dormiret, videt quendam olim commilitonem suum, qui Petrus dicebatur de Rocha, quod castrum in Gebennensi diocesi situm est. Defunctus vero fuerat iam dictus miles in Ierosolimitano itinere, ante non multum temporis, set eius obitum supra nominatus frater penitus ignorabat. Nondum enim vel tenuis fama mortis eius, ad eum pervenerat. Visus est ergo ei ut dixi iam dormienti, in spetie illa qua eum in seculo videre consueverat."

37. *Ibid.*, 252–253. The original reads: "in primordiis pontifica-

tus domni pape Eugenii, ad visitandum tam ipsum quam communem matrem romanam ecclesiam, Romam adii. Illuc perveniens, apud cardinalatum Sancte Marie Nove, quod iuxta antiquum Romuli templum constructum est, hospicium suscepi. Ibi dum nocte quadam quiescerem, ecce vir venerande vite domnus Willelmus qui nuper de vita excesserat, michi dormienti visus est in somnis astare. Et quia sequenti narrationi hoc necessarium est, quis iste, vel cuius vite fuerit, quo insuper eventu e vita migraverit, breviter inserendum est."

38. J.-C. Schmitt, *La conversion d'Hermann le juif: Autobiographie, histoire et fiction* (Paris, 2003), 110.

39. *Ibid.*, 111–114.

space, but also a very specific liturgical gesture, that is to say, the censing of the altar. Following this, Christ addressed the monks who were taking part in the ceremony, upbraiding them for their vices, then "beyond the choir," he encouraged the laity to persevere on the path of righteous behavior.

At the end of the Early Middle Ages, the most prolific writer in terms of vision narratives where the liturgy is given a prominent role was undoubtedly Rupert of Deutz. Jean-Claude Schmitt has called Rupert of Deutz' twelfth-century accounts of visions a veritable visionary exegesis.[40] Indeed, it will be clear that Rupert of Deutz' texts also present a synthesis of the themes developed in vision narratives of the Early Middle Ages where great importance is given to liturgical contextualization. For Rupert of Deutz, as for other authors before and after him, the liturgical contextualization of the vision narrative constituted an element essential to the visionary experience, as the liturgy *was an integral part* of the vision, and it was even its main *sign* and its main *medium*.

Rupert of Deutz' life and his abundant theological works are well known and have been studied extensively. It is therefore not necessary to deal with them at any length in this essay. His vision narratives can be found in various texts, some of which are theological and exegetical commentaries. Most date from the first half of the twelfth century. In almost every case, Rupert insists that he had visions which took place during dreams and which have an extremely important spiritual significance.[41] Commenting on the Song of Songs, he relates several night visions he had, and which offer a powerful spiritual exegesis of several passages of the Biblical text. In a passage that strongly recalls some of the vision narratives from the Early Middle Ages, the emphasis is clearly on the efficacy of liturgical prayer for the visionary experience:

Besides, about this trembling [referring to the vision preceding this one in Rupert's commentary], this divine and healthy trembling, she [the young girl] recounted this event which had happened to her: in a church, she was gazing on an image of the Savior attached to the cross, high up, where it is customary to show it to the people who pray and adore. As she was looking at it with more intensity, the image seemed to her to be alive, presenting a royal face, with radiant eyes and a noble appearance. Then the Beloved deigned to detach his right hand from the gibbet and with a magnificent expression on his face, he made the sign of the cross over the one who was gazing at him. This was not a vain vision; on the contrary, to the one who was having the vision, the meaning of such a great miracle was immediately clear. For afterwards, as she had immediately awoken, just as the leaf on the tree trembles when a strong wind shakes it, she was for some time shaken by a sweet trembling in her little bed, a trembling which was really pleasant and sweet in the extreme.

The richest and probably the most famous of Rupert of Deutz' visions, dated to around 1100, concerns the theological theme of the Trinity and, in this account, the place given to liturgical contextualization is most prominent:

As I was lying half-asleep in my bed, I saw a great light like the sun spread above me, while I heard the

40. *Ibid.*, 119–138.

41. *Ibid.* See also the important contribution of F. Boespflug, "La vision-en-rêve de la Trinité de Rupert de Deutz (v. 1100): Liturgie, spiritualité et histoire de l'art," *Revue des sciences religieuses* 71 (1997), 205–229. The translations from Rupert visions are from Jean-Claude Schmitt and François Boespflug. The original in Migne PL 168:1592 reads: "... somno me dederam hora solitae orationis, cum ecce video semivigilans in ipso lectulo magnam lucem velut solem super me incumbentem, et audio sonans in ecclesia signum, ut fieri solet dum statutam convocamur add orationem. Surgere et ad orationem currere mihi visus sum. Fiat mihi secundum voces aut verba quae audivi, canente uno conventu multorum, quos nescivi, in una parte ecclesiae psalmum quinquagesimum, 'Miserere mei, Deus,' et alio conventu in alia parte ecclesiae psalmum vicesimum sextum 'Dominus illuminatio mea,' stante maligno adversario contra me in angulo in ingressu oratorii: quem ut vidi, exprobravi, velut exprobrare solemus quempiam larvalem aspectum signo totius faciei potius quam verbis ... oratione omissa, quam consueveram, somno cum tristitia me reddi, cum ecce tenuiter dormienti similiter, ut pridie visum est signum ad orationem commoveri. Surrexi et ad ecclesiam cucurri, et ecce quasi pro solemnitate Domini multa ecclesiam compleverat turba diversorum ordinum, maxime autem monachorum, quodam venerandae canitiei episcopo celebrante solemnia missarum. Multa ad offerendum quasi post evangelium, quando solet offerri sanctum sacrificium, ascendebat processio utriusque sexus personarum venerabilium."

bell of a church ring, as it is customary when we are called to one of the regular hours of prayer. It seemed to me then that I was getting up and running towards the church. May it happen to me according to the words and utterances I heard then, coming from a choir composed of many people I didn't know and who, in one part of the church, were singing Psalm 50 *Miserere mei Deus*, while another choir in a different part of the church was singing Psalm 26 *Dominus illumination mea*. The cunning adversary was standing opposite me at the entrance to the sanctuary, in a corner; when I saw him, I started to revile him, as one does when one sees a ghost, with an expression of all my face rather than with words … and having neglected to say the prayer I was in the habit of saying as the day was breaking or at the next dawn, I turned back to sleep with sadness when, my sleep being light again, it seemed to me that, like the day before, a bell was being rung to call to prayer. I got up and ran to the church; and it was filled with a crowd of people of various orders but mostly monks, as for a festival of the Lord. A bishop with venerable white hair was celebrating the mysteries of the Mass. A great procession of venerable people of both sexes was walking up towards the altar for the offertory, as it is customary to do after the reading of the Gospel. I ran towards it too, as if to beg for charity from these offerings.

After this description of the setting of the vision, Rupert of Deutz' emphasis is very much on specific elements of the liturgical ritual, almost as if it was described in an *ordo*. The author receives a vision of the Trinity in the form of three venerable people standing near the right-hand corner of the altar. Jean-Claude Schmitt compared Rupert of Deutz' dream to a "conversion dream," which was a benchmark in his life. As can be easily imagined, the theme of Rupert's dream has very strong theological connotations, as has been shown by François Boespflug. This last author also noted that in the account of this vision, which takes place in a state of semi-sleep—and therefore in a state of semi-consciousness—Rupert goes into the choir of the church twice. It was as if he was following an imaginary route—one which he had followed many times in his assiduous day-to-day liturgical practice. François Boespflug also carefully noted the theological im-

plications of the liturgical elements in the dream (the procession, the offerings during the offertory…). I believe that these ritual elements, which assert a strong liturgical contextualization of the vision, fully belong to the vision itself and that they constitute its normal frame. In this regard, it is interesting to note that this vision takes place in a state of half-wakefulness, very similar to a dream, where it is difficult to know what "reality" is. Yet in this dream Rupert describes elements of liturgical practices as if he were writing down an *ordo* and as if he were witnessing a real ritual. In other words, not only is the description of the ritual in a vision narrative to be considered part of the vision, but the ritual itself also needs to be seen as an integral part of it. The confusion between dream and reality is maintained in the rest of Rupert's account, and he writes in the last part:

> For, as I was led to see, I know that I jumped out of my bed and that I ran straight to the church along the path normally used by those who are awake; and once the vision was over, as I wanted to follow the people who were leaving and as I was not allowed to do so, I noticed I was naked and completely without clothing; and hurrying back to the place I had come from, I got back into my bed and suddenly woke up.

Conclusion

Although this brief contribution is incomplete, I hope that I have shown how worthwhile it can be to scrutinize various types of early medieval texts about visions in search of a liturgical dimension to the visionary experience. It seems obvious that in the literature and thought of the Early Middle Ages, liturgical efficacy and in particular the efficacy of prayer of a devotional nature is a decisive factor. It is this which brings about visions and these are born out of the contemplation of liturgical objects. In the narratives, the strength of an individual's faith as expressed through prayer is at the heart of the whole process that leads to a vision. In these it is possible to detect some common features of a strictly liturgical nature, such as solitary prayer, generally taking place by night, within a sa-

cred space (very often the choir of the church or sometimes a more "intimate" location, such as the crypt) and considerably long prayers leading the faithful to the threshold of what could be described as a sort of spiritual trance that allows the vision to take place and to "reveal" itself to the one who is so intensely practicing the devotional ritual. In this sense, the vision could almost be considered as equivalent to the sacramental revelation that takes place during "normal" liturgical rituals. The vision belongs to the supernatural, just as the liturgy partakes of the mystery, the sacred and sometimes sacramental nature of the rites celebrated. The line is obviously tenuous between "normal" and "paranormal," between dream and reality, between natural and supernatural, to use the categories proposed by Barbara Newman in her analysis of the visionary culture of the medieval West.[42] In the above analysis of the vision narratives it is clear that it was important to "locate" visions with strong theological connotations in the space and time of the liturgy, but also to see the necessary link between vision and liturgy. It is possible to conclude that the liturgy is also an integral part of the vision, for the liturgy itself can be seen as a supernatural vision. In this regard, Rupert of Deutz' vision of the Trinity offers a wide range of possible comparisons between liturgy and vision. It is very clear that for Rupert the exact description of the liturgical elements that "frame" the vision are *already* a part of the vision itself. In this narrative, as in almost all the other accounts, the importance of the gaze, or of the "gazing ritual," to use the expression coined by Thomas Lentes,[43] is conspicuous. This should not surprise us, as the gaze is intimately connected with the phenomena of visions and visionary experiences.

The liturgy is an essential component of the vision, and is very much present in accounts of visionary experiences, not only because it creates a familiar spatial and temporal frame or because it belongs to the "literary" *topos* of this type of texts, but above all because there is a natural link between the liturgy and visions from a strictly theological perspective. Both belong to the general category of the *signum*, that is to say the theological concept of the sign, so important in Christian medieval theology. This was of course influenced by the Augustinian theory of the sign, which Irène Rosier-Catach has recently discussed in relation to the efficacy of ritual language.[44] Liturgy in itself is a "sign" and it is also made up of "signs," be they vocal, linguistic, visual, or spatial, etc., and these need to be reached and understood so that it is possible to "see" the reality of the church's mysteries. By their very nature, these signs can be perceived by the senses, through the liturgy and also through the vision. For those signs that make up the liturgy, the invisible is the sacramental dimension, while those that make up the vision have to do with spirituality and are only visible in the vision.

According to Augustine's theory, as Irène Rosier-Catach reminds us, every "thing" can become a sign, but only if it is perceived as such. It is the possibilities afforded by the vision that allow the liturgy to be perceived as a sign, and that make it the core of the visionary experience. The liturgy, much like the vision, underlines the strongly operative character of the sign, which allows one to see and to perceive certain invisible things relative to the theological mysteries of the liturgy, or to the dogmatic functions of some visions, like the vision of the Trinity by Rupert of Deutz. The "liturgical vision" allows a "thing" to be perceived as a sign, and therefore to transform this "thing" into an invisible sign. Furthermore, according to this theory, an interchangeability between the "sign" and the "signified," between the form and the content, exists in the sign. The sign is what the senses perceive and the texts above have shown how important the senses are in accounts of visions "located" within liturgical time and space. This is exactly the effect produced both by the liturgy and by the vision, as well as by what I have called the "liturgical vision."

I shall conclude by referring to the exceptional richness of the double composition of an early eleventh-century glossed Psalter from Reichenau (Bamberg,

42. Newman, "What did It Mean" (as in note 2), 3–4.
43. Lentes, "As Far as the Eye" (as in note 29).

44. I. Rosier-Catach, *La parole efficace: Signe, rituel, sacré* (Paris, 2004), 481–491.

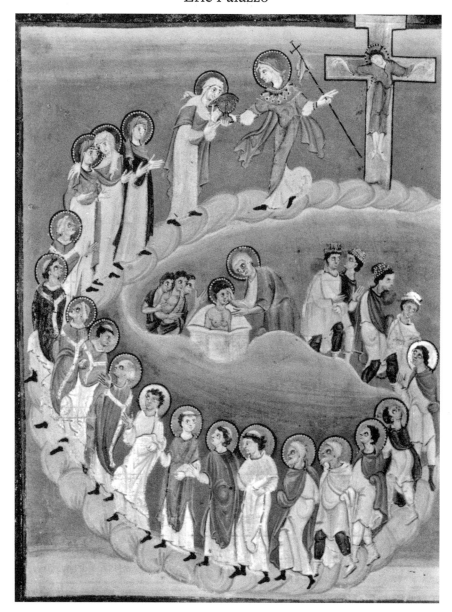

FIG. 2. Liturgical Procession in Canticum Canticorum, Reichenau School, Late tenth or early
eleventh century. Bamberg, Staatliche Bibliothek, Ms. Bibl. 22, fol. 4ᵛ (photo: Photothèque du
CESCM, Poitiers).

Staatliche Bibliothek, Ms. Bibl. 22, folios 4ᵛ and 5ʳ)
(Figs. 2–3).[45] This double composition presents an ex-
tremely complex iconography and offers a complete
visual treatise on Ottonian political theology, which
is almost entirely based on the liturgy of baptism and
the Eucharist. The essential idea that the liturgy is a

"sign" and a vision in its own right is strongly rep-
resented, as is the idea that it allows the "direct" vi-
sion of the Church members with Christ at the end of
times. It is possible to see an ideal procession of the
Church on earth on the first folio (4ᵛ). This consists
of various members of society, stretching from bap-

45. G. Suckale-Redlefsen, *Die Handschriften des 8. bis 11. Jahrhunderts der Staatsbibliothek Bamberg,*
(Wiesbaden, 2004), n° 63, 85–88.

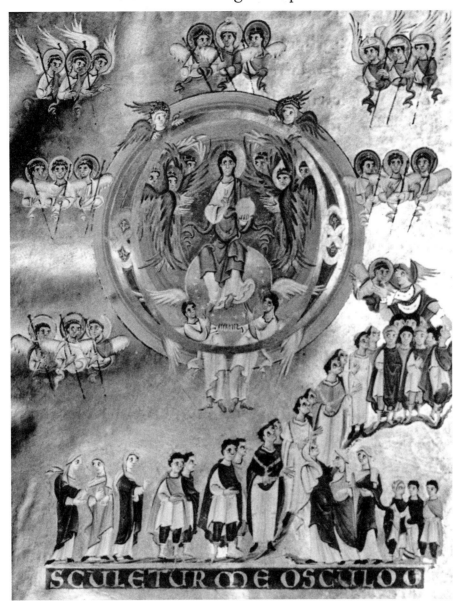

FIG. 3. *Maiestas Domini* vision in Canticum Canticorum, Reichenau School, late tenth or early eleventh century. Bamberg, Staatliche Bibliothek, Ms. Bibl. 22, fol. 5ʳ (photo: Photothèque du CESCM, Poitiers).

tism to the communion granted by Ecclesia through the image of the crucifixion. This terrestrial journey is made possible by practicing the sacraments within the Church, and it is the only guarantee that in the afterlife the faithful will be able to receive the vision of Christ in majesty and to contemplate him on a face-to-face level. In other words, beyond everything that this composition expresses in complex ways, there is also the idea that the liturgy *is* itself a vision. The procession of the earthly Church goes on in heaven, in the afterlife, within the heavenly Church. What is also underlined, however, is that the liturgy is the "sign" *par excellence* that allows and makes possible the vision, the visionary experience, which in this case is the face-to-face contemplation by the members of the Church of Christ in Majesty.

LISA M. BITEL

Looking Like Christians:
The Material Environment of Religious
Visions in Early Medieval Europe

SAINT PATRICK of snakes and shamrock fame had a series of visionary encounters before his mission to the Irish in the mid-fifth century. According to his *Confessio*, which he wrote in the later 400s, he had grown up in western Britain and had been kidnapped into slavery in Ireland as a teenager. He spent six years tending his master's sheep in the wilds of County Mayo, praying a hundred times daily in all weather until finally, one night as he slept, he heard a voice instructing him to fast. On a night shortly after, the same voice revealed that a ship sat ready for him in an eastern harbor. Patrick escaped, trudged two hundred miles to the coast, and finagled his way aboard a ship bound back to Britain.

However, the future saint's trials were not over. The voyage went astray. Patrick and shipmates washed ashore somewhere in southern Britain or northern Gaul (or perhaps only in Patrick's imagination).[1] Patrick wrote afterward that they wandered the wilderness for twenty-eight days until the irritable sea captain, a pagan, finally reproached him: "What about it, Christian? You say your god is great and all-powerful; well then, why can't you pray for us? We are in danger of starving—there is little chance of our ever seeing a living soul." Patrick suggested that if the captain put his trust in the Christian God, they would all find food—and, sure enough, as he wrote later, a herd of pigs suddenly crossed their path. The sailors discovered honey, too. One of them offered Patrick a piece of honeycomb, calling it a "sacrifice" (*immolaticium*).

Patrick didn't see it that way. "Thanks be to God," he noted primly, "I tasted none of it."

That night, however, while Patrick slumbered in the open, untainted by pagan honey, Satan (*Satanas*) attacked him. "A huge rock seemed to fall on me," he recalled much later in life, "and I was completely paralyzed. What gave me, in my spiritual ignorance, the idea of calling on Helias? I saw the sun rising in the sky and on shouting, Helias Helias! with all my might, see, the brilliance of that sun fell on me and at once shook me free of all the weight. I believe that I was aided by Christ my Lord." He concluded his retrospection with a verse from the evangelist Matthew: "It is not you who speak but the Spirit of your Father who speaks within you."[2]

The episode is dense with negotiations about the many visible and invisible worlds of northern Europe in the fifth century. Pagans, Christians, rough seamen, Britons, Irishmen, the Romanized and non-Roman, those who could not see the truth right in front of them, and he who saw all in a backwards glance—Patrick's *Confessio* packs them into this single enigmatic tale of shipwreck, Satan, and blinding light in the night. Celticists and Irish historians have been arguing over the meaning of the Helias episode for a hundred years or more. Who was Helias, where did Patrick find literary models for his story, and how did he get home again? Equally perplexing, though, is the question of where exactly Patrick located his vision and why it happened at that particular spot in his month-long odyssey.

1. Thomas Charles-Edwards, *Early Christian Ireland* (Cambridge, 2000), 217–18.
2. Matt. 10:12, Patrick, *Conf.*, 17–20. All quotations and translations from A. B. E. Hood, *St. Patrick: His Writings and Muirchú's Life* (London, 1978).

Patrick probably wrote his *Confessio* as an old bishop nearing the end of his career in Ireland.[3] His visionary experience, although unusual, was not unique among descriptions of Christians' visions at the time. However, Patrick was the earliest European Christian from the less-romanized north to relate his own religious visions. Other documents from the brink of the European Middle Ages (and there are not many) offer only second- or third-hand accounts of visions. Set in the context of Ireland's Christianization and compared to visionary incidents from other regions of expanding Christendom, Patrick's story helps explain how northern Europeans first learned to see as Christians.

Far to the south of Patrick's Ireland, other Christians had already established visionary practices and set a doctrine of revelation based on biblical texts, classical philosophy, and the visual culture of the urbanized Mediterranean world. In order to see what other Christians saw, believers from the north needed to translate these orthodox visionary traditions from the classical settings of that southern environment. But how did believers with no visual understanding of Judean deserts, complex Roman cities, or the road to Damascus envision historical revelations and their distant locations? Patrick and other northern visionaries not only struggled with the impossible task of reporting personal religious experience, but also of describing visions that were both faithful to historical Christian models and visually meaningful to their local co-religionists.[4]

The theology and doctrine of visions that reached the northwestern edge of Europe beginning in the third century had taken shape in Rome, Jerusalem, Antioch, and other cities closer to the heart of the Empire—places invisible to those who had never visited them—and traveled north in the baggage of missionaries. Learned men in these ancient places developed theories about religious visions derived from classical ideas about sight, Neoplatonic concepts of reality, and the earliest writings of Jesus-followers about both personal and collective revelation.[5] Both the aniconic heritage of Jewish monotheism and the sophisticated philosophies of Neoplatonists, which denied the visual reality of God, were influential on late antique theorists of visions. (However, these traditions were not as rigorously iconoclastic as scholars have suggested. They included symbolic languages of vision and also admitted the existence of visible signs from heaven and supernatural phenomena, such as angels.)[6]

The Gospels drew on Jewish and Hellenistic ideas about visible divinity but also offered God's image made visible in Jesus' human incarnation. The twelve apostles proved eventually to be useful models for early medieval preachers and artists up north. They showed Christians how to look at divinity and its signs. They followed and observed Jesus while he walked the earth. They witnessed his death and resurrection. They observed his final ascent into the clouds. Finally, they experienced an exclusive revelation brought by the Holy Spirit, handily described for readers in the Acts of the Apostles. Although the Twelve had not received the Pentecost through their eyes, the revelation of each had been visible to the others as tongues of flame hovering over his fellows' heads.[7] Alone among Gospel characters, they simultaneously experienced personal vision and observed confirmation of their comrades' identical visions. Other witnesses of the Pentecost did not see the flames, but only the after-effects of revelation—the twelve men started babbling, so the crowd concluded that they were drunk.

3. Charles-Edwards, *Early Christian Ireland*, 219–20.

4. Other scholars have explored classical and Christian traditions of religious visions, dreams, and prophecy. Well-known art historians have analyzed depictions of such experiences while historians and sociologists have explained the social, scientific, and political importance of religious visions in several periods of the European past. A few examples: Isabel Moreira, *Dreams, Visions and Spiritual Authority in Merovingian Gaul* (Cornell, 2000); Jerome Kroll and Bernard Bachrach, *The Mystic Mind: The Psychology of Medieval Mystics and Ascetics* (New York, 2005); Herbert

Kessler, *Spiritual Seeing: Picturing God's Invisibility in Medieval Art* (Philadelphia, 2000); David Freedberg, *The Power of Images: Studies in the History and Theory of Response* (Chicago, 1989); Hans Belting, *Likeness and Presence: A History of the Image before the Era of Art* (Chicago, 1996); Paul Edward Dutton, *The Politics of Dreaming in the Carolingian Empire* (Lincoln, 1994).

5. Bernard McGinn, *The Foundations of Mysticism: Origins to the Fifth Century* (New York, 1991); Moreira, *Dream, Visions*, 13–38.

6. Paul C. Finney, *The Invisible God: The Earliest Christians on Art* (New York, 1994). 7. Acts 2.

Although the Gospels showed converts to Christian-
ity how to have a Christian vision, biblical writers of-
fered contradictory advice about how to demonstrate
the relevance of what only one person had claimed to
see. In episodes about Jesus' resurrection, the savior
had given a series of complex lessons about authenti-
cating human vision. The risen Christ appeared first
to Mary Magdalene in the garden of his tomb, but
would not let her touch him. He also showed himself
to the apostles, proving his identity by uncovering his
wounds. But when the apostle Thomas, who had been
absent from that viewing, heard reports of the savior's
reappearance he had demanded to touch the wounds.[8]
Jesus complied, ordering Thomas to "reach out and
put your hand into my side, stop doubting and be-
lieve," but adding, "Because you have seen me, you
have believed; blessed are those who have not seen
and yet have believed." Who among these characters,
then, had responded most faithfully?

The problem for ordinary Christians after the sav-
ior's final disappearance into scriptural history and
doctrinal promise was that, short of visible flames,
there was no reliable method for deciding whether in-
dividual believers were consumed by the Holy Spirit
or had simply consumed too much alcohol—or were
in some other delusional state or even faking—when
they claimed revelation. Christian texts of the next
couple of centuries promoted revelation, rather than
the prophetic practice so prominent in Torah, but also
emphasized that revelation would occur for all believ-
ers simultaneously at Jesus' second coming.[9] In the
meantime, individual revelation, although attested in
the Gospels, posed problems of authenticity and au-
thority for organizers of the new religion. Tension
erupted between visionaries and bishops, who were
responsible for guiding their congregations to even-
tual collective revelation.[10] Doctrinal controversies in
early Christian communities flared up around issues of

prophetic authority. The problem was not what peo-
ple saw, or even whether they saw anything at all, but
whose visions conveyed meaningful messages to other
believers.

Writers from Gaul, Britain, and Ireland, who lived
long after the age of apostles and far from Mediter-
ranean shores, worked through conflicting scriptural
positions on religious visions with the help of think-
ers from the south, including Jesus' disciple Paul and
Saint Augustine of Hippo, among others. Saint Paul
had offered a seemingly useful resolution of the ten-
sion between personal revelation and communal dis-
trust of any individual's visions. He himself had vi-
sions—and I use the term ambiguously here, as Paul
does, to mean all sorts of religious experiences in-
cluding other sensations with religious meaning—but
Paul had refused to claim them.[11] As he wrote to the
Christians of Corinth, "I know a man in Christ who
fourteen years ago was caught up to the third heaven.
Whether it was in the body or out of the body I do not
know—God knows." Late antique and medieval inter-
preters decided that Paul himself was the visionary in
his account. How could a smart man like Paul have not
known, Saint Augustine demanded, whether he was in
or out of his own body?[12] In Paul's own words, how-
ever, revelations were "inexpressible things, things
that man is not permitted to tell." To relate a personal
vision would actually decrease its authenticity by re-
ducing it to insufficient words. "I will boast about a
man like that, but I will not boast about myself," Paul
also wrote. "If I should choose to boast," he contin-
ued, "I would not be a fool, because I would be speak-
ing the truth. But I refrain, so no one will think more
of me than is warranted by what I do or say."[13]

Paul's model allowed every Christian to have vi-
sions but denied such personal revelation as the basis
for public leadership. Yet his coy publication of his
own vision also suggested a hierarchy of seers and see-

8. John 20:14–29.

9. Joel 2:28, Acts 2:17.

10. Jaroslav Pelikan, *Emergence of the Catholic Tradition*
(*100–600*) (Chicago, 1971), 105–108; *Didache* 11–15, translated
in Cyril C. Richardson, *Early Christian Fathers*, Library of Chris-
tian Fathers (New York, 1970), 176–78.

11. From the fourth century, if not earlier, interpreters assumed
that Paul was recounting his own visions but was cagey about au-
dience reaction: see Jan N. Bremmer and Istvan Czachesz, *The
Visio Pauli and the Gnostic Apocalypse of Paul* (Leuven, 2007).

12. *De Gen.* 12:1–2; *Confessio* 1:1–5.

13. 2 Cor. 12.

ing that would quickly become doctrine in the pages of the third-century theologian and others who, in turn, influenced northern proselytizers with a mystical zeal for visions and a concern for distinguishing true from false ones.[14] Around 408, Augustine laid out a three-part theory of human vision that quickly became popular among other religious writers, and which also helped reduce the confusion between divine revelations actually seen or sensed by other means. Corporeal vision, the lowest form, was ordinary physical sight, including sight of the fantastic and supernatural. The second kind, spiritual vision, was the sight of "corporeal things that are absent," similar to (but not the same as) seeing something in memory, dream, or imagination. Intellectual vision, the highest form, was the soul's direct experience of divinity without any reference to body. All reality, then, whether tangibly or visually experienced, read, imagined, or otherwise perceived, could be reduced to three modes: simply actual; multivalent; and invisibly, inexpressibly, profoundly true.[15]

Patrick the Briton, who was about a generation younger than Augustine, probably did not read Origen or the Bishop of Hippo's works, but he shared with Augustine a Neoplatonic understanding of sight and vision. He read Latin, although not widely, according to his own testimony. Patrick had grown up on a Romano-British *villula* (little villa) in the Welsh borderlands where his father was a deacon and *decurio* or minor noble, and his grandfather some sort of Christian official, perhaps a priest.[16] He only produced two documents, his *Confessio* and a letter of complaint to a badly behaved British king. So far as we know, he received no formal training for the priesthood.[17] Later in life, as a bishop in Ireland, he was in touch with clerical colleagues in Britain and Gaul. He knew his scriptures

well, including Paul's Epistles. So, although he claimed not to have understood the word Helias when he had supposedly cried it in the wilderness, by the time he wrote his account of the vision he was able to draw on both Old and New Testaments in a skillfully explicative wordplay. Helias suggested Eli, that is God, one of Jesus' last words (*Eli, Eli, lama sabachthani?*); it also evoked Elijah, the visionary prophet that bystanders at the crucifixion mistakenly thought Jesus was summoning; and Helias also referred to Helios Apollo, the Greek sun-god whose iconography Christians everywhere had co-opted.[18] As the Celticist Joseph Nagy has argued, Patrick was rhetorically equating himself with Jesus at the savior's darkest hour.[19]

Patrick's accounts of his visions revealed the bishop's sensitivity to longstanding doctrinal problems surrounding Christian visions and prophetic authority. According to the *Confessio*, when Patrick finally did make it back to his home in Britain, he had a series of extraordinary visual encounters. One night he saw a supernatural figure self-identified as Victoricus who seemed to come from Ireland bearing letters addressed to Patrick. (Seventh-century hagiographers explicitly identified Victoricus as an angel, but Patrick never did.)[20] When Patrick opened one epistle marked "Voice of the Irish," he instantly heard the people of County Mayo calling "we beg you, Holy Boy, to come and walk again among us." Stung with remorse for abandoning the pagan Irish, he could not go on reading.[21] On another night a mysterious voice addressed him. "I do not know, God knows," he later explained, "whether it was within me or beside me." *Nescio Deus scit* he wrote, directly quoting Paul's visionary episode in Second Corinthians. The voice told Patrick that "He who gave His life for you, He it is who speaks within you." Patrick actually saw this same entity

14. Origen, *Homily* 27 on *Numbers* (11); Steven Fanning, *Mystics of the Christian Tradition* (New York, 2001), 25–27.

15. It was not until the later ninth century with Johannes Scotus Eriugena that any Western theorist would elaborate a Neoplatonic ontology or speculate systematically about mystical revelation. See Bernard McGinn, *The Growth of Mysticism: Gregory the Great through the 12th Century* (New York, 1994), 88–92.

16. *Ep. ad Corot.*, 10.

17. Some nineteenth- and twentieth-century scholars argued

that Patrick trained for his missions with highly-educated patrician bishops in Gaul, but most current historians think it unlikely. See Charles-Edwards, *Early Christian Ireland*, 232–34.

18. Matt. 27:45–48: *Eli, Eli, lama sabachthani?*

19. Joseph Falaky Nagy, *Conversing with Angels and Ancients: Literary Myths of Medieval Ireland* (Ithaca, 1997), 29–36.

20. Muirchú, *Vita*, 1, in Ludwig Bieler, ed. and trans. *Patrician Texts in the Book of Armagh* (Dublin, 1979).

21. Patrick, *Conf.*, 23–24.

"praying within me and I was, as it were, inside my own body and I heard him above me, that is to say above my inner self and he was praying there powerfully and groaning." The voice further explained itself with scripture, quoting Paul's letter to the Romans to point out that "we do not know what to pray for as we ought, but the Spirit Himself intercedes for us with unspeakable groans which cannot be expressed in words." [22] In other words, during his out-of-body experience, Patrick had been possessed by the Holy Spirit, as were the apostles at Pentecost, and as Paul was when lifted up to heaven.

Looking back at his history, Patrick explained how he became increasingly adept at visionary perception through his progressive schedule of visions. He was already harboring the Holy Spirit before his first vision, he realized in his later writing, when he prayed in the Mayo pastures: "There was no listlessness in me—as I now realize, it was because the Spirit was fervent within me." [23] First, Patrick dreamed of an ordinary ship; in the second vision, he saw and felt a conflict between abstract symbols of good and evil (the weight of a devilish rock, the saving light of goodness, the ineffable power of God's many names), which he later understood to represent his interior conflict; in the third vision he was able to interpret instantly the symbolism of what he saw, that is, an angel bearing legible messages, like himself as a Gospel-toting missionary; and in the last vision he saw himself without using his eyes but by sharing the perception of the Holy Spirit that possessed him. His series of visions formed a metaphorical narrative within the larger autobiography of his *Confessio*: The first night-vision had called him home to Britain; the next had led him to epiphany in the wasteland, thus purifying him for missionary work, as Christ's time in the desert had prepared him for crucifixion; the next used written words to summon him into permanent exile; and, finally, the last vision gave him a pentecostal mandate for preaching. The settings of Patrick's successive visions became more civilized and Romanized as his visions included more obviously Christian motifs. The first vision took place on an open hillside in pagan County Mayo; the second in the marginal wasteland of a former Roman province; the last two occurred at home on his family *villula* in a Christian community. Each experience was more exalted than the previous one, yet each was more easily interpreted than the last. The rest, as they say, is hagiography—Patrick returned to Ireland on a god-sent mission and never looked back.

Patrick's *Confessio* of the 460s told a story already familiar in Gaul, which had welcomed Christian missionaries more than a century before Patrick arrived in Ireland. Gallo-Romans already had congregations, churches, saints, home-grown theology, and complex Christian visual culture. The conversion of visual regimes had gone more smoothly in this Roman province, especially in the south where imperial architecture was familiar and the literate aristocracy understood both Scripture and Neoplatonism. Saint Martin, who had proselytized Gaul in the mid-300s, had arrived in Tours from his boyhood home in Pannonia (modern Hungary), via a stint in the Imperial army, exile in Italy, and time on an island hermitage in the Tyrrhenian Sea, so he had been completely at ease in the towns of southern and mid-Gaul. Martin had absorbed the visual codes of classical Christian *romanitas*, according to his aristocratic Aquitainian hagiographer, Sulpicius Severus. No mysterious rocks or Greek aliases bothered Martin. When Martin encountered devils, he recognized them instantly and dispelled them with carefully chosen words. For instance, according to Sulpicius, the saint had once been praying alone in his cave outside Tours when a resplendent figure dressed in royal purple and a golden crown appeared suddenly before him. "Martin," the figure cried, "you see me! Acknowledge me. I am Christ." When Martin hesitated, the figure scolded him with a twist of Jesus' words to Thomas: "Why so slow to believe what you see?" The saint pointed out that Jesus had not promised to return in fancy dress, and therefore he, Martin, would only believe in a Christ "who

22. Nagy, *Conversing with Angels and Ancients*, 30; Patrick, *Conf.*, 24–26.
23. Patrick, *Conf.* 16.

comes in the garments ... of his passion ... bearing upon him the wounds of the Cross." Martin's knowledge of scripture and ability to translate it visually helped him evaluate the deceptive proof before his eyes. The false messiah instantly vanished in sulfurous smoke.[24] The devil, as Sulpicius reminded his readers elsewhere, resorted to "a thousand malicious tricks" and "would thrust his visible presence upon [Martin] under forms of the utmost diversity." Sulpicius' Gallo-Roman readers would have been familiar with the literary theme of an ascetic exposing devilish illusions, making Martin's resistance all the more admirable.[25]

Martin and Patrick represent two versions of the gradual education in vision that many northern Europeans underwent during the fourth and fifth centuries, although at different paces in different regions. Hagiographers from Sulpicius' late fourth century to Patrick's earliest Irish biographers (Tírechán and Muirchú, both writing at the end of the seventh century) used their protagonists to teach ordinary believers how and what to see as Christians. Hagiographers tried to promote the superior gaze of the clergy as justified by scripture and exemplified by the saints, but their colorful accounts of vision events also revealed continuing debates among early medieval believers about what they saw and how to interpret it. Saints' lives and Christian histories from the long period of northern Christianization are full of wonders, omens, otherworlds, and invisible forces. As hagiographers penned these stories during the fifth and sixth centuries, northern Europeans were adapting both their ways of seeing and their visual environments to accommodate new religious knowledge. Even as Sulpicius and Patrick described religious visions in northern settings, bishops, saints, and rulers were transforming the landscape by laying visible markers of Christianity across Gaul, Ireland, and Britain—in other words, creating local visual environments more receptive to Christian visionary traditions.

These new contexts helped Christians situate reli-

giously meaningful experience, gave them new things to look at while practicing religion, and also helped them gain access to higher forms of vision. Shrines and churches served as stages where ordinary believers trained to visualize and re-enact the Last Supper, collectively participating in the once historical and now miraculously trans-historical encounter with Jesus. They learned how to see the invisible transformation of bread and wine into the body and blood of Christ in plainly visible ritual acts. The formulaic architecture of the Christian basilica—even when down-sized and simplified for northern semi-urban venues—offered a setting and props, which literally gave Romanized shape to Christian ways of looking by locating seers safely inside built sacred space. Christian liturgy set a schedule for the visual experience of Christianity and added sensory drama with processions of chanting clerics and virgins, flickering lamps and reliquaries glinting in the dark, and the heavy odor of incense. Thus even as saints' lives—read aloud in church on yearly feastdays—laid out a hierarchy of Christian seers and seeing for ordinary believers, liturgy, art, and architecture taught them how to practice religious vision and aim for higher perception.[26] In quieter moments of devotion, ecclesiastical architecture and décor directed individual viewers around Christian buildings in a didactic program of meditative visualization. Icons and furniture, pavements, railings, monuments, windows, lighting, painted or sculpted images, and even written instructions painted or carved onto the walls cued the visual experiences of individual worshippers. On the wall of a shrine at Tours, near painted scenes of the apostles and the Sepulcher at Jerusalem, one inscription from around 460 ordered pilgrims,

> You who have knelt on the ground, lowered your
> face to the dust,
> and pressed your moist eyes to the compacted
> ground,
> lift your eyes and with a trembling gaze look at the
> miracles

24. Sulp. Sev., *Vita Mart.*, 24.

25. *Ibid.*, 22. For example, Athanasius, *Vita Ant.* 5 and *passim*.

26. Dale Kinney, "The Church Basilica," *Acta ad archaeologiam et artium historiam pertinentia* 15 N.S. 1 (2001), 115–135; Ruth

Webb, "The Aesthetics of Sacred Space: Narrative, Metaphor, and Motion in Ekphraseis of Church Buildings," *Dumbarton Oaks Papers* 53 (1999), 59–74.

and entrust your cause to the distinguished patron.

No [written] page can embrace such miracles ...

If you doubt, look at the miracles that are heaped
 before your eyes

And by means of which the true savior honors the
 merit of his servant.

You come as an eyewitness among so many thou-
 sands of others

When you carefully observe what must be narrated
 and repeat what you have seen.[27]

The place, the art, and the story behind the fresco lit-
erally located the viewer at first-century Jerusalem
among the apostles, turning him or her into as reli-
able a witness to the resurrection as Peter or Thomas.
With such visual aids and written instructions, north-
ern believers had no need to see any other Jerusalem;
they could visualize an entire history of miracles from
across Christendom.

The early medieval *literati* of northern Europe con-
sistently argued in stories of saints and sinners that the
scriptural call to revelation was only an invitation to
church, where visions could be safely managed and in-
terpreted in terms of Christian doctrine and historical
precedent. In most European shrines, the arrangement
of spaces gave physical shape to the classical hierarchy
of religious seeing. Only ordained clergy could enter
the holiest parts of a shrine—the sanctuary and crypt—
which remained inaccessible and practically invisible
to ordinary worshippers. When fortunate pilgrims
were allowed occasionally to approach the tombs of
saints, they were still prevented by sanctuary railing,
grilles, or the crypt's gloom from seeing the most holy
dead. Later sixth-century writers such as Gregory of
Tours recounted tales of innocent devotees acciden-
tally locked all night in a crypt but surprised and re-
warded with the sight of a long-dead saint. These
lucky ones often returned to the surface with tangible
souvenirs in the shape of a cloth, a vial of oil, or some
other relic—otherwise, audiences might doubt that
a lowly lay person had actually seen and recognized
such a precious vision.[28]

In the mid-fifth century, Patrick could still experience
the Holy Spirit at home in his *villula*, even though he
was as yet neither priest nor saint. Just a century later,
any lay person rash enough to claim a vision outside of
church was liable to be labeled a pagan or a trickster.
According to the anonymous *vita* of Saint Genovefa,
written around 529, the young saint had vowed vir-
ginity and moved to Paris around 450. Shortly after,
the Huns threatened to attack the city. Genovefa had
already experienced an allegorical vision of the Chris-
tian virtues and had been recognized by two leading
bishops of Gaul as a *bona fide* holy woman, but the Pa-
risians did not know her well enough to trust her when
she reported her visions. She tried to rally them to
pray against the invaders. She gathered the city's ma-
trons for an all-night vigil in the baptistery. She ex-
horted the townsmen not to flee town with their valu-
ables but instead to concentrate on defending the city
with fasting and prayer. According to her hagiogra-
pher, the irritable citizens called her a *pseudopropheta*
and argued about whether to stone her to death or toss
her into the Seine. No one had witnessed her visions,
which had taken place in her private quarters, and she
had no visible evidence of her experience. The savvy
Parisians were wary of fake saints and soothsayers.
Genovefa survived this challenge to her visionary au-
thority, but still had not won the trust of the Parisians
some years later when she divined the location of a lost
saint's grave. She was the only one who could see the
bones of Paris's first martyr and bishop, Saint Denis,
where they lay covered with earth and vegetation. Yet
despite her having saved Paris from the Huns by her
timely prayers, the local priests would still not believe
her vision of the buried Denis until several miracles
provided more substantial proof.[29] The hagiographer
framed Genovefa's story as a life-long attempt to win
the trust of Parisians and their clerics in her prophecies
and visions—and the text also served to authenticate
what she saw, of course, using her visions and miracles
to argue for her sanctity and continuing cult.

As the project of Christianization advanced across

27. Raymond Van Dam, *Saints and Their Miracles in Late An-
tique Gaul*, (Princeton, 1993), 312.

28. Gregory of Tours, *Glor. Mart.* 33.
29. *Vita Gen.* (A), 14–15.

northern Europe in the fifth and sixth centuries, missionaries and preachers urged believers to re-examine their surroundings with newly Christian eyes. But Patrick, writing from the earliest stage of Ireland's conversion, revealed few details about what he actually saw when he was not having a vision. He must have observed the thousands of Irish men and women that he boasted of baptizing, but he never described a single individual or mentioned a building, nor did he record the insights of his converts. Even Satan was only a shapeless weight to him and Jesus an abstract light in the dark called by a misleading name. Patrick—who commanded the tongue of the ancient world, if not the eyes of a Mediterranean citizen of Empire—was not blind to his environment but purposely reticent about relating the evidence of his eyes. The material environment held little meaning for his missionary self-history. He also knew better than to reveal what he had learned from the Holy Spirit while hovering above his own inert physical body. Like all genuine visionaries, he lacked adequate models and metaphors with which to convey and prove the depth of his experience to his readers. So instead, he reminded them about the unreliability of the visible world—which misled nearsighted pagans into worshipping the blinding majesty of the pagan sun god—and the ability of Christians to rise above their disagreements about what they saw. "This sun which we see rises daily for us at [God's] command," he wrote, "but it will never reign nor its splendour endure; all those who worship it shall be doomed to dreadful punishment. But we who believe in and worship the true sun, Christ … will abide forever just as Christ abides forever." [30]

In subsequent years, Europeans taught themselves how to see Christianity and how to see as Christians. They translated religious ideas into local visual vernaculars and, at the same time, made local visual environments look more Christian by defining episcopal and monastic territories and sacral spaces and by building new kinds of monuments. Further, by giving local shape to doctrinally approved types of visionary experience and by locating religious visions in designated places, successive generations of northern Europeans responded to the old dilemma of how to prove a Christian vision. This was not the age of solitary interiority celebrated by later medieval mystics, but instead a time of false priests, demons disguised as Jesus, and ordinary individuals with bad eyesight in ill-lit environments. Even bishops and monastics commonly misinterpreted what they saw or the visions of others. Meanwhile, innocent laypersons who blundered into Christian places reported visual encounters that required clerical investigation. [31] So northern Europeans began measuring visions by their venues rather than trusting the words of individual seers. Texts such as the sixth-century lives of the Jura Fathers, Gregory of Tours' works (560s–580s), Adomnán's *vita* of Columcille (ca. 692), along with letters from bishops across northern Christendom, suggested that a person could really only trust what he saw in a church or another sacralized space. Angels commonly appeared to saintly abbots who prayed in lonely chapels, while monks and nuns encountered long-dead saints in their convent cemeteries, and monastic cells became battlegrounds between clerics, angels, and demons. By comparison, any seer or witness—whether king or commoner, cleric or layperson—who reported a vision that occurred at home or in non-ecclesiastical public spaces was vulnerable to challenge. Writers and their audiences had as much trouble determining the legitimacy and meaning of these sightings as did Parisian mobs. The most perplexing sights for Christians took place in the wilderness of unbuilt or abandoned places where no boundaries marked sacred spaces and no manufactured landmarks helped to locate the visions of believers. Many spots in fifth- and sixth-century northern Europe still preserved landmarks of otherworlds far older than the scriptural heaven. In general, the safest response when sighting something out of the ordinary was to run away—preferably to a church—and tell a priest. [32]

Still, visions and apparitions that originated out-

30. Patrick, *Conf.*, 60.
31. Moreira, *Dreams, Visions*, esp. 108–35.

32. Lisa Bitel, "*In Visu Noctis* : Dreams in European Hagiography and Histories, 450–900," *History of Religions* 31 (1991), 39–59.

side approved settings—such as churches and shrines, deathbed scenes, dreams, Christian cemeteries, and a few other reliable places—continued to reach public notice through word of mouth, in accounts of the pagan past, or in reports of irreligious or sinful behavior. It took a long time for northern Europeans to look like Christians. It took even longer for them to agree about what they saw.

ANN MARIE YASIN

Making Use of Paradise:
Church Benefactors, Heavenly Visions,
and the Late Antique
Commemorative Imagination[1]

WE HAVE BECOME, by now, comfortable with the notion of "reading" historical images and working to analyze the various messages they communicated to their one-time viewers. Study of the decorative programs of late antique church apses, for example, has tracked the shifting ideas conveyed by these images about the nature and accessibility of Christ, Mary, and the saints. The inclusion of donor figures within the paradisiacal landscape and among the heavenly figures in a number of surviving monumental apse compositions from the sixth century, however, encourages us to consider not only what the images say about the divine, but also what they ask from their mortal viewers. The conflation of eschatological and historical time and of otherworldly paradise and place-specificity links the viewer's own world to that of the heavenly vision. Considering such monuments in light of a larger class of ecclesiastical donor memorials sheds light on how the monumental apse compositions go beyond merely communicating to the spectator to *elicit* their direct engagement and participation.

The oldest known monumental church apses used the spatially loaded site above the altar to showcase the monumental image of Christ. Even before sixth-century apse mosaics dazzled spectators with images of divine majesty and otherworldly paradise, well-attested monumental apse iconography focused on Jesus and his Apostles. Severus, Bishop of Naples between 366 and 412/13, for example, is known to have built a basilica (the so-called Basilica Severiana) "in whose apse," John the deacon writes in his Chronicle of the Bishops of the Holy Church of Naples, "he depicted in mosaic the Savior with twelve seated Apostles...."[2] Contemporary, or perhaps a little later, is the extant apse mosaic from Sta. Pudenziana at Rome that presents the seated and haloed figure of Christ elevated above the assembly of Apostles who extend out to the edges of the apse on either side with an architectural backdrop understood as a representation of the heavenly Jerusalem behind (Fig. 1).[3] Such programs, which situate Jesus amidst the apostolic band above the altar, were in some way anticipated by the decorative arrange-

1. I am extremely grateful to Lisa Bitel and Colum Hourihane for the invitation to participate in the *Looking Beyond* conference and for their careful organization of the event and the subsequent publication. In addition, I wish to extend special thanks to Daniel Richter, Cecily Hilsdale, Glenn Peers, and Cynthia Hahn for their valuable questions, feedback, and suggestions.

2. ... *in cuius* [= *basilicae Severianae*] *apsidam depinxit ex musivo Salvatorem cum XII apostolis sedentes* ... (G. B. de Rossi, "L'abside della Basilica Severiana di Napoli," *Bullettino di archeologia Cristiana* [1880], 144–60); C. Ihm, *Die Programme der christlichen Apsismalerei vom vierten Jahrhundert bis zur Mitte des achten Jahrhunderts* (Wiesbaden, 1960), 175–76, Cat. No. 32.

3. Ihm, *Programme* (as in note 2), 130–32, Cat. No. 2; E. Dass-

mann, "Das Apsismosaik von S. Pudenziana in Rom: Philosophische, imperial und theologische Aspekte in einem Christusbild am Beginn des 5. Jahrhunderts," *Römische Quartalschrift* 65 (1970), 67–81; Y. Christe, "Gegenwärtige und endzeitliche Eschatologie in der frühchristlichen Kunst: Die Apsis von Sancta Pudenziana in Rom," *Orbis scientiarum* 2 (1972), 47–60. On the architecture represented, see also W. Pullan, "Jerusalem from Alpha to Omega in the Santa Pudenziana Mosaic," *Jewish Art* 23–24 (1997–98), 405–17, and F. W. Schlatter, "A Mosaic Interpretation of Jerome, *In hiezechielem*," *Vigiliae Christianae* 49 (1995), 64–81. Compare the right-hand apse of S. Aquilino in Milan from ca. 400, Ihm, *Programme* (as in note 2), 158–9, Cat. No. 20; G. Mackie, *Early Christian Chapels in the West* (Toronto, 2003), 156–63. The original

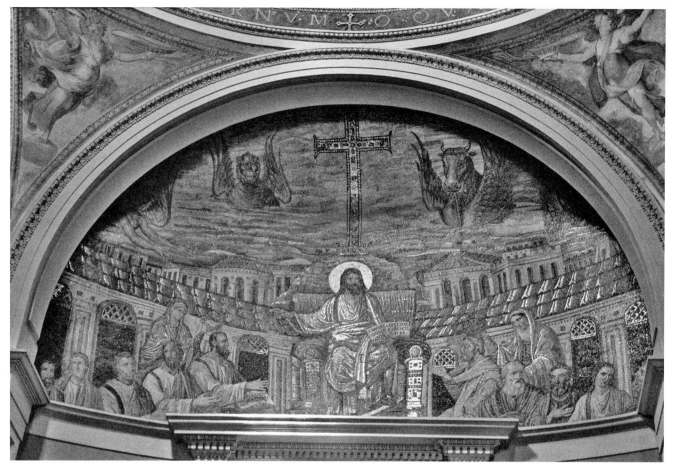

FIG. 1. Sta. Pudenziana apse mosaic, Rome (photo: Vanni/Art Resource, N.Y.).

ments of Constantine's earliest monumental church, the Basilica Salvatoris at the Lateran. Even though we cannot be sure of the original decoration of this apse, the *Liber Pontificalis* does provide valuable testimony for another element of monumental decoration at the end of the longitudinal basilica before the altar. Facing those gathered in the nave as they looked toward the altar and apse area, Constantine is said to have placed a monumental, free-standing arch or screen called a *fastigium*. It incorporated silver statues of Christ and the Twelve Apostles, framing the altar area as seen in Sible de Blaauw's reconstruction of the basilica (Fig. 2).[4] The iconography of these fourth- and early fifth-century churches, in other words, reinforced and articulated a spatial hierarchy within the structure. Jesus as teacher and head of the apostolic band was central and bestowed authority on the altar and the position of the clergymen who presided below.

apse at Sta. Sabina from ca. 430 is thought to have presented a scene similar in its main compositional lines to that of the fresco of Tadeo Zuccari, which replaced it in 1559. In this painting, Jesus sits in a rocky terrain elevated above the surrounding Apostles on a hillock from which a river flows. In his publication following the 1918 restorations that confirmed that the sixteenth-century painting followed the broad outlines of the earlier mosaic, A. Muñoz further suggested that the original composition may have included Celestine I, the bishop under whom the structure would have been

completed, see *Il restauro della basilica di Santa Sabina* (Rome, 1938), 37–39; see also Ihm, *Programme* (as in note 2), 151–53, Cat. No. 15.

4. S. de Blaauw, *Cultus et Decor: Liturgia e architettura nella Roma tardoantica e medievale*, Vol. 1 (Vatican City, 1994), 117–27. Notwithstanding the debate over the subject of the apse of St. Peter's, which may have contained an image of the *traditio legis* as early as the second quarter of the fourth century, or as others have recently contended, added the scene in the post-Constan-

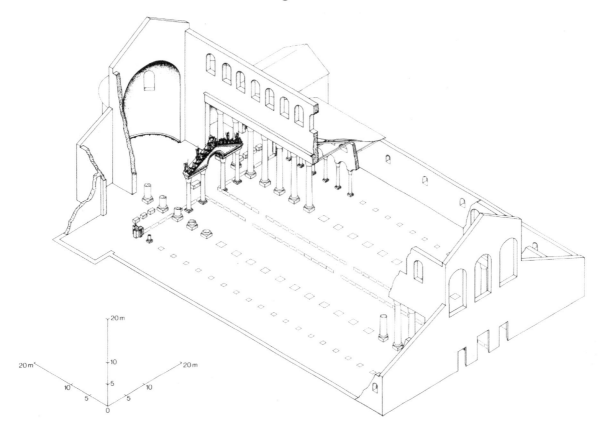

FIG. 2. Isometric reconstruction of the Lateran Basilica in the Constantinian period with *fastigium* before the sanctuary (from S. de Blaauw, *Cultus et Decor*, Vol. 2, Fig. 2; reproduced by permission of the author).

Departing somewhat from this iconography, a number of surviving programs of the late fifth and sixth century depict Christ flanked by a reduced number of figures in a distinctively paradisiacal or otherworldly setting.[5] Seventeenth-century drawings and descrip-

tions of the apse of the late fifth-century basilica of S. Andrea in Catabarbara at Rome, made before the building was destroyed in the seventeenth century, for example, indicate that it featured a figure of Christ, standing on a rock from which the four rivers of Paradise

tinian period—as maintained by J.-M. Spieser "The Representation of Christ in the Apses of Early Christian Churches," *Gesta* 37:1 (1998), 63–73; G. Bowersock, "Peter and Constantine," in *'Humana Sapit': Études d'antiquité tardive offertes à Lellia Cracco Ruggini*, ed. by J.-M. Carrié and R. L. Testa (Turnhout, 2002), 209–17; and recently B. Brenk, "Fountains, Apses and the Meaning of Water," unpublished paper presented at Picturing the Bible: The Earliest Christian Art Symposium held at the Kimbell Art Museum, Fort Worth, Texas (March 2008)—this basilica too contained a monumental image of Christ with his apostles Peter and Paul at least by the end of the century.

5. On the exploration of paradise imagery in early Christian churches, see especially H. Maguire, *Earth and Ocean: The Terrestrial World in Early Byzantine Art* (University Park, Penn.,

1987), and H. L. Kessler, "Bright Gardens of Paradise," in *Picturing the Bible: The Earliest Christian Art*, ed. by J. Spier (New Haven, 2007), 111–39. On the interpretation of apocalyptic elements in monumental early Christian art, see in particular J. Engemann, "Images parousiaques dans l'art paléochrétien," in *L'Apocalypse de Jean: Traditions exégétiques et iconographiques IIIe–XIIIe siècles. Actes du colloque de la Fondation Hardt, 29 février–3 mars 1976*, ed. R. Petraglio et al. (Geneva, 1979), 73–97; *idem* "Auf die Parusie Christi hinweisende Darstellungen in der früchristlichen Kunst," *Jahrbuch für Antike und Christentum* 19 (1976): 139–56; Y. Christe, *La vision de Matthieu (Matth. XXIC–XXV): Origines et développement d'une image de la Second Parousie* (Paris, 1973); A. Grabar, "L'iconographie du Ciel dans l'art chrétien de l'Antiquité et du haut Moyen Age," *CahArch* 30 (1982), 5–24; D. Kinney,

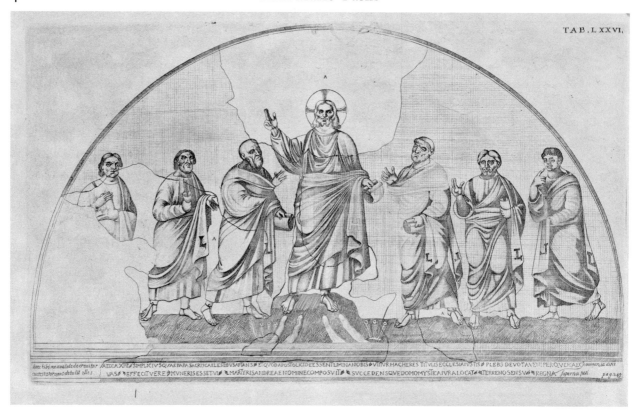

FIG. 3. Drawing of apse mosaic of S. Andrea in Catabarbara published by Ciampini in *Vetera Monimenta* (Rome, 1690), Pl. 76 (Courtesy of the Research Library, The Getty Research Institute, Los Angeles, Calif.).

flow, surrounded by six Apostles (Fig. 3).[6] Similarly, in the Roman apse mosaic of Ss. Cosmas and Damian from 526–30, Christ wearing a radiant gold tunic and pallium stands amidst the cloudy heavens flanked by Peter and Paul (Fig. 4).[7] Directly beneath the figure of Christ there stands a nimbed lamb atop a hillock from which four rivers flow. The labels in the gold band below these indicate that they are the four streams

that originated in Paradise and emerge in the inhabited world as the Gehon, Phishon, Tigris, and Euphrates.[8] Likewise, in the famous apse mosaic of the 540s from S. Vitale in Ravenna, the purple-robed figure of Christ with jeweled cross-halo sits flanked by angelic figures in a flower-strewn landscape upon the celestial orb above the four rivers of Paradise (Fig. 5).[9]

The contrast between the fourth- and early fifth-

"The Apocalypse in Early Christian Monumental Decoration," in *The Apocalypse in the Middle Ages*, ed. by R. K. Emmerson and B. McGinn (Ithaca, 1992), 200–16.

6. G. G. Ciampini, *Vetera Monimenta: in quibus praecipuè musiva opera sacrarum, profanarumque aedium structura, ac nonnulli antiqui ritus, dissertationibus, iconibusque illustrantur*, Vol. 1 (Rome, 1690), 242–49 and Pl. 76; S. Waetzoldt, *Die Kopien des 17. Jahrhunderts nach Mosaiken under Wandmalerein in Rom* (Vienna and Munich, 1964), 29; Ihm, *Programme* (as in note 2), 154–55, Cat. No. 18; Krautheimer *CBUR*, I, Fasc. I–II, pp. 64ff.; Spieser, "Representation of Christ" (as in note 4), 65.

7. For a discussion of the apse mosaic as well as the seventh-

century mosaic of the triumphal arch, see G. Matthiae, *Mosaici medioevali delle chiese di Roma*, Vol. I. (Rome, 1967), 135–42, 203–13; G. Matthiae, *Ss. Cosma e Damiano e S. Teodoro* (Rome, 1948); Ihm, *Programme* (as in note 2), 137–38, Cat. No. 5; V. Tiberia, *Il restauro del mosaico della Basilica dei Santi Cosma e Damiano a Roma* (Rome-Perugia, 1991).

8. Gen. 2:10–14. On the late antique visualization of the scriptural description of the rivers, see H. Maguire, "Paradise Withdrawn," in *Byzantine Garden Culture*, ed. by A. Littlewood, H. Maguire, and J. Wolschke-Bulmann (Washington D.C., 2002), 25–6.

9. The key publication of the architecture and decoration of the church remains F. W. Deichmann, *Ravenna: Hauptstadt des*

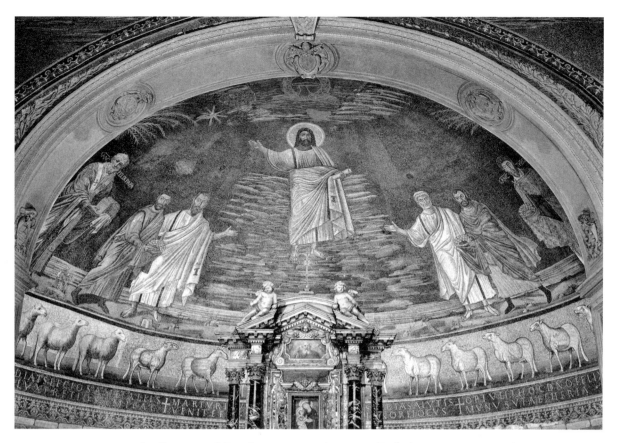

FIG. 4. Ss. Cosmas and Damian, apse mosaic, Rome (Scala/Art Resource, N.Y.).

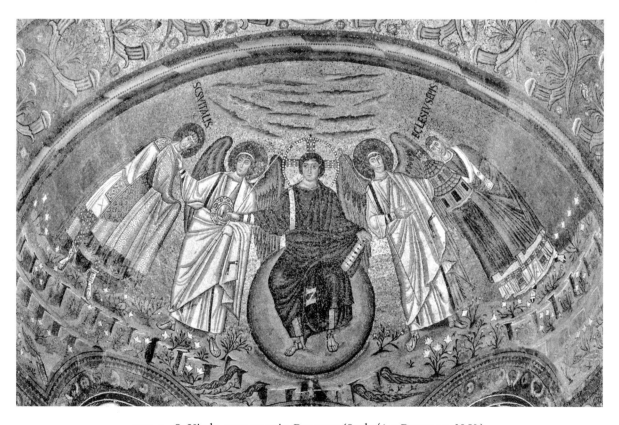

FIG. 5. S. Vitale, apse mosaic, Ravenna (Scala/Art Resource, N.Y.).

century programs and those of the later fifth and sixth centuries provides a valuable indication of a shift in emphasis in the monumental ecclesiastical images of Christ. Numerous scholars, including Christa Ihm, Thomas Mathews, and Jean-Michel Spieser have interpreted such images in broadly evolutionary terms. The representation of Christ amidst the semi-circle of Apostles emphasizes the figure of Jesus and his role as philosopher/teacher.[10] It gives way in the late fifth and sixth centuries to images that place greater emphasis on representing Christ as God. With his apostolic band reduced and the stress placed on the scenes' other-worldliness, apse images such as those at S. Andrea in Catabarbara, Ss. Cosmas and Damian, and S. Vitale have been seen to express, in Jean-Michel Spieser's words, "above all, his divinity; the god who is represented from then on is obviously not only a god invested with many powers, he is the almighty God, the sovereign of the cosmos, the *pantocrator*."[11]

Within this evolutionary narrative of monumental apse imagery, however, less attention has been paid to the non-scriptural elements incorporated into the sixth-century programs. While analysis has focused predominantly on the representation of the figure of Christ in order to assess the relative emphasis placed on his human, imperial, and divine qualities, it has sidelined the introduction of non-apostolic figures—local saints and church patrons—into the band of Christ's attendants.[12] These figures are, however, key elements of rupture in the scenes' coherence. The images of otherworldly Paradise include figures who are fundamentally earthly. The presence of local benefactors and hometown saints admits a profoundly historical dimension into an otherwise timeless image of cosmic order. This paper explores the intersection of these two aspects of the sixth-century monumental apse decorations: the divine and eschatological aspect, on the one hand, and the local and commemorative, on the other. Alongside the narrative of the evolution of the representation of Christ, I propose examining these monuments in terms of their position within a different tradition, that of commemorative monuments memorializing church benefactors. While representing a divine and eschatological image of Christ, these monuments are at the same time earthly and time-bound memorials commemorating specific people and events. Recognizing this combination, I suggest, helps us understand the social as well as theological import of the church programs and the impact such images would have had on their contemporary viewers.

Examination of the corpus of surviving decorative monuments points to the inclusion of donor images as a widespread type only in the sixth century.[13] The iconography is well known thanks to the excellent preservation of a number of examples remaining *in situ*. The mid-sixth-century apse at Ravenna's S. Vitale, perhaps the most famous case, is illustrative of the type (see Fig. 5).[14] Here, as discussed above, Christ utterly dominates the composition. Enthroned upon his blue orb, he appears in majesty as he never did in

spätantiken Abendlandes. Kommentar, v. 2 (Wiesbaden, 1976), 47–230; Ihm, *Programme* (as in note 2), 163–65, Cat. No. 24.

10. Ihm, *Programme* (as in note 2); T. F. Mathews, *The Clash of the Gods: A Reinterpretation of Early Christian Art*, rev. ed. (Princeton, 1993); Spieser, "Representation of Christ" (as in note 4).

11. Spieser, "Representation of Christ" (as in note 4), 65–66.

12. At the same time, the pictures of church benefactors have received some attention in their own right as part of the investigation of the history of donor portraits. See especially E. Lipsmeyer, "The Donor and his Church Model in Medieval Art from Early Christian Times to the Late Romanesque Period," Ph.D. diss., Rutgers University, 1981; J.-P. Caillet, "L'Affirmation de l'autorité de l'évêque dans les sanctuaries paléochrétiens du haut adriatique: de l'inscription à l'image," *Deltion tes Christianike Archaiologike Hetaireia* 24 (2003), 21–30; C. Jäggi, "Donator oder Fundator? Zur Genese des monumentalen Stifterbildes," *Georges-Bloch-Jahrbuch des Kunsthistorischen Instituts der Universität Zürich* 9–10 (2002–2003), 27–45; K. G. Beuckers, "Stifterbild und Stifterstatus. Bemerkungen zu den Darstellungen Papst Paschalis I. (817–24) in Rom und ihren Vorbildern," in *Form und Stil: Festschrift für Günther Binding zum 65. Geburtstag*, ed. by S. Lieb (Darmstadt, 2001), 56–74.

13. Lipsmeyer, "Donor and his Church Model," (as in note 12); Beuckers, "Stifterbild und Stifterstatus," (as in note 12), 59–64; Jäggi, "Donator," (as in note 12), 28. S. Sabina's apse, which in Zuccari's fresco includes figures of four ecclesiastics kneeling in the foreground before the circle of Jesus and the Apostles and may have originally included an image of Celestine I, is a possible exception: Ihm, *Programme* (as in note 2), 152; see above, note 3.

14. See above, note 9.

his life—not in historical time on earth, but dressed in purple and gold finery, nimbed with a bejeweled cross-halo, and holding a scroll conspicuously bound by seven seals. The radiant white-clad and silver-nimbed archangels who flank him usher in two additional figures on the outer edges of the composition. These two wear rich, if less exotic outfits. On the left, identified by his name spelled out above, St. Vitalis approaches with outstretched arms covered by the drapery of his *chlamys* (cloak). To him, Christ reaches out a golden, jewel-encrusted crown. Opposite Vitalis, another figure approaches with similarly draped hands, and the inscription overhead identifies this figure as "Bishop Ecclesius." He wears the garb of his office and proffers a small-scale version of a centrally planned, cross-topped building, an obvious reference to the very church in which viewers of this image would be standing.[15]

The entire composition is balanced, symmetrical, and rigid in its hierarchy. It presents a vision of the divine Christ who is at once heavenly and eternal as well as engaged and accessible. The setting of the scene is similarly multidimensional. The lush, elevated ground sprouts lilies and roses. It appears as a rich terrestrial garden whose otherworldliness is nevertheless emphasized by the four rivers flowing from beneath Christ's orb and the featureless, radiant gold background against which the figures are arrayed. It is within this paradisiacal landscape that the sixth-century episco-

pal patron joins the local saint in honoring the majestic figure of Christ.

In its most significant features, the S. Vitale apse has a number of other sixth-century parallels. An earlier example at Rome in the church of Ss. Cosmas and Damian, shows the golden-clad Christ standing elevated in the clouds against the deep blue of the semi-dome (see Fig. 4).[16] He is approached again from either side by a series of symmetrically arranged figures. Closest to him, wearing white togas, Peter and Paul each gesture with an upraised hand in Christ's direction while presenting the paired, crown-bearing titular saints, Cosmas and Damian. Behind them, two additional figures approach from the wings. The figure on the right, bearing a matching jeweled crown, is labeled St. Theodore. On the far left, with features reflecting his seventeenth-century restoration, Bishop Felix (IV) moves toward Christ with a miniature church structure in hand.[17]

Likewise, at the mid-sixth-century apse of the Cathedral of Parentium, modern Poreč in Croatia, a procession of saints and churchmen bearing gifts draws near to the enthroned Virgin and Child, access to whom is mediated by a pair of winged archangels (Fig. 6).[18] As at S. Vitale and Ss. Cosmas and Damian, viewers of the Poreč apse are presented with a timeless, heavenly vision that incorporates "modern day" mortals. The hierarchical and ordered composition balances saints on the one side—the three un-inscribed haloed

15. The same bishop also appeared in the slightly earlier apse of S. Maria Maggiore at Ravenna. Although the mosaic is now lost, the text of the dedication inscription is preserved in the historical record and enough of the figural composition was visible in the mid sixteenth century to identify Ecclesius holding a representation of his church and the central enthroned figures of the Virgin and infant Christ, see Ihm, *Programme* (as in note 2), 173–74, No. 30; Deichmann, *Ravenna Hauptstadt* (as in note 9), 343–48; R. Cortesi, "Due basiliche ravennati del VI secolo: S. Maria Maggiore, S. Stefano Maggiore," *CorsRav* 30 (1983), 49–86. Significantly, both churches were financed by Julianus Argentarius, who at least at S. Vitale is conspicuously absent from the apse imagery, see Deichmann, *Ravenna Hauptstadt* (as in note 9), 21–33, and the insightful discussion in Caillet, "Affirmation de l'autorité" (as in note 12), esp. 24–27; note also Jäggi, "Donator," (as in note 12), 31.

16. See above, note 7.

17. The chronology of the early modern and modern renova-

tions is outlined in Matthiae, *Mosaici medioevali* (as in note 7), 135 and updated after the most recent restoration campaign of 1988–89 by Tiberia, *Restauro del mosaico* (as in note 7), esp. 11–18. Felix IV's (526–30) dedication of the church is recorded in the *Liber Pontificalis* (LP 56) and commemorated in the mosaic inscription around the base of the apse: *Aula di claris radiat speciosa metallis in qua plus fidei lux pretiosa micat | martyribus medicis populo spes certa salutis venis et sacro crevit honore locus | optulit hoc dno Felix antistite dignum munus ut aetheria vivat in arce poli*—reproduced in Matthiae, *Mosaici medioevali* (as in note 7), 142, n. 2.

18. On the architecture and decoration of the complex, see B. Molajoli, *La basilica eufrasiana di Parenzo*, 2nd ed. (Padova, 1943). The church's well-preserved apse and triumphal arch mosaics have been the subject of a recent detailed study, A. Terry and H. Maguire, *Divine Splendor: The Wall Mosaics in the Cathedral of Eufrasius at Poreč*, 2 vols. (University Park, Penn., 2007), and their programs summarized by Ihm, *Programme* (as in note 2), 169.

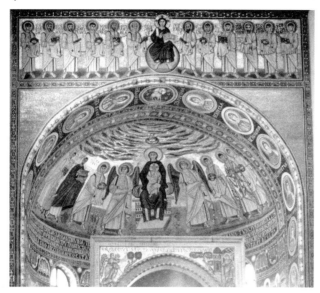

FIG. 6. Eufrasius Basilica, apse mosaic, Porcč (photo: author).

figures on the right[19]—against specific sixth-century individuals who dominate the left portion of the composition: Archdeacon Claudius bearing a jeweled book and his son Eufrasius, who carries a pair of candles, are led by Bishop Eufrasius, who cradles a small-scale representation of a basilica in his draped arms. The identity of each of these clerical figures is spelled

out for the viewer in a clear inscription against the gold ground.[20] In their pose and gift-bearing gestures, the ecclesiastics mimic St. Maurus, the next figure to the right who mediates the group's approach to the holy figures at the center. Maurus' saintly status, reinforced by both iconography and inscribed text, distinguishes him from the figures he leads, yet his identity as one of the city's early bishops also links him directly to the church-bearing Eufrasius, contemporary holder of the very same office, directly behind him.[21] The apse imagery shows, in other words, the sixth-century donor-bishop literally following in the footsteps of his illustrious episcopal predecessor, and juxtaposes the confessor's crown with the church building as worthy gifts to bring before the Virgin and Child.

Although no trace of its original apse survives, the late-sixth-century triumphal arch mosaic from S. Lorenzo fuori le Mura presented viewers with a similar composition as they looked toward the space of the sanctuary (Fig. 7).[22] Here Christ is again front and center, approached on either side by a band of hierarchically arranged pious men. All figures but one are depicted with haloes and wearing a clavi-striped tunic under a heavy mantle. Peter and Paul, patron saints of Rome, stand to either side of Jesus, and beyond them,

19. On the anonymity of these saints, see Terry and Maguire, *Divine Splendor* (as in note 18), 113–15, 142–46; H. Maguire, "Eufrasius and Friends: On Names and their Absence in Byzantine Art," in *Art and Text in Byzantine Culture*, ed. by Liz James (Cambridge, 2007), 137–60.

20. Even though the inscription, "Eufrasius eps," is heavily restored, archival evidence indicates that its reading is secure, see Terry and Maguire, *Dynamic Splendor* (as above note 18), 109. On Eufrasius, see G. Cuscito, "Fonti e studi sul vescovo Eufrasio e sulla chiesa parentina des secolo VI, bilancio critico-bibliografico," *Atti e Memorie della Società Istriana di Archeologia e Storia Patria*, 23 N.S. (1975), 61–71; J.-P. Caillet, *L'Évergétisme monumental chrétien en Italie et à ses marges d'après l'épigraphie des pavements de mosaïque (IVe–VIIe s.)* (Rome, 1993), 330–31. Like the inscription identifying Bishop Eufrasius, those of "Claudius arc" and "Eufrasius fil arc" are restored but now considered securely authentic, see Terry and Maguire, *Divine Splendor* (as in note 18), 111–12.

21. On Maurus, see J.-Ch. Picard, *Le souvenir des évêques: sepultures, listes épiscopales et culte des évêques en Italie du Nord des origins au Xe siècle* (Rome, 1988), 652–54; G. Cuscito, *Cristianesimo antico ad Aquileia e in Istria* (Trieste, 1977), 124–35. On a fragmentary inscription bearing Maurus' name found under the site of the

altar, see Maguire, "Eufrasius and Friends," (as in note 19), 155 and n. 46.

22. The small gallery church of S. Lorenzo fuori le Mura was constructed by Pope Pelagius II (579–90) over the catacomb containing the tomb of the martyr nearby a now-lost, large Constantinian ambulatory basilica. When, in the thirteenth century (under Honorius III, 1216–1227), another new basilica was attached to the west of Pelagius' structure, the orientation was reversed, the apse of the sixth-century structure destroyed, and the earlier building effectively converted to the presbytery. As a result, the mosaic decorating the sixth-century triumphal arch originally facing those entering the church could, from that date on only be seen from the vantage point of the altar. For a detailed description of the basilica, see A. Muñoz, *La Basilica di S. Lorenzo fuori le mura* (Rome, 1944), and R. Krautheimer and W. Frankl, "S. Lorenzo fuori le mura," in *Corpus basilicarum christianarum Romae: The Early Christian Basilicas of Rome (IV–IX cent.)*, Vol. 2. ed. by R. Krautheimer, W. Frankl, and S. Corbett (Vatican City, 1959), 1–151. For a discussion of the apse mosaic as well as the seventh-century mosaic of the triumphal arch, see Matthiae, *Mosaici medioevali* (as in note 7), Vol. 1, 135–42, 203–13; idem, *Ss. Cosma e Damiano* (as in note 7); Ihm, *Programme*, (as in note 2), 138–40, Cat. No. 6.

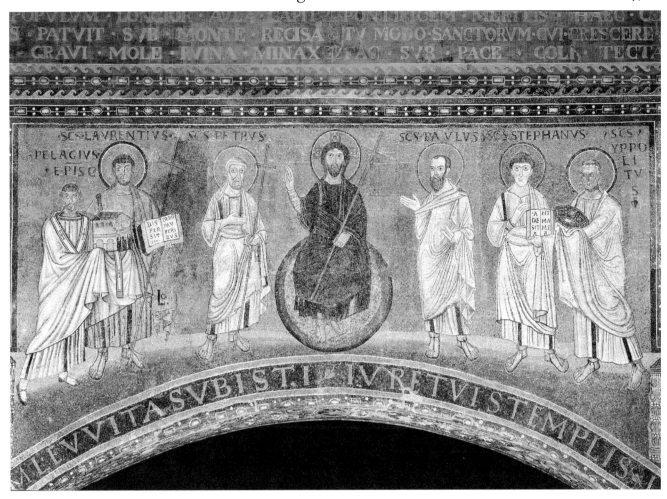

FIG. 7. S. Lorenzo fuori le Mura, triumphal arch mosaic, Rome (Scala/Art Resource, N.Y.).

at the outer edges of the composition, two pairs of additional figures move toward the seated Christ. Three of these are clearly identifiable by their inscriptions as early saints: St. Stephen and St. Hippolytus on the right and St. Lawrence, the church's titular saint, on the left. Lawrence's partner, however, at the far left of the group, in the pendant position to St. Hippolytus on the right edge, is a contemporary, local figure: Pelagius II, bishop of Rome from 579 to 590. Where Hippolytus' access to Christ is mediated by his predecessor, the protomartyr Stephen, Pelagius is led to Jesus by the local martyr Lawrence. Likewise, Hippolytus' offering of his martyr's crown is mirrored by the church building that the patron bishop stretches out toward Christ.

The apse iconography of church donors and local saints is also attested in the eastern Mediterranean. Though the mosaics from the sixth-century church of St. Sergius at Gaza no longer survive, the description of them embedded in Choricius of Gaza's panegyric of the Bishop Marcian conjures an image of the apse that includes a number of elements parallel to those just examined from Italy and Istria. The apse, Choricius tells us:

… adorned with gold and silver, displays in the center the Mother of the Saviour holding on her bosom her new-born Son; on either side stands a pious band. At the extreme right of these [groups] is a person who is in all respects like an emperor, and who is worthy both of being included in the register of God's friends and of bearing the name [Stephen] of the chief

of God's deacons as partner of his labours, he has donated the church to his fellow-citizens, knowing well that whereas other liberalities result only in the adornment of the city, the construction of churches brings in not only beauty, but a name for godliness besides. He it is who, standing next to the patron of the church, asks him to accept the gift graciously; the latter consents and looks upon the man with a gentle gaze as he lays his right hand on the man's shoulder, being evidently about to present him to the Virgin and her Son, the Saviour.[23]

Here, interestingly, the donor is not a bishop but a secular official, the governor Stephen, who was shown in company with the Virgin and Child and in direct contact with St. Sergius, patron saint of the church. Beyond diagramming the iconographic layout, Choricius' description stresses the causal link between the official's financing of church construction and his intimacy with the holy figures.[24] In addition to the civic praise and honors garnered by euergetistic benefaction, building the church also earns its donor a new status. The material church structure, the gift held in Stephen's hands, is the means through which this mortal gains access to the heavenly circle.

In each of these programs, the benefactor of the church inserted himself into the scene of divine majesty with Christ, or the Virgin and Child, ensconced at the pinnacle of the hierarchical composition of sacred figures. The apses deploy both text and imagery to testify and make manifest to the viewer the donor's identity, the nature of his gift, and his personal relation-

ship with the heavenly figures. The representation of the historical donor figures provides spectators with a very particular point of geographical and chronological entry into the timelessness of the theological vision. At the same time, in monumentalizing the commemoration of mortal donors and their financial benefaction, these monuments tap into an older tradition. Indeed, throughout the late antique world, the very walls and floors of churches frequently spoke of their own inception, thanks to the benefactors whose generosity had made it possible. A central goal was the advertisement to the viewer of the donors' identities, their contributions, and often the responses they hoped from the viewer in return.

To take just one example, at the Basilica of Chlef in Algeria (previously Orléansville or Al-Asnam, the ancient site of Castellum Tingitanum in Mauretania Caesariensis), on the pavement along the central axis of the nave, at what was most likely the original entrance-end of the church (prior to the construction of the western counter-apse), was a dated dedication inscription.[25] The text, which unfortunately no longer preserves the donor's name, was oriented so as to be read by a viewer standing facing the altar and apse to the east (Fig. 8):

The 285th year of the province, the twelfth day (before the) kalends of December [November 20, 324 c.e.], the foundations of this basilica were placed and [*lacuna*]... the 290th(?) year of the province [329–338 c.e.] [*lacuna*]... Bear in mind [*name*]..., servant of God,... May you live in God.[26]

23. *Laudatio Marciani* 29–31. Trans. by C. Mango, *The Art of the Byzantine Empire 312–1453: Sources and Documents* (Toronto, 1986), 62. F.-M. Abel, "Gaza au VIe siècle d'après le rhéteur Chorikios," *Revue biblique* 40 (1931), 12 ff. The church was probably built before 536, see Mango, *The Art of the Byzantine Empire*, 60, n. 26.

24. The emphasis on vividness in Choricius' description is at the same time a central characteristic of the ekphrastic literary form, see R. Webb, "The Aesthetics of Sacred Space: Narrative, Metaphor, and Motion in Ekphraseis of Church Buildings," *DOP* 53 (1999), 59–74.

25. The site, first excavated in the mid nineteenth century, is largely destroyed, and the mosaics, lifted from the site, restored, and installed as decoration in a modern church, were heavily damaged in the Algerian War of Independence (1954–62). J.-P. Cail-

let has recently provided a thorough resumé of the history, scholarship, and current state of the site, see "Le Dossier de la basilique chrétienne de Chlef (anciennement El Asnam, ou Orléansville)," *Karthago* 21 (1986–87), 135–61. Most of the archaeological literature refers to the site as "Orléansville," although its name was changed in 1964 to "Al-Asnam" and again in 1981 to "Chlef." On this church and other examples of "double-apsed" basilicas, which were particularly prevalent in late antique North Africa, see N. Duval, *Les églises africaines a deux absides*, 2 Vols. (Rome, 1971–73).

26. *Pro(vinciae anno)* | *CCLXXX et V, XII kal(endas)*. | *dec(embres), eius basilicae* | *fundamenta posita* | *sunt et* ... | *prov(inciae anno) CC et* ... [*in* ?] | *mente habea[s]* ... | *servum Dei* ...[*et in* ?] | *Deo vivas* (*CIL* VIII, 9708 = *ILCV* 1821). For transcription, variant readings based on transcriptions from the 1840s before the mo-

FIG. 8. Dedicatory inscription from the nave of the Basilica at Chlef, Algeria (G. Vidal, *Un témoin d'une date célèbre: la basilique d'Orléansville*. Algiers, 1936, p. 54, Fig. 38; reproduced in Caillet, "Dossier de la basilique," p. 144, Fig. 10).

This text makes clear the relevant historical details of the benefaction. It originally conveyed the date, nature, and agent responsible for the pious donation. But the inscription was much more than an archival record of the donor's gift to a heavenly patron. It made direct appeal to its human audience and specifically elicited their memory and prayers. Viewers encountering the inscription on the church pavement were literally instructed to "bear [the donor] in mind." The next line further underscored the donor's selflessness by labeling him a "servant of God." [27] Having come to the end of the text, and thus performed commemoration of the donor, the reader received his or her own benediction: "[in] Deo vivas." This monument recording the do-

nor's pious gift, incorporated into the very fabric of the structure given, thus implicated the buildings' users in the exchange to which it testified. It enjoined viewers in the present to recall the historical act of ecclesiastical donation, to pray for the donor who brought it about, and thereby to enjoy their own reward for the act of pious commemoration.

While ecclesiastical benefaction inscriptions were frequently spelled out across the floor along the main architectural axes, or overhead on the carved lintels of doorways, a number of well-documented or preserved decorative programs indicate that the sites of donor commemoration frequently extended all the way to the upper reaches of the church's spatial hierarchy—to triumphal arches and apses where they underscored the figural imagery above and framed the action taking place in the sanctuary below. They were also monumental in scale and crafted for optimal visibility. In Rome, for example, the triumphal arch of the Basilica of Sta. Maria Maggiore from the second quarter of the fifth century has announced itself to nearly sixteen centuries of churchgoers as an offering from "Bishop Sixtus (III) to the people of God" (Fig. 9).[28] Against the deep blue ground, the white letters of Sixtus' inscription are as tall as the heads of the surrounding figures and more crisply legible. Likewise, the lost apse of S. Andrea in Catabarbara from ca. 470–80, which depicted the scene of Christ with his Twelve Apostles described above, also underlined its iconography with a monumental inscription celebrating its ecclesiastical donor, its divine recipient, and its titular saint (see Fig. 3).[29] At the famous late-sixth-century apse mosaic at Sinai, the commemoration of donors is not only textual (Fig. 10).[30] The words of the mosaic inscription

saic was installed in its current position, and reconstructions of the provincial dates, see Caillet, "Dossier de la basilique" (as in note 25), 146–50.

27. Probably indicating that he was an ecclesiastic (Caillet, "Dossier de la basilique" (as in note 25), 150).

28. B. Brenk, *Die frühchristlichen Mosaiken in S. Maria Maggiore zu Rom* (Wiesbaden, 1975), 1–2.

29. *Haec Tibi mens Valilae devovit praedia XPe | Cui testator opes detulit ille suas | Simplicius qu(a)e Papa sacris coelestibus aptans | Effecit vere muneris esse tui | Et quod apostolici deessent limina nobis*

| *Martyris Andreae nomine composuit. Utitur haec heres titulis ecclesia iustis | Succedensque domo mystica iura locat | Plebs devota veni perque haec commercia disce | Terreno censu regna superna peti.* Reproduced in Ihm, *Programme* (as in note 2), 155. On the church, see above, note 6. Cf. S. Pudenziana where the decoration was accompanied by a donor inscription that was still visible in the sixteenth-century, see W. Oakeshott, *The Mosaics of Rome from the Third to the Fourteenth Centuries* (Greenwich, Conn, [1967]), 65.

30. The construction of the monastery and the church can be confidently dated to the period between Theodora's and Justinian's

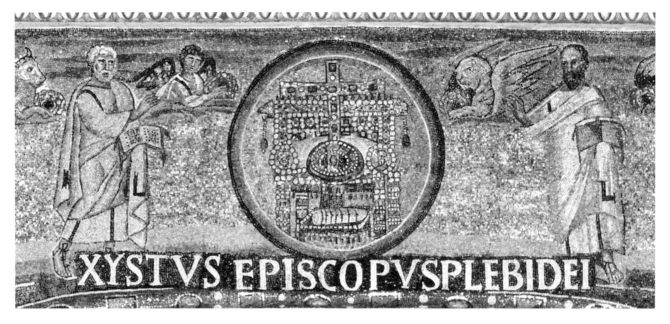

FIG. 9. Sta. Maria Maggiore, triumphal arch inscription, Rome (Scala/Art Resource, N.Y.).

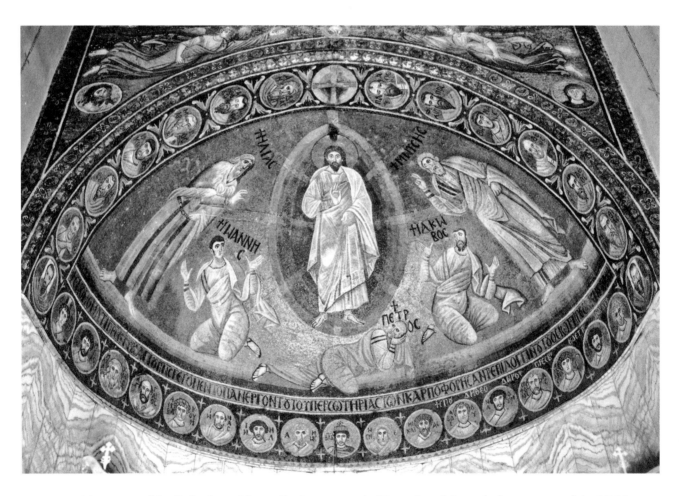

FIG. 10. Monastery of St. Catherine at Mount Sinai, apse mosaic (Reproduced through the courtesy of the Michigan-Princeton-Alexandria Expedition to Mount Sinai).

inserted between the horizontal medallion band and
the central apse imagery of the Transfiguration above
credits the work to Longinus, priest and abbot, and to
his "second in command," a certain priest Theodore.[31]
These individual patrons also enter the apse composi-
tion by means of their visual images, for they have been
included in the chain of medallion portraits (of proph-
ets along the horizontal edge and apostles along the
row arching over the top of the apse), which encircles
the central Transfiguration scene. The two clergymen
are inserted into the corners where the two rows meet
(Fig. 11). While conforming to the same scale and for-
mat, these two are contrasted with the other medallion
figures by their monks' habits, square haloes, and in-
scribed monastic offices. These features draw attention
to the fact that the two corner figures belong to neither
prophet nor apostle set, and underscore their status as
contemporary, non-scriptural figures.

Thus, late antique church buildings regularly pro-
nounced the identity and deeds of their benefactors
and appealed to the viewer for their prayers on behalf
of the donor's salvation by exploiting positions of vi-
sual and architectural prominence to put their com-
memorative message before the viewer. Some donors
even encroached on the hierarchical site of apse, the
decorative and architectural culmination of the church
program. Such is the case, for example, at S. Andrea in
Catabarbara, with its dedicatory inscription that un-
derscored the image of Jesus and the Apostles, and
Sinai, where the inscription accompanied by portraits
of the donors inserted among the images of apostles
and prophets encircles the representation of the di-
vine Transfiguration in the conch (see above, Figs. 3
and 10). When, therefore, churches such as Ss. Cos-

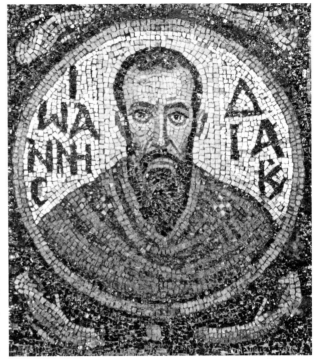

FIG. 11. Monastery of St. Catherine at Mount Sinai, apse
 mosaic, detail of John the Deacon medallion (© Dumbar-
 ton Oaks, Image Collections and Fieldwork Archives,
 Washington, D.C.).

mas and Damian, S. Vitale, and the Poreč Basilica in-
clude representation of their benefactors in the apse
proper, it may be seen as a continuation of a trend to-
ward capitalizing on the visual and spatial hierarchy
of the church structure. At the same time, however,
the message and impact of the incorporation of the do-
nor's dedicatory text and image in these apses are not
only conveyed through their architectural location.
For when these donors cross over the frame into the
picture plane of the apse, they literally stand among

death (i.e., 548–65) and the apse mosaic has been dated to before
600 based on the paleography and formulae of the inscription, see
I. Sevčenko, "Inscriptions," in G. H. Forsyth and K. Weitzmann,
*The Monastery of Saint Catherine at Mount Sinai: The Church and
Fortress of Justinian* (Ann Arbor, [1973]), 19.

31. + Ἐν ὀνόματι π(ατ)ρ(ὸ)ς κ(αὶ) υ(ἱο)ῦ κ(αὶ) ἁγίου
πν(εύματο)ς· γέγονεν τὸ πᾶν ἔργον τοῦτο ὑπὲρ σωτηρίας τῶν
καρποφορησάντ(ων), ἐπὶ Λογγίνου τοῦ ὁσιωτ(άτου) πρεσ-
β(υτέρου) κ(αὶ) ἡγουμ(ένου) + | + Σπουδῆ Θεοδώρου πρεσ-
β(υτέρου) κ(αὶ) δευτ(εραρίου), ἰνδ(ικτιῶνος) δϊ +. The text of
the Sinai apse inscription is transcribed and its date discussed in

I. Sevčenko, "The Early Period of the Sinai Monastery in Light of
Its Inscriptions," *DOP* 20 (1966), 256–57, 259–61, and 263, No.
7. On economic, craftsmanship, and transportation grounds, it is
thought likely that the mosaics were carried out during Justinian's
lifetime (d. 565) and certainly not later than the early seventh cen-
tury, see *ibid.*, 259–61; Weitzmann, "Introduction to the Mosaics
and Monumental Paintings," in Forsyth and Weitzmann, *Monas-
tery of Saint Catherine* (as in note 30), 11. On the larger topogra-
phy of donor inscriptions at the site, see S. Coleman and J. Elsner,
"The Pilgrim's Progress: Art, Architecture and Ritual Movement
at Sinai," *World Archaeology* 26:1 (1994), 78–81.

the holy figures and participate in their exchange of gifts. These programs thus mark a new level of the donors' appropriation of the theological and eschatological themes central to the apse imagery.

At the same time, the apses present their viewers with an object lesson in giving. The monumental images of benefactors depict not only their countenances, but also their gift and the very act of its presentation. The power of pious benefaction to earn heavenly rewards for those who practice it is central to both visual and epigraphic aspects of the decorative programs. As with the dedicatory inscriptions, however, the representation of a benefactor's donation is not in itself new. Quantifying the size of a benefactor's gift is common, for example, in records of preserved mosaic on pavement inscriptions. The pavement inscription from the late fifth- to early sixth-century basilica under the Florence Cathedral, for example, gathers together its donors' names and the record of their financial contributions into a common panel in the center of the nave (Fig. 12). It presents a catalogue of fourteen benefactors in order of decreasing generosity, with the deep-pocketed deacon who funded 300 feet of mosaic pavement topping the list, followed by those who funded 200 feet, and so on.[32]

Very occasionally, the donor is depicted in the act of dispensing his or her wealth. The mosaic pavement from the sixth-century church at Kissufim in the Negev, for example, includes a panel between two columns of the north colonnade that depicts a well-dressed female donor labeled, "The Lady Sylthous" (or "the Lady of Syltho") who literally drops coins from her right hand (Fig. 13).[33] The aristocratic Constantinopolitan benefactor Anicia Juliana performs the same gesture on the presentation page of the manuscript given to her in thanks for her construction of a church, while the per-

FIG. 12. Dedicatory inscription from the nave of Sta. Reparata, Florence (photo: author).

sonification of Magnanimity (*Megalopsychia*) stands behind her on the left bearing an armful of gold coins (Fig. 14).[34] By contrast, however, the sixth-century

32. For a summary, transcription, and discussion of the date of the early church to the end of the fifth through the first quarter of the sixth century, see Caillet, *Évergétisme monumental* (as in note 20), 25–30.

33. The Kissufim pavement also contains a dated inscription placing the construction of the nave mosaic in 576. See R. Cohen, "A Byzantine Church and its Mosaic Floors at Kissufim," in *Ancient Churches Revealed*, ed. by Y. Tsafrir, (Jerusalem, 1993), 277–82.

34. Anicia Juliana is also surrounded by personifications of her other virtues: *Phronesis* (Prudence or Understanding) stands on the right, while *Eucharistia Technon* (Gratitude of the Arts) kneels at her feet with the putto labeled *Pothos tes Philoktistou* (Affection for the One Who Loves Building) behind. See L. Brubaker, "The Vienna Dioskorides and Anicia Juliana," in *Byzantine Garden Culture*, ed. by A. Littlewood, H. Maguire, and J. Wolschke-Bulmahn (Washington D.C., 2002), 189–214.

FIG. 13. Donor's portrait from the pavement of the Basilica at Kissufim, Israel (Rudolf Cohen, "A Byzantine Church and its Mosaic Floors at Kissufim," in *Ancient Churches Revealed*, ed. Yoram Tsafrir, Jerusalem: Israel Exploration Society, 1993, p. 280; reproduced by permission of the publisher).

apse images show not only images of the donors, but also graphic portraits of the actual buildings funded.[35] These are not abstract representations of the benefactor's virtue of generosity, but literalized depictions of the economic (and spiritual) transaction: the building is shown as a physical thing, an object handed over for possession, part of an economy of exchange in which reciprocity is expected.

In a number of cases, this expected return is specifically articulated in the inscriptions below. Magnificent large-scale tessellated texts survive in place, for example, at both Ss. Cosmas and Damian (see Fig. 4) and the Eufrasius Basilica at Poreč, forming the lower border of the composition in the apse's semi-dome. These inscriptions identify and commemorate each church's donor, but they also do much more. Felix IV's gold-lettered text, punctuated with golden crosses at Ss. Cosmas and Damian, picks up on the luminous character of the materials: "This hall of God shines brightly with mosaics; the precious light of faith gleams in it even more brightly. To the people a sure hope of salvation comes from the martyred doctors, and the place before named as sacred has increased in honor..."[36] The gift, in other words, implicates its audience, and the

35. Lipsmeyer, "Donor and his Church Model," (as in note 12), 121–29.

36. *Aula di claris radiat speciosa metallis | in qua plus fidei lux pretiosa micat | martyribus medicis populo spes certa salutis | venit* *et ex sacro crevit honore locus | optulit hoc dno Felix antistite dignum | munus ut aetheria vivat in arce poli.* Text reproduced in Oakeshott, *Mosaics of Rome* (as in note 29), 94, and translation after *idem* and Kessler, "Bright Gardens" (as in note 5), 138. On the

FIG. 14. Dedication page of the Vienna Dioscorides (med. Gr. 1), fol. 6ᵛ (photo: Austrian National Library Vienna, Picture Archive).

message is explicitly didactic: salvation comes to the people through the saints, and not just any saints, but specifically "the doctor martyrs," i.e., Saints Cosmas and Damian, patrons of *this* church. The final lines of the inscription call direct attention to the spiritual commerce between donor and divinity: "Felix has made to the Lord this offering, worthy of the Lord's servant, that he might live in the airy vault of heaven."[37] The

inscription thus clarifies the hoped-for outcome of the bishop's gift, and the imagery above can be seen to assert the success of that wish. The votive's petition for Felix's admission to "the vault of heaven" is granted by the apse imagery—here the bishop is shown already standing within the heavenly vault, presented to Christ by the church's saintly patrons.

Moreover, the inscription informs its readers that

theme of the shining and radiating materials emphasized by this and other inscriptions, see E. Borsook, "Rhetoric or Reality: Mosaics as Expressions of a Metaphysical Idea," *Mitteilungen des Kunsthistorischen Institutes in Florenz* 44:1 (2000), 2–18, esp. 4–5; and E. Thunø, "Materializing the Invisible in Early Medieval Art: The

Mosaic of Santa Maria in Domnica in Rome," in *Seeing the Invisible in Late Antiquity and the Early Middle Ages*, ed. by Giselle de Nie et al. (Turnhout, 2005), 265–89.

37. See previous note.

they, too, "the people," can enjoy the same reward by venerating the very saints represented overhead. The monumental program thus extends beyond the holy figures and beyond the ecclesiastical benefactor to incorporate the community of the churchgoers, the mass of beholders of the apse, in its social web. It visualizes the basilica builder's relationship with the saints and God by means of the church, and verbally assures the people who stand within that church of the possibility of their own salvation through their piety towards the same saints represented overhead. The apse, in other words, simultaneously presents viewers with both visual proof of the donors' ultimate salvation as well as a means to their own.

The message of such programs is made all the more explicit by the paradisiacal setting of the exchange. The association of images of Paradise with the commemoration of church benefaction is not unique to apse programs. At the Basilica of Dumetios at Nikopolis, for example, a mosaic panel that represents, as Henry Maguire has shown, a very literal depiction of earthly paradise with a variety of fruit trees and birds, is paired with a dedication inscription set in a *tabula ansata* frame below: "Here you see the famous and boundless ocean containing in its midst the earth, bearing round about in the skilful images of art everything that breaths and creeps. The foundation of Dumetios, the great-hearted archpriest."[38]

In sixth-century apses, however, the donor's presence in a paradisiacal realm is not merely evoked by the juxtaposition of text and image as at Nikopolis, but is visualized in literal terms. In so doing, the apse compositions reposition the benefactors both geo-graphically and socially. The donors are linked to the heavenly kingdom and its personnel both through the depiction of their physical proximity to the saints as well as through their parallel poses and gestures of exchange and interaction.[39] At the Poreč basilica, for example, sixth-century clerical benefactors join the saints who approach the angel-flanked Virgin and Child from either direction (see Fig. 6). The figures all share the same pictorial space. Each brings an offering to the enthroned Mary and Jesus at the center, and with the exception of the child Eufrasius, each is shown at approximately the same scale. Compositionally, in other words, the saints and the modern ecclesiastics are on a par. Only iconography and identifying text signal the mortal status of three figures on the left.

Moreover, an elaborate commemorative inscription below the apse composition expands upon the bishop's accomplishment and generosity. Eufrasius' four long lines of golden script form a formidable base atop which the apse scene the Virgin and Child with surrounding figures is arranged. The inscription elaborates the ruinous state of an earlier church on the site, which:

> … Eufrasius, provident bishop and fervent in the zeal of faith … demolished … in order to set it more firmly. He built the foundations and erected the roof of the temple, finishing what you now see shining with new and varied mosaic. Completing his undertaking, he decorated it with great munificence and naming the church he consecrated it in the name of Christ. Thus, joyful from his work, a happy man, he fulfilled his vow.[40]

Here, as at Ss. Cosmas and Damian, the inscription is

38. Ὠκεανὸν περίφαντον ἀπίριτον ἔνθα δέδορκας | γαῖαν μέσσον ἔχοντα σοφοῖς ἰνδάλμασι τέχνης | πάντα πέριξ φορέουσαν ὅσα πνίει τε καὶ ἔρπει· | Δουμετίου κτέανον μεγαθύμου ἀρχιερῆος. H. Maguire, *Earth and Ocean* (as in note 5), 21–24; text and translation reproduced from E. Kitzinger, "Studies on Late Antique and Early Byzantine Floor Mosaics, I: Mosaics at Nikopolis," *DOP* 6 (1951), 100.

39. On the role of saints in early Christian church programs more broadly, see A. M. Yasin, *Saints and Church Spaces: Architecture, Cult, and Community in the Late Antique Mediterranean* (forthcoming). On the appearance of saints along with donors in monumental church apses, see also Jäggi, "Donator," (as in note 12),

37–8; and Caillet, "Affirmation de l'autorité," (as in note 12), esp. 29.

40. + *Hoc fuit in primis templum quassante ruina terribilis labsu nec certo robore firmum, exiguum magnoque carens tunc furma metallo,* | *sed meritis tantum pendebant putria tecta.* + *Ut vidit subito labsuram pondere sedem, providus et fidei fervens ardore sacerdus Eufrasius s(an)c(t)a precessit* | *mente ruinam. Labentes melius sedituras deruvit aedes; Fundamenta locans erexit culmina templi.* + *Quas cernis nuper vario fulgere metallo, perficiens coeptum decoravit* | *munere magno, aecclesiam vocitans signavit nomine Xpi. Congaudens operi sic felix vota peregit.* Text and translation in Terry and Maguire, *Dynamic Splendor* (as in note 18), 4–5, and 109, n. 14.

broadly honorific in the sense of traditional memorials of the Roman world that memorialize euergetistic acts. At the same time, however, the church inscriptions stress the nature of the construction as a votive offering by explicitly identifying the construction as a gift to the divine that has been made for the donor's salvation and that the spectators are called to witness.

To viewers in the church below, the saints depicted in the apse act as visual intermediaries to the central seated figures and clear indices with which to measure the non-saintly figures in their midst. St. Maurus, one of Poreč's early bishops, shown approaching the angel to the Virgin's right, introduces Eufrasius, the latter-day successor to his office, as well as the archdeacon and his son. In their visual parallels and compositional juxtaposition, the saints highlight the privileged position of the clerical figures. They do so, moreover, immediately above the altar and the space from which the clergy preside over the liturgy, and thereby forge a connection between the clerical office holders represented with them in the apse and the living figures presiding over the liturgy in real time below. In this way, the architectural and decorative program offers a powerfully graphic illustration of the chain of intercessory relationships linking God to his saints and his saints to those who honor them.

The same visual mechanisms were deployed in the related compositions in the apse at Ravenna's S. Vitale, at Ss. Cosmas and Damian in Rome, and on the original triumphal arch mosaic at S. Lorenzo fuori le Mura (see Figs. 5, 4, and 7). At S. Vitale, Ecclesius is cast as the titular saint's pendant in the composition. He shares the saint's proximity to Christ and participates with the church he offers in the same commerce of divine exchange as the martyr receiving his crown of victory.[41] At Ss. Cosmas and Damian too, the monumental decorative program underscores the saints' role as intercessors between Christ and the Christian community and simultaneously elevates the leader of that community above the status of his fellow men. Once again, the saints mediate the approach to the divine and admit a contemporary sixth-century figure into their midst. Although the style of figure of Felix IV betrays the hand of the seventeenth-century restorer, his stance reflects the parallelism sought by the sixth-century program design.[42] The mosaic stresses a direct visual analogy between the gesture of the figures and the objects they offer. As a result, not only is Bishop Felix elevated to the level of St. Theodore and the titular saints Cosmas and Damian, but his church offering is also equated to the status of the martyrs' crowns and earns him a place in the same representational space.[43] The original triumphal arch mosaic at S. Lorenzo fuori le Mura demonstrates the continued popularity of the increasingly canonical composition in which the ecclesiastical patron of the church is introduced into the company of Jesus through a chain of locally significant saints (see Fig. 6).[44] The abstract concept of saintly intervention is, thus, explicitly particularized by celebrating its fundamental localism—access to the divine is articulated here through the relationship between God, the city's patron saints, this very church's patron saint, its clergy, and, by extension, its people.

In this sense, these apse programs are not only about remembering the donor bishop and his action (in the past), but also very directly impact the viewers and users of the space in the present. The visual presentation of local saints and the local bishop-benefactor in the company of Christ in majesty provides a visual articulation of the community's connection with the cosmic hierarchy. Likewise, the visualization of the gift-church in the hands of the donor provides direct proof for the viewer of the offering as well as the outcome that such benefaction enjoys.

Thus, while the sixth-century compositions draw on elements that evoke the paradisiacal, the otherworldly, and the timeless, I suggest that central to their func-

41. See above, note 9.

42 The figure of Felix IV was remade under Alexander VII (1655–1667) along the lines of the original design (see above note 7).

43. Matthiae, *Mosaici medioevali* (as in note 7), 137–38.

44. See above, note 22.

tion is the incorporation of other, incongruous temporal and spatial dimensions. The images resonate with notions of the eternal and the future, but insofar as they are explicitly commemorative, they are also significantly about the past and the act of viewing and remembering that past in the present. Likewise, as much as the images present visions of otherworldly paradise or the celestial kingdom, the coherence of that spatial world is broken by the incorporation of historical, mortal donor figures and local saints. The benefactor enters into the realm of the divine thanks to his pious actions and the patron saints' intercession. By depicting his access via the saints' introduction, the church programs give local expression to the theological hierarchy established between God, his saints, and the Christian community. This is a chain in which the viewer too has a role. For just as the donor reaches God through the local saint, so the viewer of the images worships in that very saint's church. By depicting the donor's access into the divine realm through his gift of the church in which viewers stand, these visions of paradise invite the beholders, and teach them how, to participate in that world as well.

GEORGIA FRANK

Death in the Flesh:
Picturing Death's Body and Abode in
Late Antiquity

IN RECENT DECADES, ethicists, historians, scientists, and physicians have grappled with defining death. In an age of televised warfare and life-support systems, should death be regarded as a moment or a transition, a cessation or a liberation? Few today spend much time imagining death as a *person*. In Antiquity and the Middle Ages, however, Death was not only personified, but thoroughly embodied, with a propensity to walk, talk, dance, eat, sing, and weep. That anthropomorphized body was known by many guises: as corpse, crowned skeleton, queen, hunter, or horseman, to name a few.[1] By the fifteenth century, Christians in Western Europe had grown accustomed to seeing Death as a person.[2]

Seeing the dead and seeing Death personified were processes that unfolded slowly in the Christian tradition. Ritual gatherings provided an important setting for these representations of death to emerge. Already

in the 50s, the Apostle Paul reminded his followers in Galatia, "It was before your eyes that Jesus Christ was publicly exhibited as crucified!"[3] By the third century, the *Odes of Solomon*, probably composed for liturgical settings, referred to Death and Sheol's violent responses to Christ's arrival in Hell.[4] At martyrs' shrines, devotees learned to look upon fragments of the dead. There, they praised martyrs who, in the words of one account, "endured even when their skin was ripped to shreds by whips, revealing the very anatomy of their flesh, down to the inner veins and arteries."[5] Such repeated evocation of the martyr's body and its viscera confronted Christian audiences with the ritualized visibility of death. Defenders of relic veneration underscored that lingering gaze, by looking upon a fragment of dust or bone to visualize life.[6] Unlike corpses that signify a life once lived, the relic testified to a life that still lived, still granted divine power. Catechu-

1. I distinguish here between personifications of Death as a lone figure and representations of the dead, e.g., "The Legend of the Three Dead and the Three Living," in which three young hunters encounter their own post-mortem selves, or the Dance of Death, in which several skeletal figures represent the various occupations and ages, or the "transi tombs," which include representations of the deceased in later stages of putrefaction. On these themes, see *'Humana Fragilitas': The Themes of Death in Europe from the 13th to the 18th Century*, ed. by A. Tenenti (Clusone, 2002); S. Oosterwijk, "Food for Worms—Food for Thought: The Appearance and Interpretation of the 'Verminous' Cadaver in Britain and Europe," *Church Monuments* 20 (2005), 40–80, 133–40; *eadem*, "Of Corpses, Constables and Kings: The Danse Macabre in Late-Medieval and Renaissance Culture," *The Journal of the British Archaeological Association* 157 (2004), 169–90.

2. L. E. Jordan, III, *The Iconography of Death in Western Medieval Art to 1350* (Ph.D. diss., University of Notre Dame, 1980);

K. S. Guthke, *The Gender of Death: A Cultural History in Art and Literature* (Cambridge, 1999).

3. Galatians 3:1; cf. Romans 6:5–11; Colossians 2:12.

4. Odes Sol. 42.11–13, trans. by J. Charlesworth, *The Old Testament Pseudepigrapha*, 2 vols. (Garden City, N.Y., 1985), 2:771.

5. *Martyrdom of Polycarp* 2, in *Apostolic Fathers*, ed. and trans. by B. Ehrman, 2 vols. (Loeb Classical Library 24–25; Cambridge, Mass., 2003), 1.369. On the spectacle of death in early Christian martyr veneration, see E. A. Castelli, *Martyrdom and Memory: Early Christian Culture Making* (New York, 2004), 104–33.

6. E.g., G. Clark, trans., "Victricius of Rouen, Praising the Saints," *Journal of Early Christian Studies* [hereafter: *JECS*] 7 (1999), 365–99, esp. §§ 9–10 (pp. 390–91); on the dialectic between fragmentation and wholeness, see P. C. Miller, " 'Differential Networks': Relics and Other Fragments in Late Antiquity," *JECS* 6 (1998), 113–38.

mens in the late fourth century also learned to picture death by re-symbolizing the liturgy of the Eucharist. One bishop, Theodore of Mopsuestia (ca. 350–428/9), called on new Christian converts to regard the Eucharist as a re-enactment of Jesus' death.[7] By casting these catechumens as silent onlookers and mourners at Jesus' funeral, Theodore taught Christians to visualize the death of Jesus.

Early on, then, Christians devised the means to gaze upon the dead (or, more precisely, the fragments of death) in order to visualize life. To regard Death as a person would require no less a concerted effort to train the senses to visualize this body. Before Christians could *see* Death, they learned to *listen* for its voice. As this essay suggests, ritual would provide the training ground for this education of perception.[8] Early Christians learned through rituals how to see Death and the underworld personified. In particular, this essay examines ritual storytelling related to the descent of Christ to Hell in the days following his death, but prior to his resurrection.

Personification

Before I turn to these legends, it is worth clarifying the term personification. In general usage, a personification can mean intensifying a trait or characteristic by inscribing a human form to it, as in "he was evil personified" or "she is patience personified." In art history and literature, personification involves taking a non-substantial quality and representing it as a person.[9] This transfer of incorporeal to corporeal can occur in a single, contained phrase or line ("O, death, where is thy sting?" [1 Cor. 15:55]). One may further draw a distinction between anthropomorphisms as figures of speech and anthropomorphisms that function in a "complete narrative world."[10] In this heightened personification, the corporeal being is endowed with feelings, thought, and language.

Personifying Death can be trickier. As literary theorist James Paxson notes, "Death is a unique personification character in that, as a sign, he does not always point clearly to an incontestable personified."[11] In other words, who or what is personified is not always clear. As Paxson asks, "Does he [Death] signify the dead or the process of dying?"[12] Thus, the personification of Death is never fully independent of the actual dead, such that a corpse clings to Death's shadow. That proximity between Death and the dead certainly holds for early Christian preaching and ritual related to the events surrounding Jesus' death. Here, personified Death literally ingested the dead at the moment of death. The narrative world, however, emerged the day Jesus died on the cross.

Christ's Descent to Hell

Christian legends known as the Descent of Christ to Hell, or the Harrowing of Hell, describe the underworld events that took place between Christ's death and his resurrection (Figs. 1 & 2). For Christian storytellers, what followed Christ's last breath was anything but silence. Some New Testament epistles mention a post-mortem journey to the underworld: Christ descended "into the lower parts of the earth," according to Ephesians 4:9 and, as 1 Peter put it, "preached to the spirits in prison" (1 Peter 3:19; cf. 4:6).[13] The "soundtrack" to that journey would be further

7. Theodore of Mopsuestia, *Catechetical Homily* 5 in *The Commentary on the Nicene Creed and The Commentary on the Lord's Prayer and the Sacraments of Baptism and Eucharist*, ed. and trans. by A. Mingana. Woodbrooke Studies 5 and 6 (Cambridge, 1932–33), 86–88. On visualization and catechesis, see G. Frank, "'Taste and See': The Eucharist and the Eyes of Faith in the Fourth Century," *Church History* 70 (2001), 619–43.

8. My thinking on the formation of perception is shaped by L. E. Schmidt's *Hearing Things: Religion, Illusion, and the American Enlightenment* (Cambridge, Mass., 2000).

9. J. J. Paxson, *The Poetics of Personification* (Cambridge, 1994),

42; cf. E. Stafford, *Worshipping Virtues: Personification and the Divine in Ancient Greece* (London, 2000), 3.

10. Paxson, *Poetics of Personification* (as in note 9), 35.

11. *Ibid.*, 47. 12. *Ibid.*, 47.

13. R. Gounelle, *La descente du Christ aux enfers: institutionnalisation d'une croyance* (Paris, 2000). Also useful, J. A. MacCulloch *The Harrowing of Hell: A Comparative Study of an Early Christian Doctrine* (Edinburgh, 1930); D. Sheerin, "St. John the Baptist in the Lower World," *Vigiliae Christianae* 30 (1976): 1–22; K. Roddy, "Politics and Religion in Late Antiquity: The Roman Imperial Adventus Ceremony and the Christian Myth of the Harrowing of

FIG. 1. The Harrowing of Hell, detail from a thirteenth-century Antiphonary made for Abbess of Saint-Marie of Beaupré. Flemish, 1290, The Walters Museum, Baltimore, Ms. W. 759, fol. 2ʳ.

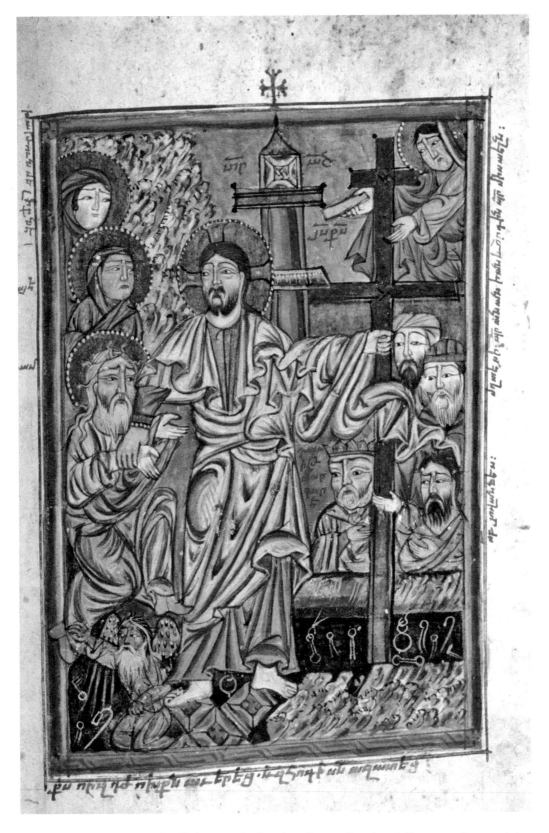

FIG. 2. The Harrowing of Hell showing the kneeling figure of Hades. Full-page prefatory minia-
ture from a Gospel Book. Armenian, circa 1449, Princeton University Library, Ms. Garrett 18,
fol. 18ʳ.

elaborated outside the canon. Ancient Christian writers described how during his brief stay in Hades, Jesus preached to the dead, baptized them, defeated Hell, and liberated the just. Within this basic plotline, narrators proliferated. In some versions Christ himself told the tale, in others a series of dumbfounded eyewitnesses offered their versions of events. Roman centurions, grieving disciples, biblical patriarchs and prophets recounted the descent; even Hades and Satan—typically personified—recalled the event.[14] These legends emerged slowly over centuries.

In the centuries following the legalization of Christianity under the Emperor Constantine in 312, Christians took greater interest in Jesus' descent to Hell. By the mid-fourth century, the event entered creeds taught to the faithful.[15] Bishop Cyril of Jerusalem told candidates for baptism that the descent was among the ten key doctrines of the faith, including that Christ "descended to the regions beneath the earth, that then He might redeem the just." [16] By the fifth century, the story was woven into the celebration of Easter, as the long hours of the all-night vigils inspired meditations on Hell.

As narrated by eavesdroppers and unwitting eyewitnesses, Christ's descent to Hell allowed ancient Christians to see the victory over death by hearing the voice of both the victor and the liberated. To hear voices of the vanquished, however, Christians soon discovered the power of dialogue, mainly between the vanquished, including Death, Satan, and Hades. These underworld figures found their fullest expressions in the work of two hymnists from Syria, Ephrem (ca. 306–373), deacon of Nisibis and Edessa, and Romanos the Melodist (d. ca. 555), who was active two centuries later in Constantinople. Although Ephrem and Romanos were not the only poets to personify Death in ancient Christianity, their poems did much to characterize Death as an embodied personification, one whose appetites and ailments propelled the narrative of Christ's descent.

Underworld Dialogues in Ephrem the Syrian's Nisibene Hymns

A prolific hymnist, Ephrem spent most of his life in Nisibis until he migrated to Edessa in 363. Known as "The Harp of the Spirit," Ephrem was remembered for stanzaic poems (madrashe), narrative couplets (memre), and prose. His poems were collected in various cycles by the late fifth century, and arranged thematically: the Nativity, the Fast, the Church, Unleavened Bread (Azymis), Faith, Paradise, as well as poems ascribed to his Nisibene days, and volumes of polemical and doctrinal works.[17] Several of his poems followed a Syriac tradition of dialogue hymns, in which biblical stories were expanded by incorporating dramatic dialogue between biblical characters.[18] After Ephrem, the

Hell," *Apocrypha* 11 (2000):147–79; C. Perrot, "La descente aux enfers et la prédication aux morts," in *Etudes sur la première lettre de Pierre*, ed. by C. Perrot (Paris, 1980), 231–46; H. W. Attridge, "Liberating Death's Captives: Reconsideration of an Early Christian Myth," in *Gnosticism and the Early Christian World: In Honor of James M. Robinson*, ed. by J. E. Goehring et al. (Sonoma, Calif., 1990), 103–15. On Byzantine visual representations, see A. D. Kartsonis, *Anastasis: The Making of an Image* (Princeton, 1986), 4–9.

14. A fuller synopsis of these legends appears in my recent article, "Christ's Descent to the Underworld in Ancient Ritual and Legend," in *Apocalyptic Thought in Early Christianity*, ed. by R. Daly (Grand Rapids, Mich.: Baker Academic, 2009), 211–26. I thank the editors at Baker Academic for permission to revise portions of that article here.

15. The phrase, "and he descended into hell and on the third day rose again from the dead," remains part of the Apostles' Creed today. On its origins in creed, see J. N. D. Kelly, *Early Christian Creeds* (London, 1950), 378–79; R. Gounelle, "Le frémissement

des portiers de l'Enfer à la vue du Christ: Jb 38,17b et trois symboles de foi des années 359-60," in *Le Livre de Job chez les Pères*. Cahiers de Biblia Patristica, 5 (Strasbourg, 1996), 177–214.

16. *Cat.* 4.11; 14.17–19, esp. 19; incarnation (11.23), the holy sepulchre (4.11–12); resurrection (14.17–20); *The Works of Cyril of Jerusalem*, trans. by L. McCauley and A. A. Stephenson, 2 vols; Fathers of the Church 61, 64 (Washington, D.C., 1969–70), 2:43.

17. My summary is based on the introduction to *Ephrem the Syrian: Select Poems*, trans. and ed. by S. P. Brock and G. A. Kiraz (Provo, Utah, 2006), x xii; E. Beck, "Éphrem le Syrien," *Dictionnaire de spiritualité, ascétique et mystique, doctrine et histoire*, ed. by M. Viller et al. (Paris: Beauchesne, 1960), 4/1: cols. 787–800. For a detailed overview of Ephrem's extant corpus, see S. P. Brock, "A Brief Guide to the Main Editions and Translations of the Works of St Ephrem," *The Harp* 3:1–2 (June 1990), 7–25.

18. On the origins and development of this genre, see S. A. Harvey, "Spoken Words, Voiced Silence: Biblical Women in Syriac Tradition," *JECS* 9 (2001): 105–31, esp. 107–11; on Syriac Dia-

soghyatha, as these dialogue hymns are called, continued to be composed for the Syriac church, to be performed during rites of the Night Office during Holy Week. Thus, on Palm Sunday, the Church debated Sion; on Monday, Cain sparred with Abel; on Tuesday, Abraham, Isaac (and Sarah) recriminated one another; on Thursday, the sinful woman locked horns with Satan; on Friday, the two thieves wrangled; and on Saturday, Death and Satan quarreled.[19]

Ephrem's Nisibene hymn collection (hereafter *HNis*) includes over a dozen hymns containing dramatic dialogue between underworld figures, including Satan (often referred to as "The Evil One,"), Sin, Sheol, Death, and the dead.[20] For Ephrem, the otherworldly spheres are divided into three regions: Paradise, once lost; Sheol, the realm of the dead; and Gehenna, an eschatological place where the wicked will be punished at the final judgment.[21] Death speaks and reigns in Sheol, represented by Ephrem both as a place and a feminine personification. As if separated from earth by one-way glass, the underworld figures may look and listen to the living, yet they remain unheard and unseen by those above. Their underworld running commentary on the events of Christ's crucifixion and impending descent animate the dialogues in Ephrem's hymns. Where other Christian storytellers had Adam, Abraham, or Moses narrate the arrival of Christ, Ephrem cast only one biblical character in his dialogues, Satan, and used personifications as interlocutors, mainly Sin, Death, and Sheol. By stripping the tale of patriarchs and prophets, Ephrem shifted attention from the liberated to the actual victims of these events.

Striking in Ephrem's representation of Death is that figure's penchant for conversation. He rarely appears in isolation, but shares his fears and concerns with those around him. Death's neighbors include his "kinsman,"—the Evil One, or Satan (*HNis* 41.15), and a tacit Sheol, here represented as female. From his "cave" Death beholds the crucifixion (41.13) and Satan joins him to see it as well (41.15). Their relationship is mocking, scolding, and contemptuous, yet they continue to debate.

When Death is not arguing, he allows himself to reminisce about his appetites. Death recalls the many feasts he once savored, thanks to the bounty of God's harvest when enemies and transgressors were dispatched directly to Sheol like a "fount of milk and honey" (39.4). Divine punishments, such as the destruction of the Nephilim and Sodom (Genesis 6:4–7; 19:24–25) become appetizers in a memorable meal: "By fire" God served him "the Sodomites, and by flood the Giants" (35.7). Those who died by the sword were served up to Death kabob-style, "on the head of [Phinehas's] spear for my delight" (39.5 cf. Numbers 25:7–8, 14–15). Death feasted on the prophets of Baal who died at the hand of Elijah and the prophets killed by Jezebel (39.18 cf. 1 Kings 18:4, 40). Like a succulent sauce, "the blood of the slain" is, according to Death, "a delight" and "sweet perfume" (39.19). Thanks to God's provisioning and biblical warriors' catering, "Gluttonous Death," as this figure is first

logue hymns, see S. P. Brock, "Syriac Dialogue Poems: Marginalia to a Recent Edition," *Le Muséon* 97 (1984): 29–58; K. Upson-Saia, "Caught in a Compromising Position: The Biblical Exegesis and Characterization of Biblical Protagonists in the Syriac Dialogue Hymns," *Hugoye: Journal of Syriac Studies* 9:2 (July 2006), available on-line URL: syrcom.cua.edu/Hugoye/.

19. For a helpful overview of the debate, see Av. Cameron, "Disputations, Polemical Literature and the Formation of Opinion in the Early Byzantine Period," in *Dispute Poems and Dialogues in the Ancient and Mediaeval Near East: Forms and Types of Literary Debates in Semitic and Related Literatures*, ed. by G. J. Reinink and H. L. J. Vanstiphout. Orientalia Lovaniensia Analecta, 42 (Leuven, 1991), 91–108, esp. 92–93. On the Syriac context, see S. P. Brock, "Dialogue Hymns of the Syriac Churches," *Sobornost* 2 (1983): 35–45, esp. 39; on anonymous hymns from the fifth- and sixth-centuries, see *idem*, *Sogiatha: Syriac Dialogue Hymns* (Kottayam, 1987).

20. *Carmina Nisibena* (hereafter *HNis*), ed. by E. Beck, (Louvain: Corpus scriptorum christianorum orientalium, 1961), Vols. 218–19 and 240–41, esp. 240–41. I follow the translation of J. T. Sarsfield Stopford in *NPNF*, ed. by J. Gwynn, 2.13.193–219 (Oxford/New York, 1898; repr. Grand Rapids, Mich., 1980–83). With the exception of Hymns 41 and 53, I follow this translation for the other *HNis* cited here.

21. On Ephrem's cosmology, see T. Buchan, *"Blessed is He Who Has Brought Adam from Sheol": Christ's Descent to the Dead in the Theology of Saint Ephrem* (Piscataway, N.J., 2004), 35–46, 55–68. G. A. M. Rouwhorst, *Les Hymnes pascales d'Ephrem de Nisibe*, 2 vols. (Leiden, 1989), 1.107–9.

introduced (35.6), has dined well, indeed. Little wonder that upon seeing Jesus on the cross, Death anticipates his next meal, taunting Jesus with these words: "Will you be food for me in place of the tasty Lazarus, whose taste I still have in my mouth?" [22] Instead, Death encounters fast and famine. For the first time, Death declares, "I have learned fasting"(35.6). By feeding multitudes, Jesus starved Death ("to others he has multiplied bread, but our bread even ours from our mouths He snatches" [39.3]). Although *Nisan*, the month of the ten plagues, once marked a time for a "pasture of corpses" (39.3), Christ's death and resurrection in that very month, now marks the time when the undigested dead must be returned. As Death describes the shift from feast to famine, "The righteous has constrained me to devour, but Jesus has compelled me to disgorge" (39.18).

A third, if silent, *persona* in these dialogues is Sheol, also called the Devourer (35.15). Her spokesman is Death, who laments her plight. He likens her to Lazarus' sisters who mourned their brother's death, whereas Sheol shed bitter tears at his resurrection (37.6). Like Death, she craves corpses: as Death describes her addiction, "Streams of corpses are hurled by me into hell, and though they pour into her she is athirst" (36.4)[23] Yet like Death, Sheol also "gave up the dead and learned, to fast soberly" and eventually "disgorged and gave up the dead." [24]

More so than ingesting the dead, her greatest suffering happened when she birthed the dead. According to Death, Sheol suffered the "strange pangs" when the dead within her "were roused, [broke] forth and came out from her bowels" (37.3). Her visceral suffering prompts Death to recall the convergence of two prophecies he once heard:

For [Isaiah] said that a virgin should conceive and bring forth (cf. Isaiah 7:14); and he said again that the earth should bring forth (cf. Isaiah 66:8). But lo! the Virgin has brought Him forth, and Sheol the barren has brought Him forth; two wombs that contrary to nature, have been changed by Him; the Virgin and Sheol both of them (37.4).

This parallel between Sheol's womb and Mary's evokes a long Syriac tradition, in which writers spoke of the major events of salvation history in terms of Jesus's birth from several wombs: first, the Father's, then Mary's, then the Jordan's, followed by Sheol's. [25] These wombs appear in close proximity in Ephrem's poetry, as in one of the Resurrection Hymns, "The Word of the Father came from His womb | and put on a body in another womb: | the Word proceeded from one womb to another—| and chaste wombs are now filled with the Word: blessed is He who has resided in us." [26] As Syriac scholar Sebastian Brock notes, Ephrem and other Syriac writers used the word ʿubbeh (womb) for God's bosom or lap. [27] This verbal ambiguity is most striking when Ephrem juxtaposes the ʿubbeh of the Father with that of Mary. This double-sense of ʿubbeh draws Ephrem's Death and Sheol even closer, as both participate in a resurrection as rebirth.

Even in her silence, then, Sheol expanded the personification of Death by allowing him a visceral empathy with her sufferings. Both bodies hungered and thirsted, both disgorged. A striking feature of Ephrem's *Nisibene Hymns* is how much their capacity to ingest, feel pain, and disgorge is bound up with a body memory, a capacity to recall events of salvation history by means of bodily sensations. By the sixth century, the players in this drama would shift slightly, as Sheol and Death's voices merged into that of Hades

22. *HNis* 41.13 (Brock/Kiraz [as in note 17], 148–49); cf. John 11:1–44.

23. Cf. the speech of Wisdom personified (Sirach 24.21: "those who drink of me will thirst for more").

24. *HNis* 67.8; *De Azymis* 3.11 (Brock/Kiraz [as in note 17], 118–19).

25. *HNis* 38.7; cf. *De Res.* 1.7–8 (Brock/Kiraz [as in note 17], 84–85); *De Azymis* 16.4 (Rouwhorst [as in note 21], 2.33) on wombs of Sheol/Mary. On Jordan as womb: *Eccl.* 36.3 (Brock/Kiraz [as in note 17], 70–71). On the wombs of Christ, see S. P.

Brock, "Baptismal Themes in the Writings of Jacob of Serugh," *Orientalia christiana analecta* 205 (1978): 325–47, esp. 326; on the four wombs Christ dwelled (those of Father, Mary, the Jordan, and Sheol) in Ephrem, see Buchan, *Christ's Descent* (as in note 21), 78–106.

26. *Hymns on the Resurrection*, 1.7, trans. by S. Brock in *The Luminous Eye: The Spiritual World Vision of Saint Ephrem the Syrian* (Rome, 1985; rev. ed., Kalamazoo, Mich.: 1992), 171; translation of the entire hymn appears in Brock/Kiraz (as in note 17).

27. Brock/Kiraz (as in note 17), p. 85 n. 5.

who would render the physical sufferings of the underworld victims even more vividly.

Romanos the Melodist (d. ca. 555) [28]

Death's slow and tragic realization of his demise is at the center of several chanted homilies that the preacher Romanos the Melodist composed in the first half of the sixth century. Performed in churches on the outskirts of Constantinople, these chanted sermons, later known as kontakia, were typically sung at night vigils on the eve of various church festivals.[29] In these stanzaic poems, biblical characters—some marginal, some not—retold episodes from Jesus' life pertinent to the feast day. Lepers and prostitutes offered their stories, as did Jesus' mother or Peter. Even Hell, Death, and Satan sang their tales. Audiences shared in the characters' joys, sorrows, and even ridicule, as one hymn recalls what delight there is in "wounding the enemy." [30] Whatever the character, every part was sung by a soloist, who was probably joined by the audience in a one-line refrain that closed each stanza.

Although Christ's descent to Hell would have been observed on Good Friday or Holy Saturday,[31] Romanos' subterranean dialogues began a week earlier. His audiences would have first heard Hades and Death squabbling on the day before Palm Sunday, when Christians sang the raising of Lazarus. In this hymn, Hades and Death witnessed Christ's agony, trial, and torture and assured themselves that they had sufficient allies above-ground (namely, Jewish leaders) to ensure Christ's defeat.[32] By Friday of Holy Week, however, Death's voice had faded; and the underworld conversation shifted to Hades and Satan (here, in the form of a serpent). Romanos' "Victory of the Cross" [33] focuses on Hell and Satan's slow and agonized realization of their own demise as the Savior's descent to the underworld loomed.[34] Taken together, these dialogues formed a running underground commentary that would shape the faithful's perceptions of Jesus' days within, below, and beyond Jerusalem.

Most fascinating to Romanos was the figure of Hades. Beginning with the events leading up to the raising of Lazarus, the audience could eavesdrop on Hades as he heard the sound of Christ's footsteps overhead. In hushed tones, Hades asked his companion, Death, "What are those feet [...] which march over my head?" [35] Dreading the loss of another prisoner to Christ's miracle working, Hades turned ill and complained of acute indigestion. Fearing that he was unable to keep down the dead he ingested, Hades blamed Death for serving tainted meat: "You bring me the bound dead, and when I swallow them, I vomit." [36] Death had no sympathy for these ailments, scolding Hades for swallowing (katapinôn) human life "like water." [37]

To regard resurrection as regurgitation was a commonplace in Romanos' hymns. For his Easter vigils, he played up this gastrointestinal metaphor: in one hymn, a dumbfounded Hades anticipates Christ's liberation with these words, "He arises and the hands which I bound He places around my throat, and all the

28. An earlier version of this section appears in G. Frank, "Christ's Descent," (as in note 14).

29. The Greek text of Romanos used here is J. Grosdidier de Maton's five-volume edition in the Sources chretiénnes series Vols. 99, 110, 114, 128, 283 (hereafter, SC). Another fine edition, Sancti Romani Melodi Cantica: Cantica Genuina, ed. by P. Maas and C. A. Trypanis (Oxford: Clarendon, 1963), numbers the hymns differently. I follow the SC edition's hymn and strophe number, with the Oxford [Oxf.] hymn number supplied in brackets in the first citation of any given hymn. I adhere to the English titles furnished by the Oxford edition. On the kontakia, see J. Grosdidier de Matons, Romanos le Mélode et les origines de la poésie religieuse à Byzance (Paris: Éditions Beauchesne, 1977); idem, "Liturgie et Hymnographie: Kontakion et Canon," Dumbarton Oaks Papers 34/35 (1980-81): 31-44.

30. "On the Man Possessed with Devils" 22.2 [Oxf. 11].

31. J. Grosdidier de Matons, Romanos le Mélode: Hymnes, IV, SC 128 (Paris, 1967), 265.

32. SC 37.

33. SC 38 [Oxf. 22]; St. Romanos the Melodist, Kontakia: On the Life of Christ, trans. by E. Lash, (San Francisco, 1995), 155–63.

34. SC 41 [Oxf. 24]; 42 [Oxf. 25]; 43 [Oxf. 28], esp. 17–32; 44 [Oxf. 26]; 45 [Oxf. 27].

35. SC 26.8, trans. by M. Carpenter, in Kontakia of Romanos, Byzantine Melodist, 2 vols.; (Columbia, Missouri, 1970, 1973), 1:144.

36. SC 26.9, Kontakia (as in note 35), 1:144.

37. SC 26.11, ibid., 1:145.

people I had swallowed I disgorge as they cry, 'The Lord is risen.'" [38] The dead scorn his gluttony by crying "Why do you open up your large gullet? ... Why do you rush for food, causing distress to your stomach (*gastera*)?"[39] Hell, the ogre rendered ill by undigested prey, senses Christ's approach—quite literally—in his gut.

Striking in Romanos' grotesque imagery is that he also endows this glutton with keen senses of hearing and smell. Hades listens as Death warns, "the feet which you hear, and I see they are threatening, | Are footsteps of one who is raging ... as he draws near the tomb, he kicks at your gates and searches for the contents of your belly (*koilia*)." [40] Hades remarks that the "bad odor has disappeared." As putrefaction gives way to perfume, Lazarus' limbs begin reassembling as the worms beat a hasty retreat.[41] These sensory cues trigger a visceral reaction, as Hades likens Christ to a purger (*ho kathairôn*) tearing through his bloated body. Shaken to the core, Death and Hades hold hands and cling together in terror as they witness Christ's remaking of Lazarus:

> the fragrance of the Son of God permeated his friend.... it reordered his hair and reconstructed his skin, and put together his inner organs, and stretched out his veins so that the blood could again flow through them, and repaired his arteries.[42]

This description of the remade body tells much about each hair of the head, and no less about the painstaking care in crafting of the body's interior: its veins, arteries, and organs. We have here mortuary practice reversed. Instead of mummifying the body by extracting and separating inner organs, Jesus *de*-mummifies Lazarus by repairing and reuniting the body's arteries. Thus, Hades' visceral response anticipates Christ's *re*-visceration of Lazarus.

Hades' somatic encounter with resurrection is prominent in a Good Friday hymn, known as "The Victory of the Cross." Here, Romanos explores the wounding of Hades by Christ's cross. The hymn opens on Golgotha but within a stanza burrows underground to Hades as place and Hades as speaker:

> Who has fixed a nail in my heart?
> A wooden lance has suddenly pierced me and I am being torn apart.
> My insides are in pain, my belly in agony,
> my senses make my spirit tremble,
> and I am compelled to disgorge Adam and Adam's race.[43]

By these words Romanos rapidly draws the audience from the lofty crosses and plunges them into a subterranean unknown. What joins these two realms is a piercing wound, first Christ pierced on the cross, at the same time that Hell is pierced by that cross.[44] Middle Byzantine artists would capture that scene in a tenth-century ivory plaque now displayed at the Metropolitan Museum of Art (Fig. 3).[45] Here one sees a crucifixion scene whereby the stake of the cross pierces the earth's surface and reaches down to puncture a recumbent Hades. The story's two planes are joined by one cross.

A striking difference between Hades and Satan in these hymns is their body types. Whereas Hades has an anthropomorphic body, Satan is endowed with a serpent's body. Satan's animal body may account for why he cannot feel his friend's pain or perceive the effect of the cross below ground. Hades rebuffs him: "Come to your senses ... Run, open your eyes, and see the root of the Tree inside my soul." [46] Yet, Satan perceives no danger, no damage, even as Hades begs him: "Lift up your eyes and see that you have fallen

38. SC 42.3, *ibid*, 1:264. 39. SC 42.4, *ibid.*, 1.264.
40. SC 26.11, *ibid*, 1:145. 41. SC 26.12, *ibid.*, 1:145.
42. SC 26.13, *ibid*, 1:145.
43. SC 38.1, *St. Romanos* (as in note 33), 155–56.
44. Cf. Ephrem the Syrian who links Christ pierced by the soldier's lance as a portal back into Eden, and invites the worshipper to "enter by the wounded side." *Comm. in Evang. Concordans*, 21.10, trans. in R. Murray, "The Lance which Re-opened Para-

dise: A Mysterious Reading in the Early Syriac Fathers," *Orientalia christiana periodica* 39 (1973): 224–34, esp. 224.

45. 17.190.44, see *The Glory of Byzantium: Art and Culture of the Middle Byzantine Era, A.D. 843–1261*, ed. by H. C. Evans and W. D. Wixom (New York, 1997), § 97, pp. 151–52; also found online at www.metmuseum.org/collections. M. E. Frazer, "Hades Stabbed by the Cross of Christ," *Metropolitan Museum Journal* 9 (1974): 153–61.

46. SC 38.2.

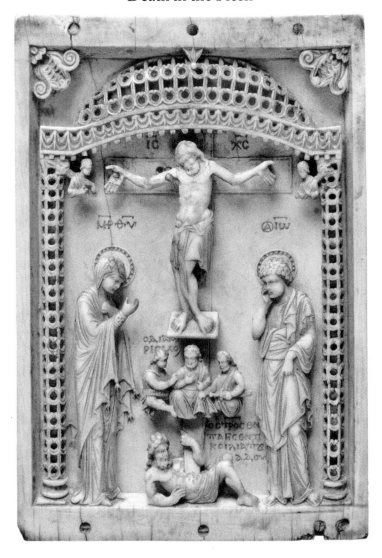

FIG. 3. Christ's Cross Stabbing Hades. Ivory possibly made in Constantinople; 5 × 3½ in. (12.7 × 8.9 cm). Byzantine, mid-10th century, Metropolitan Museum of Art, New York, Gift of J. Pierpont Morgan (17.190.44). Image © The Metropolitan Museum of Art.

into the pit which you created." [47] Incapable of somatic empathy, Satan is indifferent to the agonized cries of a Polyphemus-like Hades. [48] Instead, the cunning serpent only mocks him: Is Hades truly scared by a tree? frightened by a crucifixion? [49]

Unable to make Satan see, the stricken Hades urges him to listen: "Now is the moment for you to open your ears," he insists, "Jesus is nailed and hears the thief crying to him." At this point, Romanos inserts the Gospel of Luke's dialogue verbatim: "Lord, remember me in your kingdom," the thief beseeches Jesus, and Jesus assures him that he will be in

47. SC 38.5, *St. Romanos* (as in note 33), 157.

48. Like Homer's Cyclops, Hell is portrayed as a pierced and wailing monster, whose agonized pleas are comically dismissed by countrymen (*Ody.* 9. 371–412, esp. 401–12). On blindness, cf.

38.7, *St. Romanos* (as in note 33), 158: "Look, you are walking in darkness, feel around, lest you fall."

49. SC 38.8, *St. Romanos* (as in note 33), 158–59.

Paradise.[50] Christ's words, not Satan's or Hell's, put a stop to the evil duo's bickering and elicit harmonized lamentation, as the Devil invites Hades to join him in song. The pair vows to stop tormenting the race of Adam, while the final word belongs to the congregation, who sing as redeemed humanity with these words: "[we] sing to you, the Lord of all, from the songs of Sion" (38.18).

From the agonized words at Golgotha, Romanos has generated a drama in four voices, Jesus and the thieves, with Hades' and Satan's *basso continuo*. Hades sees and speaks, but his words fall on deaf ears.

Hell's Belly

To personify Death, here, Romanos goes for the belly. Students of Roman satire may recall the mocking depictions of the gluttonous rich who suffer "death by dinner." Satirists such as Persius and Juvenal described symposiasts so bloated by food that they died in their own vomit or suffered sudden heart attack in the bath.[51] The Apostle Paul condemned enemies for whom "their god is the belly" (Phil. 3:19; cf. Romans 16:18; Titus 1:12). Thus, Euripides ridiculed Polyphemus, who declared his belly "the greatest of divinities."[52] As Cato remarked, "It is indeed difficult … to talk to bellies which have no ears."[53] This is no less the case with Hades, whose wounded belly renders his ears deaf. Visceral villains make easy targets. If God condemned the serpent to slither on his belly (Gen.

3:14),[54] Hades finds himself enslaved to that selfsame member.

The liturgical season of the song also renders this personification more vivid. Listening during Lent, Romanos' audience could have associated Christ's death with the stirrings of the belly. After all, they sang and heard these hymns during Holy Week, the culmination of a long season of fasting. In this liturgical setting, hungering Christians were made to contemplate the contents of Hell's bloated belly.[55] His belly engorged by putrefied flesh, Hades wailed a lament that clanged against the hollow bellies of his congregants.[56]

For some Christian preachers, the Lenten season also prompted reflection on another monster's belly: the great fish who devoured the prophet Jonah. The fourth-century bishop, Cyril of Jerusalem, explained to Christians preparing for baptism that Christ in the belly of Hell recalled Jonah in the belly of the great fish. By likening Hell to a fish's belly, Cyril personified death such that it had to "disgorge those it had swallowed up."[57] Cyril not only somatized the figure of Hell, but also evoked a familiar patristic theme of portraying resurrection as indigestion.[58]

According to some accounts of Christ's descent, Death's body was feeling the lingering effects of ingesting Jesus, both an emetic and a poison whose full damage would be evident at the final judgment. The fourth-century Syrian writer Aphrahat described Jesus' descent as a bitter medicine for Death, who "tasted the medicine that was deadly to him, and his

50. SC 38.9, *St. Romanos* (as in note 33), 159; cf. Lk. 23:42–43.

51. "The sequel," Persius concludes, "is funeral march and candles." Persius, *Sat.* 3.98–103; quoted in W. Braun, *Feasting and Social Rhetoric in Luke 14*, Society for New Testament Studies Monograph Series (*SNTSMS*) 85 (Cambridge, 1995), 39 n. 52. Cf. Juvenal, *Sat.* 1.143–46.

52. Euripides, *Cyclops*, 323–41, quoted in K. O. Sandnes, *Belly and Body in the Pauline Epistles* (Cambridge, 2002), 38.

53. Quoted in Plutarch, *Mor.* 996D (Loeb Classical Library 12:562–3).

54. SC 27.10.6.

55. *Apostolic Constitutions* 5.18, cited in D. J. Sahas, "Lent," in *Encyclopedia of Early Christianity* (2nd ed. New York, 1998), 673–74. On the link between fasting and affliction, see D. Lambert, "Fasting as Penitential Rite: A Biblical Phenomenon," *Harvard Theological Review* 96 (2003): 477–512, esp. 480.

56. I thank Dr. Alexei Khamine for calling my attention to this important liturgical detail.

57. *Cat.* 14. 17, *Works of Cyril* (as in note 16), 2:43. Cf. Hosea 13:14.

58. Tertullian, *De res.* 4, Augustine, *Serm.* 127, 5.6, discussed in Caroline Walker Bynum, *The Resurrection of the Body in Western Christianity, 200–1336* (New York: Columbia University Press, 1995) esp. 41, 102–4, respectively; on the mouth of hell in medieval iconography, see Pls. 12, 13, 14, 16, 28, 32, as well as P. Sheingorn, "'Who Can Open the Doors of His Face?': The Iconography of Hell Mouth," in *The Iconography of Hell*, ed. by C. Davidson and T. H. Seiler (Kalamazoo, Mich.: Medieval Institute Publications, 1992), 1–19; G. D. Schmidt, *The Iconography of the Mouth of Hell: Eighth-Century Britain to the Fifteenth Century* (Selinsgrove, Pa., 1995); K. Tamburr, *The Harrowing of Hell in Medieval England* (Cambridge, 2007).

hands dropped down."[59] Realizing that eating Christ brought less pleasure than other human fare, Death regurgitated Christ. Likened to a man who detects poison in food he has eaten, Death, according to Aphrahat, "casts up again from his belly the food in which poison was mingled; but the drug leaves its power in his limbs, so that little by little the structure of his body is dissolved and corrupted."[60] Thus, for Aphrahat, Christ's "promise of life" is that lingering poison.[61]

In addition to the poisoned body, Romanos also evokes intimations of the birthing body of Death. Like Ephrem's Sheol, Romanos' Hades brings forth new life. The theme of second birth appears already in the Gospel of John, as in Jesus' response to the earnest if witless Pharisee Nicodemus, "No one can see the kingdom of God without being born *anôthen*," a play on the double sense of *anôthen*, which can mean "from above," but also "again." Oblivious to the spatial sense of the word, Nicodemus puzzles over its temporal meaning: "How can anyone be born after having grown old? Can one enter a second time into the mother's womb and be born?" (John 3:2–3 NRSV). Nicodemus' misunderstanding, however, did not prevent later Christians from imagining a return to the mother's womb. As mentioned earlier, ancient Christians understood multiple wombs for Christ. For Greek-speaking writers, the connection was rather straightforward, as *gastêr* could stand for belly as well as for womb.[62]

Rather than a return to the mother's womb, about which Nicodemus asked Christ in the Gospel of John, Romanos offered a second womb, now gendered as male. Like the titan Cronus' grotesque ingestion of his fresh-born children,[63] regurgitation would be vehicle of second birth. Thus, Romanos' repeated emphasis on the gluttonous Hades is more than mockery. The

suffering body enduring indigestion and birthing secures the link between incarnation and resurrection of the physical body.

That link between the digestive and birthing body of Hades is also found in ninth-century Byzantine illustrated psalters. Emma Maayan-Fanar calls attention to the contrast between images of Hades in Byzantine ninth-century psalters, which depict Hades as a full-bellied and fleshy figure, and Western psalters, which reduce Hades to a pit in the form of gaping jaws.[64] In later related Byzantine psalters, such as the Theodore Psalter (1066), Hades is represented as a huge, bald, semi-nude, fleshy, Silenic figure, notable for his belly (Fig. 4). Two additional images in the same psalter show Hades inverted and prone. In one, he is upside down, knees bent, with a mandorla of Christ resting on Hades' lower abdomen (Fig. 5); the folio following shows him inverted with smaller-scale Adam and Eve standing on his lap and extending hands to Christ in a mandorla (Fig. 6). In all these images, the belly is pronounced as a container of bodies as well as a doormat, of sorts, for the liberating and liberated bodies.

As Maayan-Fanar persuasively shows, it is a striking contrast to Western depictions of the Harrowing, in which the emphasis is on the punishment of sinners. Whereas the Byzantine tradition preserved a full-bodied Hades, the West reduced that body to the gaping maw known as "hell mouth" (Figs. 7 and 8). Maayan-Fanar's insights prompt two further observations. First, we see that the hell mouth became the new container, the new devourer, so that in late medieval iconography Death would lose the belly, appearing instead as emaciated or skeletal (Fig. 9). Both figures hunger, yet only one looks hungry. Second, all punishment began at the open mouth, the entrance. In Byzantine marginal images, by contrast, the belly

59. *Dem.* 22.4 (*NPNF* 2.13.403). I thank Dr. Naomi Koltun-Fromm for calling my attention to this passage.

60. *Dem.* 22.5 (*NPNF* 2.13.403); cf. the dissolution of the body in Psalm 22, where the psalmist laments: "I am poured out like water, | and all my bones are out of joint; | my heart is like wax; it is melted within my breast" (Ps. 22:15 NRSV). See Lambert, "Fasting as Penitential Rite" (as in note 55), 489.

61. Dem. 22.5 (*NPNF* 2.13.403).

62. Lampe, *Patristic Greek Lexicon*, 308a.

63. E.g., Hesiod, *Theogony*, 492–500; on the use of emetics in some versions of the myth, see Apollodorus, *Bibliotheca*, 1.2.1, discussed in T. Gantz, *Early Greek Myth: A Guide to Literary and Artistic Sources* (Baltimore, 1993), 44–48, esp. 44.

64. E. Maayan-Fanar, "Visiting Hades: A Transformation of the Ancient God in the Ninth-Century Byzantine Psalters," *Byzantinische Zeitschrift* 99 (2006): 93–108, Pls. VII–XII. The article focuses on a comparison between the Chludov and the Utrecht Psalters.

FIG. 4. Hades used to illustrate Psalm 9, verse 17, from the Theodore Psalter. Byzantine made by Theodore the Studite I (1066). British Library, Ms. Add. 19352, fol. 9ʳ.

FIG. 5. Hades and the Harrowing of Hell used to illustrate Psalm 68, verse 1, from the Theodore Psalter. Made by Theodore the Studite I (1066). British Library, Ms. Add. 19352, fol. 82ᵛ.

FIG. 6. Hades and the Harrowing of Hell used to illustrate Psalm 68, verse 6, from the Theodore Psalter. Byzantine made by Theodore the Studite I (1066). British Library, Ms. Add. 19352, fol. 83ʳ.

FIG. 7. Hell Mouth and the Harrowing of Hell (upper zone). Full-page prefatory miniature from the Winchester Psalter, English 1150–1160, British Library, Ms. Cotton Nero C. IV, fol. 24ʳ.

FIG. 8. Hell Mouth and funeral. Hours of Catherine of Cleves, by the Master of Catherine of Cleves. Low Countries, possibly Utrecht, ca. 1440, Morgan Library, New York, Ms. M. 945 (fols. 168ᵛ–169).

FIG. 9. Portrait of Death used to illustrate Psalm 116. Full-page miniature from the Hours of Anne of France by Jean Colombe and workshop, French, 1470–1480, Morgan Library, New York, Ms. M. 677, fol. 245ʳ.

remained the site of punishment, something to be emptied and trampled, left distended and aching. By retaining the body, Byzantine artists gave no reprieve to the victim: Hades' belly pains both extinguished life and re-birthed it. That enduring belly, I have suggested here, had deeper roots in a liturgical tradition that sang the sufferings of that belly.

Hades and Death as Figures of Speech

To conclude, this analysis of Ephrem and Romanos' underworld dialogues focused on personifications who acted as "figures of speech," in the most literal sense. Endowed with belly, as well as the senses of taste, sight, smell, and hearing, these figures rendered into speech the visceral effects of Christ's descent into the underworld. Whereas Ephrem populated his underworld dialogues with several *dramatis personae* (some, like Sheol, silent but no less present and suffering), Romanos limited his dialogues to two interlocutors, Hades and Death (at the resurrection of Lazarus) and Hades and Satan (at the descent of Christ). Whatever the pairing, Romanos retained the belly, aching, bloated, trembling. Hades' belly, in particular, contrasts with the silent and emaciated portrayals of Death in the late medieval West (Fig. 9). Within a liturgical tradition attentive to the embodied effects of salvation history, both Ephrem and Romanos deepen our understanding of how late antique and Byzantine Christians looked not just beyond the crucifixion but also *beneath* it to see the drama of resurrection in the unseen spaces of the underworld.

ALISON I. BEACH

The Vision of Bernhard of Petershausen: An Image in a Reformed Landscape

IN 1086, a group of monks from Hirsau, an important center of monastic reform in the Black Forest, arrived at the Benedictine monastery of Petershausen. Summoned by Petershausen's episcopal proprietor, Gebhard III, these men were charged with restoring "the vigor of religious life" to the monastery.[1] The community, however, was divided in its response to the reformers' demands for strict adherence to the Rule of St. Benedict and their plans to expand the liturgy. Many of the monks simply left. A small group transferred to nearby Reichenau, while others returned to the world as secular priests. Seven of the monks agreed to stay on and accept the changes imposed by the reformers.

These seven witnessed the internal transformation of their community. The reformers immediately established two significant new sub-populations: one of lay brothers and the other of nuns. The reform also linked the monastery—once tied more or less informally to a small circle of relatively local Benedictine houses such as Einsiedeln and Reichenau—to a broader network of reformed communities well beyond the diocese of Constance. The arrival of the Hirsau reformers marked not only the starting point of reform, but also the beginning of a period in the monastery's history marked by conflict, insecurity, and uncertainty about its collective identity as a community. Petershausen had to re-imagine itself as a community, both united internally and linked to the generations of monks who had come before the reform.

This process of defining (or redefining) Petershausen's identity is reflected in the *Casus monasterii Petrishusensis*, the monastery's twelfth-century chronicle, preserved in University of Heidelberg, *Codex Salemitani* IX 42a, fols. 35ʳ–98ᵛ.[2] The chronicle was the work of an anonymous monk who began to create this history for his community shortly after 1134. One of the most striking features of the chronicle is the inclusion of a number of visions, concentrated exclusively within the chapters of the text that cover the period of reform. Interpreted within the reformed landscape in which they occurred and were remembered, these visionary experiences reflect tension and division within a community still emerging from the upheaval of reform.

In the most striking of these visions, and the only one accompanied by an image, the monk Bernhard climbs a ladder to heaven and squeezes through a small portal to witness and participate in a Last Judgment. Bernhard's vision stands out from the others, not only for its unusual penitential and Eucharistic imagery, but also as the only vision that the chronicler reported in the words of the visionary himself.[3]

Perhaps because the chronicler began his work

1. *Casus Monasterii Petrishusensis. Die Chronik des Klosters Petershausen*. ed. and trans. Otto Feger. Schwäbische Chroniken der Stauferzeit 3, ed. Kommission für geschichtliche Landeskunde in Baden-Württemberg (Lindau, 1956), 124–125. For an earlier printed edition of the *Chronicle of Petershausen*, see MGH Scriptores 20 (Hannover, 1868), 621–682. All of the Latin quotations from the chronicle reflect my own transcription of the manuscript text, for which I frequently consulted Feger's edition; On the history of Petershausen, see Sibylle Appuhn-Radtke and Annelis Schwarz-

mann, eds. *1000 Jahre Petershausen. Beiträge zu Kunst und Geschichte der Benediktinerabtei Petershausen in Konstanz* (Constance, 1983); *St. Gebhard und sein Kloster Petershausen. Festschrift zur 1000. Wiederkehr der Inthronisation des Bischofs Gebhard II. von Konstanz*, ed. Kath. Pfarrgemeinde St. Gebhard, Konstanz (Constance, 1979).

2. This manuscript has been fully digitized by the University of Heidelberg, and can be accessed on the internet at http://diglit.ub.uni-heidelberg.de/diglit/salIX42a/.

3. Autobiographical accounts of visions were not the norm in

some four decades after Bernhard's death, or perhaps because Bernhard himself had been a person of importance and authority within the community, the chronicler framed the narrative of the vision with an introduction that stressed the autobiographical nature of the account that followed. He made it clear that he was passing along, not an oral tradition, but the written words of Bernhard himself:

> Bernhard ... was an excellent teacher who also shone forth as a most diligent keeper of monastic discipline. One night he saw a vision, which he himself put down in writing.[4]

His insistence that Bernhard had not just seen, but also *written*, likely also refers to the Apocalypse of John: "Write, therefore, what you have seen, what is now and what will take place later." (Rev. 1:19).

The scribe then created a visual break in the text, drawing a large red P[ost] to signal the transition into the visionary's own words. "After midnight," Bernhard began, "when the body is at rest and dreams are their most true—and before the bell for matins was sounded—I saw myself standing in the open air with four others." He continued:

> When I looked up, a great ball of glowing embers suddenly burst forth, and did not immediately drop, but sent forth an unending stream that moved first across though the air and then down to the earth. I then saw what appeared to me to be a ladder extending from the earth to the sky, and the summit of the ladder touched heaven, or rather the edge of the opening in the sky. All men, by divine decree, had to

climb this ladder to heaven so that they might be incinerated by the fire in the sky, and the damned and the elect alike be sent forth as glowing ashes. This was also true for those of earlier eras who died and were then resurrected.[5]

Realizing that the group was being shown events foretold in Scripture, Bernhard stepped into his accustomed role as teacher and offered his companions an interpretation of this strange sight that drew both on biblical imagery, perhaps referring to Revelation 20:11–15, in which the dead, "great and small" stand before the throne of Judgment, and on emerging contemporary belief about the purification of souls after death:

> Seeing this, I said to the people around me: "Behold, we have here what we have heard concerning the end of the world already at hand. Do you see the flying glowing ashes, white and black? For I saw the flying ashes, of which the greater part appeared to be white, and the smaller part black. "The white ones," I said, "are the souls of the saints, made pure by the testing fire."[6]

Bernard was clearly accustomed to this pedagogical role. The chronicler refers three times to the monk's high level of learning, noting that he was one of the masters of the monastery school both before and after the reform (3:2), calling him *scholasticus* (3:14), and praising him as an excellent teacher (3:17). Education, geared toward the study of the Bible, was one of the core ideals of the reformed monastic tradition of which Bernhard was a part.

the twelfth century. None of the sixteen ghostly apparition/vision stories that comprise the contemporary *Deeds of the Abbey of Marmoutiers*, for example, were autobiographical. See Sharon Farmer, *Communities of Saint Martin: Legend and Ritual in Medieval Tours* (Ithaca and London, 1991), 134–150; Jean-Claude Schmitt, *Ghosts in the Middle Ages: The Living and the Dead in Medieval Society* (Chicago, 1998), 68–71.

4. Bernhardus [quem etiam superius nominavimus] doctor erat eximius, monastice quoque discipline custos enituit diligentissimus. Hic quadam nocte visionem vidit, quam ipse litteris comprehendit, ita scribens. fol. 62ᵛ, lines 16–19; Feger, *Chronik*, 134–135.

5. Post medium noctis cum pulso torpore somnia sunt verissima, interim scilicet dum pulsabantur matutine, videbar sub divo cum aliis quatuor stare. Ubi cum oculos ut fit in altum erigerem, ecce de foramine celi maximus favillarum globus subito erupit, qui

non preceps in ima cecidit, sed transverse per aerem lapsus ad terram usque pervenit, cuius finis non erat. Ad hec scala ut mihi videbatur de terra in altitudinem porrecta erat cuius summitas celum id est oram eiusdem foraminis tangebat, per quam ut divinitus decretum erat, homines celum ascendere debuerant, ut superioris flamme que in celo erat incendio cremarentur, sicut et ceteri qui in transacto mundi evo defuncti |63ʳ| tunc resurrexerunt, et mox reprobi cum electis mixti in terram per favillas emitterentur; fol. 62ᵛ, line 19–fol. 63ʳ, line 2; Feger, *Chronik*, 134–135.

6. Hoc ego videns, dixi astantibus. Ecce quod semper de fine mundi audivimus, iam in manu habemus. Videtis favillas volantes albas cum nigris? Videbam enim favillas volare, quarum maxima pars candida, pars autem aliquantula apparuit nigra. Albe inquio que videntur faville, sanctorum sunt anime, examinatorio igni purgate. fol. 63ʳ, lines 2–7; Feger, *Chronik*, 134–137.

Next, Bernhard urged the group to ascend the ladder without delay and to submit themselves to this process of purification and judgment. Once at the top, Bernhard, like John in Revelation 4, was allowed to look through a portal into heaven.[7] There Bernhard and his single remaining companion saw innumerable glimmering soul-rays returning to Heaven to be judged:

> ... after the flight through the air, [the soul-rays] returned through the same opening in the sky and there again received flesh according to the merit by which they were judged ... [The Guard] separated the glowing ashes from one another after their return: he allowed the good to enter a palace in the presence of a judge, but enclosed the bad in a neighboring room soon after they had entered with the elect, so that the Scripture might be fulfilled: it will come to pass that the wicked shall not see the glory of God.[8]

The fire purified the souls of the good, and made them visible to the judge, through a kind of color-coding, determining which souls (the light) deserved to see the glory of the Lord, and which souls (the dark), did not.

The vision took an even stranger turn when Bernhard and his companion slipped by the guard and stole into the Other World. Here Bernhard's vision begins to reflect considerable anxiety about the state of his soul:

> While I stood there on the ladder blocking the opening, the flames, which were burning the bodies above and sending their ashes from heaven, died down (just as happens when one blocks the opening of an estuary), thus decreasing the density of the smoke. This comparison was also shown to me in a dream. After the reduced fire in the sky ceased to emit embers, having gathered all of my strength, climbing on my

hands, feet, and elbows, I squeezed through the opening. The guard did not stop me, and I entered, fearing greatly, aware as I was of my own delinquency, that I would not see the glory of God....[9]

Aware of their precarious status, the two monks hid themselves among the ranks of the saints, who were preoccupied with a quarrel about seating order as they lined up to participate in a special meal. The reference here to Revelation 7:9–17, in which the "great multitude" in white robes stand before the throne of God, is clear:

> Disagreement broke out among the great number of the elect in their shining white robes about the order in which they were to be seated at the table for a meal of lamb. Therefore, desiring to be hidden among those fighting so that the judge, seeing me, might not order that I be cast into the room of the damned, I repeatedly asked the saints among whom I was hiding if by helping me they would like to repay me for the for the veneration that I had accorded them on earth. It seemed to me that the judge didn't see me as long as I stood hidden between the holy saints.
>
> Finally, after the uproar died down, and they arranged themselves in such a way that they extended from one end of the palace to the other, where the entrance was, arranged in a single line: first came the holy patriarchs and prophets, then the ranks of other saints who had, since the beginning of the world, rejected worldly things, and finally at the very end of the line, the twelve apostles called in the last age of the world. This row was placed along the length of the palace, and the other part along its breadth, so that the apostles were positioned before the throne of the Lord.[10]

7. After this I looked, and there before was a door standing open in heaven. And the voice I had first heard speaking to me like a trumpet said, "Come up here and I will show you what must take place after this." (Rev. 4:1).

8. ... post pervolatum aerem in celum per idem foramen reverterentur, ibique carnem recepture iuxta meritum iudicarentur. Superius vero custos foraminis positus erat, qui favillas post reversionem animatas ab invicem segregaret, ita videlicet ut bonos in eodem palatio in iudicis presentia deambulare permitteret, malos vero mox ut cum electis ingrederentur in quandam cameram proxime positam recluderet, ut scriptura impleretur. Tollatur impius ne videat gloriam Dei. fol. 63ʳ, lines 11–18; Feger, *Chronik*, 136–137.

9. Ast ego in summitate scale restiti differens introitum donec

flamma que superius corpora comburens de celo in aerem per favillas emittebat, mitigaretur quasi qui differt ingressum estuarii intus adhuc cessante densitate fumi. Que etiam comparatio, tum mihi visa est in somnio. Postquam vero flamma in celo mitigata favillas eructuare desiit, mox omnibus collectis viribus, manibus et pedibus et ulnis innitens, ipsum foramen vix, custode licet non prohibente intravi hoc multum timens, ne qui mihi scelerum conscius fui privarer gloria Dei. fol. 63ʳ, lines 21–29; Feger, *Chronik*, 136–137.

10. De multitudine autem electorum in alba veste nitentium ingens strepitus fiebat, videlicet quo ordine eos daretur ad cenam agni recumbere. Ego igitur inter illos strepentes cupiens occultari ne me iudex respiciens iuberet in cameram reproborum detrudi sine cessatione illis sanctis inter quos latebam supplicavi ut subveniendo

Like the humble wedding guest in the Gospel of Luke, Bernhard took the last place at the feast, selecting the seat behind his companion.[11]

> There was very little space left at the end of the row beyond the apostles—hardly enough for two men. But, because I wasn't able to find a seat in the row of saints, with a certain of my companions who accompanied me, I furtively took one of the empty seats that I had seen at the end of the row of apostles, desiring to hide myself there at the end. Fearing the judge, however, under whose gaze I took my place, I dared not to sit upright like the others, but rather remained prostrate, and with my companion, I hid myself like a snake in the grass.[12]

Thus hidden, and falsely believing that he had avoided the judge's notice, Bernhard witnessed the distribution of a meal of bread and of wine to the saints. Here the Eucharistic imagery is obvious:

> While we stayed there, the guard of the opening of heaven came forward and carried with him innumerable loaves of the whitest bread, and beginning from the first in the palace—that is, the patriarchs and prophets—he began to distribute a loaf to each one in the row, continuing in this all the way to the end of the apostles, who were seated at the very end of the

row. Then two loaves remained—one of spelt and the other of wheat—which the server threw to us almost in anger, since we, spared up to that point from incineration, now should have a part in the pure community of the saints. The wheat loaf fell, by chance, to me, who stood behind my companion at the very end of the palace.[13]

The loaves of wheat and spelt may possibly refer to Exodus 9:32, in which the survival of these two types of grain in the wake of the plague of hail sent down on the Egyptians is attributed to their late ripening.[14] Like the wheat and the spelt, Bernhard and his companion seemed to have avoided destruction. Even when the judge noticed them for the first time as each received his loaf, he did not react in anger to their illegitimate participation in the meal. He interpreted the friendly nod from the judge as an invitation to take a higher seat at table:

> I do not know [how to describe] the cheerful nod with which he signaled to me. Sensing what I needed to do, I stood up—for I had before prostrated myself—and jumped forward into the place of my companion who was in front of me and snatched the bread that had been given to him together with his place, and shoved him, not unwillingly, into the place where

recompensarent mihi, si quid alicui eorum in terra positus deservivi. Adhuc ut mihi visum fuit iudex me inter illos occultatum non respexit. Tandem strepitu composito, residebant et ita se invicem ordinabant ut ex una parte palatii usque in alteram ubi introitus erat in uno ordine essent locati inprimis videlicet sancti patriarche et prophete, deinde alii sanctorum cetus ab initio mundi per temporum lapsus de seculo abstracti deinde quasi in ultima mundi etate sero vocati apostoli duodecim in extremitate eiusdem ordinis simul iuncti. Hic ordo in longitudine palatii positus erat. At ex altera parte idem in latitudine palatii, videlicet coram obtutibus apostolorum positus erat thronus domini … fol. 63ᵛ, lines 7–23; Feger, *Chronik*, 136–139.

11. When someone invites you to a wedding feast, do not take the place of honour, for a person more distinguished than you many have been invited. If so the host who invited both of you will come and say to you, "Give this man your seat." Then, humiliated, you will have to take the least important place. But when you are invited, take the least important place, so that when your host comes, he will say to you, "Friend, move up to a better place." Then you will be honoured in the presence of your fellow guests. For everyone who exalts himself will be humbled, and he who humbles himself will be exalted (Luke 14:8–11).

12. In fine autem sedis apostolorum nullum locale spacium restabat, nisi quod vix duos homines capere valeret. At ego in ordine sanctorum nusquam locum arripere valens, cum quodam socio meo qui me comitabatur furtim illum invasi quem in fine apostolorum vacuum perspexi optans vel illic in extremis occultari. Timens vero iudicem in cuius aspectu locum rapui non ausus sum erectus sedere ut ceteri sed prostratus ut anguis in herba cum predicto comite meo latitare cepi. fol. 163ᵛ, line 23 – fol. 16ʳ, line 1; Feger, *Chronik*, 138–139.

13. Nobis igitur sic locatis, custos supradicti foraminis procedebat et secum innumeros candidissimos panes apportabat. Et incipiens a primis in aula, id est patriarchis et prophetis, unicuique per ordinem panes singulos distribuebat sicque dispensans usque in finem apostolorum perveniebat qui in extremitate eiusdem ordinis simul residebant. Tunc duo panes superfuerunt, alter speltaneus, alter vero sigilinus. Quos minister iratus nobis proiecit, quasi indignans, nos qui adhuc a combustione eramus incorrupti purgatis sanctorum cetibus debere participare. Sed sigilinus mihi qui socio meo inferior extiti id est [*id est* added above] in aula extremus sorte venit. fol. 64ʳ, lines 1–10; Feger, *Chronik*, 138–139.

14. The wheat and the spelt, however, were not destroyed, because they ripen later (Exodus 9:32).

I had been before. Then, hungering, I ate his bread which I had taken, just as the others were doing. I rightly rejoiced in these events, for I remembered the reading of the Gospel, in which it is said to the guest in the last place: "Friend, move up!" (Luke 14:8).[15]

Even after considering the words of Luke, Bernhard's thoughts turned again to his unworthiness—to sins unconfessed, to penances not completed:

After I had eaten half of my bread, my soul was seized with care, and I said to my companion, who was sitting next to me: the bread is indeed sweet, but I am filled with fear thinking about the sins for which I must deservedly later pay.[16]

But Bernhard's companion admonished him for his concern, continuing and extending the reference to Luke:

My companion answered: Keep silent, most foolish man! Have you not read in Scripture: "Blessed is he who shall eat bread in the kingdom of God?" [Luke 14:15][17] Comforted by these words, I again began to eat as before.[18]

The meal then continued with the distribution of wine. Although the server included Bernhard angrily and reluctantly, and only at the insistence of the judge, his companion again received nothing. The judge ordered the provision of food to the damned, "... for he did not want them to suffer a double loss, cut off both

from his glory and from food. The server did this immediately and willingly."[19]

Because he had taken ill-advised comfort in the words of Luke cited by his companion, the final moments of the vision come as a surprise:

After the meal was finished, however, suddenly, in that same palace a burning furnace opened behind our backs, into which, as has already been said, the judge was obliged to throw the guilty. I stood before it and looked at the flames and was stricken with very great sadness, for I knew that I would not escape the penalty for misdeeds which I had committed on earth, even though the judge had not yet condemned me for any sins.[20]

Here Bernhard's anxiety crescendos, and the spiritual, didactic message of the vision becomes clear: like each of the guests invited to the wedding banquet in Luke 14, Bernhard had made excuses, and like them he was not to be one of the guests at the feast. Having come to this point in the drama of human salvation, an individual's recourse to earthly penance had been foreclosed. It was simply too late:

When he came to throw the guilty into the fire, I begged him desperately that I might be allowed to return to earth for the briefest hour to chasten myself with lashes, since this type of penance is most quickly effective. But the judge said: 'You are no longer

15. ... et nescio quo hilari vultus sui nutu mihi innuit. At ego quid fieri vellet satis sentiens, surrexi, nam antea prostratus iacui, et in locum superioris socii mei prosilui et panem qui sibi positus est cum loco rapui illum vero non invitum in locum in quo prius iacebam detrusi et ut alii panem quem rapui esuriens manducavi. Hoc autem mihi obtigisse tunc iure gratulabar, nam evangelice lectionis recordabar, in qua ultimo convive dicitur. Amice, ascende superius. fol. 164ʳ, line 12–19; Feger, *Chronik*, 138–139.

16. Cum autem dimidiam panis mei partem consumerem egritudine animi gravatus, dixi ad socium assidentem. Iam panem licet suavissimum fastidio, cum penas me postea luiturum pro meritis considero. fol. 64ʳ, lines 19–22; Feger, *Chronik*, 138–139.

17. Blessed is he that shall eat bread in the kingdom of God. But he said to him: A certain man made a great supper, and invited many. And he sent his servant at the hour of supper to say to them that were invited, that they should come, for now all things are ready. And they began all at once to make excuse. The first said to him: I have bought a farm, and I must needs go out and see it: I pray thee, hold me excused. And another said: I have bought five yoke of oxen, and I go to try them: I pray thee, hold me ex-

cused. And another said: I have married a wife, and therefore I cannot come. And the servant returning, told these things to his lord. Then the master of the house, being angry, said to his servant: Go out quickly into the streets and lanes of the city, and bring in hither the poor, and the feeble, and the blind, and the lame. And the servant said: Lord, it is done as thou hast commanded, and yet there is room. And the Lord said to the servant: Go out into the highways and hedges, and compel them to come in, that my house may be filled. But I say unto you, that none of those men that were invited, shall taste of my supper (Luke 14:15–23),

19. Deinde ministrum reprobis in privata custodia reclusis cibum dare iussit, se non posse pati attestans, quod utrumque damnum sustinerent, quod et ipsius gloria et cibo carerent. fol. 64ᵛ, lines 6–8; Feger, *Chronik*, 138–141.

20. Cena autem facta, subito in ipso palatio clibanus ardens post terga nostra apparuit, in quem ut ibi dictum est iudex reos mittere debuit. Ante quem ego positus flammam intuebar et nimia tristicia afficiebar, nam pro delictis que in terra positus commisi has penas me non evasurum scivi, quamvis iudex nulla peccata succenseret mihi. fol. 64ᵛ, lines 8–14; Feger, *Chronik*, 140–141.

allowed to be purified; on earth you could once think freely about this. Your penance, deferred too long with windings of words now comes too late. Vainly now you seek to offer this penance, since then you pretended to atone through good works.' I should have been thrown into the fire at this time because he pardoned me—I have no idea why—and delayed the last day for a few months, not years. I awoke and was happy that this was not real.[21]

This seems to have been a final, destructive fire—the "second death" of Revelation 20:14 rather than the purging or purifying fire coming, at that time, to be associated with Purgatory. Bernhard had been granted a stay of destruction. Upon awaking, he was happy, not that the dream was untrue, but that his participation in the drama of Judgment that he had been shown was *not yet* real. With time left on earth, he could heed this warning and atone for his sins through penance.

At the end of the text, at the bottom of folio 64ᵛ, the scribe left two blank lines; in this space, and extending into the lower margin of the page, he drew

a simple pen-and-ink diagram that replicated a (now lost) original that Bernhard himself had sketched (see Figs. 1 and 2). The image, drawn in the same red and dark brown ink used for the text, sits in a rectangular frame divided roughly into quarters. The ladder (*scala*) stands at the center, and directly above it we see the seat of the judge (*sedes iudicis*). To the right of this seat is the fire that incinerates the newly arrived souls (*flamma comburens animas hominum*). The glittering soul-rays (*faville candentes*), represented by many short, wavy brown and red lines, cross the center of the image in an arc and descend into the bottom right quadrant of the frame. The room of the damned (*camera reproborum*) is shown at the top right, opposite the seats of the patriarchs, prophets, and apostles (*sedes patriarcharum, prophetarum, et apostolorum*). The image is dominated, however, by the circle at the center, which represents the burning furnace (*clibanus ardens*) into which the damned are thrown.[22]

The chronicler followed this text and image with an account of a second, related vision. During a night just

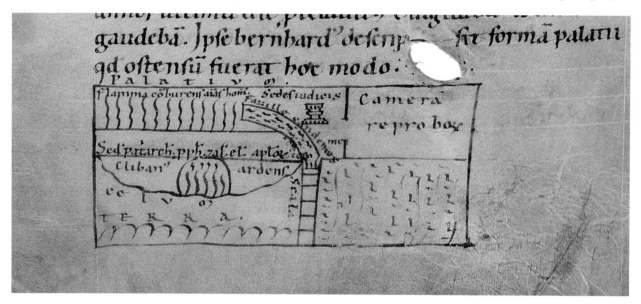

21. Quem venientem ut in fornacem reos mitteret, subnixe rogavi ut me dimitteret brevissima hora ad terram descendere et aliquid per verbera memetipsum purgare nam id genus penitentie citissimum dixi fore. At ille. Non tibi inquit licet modo purgari sed olim in terra libere positum hoc oportuit premeditari. Hec penitentia per verborum ambages tantum prolata nimium est sera, quam etiam nunc frustra conaris proferre, quandoquidem per bona opera tunc dissimulasti penitere. Iam iamque prope erat, quod me incen-

dio traditurus erat. Et nesci quomodo mihi indulsit, et per quot menses non annos, ultimum diem protelavit. Evigilabam et verum non esse gaudebam. fol. 64ᵛ, lines 15–25; Feger, *Chronik*, 140–141.

22. For a brief description of this sketch, to which the author refers as "until now completely unnoticed" (77), see Peter Dinzelbacher, "The Way to the Other World in Medieval Literature and Art," *Folklore* 97 (1986), 70–87. I am not aware of other scholarly discussions of the image.

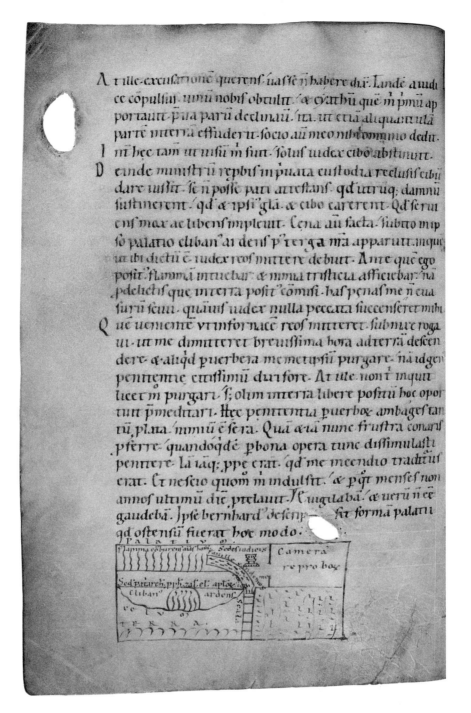

FIG. I. Pen-and-ink drawing from the twelfth-century chronicle, *Casus monasterii Petrishusensis*, now in the University of Heidelberg, (*Codex Salemitani* IX 42a, fol. 65ᵛ). A fully-digitized version of this work is on the Internet at http://diglit.ub.uni-heidelberg.de/diglit/salIX42a/.

FIG. 2 (*opposite*). Detail showing the ladder at the center, and directly above it the seat of the judge. The fire that incinerates the newly arrived souls is to the right of this seat. Glittering soul-rays represented by short, wavy lines, cross the center of the image in an arc and descend into the bottom right quadrant of the frame. The room of the damned is at the top right, opposite the seats of the patriarchs, prophets, and apostles. The image is dominated by the circle at the center, which represents the burning furnace into which the damned are thrown. University of Heidelberg, (*Codex Salemitani* IX 42a, fol. 65ᵛ).

after Bernhard's death, an unnamed monk had a vision of him stretched out over hot coals.[23] Such visions of the dead in trouble were an accepted, even expected, fact of life in Hirsau monasteries. Book One, Chapter 56 of the Constitutions of Hirsau, promulgated under William of Hirsau in the eleventh century, sets forth a clear procedure to be followed in cases in which a living member of the community has a vision of a deceased member in torment (*in poenis*). This was not considered a private matter. The person who had experienced the vision was to report it immediately, in secret, either to the abbot or the prior. The superior would decide whether or not to report the vision to the community gathered for their daily chapter. The monks could then undertake intercessory prayer on behalf of the suffering brother. This procedure stressed the suffering monk's dependence on the prayers of the community and reinforced the idea that such prayer could preserve community even in the face of death. But it also reflects a rather pragmatic understanding of the potential of visions, used maliciously, to divide a community.

The chronicler's account of the community's response to the monk's vision of Bernhard in torment illustrates this point nicely. The monk seems to have followed the procedure set forth in the Constitutions and reported his vision to his superiors. Perhaps divided over the correct communal response to this vision, or even doubting the motives or veracity of the self-identified visionary, the monks consulted Bishop Gebhard, who declared definitively that the vision was false, and spoke reassuringly to the monks:

> Do not concern yourselves with this vision, because those who were known to hate him when he was alive seem to be dreaming up bad things about him now that he is dead. Holy Bernhard served the Lord

blamelessly in this life, and you should therefore believe that he has already entered into eternal rest.[24]

Surely, a monk who embodied so many of the ideals of Gebhard's reform could not have been in torment! The bishop's strong words, however, seem not to have put the matter entirely to rest, for shortly afterwards, another monk saw Bernhard's ghost walking the halls of the monastery at night:

> Because he knew Bernhard was dead, he began to shake, but nevertheless questioned him, saying: "How is it that you are walking here? How is this possible?" And Bernhard replied: "I walk because it pleases the Lord, who according to his judgment assigned me the penalty of walking through the halls of the monastery and watching, for as long as it pleases his mercy."[25]

Bernhard, it seems, had had the final word. The precise status of his soul, like so much at the monastery of Petershausen in the wake of reform, remained uncertain.

* * *

The visionary monk Bernhard had been a person of importance at the newly reformed monastery of Petershausen. A former monk of Hirsau, praised by the chronicler for his advanced learning, teaching skills, and devotion to monastic discipline, Bernhard embodied many of the ideals of the Hirsau Reform. But the years following the reform were marked by profound structural and spiritual change that necessitated a redefinition of Petershausen as a community, and Bernhard's *memoria*, the way in which we was to be remembered by the community, became a flashpoint in this process of redefinition. For Gebhard III, the bishop who had imposed the reform, Bernhard's exemplary life was a sure sign of his safe passage into heaven. Some of the monks, perhaps rivals within the com-

23. Cum autem idem Bernhardus in sancto proposito beato fine quievisset, postea cuidam fratri per visum nocte videbatur, quasi eundem Bernhardum super vivos carbones prostratum videret torteri. fol. 65ʳ, lines 1–3; Feger, *Chronik*, 140–141.

24. De hoc visu nolite curare, quoniam qui eum viventem odisse probantur, nunc etiam de mortuo, dura somniare videntur. Nam beatus Bernhardus in hac vita sine querela domino militavit, et ideo vere credendum est, quod iam beatam requiem per-

petuo regnaturus intravit. fol. 65ʳ, lines 5–9; Feger, *Chronik*, 140–143.

25. ... quem sepultum noverat, intremuisset, eum tamen interrogavit dicens: Quid est hoc, quod hic deambulatis, vel quomodo habetis? At ille: Sicut, inquit, domino placet, nam eius iudicio mihi pro pena concessum est, angulos huius claustri circuire et observare, et hoc tamdiu quamdiu eius misericordie placuerit. fol. 65ʳ, lines 11–15; Feger, *Chronik*, 142–143.

munity, clearly did not agree. Even Bernhard himself, walking the halls as a ghost, left the question open.

The communal response to the visions prescribed by the Constitutions of Hirsau both reinforced the idea that community could be preserved even in the face of death, and acknowledged the potential of visions and visionaries to divide. The anonymous monk who wrote the Chronicle of Petershausen appropriated accounts of these visions for his creative imagining of a history for a community whose identity *as community* in the middle years of the twelfth century remained uncertain—rooted as it was in tradition—and both threatened by and pulled towards change.

FIG. 1. View of Church and Martyrium of Sta. Lucia, Syracuse (photo courtesy Mariarita Sgarlata and Grazia Salvo).

GLENN PEERS

Finding Faith Underground:
Visions of the Forty Martyrs Oratory
at Syracuse [1]

ALTHOUGH now integrated into mostly non-descript post-war residential housing, the complex of the martyrium of Sta. Lucia on the northern outskirts of ancient and medieval Syracuse has a great deal to tell us still about medieval Sicily (Fig. 1). This site is the object of great devotion on the part of Siracusani still, because Lucia is the patron of the city, and her feast day, 13 December, is marked with great celebratory sadness. Her remains are kept in the octagonal martyrium ascribed to the seventeenth-century master Giovanni Vermexio, and the church communicates with that building by means of an underground passageway (Fig. 2). That join reveals one of the remarkable aspects of Syracuse: its extensive subterranean passages and chambers that comprise a catacomb system second only to Rome. Even though scholars have studied these catacombs, beginning with the great Paolo Orsi in 1916 and 1919, and although Mariarita Sgarlata and Grazia Salvo have continued to do important work here, much remains to be done. The catacombs below Sta. Lucia have rarely been open to the public, but work is being done to change that situation; and they have suffered damage over the centuries that make them rather sad testimonies to an important aspect of the history of Mediterranean culture and religion.[2]

FIG. 2. Plan of Buildings and Catacombs, Sta. Lucia, Syracuse (photo courtesy Mariarita Sgarlata and Grazia Salvo).

tened and talked about Syracuse, my thanks for their indulgence and advice: Franco de Angelo, Anne-Marie Bouché, Peter Brown, Martin Eisner, Barry Flood, Oleg Grabar, Herbert Kessler, John Osborne, Barbara Roggema, Ramzi Rouighi, and Rabun Taylor. Marcia Tucker at the Institute for Advanced Study, Princeton, very kindly helped me with some bibliographic puzzles. Finally, Mariarita Sgarlata and Grazia Salvo allowed me to use their photographs here, and my heartfelt thanks for that—for art historians—ultimate collegial kindness. (Note that abbreviations below conform to the *Oxford Dictionary of Byzantium*.)

1. This project on medieval Syracuse, of which this article forms a part, began in teaching students from the University of Texas at Austin in that fascinating Sicilian city, and I should like to thank those students who made the experience so memorable. I should also thank Lucia Ortisi and the staff at the Mediterranean Center for Arts and Sciences, as well as Grazia Salvo and Mariarita Sgarlata, all of whom made Syracuse a happy and stimulating "home"; William Johnson and his family made me realize how important friendship is; to them, warm gratitude. To colleagues who lis-

2. On the Oratory, see M. Sgarlata and G. Salvo, *La catacomba di Santa Lucia e l'Oratorio dei Quarante Martiri* (Syracuse, 2006); *La catacomba di Santa Lucia a Siracusa: Nuove indagini per un progetto di conservazione*, ed. by M. Sgarlata (Syracuse, 2004); M. Falla Castelfranchi, "Pitture 'iconoclaste' in Italia meridionale? Con un'appendice sull'oratorio dei Quaranti Martiri nella catacomba di

FIG. 3. View of Oratory of the Forty Martyrs, Syracuse (photo courtesy Mariarita Sgarlata and Grazia Salvo).

Among other important aspects of the medieval shrine, an Oratory lies below and near the martyrium of Sta. Lucia and the church dedicated to her (Fig. 3). Now called the Oratory of the Forty Martyrs, it lies in the complex of passages and rooms dug out of limestone, like much of the catacomb system in the area, which began as aqueducts and were enlarged between the third to sixth centuries to accommodate burials for the diverse citizenry of Syracuse. The Oratory was originally a discrete chamber, but in the early modern period this area was enlarged for use as a cistern. It then lost its walls, including the apse, and its use during the Second World War provided the catacombs with no real benefit, unless one counts the electrical wiring. The surviving frescoes are fragmentary, but they do reveal what must have been a powerful, compact ensemble of figural painting: on the side wall, the best preserved passage of the paintings shows six bust-length saints against a neutral background defined by a colonnade swathed with drapery. These figures include local heroes Lucia (Helena is also a possibility, however) (Fig. 4), Marziano—the legendary disciple

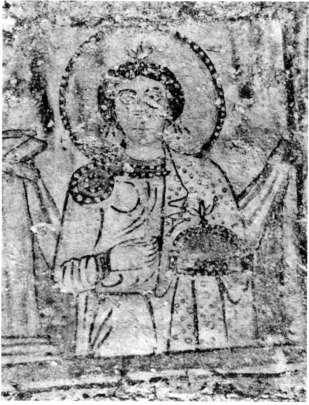

FIG. 4. Detail Side Wall, Female Saint (Lucia?), Oratory of the Forty Martyrs, Syracuse (photo courtesy Mariarita Sgarlata and Grazia Salvo).

of Paul and first leader of the Christian community in Syracuse—(Fig. 5), two male figures identifiable perhaps as Ss. Cosmas and Damian, and two male ecclesiastical figures. None of the figures have surviving inscriptions, and so the identifications are not without difficulties (Fig. 6).

On the vault of the Oratory, a rendering of the martyrdom and vision of the Forty Martyrs of Sebaste is discernible, although very poorly preserved (Fig. 3), and one has to rely on early twentieth-century drawings for its full interpretation (Fig. 7). In any case, the iconography is still quite clear: the Forty are divided

Santa Lucia a Siracusa," in *Bisanzio e l'Occidente: arte, archeologia, storia. Studi in onore di Fernanda de' Maffei*, ed. by C. Barsanti et al. (Rome, 1996), 409–25; T. Velmans, "Le décor de la voûte de l'Oratoire Santa Lucia: Une iconographie rare des Quarante Martyrs," in *La Sicilia rupestre nel contesto delle civiltà mediterranee*, ed.

by C. D. Fonseca (Galatina, 1986), 341–54; G. Agnello, *Le arti figurative nella Sicilia bizantina* (Palermo, 1962), 162–9; idem, *L'architettura bizantina in Sicilia—Sicilia bizantina*, vol. 2 (Florence, 1952), 180–92; and P. Orsi. "Siracusa: La catacomba di S. Lucia. Esplorazioni negli anni 1916–1919," *NS* ser. 5, 15 (1918), 282–5.

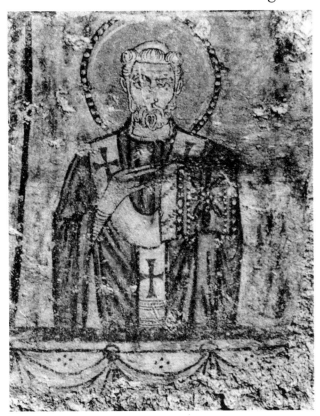

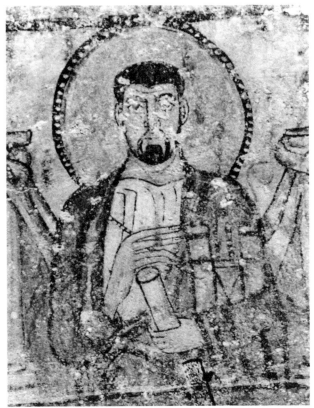

FIG. 5. Detail, Side Wall, Male Saint (Marziano?), Oratory of the Forty Martyrs, Syracuse (photo courtesy Mariarita Sgarlata and Grazia Salvo).

FIG. 6. Detail, Side Wall, Male Saint (Cosmas?), Oratory of the Forty Martyrs, Syracuse (photo courtesy Mariarita Sgarlata and Grazia Salvo).

into four groups according to the quadrants created by an elaborately decorated cross.[3] The Forty are shown nude with water to their waists, and crowns descend from above to mark their achievement. The episode of the bath attendant, who takes the place of the turncoat fortieth, is shown in the southwest corner of the cross. Typically, the mother who adds her still-living son to the martyred group is missing. An unusual element was added, however: an unidentified figure in the northwest corner of the vault, who is in the act of writing. The spine of the cross runs east-west, from

entrance to apse—the dimensions of the Oratory are modest, the vault measuring 4.3 m × 2 m—and the lateral arm bisects the vault on a north-south axis (Fig. 8). At the center of the cross is a medallion containing Christ, while at the lateral ends are two archangels; the *orans* Virgin Mary occupies a medallion at the base of the cross. Unfortunately, if a medallion was depicted at the top of the cross at the east end of the Oratory, the evidence is lost, just as the north wall was demolished for the creation of cisterns, with no record being made.

The program, then, is fragmentary, and its fragments

3. On the iconography of the Forty, see T. Velmans, "Une icône au Musée de Mestia et le thème des Quarante martyrs en Géorgie," *Zograf* 14 (1983), 40–51; Z. Gavrilovic, "The Forty Martyrs of Sebaste in the Painted Programme of Zica Vestibule: Further Research into the Artistic Interpretations of the Divine Wisdom-Baptism-Kingship Ideology," *JÖB* 32/5 (1982), 185–93; G. P. Schiemenz, "Wunderkraft gegen kämpfende Widersacher," *EEBS* 44 (1979–80), 165–221; D. T. Rice, "Ivory of the Forty Martyrs at

Berlin and the Art of the Twelfth Century," in *Mélanges Georges Ostrogorsky*, ed. by F. Barisic, 2 vols. (Belgrade, 1963), 1:275–9; O. Demus, "An Unknown Mosaic Icon of the Palaiologan Epoch," *ByzMetabyz* 1 (1946), 107–18 [= Demus, *Studies in Byzantium, Venice and the West*, 2 vols., ed. by I. Hutter (London, 1998), 1:164–72.]; and *idem*, "Two Palaeologan Mosaics Icons in the Dumbarton Oaks Collection," *DOP* 14 (1960), 87–119 [= Demus, *Studies in Byzantium*, 1:192–222].

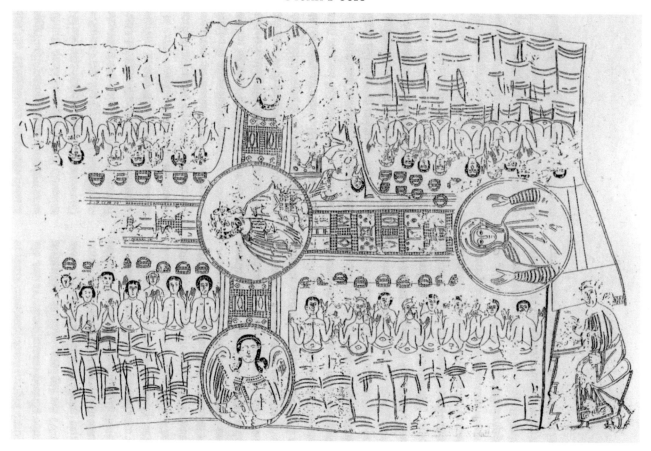

FIG. 7. Drawing of Vault, Oratory of the Forty Martyrs, Syracuse (photo courtesy Mariarita Sgarlata & Grazia Salvo).

FIG. 8. Reconstruction of Oratory of the Forty Martyrs, Syracuse (photo courtesy Mariarita Sgarlata & Grazia Salvo).

resist clarity in all their details. Likewise, the situation in which we find the Oratory is historically difficult. We assume a shrine for Lucia existed from an early date, and Gregory the Great (r. 590–604) mentioned a monastery at this location in the late sixth century,[4] but the archaeological record for that complex or any other from before the twelfth century, when the monastery was rebuilt along the general lines visible today, is meager indeed. Such difficulties only increase the attraction for some scholars, and, beside the work already mentioned by Orsi and a recent book co-written by Sgarlata and Salvo, Marina Falla Castelfranchi and Tania Velmans have published studies on the Oratory in 1996 and 1986, respectively. All of these scholars have interpreted the Forty and the six saints in the con-

4. See G. Salvo, "Monachesimo e monasteri siracusani nel VI secolo" in *Di abitato in abitato: 'In itinere' fra le più antiche testimonianze cristiane degli Iblei*, ed. by F. P. Rizzo (Pisa and Rome, 2005), 117–33.

text of Byzantine monastic art, and they have rightly situated the program within a particularly Sicilian context that bridged monastic and religious trends in both Constantinople and Rome.

Despite the state of preservation of the Oratory frescoes, I should like to offer a different interpretation of the program, one that does not deny the importance of the bridge between those two centers, but that directs the focus of its interpretative analysis to larger issues of the Mediterranean in the early Middle Ages: that of Christian self-definition and survival in a region either under threat of absorption into the Islamic *ummah* or already within it. My argument, in other words, takes issue with seemingly natural dating of this monument—and many others like it—to the period before the Islamic conquest of Sicily, which began in 828, and specifically of Syracuse, with its defeat after a long, bitter siege in 878. In spite of the condition of the frescoes, I shall offer an argument for dating them within the range of the ninth to eleventh centuries, and consequently for situating them in a different cultural context, when Muslims were a threat or dominant. The program survives to the degree that one can argue for a necessary presentation of self-image on the part of Greek Christians in early medieval Syracuse, in which they were able to look beyond in ways that provided comfort and resolve: the Oratory revealed to that community its historical claims to covenant, its reward for self-sacrificing faith, and its promise of deliverance in the theophany overhead and so near.

Early Medieval Christian Painting on Southeastern Sicily

Dating of painting in this period is notoriously difficult, if the proof is style[5]—witness the sliding chronologies in Cappadocian painting in work of the last de-

cade or so.[6] Absolute proof in such a matter is likely out of reach, but connections among Syracusan painting, painting in the southeastern corner of Sicily and southern Italy generally, and in Rome, make a case for associating the Oratory frescoes with ninth- to eleventh-century programs, and, thus, for establishing another cultural milieu in which the paintings need to be situated.

The dating of the Oratory has rested on an assumption that Christian art was not produced during the period from the ninth to the eleventh centuries, when Sicily was ruled from Ifrīqiyā rather than Constantinople. The argument for a dating of the frescoes from the late seventh, eighth, or early ninth centuries, which has been offered so far exclusively, rests on the presumption that Syracuse was following the trend of devotion to the Forty Martyrs shown most vividly now in the frescoes of the seventh and eighth centuries in the Oratory of the church of Sta. Maria Antiqua in the Roman Forum. Stylistically, the frescoes appear unrelated, and the iconographic similarities are slight, given the disposition of the martyrs in quadrants on the Oratory ceiling and the three scenes of martyrdom and reward on the walls of the vestibule at Sta. Maria Antiqua. Castelfranchi also adduced the small "chapel" at the church of San Lorenzo fuori le Mura in Rome, which has traditionally been dated to the eighth century, but John Osborne has established that that fresco program dates to the twelfth century.[7] Other elements in the Oratory give some good possibility of a late ninth- to tenth-century dating: the swags of drapery between the pillars, serving as honorific backdrops to the row of saints, were revived in the post-iconoclastic period in Byzantium, and the "pearled" haloes do not appear in Rome and in Byzantium until about the tenth century.[8] And yet the Roman overtones of the series of saints on the lower part of the wall seem

5. But also building materials, for which see E. Pezzini, "Alcuni dati sull'uso della terra nell'architettura medievale a Palermo: Fonti documentarie e testimonianze materiali," in *III Congresso Nazionale di Archeologia Medievale. Castello di Salerno, Complesso di Santa Sofia. Salerno, 2–5 ottobre 2003*, 2 vols., ed. by R. Fiorillo and P. Peduto (Florence, 2003), ii:624–8.

6. See, for example, H. Wiemer-Enis, *Spätbyzantinische Wandmalerei in den Höhlenkirchen in der Türkei* (Petersburg, 2000), and

N. Thierry, "De la datation des églises de Cappadoce," *BZ* 88 (1995), 419–55.

7. J. Osborne, "Dating Medieval Mural Paintings in Rome: A Case Study from San Lorenzo fuori le mura," in *Roma felix: Formation and Reflections of Medieval Rome*, ed. by É. Ó Carragáin and C. L. Neuman de Vegvar (Aldershot, 2007), 191–206.

8. See, for example, A. Cutler and J.-M. Spieser, *Byzance médiévale: 700–1204* (Paris, 1996), 24, 132, 137, 201.

clear, too, and parallel passages like that found in the temple of Fortuna Virilis / Sta. Maria Egiziaca in Rome, painted in the 870s.[9]

For establishing not only a date for the Syracusan Oratory, but also for providing a wider cultural context, those monuments in Rome are key. Christian art *was* produced when Sicily was Muslim, and the region of southeastern Sicily offers vital information for the art-historical context. Near Syracuse, the honey-combed-flanks of the ravines at Pantalica reveal a great deal of evidence of habitation and decorated shrines.[10] This area is a rich nature reserve with great quantities of water, but despite these natural resources, Pantalica was settled only in the Late Bronze Age, up to the period of Greek colonization in the seventh century B.C.E., and in the early Middle Ages, from the seventh and into the twelfth century. These medieval settlers took over some of the rock-cut habitations from the prehistoric period, as well as decorating some of the rock-cut chapels with frescoes, some of which survive in very poor condition. For that reason, these frescoes are hard to date, but there is no reason to deny them a date after the ninth century. The shrines are Greek: the inscriptions are in Greek, even if they are not quite legible. The style of the painting is consistent with a date of the ninth to the eleventh centuries. Whether the rock-cut chapel of S. Nicolicchio was freshly dug in the Middle Ages is difficult to say, and the archaeology performed by Paolo Orsi in the late nineteenth century in the area is not very useful in that regard. But the documentary evidence shows that settlement in the area dates between 1093–1151, and one coin

hoard dates to the second half of the seventh century. Clues such as the pearled halo of the saint from the rock-cut chapel of S. Micidiario at Pantalica and of the saints in the Oratory of the Forty Martyrs allow a hypothesis that these paintings were done between the ninth and eleventh centuries.[11]

A cave church, S. Nicolò Inferiore, in the town of Modica, about 100 kms from Syracuse, is a vivid example of the discoveries made on Sicily.[12] Examples from southeastern Sicily fill out a picture of art production in the Early Middle Ages that otherwise appears largely blank. In the early 1990s, some boys were playing soccer and kicked the ball against the wall of what was a storage shed. Bits of plaster came away from the wall and revealed some painted fresco underneath; a restoration campaign was mounted and this chapel was found, a chapel that seems to have had a very long life. The rock-carved chapel has a synthronon in the apse, which suggests an early date for its founding, perhaps the sixth century, and the frescoes themselves reveal a long use of the space, apparently into the early modern period. The earliest layer of fresco, still visible in the vault and peeking through other layers on the apse wall, reveals an Ascension scene with Christ seated on a rainbow arc and borne aloft by angels. A Virgin and Child composition, or an *orans* Virgin, was likely in the lower apse. Stylistically and iconographically, the scene of the Ascension has its closest parallels in the wall paintings found in rock-cut churches in Cappadocia. According to a recent argument by Castelfranchi, this lowest stratum belongs to the same period to which the paintings in

9. S. Lafontaine-Dosogne, *Peintures medievales dans le temple dit de la Fortune virile a Rome* (Brussels, 1959).

10. See E. Blake, "The Familiar Honeycomb: Byzantine Era Reuse of Sicily's Prehistoric Rock-Cut Tombs," in *Archaeologies of Memory*, ed. by R. M. van Dyke and S. E. Alcock (Malden, Mass., 2003), 203–20, as well as A. Messina, *Le chiese rupestri del Siracusano* (Palermo, 1979), and G. Agnello, *L'architettura bizantina in Sicilia* (Sicilia bizantina, vol. 2), (Florence, 1952).

11. Examples from southern Italy show connections with Sicily, and Marina Falla Castelfranchi has recently published a fresco from Naples, the *hypogeum* of Sant'Aspremo. See her "La pittura bizantina in Italia meridionale e in Sicilia (secoli IX–XI)," in *Histoire et Culture dans l'Italie Byzantine. Acquis et nouvelles recherches*,

ed. by A. Jacobi, J.-M. Martin and G. Noyé (Rome, 2006), 216–8. The fresco is damaged, but it shows a gemmed cross with figures in the quadrants created on the vault by the cross; and the swags of drapery, too, show incidental parallels with the details of the Syracusan program. The date for this fresco appears to be the second half of the tenth century.

12. Falla Castelfranchi, "La pittura bizantina in Italia meridionale e in Sicilia" (as in note 11), 215; *eadem*, "La decorazione pittorica bizantina della cripta detta di San Nicolò Inferiore a Modica (RG): Una testimonianza significativa d'epoca araba," in *Studi in memoria di Patrizia Angiolini Martinelli*, ed. S. Pasi (Bologna 2005), 155–63; and G. Di Stefano, *La chiesetta rupestre di San Nicolò inferiore a Modica* (Ragusa, 2005).

Cappadocia are normally dated, that is, the tenth or eleventh century. The Ascension with *orans* Virgin below from the eleventh-century frescoes in Karanlik Kilise, Göreme, is a telling comparison for showing the points of contact between Cappadocian and Sicilian programs in this period.[13]

One can make a case, then, for the production of good quality painting from the ninth to the eleventh centuries in the south of Italy, not only in the Christian part of the peninsula, but also in the Muslim-controlled areas of Sicily. Monuments in Rome, Syria, Constantinople, and Cappadocia share features, stylistic and iconographic, with the Oratory in Syracuse, but none match it in every detail.[14] Clearly, painters and their workshops traveled across borders, just as hagiographies from the period tell us saints did, too.[15]

The hagiography of Elias the Younger (823–903) is a remarkable text in many ways, not least for what it reveals about the peripatetic quality of the monastic life possible for some men.[16] People and culture moved around the Mediterranean, of course, and the shared experience and common beliefs of Greek-speaking Christians in the east and central Mediterranean, and maybe also of Christians generally within or near Muslim-dominated regions, aided that movement.[17] And precious evidence does exist from Syracuse itself for building and decoration, in the form of inscriptions on marble architectural fragments that date from the tenth century. Two inscriptions, now in the Museo Bellomo, Syracuse, are evidence of decoration of churches in the city during a period when Christian patronage has been said to be moribund.[18] Naturally,

13. On common practices and common interest in caves as sanctuaries, see A. Wharton Epstein, "The Problem of Provincialism: Byzantine Monasteries in Cappadocia and Monks in South Italy," *JWarb* 42 (1979), 28–46. On the importance of cave churches in Eastern Christian practice, see S. Curcic, "Cave and Church: An Eastern Christian Hierotopical Synthesis," in *Hierotopy: The Creation of Sacred Spaces in Byzantium and Medieval Russia*, ed. by A. Lidov (Moscow, 2006), 216–36. Connections between Syria and Sicily were also strong in the period preceding the Muslim conquests. See L. Cracco Ruggini, "La Sicilia fra Roma e Bisanzio," in *Storia della Sicilia*, 10 vols. (Naples, 1977–81), III:38. At the church of Mar Musa al-Habashi, near Damascus, Mat Immerzeel has discerned a version of the Forty Martyrs of Sebaste at the earliest level of the fresco program, dating 1058–88. See M. Immerzeel, "Some Remarks about the Name of the Monastery and an Enigmatic Scene," *Journal of Eastern Christian Art* 4 (2007), 125–30, and *idem*, "Monasteries and Churches of the Qalamun (Syria): Art and Pilgrimage in the Middle Ages," forthcoming in *Journal of the Canadian Society for Syriac Studies* 7 (2007).

14. Devotion to the Forty Martyrs began very early in Cappadocia, in the early fourth century, and frescoes depict their martyrdom in churches in that region, naturally. For example, in a two-naved church dedicated to them near Sahinenfendi (1216–7), in the north nave, the Forty are shown on the vault and west tympanum. While at Hagios Basilios at Göreme (tenth century), a vivid cross in glory is in the vault, but no figuration. See C. Jolivet-Lévy, *La Cappadoce médiévale: images et spiritualité* (Paris, 2001), 336–7, and 65, respectively. The motifs at Syracuse were combined in a highly unusual manner.

15. See C. Morrison, "La Sicile byzantine: Une lueur dans les siècles obscures," *Numismatica e antichità classica* 27 (1998), 307–34.

16. See *Vita di sant'Elia il Giovane*, ed. by G. Rossi Taibbi

(Palermo, 1962), as well as S. Efthymiades, "Chrétiens et Sarrasins en Italie méridionale et en Asie Mineure (IX^e–XI^e siècle). Essai d'étude comparée," in *Histoire et Culture dans l'Italie Byzantine. Acquis et nouvelles recherches*, ed. by A. Jacob, J.-M. Martin and G. Noyé (Rome, 2006), 600–2; G. Da Costa-Louillet, "Saints de Sicile et d'Italie méridionale aux VIII^e, IX^e et X^e siècles," *Byzantion* 29–30 (1959–60), 95–109; and M. Amari, *Storia dei Musulmani di Sicilia*, 3 vols., 2nd ed. (Catania, 1933–39), I:654–61. See for the earlier period, F. P. Rizzo, "Fulgenzio a Siracusa," in *Studi di filologica classica in onore di Giusto Monaco*, 4 vols. (Palermo, 1991), IV:1473–82.

17. On the necessity of travel for Muslims in Sicily, see W. Granara, "Islamic Education and the Transmission of Knowledge in Medieval Sicily," in *Law and Education in Medieval Islam: Studies in Memory of George Makdisi*, ed. by J. E. Lowry, D. J. Stewart, and S. M. Toorawa (London, 2004), 150–73, and, more broadly, M. McCormick, *Origins of European Economy: Communications and Commerce, A.D. 300–900* (Cambridge, 2001), 510–5. Intellectual exchange between Christians and Muslims in Sicily was not only likely, but the further exchange with centers in the eastern Mediterranean was also surely a possibility. For example, see A. Ahmad, *A History of Islamic Sicily*, Islamic Surveys, Vol. 10 (Edinburgh, 1975), 41–7. The fact that Nilus of Calabria read John of Damascus may be more likely due to Sicilian contacts with the Holy Land than with Constantinople; see *Vios kai politeia tou hosiou patros emon Neilou tou Neo*, ed. by P. Germano Giovanelli (Grottaferrata, 1972), 71 (23), as well as V. von Falkenhausen, "La vita di S. Nilo come fonte storica per la Calabria bizantina," in *Atti del congresso internazionale su S. Nilo di Rossano* (Rossano and Grottaferrata, 1989), 295.

18. A. Guillou, *Recueil des inscriptions grecques médiévales d'Italie* (Rome, 1996), 231–3. Eleventh-century inscriptions from Kairouan reveal Christian presence and activities there, too; see

these inscriptions belonged inside churches, typical of the prohibition on new church building and public declarations of Christianity in *dhimmitude*.

No evidence exists, to my knowledge, that shows the persecution or oppression of Christians in Syracuse or in the general area after the Muslim conquest. Although the fall of the city was memorably terrible, the prisoners taken in 878 were ransomed and returned to the city within several years, so resources were still available to some of the Christians left in the city and the surrounding area, it would seem.[19] In other words, the break may not have been so cataclysmic when the government changed in 878, and the transition to an economic network based in the Maghrib and Egypt was apparently not difficult, according to historians.[20] However, the end of Muslim rule was by no means a peaceful transition, and the instability of the Norman conquest makes it unlikely that conditions were right for commissioning art.[21] One has to fit the Oratory into a Muslim-dominated milieu where the resources, opportunity, and need to decorate a Christian chapel at a locally venerated shrine existed. Before I proceed to make an argument for what the program means in such a milieu, I wish to address briefly the historiography of Muslim Sicily for the light it sheds on why we understand Muslim Syracuse as we do.

History and Islamic Sicily

The historical trajectory of the understanding of Muslim Sicily has been subject to the same currents of ethnic, religious, and political engagement that have affected every humanistic discipline.[22] This is especially evident in the silences around the centuries of Muslim rule in and around Syracuse.

In the late eighteenth century, Islam's history in Sicily was little understood and was only beginning to be of interest. In the 1780s, a priest, Giuseppe Vella, published a series of studies claiming to be based on manuscripts he had found containing correspondence among Count Robert Guiscard, of Apulia and Calabria, Count Roger I of Sicily, and the Fatimid caliph, al-Mustansir, in Cairo.[23] By 1792, six volumes had appeared, financed and patronized by the King and papal representatives. The studies were scholarly bestsellers, immensely popular amongst patriotic Sicilians, who wanted to see a prestigious history of the island made better known. While the books struck a responsive chord among patriots, they were based on simple forgeries devised by the priest. He was arrested in 1793, but shortly after released to his order, and he continued to forge nonetheless.

A. Mahjoubi, "Nouveau témoignage épigraphique sur la communauté chrétienne de Kairouan au xɪᵉ siècle," *Africa* 1 (1966), 85–103.

19. See the *Cambridge Chronicle*, G. Cozza-Luzi, *La cronaca siculo-saraceni di Cambridge con doppio testo Greco scoperto in codici contemporanei delle biblioteche Vaticana e Parigina* (Palermo, 1890), 34; *Biblioteca arabo-sicula*, trans. by M. Amari, 2 vols. (Turin and Rome, 1880), 1:279; and Vasiliev, *Byẑ. Arabes*, ɪɪ/2:100; as well as M. Talbi, *L'émirat aghlabide (184–296/ 800–909): Histoire politique* (Paris, 1966), 485–9; and Amari, *Storia* (as in note 16), 1:551.

20. See C. Wickham, *Framing the Early Middle Ages: Europe and the Mediterranean, 400–800* (Oxford, 2005), 737–8, and McCormick, *Origins of European Economy* (as in note 17), 508–15.

21. See A. L. Udovitch, "New Materials for the History of Islamic Sicily," in *Del nuovo sulla Sicilia musulmana (Roma, 3 maggio 1993)* (Rome, 1995), 193. From a letter written by a refugee, who fled from Sicily to Fustat ca. 1060: "Indeed God did well to you, since nothing good remains in Sicily … Let me now begin to describe to you the civil strife that has occurred in Sicily. We saw

something I would not wish to see (again) at all; there was such bloodshed that we were walking on corpses as one would walk on the ground. There also was a tremendous plague." Trans. by M. Gil, "The Jews in Sicily under Muslim Rule, in the Light of the Geniza Documents," in *Italia Judaica* (Rome, 1983), 87–134, text 107–11, here 110.

22. On these issues, see R. M. Dainotto, *Europe (in Theory)* (Durham-London, 2007), 172–217; K. Mallette, *The Kingdom of Sicily, 1100–1250: A Literary History* (Philadelphia, 2005); *eadem*, "Translating Sicily," *Medieval Encounters* 9 (2003), 140–63; and A. Nef, "Jalons pour de nouvelles interrogations sur l'histoire de la Sicilie islamique," *MEFRM* 116 (2004), 7–17. See also J. Johns, "Arabic Sources for Sicily," in *Byẑantine and Crusaders in Non-Greek Sources. 1025–1204, ProcBrAc*, Vol. 132, ed. by M. Whitby (Oxford, 2007), 341–60. For the comparable situation in the history and historiography of Spain, see A. Christys, *Christians in al-Andalus (711–1000)* (Richmond, Surrey, 2002).

23. See Mallette, *The Kingdom of Sicily* (as in note 22), 17–8, and R. Gottheil, "Two Forged Antiquities," *JAOS* 33 (1913), 306–12.

That scandal did bring about more energetic study of Muslim Sicily, and for reasons that appear to have had particular resonance for those who wished to relive eras when Sicilians ruled Sicily, or when it knew glory and fame. The great scholar of Muslim Sicily, Michele Amari (1806–89), began his career as such an historian, when he wrote his account of the Sicilian Vespers, the popular uprising against Angevin dominion of 30 March 1282. He wrote the book as a thinly veiled attack on Bourbon rule; it did pass the censors, but when he was called to court to explain, he went into exile in Paris. That episode has interest because it shows the nationalistic underpinnings of his work, especially in contradistinction to the French biases evident in the history of the Vespers by Adolphe Noël de Vergers (1805–67); exile also provided Amari the opportunity to begin his training as an Arabist, which is the basis of his longstanding scholarly fame.[24]

More than anyone else, Amari put the study of Muslim Sicily on firm ground—and by extension Christians' relations to it. His identification of what was and was not Muslim is of the first importance, as before his multi-volume work on the history of Muslims in Sicily appeared, monuments like La Zisa, which we now know to be Norman, were believed to be from the period of Muslim dominion over Sicily. The building's inscriptions, for instance, needed the penetrating reading of a gifted scholar like Amari; before that, they were largely opaque. Amari radically remade visions of the past. Up to that point, Sicilians could proudly see buildings like La Zisa as evidence of a rich heritage, with a more progressive view of Islam to Christianity. But after him, they had to take account of the relative emptiness of the period preceding the Normans.[25]

In other words, as traces of Islam were recognized and absorbed, they were read in ways appropriate to the dominant culture. Amari's project began as patriotic scholarship, since he was early in his life a fierce proponent of Sicilian independence. As his scholarship developed in Paris and elsewhere, his political views also developed to the point that he is now considered a great champion of Italian unity. That trajectory leading from Sicilian independence to Italian nationalism was conditioned, one can argue, by his growing understanding of the experiment in diversity and coexistence of Norman Sicily. Reclaiming the memory of that Norman experiment and re-writing the previous memory of an Islamic Sicily was the great work of Amari, but for the most part those memories cancelled other memories, some admittedly false, a great material culture of Muslim Sicily. The nature of that canceling was in part the doing of that great scholar, but the real canceling of Muslim relics had been performed many times over and in the distant past.

Muslim Syracuse

We are confronted in Sicily with a loss of a memory that has been discovered only in the last century and a half. That loss is poignant in the early twenty-first century, when a desire to find a world where Islam, Christianity, and Judaism could co-exist (and very well indeed in medieval terms) is intense. The precariousness of that co-existence is vivid, and reclaiming an imagined world of relative harmony is of great importance.[26] In and around Palermo, we see those traces of a memory of Islam, naturalized to a Christian kingdom, and they are extraordinary. In other places, real silence prevails. In Syracuse, the ghosts of Islam prevail unrecognized, except in the longing voice of the great exiled poet, Ibn Hamdīs (1056–1133), from the nearby ghost town of Noto Antica.[27] In the city and

24. As well as her studies above, see also K. Mallette, "Orientalism and the Nineteenth-Century Nationalist: Michele Amari, Ernest Renan, and 1848," *Romanic Review* 96 (2005), 233–52.

25. A point made by Dainotto, *Europe (in Theory)* (as in note 22).

26. The recent fiction of Barry Unsworth, *The Ruby in Her Navel: A Novel of Love and Intrigue set in the Twelfth Century* (2006) and Tariq Ali, *A Sultan in Palermo* (2005) is an indication of the attraction that precious—and doomed—equilibrium has for us.

27. Ibn Hamdis' poetry of nostalgia evokes the pain of loss of Muslims when Sicily was lost to the Normans. Ibn Hamdis paints a landscape in which Greek monks strike the plank to call the faithful and in which Christian sounds were then heard, not those of the true faith. For these poems, see *Diwan Ibn Hamdis*, ed. by I. 'Abbas (Beirut, 1960), 274–6, trans. by Mallette, *The Kingdom of Sicily* (as in note 22), 134–7. S. Sperl, in "Crossing Enemy Boundaries: al-Buhturi's Ode on the Ruins of Ctesiphon Re-read in the Light of Virgil and Wilfred Owen," *BSAOS* 69 (2006), 365–79, describes

region, real forgetting happened, intentionally on the part of the later Christians, and additionally through the great destructive force of the earthquake that shook the southeast corner of the island in January 1693. The old neighborhoods of Ortygia give a sense of medieval patterns of living and interacting, but except for some street names, they are not forthcoming about the different inhabitants the city once housed. Signs of a multi-faith past *are* visible, but we need to look at these little-known monuments with eyes a little less dazzled by the Norman achievement and give back some of the credit that Amari took from the Muslim and Greek-Christian inhabitants of the area.[28]

Evidence of absorption and transformation certainly exists in Syracuse. The façade of the Duomo reveals its post-earthquake identity without any hedging, and the heterogeneity of the rest of building, maybe the best thing one can say about the Duomo, is likewise clear and highly compelling. The Doric temple of the early fifth-century B.C.E. emerges from the walls on the north side of the Duomo, but the date of the transformation is not clear. It appears that by the late sixth century the Bishop had moved from Sta. Lucia on the mainland to this converted building.[29] This move implies that the building had been left empty until its conversion in the sixth century. The building was ab-

sorbed into the Christian cityscape long after it had been neutralized. This pattern is typical throughout the Mediterranean not only for conversion of temples, but also for retrenched settlement, where raids from the sea made retreat to easily defensible positions necessary.[30] Siracusani mainly lived within Ortygia by the sixth to seventh century, and the Duomo was in active use when Muslims finally gained control of the city on 21 May 878. The great loot from the city and its churches was widely reported.

Mystery surrounds Muslim Syracuse. In the absence of any evidence, everyone assumes that the new rulers altered the Duomo to function as a mosque.[31] No traces remain, naturally, as the Normans, who took the city in October 1086, renovated the Duomo by adding a new roof and mosaic decoration (all of which is lost). No other likely candidates for the city's Friday mosque have been found or offered. It must be noted, too, that Normans did more than suppress evidence of Muslim power at Syracuse. They also altered the east end of the Duomo to make distinct chapels to either side of the sanctuary, and this new arrangement fundamentally altered the liturgical function of the east part of the church from the Greek usage, which had been the dominant form at the city from at least the sixth century and presumably through the Muslim pe-

the self-knowledge that comes from empathy for one's adversaries, a process which has meaning in this context, too.

28. On the history of medieval Greek Sicily, see V. Von Falkenhausen, "La presenza dei greci nella Sicilia normanna: L'apporto della documentazione archivistica in lingua greca," in *Byzantino-Sicula IV: Atti del I congresso internazionale di archeologia della Sicilia bizantina* (Corelone, 28 luglio–2 agosto 1998), ed. by R. M. Carra Bonacasa (Palermo, 2002), 31–72; *eadem*, "Il monaschesimo greco in Sicilia," in *La Sicilia rupestre nel contesto delle civiltà mediterranee*, ed. by C. D. Fonseca (Galatina, 1986), 135–74; and *eadem*, "La lingua greca nella Sicilia medievale," *CorsiRav* 27 (1980), 55–8; but also J. Irigoin, "Viri divites et eruditi omni doctrina, graeca quoque et latina," *Kokalos* 43–44 (1997–98), 139–51; D. J. Geanakoplos, "The Greek Population of South Italy and Sicily and its Attitudes toward Charles of Anjou and Michael Palaeologus before and during the Early Phase of the Sicilian Vespers (1282)," in *Constantinople and the West: Essays on the Late Byzantine (Palaeologan) and Italian Renaissances and the Byzantine and Roman Churches* (Madison, 1989), 189–94; J. M. Powell, "Frederick II's Knowledge of Greek," *Speculum* 38 (1963), 481–2; R.

Weiss, "The Greek Culture of South Italy in the Later Middle Ages," *ProcBrAc* 37 (1951), 25–50; and C. H. Haskins, *Studies in the History of Mediaeval Science* (Cambridge, Mass., 1927), 155–93.

29. See S. Giglio, *Sicilia bizantina: L'architettura religiosa in Sicilia dalla tarda antichità all'anno mille* (Catania, 2003), 107–11; T. W. Lyman, "Syracuse after Antiquity," in *Syracuse, the Fairest Greek City. Ancient Art from the Museo Archeologico Regionale 'Paolo Orsi'*, ed. by B. D. Wescoat (Rome and Atlanta, 1989), 49–51; P. Magnano, *La cattedrale di Siracusa* (Syracuse, 1990); S. L. Agnello, "Chiese siracusane del VI secolo," *Archivio Storico Siracusano* 5 (1978–79), 115–36 [= *CorsiRav* 27 (1980), 13–26]; A. Agnello, *Siracusa nel medioevo e nel rinascimento* (Caltanissetta-Rome, 1964), 13; and G. Agnello, *L'architettura bizantina in Sicilia* (as in note 2), 35–77.

30. N. Christie, *From Constantine to Charlemagne: An Archaeology of Italy A.D. 300–800* (Aldershot, 2006), 44, 93, 132.

31. On relations between church and mosque buildings, see P. Wheatley, *The Places Where Men Pray Together: Cities in Islamic Lands Seventh through Tenth Centuries* (Chicago, 2001), 232–3.

riod.[32] In other words, Normans revised the building from mosque *and* from Greek-rite church when they re-made it at the end of the eleventh century.

That medieval Greek memory is almost lost, just as one could say that the silence of Islam at Syracuse is nearly total—I say nearly because, for example, one Arabic graffito was found during the cleansing program that led to the creation of the precinct for the Temple of Apollo at the north end of Ortygia before and after the Second World War.[33] Of course, this precinct reflects attitudes about the right kind of memory that a culture should have, and the proper kind is that pure moment of early Doric, when the Syracusans may well have built the first temple of this magnitude. That is a significant claim, but sacrificed to it were the tenements that had grown up, one presumes, in the course of the later Middle Ages. This after-growth saw an Arabic-speaking presence, for on the north-facing wall of the cella was found the graffito in Arabic with one word in the second line decipherable, Muhammad. This evidence is tenuous, but some have hypothesized that this building, converted to a church, too, before the ninth century, was another mosque in operation sometime between the late ninth and late eleventh centuries. Despite plans like this one that show a hypothetical use as a mosque, that use has left no discernible trace, as the building became a Norman church in the twelfth century, and, like the Duomo, its identity as mosque was erased. Moreover, if the graffito was difficult to decipher in the late 1940s, it is entirely invisible now.

Community in Muslim Syracuse

The difficulty posed by the archaeology of Syracuse is not unusual for Muslim Sicily, although discoveries are being made, for example, the foundations of a mosque at Segesta in the west.[34] And yet these traces are disappointingly slight. At Syracuse, a stele now in the Museo Bellomo, but found near Sta. Lucia, shows that a community of Muslims was not an abstract notion for Christians focusing devotion on that martyrium.[35] And a twelfth-century document made it evident, too, that a Jewish community sought burial ground nearby and had to pay compensation to the Monastery of Sta. Lucia there.[36] Although we can catch only a dim glimpse of it, the landscape of Sta. Lucia included Jews and Muslims both. The sources for the period are not a great deal more extensive than the archaeological record, and this relative void is one of the serious obstacles that any scholar of the period—from Amari on—confronts.[37] Indeed, Muslim culture in Sicily, before the Normans, has left few reminders, and we cannot simply assume that the transformed cultures of the Norman kingdom reflected continuity. Jeremy Johns has demonstrated the break in administrative practice that occurred in the decades between 1111–30, and this gap in the use of Arabic must also have had consequences for cultural production.[38] In this way, the Islamic splendor of the Cappella Palatina in Palermo was not the result of a natural absorption of Aghlabid culture, but a conscious rejection of it in

32. Giglio, *Sicilia bizantina* (as in note 29), 107–11.

33. A. Messina, "Sicilia medievale: I. Le chiese rupestri di Cava d'Ispica (Ragusa); II. Resti di una moschea nell'area dell'*Apollonion* di Siracusa," in *Scavi medievali in Italia* (Rome, 1995), 92–4; G. M. Agnello, "Epigrafi arabiche a Siracusa: Nota bibliografica," *Archivio Storico Siracusano* 5 (1978–79), 222–36; and G. Cultrera, "L'Apollonion-Artemision di Ortigia in Siracusa," *Monumenti Antichi* 41 (1951), 724.

34. See *L'arte siculo-normanna: La cultura islamica nella Sicilia medievale* (Palermo, 2007), 213–5. For a general overview, see F. Ardizzone, "Sicilia: epoca islamica," in *Enciclopedia dell'arte medievale*, 12 vols. (Rome, 1991–2002), X:594–8.

35. Agnello, "Epigrafi arabiche a Siracusa" (as in note 33), 225, Pl. XVI/2.

36. J. Wansbrough, "A Judaeo-Arabic Document from Sicily," *BSAOS* 30 (1967), 305–13. See, also, N. Golb, "A Judaeo-Arabic Court Document of Syracuse, A.D. 1020," *JNES* 32 (1973), 105–23, for the unusual Syracusan tradition of swearing oaths on an open Torah and also reciting the Ten Commandments. The Jewish minority in Syracuse through the Middle Ages, until their expulsion in 1493, is an important, nearly invisible undercurrent in the cultural history of the city and region. See, generally, A. Scandaliato and N. Mulè, *La sinagoga e il bagno rituale degli ebrei di Siracusa* (Florence, 2002).

37. Dainotto, *Europe (in Theory)* (as in note 22).

38. J. Johns, *Arabic Administration in Norman Sicily: The Royal Diwan* (Cambridge, 2002).

favor of more current practices and trends at Fatimid court centers, most importantly at Cairo.[39]

The silences, then, of ninth- to eleventh-century Sicily are both assumed and imposed. They are forced on us by the limited archaeological remains on the island, because of the natural erasures of time. But assumptions are strong, too, because subsequent cultures successfully re-made or suppressed that earlier Muslim voice. The silences, however, are momentous and are only slowly being broken.

The attempt to contextualize Christian art in a Sicily where Christians, Muslims, and Jews worked, lived and practiced their faiths is open to pitfalls, but just the same, it needs to be made in order to reclaim the meaning of monuments otherwise without voice. The Oratory at Syracuse is strikingly elusive on this count, but it needs to be examined in light of issues of community and faith in Sicily, and in view of the consequence of the interaction, positive *and* negative, amongst Christians and Muslims in the central Mediterranean. In the final part of this essay, I should like to argue that the fresco program makes its own case for how "looking beyond" is an especially Hellenic Christian response to pressures from outside their community, both to define their own faith and to withstand the pressures being brought to bear on them from a dominant culture outside. The Forty Martyrs—rewarded by theophany of the Incarnate God and attended by saints who are local and universal—are a vision themselves of how community forms and is formed by its art practices.[40]

Although Syracuse was not the last center to fall to the Muslim armies in Sicily—the northeast region held out until the end of the century—its defeat sent shockwaves through Byzantium. The heroic defense of the siege and the terrible destruction of this wealthy, cultured city made a deep impression on contemporaries. Leo VI (r. 886–912) wrote poems about this tragedy, and theologians attempted to understand how God could have allowed the greatest Greek city of the west, visited and converted by Paul himself, to be overcome by unbelievers. Answers included the divine anger at the sins of his people and for the divisions in his church, such as the rifts caused by the patriarchal disputes between parties of Ignatius (r. 847–58, 867–77) and Photius (r. 858–67, 877–86).[41] Evidently, the fall of the city in 878 was another traumatic proof of the unstoppable expansion of Islam that the ninth century had seen so frequently.

However, the historical picture of Christian life in Muslim Sicily is a combination of accommodation and struggle. Several years after the fall of Syracuse, in 884–5, the inhabitants were able to ransom back prisoners for cash.[42] Only the mention survives, but it does suggest that the city had not been entirely decimated. Its Christian inhabitants had been allowed, apparently, to keep an economy functioning sufficiently well to recover to some degree. Such a reaction on the part of Aghlabid governors would not have been out of character, in any case. Despite the fact that *jihadi* ideology was an important foundation for the military actions of the Aghlabid conquerors,[43] that ideol-

39. Johns, *Arabic Administration in Norman Sicily* (as in note 38), 266–7, and see also W. Tronzo, *The Cultures of his Kingdom: Roger II and the Cappella Palatina in Palermo* (Princeton, 1997).

40. I should like to thank Barry Flood here for allowing me to read passages from his forthcoming book, which greatly helped me in my thinking about this Siracusan situation. See F. B. Flood, *Objects of Translation: Material Culture and Medieval 'Hindu-Muslim' Encounter*, forthcoming from Princeton University Press.

41. See Efthymiades, "Chrétiens et Sarrasins en Italie méridionale et en Asie Mineure" (as in note 16), 593–5; F. Ciccolella, *Cinque poeti bizantini: Anacreontee dal Barberiniano Greco 310* (Alessandria, 2000), XXVIII–XXXIII; *Spicilegium Romanum*, ed. by A. Mai et al., 10 vols. (Rome, 1840; repr. Graz, 1974), IV:XXXIX; B. Lavagnini, "Anacreonte in Sicilia e a Bisanzio," *Diptycha* 1 (1979), 291–9; *Nicholas I Patriarch of Constantinople: Letters* (Corpus fon-

tium historiae byzantinae, Vol. 6), ed. and trans. by R. J. H. Jenkins and L. G. Westerink (Washington, D.C., 1973), 326; Nicetas David Paphlagon (late ninth/early tenth century), *Vita Ignatii*, PG 105:573B; Zuretti, "La espugnaione di Siracusa nell'880" (as in note 34), 1:165–7.

42. See citations in note 19 above.

43. W. Granara, "Sicily," in *Medieval Islamic Civilization: An Encyclopedia*, ed. by J. W. Meri, 2 vols. (New York and London, 2006), II:744–5; *idem*, "Jihad and Cross-Cultural Encounter in Muslim Sicily," *Harvard Middle Eastern and Islamic Review* 3 (1996), 42–61; Y. Lev, "The Fatimids and Byzantium, 10th–12th Centuries," *Graeco-Arabica* 6 (1995), 191–2; and A. Pellitteri, "The Historical-Ideological Framework of Islamic Fatimid Sicily (Fourth/Tenth Century) with Reference to the Works of the Qadi L-Nu'man," *Al-Masaq* 7 (1994), 111–63.

ogy was not a principle guiding their policy towards the *dhimmi* communities, because *jihad* against a *dhimmi*, a protected community, was forbidden. Criticism was directed at them for their slackened sense of purpose for *jihad*,[44] but the Muslim governors made many improvements in the economic functioning of the island. Amari even saw the Aghlabids as liberators from the corruption and parochialism of the Byzantine Empire.[45]

This statement of the benefits of Aghlabid material self-interest does not wish away the instances of injustice and the humiliations of the newly subjected Christians of Sicily generally. As in most *dhimmi* communities elsewhere, Sicilian Christians had to wear identifying clothing, not display any outward and public signs of Christianity, and make degrading concessions to Muslims in many aspects of public life.[46] For example, the practice of neck sealing is attested archaeologically on Sicily in this period, in which lead seals were worn by payers of the poll tax;[47] this practice was probably continued on from late Roman and Byzantine administrators, who had used it for tax purposes, slavery, and executions.[48]

And yet acculturation did occur: for example, the traveler, Ibn Hawqal, who compiled his accounts in the *Sūrat al-Ard* or *The Face of the Earth* in 977, wrote disapprovingly of the accommodations Muslims had made on Sicily to their Christian neighbors. Ibn Hawqal described the phenomenon of intermarriage of Christians and Muslims as common, and he disapprovingly noted the practice of both faiths within the same family—daughters could be Christian like their mothers, but sons had to become Muslim.[49] In economic and political terms, sources speak of the wealth of the Christian community of Sicily, which tried in 1023-4 to buy with a large sum of money the relics of a saint taken from a miraculous shrine near Carthage and being transported to Andalusia by Franks.[50] Likewise, Christians also appear to have been active in the civil service and able to attain high office.[51]

In some ways, the successful integration of Christians into this new Muslim land was a potential threat to self-identity amongst some Christians of the island. *Dhimmitude*, on the positive side, meant more power for self-governance devolving to the different groups within the faiths of the book. And it also meant in the

44. Granara, "Jihad and Cross-Cultural Encounter in Muslim Sicily" (as in note 43), 51. More generally, see A. Borruso, "Some Arab-Muslim Perceptions of Religion and Medieval Culture in Sicily," in *Muslim Perceptions of Other Religions: A Historical Survey*, ed. by J. Wardenburg (New York and Oxford, 1999), 136-42.

45. See Dainotto, *Europe (in Theory)* (as in note 22), 201-2. M. A. Handley, "Disputing the End of North Africa," in *Vandals, Romans and Berbers: New Perspectives in Late Antique North Africa*, ed. by A. H. Merrills (Aldershot, 2004), 291-310, has persuasively argued for a new interpretation of the survivals of Christians in post-conquest North Africa, and this view needs also to be integrated into our understanding of how Christians adapted on Muslim Sicily. One might also cite the recent book by Christopher MacEvitt on Eastern Christians under Latin Christians in the Crusader kingdoms as a useful parallel for the situations Christians faced in Muslim realms; see his *The Crusades and the Christian World of the East: Rough Tolerance* (Philadelphia, 2008). Finally, recent work in the Persian Gulf reveals evidence for flourishing Christian communities after the rise of Islam; see R. A. Carter, "Christianity in the Gulf during the First Centuries of Islam," *Arabian Archaeology and Epigraphy* 19 (2008), 71-108.

46. Efthymiades, "Chrétiens et Sarrasins en Italie méridionale et en Asie Mineure" (as in note 16), 596, and Talbi, *L'émirat aghlabide* (as in note 19), 468.

47. P. Balog, "Dated Aghlabid Lead and Copper Seals from Sicily," *Studi Magrebini* 11 (1979), 125-32.

48. See C. F. Robinson, "Neck-Sealing in Early Islam," *Journal of the Economic and Social History of the Orient* 48 (2005), 401-4, and D. Woods, "St. Maximilian of Tebessa and the *Jizya*," in *Hommages à Carl Deroux. V. Christianisme et Moyen Âge, Néo-latin et survivance de la latinité*, Collection Latomus, Vol. 279, ed. by P. Defosse (Brussels, 2003), 266-76.

49. *Configuration de la Terre (Kitab surat al-Ard)*, trans. by J. H. Kramers and G. Wiet, 2 vols. (Paris-Beirut, 1964), 1:128. On Ibn Hawqal, see W. Granara, "Ibn Hawqal in Sicily," *Alif* 3 (1983), 94-9, and F. Gabrieli, "Ibn Hawqal e gli Arabi di Sicilia," *Rivista degli studi orientali* 36 (1961), 245-53. One can presumably use, in general terms, the conditions available for Christians in North Africa to understand how Christians on Sicily lived; see R. Marston Speight, "The Place of the Christians in Ninth-Century North Africa, According to Muslim Sources," *Islamochristiana* 4(1978):47-65.

50. E. Lévi-Provençal, *La Péninsule Ibérique au Moyen-Age d'après le 'Kitab ar-Rawd al-Mi'târ fi Habar al-Aktâr' d'Ibn 'Abd al-Mun'im al-Himyarî* (Leiden, 1938), 182.

51. H. Bresc and A. Nef, "Les Mozarabes de Sicilie (1100-1300)," in *Cavalieri alla conquista del Sud. Studi sull'Italia normanna in memoria di Léon-Robert Ménager*, ed. by E. Cuozzo and J.-M. Martin (Rome and Bari, 1998), 138-9.

context of Sicily greater unity within the *dhimmis* than was possible for the different Muslim groups that comprised the dominant segment of that society.[52] On the negative side, Greek-speaking Christians went from being the faith of the Empire to one Christian group among several. Evidence exists for a Coptic village outside Palermo and for Christian services in Latin, Greek, and Arabic continuing into the fourteenth century, although Ludolf de Sachsen (ca. 1300–1377/8) also noted in 1330 that the three did not get along.[53] Sicilian Greeks of the eastern seaboard were always seen as being loyal to the Empire, and therefore being a suspect group, and this perception was confirmed by the popular uprising that greeted the ill-fated invasion in 1038 by the Byzantine general George Maniaces.[54] The situation for Greek-speaking Christians on Sicily may have been similar to that faced by Chalcedonian Christians after the invasion of Egypt in the seventh century, when they went from being adherents of the dominant, official religion to being another Christian *dhimmi*—and one not in particular favor with Muslim authorities.[55]

"Looking beyond" in this sense means the possibility of visual art declaring and demonstrating the unique truth of a faith community put in a defensive position by dominant Islams and competitive Christianities.[56] Encroaching, threatening, oppressing, all-too-cooperative, Islam from the ninth to the eleventh centuries was the foil for Greek-speaking Christians in eastern Sicily, but, additionally, one should not discount that other *dhimmis* were permitted in Syracuse. In either case, the Oratory of the Forty Martyrs manifestly worked on a variety of levels to distinguish and preserve the dogma, practices, and history of Greek Christianity. That work did not simply involve a statement of allegiance to Constantinople, for Rome was an important node of this identity, too.[57] But the special past that bound its church to the Holy Land, to Constantinople, and to Rome in a chain of venerable figures of ancient Christianity made Syracusans particularly mindful of the claims they could make to belonging to an exclusive covenant with God.

To be sure, the program at the Oratory is fragmentary and was more elaborate and developed than can be shown in its current state of preservation. But the elements that do survive are sufficiently expressive of their historical context that an argument for their meanings can certainly be developed. The choice to decorate an underground chapel with figures from the local and universal history of Christianity, and with an epiphany validating those figures and their sacrifices, can only be understood in terms of "looking beyond" present pressures and tensions to ultimate arbitration, where God appears in bodily form to make perfectly clear who his favored are and how they are to remain so.

52. Granara, "Jihad and Cross-Cultural Encounter in Muslim Sicily" (as in note 43). Moreover, Aghlabids and Fatimids professed different ideas about the meaning of Islam. For example, the Aghlabids were strongly opposed to the Khāridjites amongst Berbers, and so this diversity of Islam was also a factor in the lack of political and military unity amongst the ruling Muslims of Sicily and Ifrīqiyā.

53. *Ludolphi, rectoris ecclesiæ parochialis in Suchem, De itinere Terræ Sanctæ liber*, ed. by F. Deycks (Stuttgart, 1851), 20. And despite the fact that Muslims were deported from Sicily in the second quarter of the thirteenth century, testimony survives for a mosque again in seventeenth-century Palermo. See A. Fuess, "An Instructive Experience: Fakhr al-Din's Journey to Italy, 1613–18," in *Les européens vus par les libanais à l'époque ottomane*, ed. by B. Heyberger and C.-M. Walbiner (Beirut, 2002), 34. On the expulsion, see J. Taylor, "Muslim-Christian Relations in Medieval Southern Italy," *Muslim World* 97 (2007), 190–99, and *eadem, Muslims in Medieval Italy: The Colony at Lucera* (Lanham, Md., 2003).

54. E. Merendino, "La spedizione di Maniace in Sicilia del *Bios di san Filareto di Calabria*," *Nea Rhome: Rivista di ricerche bizantinische* I (2004), 135–41, and Bresc-Nef, "Les Mozarabes de Sicilie" (as in note 31), 139.

55. Communications between Egyptian Melkites and Sicilian Christians did occur. See Bresc-Nef, "Les Mozarabes de Sicilie" (as in note 31), 136–7.

56. For example, see my "Vision and Community among Christians and Muslims: The Al-Muallaqa Lintel in Its Eighth-Century Context," forthcoming in *Arte medievale* (2007), 73–94.

57. On this relationship, see the divergent arguments of Wickham, *Framing the Early Middle Ages* (as in note 20), 208; S. Pricoco, "Studi recenti su alcuni aspetti e problemi del primo cristianesimo in Sicilia," *Kokalos* 43–44 (1997-98), 813–26; M. van Esbroek, "La contexte politique de la Vie de Pancrace de Tauromenium," in *Sicilia e Italia suburbicaria tra IV e VIII secolo*, ed. by S. Pricoco, F. Rizzo Nervo and T. Sardella (Soveria Manelli, 1991), 185–96; and E. Patlagean, "Les moines grecques d'Italie et l'apo-

The Forty at Syracuse

The choice of the Forty was surely made with real care for maximum communicative potential. The martyrs were extremely popular from the fourth century on, and their popularity was encouraged by powerful homilies written by great churchmen that included Basil of Caesarea (ca. 329–79),[58] Gregory of Nyssa (ca. 335–after 394),[59] Ephrem the Syrian (ca. 306–73),[60] Severus of Antioch (ca. 465–ca. 540),[61] and Romanos the Melodist (*fl.* sixth century).[62] The versions of the deaths of the Forty told by these writers made for a rich, multivalent tradition in which to think about martyrdom and its rewards, and these continued to resonate through the Early Middle Ages long after the Roman State had ceased to be a threat to the faith.[63] In the event, the Forty stood for many aspects of Chris-

tianity, faith, and identity. Since they were understood to have died from entering a freezing cold lake to have and found salvation through that element, their connection with baptism was often cited.[64] No one has proposed baptism underground in Syracuse, and in the absence of pre-Norman structures above ground, one cannot state what the sacramental centers of the monastery of Sta. Lucia were and where they were located. Their appeal as protective saints was also high, and they were often included in amuletic contexts because their powerful names were listed in their own, probably authentic *Testament*.[65] The setting of the Oratory has an obvious connection with death and burial, and, of course, the nearby martyrium of Sta. Lucia and the burials in this complex of catacomb chambers and *loculi* had great power for Christians in this region.[66] In this interpretation, the parousiac element is strongly pronounced here not only to establish the *bona fides* of

logie des thèses pontificales (VIIIᵉ–Xᵉ siècles)," *StMed* 5 (1964), 579–602.

58. Migne PG 31:508–26; *"Let Us Live That We May Live"*: *Greek Homilies on Christians Martyrs from Asia Minor, Palestine and Syria c. A.D. 350–A.D. 450*, trans. by J. Leemans, W. Mayer, P. Allen, and B. Dehandschutter, (London and New York, 2003), 68–76. On the dissemination of this homily into various languages, see P. J. Fedwick, *Bibliotheca Basiliana Universalis: A Study of the Manuscript Tradition, Translations and Editions of the Works of Basil of Caesarea*, 5 vols. in 8 pts. (Turnhout, 1993–2004), II.

59. "On the Forty Martyrs of Sebaste," in *Gregorii Nysseni Sermones Pars II*, Gregorii Nysseni Opera, Vol. 10/1, ed. by O. Lendle (Leiden, 1990), 135–69; trans. by *"Let Us Live That We May Live"* (as in note 58), 93–107.

60. "Encomium in sanctos quadriginate martyres," in *Tou en agiois patros emon Ephraim tou Syrou ta evriskomena panta*, ed. by G. L. Assemani, 6 vols. (Rome, 1743), II:341–56 (not accessible to me).

61. "Les *Homiliae cathedrales* de Sévère d'Antioche. Traduction syriaque de Jacques d'Édesse. Homélies XVIII à XXV," ed. by M. Brière and F. Graffin, *PO* 37,1 (1975), 6–23.

62. *Sancti Romani melodi cantica: cantica genuina*, ed. by P. Maas and C. A. Trypanis (Oxford, 1963), 487–505.

63. See J. Leeman, "'Schoolrooms for Our Souls': The Cult of the Martyrs: Homilies and Visual Representations as a Locus for Religious Education in Late Antiquity," *Pedagogica Historica* 36 (2000), 113–27; P. Maraval, "Les premiers développements du culte des XL Martyrs de Sébastée dans l'Orient byzantin et en Occident," *VetChr* 36 (1999), 193–211; and P. Karlin-Hayter, "*Passio* of the XL Martyrs of Sebasteia: The Greek Tradition: The Earliest Account (*BHG* 1201)," *AB* 109 (1991), 249–304.

64. K. Gulowsen, "Some Iconographic Aspects of the Relationship between Santa Maria Antiqua and the Oratory of the Forty Martyrs," in *Santa Maria Antiqua al Foro Romano cento anni dopo: Atti del colloquio internazionale, Roma, 5–6 maggio 2000*, ed. by J. Osborne, J. Rasmus Brandt, and G. Morganit (Rome, 2004), 187–97.

65. See "Testamentum (BHG 1203)," in *Acta martyrum selecta*, ed. by O. von Gebhardt (Berlin, 1902), 166–70, and *The Acts of the Christian Martyrs*, ed. by H. Musurillo (Oxford, 1972), 357–61 (the latter with text and translation). On prophylaxis, see F. Jourdan, *La tradition des Sept Dormants: une rencontre entre chrétiens et musulmans* (Paris, 2001), 96; D. Hagedorn, "PUG I 41 und die Namen der vierzig Märtyrer von Sebaste," *ZPapyEpig* 55 (1984), 146–53; and Schiemenz, "Wunderkraft gegen kämpfende Widersacher" (as in note 3), 181–2.

66. See S. Piazza, *Pittura rupestre medievale: Lazio e Campania settentrionale (secoli VI–XIII)* (Rome, 2006), 11–25. For another crypt-shrine dedicated to the Forty, see J. Mitchell, "The Archaeology of Pilgrimage in Late Antique Albania: The Basilica of the Forty Martyrs," in *Recent Research on the Late Antique Countryside*, ed. by W. Bowden, L. Lavan, and C. Machado (Leiden-Boston, 2004), 145–86; and W. Bowden and J. Mitchell, "The Church of the Forty Martyrs," *Minerva* 13 (2002), 31–3. Decoration of crypts with theophanies of God, surrounded by angels and saints, is not uncommon in western Europe, as well (as Anne-Marie Bouché brought to my attention). See, for example the eleventh-century painting in R. Favreau, M.-T. Camus, and F. Jeanneau, *Notre-Dame-la-Grande, Poitiers* (Poitiers, 1995), 42–4.

the Forty, but as proleptic theophany when God appears with his host at the final judgment. The jeweled cross, attendant angels, and the Virgin Mary indicate the moment out of time when justice will be effected for those in covenant with the true God.[67] These moments are indicated not only through analogy with the elders of Revelation (4:4), but also through events in the hagiographic tradition, when the sky opens to reveal the celebratory host and it is possible to look beyond the passing pain of their death to the joy and festivities it occasioned in heaven and on earth. The Forty rushed to their death like victorious athletes, with no hesitation or doubt—except for the fortieth who retreated, only to be replaced by the bath attendant.[68] The cosmic rightness of the number forty was remarked on by writers, and the necessity of the full complement for the divine economy made this exchange inevitable.

In a context where Islam is pressing or dominant, the representation of the Forty Martyrs being rewarded with crowns and receiving a personal welcome into paradise by Christ and court has particular meanings. Beyond the many associations already acquired in devotion to the Forty—not to say that those associations are not present, too—the martyrs are paradigmatic figures of righteous resistance and self-sacrifice for proper faith. Authority is highly suspect in the homilies on the Forty, in which the Devil and general are conflated, and, moreover, in a period when Islam

may not have turned out to be such a terrible neighbor, how much more energetically does the Church have to assert its cause? Reading the program as a self-evident document of communal resistance, in which all constituents were active and in agreement, is not necessarily the correct way to proceed to interpret its meanings. Where cultural and religious debates are raised, and positions asserted, a text or monument cannot be approached simply as a reflective mirror of opposition within an entire community.[69] In that sense, then, the "looking beyond" may well be to provide a vision of eternal promises over present accommodations.[70] Visions remind viewers of what they might otherwise neglect or forget, in this case, their Christian duty to remember *jihad* directed against them and to stay strong in their faith.

In a period in which conflict with Islam in the eastern Mediterranean was ongoing and volatile, the Forty provided models for resistance and sacrifice. Their commemoration in Syracuse, in other words, was invested not only in the historical glories of the Christian past, but also in its contemporary relevance for Christians caught in impossible situations where their lives and souls were at stake. The most dramatic instance of the Forty as exemplars of neo-Christian martyrs occurred in the hagiography of the Forty-Two Martyrs of Amorium, an important city on the steppes of western Anatolia that was taken by Muslim forces in

67. The cross is also a powerful sign of group cohesion and faith, in the face of its disturbing associations with a demeaned God. See M. N. Swanson, "The Cross of Christ in the Earliest Arabic Melkite Apologies," in *Christian Arabic Apologetics during the Abbasid Period (750–1258)*, ed. by S. K. Samir and J. S. Nielsen (Leiden, 1994), 115–45. The cross in the heavens is also a sign of the end of time, and apocalyptic texts were being produced in this period in Sicily. See P. J. Alexander, *The Byzantine Apocalyptic Tradition*, ed. by D. deF. Abrahamse (Berkeley, 1985), 61–95, 98–101, and 115–6. On apocalypse more generally, see now J. Baun, *Tales from Another Byzantium: Celestial Journey and Local Community in the Medieval Greek Apocrypha* (Cambridge, 2007).

68. See F. Vinel, "Sainteté anonyme, sainteté collective? Les quarante martyrs de Sébastée dans quelques textes du iv^e siècle," in *Du héros païen au saint chrétien*, *Actes du colloque organisé par le Centre d'Analyse des Rhétoriques Religieuses de l'Antiquité (C.A.R.R.A.), Strasbourg, 1er–2 décembre 1995*, ed. by G. Freyburger and L. Pernot (Paris, 1997), 125–31.

69. See A. Shboul and A. Walmsley, "Identity and Self-Image in Syria-Palestine in the Transition from Byzantine to Early Islamic Rule: Arab Christians and Muslims," *Mediterranean Archaeology* 11 (1998), 255–87.

70. The Forty were also available to Muslims, it would seem. See the mention of a mosque and dervish monastery at the site of a shrine visited by Greeks and Armenians at Sarim in H. Grégoire, "Rapport sur un voyage dans le Pont et en Cappadoce," *BCH* 33 (1909), 25–6. See the mention, also, of a fresco of the Forty in the Melkite monastery of Al-Kusair, church of S. Sabas, near Cairo, in B. T. A. Evetts and A. J. Butler, *The Churches and Monasteries of Egypt Attributed to Abu Sâlih, the Armenian* (Oxford, 1895; repr. London, 1969), 150–1, and J. Simon, "Le culte des XL Martyrs dan l'Egypte chrétienne," *Orientalia* 3 (1934), 174–6. On this question more broadly, see A. Cuffel, "From Practice to Polemic: Shared Saints and Festivals as 'Women's Religion' in the Medieval Mediterranean," *BSOAS* 68 (2005), 401–19.

838.[71] The hagiography was written by a monk, Evo-
dus (d. 883), who claimed to be an eyewitness to the
events described in his account. The tenor of the text
is remarkably factual, but also included liturgical in-
vocations of the saints at the conclusion, before which
Evodus calls them worthy rivals of the Forty Mar-
tyrs of Sebaste.[72] The text is an intelligent account,
and Evodus evidently read other texts of Muslim-
Christian debates, probably the most important
being the anti-Muslim texts of John of Damascus (ca.
675–ca. 750) and Nicetas of Byzantium (active sec-
ond half of the ninth century)[73] The Forty-Two were
not an invention for polemical purposes, however. Al-
though they did serve that end, they were canonized
and entered the liturgical calendar for annual celebra-
tion on 6 March (the Forty's feast falls on the 9th).

When the city of Amorium fell in 838, the loss for
the Byzantine cause was acute, because it was a major
regional power in the defense system of Anatolia. The
long captivity of a group of well-born men, which ap-
pears to have been about seven years in duration, gave
them plenty of opportunity for the testing of their faith;
indeed, the length of imprisonment allowed them to
love life less and their souls more.[74] Their souls be-
came the subject of great struggle for their captors, and
in this way, despite their many deprivations, the tables
were turned: the prisoners gained power through their
disregard for their mortal lives. The disregard was not
silent, however, but was expressed in extensively re-
ported debates in which the prisoners asserted and rea-
soned their stronger truths.

The debates that took place in the text amongst
the Forty-Two and their Muslim captors, as well as
amongst converted Christians in that camp, were not
simplistic recapitulations of tired tropes.[75] Rather,
Evodus reported the exchanges with unusual restraint,
and he stands out for that reason among the many
overheated theologians and historians in this genre
of polemical literature. He does, however, betray his
strong certainty of the rightness of his cause, and one
cannot imagine this text being read by anyone but
Greek Christians.

The arguments given are often carefully reasoned,
along the lines of the philosophical framework used
by Nicetas of Byzantium. Reason enters into the dis-
course, but faith has to carry some of the argument
just the same. As in any place where Islam was vic-
torious, Christians questioned the cause of their pun-
ishment by God. In the course of the hagiography,
the Muslim captors naturally argue for their new cov-
enant with God as being proven through their vic-
tories. And Evodus recognizes the tip in the balance
as when the frontier at Syria was breached and Mus-
lims made manifest the anger of God—and worse is
to come, he says.[76] The Forty-Two take the histor-
ical view, adducing such ancient civilizations as the
Persians and Greeks, but God, they state, corrects his
own.[77] The argument is also advanced that Muham-
mad was the prophet promised by God and scripture,
and in an attempt at *rapprochement*, Muhammad is said
to be the prophet sent to complete the promises made
by Jesus. Notwithstanding, the Forty-Two deny any

71. Texts of the hagiography in V. Vasil'evskij and P. Nikitin,
"Skazanija o 42 amorijskich mucenikach," *Mémoires de l'Académie
impériale des sciences de Saint-Pétersbourg. Classe historico-philolo-
gique*, ser. 8, 7/2 (1905), 61–78, and *AASS* March 1, 880–86. See
also S. Efthymiades, "Le miracle et les saints durant et après le se-
cond iconoclasme," in *Monastères, images, pouvoirs et société à By-
zance. Nouvelles approches du monachisme byzantin (XXᵉ Congrès in-
ternational des Études Byzantines, Paris, 2001)*, ed. by M. Kaplan
(Paris, 2006), 154; *idem*, "Chrétiens et Sarrasins en Italie méridio-
nale et en Asie Mineure (IXᵉ–Xᵉ siècle)" (as in note 16), 613–4;
A. Kolia-Dermitzaki, "The Execution of the Forty-Two Martyrs
of Amorion: Proposing an Interpretation," *Al-Masaq* 14 (2002),
141–62; A.-T. Khoury, *Les théologiens byzantins et l'Islam: textes et
auteurs VIIᵉ–XIIIᵉ siècles* (Louvain and Paris, 1969), 163–79; and
Vasiliev, *Byz. Arabes*, I:144–77.

72. "Skazanija" (as in note 71), 76 (40), and *AASS* March 1, 892.
73. For John, see now S. H. Griffith, *The Church in the Shadow of
the Mosque: Christians and Muslims in the World of Islam* (Princeton
and Oxford, 2008), 40–2; and for Nicetas, see his *Refutatio Moha-
medis*, Migne PG 105:669–842; and Khoury, *Les théologiens by-
zantins et l'Islam* (as in note 71), 110–62.
74. "Skazanija" (as in note 71), 71 (27), and *AASS* March 1, 883.
75. See R. G. Hoyland, *Seeing Islam as Others Saw It: A Sur-
vey and Evaluation of Christian, Jewish and Zoroastrian Writings on
Early Islam*, (Princeton, 1997).
76. "Skazanija" (as in note 71), 63 (5–6), and *AASS* March 1,
880.
77. "Skazanija" (as in note 71), 61–2, 70–1 (1–2, 26), and *AASS*
March 1, 880, 882–3.

connection between the two, and, beyond the self-evident divinity of Christ, they contradict any claim that Muslims make to scripture foretelling Muhammad or the third covenant Islam claims.[78] Muslim proof-texts like Isaiah 9:13–4 are simply false, they say, and, showing the real meaning of the passages, the Forty-Two reveal the misinterpretations of Scripture that have led Muslims to this fundamental error of belief.[79] The moral turpitude of Muslims is also asserted by the Forty-Two, and their Muslim interlocutors obligingly agree that Islam is in fact based on polygamy, debauchery, and night-long feasts.[80] For all these reasons, the Christian captives hold fast to their faith, even in the face of mild coercion on the part of converted Christians and Muslims, who advise superficial adherence to the newer faith. Even on the point of their execution, they are offered a chance to pray with the governor as sufficient proof of recognizing Islam. Striking in stories like these is the degree to which Christian martyrs had to *insist* on martyrdom.[81] Accommodations were offered, compromises devised, but in the face of Islam, such men clung to their conviction of final rewards. In the end, because they were not iconoclasts, because they fought for their country, and because they died as witnesses to Christ, the Forty-Two Martyrs of Amorium were blessed, Evodus wrote.[82] Like other ninth-century group martyrs, such as the victims of the war of 811 and the prisoners in Thrace in 813, they stood for resistance to apostasy and death for faith.[83]

Despite the crisis the capture of Syracuse in 878 provoked in Byzantium and the sorrows described by the

monk Theodosius in his eyewitness account,[84] nothing like the hagiography of the Forty-Two of Amorium was produced for Syracuse. And yet a similar structure of dialogue is found in hagiographies of the ninth and tenth centuries that describe interactions between Muslims and Christians in Sicily and in southern Italy. Having been taken prisoner more than once himself, Elias the Younger intervened on behalf of Christian families with relatives who needed rescuing from Muslim captors, but he also delivered Muslims from illness, even while engaging with them in high-level disputes about theology.[85] For example, Elias claimed that Islam had no witness in the prophets, had no moral basis, and was, in fact, a mixed set of heresies. His defense of Christianity was direct and strong, "Believing in the Father, in the Son and in the Holy Spirit, not glorifying three divinities, or three natures, or three great or minor deities … but we believe in a single principle of a single divinity, a single majesty, a single power, a single force, a single action, a single counsel, a single will, a single authority, a single lordship of a unique essence and nature in three persons and substance."[86] Elias' understanding of and opposition to Islam were strong, it would seem, and his relationship to the people of that faith was unusually complicated.

It is again worth recalling that not only were prisoners ransomed within several years, but also the bishop and Theodosius were taken to Palermo in 878, where they engaged in a brief religious dialogue with the emir. The assault on a city after a long siege can

78. "Skazanija" (as in note 71), 69 (22–23), and *AASS* March 1, 882.

79. "Skazanija" (as in note 71), 70 (24), and *AASS* March 1, 882.

80. "Skazanija" (as in note 71), 70 (25), and *AASS* March 1, 882.

81. See J. R. Zaborowski, *The Coptic Martyrdom of John of Phanijoit: Assimilation and Conversion to Islam in Thirteenth-Century Egypt* (Leiden and Boston, 2005).

82. "Skazanija" (as in note 71), 76 (39), and *AASS* March 1, 884.

83. *Sancti patris nostri et confessoris Theodori Studitis praepositi Parva catechesis*, ed. E. Auvray (Paris, 1891), 220–4; Theodore Stoudite, *Petites catéchèses*, trans. by A.-M. Mohr (Paris, 1993), 145–7; *Synax.CP* 837–8 (23 July), 846–8 (26 July), 414–6 (22 January); *Menologium of Basil II*, Migne PG 117:276D–277A (22 Jan-

uary); and I. Dujcev, "La chronique byzantine de l'an 811," *TM* 1 (1965), 216.81–6.

84. Text in C. O. Zuretti, "La espugnaione di Siracusa nell'880: Testo greco della lettera del Monaco Teodosio," in *Centenario della nascita di Michele Amari* (Palermo, 1910), 1:165–7. See also Vasiliev, *Byz. Arabes*, 11/1:70–9, and B. Lavagnini, "Siracusa occupata dagli Arabi e l'epistola di Teodosio Monaco," *Byzantion* 29–30 (1959–60), 267–79.

85. For Muslim-Christian relations as revealed in the hagiography, see von Falkenhausen, "La vita di S. Nilo come fonte storica per la Calabria bizantina" (as in note 17), 290–5.

86. *Vita di sant'Elia il Giovane*, 32–6 (23–4). See Efthymiades, "Chrétiens et Sarrasins en Italie méridionale et en Asie Mineure (ixᵉ–xⁱᵉ siècle)" (as in note 16), 600–2.

be a terrifying occurrence, and Theodosius vividly evoked it, but apparently recovery was not so arduous. Perhaps the integration of the southeastern region of Sicily into the common market of the *ummah*, most immediately the Maghrib and Egypt, provided significant benefit to Muslims, Jews, and Christians alike.

The Oratory of the Forty Martyrs at Syracuse does not arise directly out of a text, like the account of the beliefs and deaths of the Forty-Two of Amorium, but it does belong to this milieu in which Greek-speaking Christians were all too conscious of the upheavals brought about by Islam over the Mediterranean. And while arms had been proved ineffectual too often already, arguments were still needed whether Muslims were pounding on the city gate or building a mosque within the vanquished city. Perhaps the need was more compelling in the latter instance, for Islam as Other is often easier to fight than Islam as neighbor. Those arguments advanced by the Forty-Two, for example, were necessary for a Christian sense of rightness of faith, which perhaps wavered for not only some of the companions of the Forty-Two, but also of the Forty—that bath attendant took the place of the cowardly fortieth, but the average Christian's fear of persecution and of death for faith was surely a great danger for the church. Conversion was a fact of life in Muslim Sicily, for economic and social reasons, and steadfastness in faith was a strong mission of a church in a defensive position.[87]

The situation of intermarriage described in a critical fashion by Ibn Hawqal could not have been any more palatable to the Church than it was to him. And the moral struggle proposed in the hagiography of the Forty-Two must have been a necessary argument in situations where Muslims and Christians were living together. The Other is always morally inferior, after all. The feasting and incontinence of Muslims is well attested as a trope of Christian polemical literature, and the martyrs were exemplars of godly virtue in the face of such temptations. The Forty Martyrs, in an effective inversion, discarded their clothes with joy, just as if they were shedding sin.[88] Such assertions of Christian modesty and moral correctness as one finds in the hagiographies and in the Oratory itself—*and* their ultimate rewards—were entirely natural to contexts of intermarriage and conversion. These were realities faced by Christians at all times, and not just in Sicily. For example, the mid-ninth-century martyrdom of St. Michael the Sabaite had the saint censure Islam for its sexual promiscuity, and more importantly for its use of that openness to entice converts.[89] Likewise, a Coptic hagiography told the story of John of Phanijoit, who forsook Christianity for the love of a Muslim woman, recanted and insisted on martyrdom to expunge that sin.[90] Faith is never an impediment to love, but that is not to say that communities tolerate these defections well, and Muslim and Christian hagiographies and art worked to convince that earthly love is no recompense for the reward of the love of the true God.

This conviction, then, is the persuasive lever of the Oratory. The sky opens to reveal that vision of God beyond, that *particular* version of the incarnate God beyond and of the joy of heaven at the Forty's sacrifice. Here, underground, community sees its rewards for cohesion. Just as the Forty stayed together, so a Christian community must stay united. The composition of this community is changeable. The community comprises the living and the dead, and the catacombs nearby naturally assert the wait for that joyous appearance granted the Forty. It comprises the monastic community, and these martyrs were also the community of monks harnessed to a common salvation-making

87. See V. Von Falkenhausen, "La presenza dei greci nella Sicilia normanna: L'apporto della documentazione archivistica in lingua greca," in *Byzantino-Sicula IV: Atti del I congresso internazionale di archeologia della Sicilia bizantina (Corelone, 28 luglio – 2 agosto 1998*), ed. by R. M. Carra Bonacasa (Palermo, 2002), 31–72, and J. Johns, "The Greek Church and the Conversion of Muslims in Norman Sicily?" in *Bosphorus: Essays in Honour of Cyril Mango* (*ByzF*, vol. 21), ed. by S. Efthymiadis, C. Rapp and D. Tsougarakis (Amsterdam, 1995), 133–57.

88. For example, see Basil at Migne PG 31:5167A.

89. S. H. Griffith, "Michael, the Martyr and Monk of Mar Sabas Monastery, at the Court of the Caliph 'Abd al-Malik: Christian Apologetics and Martyrology in the Early Islamic Period," *Aram* 6 (1994), 120–2 and 130–5.

90. Zaborowski, *The Coptic Martyrdom of John of Phanijoit* (as in note 31), 15–24.

yoke. Theodore the Stoudite (759–826) made a point of describing the ninth-century martyrs as parallels to the monk as martyr; each sacrifices an earthly life for eternal reward.[91] The Forty, moreover, can stand for the corporate nature of the Church itself, the institution founded by Christ and loyally supported by his followers in the face of all adversities. Ultimately, the vision beyond here makes explicit the triumphalist nature of the argument declared in the Oratory.[92] Gregory of Tours (ca. 538–94) reported that in 575 Persians had tried to burn the shrine of the Forty and the town of Sebaste, but had failed and been forced to retreat.[93] Likewise, the hagiography of St. Vitalus of Sicily (d. 990) described wondrous events during a Muslim attack in which the saint made the sign of the cross and the enemy fell at his feet; the Muslim said the cross emitted flames and stood to the heavens, and an angel came to bless the saint.[94] Deliverance is at hand, therefore, because like the cross, the Forty always protect, and they always endure. Just as God, suspended in the sky with his court and descending as his sign of salvation, ratifies their work and reward, so he reveals it to his local church, longstanding and lasting till eternity.

Christian Revelation Seen and Written

All the subsidiary characters and scenes from the Oratory can no longer be known, but the ones that do survive provide moral support, one might say, to the Forty above and nearby. The writing figure in the northwest corner of the vault is highly unusual and, without inscription, unidentifiable with certainty.[95] Various possibilities have been raised: natural candidates are Gregory of Nyssa, Basil of Caesarea, or Romanos the Melodist, who wrote well-known works on the popular martyrs, but the writer could also be John writing Revelation, or Paul, who is absent at least from the existing passages of painting, or the prophet Isaiah, who was often a contentious figure in Christian-Muslim polemics. Orsi also offered Ezra as a possibility and as a later parallel to the figure in the Codex Amiatinus (Florence, Biblioteca Medicea Laurenziana, fol. 4/v recto); that identification makes possible an understanding of his writing as a restoration of the Temple—that is to the say, the Christian Church here—through study of sacred writings and work as scribe.[96] And like other early medieval monuments, depicting literary activity of holy figures reveals an important means for receiving the word of God. Such activities continued into the Early Middle Ages, too, of course, and one telling example is the hagiography of an Early Christian martyr, Maximilian of Tebessa, that purported to be an original of that early period, but was in fact written at Carthage in the eight or ninth century.[97] The writer was asserting the inequities of Muslim rule through the lens of Christian martyrdom, and the results of his scribal falsifications mediated his own and his community's hope for God's intervention.

The movement from God to writer on the vault of the Oratory is vital, but the direction of movement

91. *Sancti patris nostri et confessoris Theodori Studitis praepositi Parva catechesis* (as in note 83), 35–9, 124–6, 220–4; *Petites catecheses* (as in note 83), 35–7, 88–9, 145–7 (the last on the Bulgarian martyrs).

92. For example, on the church of the Grand Pigeonnier, Çavusin, see C. Jolivet-Lévy, "Culte et iconographie de l'archange Michel dans l'Orient byzantin: le témoignage de quelques monuments de Cappadoce," *Les Cahiers de Saint-Michel de Cuxa* 28 (1997), 187–98 [= *eadem*, Études cappadociennes (London, 2002), 413–46]. Here, the Forty are arrayed in the lower register of the northeast corner and are processing behind imperial figures, including Nicephorus Phocas (r. 963–9). The presence of his portrait dates the church.

93. *Historia*, x.24, *MGH, SRM*, I.1, ed. by B. Krusch and W. Levison, 515–6.

94. *AASS* March 11, 31.

95. Inscriptions would have provided data for linguistic and cultural filiation in the program, too. On a case where such data is available—and the implications explored, see S. J. Lucey, "Art and Socio-Cultural Identity in Early Medieval Rome: The Patrons of Santa Maria Antiqua," in *Roma felix: Formation and Reflections of Medieval Rome*, ed. by É. Ó Carragáin and C. L. Neuman de Vegvar (Aldershot, 2007), 139–58.

96. C. Chazelle "'Romanness' in Early Medieval Culture," in *Paradigms and Methods in Early Medieval Studies*, ed. by C. Chazelle and F. Lifshitz (New York, 2007), 89.

97. See Woods, "St. Maximilian of Tebessa and the *Jizya*" (as in note 48).

is not entirely clear. Is God giving inspiration to the writer by his appearance in the sky, or is the writing figure bringing about this vision through his scribal activity? Perhaps it is the reciprocity of the movement that gives this vision its special emphasis on the nature of revelation.[98] Mediation is clearly essential, and—with the authority that divine sanction of vision provides—the writer here brings this historical reality of the Forty into view and the prolepticizing joy of the Incarnate God in glory. The role of the writer is ambivalent, according to the state of the painting. He resembles a traditional writing evangelist, but he is raising a hand from his writing desk to address the viewer or to indicate that the vision emanating from his pen projects further into the room. Following his lead, the spectator proceeds deeper into the space and is umbrellaed by the vision above.[99] The stable witnesses on the sidewall only intensify the sense of the dramatic encounter above. That drama is a composite of the written tradition on the Forty, and it comes as well from the depicted writer whose authority allows him to guide the viewer into a direct encounter, a vision no one until now had quite seen, and surely never in this company. Light in this space can only have intensified this canopy of heaven, catching on the jewels of the cross, the bare torsos of the Martyrs, the face

of God at the apex. The Forty sometimes appeared in gleaming dress; here their flesh is the pale reflecting field.[100] The vision is emanating from the single figure in the corner, but it is also a representation, and that figure seems to recognize it as such, too, if one reads his gesture as declarative.[101]

The nature of this represented vision needs also to be stressed in this context, too, for it is the medium that is as significant as the message. In contrast to the strong linguistic bias of Islamic revelation, *depicting* a writer—one of a series of men informed by God—carried great persuasive power.[102] The history of figuration in Christianity is based on the incarnation of God, and, after the ninth century, no right-thinking Greek Christian could avoid the seventh ecumenical council at Nicaea in 787. The qualifications of the martyrs of Amorium were, of course, their deaths, their status as warriors for their fatherland, *and* that they did not profess iconoclasm. That last is crucial for understanding the reason for this fresco of the Forty in Syracuse, for this ability to show God and his creation was a characteristic that absolutely defined community in the Middle Ages. Knowing and depicting the face of God was a singular claim Christians made and could defend within the terms of their own revelation.[103] And the Forty, through the homily of Basil of Caesarea

98. D. Krueger, *Writing and Holiness: The Practice of Authorship in the Early Christian East* (Philadelphia, 2004), 59–60, "These themes of textual mediation downward from the realm of God to the realm of humanity complement the themes of sacrifice through which humanity renders its offerings upward to God."

99. Useful studies of spatial cognition are D. L. Chattford Clark, "Viewing the Liturgy: A Space Syntax Study of Changing Visibility and Accessibility in the Development of the Byzantine Church in Jordan," *World Archaeology* 39 (2006), 84–104, and G. Stavroulaki and J. Peponis, "Seen in a Different Light: Icons in Byzantine Museums and Churches," in *Space Syntax: 5th International Symposium* (Amsterdam, 2005), 251–63.

100. Sozom. *HE*, IX.2.7; *Kirchengeschichte*, ed. by J. Bidez, Berlin, 1960, 393. See, also, P. Maraval, "Songes et visions comme mode d'invention des reliques," *Augustinianum* 29 (1988), 592, and the hagiographic text in Zaborowski, *The Coptic Martyrdom of John of Phanijoit* (as in note 31), 119–21, at which both Christians and Muslim are said to have experienced visions of light over the body of John the martyr.

101. V. I. Stiochita, *Visionary Experience in the Golden Age of Spanish Art*, trans. by A.-M. Glasheen (London, 1995), 115, "Sight (vision) interrupts—and subsequently provokes—the representation."

102. See J. Wansbrough, *The Sectarian Milieu: Content and Composition of Islamic Salvation History* (Oxford, 1978; repr. New York, 2006), 141. This use of figuration as a weapon against Islamic beliefs was not always exclusively Christian, if the persuasive argument of Robert Hoyland about late seventh-century depictions of Muhammad on coins is taken into account. See his "Writing the Biography of the Prophet Muhammad: Problems and Solutions," *History Compass* 5 (2007), 593–6.

103. For example, see *A Treatise on the Veneration of the Holy Icons Written in Arabic by Theodore Abu Qurrah, Biship of Harran* (c. 755–c. 830 A.D.), trans. by S. H. Griffith (Louvain, 1997), 60–1 (XI). On theophany and Iconoclasm, see W. T. Woodfin, "A Majestas Domini in Middle-Byzantine Constantinople," *CahArch* 51 (2003–04), 45–53, and my "Angelophany and Art after Iconoclasm," *DChAE* 26 (2005), 339–44.

that was quoted by the iconophile Germanus, became a trope for the power of vision to reveal Christian truths.[104] If a defining act of Christianity was martyrdom, when one could declare—as the Forty did—I am a Christian,[105] then a defining act open to all Christians was looking, but "looking beyond" to what God really looked like and to what he will look like when he comes to make his own know him face-to-face.[106]

The character and expression of salvation history were both essential concerns in a world in which strongly competing models were available. The choice of the Forty was important for recalling great Christian centers of the Mediterranean, as did the figures on the side wall: Rome, Constantinople, the Holy Land. And the modality of showing these great figures of the past was essentially Christian, too: face-to-face. The mode of revelation shown was not the scribal reception of Muslim history, but the active creation of holiness through the writing figure and through the epiphany generated through that writing of sacrificial history.[107] In the Oratory, the message was meant to be a comfort, a warning, and a benign lesson in the plan God devised for his own. It was underground, hidden, suppressed, but gloriously available to those with the faith to see.[108]

104. Germanus, *Epistola* IV, Migne PG 98:172CD. See Maguire, *Art & Eloquence*, 8–9.

105. See D. Boyarin, *Dying for God: Martyrdom and the Making of Christianity and Judaism* (Stanford, 1999), 95–6. For the other side, see now the discussion by D. Cook, *Martyrdom in Islam* (Cambridge, 2007).

106. Another defining trait may be the Forty's painless suffering. See G. Kalas, "Topographical Transitions: The Oratory of the Forty Martyrs and Exhibition Strategies in the Early Medieval Roman Forum," in *Santa Maria Antiqua al Foro Romano cento anni dopo: Atti del colloquio internazaionale, Roma, 5–6 maggio 2000*, ed. by J. Osborne, J. Rasmus Brandt, and G. Morganit (Rome, 2004), 198–211.

107. See Wansbrough, *The Sectarian Milieu* (as in note 102), 44–5, and *idem, Quranic Studies: Sources and Methods of Scriptural Interpretation* (Oxford, 1977; repr. Amherst, N.Y., 2004), 33–8.

108. See J. C. Scott, *Domination and the Arts of Resistance: Hidden Transcripts* (New Haven and London, 1990), 111, "By definition, we have made the public transcript of domination ontologically prior to the hidden, offstage transcript. The result of proceeding in this fashion is to emphasize the reflexive quality of the hidden transcript as a labor of neutralization and negation. If we think, in schematic terms, of public transcript as comprising a domain of material appropriation (for example, of labor, grain, taxes), a domain of public mastery and subordination (for example, ritual of hierarchy, deference, speech, punishment, and humiliation), and, finally, a domain of ideological justification for inequalities (for example, the public religious and political world view of the dominant elite), then we may perhaps think of the public transcript. It is, if you will, the portion of an acrimonious dialogue that domination has driven off the immediate stage."

NINO ZCHOMELIDSE

Deus – Homo – Imago: Representing the Divine in the Twelfth Century

AT FIRST GLANCE, the program of the tympanum of the center portal of the north façade of San Miguel in Estella in Spanish Navarre, made in the mid-twelfth century, appears to be rather conventional (Fig. 1).[1] A cross-nimbed Christ is seated on a *faldistorium*, his right hand raised in blessing, while his left hand holds a book with the Chi-Rho monogram, pendant Alpha and Omega, and an S entwined around the lower part of the Rho, towards the viewer. Encompassed by a deeply carved quatrefoil, the figure of Christ is separated from two pairs of the apocalyptic beasts on either side.

Textual sources for the *Maiestas Domini* are the Old Testament visions of Ezechiel 1:4–6,[2] and Isaiah 6:1–4,[3] which describe the four beasts, God enthroned on the heavenly four-wheeled wagon, the rainbow, seraphim, etc., and John's vision from his Book of Revelation 4:1–9, where he sees God on the heavenly throne, surrounded by the four beasts and the elders.

Contemporary examples for this Spanish *Maiestas Domini*—also found on tympana, as in St-Pierre in Moissac (1115–1135) and in the central portal of the west façade of the cathedral in Chartres (1144–50)—are in keeping with the biblical texts and show the enthroned Christ with the four beasts (Fig. 2). They follow an iconographic tradition that has its origins in monumental apse decoration, such as in the Hosios David monastery in Thessaloniki,[4] which dates to late fifth or early sixth century and in Sta. Pudenziana in Rome,[5] dating around 400 (Fig. 3). This iconography became a standard frontispiece composition in early medieval book illumination, for example in the magnificent bibles made in Tours, in which the four beasts and the evangelists were organized inside and outside a lozenge-shaped form (Fig. 4).[6]

The Estella tympanum, however, additionally features the figures of Mary and John the Evangelist at the far left and right ends, effectively framing the com-

1. For the parish church San Miguel in Estella and its sculptural program, see the recent monograph by Claudia Rückert, *Die Bauskulptur von San Miguel in Estella (Navarra): Königliche Selbstdarstellung zwischen Innovation und Tradition im 12. Jahrhundert* (Mainz: Philip von Zabern, 2004) with further references. The north façade of the church was oriented to the market square of the medieval town and thus functioned as the main entrance to the church.

2. Behold, a great cloud with fire flashing forth continually and in its midst something like glowing metal. Within it there were figures resembling four living beings. They had human form. Each of them had four faces and four wings (Ezechiel 1:4–6.)

3. In the year of King Uzziah's death I saw the Lord sitting on a throne, lofty and exalted, with the train of His robe filling the temple. Seraphim stood above Him, each having six wings: with two he covered his face, and with two he covered his feet, and with two he flew. And one called out to another and said, "Holy, Holy, Holy, is the LORD of hosts, The whole earth is full of His glory." And the foundations of the thresholds trembled at the voice of him who called out, while the temple was filling with smoke. (Isaiah 6:1–4,).

4. Friedrich Gerke, "Il mosaico absidale di Hosios David di

Salonicco," in *Corso di Cultura sull'Arte Ravennate e Bizantina* XI, Università degli studi di Bologna, Istituto di Antichità Ravennati e Bizantine (Ravenna: Edizioni Dante, 1964) 179–199; Rotraut Wisskirchen, "Zum Apsismosaik der Kirche Hosios David, Thessalonike," in *Stimuli: Exegese und ihre Hermeneutik in Antike und Christentum*, Jahrbuch für Antike und Christentum: Ergänzungsband, 23, ed. by Georg Schöllgen and Clemens Scholten (Münster: Aschendorff, 1996) 582–594.

5. Vitaliano Tiberia, *Il mosaico di Santa Pudenziana a Roma: il restauro*, Ministero per i Beni e le Attività Culturali, Soprintendenza Speciale per il Polo Museale Romano (Todi: Ediart, 2003), 22–86; Maria Andaloro, *L'orizzonte tardoantico e le nuove immagini 312–468; La Pittura Medievale a Roma 312–1431*, ed. by Maria Andaloro and Serena Romano, Vol. 1 (Milan: Editoriale Jaca Book, 2006) 114–124, see p. 124 for further references.

6. For the iconography of the Maiestas Domini, see Søren Kaspersen, "Majestas Domini–Regnum et Sacerdotium: Zu Entstehung und Leben des Motivs bis zum Investiturstreit," *Hafnia* 8 (1981), 83–146, and more recently Anne-Orange Poilpré, *"Maiestas Domini" Une image de l'Église en Occident Vᵉ – Iˣᵉ siècle* (Paris,

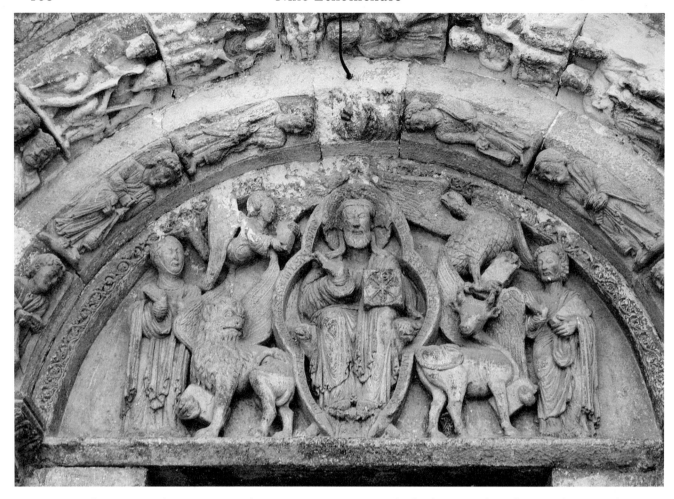

FIG. 1. Estella, San Miguel, Tympanum with *Maiestas Domini*, Mary and John the Evangelist (photo: Colum Hourihane).

position—and this constitutes a rather unconventional treatment of the theme.[7] These figures, through their gestures of intercession, form a variation of the Byzantine *Deësis* that can be traced to the context of the Last Judgment. A *Deësis* icon of the eleventh century from the Monastery of St. Catharine on Mt. Sinai and a western variation of this theme in a Last Judgment tympanum from the central portal of the south transept of Chartres cathedral dating to the first quarter of the thirteenth century illustrate this point (Figs. 5, 6).

In the medieval West, this replacement of John the Baptist with John the Evangelist is a rather common phenomenon. Mary and John the Evangelist, traditionally depicted flanking a cross, refer to the passion and death of Christ and thus establish a connection between the Passion and the End of Time that defines the Estella tympanum within the framework of salvation.

Moreover, an inscription incised in the frame of the quatrefoil comments on the relationship of this image to the salvation: "It is neither God nor Man who is

Editions du Cerf, 2005), and recently Éliane Vergnolle, "'Maiestas Domini' Portals of the Twelfth Century," in *Romanesque Art and Thought in the Twelfth Eentury: Essays in Honor of Walter Cahn*, ed. by Colum Hourihane (Princeton, Index of Christian Art, 2008) 179–199.

7. Rückert recognizes this iconographic particularity and con-

nect it with other examples, as in Santa Maria Magdalena in Tudela and in San Esteban in Sos del Rey Católico (Aragón). The additional figures in these examples are not Mary and John, but two female figures in Tudela and several angels in Sos del Rey Católico, see Rückert, *Estella* (as in note 1), 53–55.

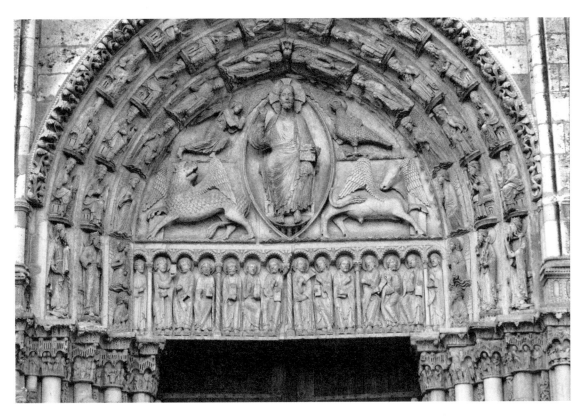

FIG. 2. Chartres Cathedral, West façade, central portal, Tympanum with *Maiestas Domini* (courtesy Saskia Ltd., © Dr. Ron Wiedenhoeft).

FIG. 3. Sta. Pudenziana, Rome, Apse mosaic, Apocalyptic Vision of Christ in the Heavenly Jerusalem (photo: Michael Imhof Verlag).

FIG. 4. *Maiestas Domini*, Moutier-Grandval Bible, London, British Library, Ms. Add. 10546, fol. 352ʳ (photo: British Library).

FIG. 5. *Deësis*, Icon from Monastery of St. Catherine, Mount Sinai, Eleventh century (photo: Princeton-Michigan Expedition to Mt. Sinai).

FIG. 6. Chartres Cathedral, south transept, central portal, Tympanum with Last Judgement and *Deësis* (photo © Kathleen Cohen).

present; what you see is an image. But it is God and Man that the holy image represents (Fig. 1)."[8] This short phrase, which on first reading seems rather simple and straightforward, opens up a wide horizon of meanings and provides rather surprising insights into how we might understand this particular iconography.

First and foremost, the inscription emphasizes the theological concept of the vision of God that is already indicated by the flanking figures in the tympanum. This distinction made in textual terms between the two natures of Christ thus responds to the implicit connec-

tion between incarnation and salvation and the end of time, which are both conflated in the visual program.

Furthermore, the distich introduces the viewer to the theoretical discussion of images in the High Middle Ages—a discourse on representation that ultimately addresses the choices that were available for the depiction of the invisible God.[9] In this essay I shall use several case studies to elucidate the ways in which the theoretical content of this short text was tightly imbricated with the theological discourse on the *visio Dei* and the ways in which it was connected with the repre-

8. NEC DEVS EST NEC HOMO PRESENS QVAM CERNIS IMAG(O) SET (!) DEVS EST ET HOMO QVEM SACRA FIGVRAT IMAGO. See Rückert Estella (as in not 1), 56–59; for further bibliographical references on the distich in Estella see her note 398; Herbert L. Kessler, *Neither God nor Man: Words, Images, and the Medieval Anxiety about Art* (Freiburg i. Br.: Rombach Verlag, 2007), 71–73.

9. For the medieval discourse on repraesentatio, see *Der Begriff der Repraesentatio im Mittelalter: Stellvertretung, Symbol, Zeichen, Bild*, ed. by A. Zimmermann (Berlin, New York: Walter de Gruyter, 1971); H. Hofmann, *Repräsentation: Studien zur Wort und Begriffsgeschichte von der Antike bis ins 19. Jahrhundert* (Berlin: Duncker und Humblot, 1974), 47–80.

sentational character and the materiality of the respective images.

The short text is a well known *distichon* that appears for the first time in the context of the Gregorian Reform, originating in French Benedictine circles sometime before or around 1100.[10] The titulus is first documented in a larger compilation of epigrams by Baudri of Bourgueil, a Benedictine monk who had close ties to the court of Adele de Blois.[11] In this example the verses are defined in relation to their functional connection with a crucifix (*circa crucifixum*). It is quite likely, then, that from its very beginning, the text was composed in conjunction with an image. Interestingly, in the early surviving examples—with the exception of a twelfth-century manuscript page from Verdun, where it appears above a deposition from the cross[12] and a late medieval antependium from Kinsarvik in Norway (ca. 1275)[13]—the distich is *never* found in the context of a crucifixion. Instead, it appears consistently in relationship with a range of images that deal with the vision of God.

Despite its first appearance around 1100, the distich is tightly connected with the authorized condemnation of iconoclasm in Byzantium in the eighth and ninth centuries.[14] In its resolutions, the iconophile council of Nicaea in 787 stated that the making of an image of Christ in his human form testifies to the real and not the spiritual incarnation of the God-Logos and defined the relationship between image and prototype.[15] In this discourse the iconodule positions of John of Damascus, the important Syrian theologian, played a crucial role. In his treatise "Three apologies against those who attack holy images" (1. Treatise, chapter 4) from 726, he invoked the incarnation of God as his main argument for the legitimization of His depiction:

> Therefore I am emboldened to depict the invisible God, not as invisible, but as he became visible for our sake, by participation in flesh and blood. I do not depict the invisible divinity, I depict God, made visible in the flesh.[16]

John distinguishes between a visible and an invisible God, and refers to the incarnation as the event through which God became visible and, consequently, capable of being depicted. The distich uses similar concepts, but rather than focusing on the idea of incarnation as the foundation of and reason for the image, it highlights the multiple connections and interrelationships of three key terms: God, Man, and Image, thereby

10. Nino Zchomelidse, "Das Bild im Busch: Zu Theorie und Ikonographie der alttestamentlichen Gottesvision im Mittelalter," in *Die Sichtbarkeit des Unsichtbaren: Zur Korrelation von Text und Bild im Wirkungskreis der Bibel*, ed. by Nino Zchomelidse and Bernd Janowski (Stuttgart, 2003), 165–189; Kessler, *Neither God* (as in note 8), 45–53.

11. The authorship of the distich is not resolved and another possible candidate is Hildebert of Lavardin, like Baudri, a Benedictine Reform monk. For the history and the importance of the distich in medieval and early modern art, see Ragne Bugge, "Effigiem Christi, qui transis, semper honora: Verses Condemning the Cult of Sacred Images in Art and Literature," in *Acta ad archaeologiam et artium historiam pertinentia* 6 (1975), 127–140; Arwed Arnulf, *Versus ad picturas: Studien zur Titulusdichtung als Quellengattung der Kunstgeschichte von der Antike bis zum Hochmittelalter* (München: Deutscher Kunstverlag, 1997), 280–283; Zchomelidse, "Bild im Busch" (as in note 10); Kessler, *Neither God* (as in note 8).

12. Verdun, Bibliotheque Municipale, Ms. 95, fol. 57; see Kessler, *Neither God*, 57–59, also for further references on the manuscript.

13. Signe Horn Fugelsang, "Norwegian Frontals with Tituli: Nedstryn and Kinsarvik," in *Norwegian Medieval Altar Frontals and Related Materials*, Papers from the Conference in Oslo, 6th to 19th December 1989, Acta ad archaeologiam et artium historiam pertinentia, 11 (Roma: L'Erma di Bretschneider, 1995), 25–30; Nigel J. Morgan, "Iconography," in *Painted Altar Frontals of Norway, 1250–1350*, Vol. 1. Artists, styles and iconography, eds. by Erla B. Hohler, Nigel J. Morgan, and Anne Wichstrøm (London: Archetype Publications, 2004), 39–65, and Cat. entry 107–108; Kessler, *Neither God* (as in note 8), 65–67.

14. Bugge "Effigiem Christi" (as in note 11), 127–131; Zchomelidse "Bild im Busch" (as in note 10), 174; Kessler, *Neither God*, 30–32.

15. For the text of the definition of the Seventh Ecumenical Council in Nicea, see Daniel J. Sahas, *Icons and Logos: Sources in Eight-Century Iconoclasm* (Toronto, Buffalo, London: Toronto University Press, 1986), 176–180; for the most recent discussion of the Seventh Ecumenical Council in Nicea, see Hans Georg Thümmel, *Die Konzilien zur Bilderfrage im 8. und 9. Jahrhundert: Das 7. Ökumenische Konzil in Nikaia 787* (Paderborn, München, Wien, Zürich: Verlag Ferdinand Schöningh, 2005), particularly for the image theoretical implications, 180–184.

16. St. John of Damascus, *Three Treatises on the Divine Images*, trans. and intro. by Andrew Louth (Crestwood, N.Y.: St. Vladimir's Seminary Press, 2003), 22.

touching on the dogma of the dual nature of Christ and the creation of Man in God's image, as formulated in Genesis 5:1.

A late medieval example of the distich in the Vatican Library (BAV, Reg. lat. 1578, fol. 46ʳ) organizes the text in an interesting diagram that illustrates precisely the basis of this argument (Fig. 7).[17] Instead of a two- or one-line schema, the diagram organizes the text into three verses. Connections drawn between the different lines help the viewer visualize the antithetical and referential structure of the distich, and underscore the three central terms: *deus* (God), *homo* (Man), and *imago* (image). The various relationships, made obvious by the diagram, visualize the paradoxes described in the verses.

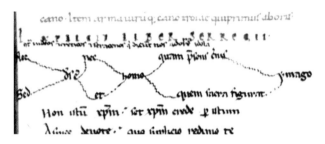

FIG. 7. Vatican Library, BAV, Reg. lat. 1578, fol. 46ʳ (photo: Vatican Library).

Herbert Kessler has recently linked the origins of the distich to Carolingian and Ottonian positions within the controversial debate on image veneration.[18]

According to that discourse, the faithful viewer should ascend, by means of visible images, to a higher invisible truth.[19] The distich, however, seems to be more closely connected to early scholastic concepts of *imago* and representation as intensively discussed in the circle of French cathedral schools from the eleventh century onwards.[20] In these circles the concept of *imago* was based on the connection between the creation of man in the image of God and the creation of Christ as the image of God. The concept of *imago* explained the relationships of Man and Christ to God, just as incarnation and human creation explained the relationship between images and their referents. Because of the awareness of early-scholastic theologians towards likeness and dissimilitude and the diversity of the three divine persons in the Trinity, likeness was not conceived in terms of visual appearance, but as a relationship between form and matter.[21]

The distich plays with the equivalences between the philosophically and theologically determined theory of representation and the medieval discourse on images. It also connects with the medieval theories of vision that depart from Augustine's exegesis of Genesis, which distinguished between several levels of vision—corporeal, spiritual, and intellectual—and which had been further developed in the twelfth century with the addition of even more levels of vision.[22] Additionally, from the twelfth century onwards, the interest of theologians began to focus more intensively on seeing

17. Bugge "Effigiem Christi" (as in note 11), 135; Kessler, *Neither God* (as in note 8), 13–14; Arnulf, *Versus ad Picturas* (as in note 11), 281, reads the folio number as 45, as does Rückert *Estella*, (as in note 1), 56. Because the Vatican Library has been closed since July 2007, I have not been able to ascertain the correct folio number.

18. Kessler, *Neither God* (as in note 8), 31–38.

19. H. Kessler, "Hoc visibile imaginatum figurat illud invisibile verum": Imagining God in pictures of Christ," in *Seeing the Invisible in Late Antiquity and the Early Middle Ages*. Papers from "Verbal and Pictorial Imaging: Representing and Accessing Experience of the Invisible, 400–1000" (Utrecht, 11–13 December 2003), ed. by G. de Nie, K. Morrison, and M. Mostert (Turnhout: Brepols, 2005), 294.

20. For the pre-scholastic discussion on images, see Brigitte Bedos-Rezak, "Replica: Images of Identity and the Identity of Images in Prescholastic France," in *The Mind's Eye: Art and Theolog-*

ical Argument in the Middle Ages, ed. by J. Hamburger and Anne-Marie Bouché (Princeton, Department of Art and Archaeology, Princeton University, 2006), 46–64.

21. Brigitte Bedos-Rezak, "Medieval Identity: A Sign and a Concept," in *American Historical Review* 105 (2000), 1489–1533.

22. For the medieval tradition of the vision of God in the context of the Apocalypse commentaries, see Wilhelm Kamlah, *Apokalypse und Geschichtstheologie: Die mittelalterliche Auslegung der Apokalypse vor Joachim von Fiore* (Historische Studien 285, Berlin: Verlag Dr. Emil Ebering, 1935 and Vaduz, Kraus Reprint, 1965); *The Apocalypse in the Middle Ages*, ed. by Richard K. Emmerson and Bernard McGinn (Ithaca, N.Y.: Cornell University Press, 1992); Barbara Nolan, *The Gothic Visionary Experience* (Princeton, Princeton University Press, 1977), 3–34; Bernard McGinn, "Seeing God in Medieval Theology and Mysticism," in *Envisaging Heaven in the Middle Ages*, ed. by Carolyn Muessig and Ad Putter (New York: Routledge, 2007) 13–33. For the discussion on

and visionary experience, particularly with regard to John's Apocalypse.[23]

The Estella distich encapsulates at a minimum a twofold meaning: it implicitly refers to a medieval understanding of the image and it describes the paradox of the Christian God, and by extension, the foundations of the Christian idea of Salvation.

Seen in this light, the particular placement of the distich on the frame of the quadrilobe is already significant (Fig. 1). The quatrefoil creates a sharp distinction between the *Maiestas* and the other parts of the tympanum, thus separating the enthroned Christ within the composition and transforming him into an isolated image. The term *sacra imago* as it appears in the Estella inscription refers explicitly to this aspect, since it has a long history as a reference to cult images.[24] In the West it appears for the first time in the eighth century in the context of the annual procession of the Assumption of the Virgin, celebrated on the Vigil of August fifteenth in Rome, when an icon of Christ, the *Acheropita* from the Lateran chapel Sancta Sanctorum, was carried through the streets of the city (Fig. 8).[25]

The iconography of the Estella tympanum, oscillating as it does between *Maiestas* and *Deësis*, is designed to allow a multilayered system of meanings and connections within the individual elements of the program. The frame that circumscribes the figure of Christ functions as a powerful visual tool and is consciously used to create different visual realities that are additionally explained by the text. The relationships of the figures of the tympanum—God, the four adoring beasts, Mary and John—with the viewer by means

FIG. 8. Rome, Lateran basilica, Sancta Sanctorum chapel, *Acheropita* icon (photo from J. Wilpert, "L'acheropita ossia l'immagine del Salvatore nella Cappella del Sancta Sanctorum," *L'Arte* 10, 1907).

medieval concepts of vision, visuality, and art, see Peter K. Klein, "From the Heavenly to the Trivial: Vision and Visual Perception in Early and High Medieval Apocalypse Illustration," in *The Holy Face and the Paradox of Representation: Papers from a Colloquium Held at the Bibliotheca Hertziana, Rome, and the Villa Spelman, Florence, 1996*, ed. with an intro. by Herbert L. Kessler and Gerhard Wolf (Bologna: Nuova Alfa Editoriale, 1998), 247–278; and Cynthia Hahn "Vision" in *A Companion to Medieval Art: Romanesque and Gothic in Northern Europe*, ed. by Conrad Rudolph (Malden, Mass., Oxford, Carlton: Blackwell, 2006), 44–64.

23. Nolan, *Gothic Visionary* (as in note 22), 20–34.

24. Zchomelidse, "Bild im Busch" (as in note 10), 175.

25. For the procession, see Gerhard Wolf, *Salus Populi Romani:*

Die Geschichte römischer Kultbilder im Mittelalter (Weinheim: VCH, Acta Humaniora, 1990); Enrico Parlato, "La processione di Ferragosto e l'acheropita del Sancta Sanctorum," in *Il volto di Cristo*, ed. by G. Morello and G. Wolf, Exhib. Cat., Rome, Palazzo delle Esposizioni (Milan: Electa, 2000).

of the image of Christ, are a mediated connection. The figures of Mary and John appear to be confronted with an image and the viewer with the image of a vision, while the vision itself appears as an image.

The concept of the vision of the enthroned Christ surrounded by the four winged beasts, as described in John's Apocalypse, is visualized through the concept of the *imago* seen by Saint John himself. The *distichon* addresses the viewer and invites him to be a part of this vision of God. Thus, in the case of the Estella tympanum, *repraesentatio* as a visual strategy of substitution should be understood as a conscious choice. It is an attempt to use the multilayered concept of *imago* for the visualization of the invisible in the visible, the divine in the human.

The intention of the intellectual maker of the tympanum, or to use Beat Brenk's term of the '*concepteur*' to connect different levels of reality in a meaningful way, also becomes evident in the Chi-Rho monogram incised on the book in Christ's hand (Fig. 1).[26] The Chrismon in its specific formula paired with the Alpha, Omega, and the S, the latter referring to either *Spiritus Sanctus* or *Soter/Salvator*, enjoyed a particular popularity in the Iberian Peninsula between the eleventh and thirteenth centuries that differed from that of other European regions. In several tympana that date to the second half of the twelfth century, such as a fragment from Pamplona and the tympanum of San Prudencio in Armentia near Vitoria, the monogram replaces the image of God itself (Fig. 9).[27] As a sign of the Trinity and as a reference to the concept of the two natures of Christ, the Chi-Rho monogram presents an additional non-anthropomorphic way to represent the Godhead.

This choice seems to represent a sensitive attitude towards images that is characteristic of the region, and which was rooted in the skepticism that early Spanish theologians fostered towards the use of images. The use of images in churches was already prohibited in the synod held at Elvira, near Granada, in the early years of the fourth century.[28] It may also be explained by the immediate vicinity of Navarre with the remaining part of Muslim Spain.[29] Based on the Hadith tradition and thus connected to the statements and actions of the prophet Muhammad, figurative images were banned from religious buildings, such as mosques, *madarassas*, and holy shrines. As a result of this reluctant attitude towards images, calligraphy and ornament became the main focus for Islamic art in a religious context and flourished in Muslim Spain from the eighth to the fifteenth centuries. The complexity of the tympanum corresponds in its subtle distinctions between different levels of reality and meaning to the richness of allusions and the density of theoretical implications of the distich. It needs to be understood in this particular historical and cultural moment in medieval Spain.

The same intention to visualize the connection between image and vision also characterizes the following example that additionally documents the first use of the distich in the context of monumental art (Fig. 10). The surviving fragment of the distich "It is God and Man, which the holy image represents"[30] appears in an inscription from about 1100 within a program of wall paintings in Sta. Maria Immacolata in Ceri near Rome.[31] Image and titulus are part of an Old Testament cycle that unravels in sixteen painted panels the

26. For the introduction of the term "concepteur," see Beat Brenk, "Le texte et l'image dans la vie des saints au Moyen-Age: rôle du concepteur et rôle du peintre," in *Text et Image*, Actes du Colloque international de Chantilly (13 au 15 octobre 1982), Centre de Recherches de l'Université de Paris x (Paris: Les Belles Lettres, 1984), 31–39, and *idem*, "Der Concepteur und sein Adressat. Oder: Von der Verhüllung der Botschaft," in *Modernes Mittelalter: Neue Bilder einer populären Epoche*, ed. by Joachim Heinzle (Frankfurt/M: Insel Verlag, 1994), 431–450.

27. Ruth Bartal, "The Survival of Early Christian Symbols in 12th Century Spain," *Principe de Viana* 48 (1987), 299–315, and Rückert, *Estella* (as in note 1), 59–60 and 133–135.

28. On the Council of Elvira, see Robert Grigg, "Aniconic Worship and the Apologetic Tradition: A Note on Canon 36 of the council of Elvira," *Church History* 45 (1976) 428–433. Canon 36 "Placuit picturas in ecclesia esse non debere, ne quod colitur et adoratur in parietibus depingatur."

29. In 1238 the last Muslim part of the Iberian peninsula, the Nasrid Emirate of Granada, became subordinate to the Spanish King of Castile. The Reconquista was completed in 1492, when the last Emir of Granada, Muhammad XII, surrendered to King Ferdinand of Aragon and Queen Isabella of Castile.

30. (DEV)S EST ET HOMO QVEM SACRA FIGVRAT IMAGO.

31. On the painted decoration of the church, see Nino Zchome-

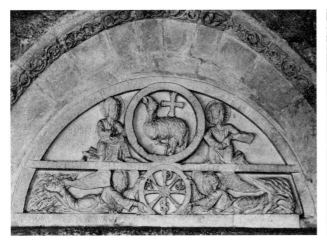

FIG. 9. Armentia, San Prudencio, Tympanum with the Adoration of the Lamb of God and Chrismon (photo: Colum Hourihane).

FIG. 10. Ceri, Sta. Maria Immacolata, Moses and the Burning Bush and the Miracle of the Snake (photo: author).

biblical history from the creation of the universe to the drowning of Pharaoh in the Red Sea. The text comments on two episodes from the book of Exodus (Ex. 3:2–6) with Moses and the burning bush and the miracle of the snake (Ex. 4:1–5) represented together in a two-fold composition.

Its use with a depiction of an Old Testament vision is significant and reflects the intellectual efforts that were made by representatives of the Gregorian Reform Movement in Rome to define the status and function of images.[32] The attitudes towards images as they were expressed in the circles of the papal curia in Rome are especially rich because they address problems of visions in general, elaborate on the possibilities of representing God, and testify to a sophisticated use of *typos* and *anti-typos* for illustrating the paradoxes inherent in Christian faith towards representing the invisible. As I have shown elsewhere, the inscription in Ceri, by means of its visual connection with the paintings of the burning bush and of the snake, becomes an argument about the Old Testament prohibition of images and a statement about images in general.[33]

The reference to the two natures of Christ and the idea of representation in the text correspond to the vision of the image of Christ. The blessing hand and the nimbus, as well as the resemblance of the bush to an apse-like niche, connect the depiction of the envisioned God with the iconographical tradition of the Savior icon from the Sancta Sanctorum in Rome, and Roman apse mosaics, such as in S. Marco (Figs. 8, 11). This way a widely known pictorial formula was used to represent the notion of vision. Just as in Estella, the vision of God—in this case the Old Testament JWHE—is visualized in the form of an image. The vision of God as an image, however, rather than addressing Moses, is directed towards the viewer, because the bush is shifted from the traditional right side to the center of the painting (Fig. 12). Christ's frontal representation in the vision changes the narrative nature of the scene into a more iconic one. Another detail highlights this shift in the wall painting. In Ceri, it is the viewer who sees God face to face; Moses, the proper addressee of the vision, looks strangely out into the void, beyond the painting's borders, even though his body and profile are turned towards the center of the composition and the burning bush. The subtle play

lidse, *Santa Maria Immacolata in Ceri: Sakrale Malerei im Zeitalter der Gregorianischen Reform* (Rome: Archivio Guido Izzi, 1996).

32. Zchomelidse, "Bild im Busch" (as in note 10), and Herbert Kessler, "A Gregorian Reform Theory of Art?" in *Roma e la ri-*

forma gregoriana: tradizioni e innovazioni artistiche (XI–XII secolo), ed. by Serena Romano (Rome: Viella, 2007), 25–48.

33. Zchomelidse, "Bild im Busch" (as in note 10).

FIG. 11. Rome, S. Marco, Apse Mosaic, (photo: Michael Imhof Verlag).

of seeing and not seeing in the painting turns the be-holder himself into the real focus of the vision. Only the beholder living in the era after the incarnation and sacrifice—*sub gratia*—is able to see God and is conse-quently elevated above the Old Testament Moses.

The exemplary nature of the burning bush in the medieval discourse on vision and image is demon-strated by its position in the literature on the allegori-cal interpretation of visions. In Augustine's three types of visions—the fundamental basis for all later treatises on the theme—the author distinguishes corporeal from spiritual and intellectual vision.[34] The burning bush episode falls into this second category, "spiritual,"

because of the typological reference inherent in the image. For Augustine, Moses, because of his perfect life, was allowed to see something close to a vision of God's substance.[35] Accordingly, he became a primary figure in the context of the Old Testament for a typo-logical interpretation of vision.

In the twelfth century, Richard of St. Victor, in his four-category model, saw Moses' vision of the burning bush as the second of two forms of corporeal visions.[36] He built upon the ideas of Augustine in describing two types of corporeal visions—the first being the truly corporeal vision, or seeing in a literal sense, the second being typological, or *typica significatione plena*. These

34. Augustinus, *De Genesi ad litteram*, XII, 11ss. For the English version, see *On Genesis*, intro., trans. and notes by Edmund Hill; ed. by John E. Rotelle; series: *The Works of Saint Augustine*, Pt. 1, v. 13 (Hyde Park, N.Y.: New City Press, 2002).

35. Augustine (Epistula 147, 31–37), see also Bernard McGinn,

"Visio dei: Seeing God in Medieval Theology and Mysticism," in *Envisaging Heaven in the Middle Ages*, ed. by C. Muessig and A. Putter (London, New York: Routledge, 2007), 17.

36. Richard of St. Victor, *In Apocalypsin Johannis*, Migne PL, 683–888.

FIG. 12. St. Catherine Monastery, Mount Sinai, Moses and the Burning Bush (photo: Princeton-Michigan Expedition to Mt. Sinai).

first two of Richard's categories are equivalent to corporeal and spiritual visions as outlined by Augustine. Richard further distinguished two spiritual forms of vision—first, a *symbolica demonstratio*, consisting of a vision of figures that are similar to the corporeal but lead to the seeing of the noncorporeal and the invisible. Richard's fourth category is the *anagogica demonstratio*, a non-sensual or free mystical vision that is achieved without the aid of images or ideas. The various levels of meaning of the images seem to refer precisely to these different types of visions.[37]

The inscription under the burning bush episode in Ceri marks an important point in the medieval understanding of vision as an allegorical form, as it reveals different layers of typological meaning and rela-

tionships inherent in the representation above it. The text explicitly addresses the viewer and again refers to the concept of *imago* as a key term for the Trinitarian God. The image of this God is presented in a kind of typological vision that unites the burning bush and the Savior.

Different ways of typological appropriation characterize the entire cycle in Ceri. The other half of the burning bush scene, which shows the transformation of Moses' staff into a snake, is an important example for this practice. As is the case with the burning bush episode, medieval exegesis—in particular that of Peter Damian, as Herbert Kessler has recently pointed out—connects this event with the moment of Christ's incarnation.[38] The depiction of the miracle of the snake

37. See also Uda Ebel, "Die literarischen Formen der Jenseits- und Endzeitvisionen," in *Grundriss der romanischen Literaturen des Mittelalter, La literature didactique, allegorique e satirique*, Vol. 1 (Heidelberg: Carl Winter Universitätsverlag, 1968), 180.

38. Kessler, *Neither God* (as in note 8), 52–53.

presents an additional argument in favor of the visualization of God as an image in the burning bush. Many of the Old Testament scenes in Ceri appear to be allegorical images of the events that would constitute the New Testament, so that examples of implicit typology—although perhaps not with the same complexity as the burning bush episode—generally characterize the program.

One strategy for linking the Old and New Testaments typologically is the distinction or "nobilitation" of positive Old Testament patriarchs with halos, as seen in the story of Cain and Abel. Here the murdered Abel is depicted with a nimbus, unlike his brother Cain (Fig. 13). This coincides with patristic typological exegesis relating Abel to the crucified Christ (Fig. 14).[39] In the episode of the ark Noah is clearly distinguished as a typos or *figura* of Christ by means of size, nimbus, and the blessing gesture of his right hand, which recalls half-length images or *clipei* of Christ (Fig. 15). The inscription below the fresco—"They will be saved in the prepared house"—evokes the interpretation of the ark as *ecclesia* and refers to the New Testament theme of salvation.[40] The choice of animals in the ark, the ass and the bull, both being present at the birth of Christ, testify thus to the incarnation.[41]

My next case features the titulus—albeit in a slightly different version—again in a narrative context. "Nec deus est nec homo presens quem cernis imago sed deus est et homo presens quem signat imago" (It is neither God or man present, what you see is an image | but it is God and man, which the present image signifies), appears above an image of the deposition from the cross painted on a folio from a twelfth-century manuscript (Fig. 16).[42] It is part of an Easter cycle found on one of four preserved pages from an Evangelistary, made in Verdun. Arranged in three registers, the folio shows several scenes from the deposition and entomb-

FIG. 13. Ceri, Sta. Maria Immacolata, Cain and Abel (photo: author).

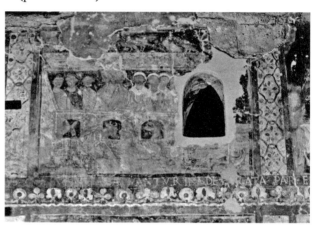

FIG. 14. Ceri, Sta. Maria Immacolata, Noah's Ark (photo: author).

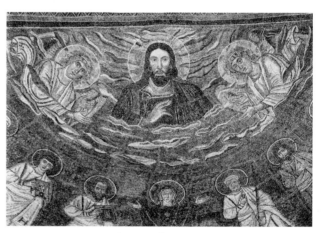

FIG. 15. Rome, Baptistery of San Giovanni in Laterano, Venantius chapel, apse mosaic (photo: Scala / Art Resource, N.Y.).

39. Augustine, Migne PL 42: 259. See also Zchomelidse, "Bild im Busch" (as in note 10), 185.

40. SALVANTVR IN AEDE PARATA.

41. Zchomelidse, "Bild im Busch" (as in note 10), 186–187.

42. Kessler, "Neither God" (as in note 8), 57–61, sees the *Necdeus* distich in close relationship to the Anastasis scene of the page. For further references of the manuscript, see Kessler, *ibid.*, 57, n. 126.

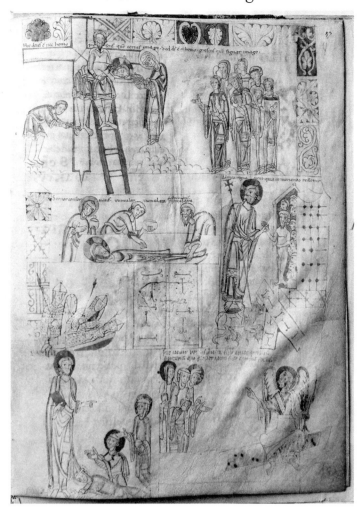

FIG. 16. Deposition from the cross, Verdun, Bibliothèque Municipale, Ms. 95, fol. 57 (photo: Verdun, Bibliothèque Municipale).

ment of Christ, the Anastasis, and the resurrection. As in the wall painting at Ceri, the distich does not appear in the context of the Crucifixion of Christ, as indicated by Baudri, but avoids additionally any iconic association. The process of taking the body of Christ from the cross, particularly the pulling of the nails from his feet, is described in great detail. A group of mourning women on the left constitute the compositional balance to the main event on the right as well as commenting on the scene. Surprisingly, the miniature lacks the non-narrative qualities of a cult image, and thus

conforms to the specific version of the distich, which omits the adjective *sacra* before the noun *imago* and exchanges the verb *figurare* with *signare*, a circumstance already recognized by Kessler.[43] Although both verbs define related semantic fields, they have slightly different meanings. In the context of the medieval concept of *figura*, the verb *figurare* means "to embody" and is connected with the idea of "being a part of." *Signare*, on the other hand, stands for "to signify" and thus defines a referential relationship.[44]

Each scene of the narrative is accompanied by a

43. *Ibid.*, 57–59.

44. For the medieval concept of *figura*, see E. Auerbach, "Figura," in *Scenes from the Drama of European Literature*, Theory and

History of Literature, 9 (Minneapolis: University of Minnesota Press, 1984), 11–76. For the medieval understanding of *signum*, see Stephan Meier-Oeser, *Die Spur des Zeichens: Das Zeichen und*

titulus. In contrast to the distich above the deposition from the cross, however, these texts are all closely related to the respective image and concentrate on the subjects of death, resurrection, and salvation.[45] The *Nec-Deus* distich fulfills a unifying role within the program of the entire page and comments on the mystery of Christ, which is based on his dual nature. As the main title for a sequence that summarizes the Easter events, the titulus ultimately defines salvation, made possible through the incarnation of God, as well as authorizing its pictorial representation.

The pictorial and textual program of my next example concerns a phylactery, made shortly after the 1150s in the Meuse region of northwestern Germany, currently in the Hermitage Museum in St. Petersburg (Figs. 17, 18).[46] It belongs to a group of objects which, defined by their form, are called *Scheibenreliquiare*, or "disc reliquaries" in German. These objects were made between the mid-twelfth and the mid-thirteenth century, particularly in the region of the Meuse.

In the literal sense, the term phylactery simply refers to a container for relics; in late antiquity and in the early Christian era they were often worn as amulets hanging from the neck and were believed to have had protective powers.[47] Only in the nineteenth cen-

FIG. 17. Phylactery, Meuse region, front (photo: The State Hermitage Museum, St. Petersburg).

seine Funktion in der Philosophie des Mittelalters und der frühen Neuzeit (Berlin and New York: W. de Gruyter, 1997), particularly, 1–102. For the referential chararcter of *signare* within medieval allegory, see Rudolf Suntrup, *Die Bedeutung der liturgischen Gebärden und Bewegungen in lateinischen und deutschen Auslegungen des 9. bis 13. Jahrhunderts*, Münster Mittelalterschriften, 37 (München: Wilhelm Fink Verlag, 1978), 118–121.

45. Kessler, *Neither God* (as in note 8), 60–61, emphasizes the allusion to the dual nature of Christ that he recognizes in all scenes and the respective tituli.

46. Rainer Kahsnitz, "Sieben halbrunde Emails in Nürnberg, London und Trier: Zwei maasländische Phylakterien des 12. Jahrhunderts," in *Anzeiger des Germanischen Nationalmuseums und Berichte aus dem Forschungsinstitut für Realienkunde 1992* (Nürnberg, 1992): 113–117; Arnulf, *Versus ad Picturas* (as in note 11), 281–282; Kessler, *Neither God* (as in note 8), 67.

47. Kahsnitz, "Sieben halbrunde Emails" (as in note 46), 111; Joseph Braun, *Die Reliquiare des christlichen Kultes und ihre Entwicklung* (Freiburg i. Br.: Herder, 1940), 23–27, 295–300; Don C. Skemer, *Binding Words: Textual Amulets in the Middle Ages* (University Park, Pa.: Pennsylvania State University Press, 2006) 11–12.

FIG. 18. Phylactery, Meuse region, back (photo: The State Hermitage Museum, St. Petersburg).

tury was "phylactery" more specifically applied to a group of reliquaries that consisted of round, oval, or poly-lobed wooden panels, which were covered with figural and ornamental enamel sheets and contained a small central repository. They measure approximately twenty to thirty centimeters in diameter. Our knowledge of their function remains uncertain, due to a lack of pictorial and textual sources. The hinges on some objects suggest that they were hung, possibly above an altar. There are others, however, that were mounted on a stand. The altar seems a possible location also in those cases, since these phylacteries could have been placed on top of it.[48] Equally little can be said about the content of the repositories, with the exception of an example from Evêché (Tournai) that is documented and another from Namur which contains pieces from the crib and the "true cross"—relics that relate to Christ.[49]

Some of these Meuse reliquaries are characterized by a text-image relationship of an exceptionally high intellectual standard, which points towards the likelihood of their fabrication and use in the context of erudite clerical circles. The central panel on the front of the Hermitage reliquary features a half-length image of Christ, sitting on a rainbow and raising his right hand in blessing and holding an open book (Fig. 17). This image is closely tied to four texts inscribed on the phylactery. The first inscription appears in the open book and refers to Christ who says about himself: "I am the way, the truth, and the life" (John 14:6).[50] In this instance of direct speech the text opens up a general theological discourse connecting the figure of Christ and the book in a significant way.

Three semicircles surrounding the reliquary's front show adoring angels, while the lower semicircular panel presents a kneeling man holding a scroll. Its inscription identifies him as the apocalyptic seer: "Be-

hold, I, John saw an open door" (Rev. 4:1).[51] On the one hand, the text further expands the main inscription in Christ's book, also from the Gospel of John; on the other hand, it presents John in the very moment of his vision of God, and places the scene on the front of the reliquary in the *de facto* context of the apocalyptic vision. As in the other examples, the vision and the visionary—as the act of envisioning and the object of the vision—are separated, permitting the viewer to see.

But in the case of the phylactery, matters become yet more complicated, because a third inscription in the frame of the square central panel surrounding the image of Christ comments directly on the vision of the beholder: "Venerate the image of Christ when you pass it by bowing. Honor not the image, but what it represents."[52] This phrase describes the understanding of the image that developed after the Byzantine iconoclastic controversy in the West. The beholder is confronted with the foundations of medieval image theory.

These reflections about the fundamental difference between divine vision and pictorial representations are continued in yet another inscription, which is added to the program of the phylactery (Fig. 18). The distich appears on the back of the object; it does not establish a direct or visual connection with the primary visual program on the front of the reliquary, but is featured as a separate self-contained unit on the small door through which the reliquary's repository is accessed: "It is neither God nor Man present. What you see is an image. But it is God and Man, which the holy image represents."[53]

On the back of the phylactery there is a clear link to the door to salvation in the vision of St. John mentioned on the obverse of the phylactery. The placement of the distich, however, is not only meant as a commentary on the concept of vision located on the

48. Kahsnitz mentions that the stands of these phylacteries, which were mostly made in France, were later additions. Kahsnitz, "Sieben halbrunde Emails" (as in note 46), 111.

49. For Evêché, see *ibid.*, 116, and for Namur, see Braun *Reliquiare* (as in note 47), 27.

50. EGO SVM VIA VERITAS ET VITA.

51. ECCE. EGO. IOH(AN)N(IS). VIDI. OSTIUM. A(pertum).

52. ESFIGIEM (!) XPI DVM TRANSIS PRONVS ADORA | NON TAMEN EFFIGIEM SED DESIGNAT HONORA. For the historical context of this text, see Bugge, "Effigiem Christi" (as in note 11), 130–133.

53. NEC DEVS EST NEC HOMO QV(E)M PRESENS. CERNIS IMAGO. | SED DEVS EST ET HOMO QV(E)M SACRA FIGURAT IMAGO.

reliquary's front, it should also be read as a reference to the small container's contents. The idea of *repraesentatio* thus appears to be extended to the relic itself, so that *sacra imago* and relic are connected in a meaningful way.

Other phylacteries from the Meuse region testify to the sophisticated level of discussion regarding the concept of *imago* and representation in the same cultural context. A similar piece from the Benedictine abbey of Waulsort dates to the 1160s and develops compatible arguments—significantly in non-anthropomorphic programs (Figs. 19 and 20).[54] It documents *quasi ex negativo* the sensitivity or awareness of the intellectual makers of these objects for the various aspects of the discussion of images.

The reliquary front shows the Lamb of God with two attributes of passion, the sponge and the victory banner (Fig. 19). Just as in the Hermitage example, inscriptions accompany the images of the precious object on both sides. Two short passages comment on the lamb on the front. The first appears on the scroll below the lamb and reads: "Behold the Lamb of God," (John 1:36).[55] Because of the reference to the sacrifice of Christ in the passion and his victory over death by means of two of the *arma Christi*, it is also represented as the sacramental and apocalyptic Lamb as described in John's Apocalypse, chapter 5, verse 6.

The second passage, a circular inscription running like a frame along the center front of the image is interesting, since it refers to a theoretical argument similar to that on the front of the Hermitage phylactery.

FIG. 19. Phylactery from the Monastery in Waulsort, front, Namur, Musée des Arts Anciens du Namurois, (photo © Musée des Arts Anciens du Namurois, Namur).

FIG. 20. Phylactery from the Monastery in Waulsort, back, Namur, Musée des Arts Anciens du Namurois (photo © Musée des Arts Anciens du Namurois, Namur).

54. H. Swarzenski, *Monuments of Romanesque Art: the Art of Church Treasures in North-Western Europe* (Chicago: University of Chicago Press, 2nd ed. 1967), 73, Pl. 188, Fig. 426; P. Verdier, "Un monument inédit de l'art mosan du XIIᵉ siècle: La crucifixion symbolique de Walters Art Gallery," in *Revue Belge d'Archéologie et d'Histoire de l'Art* 30 (1961), 144–145; Kahsnitz, "Sieben halbrunde Emails" (as in note 46), 112–113. For the specific quatrefoil or polylobe shape of phylacteries produced in the workshop of Hugo D'Oignies, see Rebecca Leuchak, "The Form of the Phylactery in the Work of Hugo d'Oignies," in *Actes du colloque autour de Hugo d'Oignies sous la direction de Robert Didier*, Jacques Toussaint (Namur: Société archéologique de Namur, 2004), 87–120.

55. ECCE AGNVS DEI.

Focusing on Christ's two natures, the sacrifice of the Cross, and the referentiality of the image, it states: "What you see is the man of the heavenly king, an image of the lamb, which takes this form because of his great piety."[56] The text refers, albeit in a different way, to the theme of vision; the *imago agni* representing God and Man, and the lamb becoming the allegorical sign for God in his two natures.

The image on the reverse represents the Old Testament vision of Ezekiel in an iconic format by means of concentric wheels in the center and the four apocalyptic beasts in the corners (Fig. 20). The beasts hold the outermost wheel with their hands and are connected to each other through it. The semicircular panels around this central square depict winged figures, identified by their inscriptions as the theological virtues *Caritas*, *Humilitas*, *Fides*, *Spes*. The two textual passages inscribed on the rims of the wheels—"the wheel in the center of the wheel" (this depicted quite literally on the panel) and "one wheel with four faces" are quotations from the book Ezekiel (1:15–16).[57] Similar to the Hermitage phylactery, text and image on the reliquary from Waulsort refer to the vision of God, because the "wheel in the center of the wheel" is typologically connected with the Lamb of the *visio Dei* of John.

This iconography brings me back to the Estella tympanum, where, just as in the phylactery from Waulsort, text and image refer to the vision of God. But in contrast to the meditation on anthropomorphic images of God, the spiritual goal of the vision in the phylactery is determined by the symbol of the lamb and the abstract configuration of the wheel. This can further be seen as an attempt to visualize an intellectual vision by means of an image.

At this point it is useful to consider the intellectual context in which these remarkable reliquaries with their sophisticated iconographies were created, which is identical with the *Nec-deus* distich. Only in connection with the content of the phylacteries does the web of references generated by the inscriptions unfold to its full effect. The theory-laden "frames" into which the material relic was embedded highlight an *aporia* in the understanding of the medieval cult image. Encompassed by the theoretical content of the texts and encapsulated by the system of the images, the relic transmits a sense of the "real-presence"—only seemingly banned by the inscriptions to the veneration of the object. In a reciprocal process of exchange, the pictures on the outside of the phylacteries direct the material trace of Christ's existence back to its divine origin, while the relics inside integrate the images into the realm of magic rituals. How could the outer material shell, so preciously encapsulating the relic, avoid inciting the veneration that it seemingly demands? How could the act of veneration be differentiated between the image and the relic, if representation and real-presence were so closely tied? Seen in this light, the erudite "image-theoretical" frames which the intellectual makers applied so distinctively to these precious objects, appear more like a selection of apotropaic formulations, invoked in vain to prevent actual acts of veneration.

The conceptual tension between vision represented by the image and the real-presence of the relic that I have demonstrated, also works in cases where such repositories might have been used to contain the consecrated host, as has been recently suggested by Herbert Kessler.[58] Although the few available documents concerning the content of these phylacteries refer exclusively to relics—some of which were obviously related to the pictorial programs, while others may not have been—a fascinating connection can be drawn between the theological discourse on the image raised by the distich and contemporary discussions concerning the reality of the host. This discourse witnessed a significant development in the circles of the cathedral schools in France from the eleventh century onwards. Early scholastic theory considered the Eucharist a real image of God and a paradox corresponding to the paradox inherent in the two natures of Christ.[59]

56. EST QVAM CERNIS HOMO REGIS CELESTIS/IMAGO AGNI QVI SPETIEM TENET OB NIMIA PIETATE (!).

57. ROTA VNA HABENS IIII FACIES. | ROTA IN MEDIO ROTE.

58. Kessler mentions this possibility for the Hermitage phylactery; see Kessler, *Neither God* (as in note 8), 67.

59. For the pre- and early-scholastic discourse on the Eucharist, see Franz Renz, *Die Geschichte des Messopfer-Begriffs*, Vol. 1, (Frei-

Moreover, the origin of the phylacteries in the vicinity of Liège, which was one of the main centers of the discourse on the veneration of the host, suggests a close relationship between the discussions concerning the image and the host.[60] The inscriptions on the Hermitage and Waulsort phylacteries repeat several terms specifically used in the debate on the nature of the sacrament: *veritas, imago, speties*, and *figura*. Their intellectual context, as well as the discussion of the image, was determined by the early-scholastic concepts of *repraesentatio*. It is hardly by chance, then, that the host from the twelfth century onwards was increasingly confronted with the desire to be seen.

I wish to conclude this essay with a late example of the distich, where it is placed in a similar context of an altar, but in the much larger scale of an altarpiece. It confirms that the early-scholastic discourse of the sacrament and the theoretical discussion of the representation of the divine had merged in the course of the thirteenth century. The *Nec-deus* distich runs along the frame of a large wooden panel, measuring 103 × 197.5 cm, which dates ca. 1275 and formed the frontal of the main altar of the church in Kinsarvik in the diocese of Bergen in Norway (Fig. 21).[61] An allegorical crucifixion, featuring Christ with open eyes, is depicted within a Gothic frame. Several events, such as Christ's nailing to the cross, the offering of the sponge filled with vinegar, the affliction of the side wound, which occurred in a temporal sequence, disturb the narrative character of the scene. Like a traditional crucifixion, the mourning figures of Mary and John flank the cross. Four angels with incense burners placed outside the limits of the main frame add a liturgical dimension to the scene. Furthermore, the figures of Ecclesia and Synagogue, as well as the apostles Peter and Paul situate the scene within the context of salvation.

Nigel Morgan has convincingly argued that the altar frontal from Kinsarvik should be seen in the larger context of similar Crucifixion scenes in English and French manuscripts, such as the Lambeth Apocalypse (1260–1270).[62] But like the leaf from Verdun, the distich is not paired with the traditional iconography of the Crucifixion, but can be seen as part of a meditation on the cross. Thus it ultimately belongs to the realm of devotional images. A *vita Christi* panel in the Wallraff-Richartz Museum in Cologne (ca. 1370) depicts the same biblical events of the Kinsarvik crucifixion, but in synthesized form.[63] Here the instruments of the Passion, the *arma Christi*, are represented as individual signs. The distich on the Norwegian altar frontal, like the miniature in the Verdun-folio, connects the representation of Christ with the themes of death and salvation. It also places it, by means of the figures of the Roman apostles, Ecclesia, and Synagogue, in the institutional context of the Church.

Again, the inscription does not include the term *sacra imago* or the verb *figurare*, and therefore downplays any reference to cult images, even though the image it belongs to is obviously non-narrative and devotional, both in its iconography and its context of an altar. Significantly, the text is positioned on the panel's frame in such a way that it becomes visible only at close range. The distich's comment on the referential character of the representation as an image in-

sing, Im Selbstverlag des Verfassers in Commission bei F. P. Datterer, 1901–1902), 693–728; Ludwig Hödl, "Sacramentum et res-Zeichen und Bezeichnetes. Eine begriffsgeschichtliche Arbeit zum frühscholastischen Eucharistietraktat," *Scholastik. Vierteljahresschrift für Theologie und Philosophie*, 38 (1963), 161–182; Brigitte Bedos-Rezak, "Une image onthologique. Sceau et ressamblance en France préscolastique (1000–1200)," in *Études d'histoire de l'art offertes à Jacques Thirion: Des premiers temps chrétiens aux XXᵉ siècle* (Paris: École des Chartres, 2001), 45–46; P. A. Mariaux, "'Faire Dieu': Quelques remarques sur les relations entre confection eucharistique e création d'image (IXᵉ–XIIᵉ siècles)," in *Ästhetik des Unsichtbaren: Bildtheorie und Bildgebrauch in der Vormoderne*, ed. by D. Ganz and T. Lentes (Berlin: Reimer 2004), 95–103.

60. See Alger of Liege's (1060–1131) commentary on the Eucharist, *De Sacramentis corporis et sanguinis dominici*, Migne PL 180: 739–854, and Renz, *Messopfer-Begriffs* (as in note 59), 706–717.

61. Horn Fugelsang, "Norwegian Frontals" (as in note 13), 25–30; Morgan, "Iconography" (as in note 13), 107–108; Kessler, *Neither God* (as in note 8), 65–67.

62. Morgan, "Iconography" (as in note 13), 49–55.

63. Robert Suckale, "Arma Christi: Überlegungen zur Zeichenhaftigkeit mittelalterlicher Andachtsbilder," in *Stil und Funktion: ausgewählte Schriften zur Kunst des Mittelalters*, ed. by Peter Schmidt and Gregor Wedekind (Munich: Deutscher Kunstverlag, 2003), 15–58; repr. of the article in *Städel-Jahrbuch* 6 (1977), 177–208.

FIG. 21. Altar frontal from Kinsarvik, allegorical Crucifixion, Bergen Museum–Universitetet i Bergen (photo: Bergen Museum–Universitetet i Bergen).

terrupts the physical approach to the image and thus also that of a spiritual convergence with the depicted events. By moving closer to the altar and gazing upon the frontal, the beholder discovers the written piece of advice, which works like an interpretative key. Only in the immediate vicinity of the panel are the complex interrelationships of the liturgical sacrifice at the altar as an image of the sacrifice of Christ painted on the panel, and the image of Christ as the image of God, fully revealed.

PETER JEFFERY

A Faithful Witness in Heaven: Keeping Vigil with Saint Apollinaris

THE EARLIEST EVIDENCE of the cult of St. Apollinaris is a sermon of St. Peter Chrysologus, who was bishop of Ravenna about 425–51. At that time, Apollinaris was remembered as Ravenna's first bishop, who "often shed his blood" for the faith. Evidently his tomb was already a cult site, since "his body reposes among us." But Chrysologus seems to have been trying to elevate his status from confessor (one who suffered for the faith) to martyr (one who was killed for the faith): "let no one, because of the word 'confessor,' believe him to be less than a martyr." [1] About fifty years later, at the end of the fifth century or the beginning of the sixth, the oldest *Passio sancti Apollinaris* [2] pushed the envelope even farther: Apollinaris had originally come from Antioch to Rome with St. Peter. It was Peter who had personally sent Apollinaris to Ravenna, and consecrated him the first bishop of the city. Thus Ravenna became an apostolic see, possessing only slightly less authority than Rome, the See of Peter, and a worthy competitor to the Patriarchate located variously at Aquilea, Grado,

and Venice, which claimed descent from another of Peter's disciples: St. Mark the Evangelist. [3]

The *Passio* describes Apollinaris as experiencing many assaults and beatings during his long ministry to the pagan people of Ravenna; he was made to walk over burning coals and even sent into temporary exile. At length he was handed over to a Roman centurion who, being a secret Christian, allowed him to escape by night—but he was found and attacked once more and left for dead. Christians rescued him and carried him safely to a leper colony outside the city, where he preached for seven days before finally expiring. According to this text he was certainly a martyr (*martyrizatus est*), and "he was buried by his disciples in a stone coffin outside the walls of Classis; the coffin was placed underground for fear of the pagans." [4] In the sixth century, about a hundred years after the time of Peter Chrysologus, a new church was built to house the body: the well-known edifice of Sant'Apollinare in Classe, located in what was originally a cemetery in the harbor area serving Ravenna, outside the city proper.

1. Petrus Chrysologus, *Sermo* 128.2, 3, 1. "Fundebat saepe confessor sanguinem suum ... ipsa inter nos corporis sui habitatio requiescit.... Nec eum quisquam confessoris uocabulo minorem esse quam martyrem." Sancti Petri Chrysologi, *Collectio Sermonum a Felice Episcopo parata*, ed. Alexandre Olivar, Corpus Christianorum, 24B (Turnhout: Brepols, 1982), 789–91. San Pietro Crisologo, *Sermoni [125–179] e Lettera a Eutiche*, ed. by Gabriele Banterle et al., Scriptores circa Ambrosium, 3 (Milan: Biblioteca Ambrosiana and Rome: Città Nuova Editrice, 1997), 32–35. See also Hippolyte Delehaye, "L'hagiographie ancienne de Ravenna," *Analecta Bollandiana* 47 (1929), 5–30.

2. *Acta Sanctorum*, Iulii 5 (Antwerp 1727), 344–50. *Bibliotheca Hagiographica Latina antiquae et mediae aetatis*, ed. by Socii Bollandiani 1(Brussels: [Socii Bollandiani,] 1898–99) p. 101, no. 623; *Novum Supplementum*, ed. by Henri Fros, Subsidia Hagiographica, 70 (Brussels: [Société des Bollandistes], 1986), 82. For the date, see G. Orioli, "La 'Vita Sancti Apolenaris' di Ravenna e gli antece-

denti storici dell'organizzazione ecclesiastica ravennate," *Apollinaris* 59 (1986), 251–67. An obscure new edition is difficult to obtain: Mario Pierpaoli, ed. *La "Passio" di Sant'Apollinare e Canone Bizantino* (Felina: Edizioni Valleripa, 1989). For older literature: Sandra Orienti, "Apollinare, vescovo di Ravenna," *Bibliotheca Sanctorum* 2 (Rome: Istituto Giovanni XXIII nella Pontificia Università Lateranense, 1962), 239–48. Suitbert Benz, *Der Rotulus von Ravenna nach seiner Herkunft und seiner Bedeutung für die Liturgiegeschichte kritisch untersucht*, Liturgiewissenschaftliche Quellen und Forschungen, 45 (Münster: Aschendorff, 1967), 31–36.

3. Thomas E. A. Dale, *Relics, Prayer, and Politics in Medieval Venetia: Romanesque Painting in the Crypt of Aquilea Cathedral* (Princeton: Princeton University Press, 1997), esp. 7–11.

4. "... sepultus est foris muros Classis in arca saxea a discipulis suis: quae arca sub terra missa est propter metum paganorum." *Passio* 35, *Acta Sanctorum*, Iulii 5 (Antwerp 1727), 350.

The ninth-century history of the bishops of Ravenna by Agnellus Ravennas, with some support from extant inscriptions, tells us that the building was begun under St. Ursicinus (bishop of Ravenna 533–36), sponsored financially by the merchant Julianus Argentarius,[5] and consecrated by bishop Maximian (546?–ca. 554)[6] on 7 May 545.[7] An outdoor plaque on one side of the building seems to mark the site of the original underground stone coffin. Here, too, Apollinaris is called a confessor; perhaps it reproduces an older inscription that used this term, and perhaps that older inscription was what Chrysologus was referring to when he preached, "let no one, because of the word 'confessor,' believe him to be less than a martyr."[8] The body was apparently moved to a more prominent place in the church by Archbishop Maurus (642–71), perhaps as a symbolic gesture in support of his lifelong effort to "liberate his church from the yoke of servitude to Rome."[9] Since then, although the exact date is disputed, the body has been translated inside the city of Ravenna, to what was originally the palace chapel of the Ostrogothic king Theodoric (493–526)—a building that has been known ever since as Sant'Apollinare Nuovo.[10]

Evidence from Liturgical Texts

Early liturgical texts from Ravenna are scarce. In the surviving medieval manuscripts from the area, the local rite of Ravenna has largely been supplanted by the standard medieval Roman rite with its Gregorian chant, a product of the Carolingian era.[11] In this Roman-Gregorian tradition the feast of St. Apollinaris (23 July) is first attested in the earliest Roman gospel books, which represent a seventh-century state of liturgical development.[12] Perhaps the feast was introduced in Rome at the time Pope Symmachus (498–514) established an oratory in the basilica of St. Andrew next to old St. Peter's, or when Pope Honorius (625–38) built an oratory to Apollinaris in the portico of St. Peter's itself, and ordered that a procession on Saturdays begin from there.[13] These chapels at St. Peter's should not be confused with the Church of S. Apollinare alle Terme Neroniane-Alessandrine which still stands near Piazza Navona, and is now the home of a Pontifical Institute operated by Opus Dei.[14]

After the gospel books, the next oldest sources for the Roman rite are the manuscripts of the *Antiphonale*

5. Concerning whom, see S. J. B. Barnish, "The Wealth of Iulianus Argentarius: Late Antique Banking and the Mediterranean Economy," *Byzantion* 55 (1985), 5–38.

6. On the reign dates for bishops of Ravenna, I am following: Agnellus von Ravenna, *Liber Pontificalis / Bischofsbuch*, 2 vols., trans. by Claudia Nauerth, Fontes Christiani, 21 (Freiburg: Herder, 1996) 1:31–41. Also of interest, although it cites no sources, is Mario Pierpaoli, *Cronologia ravennate: Eventi storici dal 217 a.C. al 1900* (Ravenna: Longo, 1999).

7. Agnelli Ravennatis, *Liber pontificalis ecclesiae Ravennatis* 63 and 77, ed. by Deborah Mauskopf Deliyannis, Corpus Christianorum, Continuatio Mediaeualis, 199 (Turnhout: Brepols, 2006), 232–33, 244–45. Translation from: Agnellus of Ravenna, *The Book of Pontiffs of the Church of Ravenna*, trans. by Deborah Mauskopf Deliyannis (Washington, D.C.: Catholic University of America Press, 2004) 178–79, 190–92. For the inscriptions see especially Julius Kurth, *Die Wandmosaiken von Ravenna*, 2nd ed. (Munich: Piper, 1912) 201–3.

8. For the inscription, see Giuseppe Cortesi, *Classe paleocristiana e paleobizantina* (Ravenna: Sirri, 1980), 32–33. For the apparent location of the stone coffin, see Mario Mazzotti, *La Basilica di Sant'Apollinare in Classe*, Studi di Antichità Cristiana, 21 (Vatican City: Pontificio Istituto di Archeologia Cristiana, 1954), 36.

9. Agnellus, *Liber pontificalis* 114, ed. by Deliyannis, 284–6; trans. by Deliyannis in *Book of Pontiffs*, 231–33, quote from 233.

10. Mazzotti, *Basilica* (as in note 8), 223–38.

11. Kenneth Levy, "Ravenna chant," *The New Grove Dictionary of Music and Musicians*, 2nd ed., ed. by Stanley Sadie (London: Macmillan, 2001), 20:878–79. Francesco Balilla Pratella, *Pergamene di musica medievale: con notazione neumatica trovate a Ravenna, sec. XI–XIV*, ed. by Domenico Tampieri (Ravenna: Longo, 1994). Giovanni Montanari, "Culto e liturgia a Ravenna dal IV al IX secolo" (1992), repr. in G. Montanari, *Ravenna: l'iconologia: Saggi di interpretazione culturale e religiosa dei cicle musivi* (Ravenna: Longo, 2002), 87–138.

12. Theodor Klauser, *Das römische Capitulare Evangeliorum: Texte und Untersuchungen zu seiner ältesten Geschichte*, I: *Typen*, 2nd ed., Liturgiewissenschaftliche Quellen und Forschungen, 28 (Münster: Aschendorff, 1972), 32, 184.

13. Theodor Mommsen, ed., *Libri Pontificalis Pars Prior*, Monumenta Germaniae Historica, Gestorum Pontificum Romanorum, 1 (Berlin: Weidmann, 1898), 122–23, 171–2. Raymond Davis, *The Book of Pontiffs (Liber Pontificalis): The Ancient Biographies of the First Ninety roman Bishops to A.D. 715*, Translated Texts for Historians, 6, rev. ed. (Liverpool: Liverpool University Press, 2000), 47, 66. Elisabeth Will, *Saint Apollinaire de Ravenne*, Publications de la Faculté des Lettres de l'Université de Strasbourg, 74 (Paris: Belles Lettres, 1936), 46–58.

14. The latter church, it is often said, first appears in the historical record when it was rebuilt from spolia by Pope Hadrian I

FIG. I. Communion antiphon *Semel juravi* for St. Apollinaris, from Ms. Baltimore, Walters Art Museum,
w. 11, fol. 181ᵛ, 1st half of the 11th century (photo: ©The Walters Art Museum, Baltimore).

Missarum, containing the proper chants for the Mass (eighth-ninth centuries). Most of the chant texts for St. Apollinaris are taken from the common of bishops, which means they are generic in content, applicable to any bishop saint. The one exception is the communion antiphon *Semel juravi*, which in the earliest sources is used only for St. Apollinaris.[15] That suggests it may have been composed specifically for him, although we cannot tell whether it is a Roman composition or a rare Ravennate text that survived only because it was imported into the Roman rite. Figure 1 shows the earliest manuscript from the Ravenna area in which this text is supplied by musical neumes (eleventh century).[16] The melody, however, is essentially the same as in Gregorian chant manuscripts from other parts of Europe, dating back to the tenth century. Even though the melody, too, could have come from Ravenna, we cannot confirm that it did.

The text of *Semel juravi* is taken over with little change from Psalm 88—not in the Vulgate or "Gallican" Psalter[17] (see Tables 1–2), but in the local pre-Vulgate text known as the Roman Psalter, which differs from the Vulgate by only one word in the passage[18] (though the Vulgate text was also known in Rome).[19]

(772–95). A. Trinci, "S. Apollinares," *Lexicon Topographicum Urbis Romae*, ed. by Eva Margareta Steinby, 1 (Rome: Quasar, 1993), 48. But see Raymond Davis, *The Lives of the Eighth-Century Popes (Liber Pontificalis): The Ancient Biographies of Nine Popes from A.D. 715 to A.D. 817*, Translated Texts for Historians 13, (Liverpool: Liverpool University Press, 1992), 154, 201, 210.

15. René Hesbert, *Antiphonale Missarum Sextuplex* (Brussels: Vromant, 1935), 142–43.

16. Ms. Baltimore, Walters Art Museum, w. 11, fol. 181ᵛ. Giovanni Montanari, "Sul Messale del monastero di Ranchio (Walters Art Gallery, Baltimora, Ms. w. 11)" (1984) repr. in Montanari, *Ravenna: l'iconologia*, 277–90. Giampaolo Ropa, "Su alcuni libri liturgici medioevali attribuiti a Pomposa-Ravenna," *La Bibliofilia* 85 (1987), 187–200. Anselm Strittmatter, "Notes on an Eleventh-Century Missal, Walters Manuscript 11," *Traditio* 6 (1948),

328–40. *Le graduel romain: Édition critique par les moines de Solesmes* 2: *Les sources* (Solesmes 1957), 29. There is uncertainty about the date in Klaus Gamber, *Codices Liturgici Latini Antiquiores*, 2nd ed., Spicilegii Friburgensis Subsidia, 1 (Freiburg: Universitätsverlag, 1968), 2: p. 540, no. 1465 and *Supplementum / Ergänzungs- und Registerband* (1988), 139.

17. *Biblia Sacra iuxta Latinam Vulgatam Versionem ad codicum fidem*, ed. by Monachi Abbatiae Pontificiae Sancti Hieronymi in Urbe, 10: *Liber Psalmorum ex Recensione Sancti Hieronymi* (Rome: Typis Polyglottis Vaticanis, 1953), 202–3.

18. In Psalm 88:38, *sedis* or *sedes* in place of *thronus*. Robert Weber, ed., *Le Psautier romain et les autres anciens psautiers latins: Édition critique*, Collectanea Biblica Latina, 10 (Rome: Abbaye Saint-Jérome and Vatican City: Libreria Vaticana, 1953), 221.

19. See Peter Jeffery, *Translating Tradition: A Chant Historian*

TABLE 1. THE COMMUNION ANTIPHON COMPARED WITH ITS BIBLICAL SOURCE.

VULGATE PSALM 88 [= HEBREW 89]	COMMUNION ANTIPHON FOR ST. APOLLINARIS
36 *semel iuravi in sancto meo si David mentiar*	*Semel juravi in sancto meo*
37 *semen eius in aeternum manebit*	*semen ejus in eternum manebit*
38 *et thronus eius sicut sol in conspectu meo*	*et sedes ejus sicut sol in conspectu meo*
et sicut luna perfecta in aeternum	*et sicut luna perfecta in eternum*
et testis in caelo fidelis	*et testis in celo fidelis.*
diapsalma	

TABLE 2. ENGLISH TRANSLATION OF PSALM 88:36–38 (Douai-Reims Challoner).
(*The bracketed words are omitted from the communion antiphon*).

36 *Once have I sworn by my holiness:* [*I will not lie unto David:*]

37 *his seed shall endure for ever.*

38 *And his throne as the sun before me:*

and as the moon perfect for ever,

and a faithful witness in heaven.

On the face of it, it is hard to see why this would be an appropriate text for St. Apollinaris. Many Gregorian chant texts derive from the Psalms, but why were these particular verses selected, out of all possible choices? Psalmodic sentiments like "his seed shall endure forever" are common in Gregorian chant, but why the sun and the moon? The phrase "a faithful witness [*testis*] in heaven" may refer to Apollinaris' status as a martyr (from a Greek word for "witness"). But all martyrs and saints are in heaven, and Gregorian chant texts do not typically emphasize this fact. Hagiographical writings about Apollinaris do not mention the sun,

the moon, or the heavens. Instead, they emphasize his sufferings, his miraculous healings, and his relationship to Peter.[20] The Mass prayers and office antiphons that survive for the feast of St. Apollinaris, being based on the same hagiographical texts, tend to emphasize the same themes.[21]

The Grave-Church of St. Apollinaris

For the answer, then, I propose we turn instead to the original cult site, the church of Sant'Apollinare in Classe, where the morning sun shines brightly through

Reads 'Liturgiam Authenticam.' (Collegeville, Minnesota: Liturgical Press, 2005), 48–51.

20. *Acta Sanctorum*, Iulii 5 (Antwerp 1727), 328–85.

21. For the Mass prayers, see Nicholas Orchard, "The Medieval Masses in Honour of St Apollinaris of Ravenna," *Revue Bénédictine* 106 (1996), 172–84. Jean Deshusses, *Le sacramentaire grégorien: ses principales formes d'après les plus anciens manuscrits: Edition comparative, 2: Textes complémentaires pour la messe*, 2nd ed., Spicilegium Friburgense, 24 (Fribourg: Éditions universitaires, 1988), 313. Ugo Facchini, *San Pier Damiani: L'Eucologia e le preghiere: Contributo alla storia dell'eucologia medievale: Studio critico e liturgico-teologico*, Bibliotheca "Ephemerides Liturgicae" "Sub-

sidia," 109 (Rome: Edizioni Liturgiche, 2000), 498–505. For the office antiphons, see René Hesbert, *Corpus Antiphonalium Officii*, 6 vols. Rerum Ecclesiasticarum Documenta, Series Maior: Fontes, 7–12 (Rome: Herder, 1963–79), 1:269 (the Roman office), 2: 501–3 (the Benedictine office), with the complete antiphon and responsory texts printed alphabetically in vols. 3 and 4. The set of proper Mass chants for St. Apollinaris that is appended to the writings of St. Peter Damian (1007–72) in Vatican Ms. lat. 3797, fols. 374ᵛ–75ᵛ (11th or 12th century) exhibits literary dependence on the *Passio*. However, it appears to be a recent composition, not a vestige of the early Ravenna liturgy, since it includes tropes and a sequence.

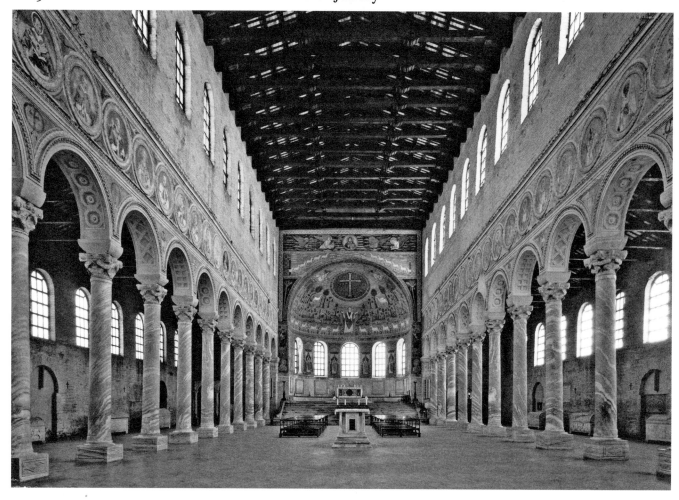

FIG. 2. Sant'Apollinare in Classe, interior (photo: Scala / Art Resource, N.Y.).

the windows of the apse, which face northeast (Fig. 2). The apse mosaic appears to date from the original sixth-century construction of the building, while many other details are of later origin. For example, the arch mosaic, with the symbols of the four evangelists and the lambs processing from Jerusalem and Bethlehem, dates from at least the seventh century, although it recapitulates some themes from the sixth-century apse mosaic.[22]

The iconography of the apse mosaic is complicated, and has received multiple interpretations. Appropriately, most of these interpretations delve into early Christian theology and iconography, and some into the politics of the age of Justinian I (527–65). None, however, take the sunlight or much of the liturgical data into account.[23] The symbolism is fundamentally theophanic, since—as all have recognized—the dominant imagery represents the Transfiguration

22. Friedrich Wilhelm Deichmann, *Ravenna: Geschichte und Monumente*, 1 (Wiesbaden: Franz Steiner, 1969), 277; 2/2 (1976), 279–80. Maria Cristina Pelà, *La Decorazione musiva della basilica ravennate di S. Apollinare in Classe*, Studi di antichità cristiane, 8 (Bologna: Riccardo Pàtron, 1970), 41–46, 106–11, diagram following p. 180.

23. Kurth, *Wandmosaiken* (as in note 7), 203–11. Carl-Otto Nordström, *Ravennastudien: Ideengeschichtliche und ikonographische Untersuchungen über die Mosaiken von Ravenna*, Figura: Studies Edited by the Institute of Art History, University of Uppsala, 4 (Stockholm: Almqvist & Wiksell, 1953), 122–32. Giuseppe Bovini, *Chiese di Ravenna*, Musei e Monumenti (Novara: Istituto Geografico de Agostini, 1957), 148–54. Deichmann, *Ravenna* 2/2: 247–72. Otto Demus, "Zu den Apsismosaiken von

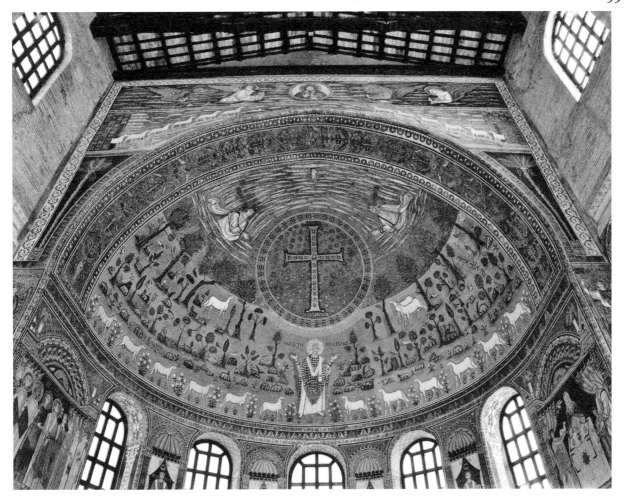

FIG. 3. Sant'Apollinare in Classe, apse mosaic (photo: Cameraphoto Arte, Venice / Art Resource, N.Y.).

(Fig. 3).[24] A golden cross inlaid with pearls and gems, standing in a starry sky and surrounded by a gloriole, is flanked in the clouds by two prophets: a clean-shaven Moses and a bearded Elijah. On the ground are three lambs representing Peter, James, and John, the three disciples who witnessed the Transfiguration

Sant'Apollinare in Classe," *Jahrbuch der Österreichischen Byzantinistik* 18 (1969), 229–38. Alberto Pincherle, "Ancora sul mosaico absidale di S. Apollinare in Classe," *Rivista di Archeologia Cristiana* 52 (1976), 109–13. Helen J. Dow, "The Apse Mosaic of S. Apollinare in Classe," *Proceedings of the Patristic, Mediaeval and Renaissance Conference* 4 (1979), 35–40. Claudia Müller, "Das Apsismosaik von S. Apollinare in Classe: Eine Strukturanalyse," *Römische Quartalschrift* 75 (1980), 11–50. D. Giovanni Montanari, "L'abside di S. Apollinarie in Classe di Ravenna: Mistero centrale, anamnesi ed eucarestia," in *Miscellanea di studi artistici e letterari in onore di + Giovanni Fallani in occasione del XXV di Presidente*, ed. by Dante Balboni (Naples: Antonino De Dominicis, 1982), 99–127. Otto G. von Simson, *Sacred Fortress: Byzantine Art and Statecraft in Ravenna*, 2nd ed. (Princeton: Princeton University

Press, 1987), 40–62. Alain Riffaud, *Lecture de Ravenne: Décor et discours* (Le Mans: Création et Recherche, 1994), 101–24. Luise Abramowski, "Die Mosaiken von S. Vitale und S. Apollinare in Classe und die Kirchenpolitik Kaiser Justinians," *Zeitschrift für antikes Christentum* 5 (2001), 289–341. Angelika Michael, *Das Apsismosaik von S. Apollinare in Classe: Seine Deutung im Kontext der Liturgie*, Europäische Hochschulschriften, Series 23: Theologie, Vol. 799 (Frankfurt am Main: Lang, 2005). The Michael book is particularly notable for offering an "interpretation in the context of the liturgy" that cites patristic statements *about* the liturgy, but very few actual liturgical texts.

24. See André Grabar, *Martyrium: Recherches sur le culte des reliques et l'art chrétien antique*, 2: *Iconographie* [Paris:] Collège de France, 1946). Christa Belting-Ihm, "Theophanic Images of

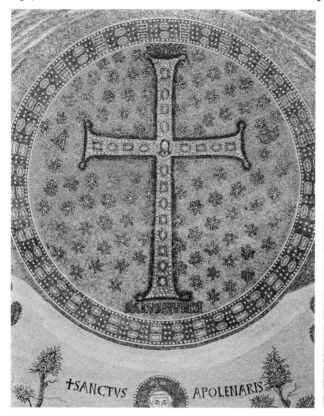

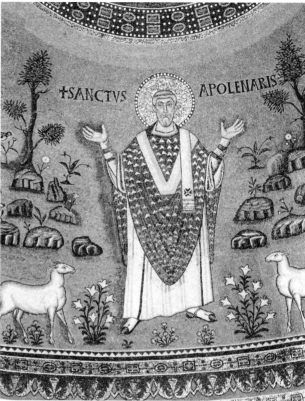

FIG. 4. Sant'Apollinare in Classe, detail of apse mosaic (photo: Scala / Art Resource, N.Y.).

FIG. 5. Sant'Apollinare in Classe, detail of apse mosaic (photo: Cameraphoto Arte, Venice / Art Resource, N.Y.).

(Mark 9:2). The cross, of course, represents the transfigured Son of God (Fig. 4): a medallion with the bust of Jesus can be seen at the center, while the arms of the cross bear Christological inscriptions: ΙΧΘΥΣ (above), Alpha and Omega (left and right), "Salus Mundi" (below).[25] The hand of God (the Father) can be seen above the gloriole at the very top of the conch.

Beneath the cross, standing on solid ground, is St.

Apollinaris himself, vested as a bishop in alb (with the narrow banded sleeves), ankle-length *tunica talaris* with wide sleeves and *clavi* (vertical stripes indicating high rank), paenula (chasuble, signifying priesthood), and pallium (the narrow white woolen cloth with a black cross, worn only by bishops), standing in the orant position of early Christian prayer (Fig. 5).[26] Like the cross, he too is flanked by sheep, six on each

Divine Majesty in Early Medieval Church Decoration," *Italian Church Decoration of the Middle Ages and Early Renaissance: Functions, Forms, and Regional Traditions: Ten Contributions to a Colloquium held at the Villa Spelman, Florence*, Villa Spelman Colloquia, 1, ed. by William Tronzo (Bologna: Nuova Alfa, 1989), 43–59. Christine Milner, "The Role of the Prophet Elijah in the Transfiguration Mosaics at Sinai and Classe," *Byzantinische Forschungen* 24 (1997), 207–17. Andreas Andreopoulos, *Metamorphosis: The Transfiguration in Byzantine Theology and Iconography* (Crestwood, N.Y.: St Vladimir's Seminary Press, 2005), esp. 117–25.

25. "Salus Mundi," of course, means "the salvation of the world." ΙΧΘΥΣ, which is Greek for "fish," is also the acronym of a Greek expression that means "Jesus Christ, Son of God, Savior."

See E. Sauser, "Fisch," *Lexikon der christlichen Ikonographie*, ed. by Engelbert Kirschbaum et al., 2 (Rome: Herder, 1970) 35–39. J. Engemann, "Fisch, Fischer, Fischfang," *Reallexikon für Antike und Christentum*, ed. by Theodor Klauser et al., 7 (Stuttgart: Anton Hiersemann, 1969), 959–1097, esp. 1091–95.

26. For an introduction to vestment terminology, see Jane Hayward, "Sacred Vestments as They Developed in the Middle Ages," *The Metropolitan Museum of Art Bulletin*, 29/7 N.S. (March 1971), 299–309. On the orant position, see André Grabar, *Christian Iconography: A Study of its Origins*, Bollingen Series 35 (Princeton: Princeton University Press, 1968), 74–76, 94–95, and accompanying illustrations.

side. The number suggests the twelve apostles, which would duplicate the three who are witnessing the Transfiguration farther up. But it would make more sense to follow medieval interpretations that present Apollinaris as a shepherd. The twelve sheep would then represent the Christian community of Ravenna, the bishop's flock. Shepherd imagery is used of Apollinaris as far back as Chrysologus, whose words may even have inspired this mosaic:

> Behold he lives. Behold, like a good shepherd he stands by amid his flock, nor is he ever separated in spirit [from us whom] he has temporarily gone before in the body. He has gone before [us], I say, in his fleshly attire; in another way the dwelling of his body reposes among us. The devil is extinct; the persecutor lies dead. Behold he reigns and lives who desired to be killed for his king.[27]

The final stanza of a sequence (a type of hymn) in a sixteenth-century Ravenna manuscript expresses a similar sentiment,[28] but also suggests the juxtaposition of Apollinaris with the transfigured Christ that is above him in the mosaic (Table 3).

The lush environment of grass, flowers, trees, and birds has been interpreted as paradisiacal, but a new book argues that it faithfully represents the local species of flora and fauna that were native to the area as late as the time of Dante.[29] If so, then we are less in Paradise or on Mount Tabor than in Classis, as present in the physical surroundings as the martyred bishop's own venerated body. Theophanic experiences recalling the Transfiguration can happen even here, and even to people like us, the sheep of his flock. Between the windows are represented four later bishops of Ravenna, from left to right they are: Ecclesius (522–32), Severus (fourth century), Ursus (d. 396), and Ursicinus (533–36).[30] The presence of these four underneath the image of Apollinaris, combined with the fact that most of the early bishops of Ravenna were buried in this building, sends a clear message: When gathered in this church, the flock of Ravenna is surrounded by its shepherds, in a continual tradition of ecclesiastical governance going back to the martyred founder.[31]

Early Christian Vigil Services

The sixth-century combination of a martyr's body, a Transfiguration, and windows that let in the rising sun has many antecedents in earlier Christian worship.[32] Christians in the early centuries made much use of

TABLE 3. THE FINAL STANZA OF THE SEQUENCE.

Iam conregnans summo regi,	*Now co-reigning with the supreme king,*
Pie pastor, parce gregi,	*Merciful shepherd, spare our flock.*
Ne sibi nos incorporet	*Nor let the lion seeking someone to devour*
Leo quaerens, quem devoret.	*join us to himself.*

27. "Ecce uiuit, ecce ut bonus pastor suo medius adsistit in grege, nec umquam separatur spiritu, qui corpore praecessit ad tempus. Praecessit, dico, habitu; cetero ipsa inter nos corporis sui habitatio requiescit. Extinctus est diabolus, persecutor obcubuit; ecce regnat et uiuit, qui pro rege suo desiderauit occidi." Chrysologus, *Sermo,* 128.3, ed. by Olivar, p. 791; ed. by Banterle et al., p. 34 and cf. n. 9 p. 35.

28. *Analecta Hymnica Medii Aevi,* ed. by Clemens Blume and Guido M. Dreves, Vol. 42 (Leipzig: O. R. Reisland, 1903), 163. The last two lines allude to 1 Peter 5:8.

29. Enzo Pezzi, Isotta Fiorentini Roncuzzi, and Arnaldo Roncuzzi, *Sant'Apollinare in Classe di Ravenna e il suo bosco perduto / S. Apollinare in Classe in Ravenna and its lost wood* (Ravenna: Longo,

2008). Compare Azelio Ortali, *Gli Uccelli nei mosaici bizantini* (Ravenna; Girasole, 1997), 81–82.

30. Good color reproductions, though not in the correct order, in: Giuseppe Bovini and Mario Pierpaoli, *Ravenna: Tesori di luce* (Ravenna; Longo, 1990), Pls. 92–95, compare Pl. 84. Rafaella Farioli, *Ravenna romana e bizantina* (Ravenna: Longo, 1977), Pls. 186–87, 190–91. For discussion, see Deichmann, *Ravenna* 2/2: 262.

31. Compare the lost apse mosaics of the medieval cathedral of Ravenna. An eighteenth-century drawing is reproduced in Paola Novara, *La cattedrale di Ravenna: Storia e archeologia* (Ravenna: Danilo Montanari, 1997), 95.

32. To be described at length in my forthcoming book, *They*

the sunrise as a kind of natural metaphor for theophany. Not only did they pray facing east, a custom preserved in the orientation of many ancient and medieval church buildings, but they often kept long nocturnal vigils that ended at sunrise. Such vigils were already practiced by the Therapeutae, a first-century Hellenized Jewish monastic group described by Philo of Alexandria, which early Christian readers identified as a Christian group.[33] Christian worship became so identified with the nighttime that a third-century apologist put these words in the mouth of a fictional pagan challenger:

> I know not whether these things are false; certainly suspicion is applicable to secret and nocturnal rites;... For why do they endeavor with such pains to conceal and to cloak whatever they worship, since honourable things always rejoice in publicity, while crimes are kept secret? ... The lonely and miserable nationality of the Jews worshipped one God, and one peculiar to itself; but they worshipped him openly, with temples, with altars, with victims, and with ceremonies.[34]

Actually nocturnal vigils were not unknown to the Jews, as Philo shows. But Christians added elements of their own, particularly the use of tombs as places of assembly. Of course Jews also honored and still honor the tombs of Biblical heroes; but Christians were unrestrained by Jewish concerns about impurity rising from contact with dead bodies. All the essential elements appear already in the second epistle of Peter, probably "the latest composition of the N[ew] T[estament], written sometime in the first quarter of the [second] century."[35] The author presents himself as an aged St. Peter, uttering his last valedictory at the approach of death. Yet his body is a reminder to stay awake and remember his life:

> I think it right, as long as I am in this body, to arouse [*diegeirein*] you by way of reminder, since I know that the putting off of my body will be soon, as our Lord Jesus Christ showed me. And I will see to it that after my departure you may be able at any time to recall these things.

Staying awake and remembering has an eschatological element; it is a kind of anticipation of the second coming of Christ himself.

> For we did not follow cleverly devised myths when we made known to you the power and coming [*parousian*] of our Lord Jesus Christ, but we were eyewitnesses of his majesty.

The ideal imagery for imagining this second coming is the Transfiguration:

> For when he received honor and glory from God the Father and the voice was borne to him by the Majestic Glory, "This is my beloved Son, with whom I am well pleased," we heard this voice borne from heaven, for we were with him on the holy mountain.

The divine Son whom the Apostles saw directly will henceforth be known in the reading of the Scriptures, which should be heard attentively, as if waiting by lamplight for the sunrise.

> And we have the prophetic word made more sure. You will do well to pay attention [*prosechontes*] to this as to a lamp shining in a dark place, until the day dawns and the morning star rises in your hearts. First of all you must understand this, that no prophecy of scripture is a matter of one's own interpretation, because no prophecy ever came by the impulse of man, but men moved by the Holy Spirit spoke from God.[36]

The Gospel of Luke employs similar imagery: in what may be adaptations of early Christian hymns, the incarnate Jesus is called "the dawn from on high [which] will visit us" (Luke 1:78) and "a light for rev-

Saw His Glory: How Judaism and Christianity Separated, as Told in their Most Ancient Hymns.

33. Peter Jeffery, "Philo's Impact on Christian Psalmody," *Psalms in Community: Jewish and Christian Textual, Liturgical, and Artistic Traditions*, ed. by Harold W. Attridge and Margot E. Fassler, Society of Biblical Literature Symposium Series 25 (Leiden: E. J. Brill and Atlanta: Society of Biblical Literature, 2003), 147–87.

34. M. Minucius Felix, *Octavius*, 9.4, 10.2, 10.44, ed. by Karl Halm in *Corpus Scriptorum Ecclesiasticorum Latinorum*, 2 (Vienna: Gerold, 1867), 13–14. Translation from *Ante-Nicene Fathers*, ed. Alexander Roberts et al. (New York: Scribner, 1899), 4:177–78.

35. John H. Elliott, "Peter, Second Epistle of," *The Anchor Bible Dictionary*, ed. by David Noel Freedman et al. (New York: Doubleday, 1992), 5:282–87, quote from 287 column b.

36. 2 Peter 1:13–20, Revised Standard Version, 2nd ed.

elation to the gentiles, and for glory to your people Israel," which permits those who have waited for the Messiah to "depart in peace" (1:32, 29). Luke's Transfiguration is a night vigil: it happens while Jesus is praying on an eighth day (i.e., Sunday), and the apostles struggle to stay awake (Luke 9:28–32). Matthew's account does not have these elements (Matthew 17:1–8), but he does tell the story of the wise and foolish virgins awaiting the eschatological Bridegroom by night with lamps (25:1–13).

It appears that Church authorities began suppressing sun symbolism in the fifth century, as in the famous sermon wherein Pope Leo the Great (440–61) admonished his congregation not to bow to the sun before entering St. Peter's basilica on Christmas morning (discussed below). I should like to propose, however, that such practices may have survived a bit longer at the tomb of St. Apollinaris than elsewhere, and that the Gregorian chant text of the communion antiphon may preserve a memory of this.

An extended description of a vigil, waiting for dawn with lamps by the tomb of a saint, comes to us in a letter of the highly literate fifth-century Gallo-Roman Sidonius Apollinaris, no relation to the martyred bishop of Ravenna.

> We had gathered at the tomb of St. Justus … [where] the anniversary celebration of the procession before daylight was held. There was an enormous number of people of both sexes, too large a crowd for the very spacious basilica to hold even with the expanse of covered porticoes that surrounded it. After the vigil service was over, which the monks and clergy had celebrated together with alternating strains of sweet psalmody (*alternante mulcedine … psalmicines*), everyone withdrew in various directions, but not far, as we wanted to be present at the third hour [the next morning] when mass was to be celebrated by the priests.
>
> Because of the cramped space, the pressure of the crowd, and the [heat of] numerous lights brought in [by the procession], we were absolutely gasping for breath. Moreover, imprisoned as we were under the

roof, we were broiled by the heat of what was still almost a summer night, although just beginning to be touched with the coolness of an autumn dawn.

> So when groups of various classes were dispersing in different directions, the leading citizens resolved to go in a body to the tomb of Syagrius, which was not quite a full bowshot away. Here some of us sat down under the shadow of a full-grown vine whose overarching foliage made a shady canopy formed by tall stems that drooped over in an interlaced pattern; others of us sat down on the green turf, which was also fragrant with flowers.
>
> Conversation ensued, pleasant, jesting, bantering, and a specially happy feature in it was that there was no mention of officials or of taxes…; certainly everyone could have told freely any story worth relating and worthy in its sentiments. The audience listened in a spirit of eager rivalry; and the story-telling, though tinged with hilarity, was not on that account formless.
>
> By and by, having for some time felt sluggish for want of exertion, we resolved to do something energetic. Thereupon we raised a twofold clamour demanding according to our ages either ball or gaming-board, and these were soon forthcoming. I was the leading champion of the ball; for, as you know, ball no less than book is my constant companion. On the other hand, our most charming and delightful brother, Dominicus, had seized the dice and was busy shaking them as a sort of trumpet-call summoning the players to the battle of the box….
>
> Well, when we had sat down the pouring sweat next prompted him to ask for water to bathe his face…. While he was drying his cheeks in leisurely fashion he remarked: "I wish you could command to be written for me a quartet of verses in honor of this towel that has done me such service."… Without further delay, I next called to my side his secretary, who had his writing tablet ready to hand, and without more ado composed the following epigram: ….
>
> Scarcely had our good friend Epiphanius the secretary written the above lines than it was announced that the bishop, at the beckoning of the appointed hour, was proceeding from his lodging, and so we arose….[37]

37. Sidonius Apollinaris to Eriphius of Lyons, *Epistolae*, 5.17.3–11; ed. by André Loyen, *Sidoine Apollinaire* 2: (Correspondance, *Livres I–V*) 2nd ed., Collection des universités de France publiée sous le patronage de l'Association Guillaume Budé, 696

In time, this remarkably casual attitude gave way to liturgical structures that were designed to last all night; conversation was replaced by prayer, poetry by psalmody, games and sports by kneeling and prostrations. Thus in the medieval rite of Milan, the vigil on saints' days included all 150 psalms.[38] In Ethiopia the vigil for saints' days came to include all 15 canticles of the Old and New Testaments.[39] At the same time, throughout the Middle Ages we find stories of individuals taking it on themselves to pray all night before a saint's tomb, without following any particular liturgical ordo.

Vigil Services at Ravenna

Was it once common to hold nighttime vigils at the tomb of St. Apollinaris in Ravenna? The pre-Carolingian rite of Ravenna is too poorly preserved for us to be able to tell.[40] Yet the ninth-century author Agnellus, who wrote the Ravenna *Liber pontificalis*, mentions nocturnal vigils many times, and at many locales in the city. For example St. Datus, the seventh bishop after Apollinaris, seems to have been particularly devoted to keeping vigils.

He indeed was a religious man and very dutiful and vigilant about night prayers [*vigilansque nocturnis fuit orationibus*].[41]

In fact, a readiness to spend entire nights in prayer seems essential to Agnellus' idea of a model bishop.[42] In this way bishop John I saved Ravenna from Attila the Hun, and Maximian almost saved Ravenna from papal domination by praying over the body of St. Andrew.[43] People holding vigils often encountered the saints: mysterious apparitions clad in angelic white robes who reveal the whereabouts of miraculous icons[44] or prevent theft.[45] St. Peter and St. Apollinaris appeared with St. Peter Chrysologus to Pope Sixtus, to tell him who was the rightful bishop of Ravenna.[46] Agnellus personally knew a man who was healed of a childhood disease while his mother kept vigil at the tomb of St. Severus, another early Ravenna bishop. While the child saw a grey-haired man with an angelic face, clad in episcopal garb, everyone else saw unlit candles miraculously bursting with light.[47] There are other unusual experiences with nocturnal light in the *Liber pontificalis* of Ravenna. Empress Galla Placidia prayed as long as the candles lasted;[48] a gem-encrusted sarcophagus shone brightly enough to illuminate the church all night.[49] Strange lights foretold trouble.[50] Agnellus himself praised the mosaics in the

(Paris: Belles Lettres, 2003), 201–4; translation from Robert Taft, *The Liturgy of the Hours in East and West: The Origins of the Divine Office and Its Meaning for Today*, 2nd rev. ed. 1993) 184–5.

38. Peter Jeffery, "Eastern and Western Elements in the Irish Monastic Prayer of the Hours," *The Divine Office in the Latin Middle Ages: Methodology and Source Studies, Regional Developments, Hagiography, Written in Honor of Professor Ruth Steiner*, ed. by Margot E. Fassler and Rebecca A. Baltzer (Oxford University Press, 2000), 99–143, see 102–3 and 135 n. 15.

39. Taft, *Liturgy of the Hours* (as in note 37), 265–66. Bernard Velat, *Études sur le Me'erāf: Commun de l'office divin éthiopien*, Patrologia Orientalis, 33 (Paris: Firmin Didot, 1966), 40–42, 133–35 on the office of Keštat za-'aryām.

40. Interesting, although it may be a fluke: one of the few fragments we have that clearly outlines a local Ravenna liturgy is a list of readings for the night office (Matins) during Lent: Girolamo Zattoni, "Un frammento dell'antico ufficio ravennate," (1905), repr. in G. Zattoni, *Scritti storici e ravennati*, ed. by Mario Mazzotti (Ravenna: Tonini, 1975), 149–63.

41. Agnellus, *Liber* 9, ed. by Deliyannis, p. 153; trans. by Deliyannis, *Book*, 108.

42. Agnellus, *Liber* 64, 100, 116; ed. by Deliyannis, 233–35, 268–69, 287–88; trans. by Deliyannis, *Book*, 181, 216–7, 235.

43. Agnellus, *Liber* 37, 76, ed. by Deliyannis, 189–95, 243–44; trans. by Deliyannis, *Book*, 139–44, 190.

44. Agnellus, *Liber* 25, 30, 41, ed. by Deliyannnis, 171–72, 178–84, 199–201; trans. by Deliyannis, *Book*, 121–23, 128–33, 148–49.

45. Agnellus, *Liber* 36, ed. by Deliyannis, 187–89; trans. by Deliyannis, *Book*, 137–38. Cf. Agnellus, *Liber* 87, ed. by Deliyannis 254; trans. by Deliyannis, *Book*, 200.

46. Agnellus, *Liber* 49, ed. by Deliyannis, 210–13; trans. by Deliyannis, *Book*, 159–61. Cf. Agnellus, *Liber* 157, ed. by Deliyannis 333–36; trans. by Deliyannis, *Book*, 280–2.

47. Agnellus, *Liber* 16, ed. by Deliyannis, 159–60; trans. by Deliyannis, *Book*, 112.

48. Agnellus, *Liber* 41, ed. by Deliyannis, 200–201, trans. by Deliyannis, *Book*, p. 150.

49. Agnellus, *Liber* 36, ed. by Deliyannis, 187–89; trans. by Deliyannis, *Book*, 138–9.

50. Agnellus, *Liber* 101, 172, ed. by Deliyannis, 270, 352; trans. by Deliyannis, *Book*, 217, 299–300.

church of St. Apollinaris because "No church in any part of Italy is similar to this one in precious stones, since they almost glow at night just as they do in the day." [51]

Although these nocturnal experiences are frequently connected with icons, tombs, or relics, the vigil often seems to have been an individual initiative, not corporate liturgical worship. The wise bilingual notary Johannicis was asked by bishop Felix (709–25) "to set forth all the antiphons which we sing now on the Sundays of the cross or of the holy apostles or martyrs or confessors and virgins, not only in Latin speech, but also in Greek words, since he was a great orator in both tongues." But every night Johannicis prayed alone, apparently without singing any antiphons. The locked doors of the church of St. John the Evangelist opened miraculously so he could prostrate himself before an icon of the Savior, apparently in silence. [52]

For a certain unnamed man, on the other hand, nocturnal prayer experiences were directly connected to the liturgy. This man sang psalms before the morning Mass was celebrated by Bishop Damianus (ca. 691–93 to ca. 708–9), who evidently stood behind the altar facing the congregation, a practice that the bishops of Ravenna have preserved down to the present day. [53]

> There was in this city of Ravenna a very religious man of good report; and when he came to the Ursiana church, his shoulders clung to the upper part of a column of the temple on the men's side. Before the introit of the mass he sang psalms, he never had any discussions with any man, and after the entrance of the mass he always gazed at the face of the bishop [Damianus].

On a certain day the bishop ordered him to approach for the blessing of St. Apollinaris, that he might be a participant at the table of the bishop. After his stomach was filled with the feast and the fibers of his heart were replete with new wine, but with a sober mind, the bishop asked him why he always looked in his face at church. But he answered, saying, "I do not gaze at you, best of bishops, but rather at him who stands behind your back, whose beauty I can hardly bear. And when you sanctify, he stands next to you. Your face now is not like his, who is always with you at the celebration of the mass and never leaves you."

After a few days [this man] died in peace; and some heard him saying before the time of his death that on a certain Sunday, when at night everyone sang the antiphon to the benedictions and said, "Mountains and hills sang praises before God," he swore that the stones of the church, columns and slabs and bricks, the roof tiles likewise and even all the marble, also sang the said antiphon along with all the people. Therefore after this man was buried, the bishop ordered the said column to be surrounded by a small screen, lest any part of the base of the column, where the holy feet had stood, should be worn away by unworthy feet, and he ordered a small cross to be fixed there for an eternal memorial, which remains up to the present day. [54]

The antiphon mentioned here is a known Gregorian chant, typically sung at Lauds on Sundays to accompany the canticle of the Three Hebrew Children, which is what Agnellus meant here by "the benedictions." [55] Even though Lauds is theoretically the sunrise office, in this story it seems to have been sung before dawn.

51. Agnellus, *Liber* 63, ed. by Deliyannis, 232–33; trans. by Deliyannis, *Book*, 179. For a striking photo of the Sant'Apollinare interior with the golden cross glowing by candlelight in the dark, see Dmitri Kessel and Henri Peyre, *Splendors of Christendom: Great Art and Architecture in European Churches* (Lausanne: Edita S. A. Lausanne, 1964), 52–53.

52. Agnellus, *Liber* 146–47, ed. by Deliyannis, 324–26; trans. by Deliyannis, *Book*, 270–2.

53. While the positions of many altars in the medieval cathedral of Ravenna are unclear, a visitor in 1700 remarked that the main altar was reversed from the usual position so that the celebrant faced the people. This unusual arrangement was maintained

when the present cathedral was built later in the eighteenth century. See Novara, *La cattedrale* (as in note 31), 161, 75, 115, 126. In the early twentieth century, according to Will, *Saint Apollinaire* (as in note 13), 17, this was regarded as a privilege the bishop of Ravenna shared only with the Pope, who still celebrated facing the people in some of the old Roman basilicas.

54. Agnellus, *Liber* 130, ed. by Deliyannis, 305–6, trans. by Deliyannis, *Book*, 252–53 modified.

55. The full text, based on Isaiah 55:12: "Montes et colles cantabunt coram Deo laudem, et omnia ligna silvarum plaudent manibus; quoniam veniet Dominus Dominator in regnum aeternum, alleluia, alleluia." In most sources this is assigned to the second

The most interesting liturgical scene is somewhat atypical, for it involves a clergy revolt against bishop Theodore (ca. 677–79 to ca. 691–93). Nonetheless, it reveals some of the Ravenna community's conventional modes of thought, which are consistent with cultural memories of holding vigil at the tomb of St. Apollinaris. Theodore seems to have been a particularly tyrannical bishop who appropriated the wealth of the clergy, burned the manuscripts that recorded their traditional customs and privileges, and fomented division between the priests and the deacons. One year, "on the day of the vigil of the nativity of the Lord" the clergy expressed their grievances to the archpriest and archdeacon—kinsmen who, confusingly enough, were both also named Theodore. When Theodore and Theodore relayed the grievances of the priests and deacons to Bishop Theodore, he only passed the blame back to them, accusing the archpriest and archdeacon of needlessly inciting the clergy.

> In this anger all hastened to the church of St. Mary ever virgin to celebrate vigils. And after the Office was completed they reported the words of the bishop to the whole clergy; and they were indignant, and taking counsel with each other, each went to his own home.

The archpriest and archdeacon decided to have the entire clergy boycott the bishop's Mass the next morning, even though it was Christmas.

> "Let us go to the church of St. Apollinaris, and entering the house of the man from Antioch, let us stand there and there hear masses. Let no one minister with [the bishop] today. Let us cast him off, that he might not be our shepherd"….
>
> That night everyone went to the church of the blessed Virgin Mary to celebrate the rite of mass; and speaking secretly with each official, they agreed and said, "Would that it had been done earlier, that we might not have fallen into such need." But when the mass completed in the church of the Apostles, with

the rising of the dawn, when the Phoebean lights had brightened the earth, everyone hastened with one mind to the church of St. Apollinaris, which is located in the former city of Classe; and crying out they wailed with bitter spirit.

It seems that the Ravenna rite called for a vigil in the church of St. Mary (Major?)—a logical location for Christmas Eve—followed by a Mass in that location, and apparently another Mass in the church of the Apostles. To get from there to the church of Sant'Apollinare in Classe they would have had to traverse some distance,[56] but so the story goes.

> However it happened, after the ray of the sun had shone forth on the earth, that the said bishop sent his notary according to custom, to call the priests that they might proceed to the church and celebrate the mass. When he came, he found none of them; and having returned he told [the bishop]. But he said, "Perhaps they sleep, because last night they were tired, they are still sunk in slumber."

The clergy had been up late celebrating the vigil and night Masses of Christmas eve, so the bishop assumed they were still asleep late. But an hour later things had not improved.

> [After] restraining him for about one hour of the day, again he sent the notary, and he did not find any of them, and he told [the bishop] that they were all gone. And [the bishop] said, "What is this? What time is it now? If they have not all come, let at least some of them come." But those attending him answered, one of them said to him, "Let not our lord master think otherwise than what I say: you will find none of your priests today to approach the altar with you in this celebration. And [the bishop] said, "Why?" And he said again, "Because all have traversed the Caesarean streets,[57] they have gone to St. Apollinaris, and there the priests, deacons, subdeacons, acolytes, *hostiarii*, readers, and singers are celebrating mass; with the rest of the clergy they have walked there; not even

Sunday of Advent, as the antiphon for the *Benedicite* (Daniel 3:57–88). Hesbert, *Corpus Antiphonalium Officii*, 3 (1968) (as in note 21), p. 340, number 3805.

56. See the maps in Deliyannis, *Book of Pontiffs*, pp. xii–xiii, or Luca Mozzati, *Ravenna* (Milan: Electa 1994), 10, 16–17.

57. *Caesareae calles*, Agnellus *Liber* 121, ed. Deliyannis 295. The Via Caesaris was the medieval road from Ravenna to the church of Sant'Apollinare in Classe. See Cortesi, *Classe paleocristiana*, Pianta B facing p. 65.

one of them is left; the church is empty, there is no keeper [*custos*]. They said that they were heavily afflicted, so they left."

Then he rose from the [episcopal] chair [*sella*] where he was sitting, he gave himself a blow on the forehead, saying, "Alas, I am conquered." Dragging sighs from the depth of his chest, lamenting to himself, he withdrew to his chamber. The people in the church, however, marveled, not knowing the cause of this.

The laity evidently had not been told about the clerical strike. They had dutifully assembled in the unnamed church where the Mass of Christmas morning was to take place. Meanwhile the clergy implore St. Apollinaris to appear from heaven and lead the Mass himself. It is interesting what they threaten to do if he will not. But, praying in front of the very apse mosaic we still see today, they naturally describe Apollinaris as their shepherd and advocate in heaven.

With these things being laid in place, immediately the bishop sent noble men with swift horses, so that all, satisfied, might return to the church. [The clergy], when they saw them coming toward them, got up all at once, with their faces cast down to the ground, and in a great voice, before the legates of the bishop had spoken, said:

"Turn back, since we do not have a shepherd, but a killer. When he entered this sheepfold, he promised not to do as he has done. Rise, St. Apollinaris, celebrate with us the mass of the day of the nativity of the Lord. Holy Peter gave you to us as a shepherd. Therefore we are your sheep. We gather around you, save us. You did not receive consecration here, but the apostle himself blessed you with his hands and gave you the Holy Spirit; he directed you to us, and we received your preaching. You were sent to govern, not to destroy. You stand before the most impartial judge; striver for us, break the cruel jaws of the wolf, that you might lead us through the sweet pastures of Christ. If you do not arise and celebrate mass today for this Nativity, we will all together leave your house and hasten to Rome to blessed Peter your teacher, and cast ourselves down before him with lamentation, and with great mourning and immense grief and with great sighs say, 'We went to your disciple, our leader and preacher, whom you gave to us, and he did not want to celebrate mass on such a dis-

tinguished day as the birth of the Lord. Either deliver us from him, or give us a new shepherd, who will defend us from the mouth of the serpent who lives within our walls, and will comfort our afflictions. Behold you yourself, a good shepherd, know that many of your sheep have turned astray because of great hardship and needy famine, and they have receded from the holy commandments and from your doctrine, with a most wicked leader suffocating them.' And if he will not hear us, then we will travel to Constantinople to the emperor and seek from him a father and a shepherd."

Without help from Apollinaris, the clergy of Ravenna will appeal to the Pope in Rome. But if that fails they will go to the Emperor, whom they seem to place above the Pope.

And with these words there arose such a lamentation and huge grief on every side that those who had been sent by the bishop could scarcely say anything because of the excessive tears and murmurings of all those priests, and they could not fulfill their mission.

After the noblemen returned empty-handed, the bishop consulted the exarch (*patricius*), the emperor's representative who resided in Ravenna. His complaint is heavy with shepherd imagery.

"My sheep have abandoned me, I am stripped of pastoral honor and repulsed and scorned. The flock of the Lord entrusted to me seeks another shepherd for itself; they have hastened to Classe, and having entered the church of St. Apollinaris, they accuse me before God and deride me."

The exarch, in turn, sent his own emissaries, who argued that, if the priests would only return to the bishop,

he would restore all their usages as they had been before. They however, indignant, began to weep and said, "If we go to Constantinople, we will also complain of this exarch, since he did not want to correct [the bishop] before this. We will not come, but up to the ninth hour we will wait for this blessed Apollinaris our pontiff; but if he delays, we will go to Rome."

The ninth hour would be about 3 P.M.; it might have been the time when Vespers traditionally began. The emissaries relayed these threats to the exarch and the bishop.

Then the exarch ordered trappings to be placed on his horse, he mounted it, he came to the aforesaid tomb of the martyr, and calling everyone to him, he poured out soothing and pacifying words, and he brought them back with him, promising to emend all things, as you heard above. And they came and in the same hour [*una hora*] celebrated mass and Vespers with the humbled bishop, as it was drawing toward evening.

So it was the exarch who resolved the issue, not the spirit of St. Apollinaris. Bishop Theodore found a way to exact institutional revenge, betraying Ravenna's cherished independence by submitting his see to the Pope of Rome, even though the Pope retained the right of the Ravenna clergy to elect future bishops without papal interference. The clergy rejoiced when, having finally passed away, Theodore was buried with the other Ravenna bishops in the church of Sant'Apollinare.[58]

The End of the Tradition

The fact that the entire clergy of Ravenna, gathered with single-minded purpose, could not conjure up an actual appearance by its holy martyr, however, does not seem to have been recognized as a failure in Agnellus' account. It is not clear why: we can hardy attribute to Agnellus a modern presumption that miracles no longer happen as they did in former times, and the saints help those who help themselves. But the story that Apollinaris did not appear, even though the clergy appealed to him from the time of Mass to the ninth hour, can serve as an opportunity to consider some historical questions. When and how, for example, did the early Christian interest in nocturnal graveside vigils, awaiting a transfiguring dawn, pass out of

mainstream liturgical worship, so that practices like midnight Mass and Easter sunrise services seem relatively marginal today? Pope Leo's stern admonition to his flock, delivered on Christmas morning in the year 451, is the most famous instance of a Christian leader opposing the practice of bowing to the morning sun, although the celebration of Masses in Roman cemeteries continued at least into the seventh century.[59]

We cannot fathom, dearly beloved, how great a mercy God has toward us. Yet Christians must take great care not to be ensnared again by the devil's traps.... For the ancient enemy, "transforming himself into an angel of light," does not stop laying down everywhere the snares of deception.... He knows to which one he should apply the flames of desire, to which one he should suggest the enticements of gluttony, to which one he should offer the allurements of sensuality, into which one he should pour the slime of envy.... Whenever he has observed an individual to be excessively taken with something, it is there that he looks for ways to do harm.

Of those whom he has bound more tightly,... [h]e makes use of both their abilities and their words to deceive others. Through them are promised remedies for illnesses, indications of future events, the appeasement of demons, and the dispelling of shades. To these are joined those who falsely claim that the entire condition of human life depends upon the effects of stars....

From such customs as this has the following godlessness been engendered, where the sun—as it rises at daybreak—would be worshiped from the higher elevations by certain sillier people. Even some Christians think that they behave devoutly when, before arriving at the basilica of the blessed apostle Peter (which has been dedicated to the one living and true

58. Agnellus, *Liber* 121–23, ed. by Deliyannis, 292–98, trans. by Deliyannis, *Book*, 240–46 (modified). The sarcophagus used by Theodore, though it was actually made a few centuries earlier, still survives: a good picture in Farioli, *Ravenna*, (as in note 30), Pl. 170, p. 203. Studies of Agnellus as an author, historian, and advocate of Ravenna's ecclesiastical independence include: Henri Louis Gonin, *Excerpta Agnelliana: The Ravennate Liber Pontificalis as a Source for the History of Art* (Doctor of Letters Proefschrift, Rijks-Universiteit Leiden, 1933). Ruggero Benericetti, *Il Pontificale di Ravenna: studio critico*, Biblioteca Cardinale Gaetano Cico-

gnani (Faenza: Seminario Vescovile Pio XII, 1994). Agnellus von Ravenna, *Liber Pontificalis*, trans. by C. Nauerth, 1: 9–75. Joaquín Martínez Pizarro, *Writing Ravenna: the Liber Pontificalis of Andreas Agnellus*, Recentiores: Later Latin Texts & Contexts (Ann Arbor: University of Michigan Press, 1995).

59. Pope John III (561–74) instituted masses in the cemeteries on all Sundays. Sergius I (687–701) was unstinting in celebrating cemetery masses while he was a priest. *Libri Pontificalis* (as in note 13), pp. 157, 210.

God), they climb the steps which go up to the platform on the upper level, turn themselves around towards the rising sun, and bow down to honor its shining disk.

This thing, done partly through the fault of ignorance and partly in a spirit of paganism, eats away at me and grieves me very much. Even if some of these perhaps revere the Creator of this beautiful light rather than the light itself, still we must refrain from even the appearance of this homage. When someone who has left behind the worship of the gods finds this among us, will they not bring this aspect of their former persuasion along with them, thinking it credible—upon having seen it to be something that both Christians and unbelievers hold in common?[60]

Was Leo right? The very name of St. Apollinaris suggests a link to Apollo. If sunrise vigils actually were held near the body of St. Apollinaris, were they simply a survival—superficially Christianized—of a pagan custom that was stamped out more successfully at the tomb of Apollinaris' mentor, Peter? I would not be quick to draw this conclusion: appreciating the sunlight and desiring healing are universal aspects of human experience, and the similarity of names could be a coincidence. It is interesting, however, that according to the *Passio*, in a story also mentioned by Agnellus, Apollinaris did have an encounter of sorts with his namesake.

But it happened after much time, while he was holding Mass among the Christians … a dissension about the name Apollinaris was suddenly raised by the pagans in the city. And the people, attacking him, led him bound to the forum, striking and wounding him. When the pontiffs of the Capitol saw him, they were indignant, saying, "This one is not worthy to be presented to the great god Jove, because he frequently mocked him. But let him be led to the temple of Apollo, and there let him know the power of the immortal gods." And as he was led [there], many noble men, both pagan and Christian, followed him along with the people. Thus the pagans were saying: "Let us see, therefore, if this man changes his mind." And when he came to the temple, and saw the statue of Apollo, the most blessed Apollinaris said to those who were standing by: "Is this the god by whom you take auguries?" The pagans responded and said "Indeed, he is the first among gods and the guardian of the city."

The most blessed Apollinaris responded, "May it never be well for him, but when he will be destroyed, the guardian of the Christians who dwell in this place will be the Lord Jesus Christ, who is truly God." And as he prayed the idol shattered, and the temple of the devil was destroyed.[61]

In the end, of course, Apollinaris himself became the main guardian of the city, even—as we saw—in disputes between Christians. Given his role in drawing tourist traffic to modern Ravenna, perhaps he still is in some sense a protector of the city. But his centuries of standing guard while the building was altered around him raises further questions. With all due respect to Pope Leo, how and when did the tradition of holding vigils in this space actually die out?

It is not just a question of a practice going out of use, for its very architecture was obscured. Today we can visit any morning and see this east-facing building blazing with light (Fig. 6). But almost within living memory it was not so. Nineteenth-century photographs show a much darker building, in which most of the clerestory windows have been bricked up—an alteration that is hard for us to understand, since it was made before electricity offered an alternative to natural daylight (Figs. 7–8).[62] But the lack of clarity

60. Leo Magnus, *Tractatus*, 27.34, ed. by Anton Chavasse, Corpus Christianorum, 138 (Turnhout: Brepols, 1973), 134–6; trans. by Jane Patricia Freeland and Agnes Josephine Conway in: St. Leo the Great, *Sermons, The Fathers of the Church: A New Translation* (Washington, D.C.: Catholic University of America Press, 1996), 112–13.

61. Passio, 26–27, *Acta Sanctorum*, Iulii 5 (1727) p. 349.

62. See also the photos in Donato Domini, Luciana Martini, and Giordano Viroli, *Ravenna Segreta: I volti nascosti della città fra Seicento e Ottocento* (Ravenna: Longo, 2002), 31, 44; and the drawings in Vincenzo Coronelli, *Ravenna ricercata antico-moderna: Accresciuta di memorie ed ornata di copiose figure* ([Venice: Frari, ca. 1708]; repr. Bologna; Forni, 1975) fourth, fifth, and sixth unnumbered plates from the end of the volume. Compare Eugenio Russo, *L'Architettura di Ravenna paleocristiana* (Venice: Istituto Veneto di Scienze, Lettere ed Arti, 2003), Pls. 52–54, pp. 86, 89.

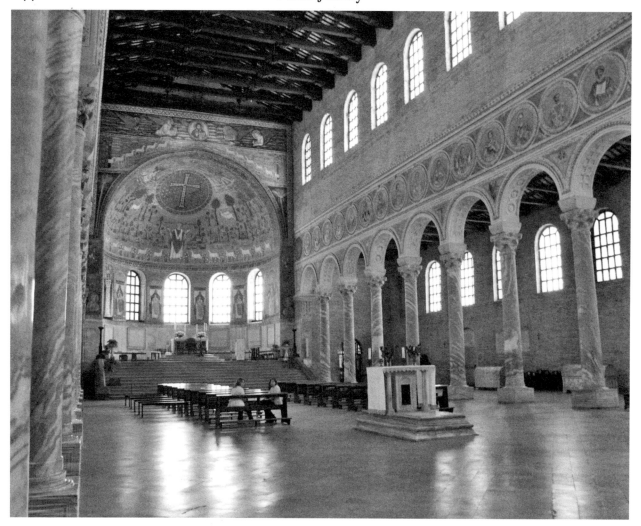

FIG. 6. Sant'Apollinare in Classe, interior (photo: Marjoke van Alphen).

extends well beyond this particular edifice, where the windows have now been re-opened. There are other early Christian tomb churches in which eastward windows bring in the morning light: S. Vitale in Ravenna, for instance, and Sta. Sabina in Rome, but there may be many others in which ancient windows remain sealed, even covered by more recent artwork we would be reluctant to remove. Thus it will not be easy to recover the geographic or chronological extent of sunrise vigils in the early Christian world.

Even the Sant'Apollinare building retains some mysteries. The present position of the altar, raised above the floor by a flight of steps, seems to date only from the ninth century, when a Carolingian ring crypt was installed.[63] Before that the altar area was closer to the level of the nave floor; the foundations of the original bema have been excavated.[64] The present eighteenth-century altar is altogether too large. A much smaller early altar with a ninth-century ciborium is now located at the east end of the north aisle.[65] An even

63. John Crook, *The Architectural Setting of the Cult of Saints in the Early Christian West c. 300–1200* (Oxford: Clarendon Press, 2000), 87–8. Mario Mazzotti, "La cripta di S. Apollinare in Classe," *Rivista di Archeologia Cristiana* 32 (1956), 201–18. Mario Mazzotti, "S. Apollinare in Classe: Indagini e studi degli ultimi trent'anni,"

Rivista di Archeologia Cristiana 62 (1986), 199–219 with 3 plates following.

64. Mazzotti, *Basilica*, (as in note 8), 72–74.

65. For a close-up photograph, see Farioli, *Ravenna* (as in note 30), Pl. 166, p. 201.

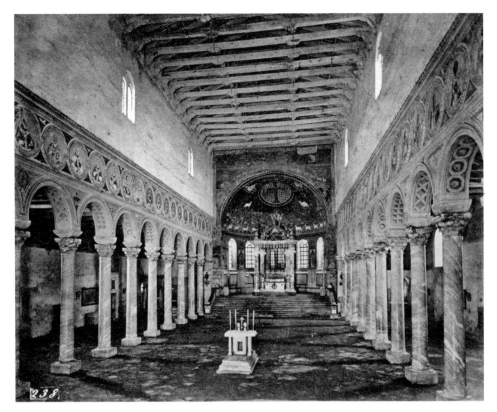

FIG. 7. Sant'Apollinare in Classe, interior ca. 1875–95, with Baroque altar canopy and most windows bricked shut. (photo: Fratelli Alinari Museum of the History of Photography–Palazzoli Collection, Florence).

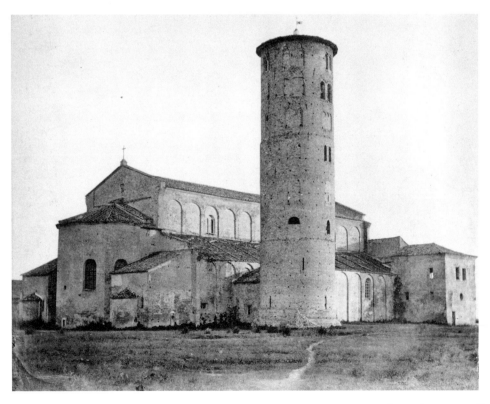

FIG. 8. Sant'Apollinare in Classe, exterior ca. 1875, with most windows bricked shut (photo: Fratelli Alinari Museum of the History of Photography–Palazzoli Collection, Florence)

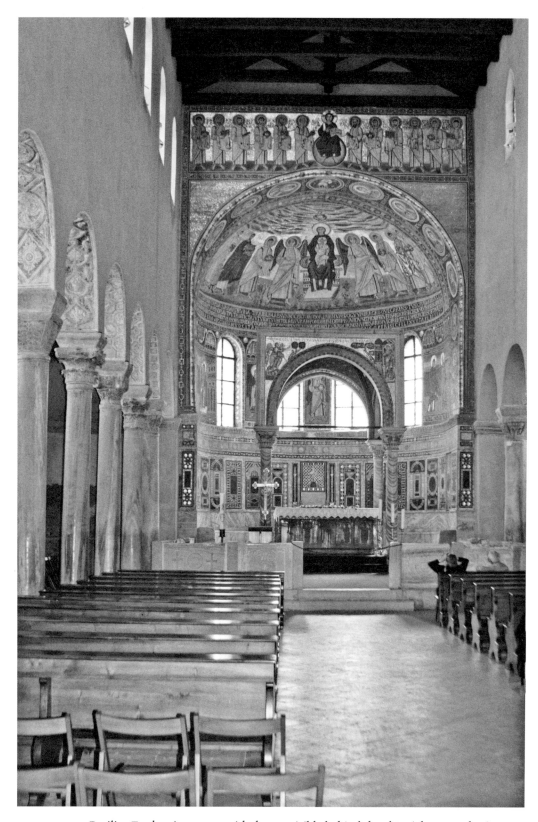

FIG. 9. Basilica Euphrasiana, apse with throne visible behind the altar (photo: author).

smaller seventh-century altar has stood for centuries in the middle of the nave (Figs. 1, 6–7).[66] If we mentally place an altar of this kind back in the apse, we shall notice something the present altar is hiding. Behind it, no longer visible from most vantage points within the church, stands an episcopal throne bearing the name of bishop Damianus (ca. 691–93 to ca. 708–9).[67]

In other words, the apse originally had a synthronon arrangement,[68] something like what can still be seen (not without the help of modern restoration) in the sixth-century Basilica Euphrasiana in Poreč (Parenzo) in the Istrian region of Croatia (Fig. 9). There the top part of the bishop's throne (cathedra) can clearly be seen centered behind the (also too big) fifteenth-century altar: a light-colored rectangle surmounted by a mosaic depicting a gold cross on a brown hill in front of a green and gold background, directly below a mosaic of St. Michael the archangel on the window level,

and directly below the Virgin and Child in the apse mosaic.[69]

At Sant'Apollinare, then, a worshipper looking up toward the front of the church would have seen the transfigured cross in the starry sky, St. Apollinaris praying on the ground, the sunlit windows between the four bishops, and—behind the altar—his own living bishop, preaching from the throne directly below the window beneath St. Apollinaris, flanked by the priests sitting left and right on two benches, paralleling the four bishops, and above them the twelve sheep and the two prophets. That picture would be very close to what the old communion antiphon describes: "The episcopal lineage of St. Apollinaris endures forever, perfect like a long moonlit night. His throne is before me like the sun, and like the sun he is a faithful witness in heaven, where Christ reigns."

66. Farioli, *Ravenna* (as in note 30), Pl. 170 *bis*, p. 205. Mazzotti, *Basilica* (as in note 8), 80 (cf. 79), 89–91.

67. Mazzotti, *Basilica* (as in note 8), 220–221.

68. Robert F. Taft, *The Byzantine Rite: A Short History*, American Essays in Liturgy Series (Collegeville, Minn.: Liturgical Press, 1992), 33–34. Robert Ousterhout, "The Holy Space: Architecture and the Liturgy," *Art and the Church in Byzantium*, ed. by Linda Safran (University Park, Penn.: Pennsylvania State University Press,

1998), 81–120, esp. 85. Thomas F. Mathews, *The Early Churches of Constantinople: Architecture and Liturgy* (University Park: Pennsylvania State University Press, 1971), 143–52, 170–71.

69. See also Thomas F. Mathews, *The Clash of Gods: A Reinterpretation of Early Christian Art*, rev. ed. (Princeton: Princeton University Press, 1993), 112–113. Bruno Molajoli et al., *La Basilica Eufrasiana di Parenzo* (Padua: Le Tre Venezie, 1943), 10, 21, 23, 25, 34, 39, 45, 51.

RICHARD K. EMMERSON

Visualizing the Visionary: John
in his Apocalypse*

"IJOHN, your brother and your partner in tribula-
tion, and in the kingdom, and patience in Christ
Jesus, was in the island, which is called Patmos, for
the word of God, and for the testimony of Jesus. I was
in the spirit on the Lord's day, and heard behind me a
great voice, as of a trumpet, saying, What thou seest,
write in a book, and send to the seven churches which
are in Asia ..." (Rev. 1:9–11).[1] With these opening
words, the Apocalypse, the final book of the Chris-
tian Bible, claims divine inspiration for John, its first-
person narrator, and identifies his status as an exile on
Patmos, an Aegean island off the coast of Asia Minor
not far from his legendary home in Ephesus. John's
first words are repeatedly depicted in the richly illu-

minated Gothic Apocalypses, often to introduce their
illustrations of Revelation. For example, the Douce
Apocalypse, one of the most stunning of the English
Apocalypse manuscripts produced in the mid-thir-
teenth century, probably for Edward I, shows in the
first of its ninety-seven miniatures John reclining on a
rocky island and resting his left hand on a book.[2] The
framed scene is placed above two columns of Latin in-
scribing the biblical text and selections from *Expositio
super septem visiones in Apocalypsis* of Berengaudus, a
monastic exegete probably writing in the eleventh cen-
tury, whose *Expositio* is one of forty extant Latin com-
mentaries on the Apocalypse produced before the thir-
teenth century.[3] The miniature's inscriptions carefully

*A shorter version of this essay was presented at "Looking
Beyond: Visions, Dreams and Insights in Medieval Art and His-
tory," a conference sponsored by the Index of Christian Art, March
15–16, 2008. It was expanded and presented as the keynote lecture
for "Vagantes," the medieval graduate student conference hosted
by Florida State University, March 5–7, 2009. I thank the organiz-
ers of those conferences, Colum Hourihane and Carey Fee, for in-
viting me to participate and am grateful for the valuable sugges-
tions made by conference attendees.

1. Biblical quotations are from the Douay-Rheims translation
of the Latin Vulgate, rev. Richard Challoner (repr. Rockford, Ill.,
1989); I have occasionally silently modified some wording to cor-
respond more closely to the medieval Latin.

2. Oxford, Bodl. Lib., Douce, 180 (Westminster? ca. 1265–70),
p. 1. For a color image, see N. J. Morgan, *The Douce Apocalypse:
Picturing the End of the World in the Middle Ages* (Oxford, 2006),
43; for a discussion of patronage, including the historiated initial
depicting Prince Edward and Princess Eleanor (fol. 1ʳ), see 7–9.
For a detailed study of the manuscript and its relationship to other
English Apocalypses, see P. Klein, *Endzeiterwartung und Ritter-
ideologie: Die englischen Bilderapokalypsen der Frühgotik und MS
Douce 180* (Graz, 1983). See also N. J. Morgan, *Early Gothic Man-
uscripts (II): 1250–1285, A Survey of Manuscripts Illuminated in
the British Isles*, gen. ed., J. J. G. Alexander (London, 1988), no.
153; and R. K. Emmerson and S. Lewis, "Census and Bibliogra-
phy of Medieval Manuscripts Containing Apocalypse Illustrations,
c. 800–1500," *Traditio* 40–42 (1984–1986), no. 98. This last refer-

ence source, which provides brief descriptions and bibliographies
for 137 medieval Apocalypse manuscripts, as well as for other
manuscripts such as moralized and historiated Bibles that include
five or more Apocalypse illustrations, will subsequently be cited
as "Census."

3. Edited Migne PL 17:765–970. For the earliest English Beren-
gaudus commentary manuscript, Longleat House, 2 ("Census,"
no. 35a), see *The Apocalypse and the Shape of Things to Come*, ed. F.
Carey (London, 2000), 65–66; and M. A. Michael, "An Illustrated
'Apocalypse' Manuscript at Longleat House," *Burlington Magazine*
126 (1984), 340–43. An unpersuasive effort has been made to iden-
tify Berengaudus as the ninth-century Berengaudus of Ferrières;
see D. Visser, *Apocalypse as Utopian Expectation (800–1500): The
Apocalypse Commentary of Berengaudus of Ferrières and the Rela-
tionship between Exegesis, Liturgy and Iconography* (Leiden, 1996).
I agree with Guy Lobrichon, however, that Berengaudus probably
was working in Flanders or the Rhineland around 1100; see *La
Bible au Moyen Age* (Paris, 2003), 132, note 16. The classic study
of medieval Apocalypse commentaries is W. Kamlah, *Apokalypse
und Geschichtstheologie: Die mittelalterliche Auslegung der Apoka-
lypse vor Joachim von Fiore* (Berlin, 1935); see also the first six es-
says in *The Apocalypse in the Middle Ages*, ed. R. K. Emmerson
and B. McGinn (Ithaca, N.Y., 1993), 3–102. Some English Gothic
Apocalypses were accompanied by an Anglo-French gloss; see S.
Lewis, "Exegesis and Illustration in Thirteenth-Century English
Apocalypses," in *Apocalypse*, ed. Emmerson and McGinn, 259–75.

identify the prophet's visionary setting ("Cest le hysle de pathmos"), showing how the exile is imprisoned by the surrounding sea ("Cest la mer de vosforum") with its fish and neighboring islands. The barefooted and nimbed John turns to look over his shoulder at the angel, who points to Heaven for his authority.

Although called the Apocalypse of John, the book's first words identify it as "the Revelation of Jesus Christ," establish its source in God the Father, and trace its transmission of authority to John: "The Revelation of Jesus Christ, which God gave unto him, to make known to his servants the things which must shortly come to pass: and signified, sending by his angel to his servant John" (Rev. 1:1). The importance of this transmission is stressed by early medieval manuscripts such as the Valenciennes Apocalypse (early 9th c.)[4] and the related later Bamberg Apocalypse (ca. 1001),[5] which include scenes authenticating the vision's divine origin, its reception by John, and his earthly authorship of the book. Both show John receiving Revelation from Heaven as a text. In the Carolingian manuscript, which probably derives the iconography of its thirty-eight full-page miniatures from "a Northumbrian model from about 700,"[6] a hand reaches down from Heaven to give John a scroll with seven seals (fol. 3ʳ). The later Ottonian Apocalypse, which includes fifty miniatures painted above or within the biblical text, modernizes the book as a codex with seven seals (fol. 1ʳ). It shows John, bowing slightly, looking up to receive the book from Christ.

The complex textual transmission from God to Christ to angel to John and then through exegetes to readers is made explicit in Beatus Apocalypses, a group of twenty-six manuscripts produced mainly in northern Spain from the ninth to the thirteenth century.[7] They generally illustrate the prophetic book of Daniel, with Jerome's commentary,[8] as well as selections from the *Vetus Latina* version of Revelation with an *explanatio* by the eighth-century abbot Beatus of Liébana.[9] In a large miniature placed above such an *explanatio*, the Morgan Beatus Apocalypse (Fig. 1) depicts this transmission in two registers.[10] In the upper scene, an angel stands to the left of an enthroned and nimbed Christ, who has an open book resting on his lap. The angel extends his right hand as if he has just given the book to Christ, having brought it from God. A second angel, standing on the right, leans forward to take the book to John, which he does in the lower register. There the prophet reaches toward a now much larger book held by the angel. This visual interpretation of Revelation's opening scene differs considerably from those of the English Gothic Apocalypses that so emphasize John's exile on Patmos. Like other earlier Apocalypses, such as Valenciennes and Bamberg, the Beatus Apocalypses

4. Valenciennes, Bibl. Mun., 99 (Liege?, early 9th c.); "Census," no. 7. See J. J. G. Alexander, *Insular Manuscripts 6th to 9th Centuries*, A Survey of Manuscripts Illuminated in the British Isles, gen. ed., J. J. G. Alexander (London, 1978), no. 64. Its illustrations, including details, are available on Enluminures, the Website for illustrated medieval manuscripts in French municipal libraries: http://www.enluminures.culture.fr/. See also F. van Jurascek, *Die Apokalypse von Valenciennes* (Linz, 1954).

5. Bamberg, Staatsbibl., Misc. Bibl. 140 (Reichenau, ca. 1001); "Census," no. 1. It is available in facsimile: *Die Bamberger Apokalypse*, 2 vols., commentary edited by G. Suckale-Redlefsen and B. Schemmel (Luzern, 2000). There is some debate about the manuscript's dating and patronage; see H. Mayr-Harting, *Ottonian Book Illumination: An Historical Study*, 2 vols. in 1, rev. (London, 1999), 2:215–28.

6. P. K. Klein, "The Apocalypse in Medieval Art," in *Apocalypse*, ed. Emmerson and McGinn (as in note 3), 161–99, esp. 178.

7. On the Beatus Apocalypses, see J. Williams, *The Illustrated Beatus: A Corpus of the Illustrations of the Commentary on the Apoca-*

lypse, 5 vols. (London, 1994–2003); and "Purpose and Imagery in the Apocalypse Commentary of Beatus of Liébana," in *Apocalypse*, ed. Emmerson and McGinn (as in note 3), 217–33. The basic, and still essential, study of these manuscripts is W. Neuss, *Die Apokalypse des hl. Johannes in der altspanischen und altchristlichen Bibel-Illustration* (Münster, 1931).

8. The standard edition is *Commentarium Danielem*, Corpus Christianorum 75A (Turnhout, 1964), 914–44; a reliable translation is *Jerome's Commentary on Daniel*, trans. G. L. Archer, Jr. (Grand Rapids, 1958).

9. For the Beatus commentary see E. R. Pose, ed., *Sancti Beati a Liébana Commentarius in Apocalypsin*, 2 vols. (Rome, 1985).

10. New York, PML, M.644, fol. 23ʳ. The manuscript, probably made in Tábara (ca. 940–45) by Maius, is available on COR-SAIR, the Morgan Library's on-line catalogue of illustrated manuscripts: http://corsair.morganlibrary.org/. For a facsimile see J. Williams and B. Shailor, *A Spanish Apocalypse: The Morgan Beatus Manuscript* (New York, 1991). See also "Census," no. 24.

FIG. I. The Angel takes the book from Christ and gives it to John. Morgan Beatus Apocalypse; New York, Pierpont Morgan Library, M.644, fol. 23ʳ.

FIG. 2. The Letter to Ephesus. Morgan Beatus Apocalypse; New York, Pierpont Morgan Library, M.644, fol. 48ʳ.

emphasize the transmission of a divinely authored text and the communication between John and angel, as the inscription written between the two figures emphasizes: "Ubi primitus Iohannes cum angelo locutus est" (fol. 23ʳ). The passing of the book is further stressed by this manuscript when it devotes an illustration to each of the seven letters that John is instructed to send to the seven churches of Asia. In the first (Fig. 2), the letter to Ephesus that opens the second chapter of Revelation, John holds a book and stands before the angel of Ephesus. The structure to the right is inscribed "Eclesia prima Efeso," which typifies the manuscript's concern to identify each church.

A later Beatus Apocalypse further highlights this

process of textual transmission, but now from John and the biblical past to the manuscript's monastic readers in the medieval present. In one of its eighteen prefatory illustrations (fol. 13ᵛ), the Saint-Sever Beatus clarifies how the visionary text migrated from John on Patmos to the Spain of Beatus by depicting eight nimbed men, four each in two framed registers.[11] In the upper left register, a barefooted John, holding the biblical scroll, faces Jerome. Like the other exegetes with names inscribed above their tonsured heads ("Agustinvs, Ambrosivs, Fulgentivs, Gregorius, Abringius, Hisidorus"), Jerome holds *not* a scroll but a book, implying the packaging of John's vision with its commentaries. The figures in this image, a compelling

11. Paris, BnF, lat. 8878 (Saint-Sever-sur-l'Adour, ca. 1050–70), fol. 13ᵛ; for this miniature see Williams, *Illustrated Beatus* (as in note 7), 3 : fig. 386; and *Apocalypse*, ed. Emmerson and McGinn (as in note 3), fig. 27. For this manuscript see Williams, *Illustrated Bea-*

tus, 3 : 44–57; "Census," no. 25; and E. A. van Moé, *L'Apocalypse de Saint-Sever* (Paris, 1943). The illustrations are available on Mandragore, the Website of BnF illustrated manuscripts: http://www.mandragore.bnf.fr/.

representation of the exegetical sources cited by Beatus,[12] are organized geographically as well as chronologically, beginning in Patmos with John's implied instructions to his future readers, moving westward through North African and Italian patristic exegetes, and culminating in the lower right register with two Spanish commentators, Apringius of Béja and Isidore of Seville.[13] The image visually links the visionary to his translator, to his commentators, and through them to the viewer/reader of this manuscript.

Not all illustrated Apocalypses are as explicit about the transmission of Revelation to the medieval reader, but the vast majority consistently represent John the visionary within his apocalyptic vision.[14] John's role is emphasized even in non-Apocalypse manuscripts such as moralized Bibles, which in their fullest manifestation include 312 roundels depicting Revelation, making them, as John Lowden claims, "The most extensive series of Apocalypse images from the Middle Ages (or from any other period)...."[15] John is often present within the roundel depicting the biblical text,

sometimes with the angel that instructs and guides him. His presence is so important in some Bible moralisée manuscripts that he is placed outside the frame of the packed image, standing precariously between roundel and text and thus breaking the carefully regulated rhythm of the manuscript's mise-en-page.[16] This essay, however, will not examine the full-range of manuscripts that illustrate Revelation, such as the extensive cycles in the Hours of Isabella Stuart and the Bedford Hours.[17] Instead, it will focus on the numerous Apocalypses produced from the tenth to the fifteenth centuries in order to survey how they represent John, the most important of Christian visionaries.[18] This key visual evidence will establish that he was understood by Christian exegetes and especially artists as, first, a visionary witness; second, an active participant within his visions; and, third, a human intermediary between his otherworldly revelatory experience and the earthly reception of that experience by the medieval viewer/reader. It will stress how John is Revelation's "dominant figure, the hero of the book...."[19]

12. See S. A. Campos, "Fuentes literarias de Beato de Liébana," in *Actas del simposio para el studio de los codices del "Commentario al Apocalipsis" de Beato de Liébana* (Madrid, 1978), 1:119–62. As Williams points out, these portraits are also included in the Girona, Turin, and Rylands Beatus manuscripts; see *Illustrated Beatus* (as in note 7), 2:47–48.

13. For patristic and early medieval commentators on the Apocalypse, see P. Fredricksen, "Tyconius and Augustine on the Apocalypse," and E. A. Matter, "The Apocalypse in Early Medieval Exegesis," both in *Apocalypse*, ed. Emmerson and McGinn (as in note 3), 20–37 and 38–50.

14. A notable exception are the five illustrated manuscripts of the Apocalypse commentary by Alexander Minorita of Bremen ("Census," nos. 118–22), which deserve much more art historical attention than they have received to date. The best-known is Cambridge University Library, Mm.v.31 (Cologne? ca. 1270–75); see *The Cambridge Illuminations: Ten Centuries of Book Production in the Medieval West*, ed. P. Binski and S. Panayotova (London, 2005), no. 42; Carey, ed., *Apocalypse* (as in note 3), 83–84; and S. Lewis, "Parallel Tracks: Then and Now. The Cambridge Alexander Apocalypse," in *New Offerings, Ancient Treasures: Studies in Medieval Art for George Henderson*, ed. P. Binski and W. Noel (Stroud, 2001), 367–88. For Alexander Minorita, see D. Burr, "Mendicant Readings of the Apocalypse," in *Apocalypse*, ed. Emmerson and McGinn (as in note 3), 89–102, esp. 99–100; and S. Schmolinsky, *Der Apokalypsenkommentar des Alexander Minorita: Zur frühen Rezeption Joachims von Fiore in Deutschland* (Hannover, 1991).

15. J. Lowden, "The Apocalypse in the Early-Thirteenth-Century Bibles Moralisées: A Re-Assessment," in *Prophecy, Apocalypse and the Day of Doom*, ed. N. Morgan (Donington, 2004), 195–219, at 195.

16. See, for example, Vienna, ÖNB cod. 1179 ("Census," no. 158), fol. 246ʳ; for a color reproduction see J. Lowden, *The Making of the Bible Moralisées*, 2 vols. (University Park, Penn., 2000), 1: pl. 3.

17. For the Hours of Isabella Stuart (Cambridge, Fitzwilliam Mus., 62), which includes 139 Apocalypse miniatures, see *Cambridge Illuminations*, ed. Binski and Panayotova (as in note 13), 202–4, no. 88; "Census," no. 168; and R. K. Emmerson, "A 'Large Order of the Whole': Intertextuality and Interpictoriality in the Hours of Isabella Stuart," *Studies in Iconography* 28 (2007), 53–99. The Bedford Hours (London, BL, Add. 18850) includes 310 Apocalypse roundels in its borders, 155 depicting scenes based on the biblical text and 155 interpreting these scenes. See "Census," no. 169; and R. K. Emmerson, "The Apocalypse Cycle in the Bedford Hours," *Traditio* 50 (1995), 173–98. The new facsimile, *Das Bedford-Stundenbuch*, 2 vols. (Luzern, 2006), includes a commentary by E. König, whose discussion of the interpretive roundels should be used with caution.

18. On John's significance see R. K. Emmerson, "The Apocalypse in Medieval Culture," in *Apocalypse*, ed. Emmerson and McGinn (as in note 3), 293–332, esp. 328–32.

19. R. Freyhan, "Joachism and the English Apocalypse," *JWCI* 18 (1955): 211–44, at 225.

John as Visionary Witness

JOHN AS SEER

In his opening words John states that he received his revelation both aurally and visually. The trumpeting voice he hears also establishes his authorial mandate, ordering "What thou seest, write in a book" (Rev. 1:11). As a visionary witness, therefore, John is shown seeing, hearing, and writing, sometimes doing all three simultaneously, sometimes performing each action separately. John's visual and auditory receptions of his vision are connected, of course, since his attention is often first caught by a voice—sometimes disembodied, usually heavenly—and then he is instructed to look. The imperative to see is emphasized in the sequence enumerating the Lamb's opening of the book with seven seals. As each of its first four seals is broken, John hears each Living Creature say, "Come and see" (Rev. 6:1–8). In a vibrant two-page image, the Saint-Sever Beatus Apocalypse (fols. 108ᵛ–109ʳ) effectively depicts each of these four invitations in a series of repeated commands and actions.[20] In roundels painted on the left and right edges of the facing pages, the Lamb lifts each of the first four seals of the book as the Four Living Creatures—the winged man, ox, lion, and eagle—pull John by the hand or wrist into the action to witness the emerging Four Horsemen mounted on the white, red, black, and pale horses. The command "veni et vidi" is inscribed four times, emphasizing John's visual reception of his vision in response to the heavenly directives.

John's role as witness is also emphasized by his repeated portrayal within Apocalypse miniatures, where he directs the viewer's attention by pointing to the visionary events he sees and will then record. His witnessing function is emphasized, for example, in the English Gothic Apocalypse now in the Morgan Library (M.524), an important mid-thirteenth-century picture-book composed of eighty-three illustrations in double registers inscribed with Latin selections from Revelation and Berengaudus.[21] Rather than being represented in one large miniature, the Four Horsemen are here depicted in four registers arranged over two pages (fols. 2ʳ–2ᵛ). In Morgan's treatment of the Fourth Horseman (Fig. 3), for example, we see through the eyes of John, who has been invited by the fourth living creature—the Eagle, John's symbol—to come and see what happens when the fourth seal of the book is broken. The eagle's command, "veni et vidi," is inscribed on a placard held in the bird's talons and supported by John to suggest his aural reception of the order. John also points at the placard, directing our attention to what follows the biblical invitation, "id est, spiritualiter intellige." Quoting the Berengaudus commentary, these words instruct the viewer not only to see John's visionary experience, but also to interpret it spiritually.[22]

John's presence within the frame of the apocalyptic vision is not limited to such picture-book Apocalypses, however. He is repeatedly depicted within the framed miniature in Apocalypses that develop a variety of page designs, whether the image is placed at the top of the folio or within the columns of biblical and exegetical texts.[23] He is sometimes given primary visual emphasis, as in the Apocalypse of Margaret of York, also in the Morgan Library.[24] For example, in the depiction of the "strong angel" who demands,

20. See Williams, *Illustrated Beatus* (as in note 7), 3: figs. 407–408; for a color reproduction, see F. van der Meer, *Apocalypse: Visions from the Book of Revelation in Western Art* (New York, 1978), 120–21.

21. Morgan, *Early Gothic Manuscripts (II)* (as in note 2), no. 122; and "Census," no. 90. All images from this manuscript are available on the CORSAIR Website. Related picture-book Apocalypses are the contemporary Bodleian Library, Auct. D.4.17 ("Census," no. 95) and the fourteenth-century Manchester, John Rylands Univ. Lib., Latin 19 ("Census," no. 81).

22. See S. Lewis, *Reading Images: Narrative Discourse and Re-*

ception in the Thirteenth-Century Illuminated Apocalypse* (Cambridge, 1995), 78, fig. 45.

23. The French prose Apocalypses that include a prologue by Gilbert de la Porrée are quite varied in their format, for example. See N. Morgan, "The Bohun Apocalypse," in *Tributes to Lucy Freeman Sandler: Studies in Illuminated Manuscripts*, ed. K. A. Smith and C. H. Krinsky (London, 2007), 91–110, esp. 94–96.

24. Pierpont Morgan Library, M. 484 (Ghent, ca. 1485); "Census," no. 89. All images from this manuscript are available on the CORSAIR Website. See also S. Lewis, "The Apocalypse of Margaret of York," in *Margaret of York, Simon Marmion, and "The*

FIG. 3. Fourth Horseman. Morgan Apocalypse; New York, Pierpont Morgan Library, M.524, fol. 2ᵛ,
 lower register.

"Who is worthy to open the book, and to loose the seals thereof" (Rev. 5:2), John seated on Patmos dominates the foreground (fol. 30ʳ; Fig. 4). He weeps "because no man was found worthy to open the book, nor to see it" (Rev. 5:4), his immediate and intense human suffering taking visual precedence over the radiant Father and Son distantly enthroned in the clouds above. One of the Twenty-four Elders approaches from the right to console John, explaining that the Lion of Judah has triumphed and will open the book. John's visual prominence in this scene is remarkable, differing from the more usual placement of the visionary in a small compartment to the side or below the heavenly court. But even in such enclosed dispositions of the scene, John's role can be quite active. For example, the Toulouse Apocalypse places John in a narrow compartment to the left of his framed vision of the enthroned Christ holding the book, surrounded by the Four Living Creatures (fol. 9ʳ).²⁵ Significantly, the spaces that distinguish the visionary from his vision are sometimes open to each other, so that in Toulouse John is able to grab one of the Twenty-four Elders depicted in the previous miniature (fol. 8ᵛ) and vigorously pull him through a door and into the visionary's

Visions of Tondal": Papers Delivered at a Symposium Organized by the Department of Manuscripts at the J. Paul Getty Museum in collaboration with the Huntington Library and Art Collections, June 21–24, 1990 (Malibu, 1992), 77–86.

25. Toulouse, Bibl. Mun., 815 (England, 14th c.); "Census," no. 116. The illustrations are available on the Enluminures Website.

This manuscript includes an Anglo-Norman translation of Revelation in 1,306 lines, a French prose commentary, and an illustrated *Visio Pauli*. For the metrical Anglo-Norman Apocalypse text see B. A. Pitts, "Versions of the Apocalypse in Medieval French Verse," *Speculum* 58 (1983), 31–59, esp. 31–38.

Lequel seoit sur le throsne ne pouoit' ouurir le liure

FIG. 4. John comforted by Elder. Apocalypse of Margaret of York; New York, Pierpont Morgan Library, M.484, fol. 30ʳ.

liminal space, its undefined locus being somewhere between Patmos and Heaven. Interestingly, John pulls with so much determination that his backside breaks the miniature's outer frame as he confronts the Elder.

Although John is often present within illustrations of his visions, he sometimes witnesses them while standing outside the enclosed visionary space. The Escorial Apocalypse, begun by Jean Bapteur (ca. 1428–35) for Amadeus VIII and completed by Jean Colombe (ca. 1482) for Charles I of Savoy, usually shows John watching the framed vision while standing on plots of earth placed within the manuscript's margins.[26] Although outside the frame, he still responds to

the larger-than-life scenes within. For example, when the brilliance of the apocalyptic Woman clothed in the Sun (Rev. 12:1) blinds him, he raises his cloak to protect his eyes (fol. 20ʳ). These frames are rarely permeable, but are so treated for the miniatures illustrating the Four Horsemen (fols. 6ᵛ–8ʳ). In these, each of the Four Living Creatures invites John into the action by reaching through the frame toward his outstretched hand as if to pull him into the visionary space. In this way the artist effectively illustrates the creature's demand that John "come and see."

The Getty Apocalypse is particularly playful in treating John's relationship to these frames.[27] Formerly

26. Escorial, Bibl. San Lorenzo, E Vitr. v; "Census," no. 57. For a facsimile, see C. Gardet, *L'Apocalypse figurée des ducs de Savoie* (Annecy, 1969). On its various illuminators see L. R. Ciavaldini, *Imaginaires de l'Apocalypse: Pouvoir et spiritualité dans l'art gothique européen* (Grenoble, 2007).

27. Los Angeles, Getty Museum, Ludwig III 1 (Westminster? 1255–60); "Census," no. 136. For a facsimile, see *The Apocalypse in Latin: MS 10 in the Collection of Dyson Perrins*, ed. M. R. James (Oxford, 1927); all images are also available on the Getty Museum Website: http://www.getty.edu/art/gettyguide/. See also Morgan,

in the Dyson Perrins collection and including eighty half-page illustrations of Revelation, this and some other thirteenth-century English manuscripts often show John peering through a window in the frame (see, in the following essay, Klein Figs. 7–10, 12). Peter Klein labels John's gaze through the window as "voyeuristic," a term hardly appropriate for the visionary who, in response to a heavenly voice inviting him to come see "the things which must be done hereafter," states, "And immediately I was in the spirit" (Rev. 4:1–2).[28] Klein, however, stresses the negative implications of John's gaze, citing some contemporary English Apocalypses that show John's enemies peeking through a window upon the naked body of Drusiana as she is baptized by the apostle (see Klein Fig. 17). Klein further notes that in a few manuscripts that insert scenes depicting a life of Antichrist, his followers look through a window as he is killed. Surely, however, the evil nature of John's enemies and Antichrist's disciples is established by their motivations and previous actions, not solely by the act of looking. Indeed, as we have repeatedly emphasized, looking is an absolutely crucial aspect of the visionary experience. Robert Freyhan, who introduced the term "voyeur" in his 1955 essay, persuasively argued against reducing the meaning of the window motif to its source: "What chiefly interests us here, however, is not the genesis but the significance of this unique motif—the transformation of the *voyeur* into the seer by way of the *ostium apertum*."[29] It is worth emphasizing, furthermore, that the Getty Apocalypse does not depict the "voyeuristic" scenes Klein cites, since it includes neither a full life of John nor the mini-life of Antichrist. Instead, it earlier shows John standing outside the miniature depicting the Seven Churches (fol. 2ᵛ) or within the framed miniature before the Son of Man (fol. 3ʳ). John does not look through a window in the frame until his

vision of the throne of God (fol. 3ᵛ), which follows the invitation to come up to Heaven (Rev. 4:1). I therefore do not agree that such depictions represent "a kind of profanization and even trivialization of spiritual experience...."[30] Instead, they are an effective way for the artist to show that it is through John's eyes that viewers of the manuscript are given access to the heavenly vision.

I also disagree with Suzanne Lewis, whose interpretation of this motif seems narrowly literal: "Whereas John's perception is limited to what he can glimpse through a narrow aperture, the reader is given a full *en face* perspective on the celestial spectacle."[31] It seems more likely that the depiction of John's looking through a window is a visual metaphor helping to explain how he sees directly into Heaven now that he is "in the spirit," and that the framed image represents what he sees and what the viewer of the manuscript sees *through his eyes*. This prevalent motif not only underscores John's continued visual reception of revelation even when he does not act within the framed visionary landscape, but also emphasizes his role as witness.

JOHN AS HEARER

As is emphasized throughout Revelation, the vision is as much auditory as it is visual. John repeatedly hears angelic commands and strident warnings, the roaring of lions and crashing of thunders, the blowing of trumpets and plucking of harps, repeated weeping and moaning as well as the singing of heavenly songs. For example, after the first four angels blow their trumpets and thereby inflict several catastrophes on earth, John hears an eagle "flying through the midst of Heaven, saying with a loud voice: Woe, woe, woe" (Rev. 8:13). The Bamberg Apocalypse (fol. 21ᵛ) effectively represents the terrifying power of this scene.

Early Gothic Manuscripts (II) (as in note 2), no. 124; and S. Lewis, "Beyond the Frame: Marginal Figures and Historiated Initials in the Getty Apocalypse," *The J. Paul Getty Museum Journal* 20 (1992), 53–76.

28. For Klein's argument, see his "From the Heavenly to the Trivial: Vision and Visual Perception in Early and High Medieval Apocalypse Illustration," in *The Holy Face and the Paradox of Rep-*

resentation: Papers from a Colloquium Held at the Bibliotheca Hertziana, Rome and the Villa Spelman, Florence, 1996, ed. H. L. Kessler and G. Wolf (Bologna, 1998), 262–69.

29. Freyhan, "Joachimism" (as note 19), 233.

30. Klein, "From the Heavenly to the Trivial" (as in note 28), 267.

31. Lewis, *Reading Images* (as in note 22), 69.

John is shown holding up a protective hand in response to a large screeching eagle, whose piercing cry recorded in the biblical text above the miniature is inscribed in an enlarged script. The aural reception of the word is stressed similarly, if more calmly, by the Flemish Apocalypse that conflates the usual ninety or so scenes of the Anglo-French tradition into twenty-two full-page miniatures, one for each biblical chapter.[32] The unusual miniature illustrating the letters to the last three of the Seven Churches (fol. 4ʳ) shows John sitting in a rocky landscape and writing on an unfurled scroll to the churches. The divine inspiration of these letters is visualized by a dove that directly links Christ's cross-nimbed head to John's. By appropriating this traditional symbol of the Holy Spirit, which is not based on the Apocalypse, the artist visualizes the scriptural refrain, "He that hath an ear, let him hear what the Spirit saith to the churches." Repeated seven times (Rev. 2:7, 11, 17, 29; 3:6, 13, 22), these words underscore the auditory nature of John's vision and the importance of the ear as well as the eye for his visionary reception.

Apocalypse manuscripts also represent more specific auditory facets of John's visionary experience, which he may receive in quiet and intimate ways. In the Morgan Apocalypse, for example, the Elder who comforts the weeping John speaks directly to him (fol. 1ᵛ). Later, after John sees the 144,000 clothed in white robes and witnesses the adoration of Christ and the Lamb (fol. 3ᵛ; Fig. 5), a crowned Elder grips John by his right wrist and questions him about the vision's meaning. The reply is inscribed on the speech placard John holds in his left hand ("Domini mi tu scis"), which encourages the Elder to whisper his explanation while pointing to a placard inscribed with Latin based on Revelation 7:13–14. A similar scene involving whispering is depicted in the Trinity Apocalypse, one

of the most impressive of mid-thirteenth-century English manuscripts that includes seventy-five miniatures illustrating selections from the Anglo-Norman biblical text and Berengaudus commentary.[33] After seeing the Army of Horsemen released by the sounding of the sixth trumpet, John states, "And I heard the number of them" (Rev. 9:16), not identifying the source of this privileged knowledge. The Trinity miniature placed directly below these enigmatic words (fol. 10ʳ) signals this aural reception of the number by inventing a figure who points to the text above while whispering to John.[34] He lowers his cloak to listen while gazing at the viewer rather than toward the horsemen who slaughter a third of mankind.

Hearing is also emphasized by the Getty Apocalypse, which, as we saw above, usually shows John gazing through a window and then responding to his vision. Its miniature (fol. 26ᵛ) illustrating the new song sung before the throne (Rev. 14:3), however, shows John kneeling outside the frame and now pressing his left ear—not his eyes—to the window.[35] The window in the frame allows the visionary to listen intently to the canticle praising the Lamb on Mt. Zion just as earlier he looked through the window at the divine mysteries he was invited to witness. This aural use of the window provides additional evidence that the opening in the frame is a metaphor for the visionary's authorized reception of his divine vision; he is not an eavesdropper here, just as he is not a voyeur in the miniatures where he is depicted gazing into the frame.

JOHN AS WRITER

A third way medieval Apocalypses stress John's role as prophetic witness is to show him faithfully transcribing his visionary experience to authenticate and then secure it for future readers. He therefore not only sees and hears, but also writes. This activity is stressed in a

32. Paris, BnF, néerl 3 (Flanders, ca. 1400); "Census," no. 137. For a facsimile, see *Flemish Apocalypse*, 2 vols., with commentary by N. de Hommel and J. Koldeweij (Barcelona, 2005). Color reproductions are available in van der Meer, *Apocalypse* (as in note 20), 202–35; and on the Mandragore Website.

33. Cambridge, Trinity Coll., R 16 2 (England, 1255–60); "Census," no. 50. See the essays in *The Trinity Apocalypse*, ed. D. McKitterick (Toronto, 2005); and Morgan, *Early Gothic Manu-*

scripts (II) (as in note 2), no. 110. For facsimiles see D. McKitterick, N. Morgan, I. Short, and T. Webber, *The Trinity Apocalypse* (Luzern, 2004); and P. H. Brieger, *The Trinity College Apocalypse* (London, 1967).

34. Lewis notes that this scene "ingeniously serves to elide an ambiguous break in the text"; see *Reading Images* (as in note 22), 101, fig. 65.

35. See Lewis, *Reading Images* (as in note 22), 146, fig. 115.

FIG. 5. Elder whispers to John. Morgan Apocalypse; New York, Pierpont Morgan Library, M.524, fol. 3ᵛ, lower
register.

thirteenth-century English manuscript perhaps given to Abingdon Abbey by Giles de Bridport, bishop of Salisbury.[36] Like the Gulbenkian Apocalypse[37] to which it is related, the Abingdon Apocalypse includes miniatures illustrating both the biblical text and the accompanying Berengaudus commentary. As is typical of the English Gothic Apocalypses, it includes the usual opening miniature set on Patmos, where an angel urgently commands John to write what he sees. Significantly, it also adds below an author portrait painted in the initial "A" of "Apocalypsis," where once again the angel directs John to write. His authorial role is similarly stressed by a fifteenth-century Apocalypse that is placed after a German Biblia Pauperum.[38] A full-page unframed miniature (fol. 11ᵛ; Fig. 6) depicts John the revelator—whom medieval exegetes identi-

36. London, BL, Add. 42555 (England, 1270–75); "Census," no. 71. See Carey, *Apocalypse* (as in note 3), 79–80; and S. Lewis, "Giles de Bridport and the Abingdon Apocalypse," in *England in the Thirteenth Century: Proceedings of the 1984 Harlaxton Symposium*, ed. W. M. Ormrod (Woodbridge, 1986), 107–19. In *Early Gothic Manuscripts (II)* (as in note 2), no. 127, Morgan disputes Lewis' association of this Apocalypse to Giles de Bridport, which is based on a fourteenth-century inscription; Morgan instead dates it to ca. 1270–75 (107).

37. Lisbon, Gulbenkian Museum, L.A. 139 (England, 1265–70); "Census," no. 62. See Morgan, *Early Gothic Manuscripts (II)* (as in note 2), no. 128. For a facsimile see *Apocalipsis Gulbenkian*, 2 vols. (Barcelona, 2002), with commentary by S. Lewis and N. J. Morgan.

38. Weimar, Zentralbibl. der deutschen Klassik, Fol. max. 4; "Census," no. 145. For a facsimile, see *Biblia pauperum: Apocalypsis*, with commentary by R. Behrends, K. Kratzsch, and H. Mettke (New York, 1978).

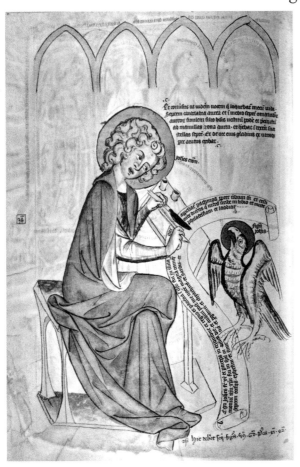

FIG. 6. John writes the Apocalypse. Biblia Pauperum Apocalypsis; Weimar, Zentralbibl. der deutschen Klassik, Fol. max. 4, fol. 11ᵛ.

fied with the author of the Fourth Gospel and the Johannine epistles—as seated and writing within a cloisters or scriptorium set off by a Gothic arcade. He is inscribed as John the evangelist and identified by his symbol the eagle, glossed as "figura ioannis." His active authorial role is suggested by the knife in his left hand. On a scroll resting on a stand supporting black and red inkpots, he writes, "I John … was on the island that is called Patmos," and at the top of the scroll, just above the eagle's head, he records his prophetic commission to write what he sees.

John is also ordered to write at particular moments in his vision. The most commonly depicted is the initial command to write to the Seven Churches, which is represented in most medieval Apocalypses from the earliest Carolingian to later Gothic manuscripts. In another visionary event that includes a command to write, John witnesses the souls of those who die in the Lord (Rev. 14:13). The Morgan Apocalypse (fol. 13ʳ) shows John seated in a rocky landscape with a large scroll unfurled across his lap, a knife in his left hand, and a pen in his right hand that he carefully examines (Fig. 7). Above his right shoulder an angel—the image's interpretation of the unspecified "voice from heaven"—swoops down from a cloud. Pointing to the scroll with his right hand, he holds a small placard above John's head commanding "Scribe." John's scroll describes what is depicted on the right: the blessed dead whose souls are received into Heaven by another angel. This scene is just one of many in the Morgan Apocalypse where John plays a major role. He is even treated as both the text's author and the manuscript's scribe. This dual role is visualized in its framed representation of the New Jerusalem descending from Heaven (Fig. 8). On folio 20ᵛ John writes a lengthy Latin inscription beginning "Et ego Iohannes uidi ciuitatem sanctam Ierusalem nonam descendentem de celo," his pen appropriately resting on his textualized name, "Iohannes."[39] Some manuscripts, furthermore, emphasize John's authorial role by repeatedly showing him writing in response to each installment of his vision. The Apocalypse completed in 1313 for Isabella of France, daughter of Philip IV and queen of Edward II, includes 182 Apocalypse illustrations, of which seventy accompany the French prose biblical text on the verso side of the folios.[40] In these, John dutifully writes what he sees as he looks across the page opening to the vision revealed on the recto of each folio. John's presence in this manuscript is remarkable. No longer a regular participant in the vision but now

39. Commenting on this scene, Lewis notes that "John no longer requires the mediating guidance of his angelic mentor but is commanded to write by the Lord himself." See *Reading Images* (as in note 22), 190.

40. Paris, BnF, fr. 13096 (Paris, 1313); "Census," no. 111. For a facsimile, see *Apocalypse of 1313*, 2 vols., with commentary by M.-T. Gousset and M. Besseyre (Madrid, 2006). The images are available on the Madragore Website.

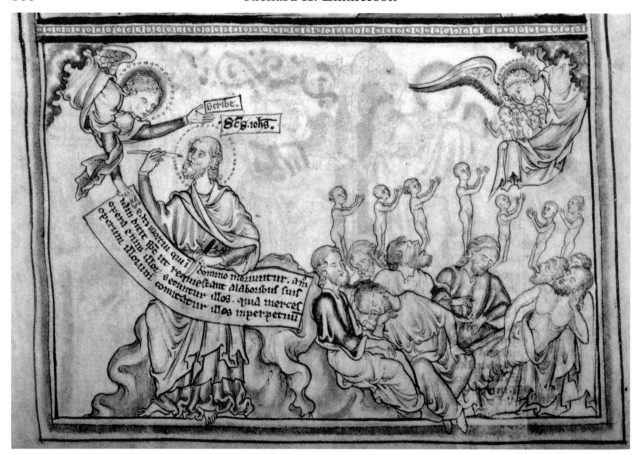

FIG. 7. John directed to write about the Blessed Dead. Morgan Apocalypse; New York, Pierpont Morgan Library, M.524, fol. 13ʳ, lower register.

primarily its faithful recorder, he writes over and over again and to such an extent that he must occasionally stop to sharpen his pen.[41]

Apocalypse manuscripts also underscore the significance of writing by depicting a crucial instance when John is *forbidden* to write. After the Locust Beasts are released, the visionary sees a Mighty Angel holding a book and standing on the sea and land. His loud voice elicits a response from the Seven Thunders, which John is about to record when a voice from Heaven interrupts, stating "Seal up the things which the seven

thunders have spoken; and write them not" (Rev. 10:4). This scene is depicted in a twelfth-century German Apocalypse at the Bodleian Library, which includes eighteen full-page compartmentalized miniatures that precede Haimo of Auxerre's commentary on the Apocalypse.[42] Folio 8ʳ (Fig. 9) shows in its middle horizontal register the Locust Beasts marching from Hell. Below them and next to the Mighty Angel standing with one foot on the sea and the other on the earth (Rev. 10:1), John faces seven anthropomorphized Thunders and prepares to record their words in the

41. On this feature of the manuscript, see S. Lewis, "The Apocalypse of Isabella of France: Paris, Bibl. Nat. Ms. Fr. 13096," *Art Bulletin* 72 (1990), 224–60, esp. 250–51.

42. Oxford, Bodl. Lib., Bodley 352 (Germany, 12th c.); "Census," no. 36. See O. Pächt and J. J. G. Alexander, *Illuminated Manuscripts in the Bodleian Library, Oxford*, vol. 1 (Oxford, 1966), no. 66. On this manuscript's relationship to Carolingian and other Ro-

manesque Apocalypse illustrations, see P. K. Klein, "Les cycles de l'Apocalypse du haut Moyen Age (IX–XIIIᵉ s.)," in *L'Apocalypse de Jean: Traditions exégétiques et iconographiques IIIᵉ–XIIIᵉ siècles* (Geneva, 1979), 135–86. For reproductions and analysis of its miniatures, see B. Polaczek, *Apokalypseillustration des 12. Jahrhunderts und weibliche Frömmigkeit* (Weimar, 1998).

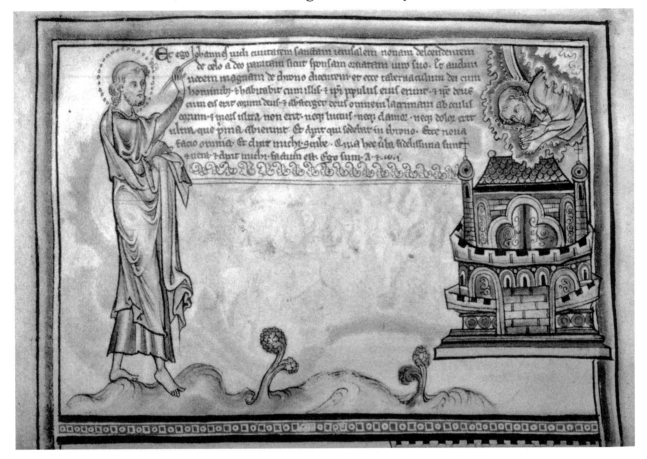

FIG. 8. John inscribes his name. Morgan Apocalypse; New York, Pierpont Morgan Library, M.524, fol. 20ᵛ, upper register.

book resting on the stand before him. A hand reaches down from Heaven to grab his pen, however, thus depicting the command inscribed in the border behind John's chair, "noli ea scribere."[43] By focusing on the brief textual prohibition, this scene underscores the centrality of writing, its control by Heaven, and therefore John's trustworthiness as a visionary witness who writes *only* under divine command.

John can only write what he first sees and hears; therefore, all three actions are crucial to his role as visionary witness. The three take place simultaneously in the modest but extensively illustrated Apocalypse in the Spencer collection of the New York Public Library, which includes 157 Apocalypse miniatures accompanied by an Anglo-Norman text of Revelation and a commentary.[44] As Lucy Sandler writes in her catalogue entry for this manuscript, the miniatures depicting the visionary "correspond pictorially to the words with which John begins each section of the text, 'And I, John' 'saw,' or 'heard,' or was told to 'write,'"[45] Significantly, the Spencer Apocalypse introduces Revelation not with John's exile on Patmos, but with Revelation's first command that he write: "What thou seest, write in a book and send to the seven churches which

43. An angel takes the pen from John in the Getty Apocalypse (fol. 15ʳ) as well; see Lewis, *Reading Images* (as in note 22), 102–103, fig. 66.

44. New York, NYPL, Spencer 57 (England, 1325–30); "Census," 91. For images, see the NYPL online Digital Gallery: http://digitalgallery.nypl.org/nypldigital/.

45. *Splendor of the Word: Medieval and Renaissance Illuminated Manuscripts at the New York Public Library*, ed. J. J. G. Alexander, J. H. Marrow, and L. F. Sandler (London, 2005), 85, no. 18.

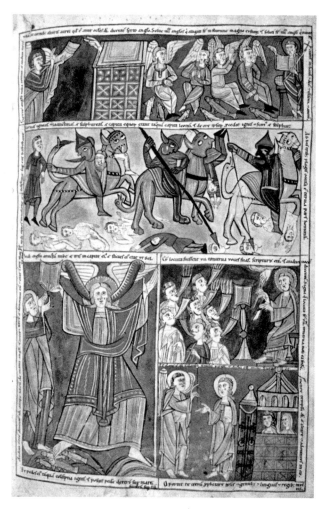

FIG. 9. John prevented from writing. Haimo Apocalypse. Oxford, Bodleian Library, Bodley 352, fol. 8ʳ.

pictured as a group. Seeing, hearing, and writing are thus closely integrated for the visionary witness.

John as Visionary Participant

In addition to his primary role as visionary witness, John is also depicted in medieval Apocalypses as an active participant within his visions. From the very beginning he reacts to what he sees and hears, thus performing crucial narrative roles within the visionary drama. Upon seeing the Son of Man among the Seven Golden Candlesticks, for example, John states that "I fell at his feet as dead" (Rev. 1:17), a scene that often follows the first miniature depicting John on Patmos, although it is interpreted in various ways. The Douce Apocalypse, for instance, shows a prayerful John looking up while kneeling at the feet of Christ, who is enthroned in an elaborate Gothic structure flanked by three large candlesticks on the left and four on the right. The Son of Man reaches down with his right hand to touch John's head slightly, an effective way to depict Christ's consoling words, "Fear not" (Rev. 1:17).[47] In contrast, the interpretation of this scene in the German Apocalypse linked to a Biblia Pauperum (fol. 21ʳ; Fig. 10) achieves a remarkably different effect.[48] It conflates several textual details to emphasize the extraordinary power and symbolic attributes of Christ as Alpha and Omega (Rev. 1:11), such as the seven stars held in his right hand, the two-edged sword emanating from his mouth (Rev. 1:16), and the massive keys of Death and Hell (Rev. 1:18) held in his left hand. These reinforce the composition's awe-inspiring verticality that contrasts heavenly power to the earthly submission of John, who sprawls horizontally as if dead below Christ's feet. A scroll placed between his lifeless outstretched arms quotes the biblical text ("Et cum videssem eum cecedi ante pedes eius tamquam mortuus") that immediately precedes Christ's reassuring words so effectively depicted in the Douce miniature.

are in Asia...." (Rev. 1:11). In a scene juxtaposed to the initial "I" introducing Revelation 1:9 ("Ieo iohan uostre frere ...," fol. 2ᵛ), John is shown sitting before a large open book that rests on a stand before him, his right hand touching the book, his left holding a pen.[46] His attention is diverted, however, when he hears "a great voice, as of a trumpet" (Rev. 1:10), which is rendered literally as a trumpet blasting into his right ear. It forces him to turn away and look across the page opening (fol. 3ʳ), where he sees all Seven Churches

46. For this scene see S. Lewis, "Apocalypse of Isabella of France" (as in note 41), 254, fig. 45.

47. As Lewis notes, this "gesture could have been read as a sig-

nifier of John's spiritual ordination by Christ"; see *Reading Images* (as in note 22), 67. For the Douce Apocalypse, see note 2.

48. For this manuscript, see note 38.

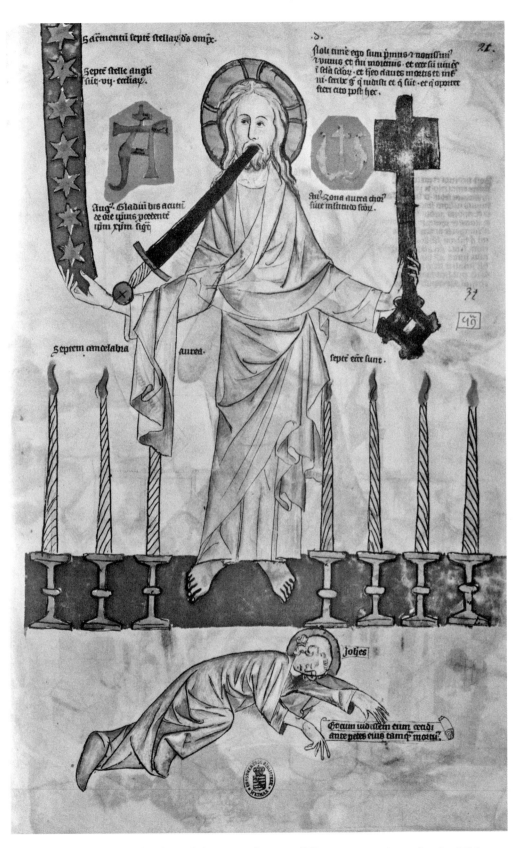

FIG. 10. John falls at the feet of the Son of Man. Biblia Pauperum Apocalypsis; Weimar, Zentralbibl. der deutschen Klassik, Fol. max. 4, fol. 21ʳ.

In a crucial scene that follows the letters sent to the Seven Churches and introduces the first apocalyptic prophecies, John is invited to come up to a door open in Heaven to see "the things which must be done here-after" (Rev. 4:1). Because the text is ambiguous about the invitation's source, medieval illustrated Apocalypses interpret the episode in varying ways. An early and important example is the scene in the Trier Apocalypse (fol. 13ᵛ; Fig. 11), which probably reflects an Early Christian archetype.[49] It interprets the voice as an allusion to the opening words of Revelation, when in response to "a great voice, as of a trumpet" (Rev. 1:10), John turns to see the Son of Man among the candlesticks, as noted above. Trier thus assigns the invitation to Christ, who is shown pointing with a long staff at an open window painted above John's head. Almost five centuries later, the Trinity Apocalypse follows the biblical text more faithfully (Fig. 12), a characteristic of its iconography underscored by Nigel Morgan.[50] John is shown in his own compressed vertical space, framed on the lower left of the main vision in which the Twenty-four Elders adore the enthroned Christ surrounded by the Four Living Creatures. John looks up to the open door above, responding to the invitation to come up inscribed in Anglo-Norman on the banner flowing from the trumpet: "Muntez sa e jo vus mustrerai ke kuvent estre fet apres ices choses" (fol. 4ʳ). This scene, a turning-point in John's visionary experience, establishes his role as prophet of the future.

The somewhat later Queen Mary Apocalypse imaginatively pictures the next stage of the visionary's response.[51] It depicts the visionary's response by showing John climbing a ladder propped on a mountainous landscape into the wide-open entrance of Heaven,

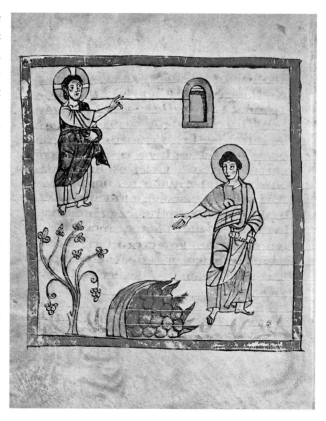

FIG. 11. Christ points to window in heaven. Trier Apocalypse; Trier, Stadtbibliothek, 31, fol. 13ᵛ.

where he is greeted by an angel emerging from a cloud.[52] The practical business of showing the ascent clarifies how John adeptly comes to look into Heaven, and it develops an ancient motif also present in contemporary manuscripts depicting mystical ascent. Nevertheless, it seems a rather mechanical interpretation of the text stating that John was immediately "in the spirit" (Rev. 4:2). The motif is also depicted in other fourteenth-century Apocalypses such as Oxford, New

49. Trier, Stadtbibliothek, 31; "Census," no. 6. See P. K. Klein, "Der Kodex und sein Bildschmuck," in *Trier Apokalypse: Kommentarband*, ed. R. Laufner and P. K. Klein (Graz, 1975), 89–112. On the iconographic links to an Early Christian archetype, see J. Snyder, "The Reconstruction of an Early Christian Cycle of Illustrations for the Book of Revelation: The Trier Apocalypse," *Vigiliae Christianae* 18 (1964), 146–62. The composition and iconography of this scene is repeated in the Cambrai Apocalypse (Bibl. Mun. 386, fol. 9ᵛ), a tenth-century copy of Trier; see "Census," no. 2. Its miniatures are available on the Enluminures Website.

50. In his discussion of Trinity's iconography, Morgan empha-

sizes its fidelity to the biblical text; see N. J. Morgan, "Iconography," in *Trinity Apocalypse*, ed. McKitterick (as in note 33), esp. 48–62.

51. London, BL, Royal 19.B.XV (England, ca. 1310–25); "Census," no. 75. It is named after its miniatures attributed to the artist of the Queen Mary Psalter. See Carey, ed., *Apocalypse* (as in note 3), 85; and L. F. Sandler, *Gothic Manuscripts, 1285–1385, A Survey of Manuscripts Illuminated in the British Isles* (London, 1986), no. 61.

52. For this miniature (fol. 5ᵛ) see *Apocalypse*, ed. Emmerson and McGinn (as in note 3), fig. 51.

FIG. 12. John summoned to come up to door in heaven. Trinity Apocalypse; Cambridge, Trinity College, R 16 2, fol. 4ʳ.

College, 65 (fol. 12ᵛ), Lambeth Palace Library, 75 (fol. 7ʳ), and Oxford, Lincoln College, 16 (fol. 143ᵛ; see Klein, Fig. 22).[53] These share a French gloss that is distinct from the Berengaudus commentary so popular in earlier thirteenth-century Apocalypses. The much later fifteenth-century Escorial Apocalypse (fol. 3ᵛ) departs even more from the letter of the biblical text.[54] Ignoring the vertical ascent implied by the invitation's "come up hither," it shows John alone in a room, moving toward a door he opens himself, as if he is merely leaving his study and book behind. This door will lead John into the heavenly realm, to be depicted in the next scene, but here the emphasis is on the visionary's earthly exile on Patmos, which is suggested by a large ship pictured behind the building.

Sometimes when the biblical text states that John is taken "in spirit," he is led or carried by an angel. The Paris Apocalypse, one of the earliest and most important of the mid-thirteenth-century English manuscripts, includes seventy-six tinted drawings illustrating an Anglo-Norman version of Revelation with a gloss related to the text of the Bible moralisée.[55] It

53. Commenting on the Lincoln College Apocalypse, Klein describes this motif as "an obvious metaphor of the seer's spiritual rapture"; see "From the Heavenly to the Trivial" (as in note 28), 268.

54. For this manuscript, see note 26.

55. Paris, BnF, fr. 403 (Salisbury?, 1250–55); "Census," no. 107. See Morgan, *Early Gothic Manuscripts (II)* (as in note 2), no. 103; and *L'Apocalypse en français au XIIIᵉ siècle*, ed. L. Delisle and P. Meyer, 2 vols. (Paris, 1901), a still important study of this manuscript and other Anglo-French Apocalypses. See also S. Lewis,

usually depicts John witnessing his vision within its framed miniatures, often with an angel who directs his attention. In two of these, the angel is shown effortlessly lifting John, cradling and transporting him to the vision's locus, as when John is taken to a mountain to glimpse the New Jerusalem (fol. 41ᵛ; see Klein, Fig. 3). Similarly the contemporary picture-book Morgan Apocalypse (M.524) shows one of the seven angels taking John "away in spirit into the desert" (Rev. 17:3; Fig. 13). There he sees the Whore of Babylon seated on the seven-headed Beast from the Sea, a symbol of Antichrist in medieval exegesis.[56] As Peter Klein notes, the "strangeness" of this carrying motif "leaves no doubt about its metaphorical meaning," the "spiritual rapture" of John.[57] As emphasized throughout this essay, John's being "in the spirit" is one of the most significant features of his visionary experience. These scenes also visually underscore his intimate relationship to the various angels who repeatedly serve as heavenly intermediaries, protectors, teachers, and guides, relationships that are among the most fascinating aspects of medieval illustrated Apocalypses.

We have already seen how John responds to the command both to write and not to write, to come and see, and to be taken in spirit. He also acts within the vision in response to other, more unusual, situations. One of the most memorable episodes of this apocalyptic drama—once again involving its most recurrent prop, a book—graphically emphasizes John's need to internalize his vision before he begins to prophesy. Shortly after being prohibited from recording the words of the Seven Thunders (Fig. 9), John is given a book to eat. The Trinity Apocalypse details this episode in two registers painted in the lower half of folio 10ᵛ (Fig. 14).[58] In the right side of the upper register, the angel hands the open book to John, while a voice from Heaven makes the unusual command: "Take the book, and eat it up: and it shall make thy belly bitter, but in thy mouth it shall be sweet as honey" (Rev. 10:9). The lower register in three scenes next unfolds the concluding stages of this fascinating narrative.[59] On the left, John first eats the book and then in the center scene he rubs his stomach to soothe its sourness. But he also turns to look toward the angel, who demands the visionary's attention and points toward a placard commanding John to prophesy: "Il te kouent derechef prophetizer as poeples e as gens e as langages e as mus reis" (Rev. 10:11). If John's response to the earlier invitation to come up to the door in Heaven gave him access to the prophetic future, then his response to the command to ingest the word now transforms him from visionary recipient to visionary prophet, from seeing and hearing to propagating his visions for all peoples, nations, and tongues.

John's relationship to the angels that serve as his visionary guides culminates toward the end of Revelation when, overcome by seeing the New Jerusalem and the River of Life, John mistakenly prostrates himself to adore the angel (Rev. 22:8). The significance of this blunder is recognized throughout the apocalyptic tradition. The early Valenciennes Apocalypse, for example, diminishes John by compressing him below the text (fol. 40ʳ). Holding the rod used to measure the New Jerusalem (Rev. 21:16), the angel leans forward, his hand suppressing John's head as if adding to the weight of the scolding words inscribed above. More than four centuries after the Carolingian miniature, the Morgan Apocalypse depicts a more sym-

"The Enigma of Fr. 403 and the Compilation of a Thirteenth-Century English Illustrated Apocalypse," *Gesta* 29 (1990), 31–43. Its images are available on the Mandragore Website.

56. On the medieval Antichrist and his depiction in art, see R. K. Emmerson, *Antichrist in the Middle Ages: A Study of Medieval Apocalypticism, Art, and Literature* (Seattle, 1981); B. McGinn, "Portraying Antichrist in the Middle Ages," in *The Use and Abuse of Eschatology in the Middle Ages*, ed. W. Verbeke et al. (Leuven, 1988), 1–48; and R. M. Wright, *Art and Antichrist in Medieval Europe* (Manchester, 1995).

57. Klein, "From the Heavenly to the Trivial" (as in note 28),

262. Lewis argues that the depiction of John being carried "provides compelling evidence for an intertextual relationship between the English Gothic archetype and the Bible moralisée cycle"; see *Reading Images* (as in note 22), 168, figs. 136, 137.

58. For this manuscript, see note 33.

59. As Morgan notes, "only in Trinity does the commentary passage from Berengaudus refer to all the additional episodes"; see "Iconography," in *Trinity Apocalypse* (as in note 50), 53. A more typical treatment of this scene is represented in the Getty Apocalypse, fol. 15ᵛ.

FIG. 13. John carried in spirit to see Whore of Babylon. Morgan Apocalypse; New York, Pierpont Morgan Library, M.524, fol. 16ᵛ, lower register.

pathetic and encouraging angel responding to John's misdirected worship. With his left hand he lifts John's head while pointing with his right hand upward to direct the visionary's attention to the rightful object of adoration, thus shifting the visual emphasis from the injunction, "do not do that," to the concluding words of this passage, "Adore God" (Rev. 22:9). As Lewis comments, "In the Berengaudus cycle, the pictorial evocation of John's *faux pas* serves as an admonition to the reader of the consequences of misreading or not reading allegorically, as conveyed in the accompanying commentary: 'However, as we have so diligently

maintained in the text of this book, it is not made to be gazed at in vain.'" [60]

John's response to the angel's admonition and encouragement is shown in the somewhat later Lambeth Apocalypse, which first depicts the angel pulling John from the ground and pointing to a mandorla just emerging from Heaven (fol. 39ʳ).[61] John's cosmic, if understandable, mistake in adoring the angel rather than God is strikingly visualized by contrasting gestures, for whereas John points to the feet of the angel, the angel points to the feet of God. The miniature hints at what the reader will see when turning the page (fol.

60. Lewis, *Reading Images* (as in note 22), 197.

61. London, Lambeth Palace Lib., 209 (London? 1260–67); "Census," no. 78. For a facsimile and commentary, see N. Morgan,

The Lambeth Apocalypse: Manuscript 209 in Lambeth Palace Library (London, 1990); see also Morgan, *Early Gothic Manuscripts (II)* (as in note 2), no. 126.

eio in cheuaus en cnsuin. e ceus ki secient sur
ceus auneient heaumes ardanz. e iacincens. e su
frint. e les testes de cheuaus. ausi cum testes de leuns.
e de lur buche iissi fu e sumeie esustre. La cere partie des
houmes est ocis de ces creis turmenz. de fu. e de sumeie
e de sufre ki issent de lur buche. Kar la pouste des che
uaus est en lur buche. e en lur kouwes. Kar lur kou
wes semblables a serpens auans chefs. eil nusent en i
ces choses. E les autres houmes ki ne sunt ocis. en ces
turmenz. ne firent repentance des ouraines de lur
mains. ke il ne aorasent diables. e les ornes sembla
unces. e argentins. e erins. e perins. e de fust. ki ne
point ueer. n oir. ne aler. e ne firent repentaunce de
lur homicidis. ne de lur enuenimer. ne de lur fornica
tiuns. ne de lur larcins. Les quire aungeles sunt des
lies. pur co ke les mauueis houmes pursiwirent le peuple
deu les queus peis auer lie deuaunt. Co ke il dist keil
furet apareiles: demustrer ke les mauueis deuaunt le tens de
pseecutiun furet prest par desir a tuer le poeple deu. Pour

est entendu. le tens del cumencement del munde treske
al diluue. Pur. le tens del diluue treske a la lai. P
meis. le tens desus la lai. P an. le tens de grace. Ceus
ki sunt signifies p les quire aungeles. sunt signifies p le host
a cheual. co sunt les pursiwrs de seinte eglise. P les cheuaus
le people deu est entendu. sur le quel li diable set. P les
heaumes. la durece des queors des reprouees. P fu cruelte
de pensee. P iacincte ki ad figure del cel. honur de deu
ke il rendureut a lur deu. P sufre ke put. blasfemie.
P les testes de cheuaus. les emperurs de roume sunt signi
fies. P le fu ki iist de lur buche. les feluns komaunde
menz. p queus les seins furent ocis. P la sumeie ke rost
enuanist. le honur ke il renduint a lur deu. P les donz.
les turmenturs de seins. les queus il poeint ocire. mes ne
mie uencre. P les kouwes. la cripse des poetes. e des filo
sofes. La cere prie ke est tue. est sauue. de la quele prie
mut sunt ocis. e les autres moreient uolunters pur deu.
si en estre fust. Les autres. co est a dire les paens. ki ne cru
rent pas en trist. perirent.

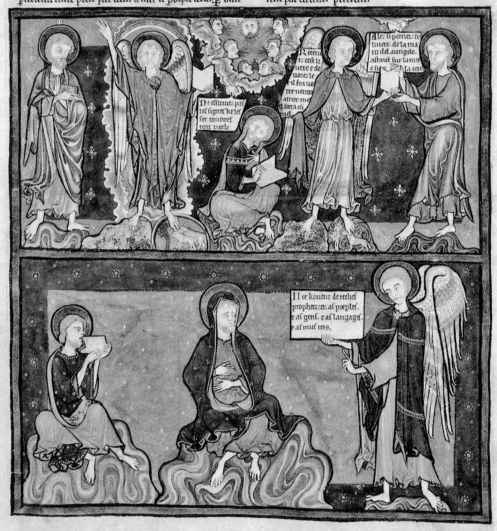

FIG. 14. John commanded to eat book, which turns sour in his stomach, and to prophesy.
Trinity Apocalypse; Cambridge, Trinity College, R 16 2, fol. 10ᵛ.

FIG. 15. John kneels before Christ. Lambeth Apocalypse; London, Lambeth Palace Library, 209, fol. 39ᵛ.

sionary to a romance hero, Suzanne Lewis has argued that "John's desire is never satisfied. In this sense, there is no narrative closure."[62] Yet, in my view, this scene provides exactly that narrative closure, as well as the emotional culmination of John's role as a participant in his vision. His visionary quest has taken him from first falling as if dead at the feet of the Son of Man (Fig. 10) to kneeling with dignity before Christ.[63] By being shown directly facing the fully revealed divine presence, John also models the quest of all faithful Christians, who are invited to follow him through his visionary experience to its final heavenly revelation. In the case of the Lambeth Apocalypse, that is the quest of the manuscript's owner, who was likely Eleanor de Quincy, Countess of Winchester.[64] She is probably the woman depicted in two scenes following the Apocalypse, a Virgin and Child (fol. 48ʳ) and an Allegory of Virtue and Vice (fol. 53ʳ). These images translate the anagogical battle between good and evil expected in the apocalyptic future into the viewer's daily life, the present tropological battle supported by Eleanor's devotion to the Virgin and Child and nourished by her book's moral instruction.

John as Visionary Intermediary

In addition to serving as a witness to the prophetic future and participating within his visions, John also becomes an intermediary linking his otherworldly visionary experiences to the lives of his earthly readers, as in the case of Eleanor de Quincy and the Lambeth Apocalypse. John's third role in the illustrated Apocalypses is primarily due to his being the human author who records his visions of superhuman events, as we have seen. In some medieval Apocalypses, furthermore, he also becomes a model Christian whose experience exemplifies the Augustinian topos that life is a pilgrimage from the earthly to the heavenly city. This notion is strikingly represented in the Escorial Apocalypse by two miniatures ingeniously contrasting the

39ᵛ), where John kneels before Christ (Fig. 15). Significantly, this image is not based on the biblical text, which does not mention John's final and proper adoration, nor is it accompanied by the Berengaudus commentary. Instead, it is motivated by the trajectory of the visual narrative, activated by the angel's pointing hand in the previous image. It now serves as the spiritual conclusion to John's visionary experience and the appropriate final image to accompany the manuscript's explicit below, which reminds the viewer/reader that this is the Revelation of the Lord. Comparing the vi-

62. Lewis, *Reading Images* (as in note 22), 23.

63. Lewis does later acknowledge that John's worship of Jesus is "without precedent in earlier traditions" and provides "the seer's

ultimate reward as he now confronts his Lord alone, gazing up at Christ in a vision no longer mediated by angels" (198).

64. Morgan, *Lambeth Apocalypse* (as in note 61), 73–79.

two cities.[65] The first (fol. 1[v]) accompanies the apocryphal letter of the Proconsul of Ephesus, which describes John's life before his exile to Patmos. The miniature (Fig. 16) shows John leaping from the ship that brought him from Domitian's Rome. Significantly, Jean Bapteur, who had visited Rome in June 1427, paints the earthly city in the distance, depicting several recognizable landmarks, including, from right to left, the Castel Sant'Angelo, Tiber River, Coliseum, Arch of Titus, and Pantheon.[66] This late medieval version of ancient Rome is contrasted with the New Jerusalem depicted at the conclusion of the Apocalypse (fol. 45[v]). Completing the manuscript some sixty years later, Jean Colombe imagines the desired heavenly home as a bejeweled walled city surrounded by sky rather than sea, a Christian city complete with a Gothic church recalling Sainte-Chapelle. These two scenes effectively frame this deluxe Apocalypse and remind its viewers, who would include Philip II of Spain as well as the patron dukes of Savoy, that John's vision of Christ in Heaven is the culmination of a journey from the city of man to the city of God.

John experienced his vision on Patmos because he was exiled by a frustrated Emperor Domitian for obeying Christ's command to preach the gospel "even to the uttermost part of the earth" (Acts 1:8). After Christ's Ascension, John went to Ephesus where his preaching was particularly effective, leading the imperial Proconsul to arrest and send him to Rome. Many Apocalypses introduce the exile of John by focusing on a key moment in his legendary life, when he is tried by Domitian and condemned to be boiled in oil. As shown in the first of eighty-five miniatures of the Apocalypse made for Jean, Duc de Berry (PML, M.133, fol. 1[r]), the nimbed and praying John stands

FIG. 16. John exiled from Rome to Patmos. Escorial Apocalypse; Escorial, Biblioteca San Lorenzo, E Vitr. V, fol. 1[v].

naked in a cauldron (Fig. 17).[67] Two torturers prepare to scourge him while a crowned Domitian and a group of accusers watch. Miraculously, John will survive this torture, which is often mistakenly referred to as his "martyrdom." Seeing that he is unharmed, the furious

65, On this manuscript, see note 26.

66. On Jean Bapteur's period in Rome, see S. Edmunds, "Jean Bapteur et l'Apocalypse de l'Escorial," in *Les manuscripts enluminés des comtes et des ducs de Savoie*, ed. A. Paravicini Bagliani (Lausanne, 1989), 193–230. On representations of Rome, see S. Maddalo, *In Figura Romae: Immagini di Roma nel libro medioevale* (Rome, 1990). I thank my colleague Jack Freiberg for bringing this helpful study to my attention.

67. New York, PML, M.133 (Paris, ca. 1415); "Census," no. 88.

See *Paris 1400: Les arts sous Charles VI* (Paris, 2004), 289–90, no. 180. The French biblical text is accompanied by a French version of the Berengaudus commentary. I am currently undertaking a detailed analysis of this manuscript, which has received surprisingly little scholarly attention. On the Master of the Berry Apocalypse, see M. Meiss, *French Painting in the Time of Jean de Berry: The Limbourgs and their Contemporaries* (New York, 1974), 1:368–72, and 2: figs. 787, 792, 808.

FIG. 17. John's torture in boiling oil. Berry Apocalypse;
New York, Pierpont Morgan Library, M.133, fol. 1ʳ.

scene is repeated in Renaissance Apocalypses, intro-
ducing, for example, Dürer's famous woodcuts, which
here and elsewhere are less a departure from medi-
eval manuscript traditions than art historians usually
acknowledge.[68]

Some manuscripts, beginning in the thirteenth
century and continuing into the fifteenth, develop a
much more extensive sequence of images to repre-
sent John's life. The Lambeth Apocalypse, for exam-
ple, places these after the conclusion of the Apocalypse
(fols. 40ᵛ–45ʳ), where they form a distinct narrative
taking up ten pages, each with two registers that de-
tail twenty of the forty scenes that comprise the vi-
sual life of John.[69] The somewhat earlier Paris Apoc-
alypse (BnF, fr. 403) uses the life of John to frame
Revelation, prefacing the Apocalypse with eight ep-
isodes from his early life (fols. 1ʳ–3ʳ; see Klein, Fig.
17) and placing another nine hagiographic scenes fol-
lowing the conclusion of his vision and detailing his
post-visionary miracles before his last mass and death
(fols. 43ᵛ–44ᵛ). The most developed, fluent, and ele-
gant visual treatment of John's life encases his vision-
ary experience in the Trinity Apocalypse (fols. 1ʳ–2ʳ
and 28ʳ–31ᵛ).[70] The manuscript includes thirty hagio-
graphic scenes painted in three registers per page, each
introduced by an Anglo-Norman caption inscribed in
the top and sometimes lower bands that frame each
register. As I have argued elsewhere, these narrative
scenes provide a visually coherent and dramatic vita
for the manuscript's thirteenth-century audience, per-
forming the life of John by means of carefully scripted
scenes, repeated speeches, vigorous gestures, and the-
matic actions.[71]

The continuing popularity of John's vita into the
later Middle Ages is exemplified by fifteenth-century

emperor exiles the apostle to Patmos. This or a simi-
lar episode from the legendary life of John often pref-
aces the visionary images in medieval Apocalypses,
providing a kind of "baptism by fire" that cleanses the
worldly and bodily traits of the apostle's life and pre-
pares John to receive his revelation "in the spirit." The

68. For Dürer, see *Die Apokalypse: Faksimile der deutschen Ur-
ausgabe von 1498 "Die Heimlich Offenbarung Johannis,"* 2 vols.,
with commentary by L. Grote (Munich, 1999). For the medieval
context of Dürer, see M. Camille, "Visionary Perception and Im-
ages of the Apocalypse in the Later Middle Ages," in *Apocalypse,*
ed. Emmerson and McGinn (as in note 3), 276–89, esp. 283–87.

69. As Nigel Morgan has shown, these miniatures are by the
artist who also added a brief cycle of images depicting the life of
Antichrist at the bottom of the manuscript's folios for chapters 10
and 11; see Morgan, *Lambeth Apocalypse* (as in note 61), 47. For a

comparative listing of scenes comprising the visual life of John, see
Lambeth Apocalypse, appendix 11.

70. On this manuscript, see note 33. The life of John sequence is
illustrated in D. R. Cartlidge and J. K. Elliott, *Art and the Christian
Apocrypha* (London, 2001), 185–206.

71. R. K. Emmerson, "Framing the Apocalypse: The Per-
formance of John's Life in the Trinity Apocalypse," in *Visualiz-
ing Medieval Performance: Perspectives, Histories, Contexts,* ed. E.
Gertsman (Aldershot, 2008), 33–56.

manuscripts and block books. For example, a German picture-book Apocalypse at the New York Public Library, which is related to the famous encyclopedia at the Wellcome Institute for the History of Medicine and to contemporary block-book Apocalypses, opens with seven tinted-outline drawings depicting John's early life.[72] They introduce seventy Apocalypse illustrations that culminate when John is shown kneeling before Christ in the upper register of folio 17[r]. The saint's life immediately continues below without a break, as John returns from Patmos to Ephesus and raises Druisiana from the dead. Similarly, John's worldly experiences play a crucial role in visually framing his otherworldly vision in contemporary block-book Apocalypses. For example, the Estense Apocalypse, a Dutch block book now at the Biblioteca Estense in Modena, closely parallels the German manuscript at the New York Public Library in strikingly juxtaposing the biblical vision and the legendary life (Fig. 18).[73] Christ now looks directly at the book's reader while holding a heavily inscribed scroll. Kneeling before him, John both worships Christ and reads the concluding words of his Apocalypse, which lead directly to the concluding events of his ministry. Directly below, John is again shown but now standing at the gates of Ephesus, where he will perform his most famous miracle. For the late medieval reader of this early printed book, this bold page juxtaposing Christ's words and John's actions suggests that the visionary experience of John not only informs but also merges seamlessly into his hagiographic vita. Such depictions establish John as both a prophet of the future and a model Christian who lived an active life impelled by his visionary experience. The image underscores his role as the human intermediary between the otherworldly visions of the Apocalypse and their medieval audience, who in this book share John's visions.

FIG. 18. Conclusion of John's vision (upper) and his return to Ephesus to raise Druisiana (lower). Estense Apocalypse; Modena, Biblioteca Estense, Alpha D.5.22, p. 46.

The scene suggests, furthermore, that the concluding words are spoken by Christ directly to the late medieval reader.

John Being "in the Spirit"

From the very beginning of Revelation, John claims to be "in the spirit" (Rev. 1:10) and throughout the Middle Ages his vision, as Robert Freyhan noted more than fifty years ago, was taken to exemplify Augustine's second visionary category, *visio spiritualis*.[74] It

72. New York, NYPL, MA 15 (Thuringia, ca. 1470); "Census," no. 129. See *Splendor of the Word* (as in note 45), no. 19, which includes Jeffrey Hamburger's detailed comparison of the manuscript's miniatures to those in the Wellcome Apocalypse (London, Wellcome Institute for the History of Medicine, 49) and a block-book Apocalypse (93–96). On the relationships between these fifteenth-century continental manuscripts and block books and the

earlier English Apocalypses, see G. Bing, "The Apocalypse Block-Books and their Manuscript Models," *JWCI* 5 (1942), 143–58.

73. Biblioteca Estense Universitaria di Modena, Alpha D.5.22, p. 46; for a facsimile see *Apocalypsis Johannis*, 2 vols., with commentary by Ernesto Milano (Modena, 1999).

74. Freyhan, "Joachism and the English Apocalypse" (as in note 19). 233, n. 2. Augustine elaborates his tripartite categorization of

should be emphasized that Christ is the origin of this spiritual vision, a foretaste of which John received earlier as a disciple when resting his head on Christ's breast. One scriptural source of this motif is the Fourth Gospel's account of the Last Supper, which states that the beloved disciple "was leaning on Jesus' bosom" (John 13:23).[75] As Jeffrey Hamburger explains, in some exegetical and mystical traditions, John held a "privileged place at the Last Supper, suggesting that while sleeping on the breast of the Lord he imbibed celestial secrets that surpassed understanding."[76] An alternate biblical locus for John's intimate relationship with Christ is the Marriage at Cana. Some exegetical and mystical traditions identify John as the bridegroom who, leaving his bride to follow Jesus, received heavenly mysteries while resting on Christ's breast.[77]

John's first revelatory experience with Christ is explicitly connected to his vision on Patmos in a fourteenth-century metrical Apocalypse made for Henry, 1st Lord of Cobham and now at Corpus Christi College, Cambridge.[78] In the first of its 106 miniatures (fol. 1[r]; Fig. 19), John appears three times. On the left, seated at a bountiful table, he rests his head on Christ's breast. Whether the meal is intended to represent the

FIG. 19. John with Christ, exile to Patmos, and vision. Corpus Christi Apocalypse; Cambridge, Corpus Christi College, Ms. 20, fol. 1[r].

visions in *De genesi ad litteram libri duodecimo*, ed. P. Agaësse and A. Solignac (Paris, 1972). See also S. F. Kruger, *Dreaming in the Middle Ages* (Cambridge, 1992), 35–50.

75. For color illustrations from manuscripts, see *Last Supper* (London, 2000), 17, 25, 29, 39, 67.

76. J. F. Hamburger, *St. John the Divine: The Deified Evangelist in Medieval Art and Theology* (Berkeley, 2002), 17.

77. On this iconography, see E. S. Greenhill, "The Group of Christ and St. John as Author Portrait: Literary Sources, Pictorial Parallels," in *Festschrift Bernhard Bischoff zu seinem 65. Geburtstag* (Stuttgart, 1971), 406–16.

78. Cambridge, Corpus Christi Coll., 20 (London? ca. 1335–1339); see "Census," no. 42; Sandler, *Gothic Manuscripts* (as in note 51), no. 103; and *Cambridge Illuminations* (as in note 14), no. 51. For a color reproduction, see C. de Hamel, *The Book: A History of the Bible* (London, 2001), fig. 109.

Marriage at Cana or the Last Supper is a matter of scholarly debate, but for our purposes its occasion is less important than is the image's emphasis on Christ's intimate relationship with the beloved apostle as primary motivation for his visionary experience.[79] This is made explicit in the miniature's two juxtaposed scenes: in the center John arrives by boat at Patmos, and on the right, he receives his apocalyptic vision. Ignoring the more traditional life of John that narrates his ministry in Ephesus and the trial before Domitian that leads to exile on Patmos, the Corpus Christi Apocalypse instead depicts the ultimate source and inspiration of the Apocalypse by emphasizing John's special relationship with Christ.

Interestingly, the Corpus Christi manuscript also includes illustrations of the popular *Visio Pauli*, thereby associating two apostles whom medieval exegesis and literature connected because each experienced a vision of the otherworld.[80] But the differences between the two apostolic visionaries should also be noted. Paul's ambiguous hints of being taken up to the third heaven and his repeated uncertainty about whether he was in body or spirit (2 Cor. 12:2–5) contrast sharply with John's certainty that his vision has divine authorization and was received while being "in the spirit." In the introductory miniature of the Corpus Christi Apocalypse (Fig. 19) the two visionary scenes linked

by the exile of John depict his corporeal eyes as closed, which typifies his depiction on Patmos (see Klein, Fig. 2). These closed eyes, however, should not lead us to characterize his experience as a "dream vision,"[81] because once John receives his heavenly vision, his eyes are always open. This characteristic is a significant sign that when John is "in the spirit" he is not dreaming but instead sees his vision through spiritual eyes—even while his body remains exiled on Patmos. Liberated from the corporeal, John looks into Heaven (Fig. 12), writes in response to what he sees and hears (Fig. 7), eats a book (Fig. 14), accompanies the angel across the visionary landscape (Fig. 13), and finally meets the source of his vision, kneeling before Christ (Fig. 15). He is not, therefore, a mere receptor of Revelation but an active figure, fully engaged as a visionary witness, participating in his visions, and serving as the intermediary between the otherworldly and the worldly.

It is appropriate that the Berry Apocalypse concludes with an image in which John speaks directly to contemporary readers and viewers (Fig. 20). In an iconographically unusual three-quarter-page miniature[82] that illustrates the angel's command introduced below by a decorated initial "E" ("Et il me dist ne songie pas les paroles" Rev. 22:10), a nimbed John stands behind a low wall preaching to six listeners sitting below in a grassy area. The scene interprets the command not

79. Although Sandler (*Gothic Manuscripts* [as in note 51], 2:182), the Cambridge catalogue (*Cambridge Illuminations* [as in note 14], 136), and de Hamel (*The Book* [as in note 78], 154) identify the first scene as a Last Supper, I agree with Lewis that it probably represents John's role as the bridegroom at Cana; see *Reading Images* (as in note 22), 28–31.

80. The essential study remains T. Silverstein, *Visio Sancti Pauli: The History of the Apocalypse in Latin, Together with Nine Texts* (London, 1935); for recent bibliography, see the essays in *The Visio Pauli and the Gnostic Apocalypse of Paul*, ed. J. N. Bremmer and I. Czachesz (Leuven, 2007). On its illustrations in the Corpus Christi Apocalypse (as in note 78) and Toulouse Apocalypse (as in note 25), see N. J. Morgan, "The Torments of the Damned in Hell in Texts and Images in England in the Thirteenth and Fourteenth Centuries," in *Prophecy, Apocalypse and the Day of Doom*, ed. Morgan (as in note 15), 250–60, esp. 256–60.

81. In *Reading Images* (as in note 22) Suzanne Lewis often refers to John as experiencing a "dream vision" in order to associate his vision with later medieval literary forms. There is, however, a sig-

nificant distinction between the role of John in the Apocalypse and that of the dreamers in dream visions, since their experience is usually problematic and they are often unreliable narrators; see, for example, R. K. Emmerson, "'Coveitise to Konne,' 'Goddes Privetee,' and Will's Ambiguous Visionary Experience in Piers Plowman," in *Suche Werkis to Werche: Essays on Piers Plowman in Honor of David C. Fowler*, ed. M. Vaughan (East Lansing, 1993), 89–121. There is a huge scholarly literature on the genre: see, for example, A. C. Spearing, *Medieval Dream-Poetry* (Cambridge, 1976); K. L. Lynch, *The High Medieval Dream Vision: Poetry, Philosophy, and Literary Form* (Stanford, 1988); and Krueger, *Dreaming in the Middle Ages* (as in note 74).

82. As Nigel Morgan has noted, the Berry Apocalypse continues the "idiosyncratic iconography" that characterizes later French Apocalypses; see N. J. Morgan, "Some French Interpretations of English Illustrated Apocalypses c. 1290–1330," in *England and the Continent in the Middle Ages: Studies in Memory of Andrew Martindale*, ed. J. Mitchell (Stamford, 2000), 137–56, esp. 146–47. On this manuscript see note 67.

FIG. 20. John warns listeners about the imminent end of time. Berry Apocalypse; New York, Pierpont Morgan Library, M. 133, fol. 85ᵛ.

to seal the book by showing John preaching, gesturing with his right index finger as if enumerating on the fingers of his left hand the reasons to heed the warning that follows: "Behold, I come quickly; and my reward is with me, to render to every man according to his works" (Rev. 22:12). The Apocalypse thus concludes, as it opened, with the testimony of Jesus Christ made known by an angel (Rev. 22:16) through John. Just as the earliest Apocalypse manuscripts stress the authorization of John as visionary prophet (Fig. 1) and the transmission of Revelation to the medieval monastic reader and viewer, so this late-medieval miniature stresses the transmission of Revelation to a contemporary secular audience through John. Here, as in the long tradition of illustrated Apocalypses that this essay has surveyed, John is the seeing, hearing, and recording witness who participates in his apocalyptic visions, serves as their authorized intermediary, and provides a model for the medieval reader/viewer of these spectacular manuscripts.

PETER K. KLEIN

Visionary Experience and Corporeal
Seeing in Thirteenth-Century English Apocalypses:
John as External Witness and the Rise of
Gothic Marginal Images[*]

The Medieval Concept of Vision

IN the last few decades, the interpretation of high- and late-medieval book illumination has especially emphasized visionary experience and this also applies to the illustration of the Apocalypse. The Apocalypse of John or Book of Revelation consists, as is well known, of a series of visions. However, the visionary character of these passages is by no means always visualized in the illustrations. To distinguish the depictions of the different forms of seeing, one has to consider the medieval concept of vision. As originally developed by St. Augustine,[1] it distinguishes between corporeal, spiritual, and intellectual vision.[2] This three-level theory of vision was maintained, or at least alluded to, in most of the medieval Apocalypse commentaries as well as in other exegetical, theological, and encyclopedic texts, from Isidore's *Etymologiae* to the Anglo-French and Middle English Apocalypses of the thirteenth and fourteenth centuries.[3] According to this widespread Augustinian theory, there is a hierarchy of vision, ascending from the corporeal, to the spiritual, up to the intellectual. As it is summed up in the twelfth-century pseudo-Augustinian treatise *De spiritu et anima*:[4] "There are obviously three kinds of vision. The first is the corporeal through which

* With a modified approach, in this contribution I return to a subject I already discussed a number of years ago. See P. K. Klein, "From the Heavenly to the Trivial: Vision and Visual Perception in Early and High Medieval Apocalypse Illustration," in *The Holy Face and the Paradox of Representation* (Papers from a colloquium held at the Bibliotheca Hertziana, Rome, and the Villa Spelman, Florence, 1996), ed. by H. L. Kessler and G. Wolf (Bologna, 1998), 247–278. I thank the Princeton Institute for Advanced Study, where this paper was written, for its hospitality and excellent working conditions, and I feel equally obliged to the Princeton colleagues Adelaide Bennett, Sarah Kay, and Irving Lavin for their helpful advice and suggestions, as well as to Colum Hourihane for polishing the English of this paper.

1. Augustinus, *De Genesi ad litteram*, XII, 7–37 (Corpus Scriptorum Ecclesiasticorum Latinorum, 28, 2), ed. J. Zycha (Vienna, 1894), 387–435.

2. See e.g., M. R. Bundy, *The Theory of Imagination in Classical and Medieval Thought* (Urbana, 1927; repr. 1970), 165–172; F. X. Newman, '*Somnium*': *Medieval Theories of Dreaming and the Form of Vision Poetry* (Ph.D. diss., Princeton University, 1962), 111–114; M. E. Korger, "Grundprobleme der Augustinischen Erkenntnislehre: Erläutert am Beispiel von *De genesi ad litteram* XII," in *Hommage au R. P. Fulbert Cayré*. Supplément à la *Revue des Études*

Augustiniennes (Paris, 1962), 33–57; R. H. Nash, *The Light of the Mind: St. Augustine's Theory of Knowledge* (Lexington, Ky., 1969), 9–11, 39ff.; G. Schleusener-Eichholz, *Das Auge im Mittelalter*, II, (Munich, 1985), 959ff.; St. F. Kruger, *Dreaming in the Middle Ages* (Cambridge, 1992), 37ff.

3. L. Delisle and P. Meyer, *L'Apocalypse en français au XIIIe siècle. Bibl. Nat. Fr. 403: Introduction et texte* (Paris, 1901), CCLIX–CCLX; F. X. Newman, "The Structure of Vision in 'Apocalypsis Goliae,'" *Medieval Studies*, 29 (1967), 113–123, cf. 115–119; *idem*, "St. Augustine's Three Visions and the Structure of the *Commedia*," *Modern Language Notes* 82 (1967), 56–78, cf. 60f.; E. Fridner, *An English Fourteenth Century Apocalypse Version With a Prose Commentary* (Lund-Copenhagen, 1961), 3f.; B. A. Pitts, "Versions of the Apocalypse in Medieval French Verse," *Speculum* 58 (1983), 31–59, cf. 36; Kruger, 61f., 189 n. 28; J. F. Hamburger, *The Rothschild Canticles: Art and Mysticism in Flanders and the Rhineland Circa 1300* (New Haven and London, 1990), 165.

4. Cf. L. Norpoth, *Der Pseudo-Augustinische Traktat De Spiritu et Anima*, Ph.D. diss. (Munich, 1924; repr. Cologne-Bochum, 1971); M. Putscher, *Pneuma, Spiritus. Geistliche Vorstellungen vom Lebensantrieb in ihren geschichtlichen Wandlungen* (Wiesbaden, 1973), 48–50.

bodies are seen by the corporeal senses. The second is the spiritual through which the spirit, not the intellect, discerns images of bodies. The third is the intellectual [vision] through which those things are perceived that are neither bodies nor forms of bodies."[5]

Within this Augustinian classification, the visions of the Apocalypse belong to the second level, the spiritual visions, in which the spirit or the "eyes of the soul" discern images of bodies.[6] Therefore, the medieval artists had to develop formal and iconographical devices clearly indicating that the apocalyptic visions referred to another kind of reality and that the visionary experience of St. John was different from the normal kind of seeing. Different metaphoric devices were developed in this regard: the dream type (Fig. 2, 14), the dove-soul type,[7] the gestures of "aposkopein"[8] and of pointing at one's eyes (Fig. 1), the grip-at-the-wrist type (Fig. 4, 5), and the lift-up type (Fig. 3), as well as the ladder motif (Fig. 22).[9] These metaphorical devices were rarely used in early medieval Apocalypse imagery, probably because the Early Christian and early medieval commentaries tended to allegorize the apocalyptic visions.[10] On the contrary, we notice a certain revaluation of the apocalyptic visions in some twelfth-century commentaries, for example by Rupert of Deutz and especially Richard of St. Victor.[11] Corresponding to this development there is an increase of depictions of visionary experience in Romanesque Apocalypse illustration. For instance, the Vision of the Enthroned of Rev. 4:1–8 in the mid-twelfth-century Oxford codex of the Apocalypse commentary by Haimo of Auxerre (Fig. 1) shows a gigantic figure of St. John who conspicuously points at his eyes while looking up to the sky, where a scroll appears with the words of the heavenly voice *ascende huc* (Come up here). Contrary to the biblical text, John neither looks at the open door next to him nor at the enthroned Lord in the center. Hence, the pointing at his eyes does not stress the normal, corporeal way of seeing, but rather focuses on the spiritual vision of the "inner eyes," according to the second level of the Augustinian vision theory.[12]

Visionary Experience in English Early Gothic Apocalypse Illustration

The thirteenth century, then, is marked by a paradigmatic change brought about by the rise of the Gothic English Apocalypses from about 1240;[13] these establish new iconographic standards that prevail until the

5. "Ista tria genera visionum manifesta sunt. Primum corporale, quo per corporis sensus corpora sentiuntur. Secundum spirituale, quo corporum similitudines spiritu, non mente cernuntur. Tertium intellectuale, quo illae res quae nec corpora nec corporum formas habent conspiciuntur." (Migne PL 40: 797f.).

6. "Quando autem penitus avertitur atque abripitur animi intentio a sensibus corporis, tunc magis ecstasis dici solet. Tunc omnino quaecumque sint praesentia corpora, etiam patentibus oculis non videntur nec ullae voces prorsus audiuntur: totus animi contuitus … in corporum imaginibus est per spiritalem … visionem…. sicut in Apocalypsi Iohanni exponebatur, magna reuelatio est, etiamsi forte ignoret ille, cui haec demonstratur, utrum e corpore exierit an adhuc sit in corpore, sed spiritu a sensibus corporis alienato ista uideat." (Augustinus, *De Genesi*, XII, 12, 25; ed. by Zycha, 396, 419).

7. Klein, "From the Heavenly to the Trivial," 256f. (as in note *), Fig. 6.

8. I. Jucker-Scherrer, *Der Gestus des Aposkopein: Ein Beitrag zur Gebärdensprache in der antiken Kunst* (Zurich, 1956), 111–120; P. K. Klein, "Stellung und Bedeutung des Bamberger Apokalypse-Zyklus," in *Das Buch mit 7 Siegeln. Die Bamberger Apokalypse*

(Exhib. Cat.), ed. by G. Suckale-Redlefsen and B. Schemmel (Luzern, 2000), 105–136, esp. 113, Pl. 11.

9. So far, these different types of expressing metaphorically the visionary experience of St. John have never been discussed altogether in detail.

10. Cf. B. Nolan, *The Gothic Visionary Perspective* (Princeton, 1977), 3–12; Klein, "From the Heavenly to the Trivial" (as in note *), 254–259.

11. W. Kamlah, *Apokalypse und Geschichtstheologie: Die mittelalterliche Auslegung der Apokalypse vor Joachim von Fiore* (Berlin, 1935), 105–114; Nolan, *The Gothic Visionary Perspective* (as in note 10), 13–34.

12. This is confirmed by one of the historiated initials of the nearly contemporary St. Albans Psalter (Hildesheim, Dommuseum, p. 119), illustrating Psalm 26:1 ("dominus illuminatio mea"): beneath the vision of the Lord in heaven, King David is tumbling down in spiritual rapture, pointing, as the Oxford St. John figure, with an extremely elongated finger at his eyes, as indication of his spiritual illumination. See Klein, "From the Heavenly to the Trivial" (as in note *), 259f., Fig. 8.

13. See G. Henderson, "Studies in English Manuscript Illumi-

FIG. I. Open Door in Heaven and Vision of the Enthroned. Haimo Commentary on the Apocalypse, Oxford, Bodleian Library, Ms. Bodl. 352, fol. 5ᵛ.

end of the Middle Ages.[14] Given the preceding development in the twelfth century, one might expect a further increase in visionary imagery, and indeed the English Gothic Apocalypses have been described as the culmination of pictured visionary experience.[15] But things are much more complex and even contradictory. On the one hand, English thirteenth-century Apocalypses continue the tendency of Romanesque Apocalypse illustration, emphasizing the spiritual vision, but, on the other hand, part of the English Apocalypses also reveals a reverse trend towards corporeal

seeing and experience. As to the visual metaphors of spiritual visions, most of the thirteenth-century English Apocalypses render the initial ecstasy of St. John on the isle of Patmos in the form of the so-called dream type,[16] the seer reclining with closed eyes on the isle of Patmos, surrounded on every side by the sea, as for instance in the Lambeth Apocalypse (Fig. 2) of about 1260–67.[17] The iconography of this composition has an antecedent in the early twelfth-century Berlin Beatus (Berlin, Staatsbibliothek, Ms. theol. lat. fol. 561),[18] an Italian codex of the Apocalypse commentary by

nation. Part II: The English Apocalypse I," *Journal of the Warburg and Courtauld Institutes* 30 (1967), 104–137; "Part III: The English Apocalypse II," *ibid.*, 31 (1968), 103–147; P. K. Klein, *Endzeiterwartung und Ritterideologie: Die englischen Bilderapokalypsen der Frühgotik und MS Douce 180* (Graz, 1983); N. Morgan, *The Lambeth Apocalypse: Manuscript 209 in Lambeth Palace Library* (London, 1990); S. Lewis, *Reading Images: Narrative Discourse and Reception in the Thirteenth-Century Illuminated Apocalypse* (Cambridge, 1995).

14. See e.g., G. Schiller, *Ikonographie der christlichen Kunst*, V (Textteil) (Gütersloh, 1990), 268ff.

15. Lewis, *Reading Images* (as in note 13), 40.

16. For this iconographic type, see F. Garnier, *Le langage de*

l'image au Moyen Âge: Signification et symbolique, 2nd ed. (Paris, 1982), 118f.; *Träume im Mittelalter: Ikonologische Studien*, ed. by A. Paravicini Bagliani and G. Stabile (Stuttgart and Zurich, 1989); Klein, "From the Heavenly to the Trivial" (as in note *), 250–252.

17. For the date and place of origin of the Lambeth Apocalypse, see N. Morgan, *Early Gothic Manuscripts* (A Survey of Manuscripts Illuminated in the British Isles, 4), II (London, 1988), 101–106, No. 126; *idem*, *The Lambeth Apocalypse*, 73–77.

18. W. Neuss, *Die Apokalypse des hl. Johannes in der altspanischen und altchristlichen Bibel-Illustration* (Münster, 1931), 250, Fig. 232; Schiller, *Ikonographie der christlichen Kunst*, V (Bildteil), 13, Fig. 19; J. Williams, *The Illustrated Beatus: A Corpus of Illustrations of the Commentary on the Apocalypse*, IV (London, 2002), Pl. 365.

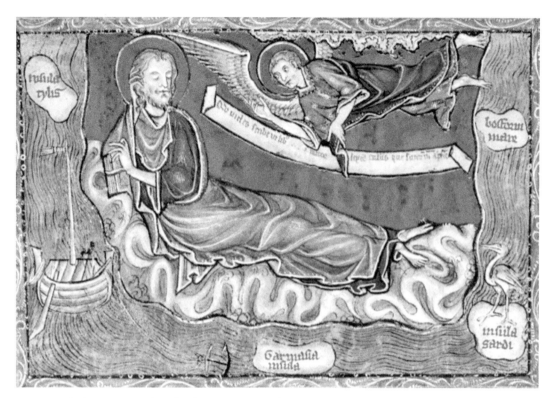

FIG. 2. John's Vision on the Isle of Patmos. Apocalypse, London, Lambeth Palace, Ms. 209, fol. 1ʳ.

FIG. 3. Vision of the Heavenly Jerusalem. Apocalypse, Paris, Bibliothèque nationale de France, Ms. Fr. 403, fol. 41ᵛ.

Beatus of Liébana, whose illustrations in the case of this manuscript follow the Romanesque Apocalypse tradition in Central Europe.[19] In a slightly different form, the dream type is already used for the same visionary scene in the Carolingian Juvenianus Codex (Rome, Biblioteca Vallicelliana, Ms. B.25.2), a miscellaneous New Testament manuscript of the first quarter of the ninth century.[20] Beside the traditional dream type, the Archetype group of the English Apocalypses also present another visual metaphor of visionary experience that is new, although having some precursors. In this type of spiritual rapture, John is literally taken by an angel who lifts the seer up in his arms. For instance, in the Vision of the Heavenly Jerusalem (Rev. 20–21) in the Apocalypse Paris Fr. 403 (Fig. 3), the earliest preserved manuscript of the English Archetype group (dating to about 1250–55),[21] an angel, who stands on a hill, has lifted the seer up to show him the heavenly city. The strangeness of this motif—an adult being lifted up and carried like a child—leaves us in no doubt about the meaning as a rather literal metaphor for the spiritual rapture of the apocalyptic seer. This visual metaphor, which also occurs in the scene of the Vision of the Babylonian Whore (Rev. 17:3–5)

in the early English Apocalypses,[22] may be compared to the metaphorical motif of pulling a person up by his wrist,[23] as in the Jerusalem illustration of the Ottonian Bamberg Apocalypse (Fig. 4), where an angel—once again standing on a hill—pulls the seer up by his wrist to show him the Heavenly City with the Lamb in its center.[24]

The External Witness in the Metz and Westminster Apocalypses

While the visual metaphors of visionary experience in the Archetype group of the English Apocalypses generally follow traditional ways, the second generation of the English Apocalypses in the so-called Metz group[25] introduces new motifs, which in this form have no antecedents in the previous Apocalypse tradition and whose meaning is rather problematic. In this regard, the deviation of the Metz Group becomes apparent when we compare the Vision of the Enthroned (Rev. 4:1–8) in both families. The Metz group, as for instance the illustration in the Lambeth Apocalypse (Fig. 6), adopts the basic structure of the respective image in the Archetype group, as in the Morgan

19. Cf. Neuss, *Die Apokalypse des hl. Johannes*, 247ff.; P. K. Klein, "Der Apokalypse-Zyklus der Roda-Bibel und seine Stellung in der ikonographischen Tradition," *Archivo Español de Arqueología* 45–47 (1972–74), 267–311, esp. 275f.; Williams, *The Illustrated Beatus*, IV (as in note 18), 46; P. K. Klein, *The Beatus Codex in Berlin* (Madrid, 2010, in press).

20. W. Messerer, "Zum Juvenianus-Codex der Biblioteca Vallicelliana," in *Miscellanea Bibliothecae Hertzianae* (Munich, 1961), 58–68, esp. 62; F. Mütherich, "Manoscriti romani e miniatura carolingia," in *Roma e l'età carolingia: Atti delle giornale di studio, 1976* (Rome, 1976), 79–86, esp. 81f., Fig. 56; P. K. Klein, "The Apocalypse in Medieval Art," in *The Apocalypse in the Middle Ages*, ed. by R. K. Emmerson and B. McGinn (Ithaca and London, 1992), 159–199, esp. 171f., Fig. 9; Schiller, *Ikonographie der christlichen Kunst*, V (Bildteil) (as in note 14), 13, Fig. 12.

21. For this manuscript, see L. Delisle and P. Meyer; *L'Apocalypse en français au XIIIe siècle (Bibl. Nat. fr. 403)*, 2 vols. (Paris, 1900–1901); Y. Otaka and H. Fukui, *Apocalypse: Bibliothèque Nationale, Fonds Français, 403* (Osaka, 1981); Morgan, *Early Gothic Manuscripts*, II (as in note 17), 63–66, No. 103.

22. See L. Delisle/Meyer, *L'Apocalypse en français au XIIIe siècle. Reproduction phototypique*, fol. 33ᵛ; Otaka/Fukui, *Apocalypse. Bibliothèque Nationale, Fonds Français, 403*, fol. 33ᵛ; Lewis,

Reading Images (as in note 13), Fig. 136; Klein, "From the Heavenly to the Trivial" (as in note *), Fig. 11.

23. For this motif and its metaphorical meaning, cf. W. Loeschke, "Der Griff ans Handgelenk," in *Festschrift für Peter Metz*, ed. by U. Schlegel and C. Z. von Manteuffel (Berlin, 1965), 46–73, esp. 48–67.

24. See P. K. Klein, "Stellung und Bedeutung des Bamberger Apokalypse-Zyklus," in *Das Buch mit 7 Siegeln. Die Bamberger Apokalypse* (Exhib. Cat.), ed. by G. Suckale-Redlefsen and B. Schemmel (Luzern, 2000), 105–136, esp. 113f.

25. This group is so called after an Apocalypse manuscript of ca. 1250–55, which was formerly in Metz (Bibliothèque Municipale, Ms. Salis 38). For this manuscript and its group, see E. G. Millar, "Les principaux manuscrits à peintures du Lambeth Palace de Londres," *Bulletin de la Société Française pour la Reproduction de Manuscrits à Peintures* 8 (1924), 1–66, 40–43; R. Haussherr, "Eine verspätete Apokalypsen-Handschrift und ihre Vorlage," in *Studies in Late Medieval and Renaissance Painting in Honour of Millard Meiss*, ed. by I. Lavin and J. Plummer (New York, 1977), 219–240, esp. 223ff.; Klein, *Endzeiterwartung* (as in note 13), 66f., 161f.; Morgan, *Gothic Manuscripts*, II (as in note 17), 18 and Nos. 108, 109, 126, 128, 129; Morgan, *The Lambeth Apocalypse* (as in note 13), 39ff.

FIG. 4. Vision of the Heavenly Jerusalem. Apocalypse,
Bamberg, Staatsbibliothek, Ms. Bibl. 140, fol. 55ᵛ.

Apocalypse (Fig. 5),²⁶ although simplifying and sym-
metrizing the composition. In both cases, the core of
the composition is formed by the enthroned Christ in
a mandorla, flanked by the seated Elders who are ar-
ranged in two tiers. However, in the Archetype com-
position (Fig. 5) the visionary experience of John is

enhanced by the seer being represented on the left side
(where the spectator's eyes start the "reading" of the
picture), where an angel pulls him forward by his wrist
while showing him the open "door" (Rev. 4:1), which
gives access to the heavenly scene (although this is not
visible to the seer, since the open scroll held by the
angel obstructs his view). In contrast to this, the illus-
tration in the Lambeth Apocalypse of the Metz group
(Fig. 6) places John and the angel outside the picture,
thus marginalizing this motif and reducing its impor-
tance. Moreover, the seer stands as a tall figure beside
the frame and, on the advice of an angel (here reduced
to a small head flying from a cloud), he peeps through
an opening—not the biblical "door," but a window—to
get a direct, unobstructed view of the heavenly scene.
Nevertheless, being separated by the frame from the
celestial sphere and standing on a strip of earth, the
seer clearly belongs to the earthly reality.

This new, singular element, which I am going to
call the external witness motif,²⁷ also occurs in nu-
merous other illustrations of the Metz group.²⁸ In the
next generation of the English Apocalypses, in the
slightly younger courtly Westminster group,²⁹ the ex-
ternal witness motif becomes ubiquitous and develops
to extremes. The most numerous and most spectacu-
lar figures in this regard appear in the Perrins Apoc-
alypse of about 1260, a manuscript now at the Getty
Museum in Los Angeles (Ms. Ludwig III, 1).³⁰ The
illustrations of this Apocalypse often dramatize the
outside spectator figure of John and are quite inven-
tive in displaying all kinds of variations:³¹ John gazes

26. For the Morgan Apocalypse M.524, which dates about
1250–55, see Morgan, *Early Gothic Manuscripts*, II (as in note 17),
pp. 92–94 No. 122.

27. In the previous literature it has been called the "ostium aper-
tum" or "voyeur motif" (R. Freyhan, "Joachim and the English
Apocalypse," *Journal of the Warburg and Courtauld Institutes* 18
(1955), 211–244, esp. 232f.; Klein, "From the Heavenly to the
Trivial" [as in note *], 265). However, these terms do not really
seem to be adequate, since our motif does not show either a door or
an erotic scene, although it often has an element of private spying.

28. Cf. e.g., Haussherr, "Eine verspätete Apokalypsen-Hand-
schrift," Fig. 6; Klein, *Endzeiterwartung* (as in note 13), Fig. 72;
Lewis, *Reading Images* (as in note 13), Fig. 37, 39, 47, 63, 128;
Morgan, *The Lambeth Apocalypse* [Facsimile] (as in note 13), fols.
2ʳ, 3ʳ, 6ʳ, 8ᵛ, 10ᵛ, 27ʳ.

29. For the "Westminster" group and its courtly character, see
Klein, *Endzeiterwartung* (as in note 13), 164–166, 178ff.

30. For the Perrins Apocalypse, formerly in the collections of
Dyson Perrins and Peter Ludwig, see M. R. James, *The Apocalypse
in Latin. MS. 10 in the Collection of Dyson Perrins* (Oxford, 1927);
Henderson, "The English Apocalypse II" (as in note 13), 103–
113; J. M. Plotzek, "Apokalypse," in *Die Handschriften der Samm-
lung Ludwig*, ed. by A. von Euw and J. M. Plotzek, I (Cologne,
1979), 183–198; Morgan, *Early Gothic Manuscripts*, II (as in note
17), 98–100, No. 124.

31. See already Henderson, "The English Apocalypse II" (as in
note 30), 106; Plotzek, "Apokalypse" (as in note 30), 194. Lewis
(*Reading Images* [as in note 13], 19ff.) somehow obscures this spe-
cific character of the Perrins Apocalypse in treating it as a general
feature of all thirteenth-century English Apocalypses.

FIG. 5. Vision of the Enthroned. Apocalypse, New York, Pierpont Morgan Library, M. 524, fol. 1ᵛ.

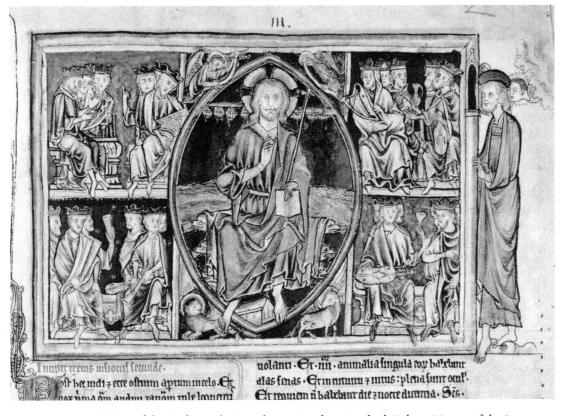

FIG. 6. Vision of the Enthroned. Apocalypse, London, Lambeth Palace, Ms. 209, fol. 2ʳ.

intensely or in amazement through a small opening, as is found in the spectator figures of the Metz group;[32] he even sticks his head through the window frame as in a peep show (Fig. 7); he turns the shutter of a window (Fig. 8); he bends down to the window to have a better view of the scene represented (Fig. 12);[33] he sits close to the window on a rock;[34] he kneels on the ground next to the window;[35] he presses his ears close to the window opening to hear the "new song" of the elect in heaven;[36] he covers his eyes with his hand because of the thunderstorms he is witnessing through the window, as in the illustration of the Ascension of the Witnesses (Fig. 9), the thunderstorms being an extra-biblical addition by the Perrins illustrator;[37] he turns around to stare through a kind of projecting window attached to the frame;[38] or he is seen in rear view, peeping through a kind of backdoor entrance of the picture frame (Fig. 10).

The Tradition and Meaning of the Window Motif

These spectacular figures of the seer in certain English Apocalypses have attracted some scholarly atten-

tion. They have been interpreted as expressive intermediaries between the visions of the biblical text and contemporary readers, enabling the latter "to experience the text as John perceived his visions, that is, 'in the spirit,'" creating some kind of "visionary perception" in the mind of the reader and beholder.[39] Certainly the marginal figures of St. John were of utmost importance for the contemporary reception of these illustrations: they seem to authenticate the seer's and author's experience and at the same time to invite the viewer to identify with the seer's response.[40] In their role as external spectators, who through a window witness and give authentic testimony to a miraculous event, these figures stand in a long, but so far not investigated pictorial tradition,[41] reaching from the witnessing Sarah in the Hospitality of Abraham (*philoxenia*) in some twelfth-century Byzantine Octateuchs,[42] to the late medieval paintings with peasants as outside witnesses of the Nativity,[43] or with onlookers behind a choir-screen watching some other kind of miracle,[44] or to the sculptured spectators of the mystical vision of St. Teresa in Bernini's Cornaro Chapel at Santa Maria della Vittoria in Rome (1645–52) and its presumable

32. As e.g. in the Adoration of the Lamb (fol. 5ᵛ), in the Preaching of the Two Witnesses (fol. 16ᵛ), in the Adoration of the Beast from the Sea (fol. 24ᵛ), or in the Vintage (fol. 29ᵛ). See Plotzek, "Apokalypse" (as in note 30), Pls. 125, 128, color pl. p. 197; Klein, *Endzeiterwartung* (as in note 13), Fig. 65, 102, 123, 145.

33. See also the Adoration of the Enthroned by the Twenty-Four Elders (fol. 4ᵛ). Lewis, *Reading Images* (as in note 13), Fig. 32.

34. As in the Defeat of the Beast (fol. 41ᵛ). Lewis, *Reading Images* (as in note 13), Fig. 18.

35. As in the Angel Censing the Altar and Pouring the Censer (fol. 10ᵛ). Lewis, *Reading Images* (as in note 13), Fig. 58.

36. Cf. the illustration of The New Song before the Throne (fol. 26ᵛ). Klein, *Endzeiterwartung* (as in note 13), Fig. 113; Lewis, *Reading Images* (as in note 13), Fig. 115.

37. See Klein, *Endzeiterwartung* (as in note 13), 96.

38. As in the Third Trumpet. Cf. James, *The Apocalypse in Latin* (as in note 30), fol. 12ʳ.

39. Lewis, *Reading Images* (as in note 30), 12, 15. See also *eadem*, "Exegesis and Illustration in Thirteenth-Century English Apocalypses," in Emmerson and McGinn, *The Apocalypse in the Middle Ages*, 259–275, esp. 267; Michael Camille, *Gothic Art: Glorious Visions* (New York, 1996), 17–19; C. Hahn, "Absent No Longer: The Sign and the Saint in Late Medieval Pictorial Hagi-

ography," in *Hagiographie und Kunst: Der Heiligenkult in Schrift, Bild und Architektur*, ed. by G. Kerscher (Berlin, 1993), 152–175, esp. 159; *eadem, Portrayed on the Heart: Narrative Effect in Pictorial Lives of Saints from the Tenth through the Thirteenth Century* (Berkeley and Los Angeles, 2001), 395, n. 44.

40. Thus already Freyhan, "Joachim and the English Apocalypse" (as in note 27), 234; Henderson, "The English Apocalypse II" (as in note 13), 106.

41. This figure type is not discussed in the otherwise useful book by C. Gottlieb, *The Window in Art: From the Window of God to the Vanity of Man* (New York, 1981).

42. M. Meyer, "The Window of Testimony: A Sign of Physical or Spiritual Conception?" in *Interactions: Artistic Interchange Between the Eastern and Western Worlds in the Medieval Period*, ed. by C. Hourihane (University Park, Pa., 2007), 245–259, esp. 250ff., Figs. 8–10. Meyer considers this motif a prophesying symbol of the Incarnation of Christ. This is possible, but it would not exclude the traditional meaning of the outside spectator as a testimony of a miraculous event.

43. See e.g. Schiller, *Ikonographie der christlichen Kunst*, I (as in note 14), Fig. 192, 195.

44. Cf. J. E. Jung, "Seeing Through Screens: The Gothic Choir Enclosure as Frame," in *Thresholds of the Sacred: Architectural, Art Historical, Liturgical, and Theological Perspectives on Religious*

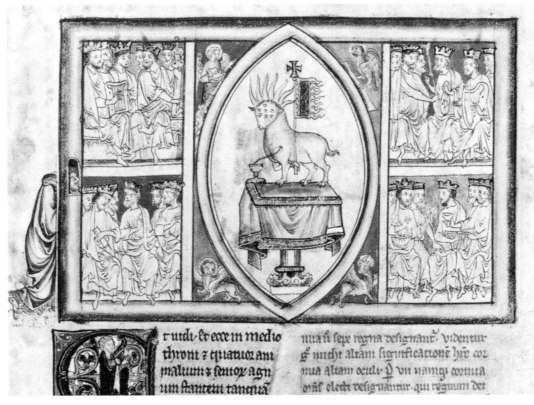

FIG. 7. Vision of the Lamb. Apocalypse, Los Angeles, J. Paul Getty Museum, Ms. Ludwig III, 1, fol. 5ʳ.

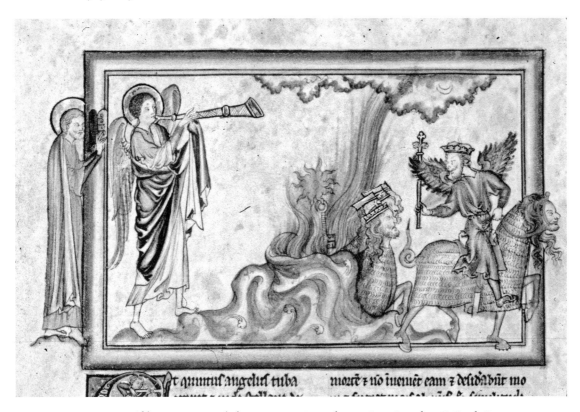

FIG. 8. Fifth Trumpet and the Locusts. Apocalypse, Los Angeles, J. Paul Getty Museum, Ms. Ludwig III, 1, fol. 13ᵛ.

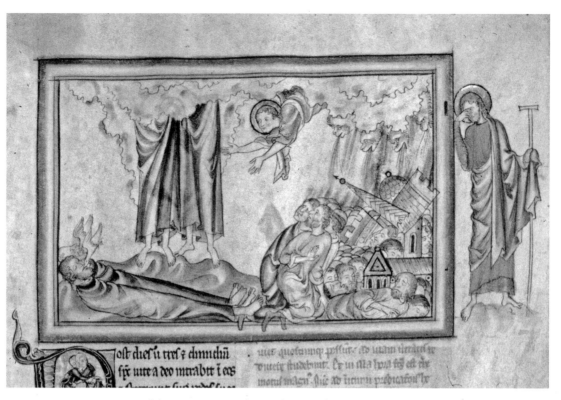

FIG. 9. Ascension of the Witnesses and Initial. Apocalypse, Los Angeles, J. Paul Getty Museum, Ms. Ludwig III, 1, fol. 18ʳ.

FIG. 10. Distribution of the Trumpets. Apocalypse, Los Angeles, J. Paul Getty Museum, Ms. Ludwig III, 1, fol. 10ʳ.

graphic model.[45] Most revealing and relevant in our context, however, is a series of Ottonian and Romanesque miniatures representing St. Gregory dictating under the influence of the Holy Spirit, which in form of a dove speaks into his ears; the saintly pope, therefore, is screened by a curtain from his scribe, who, however, peeps through a hole that he has pierced with his stylus.[46] In the best-known example, a late tenth-century single leaf of a *Registrum Gregorii* in Trier (Fig. 11),[47] Pope Gregory, surrounded by a curtain, sits within a church-like building, while the inquisitive scribe has risen from his feet to pierce a hole into the curtain. This motif of normally negatively considered *curiositas* is explained and justified here by the inscription on the wax table the scribe is holding in his left hand: it shows the beginning of Eccl. 14:22–24, where the search for divine truth and wisdom is compared to the spying through a window or the eavesdropping at a door ("Blessed the man that shall continue in wisdom … He who looketh at her windows, and hearkeneth at her door").[48] Hence, Gregory's scribe stands here for both the outside authenticating witness of a miraculous event and the search of truth.[49] The latter may also apply to the external witness figures in the Metz group (Fig. 6), whereas the majority of the outside spectator figures of St. John in the Westminster group (Fig. 7–10, 12) rather emphasize the intense curiosity of the onlooking seer.

Already for this reason we have to rule out that the external witness figures in the Westminster group are intended as visual metaphors of visionary experience in the type of spiritual vision. It should be also noticed that in some of these illustrations, as in the Killing of the Witnesses in the Perrins Apocalypse (Fig. 12), the witness motif is added even though the biblical text

FIG. 11. St. Gregory Dictating to His Scribe. *Registrum Gregorii*, Trier, Stadtbibliothek.

(Rev. 11:7) does not mention any vision at all. Furthermore, there is no difference in the emotional and physical reactions of the seer figures whether they refer to celestial visions or earthly events, such as the thunderstorms in the image of the Ascension of the Witnesses (Fig. 9). Moreover, in some of the later Apocalypse illustrations of the Westminster group, the physicality of the seer's body, his strong bodily movements, and some bold overlap enhance the corporeality

Screens, East and West, ed. by S. E. J. Gerstel (Washington, D.C., 2006), 185–213, esp. 186–188, Figs. 1, 2.

45. See I. Laving, *Bernini and the Unity of the Visual Arts* (New York, 1980), 92–103, Figs. 154, 155, 225.

46. Cf. A. von Euw, "Gregor der Große (um 540–604): Autor und Werk in der buchkünstlerischen Überlieferung des ersten Jahrtausends," *Imprimatur* NF 11 (1984), 19–41, esp. 19–24; J. K. Eberlein, *Miniatur und Arbeit* (Frankfurt, 1995), 29ff., Figs. 6–15.

47. See B. Nitschke, *Die Handschriftengruppe um den Meister des Registrum Gregorii* (Recklinghausen, 1966), 35–49; *Vor dem Jahr*

1000. Abendländische Buchkunst zur Zeit der Kaiserin Theophanu. Eine Ausstellung des Schnütgen-Museums, ed. by A. von Euw (Cologne, 1991), 139–141, No. 37.

48. C. Nordenfalk, "An Early Mediaeval Shorthand Alphabet," *Speculum* 14 (1939), 443–447, esp. 445; Nitschke, *Die Handschriftengruppe* (as in note 46), 36f.; Eberlein (as note 46), *Miniatur und Arbeit*, 98.

49. Only the latter meaning has been considered so far. Cf. Nitschke, *Die Handschriftengruppe* (as in note 46), 37; Eberlein, *Miniatur und Arbeit* (as in note 46), 98.

FIG. 12. Killing of the Witnesses. Apocalypse, Los Angeles, J. Paul Getty Museum, Ms. Ludwig III, 1, fol. 17ʳ.

of the seeing in a way that a metaphorical reading of this motif would render nearly absurd. Thus, in the Sixth Trumpet of the Westminster Apocalypse in Paris (Fig. 13), dating to around 1265–70,[50] John as the outside witness peeps from behind the frame into the picture space, where he nearly collides with the trumpet angel, who moves in his direction while turning around abruptly.

Still more important, in the preceding English book illumination, the external witness motif had a purely corporeal meaning, that of a furtive glance at a private scene, signifying an emphatically bodily seeing.[51] A well-known example is an illustration in the Dublin Life of St. Alban by Matthew Paris, dating to about 1240–50 (Fig. 15).[52] Here Alban opens a window, placed in the picture frame (comparable to some of the

50. For this manuscript, see G. Henderson, "An Apocalypse Manuscript in Paris, BN Ms. lat. 10474," *The Art Bulletin* 52 (1970), 22–31; Klein, *Einzeiterwartung* (as in note 13), 57–59, 68ff.; Morgan, *Early Gothic Manuscripts*, II (as in note 17), 145–147, No. 154.

51. This has already been noticed by Freyhan decades ago ("Joachim and the English Apocalypse" [as in note 27], 233f.), however, it has been overlooked or repressed by the following scholarship.

52. M. R. James, *Illustrations to the Life of St. Alban in Trinity College Library, Dublin* (Oxford, 1924), 20; Freyhan, "Joachism and the English Apocalypse" (as in note 27), 232; G. Henderson, "Studies in English Manuscript Illumination. Part I," *Journal of the*

Warburg and Courtauld Institutes 30 (1967), 71–104, esp. 77; Lewis, *Reading Images* (as in note 13), 38; Hahn, "Absent No Longer" (as in note 39), 156–161; Klein, "From the Heavenly to the Trivial" (as in note *), 248; C. Hahn, "Viso Dei: Changes in Medieval Visuality," in *Visuality Before and Beyond the Renaissance*, ed. by R. S. Nelson (Cambridge, Mass., 2000), 169–196, esp. 170–176; *eadem*, *Portrayed on the Heart* (as in note 39), 289–292. For the controversial dating of this manuscript, see Morgan, *Early Gothic Manuscripts*, I (as in note 17), 130–133, No. 85; F. McCulloch, "Saints Alban and Amphibalus in the Works of Matthew Paris: Dublin, Trinity College Ms. 177," *Speculum* 56 (1981), 761–785, esp. 778–785; S. Lewis, *The Art of Matthew Paris in the 'Chronic Majora'* (Berkeley and Los Angeles, 1987), 381–387.

FIG. 13. Sixth Trumpet and Angels of the Euphrates. Westminster Apocalypse, Paris, Bibliothèque Nationale de France, Ms. Lat. 10474, fol. 15ᵛ.

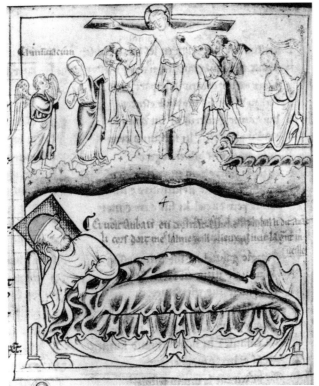

FIG. 14. Alban's Dream Vision. *Vie de Seint Auban*, Dublin, Trinity College, Ms. 177, fol. 30ᵛ.

Perrins Apocalypse illustrations, cf. Fig. 8), to have a look at Amphibalus kneeling before an altar cross (which here has the peculiar shape of a relic-cross then still extant at the monastery of St. Albans).[53] Alban's corporeal seeing in this picture—in contrast to the preceding image of his dream (Fig. 14)—is also stressed in the Anglo-Norman rubric:

> *Ci veit Auban par la fenestre*
> *De Amphibal trestut sun estre.*

> Here, through a window Alban sees
> Amphibalus as he really is.[54]

Similarly the pertinent Latin gloss reads: *Omnia miratur Albanus quae spec[ulatur]* (Alban is amazed at everything that he sees).[55] It should be noted that the scene of Alban watching Amphibalus through a window is neither contained in the twelfth-century Latin *Vita* of Alban[56]—which served as a model for Matthew Paris' Anglo-Norman poem[57]—nor in the Anglo-Norman poem itself.[58] Thus, the window motif was included in Matthew Paris' illustration for the first time,[59] and it is to this *illustrative* addition that the Anglo-Norman rubric and the Latin gloss refer, which are probably both by Matthew Paris himself.[60] Both inscriptions make explicit what the spying motif should express here: a

rectly translated by Lewis (*Reading Images* [as in note 13], 352 n. 120) as "Amphibalus who stayed behind." Hahn in her discussion of this illustration (see above note 39) does not quote the important end of this rubric.

55. Atkinson, *Vie de Seint Auban* (as in note 54), 55. Except for Klein ("From the Heavenly to the Trivial" [as in note *], 264), in the discussion of this illustration the Latin rubric has not been considered so far.

56. *Acta Sanctorum. Junii*, IV (Antwerp, 1707), 149–159, cf. 150.

57. As is common scholarly opinion, see e.g. W. McLeod, "Alban and Amphibal: Some Extant Lives and a Lost Life," *Medieval Studies* 42 (1980), 407–430, esp. 411; McCulloch, "Saints Alban and Amphibalus" (as in note 52), 762.

58. Lewis, *Reading Images* (as in note 13), 38; Hahn, "Visio Dei" (as in note 52), 171; *eadem, Portrayed on the Heart* (as in note 39), 289.

59. Hahn, "Visio Dei" (as in note 52), 176; *eadem, Portrayed on the Heart* (as in note 39), 290.

60. R. Vaughan, *Matthew Paris* (Cambridge, 1958), 168, 171; McLeod, "Alban and Amphibal," 409f. However, Atkinson (as in note 54, p. x), Harden (as in note 54, p. XIV) and Morgan (as in note 17, I, 131) leave this question open.

53. McClulloch, "Saints Alban and Amphibalus" (as in note 52), 779f.

54. R. Atkinson, ed., *Vie de Seint Auban: A Poem in Norman French, Ascribed to Matthew Paris* (London, 1876), 55; A. R. Harden, ed., *La Vie de Seint Auban: An Anglo-Norman Poem of the Thirteenth Century* (Oxford, 1968), 52. The last verse is incor-

FIG. 15. Alban Spying on Amphibalus Praying before the Cross. *Vie de Seint Auban*, Dublin, Trinity College, Ms. 177, fol. 31ʳ.

FIG. 16. Alban's Conversion and Baptism. *Vie de Seint Auban*, Dublin, Trinity College, Ms. 177, fol. 31ᵛ.

purely corporeal seeing—as in another illustration of the same manuscript, where a 'Saracen' spies through a window on the scene of the baptism of Alban in the neighboring picture.[61] However, both persons act quite differently after their spying: Alban meets Amphibalus and becomes baptized, while the "Saracen" denounces Alban's baptism to the pagan ruler, which eventually leads to Alban's martyrdom; nevertheless, their body language and way of seeing is quite the same, that of an intense looking. Even though the visual and textual facts are, therefore, obvious, recent speculative interpretations have transformed Alban's corporeal seeing to something quite different, either to a "pictorial metaphor for his visionary dream"[62] or to some kind of supernatural "vision of Christ" (embodied by the cross Amphibalus is adoring), a vision that would have caused Alban's instantaneous inner conversion.[63] These misleading interpretations fuse and confuse Alban's spying and witness motif with the preceding illustration (Fig. 14), his dream vision (clearly characterized as such by iconography and rubrics),[64] or with the following image (Fig. 16), the representation of Alban's religious instruction and conversion as well as his baptism. While the image of baptism does not need any explanation,[65] the preceding scene of Alban's instruction and conversion is more complex: Alban kneels before Amphibalus, his hands raised in an adoring or affirmatively listening gesture; his eyes are directed to the peculiarly shaped cross Amphibalus is holding in his hands while looking straight into Alban's eyes.[66] Despite the focused gaze and specific gestures of both figures, the precise meaning of this scene only becomes clear if one considers the Anglo-French rubric of the picture:

> La recunte Auban sun sunge.
> Par la croiȝ veit, n'est pas mençuenge.
> Amphibal ne li cele mie
> L'avisiun ke signifie.

There Alban tells his dream.
Thanks to the cross he recognizes that it
 [i.e., the dream] is not a lie.
Amphibalus does not conceal to him
what the vision [i.e., the dream] means.[67]

Important in our context is that, according to the rubric, it is in *this* scene that Alban recognizes the truth of Christian faith and converts to Christianity, and it is only by the first line of this rubric, the last line of the preceding rubric, as well as by the poem's text that we understand the narrative logic of the foregoing

61. James, *Illustrations to the Life of St. Alban* (as in note 52), Fig. 4, 5; Henderson, "English Manuscript Illumination 1" (as in note 52), 77, Pl. Ib; Hahn "Absent no longer" (as in note 39), 163, Fig. 5; *eadem*, "Visio Dei" (as in note 54), 184, Fig. 36; *eadem, Portrayed on the Heart* (as in note 39), 293, Fig. 132.

62. Lewis, *Reading Images* (as in note 13), 38.

63. Hahn, *Portrayed on the Heart* (as in note 39), 291. See also *eadem*, "Absent No Longer" (as in note 39), 160; *eadem*, "Visio Dei" (as in note 52), 183.

64. In the form of the dream type, Alban reclines on his bed, while in the upper zone—separated by clouds—the content of his dream vision is represented. Accordingly the Anglo-French gloss describes the dream as a seeing of Alban's soul, hence as a spiritual vision (cf. Atkinson, *Vie de Seint Auban*, 55, and Harden, *La Vie de Seint Auban*, 52 both as in note 54):

> Ci veit Alban en dormant
> Quancke Amphibal li dit avant
> Li cors dort, mes l'alme veille
> K'eu ciel veit la grant merveille

Here, while sleeping Alban sees
all what Amphibalus foretold.

The body sleeps but the soul is awake.
and in heaven it [the soul] sees the great marvel

See also the Latin rubric: "Nocte revelatur Albano visio grandis" (In the night, Alban has the revelation of a great vision) (Atkinson, *Vie de Seint Auban* [as in note 54], 55).

65. See also the Anglo-French rubric (Atkinson, *Vie de Seint Auban*, 55, and Harden, *La Vie de Seint Auban*, 52 both as in note 54):

> Auban est ja baptiȝé
> Eu nun de la trinité.

Alban has now been baptized
in the name of the Trinity.

66. This focused gaze of both figures contrasts with their unspecific look in the preceding illustration (Fig. 15), Alban glances into the window (but not in the precise direction of either the cross or Amphilus), while Amphibalus stares into the void (instead of looking at the cross).

67. Atkinson, *Vie de Seint Auban*, 55, and Harden, *La Vie de Seint Auban*, 52 (both as in note 54). See also the Latin rubric: "Praedicat Amphibalus cruce Christum virgine natum, est qui vera salus mundi, mundasse reatum." (Atkinson, *Vie de Seint Auban* [as in note 54], 55).

illustration (Fig. 15) with the window motif: after his nocturnal dream, Alban gets up early at dawn to talk to Amphibalus, his guest.[68] On the way to Amphibalus to tell him his dream,[69] through a window [70] Alban sees Amphibalus, who during the entire night was adoring the cross, "sighing and crying." [71] The question remains why Matthew Paris illustrated the transitory, accidental moment of Alban watching Amphibalus through a window. The narrative context of this illustration may offer part of an explanation: the text underneath the picture (verses 233–268 of the poem)[72] gives the lengthy description of Alban's dream, already depicted in the preceding illustration. Therefore, elaborating certain elements of the poem (Alban on his way to Amphibalus, the latter adoring the cross), Matthew Paris invented a new scene by adding the window motif, which ingeniously combines both figures with another, Alban serving as an authenticating witness of Amphibalus' virtuous, saintly life. In this context, we have to remember that both St. Alban and St. Amphibalus were patron saints of St. Albans,[73] the monastery of Matthew Paris.

In subsequent English book illumination, this win-

FIG. 17. Baptism of Drusiana. Apocalypse, Paris, Bibliothèque Nationale de France, Ms. Fr. 403, fol. 1[r].

dow and witness motif had a large and important following. The corporeal and even voyeuristic aspect of this motif becomes still more obvious in some illustrations of the Archetype group of the English Apocalypses, where this formula gets a strongly negative connotation. In the scene of the Baptism of Drusiana in the Life of St. John cycle of Paris Fr. 403 (Fig. 17),[74] the heathen—like eager voyeurs—are peeping through

68. See verse 212–214 of the poem (Atkinson, *Vie de Seint Auban*, 9, and Harden, *La Vie de Seint Auban*, 6 [both as in note 54]):

> *Le matin est leveȝ par tens a l'enjurner;*
> *Hastivement s'en va a sun hoste parler,*
> *E sa avisiun a lui apertement cunter.*

> In the morning he [Alban] gets up early at dawn.
> Hastily he goes to talk to his host [Amphibalus],
> to tell him sincerely his vision.

69. Cf. the second part of the rubric of the window scene (Fig. 15) (Atkinson, *Vie de Seint Auban*, 55, and Harden, *La Vie de Seint Auban*, 52 [both as in note 54]):

> *Mustrer li veut en bone fei*
> *De sun sunge tut le segrei.*

> In good faith, he [i.e., Alban] will display
> openly to him [i.e., Amphibalus]
> all the secrets of his dream.

70. Not in the poem's text but in the Anglo-French rubric. See above note 54.

71. See the second part of the Anglo-French rubric of this picture (Atkinson, *Vie de Seint Auban*, 55, and Harden, *La Vie de Seint Auban*, 52 [both as in note 54]):

> *Amphibal la croiȝ aure*
> *A genoilluns, suspire e plure;*
> *Ne tresublie, ne dort, ne summe*
> *Ke il ne face sa custume.*

> Amphibalus whorships the cross
> on his knees, sighing and weeping.
> He does not neglect [i.e., to pray],
> whether by sleeping or dozing,
> acting as in his custom.

See also verse 199–200 of the text (Atkinson, *Vie de Seint Auban*, 8, and Harden, *La Vie de Seint Auban*, 6 [both as in note 54]):

> *Amphibal sul i demuere e atent;*
> *Davant sa croiȝ la nuit en uraisons despent.*

> Amphibalus remains and waits there alone;
> he passes the night praying before his cross.

72. Atkinson, *Vie de Seint Auban*, 9f., and Harden, *La Vie de Seint Auban*, 7f. (both as in note 54).

73. Cf. e.g. *Lexikon der christlichen Ikonographie*, V (Freiburg, 1973), 67f., 125f.

74. See also the corresponding picture in another Apocalypse of the Archetype group, Oxford, Bodleian Library, Ms. Auct. D.4.17; Freyhan, "Joachism and the English Apocalypse" (as in note 27), Pl. 52b.

all kinds of windows, doors, and holes, to have a look at the naked body of Drusiana, who is baptized by St. John. In a similar way, in the image of the Death of the Antichrist of the Apocalypse cycle of the Archetype group,[75] a partisan of the Antichrist is staring through a window to have a glance at the disastrous defeat and punishment of his idol.

The External Witness Motif and the Rise of Gothic Marginal Images

These iconographic antecedents of the external witness motif in the Metz and Westminster Apocalypses are well known, but their impact on the meaning of this motif has not been sufficiently recognized. Still more important, the parallel emergence of the marginal witness figures of St. John in the Metz and Westminster groups as well as of Gothic marginal illustration in England, about 1250/60,[76] has so far been completely overlooked. An early and already fully developed example of Gothic marginal illustration is presented in the Rutland Psalter (London, British Library, Ms. Add. 62925), which probably originated about 1260 in London,[77] like the early generation of the Metz and Westminster Apocalypses. The Rutland Psalter contains much of the standard repertoire of profane or negatively connoted motifs, like jugglers, musicians, beggars, fables, exotic and monstrous races, genre scenes of conflict, and obscene elements.[78]

More important in our context, it also shows some marginal figures, who in a dramatic movement look up to the text, as for instance a running man, pointing upwards and looking back to the text column (Fig. 18),[79] or marginal figures who emphatically point upward to the picture, as for instance one of two marginal monstrous cannibals who gesture towards the image of Jacob's Dream (Fig. 19), an image which is related to vision scenes: Jacob, reclining in the way of the dream type, has his eyes wide open and lifts the end of the angel's pallium to have a view of the angel climbing up to heaven, thus characterizing his dream as a kind of celestial vision.

Still more important than these parallels of some marginal figures in the Rutland Psalter is the fact that the Perrins Apocalypse has not only the most numerous and most spectacular external witness figures of all English Apocalypses, but also includes a series of marginal images in the form of historiated initials, placed underneath the Apocalypse illustrations:[80] for instance, the Ascension of the Witnesses is accompanied by an initial showing the motif of two wrestling men (Fig. 9). These initials are stylistically and iconographically related to the marginal images of the Rutland Psalter.[81] Most important in our context, in a number of cases, the Perrins "marginal initials"—if this term may be used—focus on the subject of corporeal seeing, while the respective illustration shows St. John as an external witness or sometimes as an inside

75. For the respective picture in the Apocalypses Morgan M. 524, Oxford Auct. D.4.17 and Paris Fr. 403, see H. O. Coxe, *The Apocalypse of St. John, from a Manuscript in the Bodleian Library* (London, 1876), fol. 9ᵛ; Delisle/Paul Meyer, *L'Apocalypse en français au XIIIᵉ siècle* (as in note 21), fol. 18ʳ; Otaka/Fukui, *Apocalypse Fonds Français 403* (as in note 21), fol. 18ʳ; Schiller, *Ikonographie der christlichen Kunst*, V (Bildteil), Fig. 382.

76. See e.g. L. M. C. Randall, *Images in the Margins of Gothic Manuscripts* (Berkeley and Los Angeles, 1966), 9f.; J. Wirth, "Les marges à drôleries des manuscrits gothiques: problèmes de méthode," in: *History and Images: Towards a New Iconology*, ed. by A. Bolvig and Ph. Lindley (Turnhout, 2003), 277–300, esp. 277.

77. Morgan, *Early Gothic Manuscripts* (as in note 17), II, 78–82, No. 112. For a facsimile reproduction, see E. G. Millar, *The Rutland Psalter. A Manuscript in the Library of Belvoir Castle* (London: The Roxburghe Club, 1937).

78. Some of them are studied by L. F. Sandler, "A Series of Marginal Illustrations in the Rutland Psalter," *Marsyas* 8 (1959), 70–74.

79. The text above, Ps. 32 ("Exultate iusti"), has no relation to the marginal figure.

80. See S. Lewis, "Beyond the Frame: Marginal Figures and Historiated Initials in the Getty Apocalypse," *The J. Paul Getty Museum Journal* 20 (1992), 53–76. Lewis does not recognize that the initials of the Perrins respectively Getty Apocalypse belong to the tradition of marginal images. See on the contrary P. K. Klein, "Initialen als 'marginal images': Die Figureninitialen der Getty-Apokalypse," *Cahiers Archéologiques* 48 (2000), 105–123.

81. For the stylistic relationship of the Rutland Psalter and the Perrins Apocalyps, cf. Morgan, *Early Gothic Manuscripts* (as in note 17), II, 80.

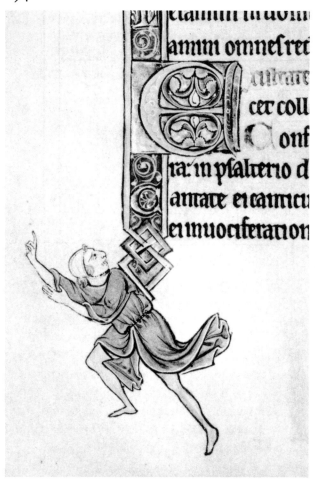

FIG. 18. Marginal Figure of Running Man. Rutland Psalter, London, British Library, Ms. Add. 62925, fol. 34ᵛ.

FIG. 19. Jacob's Dream and Marginal Figures. Rutland Psalter, London, British Library, Ms. Add. 62925, fol. 83ᵛ.

spectator. For instance, in the image of the Vision of the Lamb (Fig. 7), John as a spectacular, nearly voyeur-like figure sticks his head through a window cut into the frame to have a glance at the heavenly scene, while the adjacent initial underneath shows a small bearded figure without a halo [82] pointing to the Lamb in the upper composition. In the initial beneath the Appearance of the Beast from the Sea (Rev. 13:1–3), a frightened man runs away, looking back and pointing in an emphatic gesture towards the beast in the picture scene—similar to the running marginal figure in the Rutland Psalter (Fig. 18)—while within the picture

St. John witnesses the beast, anxiously wrapping himself within his mantle (cf. Fig. 20).[83] The illustration of the Woman in the Sun and the Dragon (Rev. 12:3–6) represents St. John squatting outside the frame, looking up to the Woman disappearing outside the picture into a band of clouds (Fig. 21), a motif deviating from the biblical text, where the Woman flees "into the wilderness" (Rev. 12:6), without this being a specific vision of St. John. In the historiated initial underneath, a grey-haired old man—leaning on his staff, cupping his chin in his hand—watches very calmly the central scene of the rescue of the Woman's new-born child (cf.

82. Thus, this is not a figure of St. John (as assumed by myself in "Initialen als 'marginal images'" [as in note 80], 111), since in the main cycle of the Perrins Apocalypse John is always distinguished by a nimbus and is beardless.

83. Cf. Klein, "Initialen als 'marginal images'" (as in note 80), 105, Fig. 2.

FIG. 20. Beast from the Sea and Initial. Apocalypse, Los Angeles, J. Paul Getty Museum, Ms. Ludwig III, 1, fol. 23ʳ.

FIG. 21. Vision of Woman in the Sun and Initial. Apocalypse, Los Angeles, J. Paul Getty Museum, Ms. Ludwig III, 1, fol. 20ʳ.

Fig. 20).[84] If one considers that the content of most of the other marginal initials in this manuscript does not refer to the main illustration,[85] one is all the more struck by the way the spectator figures in the initials reinforce the apocalyptic seer's corporeal and emotive response. Hence, there is absolutely no way to conceive the spectator and external witness figures of St. John as visual metaphors of visionary spiritual seeing.[86] Instead, we notice a kind of profanation and even trivialization of spiritual experience, which certainly does not do justice to the sacred and divine content of the Book of Revelation.

The Disappearance of the External Witness in the Later Tradition

Therefore, it does not come as a surprise that the success of the external witness motif in the Apocalypse illustration was rather short-lived, lasting just some fifteen years,[87] with the rare exceptions of some later Apocalypses, which are derivatives of the Metz or Westminster groups.[88] It soon turned out that this kind of motif was a dead end for the adequate visualization of visionary experience, and within the later tradition of the Westminster Apocalypses it was practically abandoned. While the sister Apocalypses in London (British Library, Ms. Add. 35166), of about 1250–60, and Paris Lat. 10474 still contain a number of external witness figures of John,[89] the Douce Apocalypse (Oxford, Bodleian Library, Ms. Douce 180) of 1270–74 lacks this motif completely.[90] The gradual reduction and final abandonment of this motif in the Westminster group can be easily discerned in the example of the illustration of the New Song of the Elect (Rev. 14:2–5):[91] While in the Perrins illustration John is listening as an outside witness, pressing his ear close to the window opening in the frame,[92] in the slightly younger Westminster Apocalypse in Paris Lat. 10474 the listening through a small opening is maintained; however, its external witness character is reduced by its placement within the picture space.[93] And in the last member of this group, the Douce Apocalypse, the motif of an external listener and witness is completely abandoned, with the separately framed, solemn figure of John simply pointing to the central celestial scene.[94]

The subsequent generation of English Apocalypses was even more radical in rejecting the witness motif. For instance, in their illustrations of the Great Heavenly Vision of Rev. 4:1–8, the Apocalypses of the Anglo-French prose version, as in the example at Lincoln College in Oxford (Fig. 22),[95] focus on John's visionary experience, expressed through a combination

84. Lewis, "Beyond the Frame," (as in note 80), 56f.; Klein, "Initialen als 'marginal images'" (as in note 80), 111.

85. See Klein, "Initialen als 'marginal images'" (as in note 80), 108–111. Contrary to the assumption of Lewis, "Beyond the Frame" (as in note 80), 71ff.; eadem, Reading Images (as in note 13), 250f.

86. Contrary to the interpretation of Suzanne Lewis, Michael Camille and Cynthia Hahn (see above, note 39).

87. As already noted by Freyhan ("Joachism and the English Apocalypse" [as in note 27], 233): "Our motif is thus confined to two major groups [i.e., the Metz and Westminster groups]; and even there it does not outlast in its stark intensity the thirteenth century."

88. Like the early fourteenth-century Cloisters Apocalypse (New York, Metropolitan Museum of Art, The Cloisters), a later derivative of the Metz group (cf. Klein, Endzeiterwartung, 67; Morgan, The Lambeth Apocalypse, 46 [both as in note 13]). See The Cloisters Apocalypse: An Early Fourteenth-Century Manuscript. Facsimile, ed. by F. Deuchler et al. (New York, 1971), fols. 5ᵛ, 7ʳ, 8ᵛ, 9ʳ, 14ʳ, 14ᵛ.

89. Cf. Schiller, Ikonographie der christlichen Kunst, v (Bildteil) (as in note 14), Fig. 311, 649; Klein, Endzeiterwartung (as in note 13), Figs. 28, 60, 146.

90. There is one external figure of John in the Douce Apocalypse, in the illustration of the Multitude of the Elect (fol. 22ʳ). However, here John does not look into the picture but is spoken to through a window by one of the Elders (cf. Klein, Endzeiterwartung, [as in note 13], 194). For the Douce Apocalypse and its date, see Klein, ibid., 34–49; Morgan, Early Gothic Manuscripts (as in note 17), II, 141–145, No. 153.

91. For a discussion of this illustration in the Westminster group, see Henderson, "An Apocalypse Manuscript in Paris," 28; Klein, Endzeiterwartung (as in note 13), 127f.

92. See above note 36.

93. Cf. Henderson, "An Apocalypse Manuscript in Paris" (as in note 50), Fig. 17; Klein, Endzeiterwartung (as in note 13), Fig. 114.

94. Klein, Ibid., pl. before p. 129.

95. See also the Apocalypses in the London British Library (Ms. Royal 19.B.XV) and Lambeth Palace (Ms. 75) as well as in the Oxford New College (Ms. 65). See Freyhan, "Joachism and the Eng-

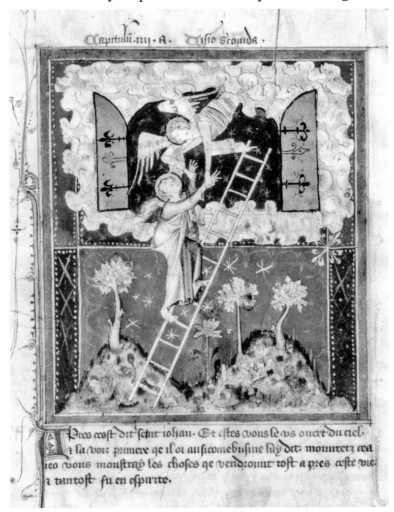

FIG. 22. Vision of Open Door in Heaven. Apocalypse, Oxford, Lincoln College, Ms. 16, fol. 143ᵛ.

of different visual metaphors: from an earthly land-scape St. John climbs up a ladder into a sphere surrounded by clouds, a well-known visual allegory of the ascent to God, or at least to the heavenly realm,[96]

here certainly meant as an allusion to the seer's ecstasy and his mystical ascent to heaven.[97] In his ascent, John is also pulled up by the flying angel, a metaphor of the seer's spiritual rapture that we have already noticed in

lish Apocalypse" (as in note 27), 232f., Pl. 53c, d; Aileen Hyland Laing, "The Queen Mary Apocalypse (London, British Museum Royal Ms. 19 B. xv)" (Ph.D. diss., The Johns Hopkins University, 1971), 205, Fig. 6; Lewis, "Exegesis and Illustration" (as in note 39), 265, Fig. 44; Michael Camille, "Visionary Perception and Images of the Apocalypse in the Later Middle Ages," in *The Apocalypse in the Middle Ages*, ed. by R. K. Emmerson and B. McGinn (Ithaca and London, 1992), 276–289, esp. 277f., Fig. 51; Ch. Heck, *L'échelle céleste dans l'art du Moyen Âge. Une image de la quête du ciel* (Paris, 1997), 194–196, Fig. 146, 147.

96. For the medieval West, see (as above) Heck, *L'échelle cé-*

leste dans l'art du Moyen Âge, 226–240; W. Cahn, "Ascending to and Descending from Heaven: Ladder Themes in Early Medieval Art," in *Santi e Demoni nell'alto medioevo occidentale* (Settimane di studio del Centro italiano sull'alto medioevo, 36, Spoleto, 1989), 697–724. For the Byzantine East, cf. J. R. Martin, *The Illustrations of the Heavenly Ladder of John Climacus* (Princeton, 1954), 10–18.

97. Cf. Freyhan, "Joachism and the English Apocalypse" (as in note 27), 232f.; Cahn, "Ascending to and Descending from Heaven" (as above), 705. On the contrary, Camille ("Visionary Perception" [as in note 95], 278), Lewis ("Exegesis" [as in note 39], 265, 270) and Heck (*L'échelle céleste* [as in note 95], 195f.)

previous examples. It is important that, in comparison to the earlier Metz-Lambeth and Westminster groups, John neither sees the Lord and his celestial court nor is the heavenly adoration of the Enthroned represented in these copies of the later Anglo-French prose version. Hence, it is left to the imagination of the beholder to picture the celestial scene behind the door.

The Cultural and Artistic Context of the Appearance of the External Witness in the English Apocalypses

If the external witness motif as well as the emphasis on corporeal seeing in the Metz and Westminster Apocalypses were an isolated and short-lived phenomenon, we are left with the question why this phenomenon appeared at all. The normal explanation for such conspicuous iconographic motifs or changes—the assumption of an influence of contemporary exegesis—is highly unlikely in this case. On the one hand, in theological terms the motif in question is rather inadequate for the biblical text; on the other hand, the accompanying Berengaudus commentary, probably dating to the eleventh century and already rather conservative by the thirteenth century,[98] is not especially concerned with visionary experience properly speaking, but rather allegorizes the Apocalyptic visions;[99] and, further, the specific excerpts from the Berengaudus

commentary in the English Apocalypses focus on the history of salvation as well as sin, death, and judgment.[100] The contemporary Apocalypse commentaries, for their part, mainly focus on the spirituality of the mendicant orders and their theology of history.[101] A further explanation, even though tempting at first sight, is also rather unlikely. This concerns the possible impact of an increased interest of contemporary English philosophy and theology in Aristotelian and Arabic theories of optics and visual perception.[102] The discussion of pinhole images and the principles underlying the "camera obscura" by Roger Bacon and John Pecham could theoretically be related to our window and external witness motif, but the respective studies by Bacon and Pecham were probably written in Paris after the Metz and Westminster groups originated.[103]

There remain two other more likely explanations, being somewhat related. Firstly, apparently the patrons and users of these Apocalypses were mostly laypersons. This is not only documented by the aristocratic and even royal owners of some of these manuscripts,[104] but it is also suggested by the fact that in these Apocalypses the illustrations and historiated initials precede the text, which is partly given in an abridged version (for instance, the Douce Apocalypse often ends its biblical and commentary quotations with *et cetera et cetera*).[105] Hence, priority is given to the illustration. Moreover, as is often noted,

compare this illustration to the corresponding French prose gloss, which interprets John's ascent to the door opened in heaven (Rev. 4:1) as the good priest listening to holy Scripture in his battle against the vices. However, in the *illustration*, neither the Scripture, nor the priest, nor the battle against the vices are represented, contrary, for instance, to analogous illustrations in the *Speculum Virginum* manuscripts (cf. M. Strube, *Die Illustrationen des Speculum Virginum*. Phil. Diss. [Düsseldorf, 1937], 29–36, Pl. 2, 4). Moreover, the French prose gloss does not interpret John's rapture to the *ostium apertum* (Rev. 4:2) as a symbol of the battle against the vices, but as an allegory for the overcoming of the "temporal things": "Ceo qu'il fu en espirite signefie que cil qui a la grace Deu se met hors de la veine cure de temporeus choses." (Delisle/Meyer, *L'Apocalypse en français au XIIIe siècle* [as in note 21], 17).

98. Klein, *Endzeiterwartung*, 19, note 126; Lewis, *Reading Images*, 42; Morgan, *Lambeth Apocalypse*, 25f. (all as in note 13).

99. Nolan, *The Gothic Visionary Perspective* (as in note 10), 11; Lewis, *Reading Images* (as in note 10), 42.

100. Morgan, *The Lambeth Apocalypse* (as in note 13), 26.

101. Delisle/Meyer, *L'Apocalypse en français au XIIIe siècle* (as in note 21), p. CCXIX; Lewis, "Exegesis and Illustration in English Apocalypses" (as in note 39), 264; Camille, "Visionary Perception and Images of the Apocalypse" (as in note 95), 279.

102. See D. C. Lindberg, *Theories of Vision from al-Kindi to Kepler* (Chicago, 1976), 94–121; C. Burnett, "The Introduction of Aristotle's Natural Philosophy into Great Britain: A Preliminary Survey of the Manuscript Evidence," in *Aristotle in Britain during the Middle Ages*, ed. by J. Marenbon (Turnhout, 1996), 21–50.

103. Cf. D. C. Lindberg, "The Theory of Pinhole Images from Antiquity to the Thirteenth Century," *Archive for History of Exact Sciences* 5 (1968), 154–176; Repr. in *idem, Studies in the History of Medieval Optics* (London, 1983), XII, 154–176.

104. See Klein, *Endzeiterwartung*, 164–166, 178ff.; Morgan, *The Lambeth Apocalypse*, 37 (both as in note 13).

105. Klein, *Endzeiterwartung*, (as in note 13), 27.

in the English Apocalypses the biblical text is rendered as a detailed, adventurous *vita* of the apocalyptic seer,[106] which seems to be more related to the narrative strategies of courtly romance—with its increasing emphasis on the hero's subjective experience[107]—and to the genre expectations of the lay reader,[108] than to pious devotion.[109] Similar tendencies can be observed in the nearly contemporary Morgan Picture Bible (New York, Morgan Library, M. 638), whose English connections as well as its courtly character are well known.[110] Comparable to the English Apocalypses, its images illustrate biblical history as real, romance-like experience[111] and—above all—it contains marginal spectator figures, like the illustration of David's Triumphant Return (Fig. 23): from the battlements above the gate, some women curiously look at, peep, and even lean into the picture space, comparable to the external spectator figures of John in the Apocalypses of the Westminster group. These conspicuous spectator figures in the Westminster Apocalypses as well as in the Morgan Picture Bible may well be related to the eye-oriented court culture of the thirteenth century and the dominance of sensory participation over intellectual perception.[112]

There is still another aspect overlooked so far, but one related to the question of the public of these Apocalypses, that is, the artistic factor. The artists of the Westminster Apocalypses try to impress the spectator and direct his attention by spectacular rear views, like

the John figure in the Distribution of the Trumpets in the Perrins Apocalypse (Fig. 10), by bold overlaps of figures and frame and strange rear views, as in the Sixth Trumpet of the Westminster Apocalypse in Paris (Fig. 13), or by figures who leave the picture space and disappear into the nowhere of clouds, like the escaping woman in the Perrins Apocalypse illustration of The Woman and the Dragon (Fig. 21). This kind of artistic virtuosity as a way to attract the viewer's attention recalls some of the spectacular marginal figures in the Morgan Picture Bible, like the outside figure of an archer and of a soldier attached to a gigantic catapult in the illustration of Saul Destroying Nahash.[113] They also recall some of the contemporary marginal images in the Rutland Psalter, which guide the reader's eyes either to the text written above, like the two wrestlers and a young man with demonic headgear, all looking upwards (Fig. 24),[114] or they direct the spectator's eyes to the upper illustration, like one of the two monstrous cannibals underneath the illustration of Jacob's Dream (Fig. 19). Of course, the marginal voyeur and spectator figure of St. John in the English Apocalypses is neither a cannibal, nor a monster, nor an evil person, but rather a saint and apostle, who as an outside spectator witnesses all kind of events, from heavenly theophanies (cf. Fig. 6, 7) to the horrible deeds of monster-like satanic figures (Fig. 12). It is, therefore, not their *content* that links the marginal witness figures in the English Apocalypses to contemporary

106. Freyhan, "Joachism and the English Apocalypse" (as in note 27), 225 f.; Plotzek, "Apokalypse" (as in note 30), 194; Lewis, *Reading Images* (as in note 13), 19.

107. R. W. Hanning, *The Individual in Twelfth-Century Romance* (New Haven and London, 1977), 5 f., 89 f., 189.

108. Lewis, *Reading Images* (as in note 13), 50.

109. As Henderson ("English Manuscript Illumination 1" [as in note 13], 116) already pointed out: "Artists and patrons alike recognized in the Apocalypse the one biblical text which fell into line with the upper-class entertainment of the day. The Apocalypse, regarded superficially, dealt with the same subjects as, say, Chretien de Troyes' Romances, ladies in affliction, noble knights riding into battle, magic and mysteries and monstrous beasts."

110. For the Morgan Bible's parallels or even connections to English book illumination, see G. von Vitzthum, *Die Pariser Miniaturmalerei von der Zeit des heiligen Ludwig bis zu Philipp von Valois und ihr Verhältnis zur Malerei in Nordwesteuropa* (Leipzig,

1907), 15 f.; S. C. Cockerell, *Old Testament Miniatures: A Medieval Picture Book* (New York, 1969), 21; R. Branner, *Manuscript Painting in Paris during the Reign of Saint Louis: A Study of Styles* (Berkeley and Los Angeles, 1977), IX, 139; P. Binski, *The Painted Chamber in Westminster* (London, 1986), 87–91.

111. L. H. Hollengreen, "The Politics and Poetics of Possession: Saint Louis, the Jews, and Old Testament Violence," in *Between the Picture and the Word: Manuscript Studies from the Index of Christian Art*, ed. by C. Hourihane (University Park, Pa., 2005), 51–71, esp. 65.

112. H. Wenzel, *Hören und Sehen—Schrift und Bild: Kultur und Gedächtnis im Mittelalter* (Munich, 1995), 60, 380.

113. Cockerell, *Old Testament Miniatures* (as in note 110), Fig. p. 117 (fol. 23ᵛ).

114. For the motif of the demonic headgear, see R. Mellinkoff, "Demonic Winged Headgear," *Viator* 16 (1985), 367–381.

FIG. 23. David's Triumphant Return. Old Testament Picture Bible, New York, Pierpont Morgan Library, M. 638, fol. 29ʳ.

FIG. 24. Marginal Figures. Rutland Psalter, London, British Library, Ms. Add. 62925, fol. 11ʳ.

marginal images, but their *functional role* as somewhat sensational guides for the reader and viewer. Hence, the rise of marginal illustration in England may well have influenced the emergence of the marginal witness figures in the contemporary English Apocalypses. This, however, remained an exception, since marginal images—at least in my view—represent an autonomous genre that only occasionally refers to the central image or central text.[115] And the marginal witness figures of John, for their part, remained a brief, although highly remarkable episode in the century-long tradition of medieval Apocalypse illustration.

115. See P. K. Klein, "Rand- oder Schwellenphänomen? Zur Deutung der Randbilder in der mittelalterlichen Kunst," in *Grenze und Grenzüberschreitung im Mittelalter* (11. Symposium des Mediävistenverbandes vom 14 bis 17. März 2005 in Frankfurt an der Oder), ed. by U. Knevelkamp and K. Bosselmann-Cyran (Berlin, 2007), 166–187; *idem,* "La représentation du corps dans les marges au Moyen Âge," *Studium Medievales: Revista de Cultura Visual—Cultura Escrita* 1 (2008), 101–123; *idem,* "Die Figurenkonsolen von San Martín in Frómista und die Tradition der 'marginal images,'" in *Hispaniens Norden im 11. Jahrhundert*, ed. A. Arbeiter et al. (Petersberg, 2009), 172–180; *idem,* "The Meaning of the Fables in the Bayeux Tapestry," in *Studies in Honour of Nigel Morgan*, ed. by J. M. Luxford, (London, 2010), 229–238.

Only during the printing of this article did I become aware of two recent publications relevant to the subject discussed here, in part, however, with a different approach and other conclusions: D. Ganz, *Medien der Offenbarung. Visionsdarstellung im Mittelalter* (Berlin, 2008), 189–216 ("Insel und Seitenrand. Die englischen Apokalypse-Zyklen des 13. Jahrhunderts"); and Peter Springer, *Voyeurismus in der Kunst* (Berlin, 2008), 37–66 ("Genese des voyeuristischen Blicks").

FIG. I. *Hedwig Codex*, Silesia, 1353, fol. 12. Top: "Here the Tartars carry the head of Duke Henry, St. Hedwig's son, on a lance to Castle Liegnitz." Bottom: "Here St. Hedwig sees in a dream the soul of her son, Duke Henry, borne by an angel into Paradise"; Hedwig's speech scroll reads: "Do not weep, dearest ones; it is God's will." Los Angeles, J. Paul Getty Museum, Ludwig XI 7 (83.MN.126) (photo: The J. Paul Getty Museum).

JACQUELINE E. JUNG

The Tactile and the Visionary:
Notes on the Place of Sculpture in the
Medieval Religious Imagination

NIGHTTIME brought little rest to the heavenly messengers of the Middle Ages. Like St. Joseph so long before her,[1] St. Hedwig, duchess of Silesia, received a visit from an angel while sleeping one night in 1241 (Fig. 1). This one needed no words to convey its news: as it cradled in veiled arms a diminutive version of her eldest son Henry, who had been leading the Silesian defense against the invading Mongols, Hedwig understood that he had fallen. Sad as it was, the revelation emboldened Hedwig to comfort her female kin, and spared them all the unpleasant alternative means of learning the news: by witnessing Henry's head impaled on an enemy spear and brandished before the gates of the nearby Castle Liegnitz (Legnica).[2]

The images depicting this episode appear in the so-called *Hedwig Codex*, a Silesian manuscript made in 1353 and presently housed at the Getty Library (Ms. Ludwig XI 7; fol. 12ʳ). The bulk of the codex is comprised of the saint's long biography, known as the *Legenda maior* (composed ca. 1300 and incorporating much of her canonization dossier), and includes some sixty-one colored drawings that refer to—but, as we shall see, in no way straightforwardly illustrate—the

definitive episodes in the saint's busy life as an aristocratic wife and mother, co-founder and fervent supporter of a Cistercian convent at Trebnitz (Trzebnica), and nurturer of the urban poor.[3] The depiction of Hedwig's dream departs from the narrative in two important ways: first, by bringing to view the supernatural mechanism by which the duchess learned of her son's death (the text merely relates that she knew of it three days before the ducal messenger arrived at her shelter); and second, by standing near the very beginning of the *Legenda*, despite the fact that the battle occurred just two years before Hedwig's own death in 1243.

On the verso of the image of Hedwig's dream is the famous full-page frontispiece in which, before the eyes of her descendents—the manuscript's patrons—Duke Ludwig I of Liegnitz and his wife Agnes, the duchess stands as a glorious visionary image herself (fol. 12ᵛ; Fig. 2).[4] Splendidly draped but uncrowned and barefoot, she gazes steadily toward us while clutching a series of small objects, most prominent among them an ivory statuette of the Virgin and Child of the kind that enjoyed vast popularity during the late thirteenth

1. I refer to the lecture by Pamela Sheingorn, "*Ecce angelus Domini apparuit in somnis Ioseph:* Seeing the Dreams of Joseph the Carpenter" at the Princeton conference, which immediately preceded my own paper.

2. A transcription and German translation of the text of the *Legenda maior*, composed around 1300, are included in the facsimile *Der Hedwigs-Codex von 1353, Sammlung Ludwig*, ed. by W. Braunfels (Berlin, 1972), 2 vols.; the text pertaining to this episode is found in 2:109 (corresponding to fol. 73ᵛ in the manuscript).

3. See J. Krása and K. Kratzsch, "Beschreibung der Handschrift und kunsthistorische Einordnung der Miniaturen," in *Hedwigs-*

Codex, 2:9–34. The best historical biography of Hedwig is J. Gottschalk, *St. Hedwig, Herzogin von Schlesien* (Cologne, 1964).

4. Cf. the catalogue entry in *Krone und Schleier: Kunst aus mittelalterlichen Frauenklöstern*, ed. by J. Frings and J. Gerchow (Bonn and Essen, 2005), 365–66, which states that the full-page miniature divides a sequence of images depicting the saint's life in the world—from her marriage to her death—from another sequence showing her holy life in the convent. In fact, the scenes of her death and burial appear near the end of the manuscript, exactly where they should in a chronological account.

FIG. 2. *Hedwig Codex* (83.MN.126), Silesia, 1353, fol. 12ᵛ. St. Hedwig with Duke Ludwig of Liegnitz and Duchess Agnes. Los Angeles, J. Paul Getty Museum, Ludwig XI 7 (83.MN.126) (photo: The J. Paul Getty Museum).

and fourteenth centuries (Fig. 3).[5] As they rise from between Hedwig's fingers, the little figures embrace each other with unusual verve; the Virgin clasps the Infant's chest and pulls him toward her as he chucks her chin with one hand and hugs Hedwig's finger with the other.[6] The intimate pose of the holy figures recalls that of the angel cradling Duke Henry's soul in the previous image; indeed, the close juxtaposition of the pictures makes the statuette of mother and child seem almost a materialization of Hedwig's own maternal tenderness toward her lost son, even if the text makes no such claims.

What the author of the *Legenda* does tell us, later in the text, is of Hedwig's special devotion to the Mother of God, which prompted her always to "carry on her person a little image of [Mary] in ivory (*ymaginem eburneam*), often holding it in her hands so that she could gaze upon it lovingly. Looking at it strengthened her devotion and aroused her to even greater love for the glorious Virgin. When she blessed sick people with this image, they were instantly cured."[7] No less than the statuette's iconography, then, its material qualities—its palpability, its easy portability—emerge here as essential factors in Hedwig's attachment to the image.[8] If the text strikes a balance between the visual and tactile elements of Hedwig's devotion, the accompanying picture presents a different view (fol. 46ᵛ; Fig. 4). Here the saint's eyes are directed not toward the ivory Virgin in her hands but toward larger sculptures of the church's patrons, Sts. Lawrence and Bartholomew, standing on an altar, the latter bearing his flayed skin over his shoulder like a grisly banner.[9] In the adjacent scene, in which the heroine extends her *imaginem* to the lips of ill men and women, Hedwig again looks past, rather than at, the carved figures.

FIG. 3. Ivory statuette of the Virgin and Child, Troyes, 18.5 cm high, ca. 1350. Victoria and Albert Museum (Inv. Nr. 7-1872) (photo: The Victoria and Albert Museum).

5. For other examples that predate the Hedwig Codex, see *Images in Ivory: Precious Objects of the Gothic Age*, ed. by Peter Barnet (Detroit, 1997), 122, 124, 127, 144.

6. For further observations on the figurine, see J. F. Hamburger, *The Visual and Visionary: Art and Female Spirituality in Medieval Germany* (New York, 1998), 437–40.

7. *Hedwigs-Codex*, 2:94: "Matrem vero Domini inter alios sanctos, quia maiori, ut dignum erat, amplexabatur amore, ideo ipsius parvam semper apud se gerebat ymaginem, quam eciam eburneam sepe accipiens in manibus deferebat, ut ex dileccione sepius eam posset respicere et respiciendo devocius se valeret ad amorem gloriose virginis amplius excitare. De qua ymagine dum aliquando benediceret languidos, protinus curabantur."

8. On the format of the ivory, see E. Walter, "Hedwigs Stellung zur bildenden Kunst im Zisterzienserorden," in his *Studien zum Leben der hl. Hedwig Herzogin von Schlesien* (Stuttgart and Aalen, 1972), 13–35.

9. A similar sculpture of Bartholomew holding his skin draped over his arm, made ca. 1470, now stands in the Musée d'art et d'histoire, Fribourg, Switzerland.

FIG. 4. *Hedwig Codex*, Silesia, 1353, fol. 46ᵛ, detail. "Here she displays fitting reverence to the saints, of whom she had many images and relics, and especially a little image of the Blessed Virgin. With this she blessed the sick and healed them." Los Angeles, J. Paul Getty Museum, Ludwig XI 7 (83.MN.126) (photo: The J. Paul Getty Museum).

Nor do they look at her: rather, they squirm and shift positions in her hands, so as better to engage visually with their beholders—either the sick who kiss them, or us who watch from beyond the vellum. What we see, then, seems to be a vision of living sculptures—a vision that the saint herself can only feel.

But is it proper to think of our visual apprehension as privileged here, and to relegate Hedwig's tactile perception to "mere" feeling? What happens if we imagine our way into the pictures, relinquishing our position as *beholders* and identifying instead with the body that *holds*? What role did tactile perception play in those encounters with God that, for lack of a more precise term, we have been calling "visionary"? And what part did sculptured images, which appealed to the sense of touch more directly and vividly than any other medium, play in molding imaginative perception? As my title indicates, I want both to pay homage to and to build upon the model of the relation between devotional images and religious imagination forged in 1969 by Sixten Ringbom's "Notes on the Place of Art in Late Medieval Private Piety" and honed so beautifully, twenty years later, in Jeffrey Hamburger's essay "The Visual and the Visionary" [10]—a model that, over

10. S. Ringbom, "Devotional Images and Imaginative Devotions: Notes on the Place of Art in Late Medieval Private Piety," *Gazette des Beaux-Arts* 73 (1969): 159–70; and J. F. Hamburger, "The Visual and the Visionary: The Image in Late Medieval Monastic Devotions," *Viator* 20 (1989): 161–82 (revised version in *Visual and Visionary*, 111–48). D. Freedberg's *The Power of Im-*

the last twenty years, has helped an entire generation of scholars understand something of the intelligence of medieval images, as vehicles of communication not only between artists and viewers but also between viewers and God, and something of their crucial role in shaping not only devotional practices but indeed the highest levels of theological discourse.[11] My essay makes no claim to comprehensiveness or finality, nor does it seek to diminish the significance of the visual issues that have so fascinated scholars in recent years. I wish, rather, to flesh out our picture of the medieval religious imagination by pulling forth those dimensions of perceptual experience that exceed the strictly visual, and engaging with artistic media that transcend the strictly pictorial. It is my hope that my paper will be regarded less as a conclusion to this volume's invitation to "look beyond" than as a provocation to keep looking *at* things—and to do so, perhaps, from some different perspectives.

Medieval Senses of Touch

In our quest to penetrate the medieval "mind's eye," or to "see how others saw," we have gained important insights into the conceptual complexity with which medieval people approached sight and its objects.[12] No less familiar to medievalists today than the Gregorian dictum that "pictures are the books of the unlettered"[13] is the Augustinian hierarchy of visual modes invoked by many of the authors in this volume—a model that, for all its authority, shifted in valence over the course of the Middle Ages in conjunction with the changing forms and functions of images.[14] Paradoxically, even as we seek to understand the nature of Augustine's supreme "intellectual" vision, a variety of sight free from the material constraints of bodies and images, we are recognizing more and more the corporeality that undergirded medieval ideas of optics. Using very different materials, such scholars as Georgia Frank and Susannah Biernoff have shown that from late antiquity through the end of the Middle Ages, the visual process was conceived in fundamentally embodied, even tactile terms.[15] The notion of optical rays shooting forth from active eyes to grasp a desired object or image, pull it back, and imprint itself within the supple matter of the brain—or, in a converse process, of self-replicating objects flying through the air into the eyes and minds of observers—is clearly enthralling to many of us medievalists, not least for its contrast with the aloof, cerebral understandings of visual perception and intellection characteristic of post-Enlightenment science.[16]

Yet for all the sexy "carnality" of medieval vision as we understand it—with its penetrations and exchanges, assimilations and transformations—both the extramission and intromission models of sight necessarily rely upon some *distance* between beholders and the things beheld. And although vision was always understood to be rooted in the body, medieval commentators

ages: Studies in the History and Theory of Response (Chicago, 1989) also looms large in my thinking about this subject.

11. See especially the essays in *The Mind's Eye: Art and Theological Argument in the Middle Ages*, ed. by J. F. Hamburger and A-M. Bouché (Princeton, 2006); H. L. Kessler, *Spiritual Seeing: Picturing God's Invisibility in Medieval Art* (Philadelphia, 2000); M. H. Caviness, *Visualizing Women in the Middle Ages: Sight, Spectacle, and Scopic Economy* (Philadelphia, 2001); and C. Hahn, *Portrayed on the Heart: Narrative Effect in Pictorial Lives of Saints from the Tenth through the Thirteenth Century* (Berkeley, 2001).

12. Hamburger and Bouché, eds., *Mind's Eye* (as in note 11); *Visuality Before and Beyond the Renaissance: Seeing as Others Saw*, ed. by R. S. Nelson (Cambridge, 2000).

13. See H. L. Kessler, "Gregory the Great and Image Theory in Northern Europe during the Twelfth and Thirteenth Centuries," in *A Companion to Medieval Art: Romanesque and Gothic in Northern Europe*, ed. by C. Rudolph (Oxford, 2006), 151–72.

14. It is also crucial to recall that Augustine's writings were often mediated by other commentators, and that other Church Fathers, such as Jerome, held competing understandings of vision. The varieties of twelfth-century ideas about vision(s) are being explored by Andrew Kraebel, a Ph.D. student at Yale University.

15. G. Frank, *The Memory of the Eyes: Pilgrims to Living Saints in Christian Late Antiquity* (Berkeley, 2000); S. Biernoff, *Sight and Embodiment in the Middle Ages* (London, 2002).

16. See D. C. Lindberg, *Theories of Vision from Al-Kindi to Kepler* (Chicago, 1981); and, as above, Biernoff, *Sight and Embodiment*. For very different applications of medieval optical theory to art historical questions, see M. Camille, *Gothic Art: Glorious Visions* (New York, 1996); J. Bennett, "Stigmata and Sense Memory: St. Francis and the Affective Image," *Art History* 24 (2001): 1–16; and B. V. Pentcheva, "The Performative Icon," *Art Bulletin* 88 (2006): 631–55.

themselves drew sharp distinctions between haptic and optical perception.[17] Many shared with Aristotle the impression that vision, that most "spiritual" sense, which provided knowledge of things far away and did so for multiple percipients simultaneously, seemed nobler than the sense of touch, which was grounded in the individual body and relied on direct contact with external objects.[18] For all its advantages, however, vision was recognized by other writers as weak and unreliable. Richard of St. Victor, in his commentary on the Apocalypse, provides us with a litany of flaws in the optical apparatus: "since [corporeal vision] is narrow, it does not comprehend the greatest things; since it is blunt, it does not discern the smallest; since it is lazy, it does not reach things far away; and since it is not attentive, it does not penetrate hidden things."[19] Visual stimuli, being distant, were subject to all sorts of interferences on their passage from object to brain—and people knew all too well that demons were apt to use visual illusions to deceive even the most devout.[20] The optical apparatus, moreover, was a delicate thing, vulnerable to the vagaries of penal law (blinding, of course, being a frequent punishment) and the more prolonged abuses inflicted by advancing age and bad lighting. The continued—even, in some cases, heightened—intellectual activity of the blind made clear that the sense of sight was not essential to mental acuity.[21]

Touch, by contrast, was a robust sense: it provided direct, immediate knowledge of the world, and, in its ability to distinguish dangerous objects from safe ones and good food from bad, was even indispensable for life. Despite its apparent baseness, no less an authority than Thomas Aquinas asserted that tactuality—the capacity both to touch and to be touched—would be present in glorified human bodies after the Resurrection.[22] In his commentary on Aristotle's *De anima*, Aquinas elaborated that touch was the one bodily sense that people possessed "at a far higher degree of precision than … any other animal."[23] "The preeminence of touch in man," he noted, "is the reason why man is the wisest of animals." Countering the possible objection that sight is a superior indicator of "mental capacity," Thomas reminded his readers that touch, being distributed throughout the body, "is the basis of sensitivity as whole," so that "the finer one's sense of touch, the better … is one's sensitive nature as a whole, and consequently the higher one's intellectual capacity." "Fine touch," moreover, "is an effect of a good bodily constitution or temperament" in a way that fine vision or hearing, which revealed the sensitivity of only small portions of the body, were not.

Rooted in the flesh, the tactile sense connected people to the earth and all its material dangers; yet, properly controlled, it could also lead to God. The elevating power of touch comes to view in a drawing from a twelfth-century manuscript made in Heilbronn Abbey, in which generic male figures clamber up a ladder whose rungs are identified with the five senses (Fig. 5).[24] In contrast to most medieval theoretical constructions of the sensory hierarchy—and to modern understandings of cognitive development, where touch is most elemental—*vis[us]* forms the very first step one

17. See R. Jütte, *Geschichte der Sinne: Von der Antike bis zum Cyberspace* (Munich, 2000), 41–114.

18. Aristotle, *On the Soul. Parva Naturalia. On Breath*, trans. by W. S. Hett (Cambridge, Mass., 1975), Book II, Chs. 7–11.

19. Richard of Saint-Victor, *In Apocalypsim Joannis*, Migne PL 196: 683–888 at 686; trans. by A. Kraebel; also discussed by B. Nolan, *The Gothic Visionary Perspective* (Princeton, 1977), 35–38; and M. Caviness, "'The Simple Perception of Matter' and the Representation of Narrative, ca. 1180–1280," *Gesta* 30 (1991): 48–64.

20. See L. Bitel's contribution to this volume; as well as N. Caciola, *Discerning Spirits: Divine and Demonic Possession in the Middle Ages* (Ithaca, 2003).

21. On the valences of sightlessness in the Middle Ages and beyond, see M. Barasch, *Blindness: The History of a Mental Image in Western Thought* (New York, 2001).

22. Thomas Aquinas, *Summa contra Gentiles, Book 4: Salvation*, trans. by C. J. O'Neil (Notre Dame, 1975), ch. 84, par. 14, 322–23.

23. T. Aquinas, *Aristotle's De Anima in the Version of William of Moerbeke and the Commentary of St. Thomas Aquinas*, trans. by K. Foster and S. Humphries (New Haven, 1951), 303. This and the following remarks appear in the chapter on smell (lec. 19, pars. 482–85, pp. 303–4). Contrasting smell and taste, which Thomas considers "a modality of touch," leads Thomas into the excursus on the latter sense from which the quotations above are drawn.

24. Jütte, *Geschichte der Sinne* (as in note 17), 91, gives no identifying information beyond its origin at Heilbronn Abbey and its present location in the Universitätsbibliothek Erlangen-Nuremberg.

FIG. 5. The Ladder of the Senses. Drawing in a manuscript from Heilbronn Abbey, 12th century, now in the Universitätsbibliothek Erlangen-Nuremberg (photo from R. Jütte, *Geschichte der Sinne: Von der Antike bis zum Cyberspace* [Munich, 2000], 91).

takes upon entering the world. Passing up over *auditus*, *gustus*, and *odoratu*[*s*], one finally reaches *tactus*; at this point the ladder cleaves into two strands, one, endowed with the seven gifts of the Holy Spirit, leading the person up toward heaven, and the other plunging him down into the demon-seething pit of hell. In contrast to the Virtues and Vices or the Labors of the Months,[25] the five senses had no stable iconography in medieval art; they could take the form of prancing horses, young women, doors labeled with bodily emblems (an eye here, an ear there), or, as at Heilbronn, a ladder.[26]

In theological, scientific, and pictorial discourses alike, tactuality was positioned, along with sight, as an extreme sense; unlike the uncontrollable, strictly receptive senses of hearing, smell, and taste, touch registered and reflected the will of the percipient.[27] The stern signs in art museums warning visitors not to touch the objects heighten our awareness of the urge to enhance our visual experience with physical contact, and call attention to the processes of self-control that restrain us from running hands or fingers along sumptuous surfaces.[28] Unlike sight, which, if not consciously channeled, absorbed all stimuli within the visual field regardless of their spiritually beneficial or corruptive qualities, an active touch grasped only what it wanted.[29] An episode from Jacques de Vitry's *Vita* of Marie de'Oignies (written shortly after her death in 1213) makes this abundantly clear.[30] When one of the young beguine's trusted male friends broke his usual decorum and "clasped her hand from an excess of spiritual affection," he instantly "felt the first masculine stirrings rise within him." Upon hearing Marie quote Christ's admonition that the Magdalene not touch him

25. See *Virtue and Vice: The Personifications in the Index of Christian Art*, ed. by C. Hourihane (Princeton, 2000); *Time in the Medieval World: Occupations of the Months and Signs of the Zodiac in the Index of Christian Art*, ed. by C. Hourihane (Princeton, 2007).

26. See E. Sears, "Sensory Perception and Its Metaphors in the Time of Richard of Fournival," in *Medicine and the Five Senses*, ed. by W. Bynum and R. Porter (Cambridge, 1993), 17–39; C. Nordenfalk, "The Five Senses in Late Medieval and Renaissance Art," *Journal of the Warburg and Courtauld Institutes* 48 (1985): 1–22.

27. On touch as an "extreme," see Jütte, *Geschichte der Sinne* (as in note 17), 81–83.

28. See also J. Hall, "Desire and Disgust: Touching Artworks from 1500 to 1800," in *Presence: The Inherence of the Prototype within Images and Other Objects*, ed. by R. Maniura and R. Shepherd (Aldershot, 2006), 145–60.

29. Active touch must be distinguished from passive touch, which registers stimuli encroaching from outside: cold winds, rain, physical punishment, etc.

30. Jacques de Vitry, *Life of Marie d'Oignies*, Book II, Ch. 75, in *Two Lives of Marie d'Oignies*, trans. by M. H. King and H. Fleiss (Toronto, 1998), 118.

(John 20:7), the embarrassed young man "withdrew from her presence and thereafter ... carefully guarded himself against such temptations."[31]

For many clerical and monastic writers, who championed the abnegation of sensory delights in both cloister and world, the perils of *tactus* seem to have outweighed its salvific promise. The shift, in the thirteenth century, toward exclusively visual devotional practices—from looking at relics through transparent stones or glass[32] to *Augenkommunion*, the consumption of the Eucharist through the eyes rather than the mouth[33]—seems to confirm the pre-eminence of opticality in the medieval sensory apparatus. Yet as numerous historians of religion are showing, many medieval writers—male and female, lay and religious—used the more immediate bodily sense of touch, as well as that of taste, to express and explore their hopes for communion with God.[34] Even if people agreed that the *visio Dei*, the sight of God's own face, would be the final and greatest reward of the Elect in Heaven,[35] accounts of those extraordinary encounters we call "visionary" often extol touch as the contemplative's ultimate prize on earth. In a period in which material images were an ubiquitous component of devotional practice, what better way to imagine divine union, which could only take place in the infinitely dark (or infinitely bright) realm of intellective vision, than as immediate bodily contact?

Along with the sermons of Bernard of Clairvaux and the poems of Hadewijch,[36] the visionary writings of the abbess Gertrude of Helfta (1256–1301/2) are especially rich in their evocations of multisensory modalities of divine communication, and sometimes explicitly reflect on the tensions between visual and tactile perception. In one long and lavish liturgical vision in which Christ revealed himself in various areas of the choir during the Eucharistic celebration, Gertrude expressed not gratitude but frustration with the *Augenkommunion* she was being offered. "Lord," she exclaimed after receiving the kiss of peace, "although I am now filled with the most incredible sweetness, yet it seems to me that *when you were on the altar you were too far from me*. Grant me, therefore, during the Blessing of this Mass, the favor of feeling that my soul is united to you."[37] No one, then or now, could accuse Gertrude of being a lackadaisical spectator, especially of liturgical rites—yet no matter how dynamic her optical rays may have been as she shot them toward the Host, they clearly did not suffice. Christ responded by enabling Gertrude "to [feel] herself clasped to his breast and firmly held in divine union that was as sweet as it was close." We can surmise from other episodes that this union needed to be brief as well. At an earlier point in the *Herald*, as Gertrude wondered how she could "sometimes be deprived of the Lord's visit without feeling any particular distress," Christ volunteered that "'too great a proximity sometimes prevents friends from seeing each other clearly. For instance, if they are very near to one another, as sometimes happens in embracing and kissing, it is not possible for them to have

31. The episode of the *Noli me tangere*, and the related scene of the Doubting Thomas, both beg for further discussion, but raise too many issues to be dealt with here. For a compelling interpretation of the former scene, see J-L. Nancy, *Noli me tangere: On the Raising of the Body* (New York, 2008).

32. C. L. Diedrichs, *Vom Glauben zum Sehen. Die Sichtbarkeit der Reliquie im Reliquiar* (Berlin, 2001); J. E. Jung, "Crystalline Wombs and Pregnant Hearts: The Exuberant Bodies of the Katharinenthal Visitation Group," in *History in the Comic Mode: Medieval Communities and the Matter of Person*, ed. by R. Fulton and B. W. Holsinger (New York, 2007), 232–33.

33. Biernoff, *Sight and Embodiment* (as in note 15), 133–64, presents this practice as emblematic of later medieval visuality.

34. See G. Rudy, *Mystical Language of Sensation in the Later Middle Ages* (New York, 1999). For olfactory and gustatory aspects, see R. Fulton, "'Taste and See That the Lord is Sweet' (Ps. 33:9): The Flavor of God in the Monastic West," *Journal of Religion* 86 (2006): 169–204; A. W. Astell, *Eating Beauty: The Eucharist and the Spiritual Arts of the Middle Ages* (Ithaca, 2006); and S. A. Harvey, *Scenting Salvation: Ancient Christianity and the Olfactory Imagination* (Berkeley, 2006).

35. For the theology behind this notion, see C. W. Bynum, *The Resurrection of the Body in Western Christianity, 200–1336* (New York, 1995), 279–317.

36. These are the main examples studied by Rudy, *Mystical Language* (as in note 34).

37. Gertrude of Helfta, *The Herald of Divine Love*, ed. and trans. by M. Winkworth (New York, 1993), Book 3, Ch. 17, p. 175; my emphasis.

the pleasure of seeing each other clearly at the same time.' And with these words she understood that when grace is withdrawn, merits accumulate."[38]

In these accounts, vision and tactility are mutually exclusive and mutually reinforcing—two equally valuable sides of the same coin. In others, touch is given the upper hand. A vision recounted in the Sister-book of the Swiss Dominican convent of St. Katharinenthal—one of a handful of chronicles from German convents detailing the virtues of the community's members and the marvelous ways God rewarded them[39]—tells of a Sister Berta von Herten, who was tormented by a yearning to leave her community and join a local forest-dwelling recluse called Guta. One day, while praying in the refectory after Mass, Berta "saw the Lord sitting high above her in the refectory, his face glowing like the sun, and waving to her with his hand." When she approached him and flung herself at his feet, Christ "took her up and tilted her head toward his lap and treated her all sweetly and lovingly." The mental image evoked here resembles nothing so much as the beautiful sculptures of Christ and St. John, which populated the Katharinenthal convent (and other monastic establishments) in various incarnations (Fig. 6).[40] As Berta reveled in the Lord's embrace, she noticed "that the refectory wall had become like glass, and on the other side of the glass there was a little person behaving as though her heart would

break, so gladly would she come through the glass to our Lord." Christ explained to Berta that the person was Guta of the Woods; "the glass that you see between her and me is the individual will; because she is not subject to a rule of obedience, she can never come as close to me as you."[41]

For modern art historians attempting to visualize this episode, Albrecht Dürer's famous woodcut of the perspectivist at work might spring to mind: on one side of a transparent barrier, a still figure intently gazing; on the other, a mass of desirable embodiedness.[42] Dürer's graphic stand-in may assume a cool, scientific attitude toward his object as he translates her form to paper, but for Guta vom Walde, casting her optical rays toward the Lord bears no such fruit. Indeed, seeing him without the possibility of touch seems to torment her more than not seeing him at all.

Even without considering the positive valences of touch in medieval understandings of the senses—an area of perceptual experience strangely neglected in the literature despite the widespread interest in the historicized body[43]—our increased recognition of the theological import of vision in the Middle Ages and of the corporeal quality of medieval optics should cause us to pay careful attention to images that possessed real bodies and thus offered at least the potential of physical contact.[44] The large image of Christ and St. John in the nuns' choir at Katharinenthal, in front of

38. Gertrude, *Herald*, Book 1, Ch. 17, p. 86. Similarly, Angela of Foligna, upon admiring a painted image of Saint Francis in the arms of Christ, heard the Lord promise to "hold [her] this closely—even closer than the eyes of the body can see"; quoted in Biernoff, *Sight and Embodiment* (as in note 15), 136.

39. G. J. Lewis, *By Women, For Women, About Women: The Sister-Books of Fourteenth-Century Germany* (Toronto, 1996).

40. On the large figure reproduced here, which stood on an altar in the nuns' choir, see *Krone und Schleier* (as in note 4), 409–11; three smaller versions from the same convent are discussed at 416–17. For a fuller discussion of the large group, see A. Knoepfli, *Die Kunstdenkmäler des Kantons Thurgau, Band IV: Das Kloster St. Katharinenthal* (Basel, 1989), 227, 231–34.

41. R. Meyer, *Das 'St. Katharinentaler Schwesternbuch': Untersuchung, Edition, Kommentar* (Tübingen, 1995), 102, *Vita* 12:4–17. For discussion of this passage with regard to transparency motifs, see Jung, "Crystalline Wombs" (as in note 32), 232–33.

42. The picture has come to emblematize modern viewing prac-

tices, as suggested by its use on the cover of J. C. Taylor, *Learning to Look: A Handbook for the Visual Arts*, 2nd ed. (Chicago, 1981). On the explicit rejection of touch in this woodcut, see Hall, "Desire and Disgust" (as in note 28), 148.

43. On the connection between the neglect of touch as a subject of investigation and the cultural predominance of two-dimensional media, see C. Classen, "Fingerprints: Writing about Touch," in *The Book of Touch*, ed. by C. Classen (Oxford, 2005), 1–9. For an anthropological and philosophical perspective, see H. Böhme, "Der Tastsinn im Gefüge der Sinne: Anthropologische und historische Ansichten vorsprachlicher Aisthesis," *Anthropologie*, ed. by G. Gebauer (Leipzig, 1998), 214–25. Important moves have been made toward incorporating touch into the study of historical response by Bennett, "Stigmata and Sense Memory" (as in note 16).

44. See also M. O. Boyle, *Senses of Touch: Human Dignity and Deformity from Michelangelo to Calvin* (Leiden, 1998); and G. A. Johnson, "Touch, Tactility, and the Reception of Sculpture in

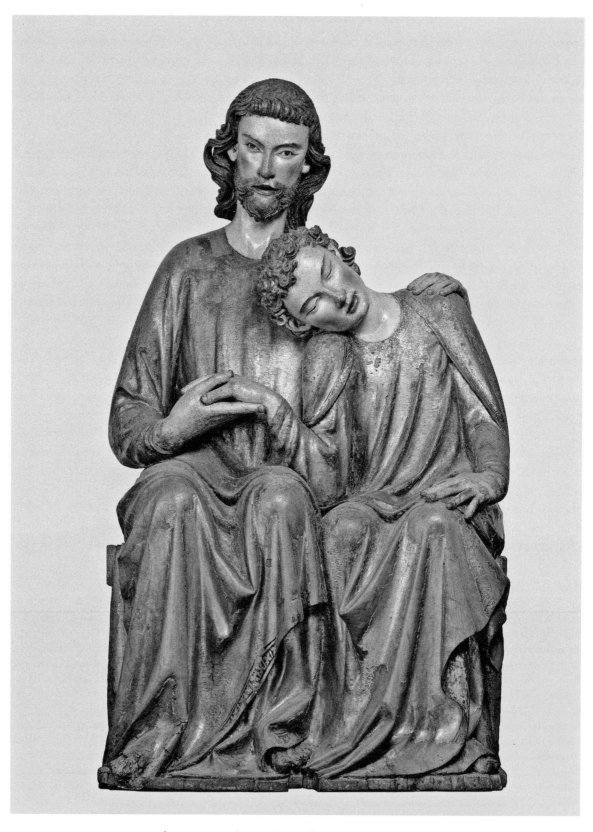

FIG. 6. Master Henry of Constance, Christ and St. John Group from Katharinenthal, ca. 1300, walnut with original polychromy, 141 cm tall. Antwerp, Museum Mayer van den Bergh, Inv. Nr. 2094 (photo: Museum Mayer van den Bergh).

which some sisters were observed to turn transparent or levitate,[45] shaped not only the iconography of Berta's vision but also its elevation of embodied contact.[46] John's eyes are closed, so that all communication between himself and Christ occurs through the body. Christ presses one hand against his beloved's shoulder while pulling his right hand up into a *dextrarum iunctio*—the conventional gesture of marriage.[47] The tensed fingers of John's left hand splay out over his thigh, as if holding in place the green cloth that undulates, in tandem with Christ's red cloth, across his lap. Carved from a single block of wood, the figures form a compact mass within a smooth outer contour; internally, limbs and folds form a rhythmic composition of interlocking curves that unite the figures across the sculpture's frontal plane as well as in depth. If the *image* of Christ embracing his beloved provided its viewers with the iconography of divine union, the *object*, with its sensual projections and crevices, its overlappings and mergings, allowed them to imagine how union might feel. Although the iconography of Christ and John quickly found its way into manuscript painting, where it assumed other meanings,[48] the sensual aspects of embodied union could be conveyed best through a three-dimensional medium. It is surely no accident that this subject—along with the equally

tactile Pietà—became a favorite motif in devotional sculpture from its introduction at the turn of the fourteen century.[49]

It is likewise no accident that, when late medieval artists depicted visionary events—as in the wings of Rogier van der Weyden's *Bladelin Altarpiece*—they often portrayed the things seen in "the mind's eye" as sculptures hovering in space (Figs. 7–8).[50] Despite many medieval writers' notorious lack of linguistic distinction between carved and painted images (or even between material images and mental ones), such paintings affirm the contention by Hans Belting and other media anthropologists that, beyond iconography, the shapes and materials in which images (*Bilder*) present themselves deeply affect the way people absorb and respond to them.[51] Scholars of modern visionary culture are making clear the integral connection between habits of looking developed through exposure to certain kinds of media and the structures of mental imagery—what people are capable of seeing and inclined to see in their minds or to read into their exterior environments.[52] Modern American counterparts of Rogier van der Weyden's ancient seers, for example, accustomed to absorbing images from flat, brightly lit screens, are apt to gaze not through windows but *at* them—for example, in the cases at Clearwater, Florida, and Milton,

Early Modern Italy," in *A Companion to Art Theory*, ed. by P. Smith and C. Wilde (London, 2002), 61–74, which came to my attention only as I was finishing revisions to this article. With the exception of J. Ziegler, *Sculpture of Compassion: The Pietà and the Beguines in the Southern Low Countries, c. 1300–c. 1600* (Brussels and Rome, 1992), scholars of medieval sculpture have been slow to address the tactile appeal of the works they study.

45. *Katharinentaler Schwesternbuch* (as in note 41), 130:42–44; 152:50–54.

46. The seminal work on the relation between visions and the images—both those they generate and those to which they refer—is E. Benz, *Die Vision: Erfahrungsformen und Bilderwelt* (Stuttgart, 1969).

47. J-C. Schmitt, *La raison des gestes dans l'Occident médiévale* (Paris, 1990), 329.

48. J. F. Hamburger, *St. John the Divine: The Deified Evangelist in Medieval Art and Theology* (Berkeley, 2002), 105–11; M. Wehrli-Johns, "Das Selbstverständnis des Predigerordens im Graduale von Katharinenthal: Ein Beitrag zur Deutung der Christus-Johannes Gruppe," in *Contemplata aliis tradere: Studien zum*

Verhältnis von Literatur und Spiritualität, ed. by C. Brinker et al. (Bern, 1995), 241–71.

49. As a motif extracted from a larger narrative, the Christ-John Group, along with the Pietà, was once regarded as the quintessential *Andachtsbild*: see W. Stechow, *Andachtsbilder gotischer Plastik* (Berlin, 1923); W. Pinder, *Die deutsche Plastik vom ausgehenden Mittelalter bis zum Ende der Renaissance* (Wildpark-Potsdam, 1924), 1:92–95; and H. Wentzel, *Die Christus-Johannes-Gruppen des 14. Jahrhunderts* (Stuttgart, 1960).

50. Cf. B. Rothstein, "Vision, Cognition, and Self-Reflection in Rogier van der Wedyen's Bladelin Triptych," *Zeitschrift für Kunstgeschichte* 64 (2001): 37–55, which suppresses the sensory modalities beyond vision on which the painting plays.

51. See especially H. Belting, *Bild-Anthropologie: Entwürfe für eine Bildwissenschaft* (Munich, 2001) and the essays in *Bild und Körper im Mittelalter*, ed. by K. Marek et al. (Munich, 2006).

52. W. A. Christian, Jr., *Apparitions in Late Medieval and Renaissance Spain* (Princeton, 1981); P. Apolito, *The Internet and the Madonna: Religious Visionary Experience on the Web* (Chicago, 2005).

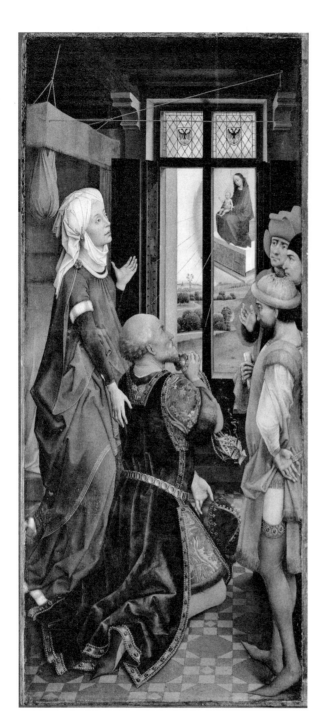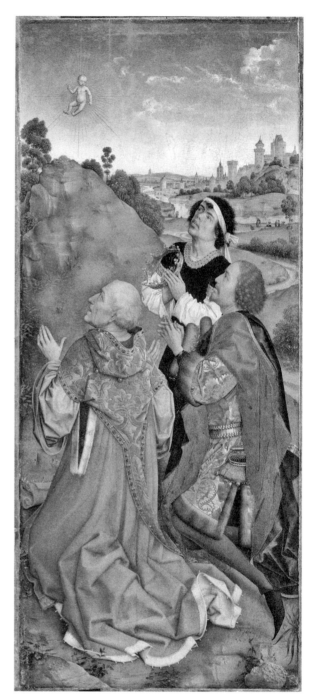

FIGS. 7 & 8. Rogier van der Wedyen (ca. 1399–1464), the *Bladelin Altarpiece*, ca. 1445. *Left wing:* The Tiburtine Sibyl reveals a vision of the Mother of God to the emperor Augustus. *Right wing:* The Three Magi behold the star in the form of the Infant Christ. Berlin, Staatliche Museen zu Berlin, Gemäldegalerie (photo: Bildarchiv Preussischer Kulturbesitz/Art Resource, N.Y.).

Massachusetts—discerning in trapped condensation the flickering outlines of familiar holy images.[53]

In a culture in which three-dimensional images were far more publicly accessible than those in two dimensions, it comes as no surprise that sculptures provided the direct impetus for, and were the subject of, much visionary experience in medieval Europe.[54] In certain respects, sculptures are more "user-friendly" than manuscript paintings, easier to perceive as animated—especially in the flickering candlelight of dark church buildings. Our customary reliance on photographic reproductions makes it all too easy to forget the embodied presence of sculptures, and the power of their ability to mimic the volumes, masses, textures, and even scale of living human forms, their sometimes aggressive intrusions into our real space, and their obedience to the rules of motion parallax, which causes the shape of things to shift in conjunction with a beholder's movement.[55] At the same time, large sculptures displayed on altars, screens, and beams in medieval churches were visually accessible to multiple persons at once, and had the advantage over living bodies of being predictable in their positioning and bodily poses. Predictable, at least, in theory; their very fixity made it all the more thrilling when sculptures slipped into animate life.

* * *

53. See D. Morgan's contribution to this volume. For photographs of the images at Clearwater and Milton—and many more apparition sites—see http://www.visionsofjesuschrist.com/miraculous_images.htm.

54. See E. Vavra, "Bildmotiv und Frauenmystik: Funktion und Rezeption," in *Frauenmystik im Mittelalter*, ed. by P. Dinzelbacher and D. R. Bauer (Ostfildern bei Stuttgart, 1985), 201–30. Even when written accounts likened a visionary visitor to a painting—as in the case of St. Teresa of Ávila analyzed by L. Corteguera in this volume—the painted depiction itself shows Christ in the form of a robust, shadow-casting sculpture, resembling the late Gothic Ascension Christs that were hoisted into church vaults during rituals; see J. Tripps, *Das handelnde Bildwerk in der Gotik* (Berlin, 1998), 150–54 and Abb. 45, 53–55, 60c.

55. Insightful discussions of the phenomenology of figural sculpture are offered, from very different standpoints, by T. Flynn, *The Body in Sculpture* (London, 1998) and K. Gross, *The Dream of the Moving Statue* (Ithaca, 1993).

56. For eyewitness reports, with photographic documentation, see www.visionsofjesuschrist.com.

Moving Crucifixes in Medieval Europe

When statues of Jesus, Mary, or other saints come to life today—as they do with surprising frequency[56]—their range of mobility is quite limited, with most movement confined to the eyes: gazes shift, eyelids blink, tears flow.[57] Crucifixes generally displayed greater flexibility in the eyes of medieval visionaries, detaching their limbs from the cross or opening their mouths to address or even kiss devotees. St. Hedwig's experience with an animated crucifix in the convent at Trebnitz is characteristic of such encounters. As the nuns dined one evening, Hedwig entered the abbey church, kissed their choir stalls, and flung herself onto the ground before the altar, where there loomed a large "*ymag[o] crucifixi*" with a "formidable expression."[58] As she prayed, the figure of Christ "removed its right hand and arm from the cross; extending it, he blessed her" and, with a sonorous voice, promised to grant all her requests. Although the text does not indicate that Hedwig saw the crucifix move—it was a "voyeuristic" sister, spying on her from a doorway, who reported the activity[59]— the accompanying picture (fol. 24ᵛ; Fig. 9) shows an alert Hedwig kneeling at the mangled feet of a life-sized crucifix that closely resembles a fourteenth-century *crucifixus dolorosus*, such as that in the church of St. George in Cologne (Fig. 10).[60] Blood drips from Christ's attached arm and gushes from his side wound

57. For case studies of sculpture animation in the early twentieth century, see W. A. Christian, Jr., *Moving Crucifixes in Modern Spain* (Princeton, 1992).

58. *Hedwigs-Codex* 2:78, where Hedwig is seen "procedentem seque prosternentem et referentem more solito gracias omnium Creatori ante altare ibidem in honore virginis gloriose constructum, cui supereminet crux non parve magnitudinis, expressam continens venerandam ymaginem crucifixi. Ubi dum in oracione prostrata moram faceret, ut solebat, ymago iam dicta manum et brachium dextrum de ligno crucis absolvens extendensque ipsam benedixit dicens voce sonora: Exaudita est oracio tua et, que postulas, inpetrabis."

59. On "voyeurism" in medieval images, see P. Klein's essay in this volume.

60. On this example, see G. Hoffmann, *Das Gabelkreuz in St. Maria im Kapitol zu Köln und das Phänomen der Crucifixi dolorosi in Europa* (Worms, 2006), 73–75.

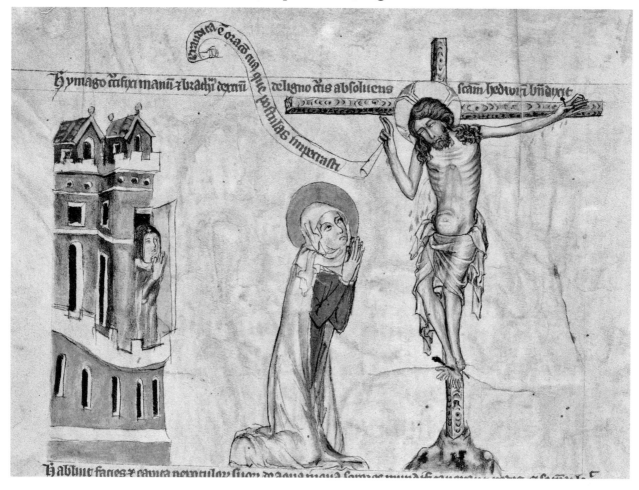

FIG. 9. *Hedwig Codex*, Silesia, 1353, fol. 24ᵛ, detail. "Here, detaching his right hand and arm from the cross beam, the image of the crucifix blesses St. Hedwig." Christ's speech scroll reads: "Your prayer has been heard. You will receive what you have requested." Los Angeles, J. Paul Getty Museum, Ludwig XI 7 (83. MN.126) (photo: The J. Paul Getty Museum).

as Hedwig gazes toward his ashen, asymmetrical face. Taken in conjunction with the text, which *denies* Hedwig the sight of the sculpture, the image reveals what the saint apparently envisioned in her prayers: a God whose merciful spirit could overcome even the basest abjection—abjection rendered so palpable in contemporary representations.

Encounters with animated crucifixes did not always provide comfort. Take the case of the nun Lukardis, who entered the Cistercian convent in Oberweimar

(Saxony) in 1274 and died in 1309 [61]—just as the grisly *Gabelkreuze* were coming into vogue. Lukardis had already gained renown within her community both as a faster of unusual stamina and as an unwitting performance artist whose body was prone to spring into fantastic contortions or launch into strange movements with little obvious motivation.[62] Praying one day during a period of illness, Lukardis "saw herself, in spirit, move into a certain portal (*per quoddam ostium*), in which she discovered Jesus Christ as if newly

61. On this saint, see A. M. Kleinberg, *Prophets in Their Own Country: Living Saints and the Making of Sainthood in the Later Middle Ages* (Chicago, 1992), 101–21.

62. For Lukardis' marvelous behavior, see C. W. Bynum, *Holy Feast and Holy Fast: The Significance of Food to Medieval Women* (Berkeley, 1989), 113–14, 131–32, 203.

FIG. 10. *Crucifixus dolorosus* in Church of St. George, Cologne, ca. 1350–75, walnut with original polychromy, 166 cm high (photo: author).

attached to the cross, shredded by the flail and piteously drenched with blood." Having "looked closely" at this spectacle (*quem diligentius intuens*), the young woman fell at his feet, half-dead with horror (*praemortua et exanimis*). Upon Christ's demand that she "rise up and help" him, the nun "lifted her eyes" to find

> his right arm loosened from the cross, pathetically hanging down; this seemed to her to sharply amplify the suffering Christ's pain. Approaching him with great compassion (*condolendo multo*), the beloved handmaiden tried to tie the arm back to the

cross with a silken thread, but could not succeed. She then began to lift his arm with her hands and, with groans, to hold it in place. The Lord then said to her: "Attach your hands to my hands and your feet to my feet and your breast to my breast, and thus shall I be helped by you to find relief (*ut levius habeam*)." Once the handmaiden of God had done this, she instantly sensed within herself the harshest pain of wounds in her hands, feet and breast, even though no wounds were visible to the eyes." [63]

These pains soon materialized as stigmata.

63. "Vita venerabilis Lukardis," *Analecta Bollandiana* 18 (1899): 305–67 at 314: "Vidit etenim in spiritu se transire debere per quoddam ostium, in quo Iesum Christum recenter cruci quasi iam affixum, flagellis caesum repperit et sanguine miserabiliter perfusum. Quem diligentius intuens famula Dei praemortua et exanimis cecidit ante pedes eius. Cui Dominus: *Surgas*, inquit, *ut me iuves*. Per quod intellexit quod non tantum memoria passionis suae, immo deberet etiam ipsum compassione sedula adiuvare. Ad verba

Although Lukardis' *Vita* does not specify whether the holy woman was praying before an actual crucifix when her vision occurred, a profoundly sculptural imagination underpins the encounter. For one thing, the body of Christ does not float freely but has a specific spatial location: he hangs in a door, like the carved crucifix at Naumburg Cathedral.[64] And although the sight of the bleeding body places Lukardis in a heightened emotional state, it is the figure's tangible properties—the weight of the arm, its mass, its obedience to laws of gravity—that cause her both physical agony and, in the end, physical grace. As with contemporary crucifixes (see Fig. 10), no outward sign of divine transcendence lifts this Christ from the realm of agonized humanity. Seemingly incapable of returning his arm to the *patibulum* independently, the Crucified relied on the young woman's muscular energy to resume his accustomed position. Following that bodily contact, which left no room for sight, the pain conveyed by his twisted limbs and lacerated flesh transferred over to her.

Visionaries of the twelfth century, accustomed to a very different view of the crucified Christ in monumental sculpture, had correspondingly different imaginative encounters with him.[65] The case of the abbot Rupert of Deutz sharing an open-mouth kiss with a crucifix that stood upon an altar is perhaps the best-known instance—and certainly most startling to modern sensibilities, to judge from the close attention and widely divergent interpretations it has received in the scholarly literature.[66] This was not, however, the only physical dalliance the great Benedictine enjoyed with an animate crucifix. Let us return to the account of 1126, to which Eric Palazzo has already introduced us.[67] When last we saw Rupert, he was dreaming of standing, at night, in the nave of an unspecified church in the Rhineland, his eyes fixed "on the image of the Savior nailed to the cross at an elevated spot" (*aspiciebat per visum in quadam ecclesia Salvatoris imaginem, cruci confixam in loco sublimi*). We saw how he noticed it looking back at him as if alive, "with a face like a king's, with radiant eyes and an awe-inspiring gaze" (*vivens imago visa est, vultu quasi regio, radiantibus oculis, aspectuque prorsus reverendo*); and we joined him

tamen Christi tandem viribus aliqualiter restituta, pavida respondit: *Quomodo te iuvare possum, mi domine?* Et elevans sursum oculos vidit eius brachium dextrum solutum a cruce misere dependere, per quod sibi dolor patientis Christi augeri acrius videbatur. Unde accedens dilecta famula condolendo multo, tentabat filo sericeo sibi ad crucem ligare brachium; sed nequivit. Coepit igitur manibus tollere brachium eius et cum gemitu sustinere. Cui Dominus: *Iunge*, inquit, *manus tuas manibus meis et pedes tuos pedibus seis et pectus tuum pectori meo, et sic ero per te adiutus ut levius habeam.* Quod dum fecisset famula Dei, in momento sensit sibi inesse acerrimum dolorem vulnerum interius tam in manibus quam in pedibus et in pectore, licet nondum vulnera ad oculum apparerent." My translation differs slightly from Kleinberg's, *Prophets*, 104.

64. On the significance of this zone, see J. E. Jung, "Seeing through Screens: The Gothic Choir Enclosure as Frame," in *Thresholds of the Sacred: Architectural, Art Historical, Liturgical and Theological Perspectives on Religious Screens, East and West*, ed. by S. Gerstel (Cambridge, Mass., 2006), 185–213.

65. On this point I disagree with Freedberg, *Power of Images* (as in note 10), who at 307 states that crucifixes "had for so long been the centrally ardent focus of all believers' attention that they had become fetishistic objects to a much greater extent than all other images, and their form was therefore more or less irrelevant to the kinds of response they engendered."

66. S. Lipton, "'The Sweet Lean of His Head': Writing about Looking at the Crucifix in the High Middle Ages," *Speculum* 80 (2005): 1172–1208 at 1175–82; R. Fulton, *From Judgment to Passion: Devotion to Christ and the Virgin Mary, 800–1200* (New York, 2002), 309ff.; R. C. Trexler, "Gendering Jesus Crucified," in *Iconography at the Crossroads*, ed. by Brendan Cassidy (Princeton, 1993), 107–19 at 108; C. W. Bynum, *Fragmentation and Redemption: Essays on Gender and the Human Body in Medieval Religion* (New York, 1992), 86; R. Haacke, "Die mystischen Visionen Ruperts von Deutz," in *Sapientiae Doctrina: Mélanges de théologie et de littérature médiévales offerts à Dom Hildebrand Bascour O.S.B.* (Leuven, 1980), 68–90 at 88–89; and C. Meier-Staubach, "Ruperts von Deutz literarische Sendung: Der Durchbruch eines neuen Autorbewußtseins im 12. Jahrhundert," in *Wolfram-Studien XVI: Aspekte des 12. Jahrhunderts*, ed. by W. Haubrichs, E. C. Lutz and G. Vollmann-Profe (city, 2000), 29–52. E. Beitz, *Rupertus von Deutz: Seine Werke und die bildende Kunst* (Cologne, 1930) seeks in Rupert's writings the origins of certain trends in medieval iconography and representational practice, but does not mention the crucifix vision I discuss here.

67. See E. Palazzo's contribution to this volume. Rupert of Deutz, *Commentaria in Canticum canticorum*, ed. by H. Haacke (Turnholt, 1974), Liber V, 110; my translation. An eloquent new translation and analysis of this whole passage appears in Fulton, *From Judgment to Passion* (as in note 66), 334–41.

in marveling as the corpus "drew its right hand down from the beam and with great vividness made the sign of the cross over the viewer" (*manumque suam dextram de patibulo adducere, signaculum crucis super aspicientem edere magnifica expressione*).[68]

Beyond its liturgical significance, the gesture reveals something about the medial specificity of this image in Rupert's imaginative devotions, for, breaking the plane defined by the cross, it requires a three-dimensional limb capable of moving freely in space. On a representational level, it also breaks the body out of the cruciform position that the gesture itself reproduces. With these multiple disruptions of expected norms, vision and signs gave way to sensation and movement. In a sudden move that would leave him feeling his own limbs tremble "like the leaves of a tree when the wind shakes them violently" (*sicut tremit folium arboris, ubi ventus vehemens illud concusserit*), Rupert was rapt into the air (*in ipso visu … virtus signaculi videntem sursum rapuit*). "With his hands outstretched" he was drawn "to those hands attached to the cross, and likewise his mouth [clung to] that mouth, so that, in the end, it seemed that his whole body adhered to that other body" (*manibus expansis ad manus illius confixas cruci, ita ut os quoque ori, totumque corpus admotum videretur ejus corpori*). This is the same image of contact in which Lukardis' vision had culminated—though in place of pain Rupert awakened to find himself "trembling with great delight" (*multum delectabiliter uigilans tremuit*).

The textual frame of this report is Rupert's commentary on the Song of Songs, specifically the heady chapter 5 verse 4, wherein "My beloved put his hand through the key hole, and my bowels were moved at his touch." This context suggests that the import of the crucifix vision to Rupert had less to do with iconographic content *per se*—the seer's special devotion to Christ crucified—than with the transcendent effects of tactility; for the visionary report was prefaced, with no transition, by a very strange account of another nighttime encounter. Here, Rupert recalls feeling "a certain likeness of a hand" (*quadam similitudinem manus*) creeping downward from the head of his bed to rest upon his chest.[69] Finding its touch "most delightful" (*erat autem tactus suavissimus*), Rupert responded by "grasping the hand with one of his own hands and stroking the sign of the cross upon it, wandering both inside and out; this motion seemed to please the hand very much" (*Et apprehendens illam suis utriusque manibus demulcebat signaculo crucis, peragrans intus et exterius, quibus delinimentis valde manus eadem delectari videbatur*). Although this silent interchange came to a halt when Rupert's fingers moved too far up his companion's arm—the person, it seems, did not want to be discovered (*quod ipse cujus erat manus, nollet se apprehendi*)—the monk allowed the experience internally by summoning up the line from the Song of Songs. Now he imagined the hand pressing into his chest "as if through a keyhole" to reach, caress, and hold his heart, and felt his "heart, within that hand, rejoicing with indescribable joy, leaping up and dancing about."[70] This encounter shares with the crucifix vision not only the effect of rapturous trembling in the percipient's body (*tremore sancto et divino*); both also place embodied contact with another being at the center of an intense emotional experience. Vision played no role whatsoever in the encounter with the hand except in its absence—and while the meeting of eyes and

68. Throughout the passage, the protagonist is a young woman (*adulescentula*), to whom Rupert refers in the third person. Although some scholars, such as P. Dinzelbacher, *Vision und Visionsliteratur im Mittelalter* (Stuttgart, 1981), 151, take this at face value, medieval commentators already recognized that Rupert was referring to himself; see Fulton, *Judgment to Passion*, 336–37.

69. Cf. Dinzelbacher, *Vision und Visionsliteratur*, 151, who identifies the hand as Christ's. The text does not make this claim.

70. The practice of imaginative work, as described by M. Carruthers, *The Craft of Thought: Meditation, Rhetoric, and the Making of Images, 400–1200* (Cambridge, Mass., 1998), and the role of

embodied experience in shaping thought, comes to view with special clarity here. Rupert, *Commentaria* (as in note 67), 110, where, after the hand leaves, "Memorabat etiam eadem adolescentula, scilicet anima nuptiis istis dedita, canticisque nuptialibus intenta, quoniam dilectus in visu noctis conspicuus, manum suam miro modo pectori ejus, quasi per foramen injecit, et cor ejus intrinsecus apprehendit, tenuitque aliquandiu suavissime stringens, et gaudebat ineffabili gaudio cor illud intra manum illam subsiliens atque tripudians. Porro de tremore illo, tremore sancto et divino, tale experimentum sibi evenisse fideli narratione referebat. My translation; but see also Fulton, *Judgment to Passion*, 334–35.

the reading of gesture marked the starting point of the crucifix encounter, sight was transcended in the great, gravity-defying melding of bodies at the end.

Rupert's reports of animated crucifixes never downplay the fact that he was engaging with an artificial body—a large-scale sculpture in a particular spatial location, normally out of reach of viewers—and they demonstrate the combination of frustration and excitement that such distance could arouse.[71] Space teased beholders, daring them to overcome the separation of vision and press against the desired body with hands and feet, breast and lips.[72] The predilection for life-sized, robustly corporeal sculpted crucifixes as the dominant image in churches (as opposed to, say, low reliefs or paintings) extended the promise of satisfying bodily contact at the end of the journey. We do not know what object in particular so excited Rupert of Deutz, but enough eleventh- and twelfth-century crucifixes survive in Germany—as well as Spain, where they exhibit closely related forms—that we can gain a general sense of their character (Fig. 11).[73] Although many of these look relatively planar when seen head-on (as they are typically rendered in photographs), views from the lowered standpoint Rupert describe bring out a strong degree of plasticity: knees jut out and hips sway, bellies bulge and shoulders tip back, and heads tilt down as if observing be-

holders on the ground. An interest in the three-dimensional possibilities of sculpted crucifixes was present at the very inception of the genre—witness the tenth-century Gero Crucifix in Cologne Cathedral[74]—and manifest an early, enduring interest in the fleshly humanity of Christ. The gore of the late Gothic *crucifixi dolorosi* may be absent in such cases, but the very physicality, the tangible presence, of Ottonian and Romanesque crucifixes gives them an insistently earthly character that our traditional designation "triumphal" belies.[75] With their three-dimensional simulation of flesh hammered into place—which the alert faces and lack of blood only make all the more uncanny—these early crucifixes hover forever "betwixt and between" triumph and abjection, life and death, body and image.

It was precisely the interpretative openness of these sculptures, I think, that made them resonate so powerfully in the imaginations of trained contemplatives. In their very ambiguity, their lack of clearly defined markers of meaning, the figures are best thought of as *embodied templates* for imaginative projection.[76] On them the pictorial "craft of thought," about which Mary Carruthers has taught us so much, could be practiced and refined; radiant gazes and blessing arms could be beamed onto the bodies with minimal interference from overly naturalizing details.[77] Even in thirteenth-century crucifixes such as that at Naumburg

71. For the crucifixes displayed atop screens, see M. Beer, *Triumphkreuze des Mittelalters: Ein Beitrag zu Typus und Genese im 12. und 13. Jahrhundert* (Regensburg, 2005).

72. See, for example, the nun Margaret Ebner, whose yearning to "kiss … and press … close to my heart" a "large crucifix in choir" that was "too high up for me and … too large in size" was satisfied when, in a dream, she "stood before the image" and "my Lord Jesus Christ bent down from the cross and let me kiss His open heart and gave me to drink of the blood flowing from His heart"; from the "Revelations," in M. Ebner, *Major Works*, trans. by L. P. Hindsley (New York, 1993), 96.

73. On the Spanish example at The Cloisters, see *The Metropolitan Museum of Art: Europe in the Middle Ages*, with essays by C. Little, T. B. Husband, and M. B. Shepard (New York, 1987), 64–65. For German survivals, see J. Pfeiffer, *Studien zum romanischen Kruzifixus der deutschen Plastik* (Giessen, 1938); U. Engelmann, *Christus aum Kreuz: Romanische Kruzifixe zwischen Bodensee und Donau* (Beuron, 1966); E. J. Hürkey, *Das Bild des Gekreuzigten im Mittelalter* (Worms, 1983); P. Thoby, *Le crucifix des origines au Concile de Trent: Étude iconographique* (Nantes, 1959). A recent

exhibition in Freising presented two newly restored wooden crucifixes, which the conservators dated (not without controversy) to the years around 900 and 1000, respectively; see *Kreuz und Kruzifix: Zeichen und Bild*, ed. by S. Hahn et al. (Freising, 2005), Cat. II.19 (crucifix from Enghausen) and II.20 (crucifix from Schaftlach), 191–98.

74. The best study remains R. Haussherr, *Der tote Christus am Kreuz: Zur Ikonographie des Gerokreuzes* (Bonn, 1963).

75. The contrast between the "triumphal" crucifixes of the early Middle Ages and the "suffering" crucifixes of the Gothic period has long been a staple in the literature; for a particularly sensitive formulation, see R. W. Southern, *The Making of the Middle Ages* (New Haven, 1953), 237–38. For a nuanced analysis of the expressive shifts that accompanied formal changes in crucifixes of the early thirteenth century, see G. Lutz, *Das Bild des Gekreuzigten im Wandel: Die sächsischen und westfälischen Kruzifixe der ersten Hälfte des 13. Jahrhunderts* (Petersberg, 2004).

76. I owe this formulation to Sara Ryu, a Ph.D. student at Yale University.

77. Carruthers, *Craft of Thought* (as in note 70).

FIG. 11. Crucifix, Léon, ca. 1150–1200. Corpus: white oak and pine with polychromy, gilding, and applied stones; Cross: red pine, polychromy, 8 ft. 6½ in. × 6 ft. 9¾ in. New York, Metropolitan Museum of Art, The Cloisters (Samuel D. Lee Fund, 1935, 35.36a, b) (photo © The Metropolitan Museum of Art).

Cathedral (Fig. 12), which seem to veer so decisively toward a so-called "Gothic realism," the movements of beholders generate a shifting array of perceived images, allowing even those with little time or talent for prolonged contemplation to experience the jolt of the body's sudden animation (Fig. 13).[78] The sculpture that creates different meanings at different standpoints, that seems to move and speak in conjunction with a viewer's own movements, and that allows or teases with the prospect of touch, is no less "a simulacrum of the visionary" than the images in manuscripts.[79] It is therefore little wonder that, when men and women of various social stripes wanted to picture the experience of communion with God, they imagined themselves embraced by a crucifix.[80]

It is likewise little wonder that, when those heavenly rays discussed by Hans Belting struck the body of Francis of Assisi, it was not into *any* image of the

78. For two different aspects of this phenomenon, see J. E. Jung, "Beyond the Barrier: The Unifying Role of the Choir Screen in Gothic Churches," *Art Bulletin* 82 (2000): 622–57 at 631–32; and *idem*, "Seeing through Screens" (as in note 64), 205–10.

79. Hamburger, *Visual and Visionary* (as in note 6), 143.
80. For this trope in painting, see Freedberg, *Power of Images* (as in note 10), 306–7.

FIG. 12. Naumburg Cathedral, crucifix on west choir screen, limestone with polychromy, ca. 1249–55 (photo: author).

FIG. 13. Naumburg Cathedral, detail of crucifix on west choir screen, limestone with polychromy, ca. 1249–55 (photo: author).

crucified Christ that the saint transformed, but quite precisely into a *sculpted* one.[81] For all their other differences, both of Francis' biographers insisted that the stigmata on his hands and feet were not the open perforations that painters would show but rather fleshly protuberances. Thus Thomas of Celano in his *First Life of St. Francis* (1229/30):

> [Francis's] hands and feet seemed to be pierced through the middle by nails, with the heads of the nails appearing in the inner side of the hands and on the upper sides of the feet and their pointed ends on the opposite sides. The marks in the hands were round on the inner side, but on the outer side they

were elongated; and some small pieces of flesh took on the appearance of the ends of the nails, bent and driven back and rising above the rest of the flesh. In the same way the marks of the nails were impressed upon the feet and raised in a similar way above the rest of the flesh.[82]

Bonaventure's account in the *Legenda maior*, which definitively replaced Thomas' biography in 1266, retains and even amplifies the volumetric quality of the wounds. As with Rupert of Deutz, Francis' optical experience culminates and is superseded by physical sensation: "As the vision [of the seraph] disappeared, it left his heart ablaze with eagerness and impressed upon his body a miraculous likeness." And as with Lukardis of Oberweimar, physical sensation quickly passes into physical change:

> There and then the marks of nails began to appear in his hands and feet, just as he had seen them in his vision of the Man nailed to the Cross. His hands and feet appeared pierced through the center with nails, the heads of which were in the palms of his hands and on the instep of each foot, while the points stuck out on the opposite side. The heads were black and round, but the points were long and bent back, as if they had been struck with a hammer; they rose above the surrounding flesh and stood out from it.[83]

Far from receding (or rising) into the realm of the purely visual, Francis' stigmata persisted in their object-ness even after his death. As his brothers examined the corpse, they marveled to see

> in his holy hands and feet … the nails which had been miraculously formed out of his flesh by God; they were so much part of his flesh that, when they were pressed on one side, they immediately jutted out further on the other side, as if they were made of solid material which reached right through.[84]

Francis had typically concealed his wounds under baggy garments so that they would not be visible, let alone touchable, to his companions during life. After his death, the curious brothers became like so many

81. Cf. H. Belting's contribution to this volume. For a very compelling analysis on Francis' stigmatized body and its representation, see Bennett, "Stigmata" (as in note 16).

82. *St. Francis of Assisi, Writings and Early Biographies: Eng-* *lish Omnibus of the Sources for the Life of St. Francis*, ed. by M. A. Habig, 2 vols. (Quincy, Ill., 1991), 1:309.

83. Habig, ed., *St. Francis*, 1:731.

84. *Ibid.*, 1:742.

Doubting Thomases, testing the wounds not just with eyes but also with fingers; unlike Thomas, however, they could not pierce the marvelous body, but rather found it pushing back against them.

Even the side wound—which, "just like the wound in our Savior's side," was open and penetrable, and often bled while Francis was alive—assumed the character of sculpture after his death. "The nails [in his hands and feet] were black like iron," Bonaventure continues, "but the side wound was red, and the flesh was contracted into a sort of circle, so that it looked like a beautiful rose." [85] The open wound over the heart thus did not offer an inlet into the saint's body, but rather spilled out into the world, blossoming into a flower, insisting on its material presence even as it became an image.[86]

Sculptural Iconography and the Haptic Imagination

My foregoing analysis suggests that medieval carvers of wood and stone deployed the sensuous qualities of their medium to prompt the desire that could lead to visionary experience. In the brief survey that follows I want to show that they also harnessed iconography and formal design to reflect on the sensory domains peculiar to their medium—and that they did so with no less sophistication or self-awareness than those painters on whom my colleagues have shed so much light.[87] Just as Giotto and Apocalypse illuminators thematized the *gaze* in their images, providing models for viewers who, like St. John, peer into illusory worlds beyond the earthly sphere, so sculptors, from the very re-emergence of their medium as a monumental art form in the twelfth century, made the act of *touching* a central theme in their works. What pictorial medium was better suited to show the plunge of a finger into a wound, as in the relief of the Doubting Thomas at Silos (Fig. 14),[88] or the succumbing of a body to gravity—and struggle of others against it—such as we see in the Deposition Group carved into the Externsteine in Westphalia (Fig. 15)?[89] The removal of Christ's body from the cross, of course, formed the subject of narrative sculptural ensembles throughout Europe long before Rogier van der Weyden translated the scene so movingly into paint (and it is important to recall here that his great painting at the Prado explicitly simulated sculpture).[90] The surviving examples of such groups in Italy and Spain, which likely played a role in extra-liturgical plays, all dramatize the interplay of weight, support, and movement that sculpture, as a medium, was specially equipped to convey (Fig. 16).[91] Nicodemus, who tends to be shown either supporting Christ's arms or grasping him around the chest or hips, was the

85. *Ibid.*, 1:742.

86. Bonaventure's description anticipates such images as the Röttgen Pietà in Bonn (ca. 1300), where the coagulated blood bursting from each of Christ's wounds echoes the forms of the roses on the base. For further discussion of this and related examples, see C. W. Bynum, *Wonderful Blood: Theology and Practice in Late Medieval Northern Germany and Beyond* (Philadelphia, 2007), 176–77.

87. See, in particular, the contributions by H. Belting, P. Klein, and R. Emmerson in this volume.

88. E. Valdez del Álamo, "Touch Me, See Me: The Emmaus and Thomas Reliefs in the Cloister of Silos," in *Spanish Medieval Art: Recent Studies*, ed. by C. Hourihane (Tempe, Ariz. and Princeton, 2007), 35–64.

89. W. Matthes and R. Speckner, *Das Relief an den Externsteinen: Ein karolingisches Kunstwerk und sein spiritueller Hintergrund* (Ostfildern, 1997) propose a ninth-century date for these sculptures, based on their close similarities to Carolingian ivory carvings.

90. Conversely, numerous sculptors of the fifteenth century would translate Rogier's composition back into three dimensions, albeit on a smaller scale; see N. Verhaegen, "The Arenberg 'Lamentation' in the Detroit Institute of Arts," *Art Quarterly* 25 (1962): 295–312; L. van Caster-Guiette, "Réminiscences rogériennes dans la sculpture brabançonne," in *Mélanges d'archéologie et d'histoire de l'art offerts à Professeur Jacques Lavalleye* (Louvain, 1970), 297–304.

91. For the spectacular ensemble from Erill la Vall (Lleida), now in Vic, whose characters have jointed arms, see *The Art of Medieval Spain, A.D. 500–1200*, ed. by J. P. O'Neill (New York, 1993), 316–18. For the Volterra group pictured here, and other Italian examples, see *Il teatro delle statue: Gruppi lignei di Deposizione e Annunciazione tra XII e XIII secolo*, ed. by F. Flores d'Arcais (Milan, 2005). On the relation of such groups to liturgical rites, see E. C. Parker, *The Descent from the Cross: Its Relation to the Extra-Liturgical "Depositio" Drama* (New York, 1978); H. Belting, *Das Bild und sein Publikum im Mittelalter* (Berlin, 1981), 224–44.

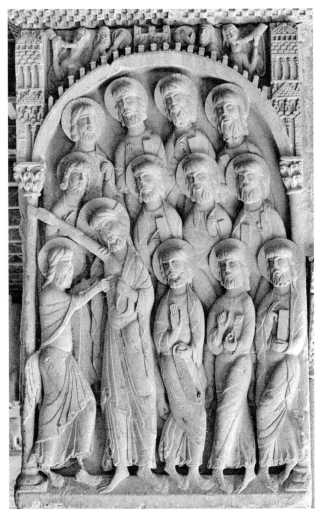

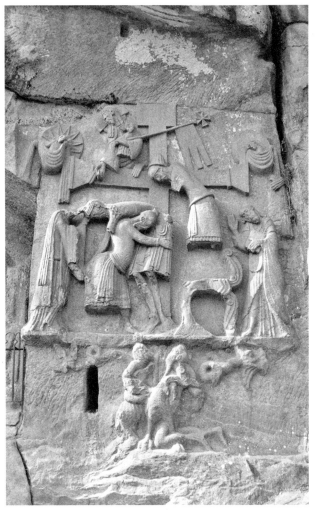

FIG. 14. Monastery of Santo Domingo de Silos, cloister, northwest pier, relief of the Incredulity of Thomas, ca. 1100 (photo: C. and E. V. del Álamo).

FIG. 15. Externsteine (Westfalia), rock-hewn relief of the Deposition, late ninth or early twelfth century (photo: Bagradian, GFDL).

patron saint of medieval sculptors, and although this has been explained with reference to legends that he carved the first crucifix just after Christ's burial,[92] it is tempting to think that it was his hands-on engagement with the corpse itself that made him a fitting prototype for creators of tactile arts.

At least some members of religious communities had occasion to assume the role of Nicodemus in Good Friday rituals, when they removed crucifixes from

their usual locations and buried them elsewhere in the church.[93] Looking at the jointed *corpora* from the late Middle Ages—such as the devastatingly realistic example from Döbeln in eastern Saxony (Fig. 17)—one need not wonder that the suffering human Christ was such a vivid presence in imaginative devotions, or that visionaries such as Lukardis of Oberweimar felt such a strange mixture of grace and panic in his presence.[94] The hollow head of the Döbeln crucifix is pierced with

92. C. Schleif, "Nicodemus and Sculptors: Self-Reflexivity in Works by Adam Kraft and Tilman Riemenschneider," *Art Bulletin* 75 (1993): 599–626.
93. See O. B. Hardison, Jr., *Christian Rite and Christian Drama*

in the Middle Ages (Baltimore, 1965), 134–38; for the use of sculptures in those rites, see Tripps, *Handelndes Bildwerk* (as in note 54), 122–41; Parker, *Descent* (as in note 90).
94. See the exhibition catalogue *Zeit und Ewigkeit: 128 Tage in*

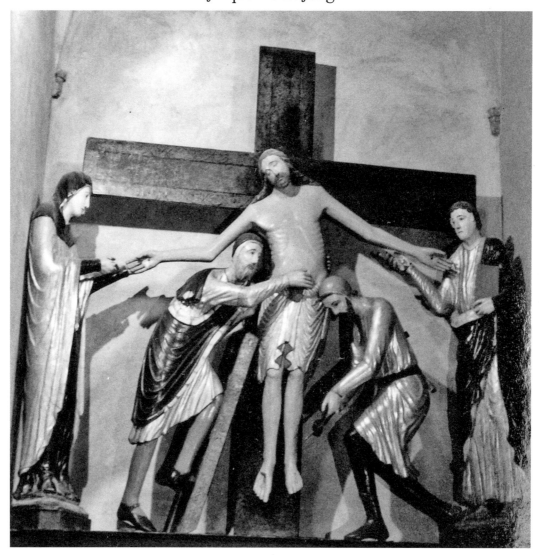

FIG. 16. Deposition Group from Volterra Cathedral, wood with modern polychromy, mid-thirteenth century (photo: Colum Hourihane).

small holes through which tufts of hair were pulled, adding to the already uncanny sense of verisimilitude that the sensitive modeling of surfaces, the naturalistic polychromy, and the flexibility of its limbs achieve.[95]

Like the life-sized, bewigged effigies of English royals newly studied by Kristin Marek, this and other moveable crucifixes, in their relation to once living but now absent bodies, created an uneasy slippage between im-

St. Marienstern, ed. by J. Oexle, M. Bauer, and M. Winzeler (Halle an der Saale, 1998), 121, 130; for a view of this crucifix with its arms outstretched, see Tripps, *Handelndes Bildwerk* (as in note 54), Abb. 44. For the still unsurpassed survey of surviving examples, see G. Taubert and J. Taubert, "Mittelalterliche Kruzifixe mit schwenkbaren Armen: Ein Beitrag zur Verwendung von Bildwerken in der Liturgie," *Zeitschrift des deutschen Vereins für Kunstwissenscaft* 23 (1969): 79–121.

95. For a fully bewigged figure from Bad Wimpfen, see Tripps, *Handelndes Bildwerk* (as in note 54), color plates 10e and 10f. For further discussion of highly lifelike late Gothic crucifixes, see F. Joubert, "Stylisation et vérisme: Le paradoxe d'un groupe de Christs franconiens du XVème siècle," *Zeitschrift für Kunstgeschichte* 51 (1988): 513–23; and J. Paoletti, "Wooden Sculpture in Italy as Sacral Presence," *Artibus et historiae* 26 (1992): 85–110.

FIG. 17. Jointed crucifix, wood with polychromy, leather, linen, and hair, in Church of St. Nikolai, Döbeln (Saxony), ca. 1510 (photo from *Zeit und Ewigkeit: 128 Tage in St. Marienstern*, ed. J. Oexle, M. Bauer and M. Winzeler [Halle an der Saale, 1998], 130).

itation and substitution, enabling beholders easily to see—and even feel—the represented persons materializing before them.[96]

Anyone confronted with the reality—or even just the prospect—of handling the effigy of Christ had a ready model for imitation in sculptured Pietàs, which had become ubiquitous throughout Europe at least since the end of the thirteenth century (Fig. 18).[97] A group of doll-like figures of Mary and the dead Christ from the Rhineland (now in the Schnütgen Museum) is unusual in being comprised of detachable bodies;[98] the majority of medieval Pietà sculptors embraced, in different ways, the "exceedingly difficult" challenge for which Wölfflin would give Michelangelo so much credit—namely, of "placing the body of a full-grown man on the lap of a seated woman."[99] Joanna Ziegler has distinguished between the *Art* of Michelangelo's great work, with its celebration of pure marble materiality, its Classical calm, and its proud assertion of authorship, and the cultic functionalism, emotionalism, and strict focus on content that, in her view, characterize medieval renditions.[100] I should like to extend—

96. See K. Marek, *Die Körper des Königs: Effigies, Bildpolitik und Heiligkeit* (Munich, 2009).

97. On the development and significance of this theme in Germany, see Stechow, *Andachtsbilder*; Pinder, *Die deutsche Plastik*, 97–101 (both as in note 47 above); W. Passarge, *Das deutsche Vesperbild im Mittelalter* (Cologne, 1924); for French examples, see W. H. Forsyth, *The Pietà in French Late Gothic Sculpture: Regional Variations* (New York, 1995).

98. Tripps, *Handelndes Bildwerk* (as in note 54), Pls. 64a and 64b.

99. H. Wölfflin, *Classic Art: An Introduction to the Renaissance*, 5th ed. (London, 1994), 41.

100. J. E. Ziegler, "Michelangelo and the Medieval Pietà: The Sculpture of Devotion or the Art of Sculpture?" *Gesta* 34 (1995): 28–36; for a fuller discussion of this genre, see her *Sculpture of Compassion* (as in note 44). A different approach to the comparison between Michelangelo's Roman Pietà and its medieval predecessors is offered by J. F. Hamburger, "'To Make Women Weep': Ugly Art as 'Feminine' and the Origins of Modern Aesthetics," *Res* 31 (1997): 9–33 at 9–13.

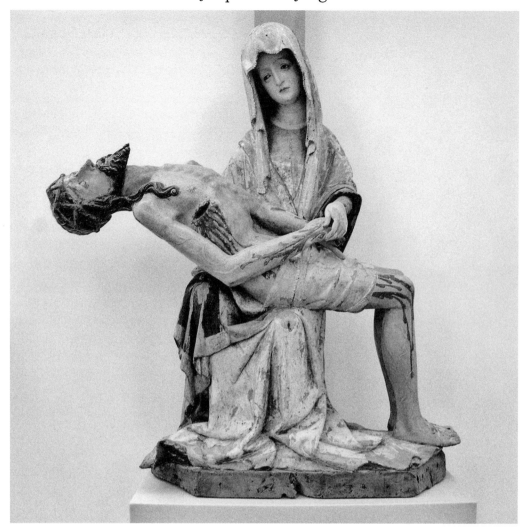

FIG. 18. *Pietà* from Brunau am Inn, Salzburg or Passau, limewood with original polychromy, ca. 1435.
Berlin, Staatliche Museen zu Berlin, Skulpturensammlung, Inv. 7669 (photo: author).

and, ultimately, nuance—this distinction by considering the degrees of manual engagement between the two figures. Michelangelo departs radically from medieval traditions by making his Mary resist touching the body splayed across her mammoth lap (Fig. 19). As Christ lies cradled between her knees, she extends her left hand *away* from him; the fingers of her right hand, which lift his upper body, press not against flesh but against cloth. This distancing gives Christ's body

the character of a devotional image itself, to be gazed at in quiet adoration. Viewers are compelled to join Mary not in a dialogue with Christ but in what Wölfflin called a "mute monologue of anguish"—a form of *kontemplative Versenkung* that, for all this work's sumptuousness, is strictly hands-off.[101]

Michelangelo's forebears, by contrast, exploited the distinctive characteristics of the sculptural medium both to express connections between the figures and to

101. Wölfflin, *Classic Art*, 41 (as in note 99). The phrase *"kontemplative Versenkung"* (contemplative immersion) comes from E. Panofsky, *"Imago Pietatis*: Ein Beitrag zur Typengeschichte des

'Schmerzensmanns' und der 'Maria Mediatrix,'" in *Festschrift für Max J. Friedländer zum 60 Geburtstage* (Leipzig, 1927), 261–308.

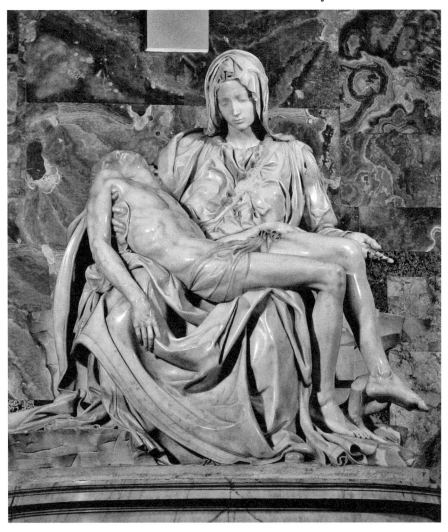

FIG. 19. Michelangelo Buonarroti (1475–1564), marble *Pietà* in St. Peter's Basilica, Rome, 1498–99 (photo: Stanislav Traykov, GNU).

explore the relations between visual and tactile sensibilities. One is hard-pressed indeed to find a medieval Pietà in which Mary's hands are not as active as her eyes.[102] Her right hand always supports Christ's back directly, with her fingers sometimes pressing into his long hair; in most fourteenth-century examples, her left hand typically cradles his hand, lifts his wrist, or clasps his thigh or groin, while in fifteenth-century examples Mary might instead finger her veil, as if preparing either to wipe her own tears or to enshroud her son.

The varied manual activities of the Virgin ensure that viewers will not see her performance as a "mute monologue" *about* her object of contemplation but rather as part of a dialogue *between* herself and an only temporarily muted other—a dialogue played out further through the interplay of opposing forms: male and female, active and passive, seated and lying, clothed and naked. Weights and masses, diagonals and curving lines, concave and protruding forms balance out or grind against each other in complex and ever-shifting ways. Christ's body may jut out from Mary's hands in stiff and angular lines (Fig. 20),[103] or droop from them

102. See the pictorial survey in Passarge, *Deutsches Vesperbild* (as in note 97).

103. This is the type Passarge, *Deutsches Vesperbild*, calls the "treppenförmiger Diagonaltyp" (36–49 and Figs. 1–17).

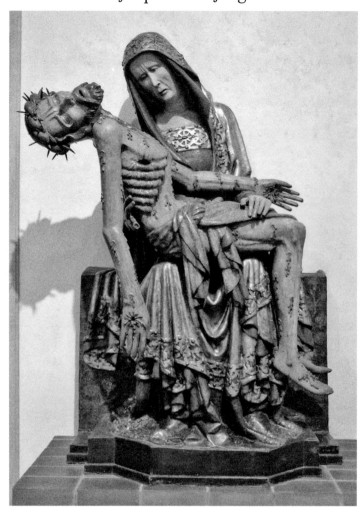

FIG. 20. *Pietà* from the Cistercian Church in Lubiąż (Silesia), wood with modern polychromy, 178 cm, ca. 1370. Warsaw, National Museum (Inv. No. Śr. 4) (photo: author).

in rubbery curves, as in the many depictions wherein Christ's body is miniaturized, as if he were a baby.[104] Whereas most Pietàs, like Michelangelo's, are oriented toward a dominant frontal viewpoint, the breathtaking example from Unna, now in Münster (ca. 1380), reveals itself fully only through the viewer's motion around it (Fig. 21).[105] Christ's legs wrap stiffly around the back of Mary's seat, their inert angularity amplified by the sumptuous swirls of her cloak, while her arms enfold and lift his blocky torso tight against both her heart and her lap.[106] For all the muscularity of her grasp, slippage seems imminent; her left knee rises as if to wedge him into place. No one angle captures the pathos—or the sculptural virtuosity—of this rendition of interlaced bodies, with its spiraling movement toward ever greater unity and ever greater despair, as the faces of mother and son merge as if in a final kiss (Fig. 22).

104. Passarge, *Deutsches Vesperbild*, calls this type "Maria mit dem kindhaft klein gebildeten Christus" (50–55 and Figs. 18–23).

105. G. Jászai, *Gotische Skulpturen 1300–1450*, Bildheft des Westfälischen Landesmuseums für Kunst und Kulturgeschichte Münster 29 (Münster, 1990), 59–61, with further literature; Passarge, *Deutsches Vesperbild*, 49 and Fig. 17.

106. A stylistically very different example, which likewise demands a viewer's movement, may be found in the Liebighaus in Frankfurt; see Passarge, *Deutsches Vesperbild*, 48 and Fig. 16.

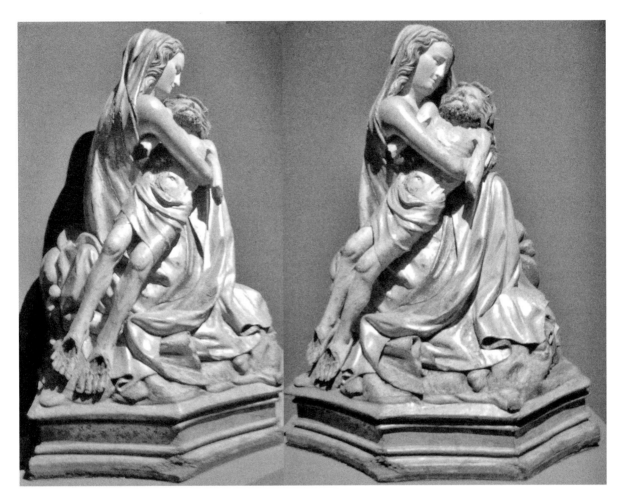

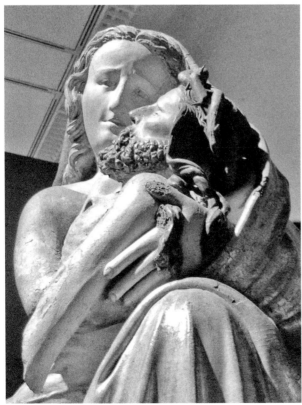

FIG. 21. Two views of the *Pietà* from the parish church of St. Clemens in Unna; made in Mainz, walnut, ca. 1380. Münster, Westfälisches Landesmuseum (Inv. No. E 140 WLM) (photos and photomontage: author).

FIG. 22. *Pietà* from the parish church of St. Clemens in Unna, detail from right side; made in Mainz, walnut, ca. 1380. Münster, Westfälisches Landesmuseum (Inv. No. E 140 WLM) (photo: author).

Now, all these figures may to some extent serve as embodied analogues to the Eucharist in its monstrance,[107] and they certainly do give visible form to the many literary evocations of the Virgin's grief under the cross.[108] But as sculptural objects, they go well beyond the needs of cultic display or devotional immersion in subject matter. In their consistent thematization of weight, mass, and volume, despite a wide array of compositions and styles, they reveal a self-conscious sense of artistry on the part of their makers—a confident display of what sculpture can *do*. On a different register, in their consistent focus on the interaction of bodies, they impress upon viewers the significance of tactile sensation in any achievement of union with God. Mary's touch of Christ's flesh and hair calls attention to the sort of suspended animation in which this cadaver rests; whereas Michelangelo's Christ has already become an object for the pious gaze to contemplate, the medieval corpses are cradled and caressed as if they were still human. The gestures seem to materialize the voice of Mary in so many late medieval Passion plays and devotional tracts, as, grasping and kissing the lifeless limbs and pressing the body to her heart, she recalls her son's vibrant infancy and strains to detect lingering warmth in his cold flesh.[109] In that sense, the Pietà becomes an emblem of the medieval sculptural encounter itself—for what else were sculptures (as critics always scoffed) but lifeless matter?[110] Yet they were lifeless matter that could—and did—come to life under the hopeful gazes of those who prayed before them.

Sculptures could also come to life in the fingers of devotees. The feet of the Baby Jesus, subject of much tender attention in devotional handbooks such as the Pseudo-Bonaventurian *Meditations on the Life of Christ*[111]—were especially apt to kick free from the material constraints of the medium, just as they kicked free from the Mother's body.[112] The experience of Sister Anne of Constance, in the Katharinenthal convent, is representative of large genre of miracle stories concerning animate images:[113] "walking in front of the image of Our Lady holding Our Lord on her arm"—probably the large sculpture that stood in the nuns' choir (Fig. 23)—"she took the Baby's little foot [*füssli*] in her hand with great devotion, and felt it become flesh and blood."[114] In its very matter-of-factness, this account reveals that the touching of sculptures was an expected part of devotions, and suggests that the sense of touch, no less than spiritual vision, could be cultivated and sensitized through the process. Often this sort of haptic animation was an end in itself, but it could also form the starting point for larger revelations. When Adelheit Öthwins, fretting over her brother's decision to leave his monastic order, prayed before a statue of the seated Madonna with the Baby on her lap, the Child responded by kicking out his *füssli* for her to fondle until she felt it become flesh and blood; he then withdrew it and his Mother took over, consoling Adelheit with tender words.[115]

The alternation of animated roles in this case, with both Mary and Jesus responding directly to the contemplative, is typical of visionary encounters with the Virgin and Child groups that figured so prominently in the ecclesiastical and urban topographies of later medieval Europe (Fig. 24).[116] Art historians have long located the significance of this type of Gothic sculp-

107. Belting, *Bild und Publikum* (as in note 91), 134.

108. W. Pinder, "Die dichterische Würzel der Pietà," *Repertorium für Kunstwissenschaft* 42 (1920): 145–63.

109. See the Virgin's outburst in Henry Suso's "Little Book of Eternal Wisdom," Ch. 19, in *The Exemplar, with Two German Sermons*, trans. by F. Tobin (New York, 1989), 264–65. Further examples are found in S. Sticca, *The Planctus Mariae in the Dramatic Tradition of the Middle Ages*, trans. J. R. Berrigan (Athens, Ga., 1988).

110. For debates that drew on the "lifeless matter" trope in Byzantium, see Kessler, *Spiritual Seeing* (as in note 11), 29–51; for a wider ranging analysis, see Freedberg, *Power of Images* (as in note 10), 378–428.

111. *Meditations on the Life of Christ: An Illuminated Manuscript of the Fourteenth Century*, ed. by I. Ragusa and R. B. Green (Princeton, 1961), 38.

112. On the prominence of the Infant's feet in Gothic sculpture, see M. Grandmontagne, *Claus Sluter und die Lesbarkeit mittelalterlicher Skulptur: Das Portal der Kartause von Champmol* (Worms, 2005), 365–382.

113. See also Freedberg, *Power of Images* (as in note 10), 301–16.

114. *Katharinentaler Schwesternbuch* (as in note 41), 107, *Vita* 23:1–13.

115. *Katharinentaler Schwesternbuch* (as in note 41), 139–40, *Vita* 53:1–11.

116. On the Magdeburg Madonna, shown here, see Ernst

FIG. 23. Workshop of Henry of Constance, two views of standing Virgin and Child from Katharinenthal, ca. 1300. Oak with remnants of original polychromy and eighteenth-century garb, 171.5 cm tall (photo from I. Futterer, *Gotische Bildwerke der deutschen Schweiz* [Augsberg, 1930], figs. 30–31).

ture in the new, humanized relationship it conveys between the charming courtly Mother and her adorable infant—a relationship that emerges all the more forcefully through its contrast with the aloof, impersonal *Sedes sapientiae* groups of earlier centuries.[117] Medi-

eval visionaries, by contrast, seem to have cared less about the figures' interactions with each other than about each character's engagement with themselves. The creators of these sculpture groups—of which the wonder-working Madonna in the south transept arm of Magdeburg Cathedral (ca. 1270–80), reproduced here, is a charming example—often encouraged such an approach by splitting the figures' attention in different directions, such that a beholder might feel addressed by the Virgin from one standpoint and by the Infant in another.[118] The resulting *Mehransichtigkeit* (orientation toward varying perspectives) of Gothic Madonna and Child groups could go some way toward explaining how, for example, the randy young men in preachers' *exempla*, who betrothed themselves to their local statue of the Virgin and were later thwarted in their amorous adventures with ordinary girls, were able so easily to imagine the baby away, attending exclusively to Mary's "body of unsurpassed beauty,"[119] while monastic women could consistently zero in on the Infant.[120] Even when the Virgin also came to life in their visions, her role was to hand off her Child to the women, permitting them, however briefly, to assume her role as his guardian, and sometimes demanding him back again. In a vision at Katharinenthal, Adelheit of St. Gall once beheld "Our Lady walking through the choir carrying the Christ Child on her arm and bowing to each [lay] sister. When she reached the nuns who were singing [the antiphon 'Ave stella' to Our Lady], she gave each sister the baby to hold on her own arm."[121]

At Katharinenthal, a life-sized statue of Mary that occupied the nuns' choir seems to have played a crucial role in giving shape and substance to this and other

Schubert, *Der Dom in Magdeburg* (Leipzig: Seemann, 1994), 78–79. Central European museums, in particular the National Gallery in Prague's Cloister of St. Agnes, the National Museum in Warsaw, and the Germanisches Nationalmuseum in Nuremberg, are treasure-troves of vivacious, multi-directional Virgin and Child groups from the thirteenth to fifteenth centuries.

117. See Southern, *Making of the Middle Ages*, 238–39 (as in note 74). On *sedes sapientiae* sculptures, see I. H. Forsyth, *The Throne of Wisdom: Wood Sculptures of the Madonna in Romanesque France* (Princeton, 1972).

118. For a brilliant analysis of a particularly fine Madonna and

Child group's demands for and responses to mobile viewing, see Grandmontagne, *Claus Sluter* (as in note 112), 106–36.

119. See K. A. Smith, "Bodies of Unsurpassed Beauty: 'Living' Images of the Virgin in the High Middle Ages," *Viator* 37 (2006): 167–87.

120. See U. Rublack, "Female Spirituality and the Infant Jesus in Late Medieval Dominican Convents," *Gender and History* 6 (1994): 37–57.

121. *Katharinentaler Schwesternbuch* (as in note 41), 106, *Vita* 20:26–29. A similar vision occurred in the convent at Engelthal; see Vavra, "Bildmotiv," 207 (as in note 54).

FIG. 24. Three views of Madonna and Child, Magdeburg Cathedral, ca. 1270/80; over-life-sized stone figure with 19th-century polychromy (photos and photomontage: author).

visionary encounters in this convent (see Fig. 23).[122] Despite the "extreme makeover" imposed on the figure in the eighteenth century, which trimmed down her waist and clipped her hair to accommodate a lavish Baroque wig and gown, her slightly downturned face and gaze still reveal the aura of psychological as well as physical presence that made it easy for her to slip into life. Like many Madonna and Child groups of the time, the Virgin holds her baby out, away from her side, as if to offer him to passersby to touch—an invitation that, as we have seen, the sisters regularly accepted. If we hold this interactive potential in mind, the ubiquitous statues of that Madonna and Child that populate churches and museums assume new inflections. Although in some cases the figures direct their attention only toward each other, many guide and re-

122. See I. Futterer, *Gotische Bildwerke der deutschen Schweiz, 1220–1440* (Augsberg 1930), Pls. 30–32. For a color photo of the figures in their costumes, see *Krone und Schleier* (as in note 4), Cat. 311, 412–13.

ward movement by providing, from certain angles, views of the Christ Child actively reaching out toward beholders.[123] The kind of engagement such sculptures seek with viewers can take humorous forms, as when the Madonna is posed as if ready to hand off the Baby to the nearest passerby (Fig. 25).

Such figures both responded to and stimulated people's desire not only to see but also to touch and play with the Infant, desire sparked, in no small part, by devotional handbooks such as the *Meditations on the Life of Christ* and other visionary writings themselves. The sisters at Katharinenthal and the numerous other convents that flourished in German-speaking lands during the fourteenth century regularly enjoyed the company of the Baby Jesus (*kindli*).[124] Summoned by their prayers during or after liturgical services, or during chores, meals, or illnesses, he would pop up to offer what they called *viel spiel*—great play—and with it, great joy.[125] The women's *gesichte* (visions) involved an infant who was sometimes primarily visual—seen from afar, like the Magi's apparition in the *Bladelin Altarpiece* (Fig. 8). But often they involved a solid, three-dimensional child that could, and wanted to, be held in the hands, hide under skirts, cavort in bed, suckle at breasts, or sit before his seer on the refectory table, a child that could press sweet apples into the hand and kisses onto the lips, a child that sometimes asked to be dressed or put into (or taken out of) bed.[126]

123. Numerous examples can be found in the Cloister of St. Agnes in Prague, among them the Madonna of Žebrák, made in Prague ca. 1380.

124. See U. Rublack, "Female Spirituality" (as in note 120).

125. These visions, and their relation to material culture, form the subject of my paper "*Viel Spiel*: The Baby Jesus and the Play of Art in a Swiss Dominican Convent," which I first presented at Yale University in October 2007 and am preparing for publication. Transcriptions of the primary sources (most from the *Katharinenthaler Schwesternbuch*) will be included in that redaction.

126. See Lewis, *By Women* (as in note 39), 100–105; for further remarks on the kind of visions that transcend distance, including Christ-Child visions, see Dinzelbacher, *Vision und Visionsliteratur* (as in note 68), 146–50.

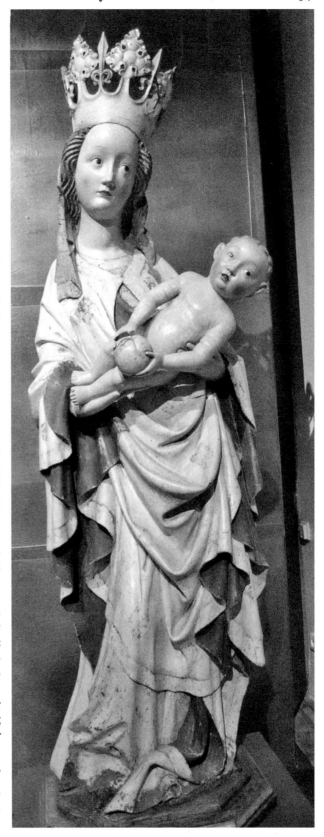

FIG. 25. Standing Virgin and Child from Franciscan church, Plzeň, ca. 1430. Prague, National Gallery, Convent of St. Agnes of Bohemia (photo: author).

In the Katharinenthal Sister-book, like others of its genre, reports of the marvelous *kindli* tend to be lapidary at best. The most detailed accounts of such play with the Christ Child come from the highly personal *Revelations* of Margaret Ebner (1291–1351), a Dominican nun who resided in the Bavarian convent of Maria Medingen during the first half of the fourteenth century. Margaret's encounters with the Baby demonstrate with unparalleled clarity the close connections between sculpture, touch, and those marvelous experiences we call visionary. "I have a statue of our Lord as a child in the manger," she tells us:

> I was powerfully attracted to it by my Lord with delight and desire and by His gracious request. This was spoken to me by my Lord: "If you do not suckle me, then I will draw away from you and you will take no delight in me." So I took the image out of the crib and placed it against my naked heart with great delight and sweetness, and perceived then the most powerful grace in the presence of God so that I began to wonder how our dear Lady could have ever endured the continuous presence of God.[127]

Like Rupert of Deutz's elevated crucifix, Margaret's sculpture of the Baby Jesus was urged into animation by a process of concentrated, desirous gazing; as with both Rupert and Gertrude of Helfta, the distance involved in looking was overcome by the reward of intimate touch.[128]

My investigations of other German conventual materials have led me to surmise that the *kindli* of women's visions were, in essence, immaterial, imaginatively generated versions of the sculpted Baby Jesus dolls that populated conventual chambers from at least the fourteenth century onward (Fig. 26).[129] The visions, I suggest, were conceived in the women's hands, as they held, fondled, and dressed the sculptures; they gestated in their minds as the women contemplated those interactions and re-performed them imaginatively (for example, creating fantastic outfits for the babies through the process of prayer);[130] and then they emerged into the world, beamed out through the nun's eyes so that she could see the baby superimposed on her surroundings.[131]

Another vision from Katharinenthal allows us to glimpse something of this process in action. One Christmas Day, Sister Cecilia von Wintertur felt a "great desire to see Our Lord as a little child. As she was contemplating this, she saw a tiny *kindli* walking on the altar. When the custodian Elsbeth von Stoffeln walked up to the altar, the Child went to her and followed her wherever her duties took her. She saw this the whole time that mass was being sung."[132] Crucial for my purposes is the fact that this story appears not in Elsbeth's *Vita* but rather in Cecilia's; the custodian, indeed, was oblivious to her diminutive companion's presence. Evidently what made the incident worth recording was Cecilia's ability to summon up the Child in visible form and imprint him on the material world—the reversal of the optical process by which images typically impressed themselves on the eyes. The fact that, in many visions at Katharinenthal and elsewhere, the Child often races into the seer's hands, adding pleasurable tactile sensations to the mental satisfaction of successful "thought-crafting," testifies to

127. Ebner, *Major Works* (as in note 72), 132.

128. See also Ebner, *Major Works*, 134, where the Baby demands to be suckled and the seer happily obliges. These accounts are discussed further in R. D. Hale, "Rocking the Cradle: Margaretha Ebner (Be)Holds the Divine," in *Performance and Transformation: New Approaches to Late Medieval Spirituality*, ed. by M. A. Suydam and J. E. Ziegler (New York, 1999), 211–40, which likewise places emphasis on the tactile dimensions of nuns' encounters with the Baby.

129. Jung, *"Viel Spiel"* (as in note 122). To my knowledge, a catalogue of medieval Baby Jesus dolls remains a desideratum. Meanwhile, see *Spiegel der Seligkeit: Privates Bild und Frömmigkeit im Spätmittelalter*, ed. by F. M. Kammel (Nuremberg, 2000), 175–77; Henk van Os, *The Art of Devotion in the Late Middle Ages*

in Europe, 1300–1500 (Amsterdam, 1994), 100–1; *Zeit und Ewigkeit* (as in note 94), 104–5; and *Krone und Schleier* (as in note 4), 113 (a figure from Rostock who retains his fabulous outfit), 457–58.

130. T. Lentes, "Die Gewände der Heiligen: Ein Diskussionsbeitrag zum Verhältnis von Gebet, Bild und Imagination," in *Hagiographie und Kunst: Der Heiligenkult in Schrift, Bild und Architektur*, ed. by G. Kerscher (Berlin, 1993), 120–51.

131. The ability to superimpose mental images on the physical world is characteristic of shamanic practices in various cultures; I draw here on R. Noll, "Mental Imagery Cultivation as a Cultural Phenomenon: The Role of Visions in Shamanism," *Current Anthropology* 26 (Oct. 1985): 443–61.

132. *Katharinentaler Schwesterbuch* (as in note 41), 136, *Vita* 47:1–6.

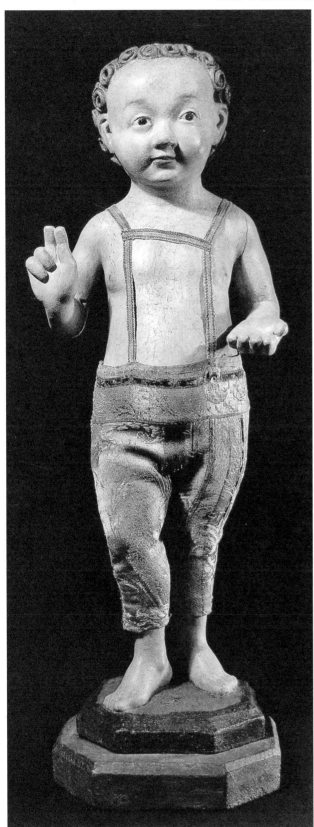

FIG. 26. Standing Baby Jesus with jointed arm, Oberlausitz, first quarter of fifteenth century; wood, with base and polychromy from the nineteenth century and silk and linen pants from the late seventeenth century, from Cistercian convent of St. Marienstern, Panschwitz-Kukau (Saxony) (photo from Dresden, Landesamt für Denkmalpflege, in *Zeit und Ewigkeit: 128 Tage in St. Marienstern*, ed. J. Oexle, M. Bauer and M. Winzeler [Halle an der Saale, 1998], 104).

the impact of the three-dimensional material substrate of the inspiring image.[133] It enables us to recognize the myriad sculptures of the seated, standing, or reclining Mary playing with her baby not just as evidence of the heightened devotion to the Virgin that characterized late medieval culture but also, more specifically, as mirrors of and models for people's imaginative encounters with the Infant Christ.[134] And it brings us back, at last, to St. Hedwig.

When we encountered the duchess earlier, she was holding her ivory statuette of the Virgin and Child, using it as an instrument of private prayer, as a tool of social healing, and as an emblem of her devotion. We noticed that the figures seemed animated, shifting position from one scene to the next. Looking more closely at the images, and bearing in mind the interactive potential of sculptures, it becomes important to notice that the movements of the ivory figures register and reflect those of the living body that holds them: Mary holding the Christ Child becomes an analogue of Hedwig holding the sculpture, and vice-versa. As if in a kind of feedback loop, the little figures simultaneously are activated by the saint's hands and provide a model for her own devotional acts. Watch how their bodies move: when they are clutched with one hand near Hedwig's waist, Mary grasps Christ's belly (Fig. 4, left side); when they are extended toward the pursed lips of townsfolk, they lunge forward with lifted hands

133. My understanding of the interaction among art, imagination, and visionary experience owes much to Carruthers, *Craft of Thought* (as in note 70).

134. For sculptures of Mary playing with the Baby in various ways, see *Krone und Schleier* (as in note 4), 454–55. An especially beautiful example is the relief of the Nativity at Katharinenthal from ca. 1330, reproduced in *ibid.*, 415.

FIG. 27. *Hedwig Codex*, Silesia, 1353, fol. 87. Top: "Here she healed Sister Jutta of a dangerous and fatal inflammation of her hand and arm." Bottom: "Here St. Hedwig is buried, and a radiance appeared and an exceedingly sweet fragrance wafted from her body." Los Angeles, J. Paul Getty Museum, Ludwig XI 7 (83.MN.126) (photo: The J. Paul Getty Museum).

FIG. 28. *Hedwig Codex*, Silesia, 1353, fol. 137ᵛ, detail. Translation of St. Hedwig's relics by clergy and nobles. Los Angeles, J. Paul Getty Museum, Ludwig XI 7 (83.MN.126) (photo: The J. Paul Getty Museum).

(Fig. 4, right side); when they are cradled against the chest, Mary lifts the baby against her own (Fig 2).

And when they are nestled against the womb, as Hedwig lies on her deathbed, they merge together fluidly, like Christ embracing St. John (fol. 87; Fig. 27). Toward the end of the pictorial cycle, as her bodily daughters grieve and her monastic sisters sing, Hedwig herself becomes a kind of devotional sculpture, one with wonder-working powers that reside in her own tactile presence; touching the arm of the newly deceased saint, Sister Jutta, standing behind her, is cured of a deadly infection that has swollen her own hand and forearm. Hedwig would go on to be buried with the little statue, but its story does not end at the grave. Upon the exhumation and translation of the new saint's remains in 1267, twenty-four years after her death, the assembled clergy and nobles were thrilled to discover that the three fingers clutching the statue remained intact (fol. 137ᵛ; Fig. 28)—protected, her biographer explained, by the incorruptible Mother of God herself.[135] The new, partially organic sculptural ensemble was processed, along with her brain (encased within her skull) and other bodily fragments, into the church at Trebnitz, to become the chief prize of the Cistercian community she had established there—a solid, enduring manifestation of their patron's connection to God.[136]

Within the larger narratives that I have tried to

135. See *Hedwigs-Codex* 2:154: "... mater incorrupta ymaginis sue retinacula tanto tempore a corrupcionis vicio preservavit intacta." This implies a full identification of Mary herself with her material representation, affirming the propriety of Hedwig's image-devotion.

136. Cf. Hamburger's discussion of the image of Hedwig's

piece together from so many fragments of the past—
the story of Hedwig, but also the story of touch, its
objects, and their impact on the imagination in the late
Middle Ages—the iconic depiction of the holy woman
assumes a new significance (see Fig. 2). It becomes
emblematic not only of a special affinity for *images* on
the part of medieval women but of a fierce adherence,
across medieval Christian culture, to the *materiality* of
images, the *things* of devotion. Tangibility, as much
as visibility, is key to the representation: the book
squeezed around fingers, the rosary beads stretched
between hands, the flaccid boots stubbornly flung over
the forearm (a mocking concession to a husband and
a confessor who commanded the saint to wear shoes),
the statuette—all these testify to the value of *objects* as
bearers of the sacred. The manuscript's tiny patrons
gaze from their ambiguous space at the border of the
architectural frame—but what holds them in thrall is
a marvelous body, composed volumetrically, like a
sculpture itself, and demonstrating, through its manual
activity, its power to know—to *grasp*—the divine.[137]

translation in *Visual and Visionary* (as in note 6), 438, which over-
looks the fact that what the bishop holds is the *hand* clutching the
statuette. Once again, the artist has flouted the text: whereas the
latter specifies that only three fingers of one hand survived, the pic-
ture shows us the right hand with four fingers and the left, holding
the ivory figures, completely intact.

137. Many thanks go to Colum Hourihane, Lisa Bitel, and the
speakers and audience members of the Princeton Symposium,
in which it was an honor to participate. The present paper took
shape over the course of two other greatly enriching communal
endeavors: an interdisciplinary summer seminar called "The Vi-
sion Thing: Studying Divine Intervention," organized by William
A. Christian, Jr., and Gábor Klaniczay and sponsored by SIAS, in
2007, and a graduate seminar I taught at Yale on "Visions and Art
in Medieval Europe" in spring 2008. The participants in both fo-
rums will recognize how deeply our conversations have shaped my
thoughts.

MICHELLE GARCEAU

I saw him!
Visions of the Saints in Miracle
Stories in Cataluña*

MARIA opened her eyes in 1278 with an amazing story to tell that had started days earlier. She was confined to bed in her home near the cathedral in Barcelona. Her body contracted and weak, particularly her hands and feet, she could not rise or even feed herself. She was unable to remember how many days she had been like this. One day, another woman, Paschala Dominica, who had a particular devotion to the Dominican Ramon de Peñafort, visited. She told Maria how the deceased friar had performed a miracle, curing a knight of leprosy. Paschala encouraged Maria to have faith in Ramon and both women began to pray. Devotedly and with tears, Maria invoked Ramon's help and his merits and Paschala went down on her knees. Suddenly, Maria fell asleep and, when she awoke, she spoke of a miraculous visitor. Brother Ramon, whom she knew was dead, had come to her.

He had touched her and her hand and, upon awaking, Maria found that she was cured. She could place her hand above her head and rise from the bed; she walked, moved, ate, and was able to continue with her work. Ramon de Peñafort had cured her.[1]

This essay will focus on two groups of apparition miracles of the "very special dead" in Cataluña.[2] The first group dates from the middle of the twelfth century and was performed by bishop Oleguer (d. 1137) of Barcelona.[3] Several saints were responsible for the second group of miracles, which date from the middle of the thirteenth century through 1347—including Bernat Calbó (bishop of Vic, d. 1243), Ramon de Peñafort (Dominican, d. 1275), Maria de Cervelló (Mercedarian, d. 1290), Dalmau Moner (Dominican, d. 1341), and the (Black) Virgin of Montserrat.[4] Using their testimonies, I hope to explore how medieval Catalans

* A version of this article was originally presented at the 2008 NYC Inter-University Doctoral Consortium—Annual Medieval Studies Colloquium "Spectatorship and Visuality in the Medieval World" (25 April). I should like to thank the organizers and participants for their comments and suggestions. I should also like to thank Professor William Chester Jordan (Princeton) under whose supervision I have been working for the last several years. Without his assistance and patient guidance, this article, as well as the dissertation from which it emerged, would not be possible.

1. San Raimundo de Penyafort, *Diplomatario* (*Documentos, vida antigua, crónicas, procesos antiguos*), ed. by José Rius Serra (Barcelona, 1954), 258–60.

2. Peter Brown coined the term "the very special dead." See, Peter R. L. Brown, *The Cult of the Saints: Its Rise and Function in Latin Christianity*, ed. by Joseph M. Kitagawa, The Haskell Lectures on History of Religions, New Series, No. 2 (Chicago, 1981), esp. Chap. 4 "The Very Special Dead." For the purposes of this article, I use "apparitions," "manifestations," and "visions" interchangeably. In the Middle Ages, apparitions and manifestations could refer to ghosts (as opposed to, or in addition to, the saints

discussed here). I shall also employ the terms "the holy dead," "the very special dead," and "the saints" interchangeably. I define a saint as my sources do—a man or woman who, after death (and because of their *virtus*), was believed to be able to perform miracles. None of the saints used in this discussion were canonized until after the Middle Ages; some remain un-canonized. As Finucane said about ghosts, "Even though ghosts or apparitions may exist only in the minds of their percipients, the fact of that existence is a social and historical reality: the phenomena represent man's inner universe just as his art and poetry do." Ronald C. Finucane, *Appearances of the Dead: A Cultural History of Ghosts* (London, 1982).

3. These miracles survive in a mid-fourteenth-century manuscript located in the Barcelona cathedral. Jacobus de Voraigne, "ACB Codex 105: Flos Sanctorum" in *Arxiu Capitular de Barcelona* (Barcelona, 1340–1360), fols. 81ʳ–87ᵛ. Martin Aurell edited and published this text. "Prédication, croisade et religion civique: *Vie et miracles* d'Oleguer (d. 1137), Évêque de Barcelone," *Revue Mabillon* 10, No. 71 (1999). Unless otherwise noted, all translations are mine.

4. Bernat Calbó: "ACV 36/1: 'Hic Incipiunt Miracula Beati

interacted with the holy dead and, on occasion, with the Virgin. The central contention of this essay is that between the twelfth and early-fourteenth centuries, men and women in Cataluña saw the saints less and less. Saints continued to grant miracles, just as they had in earlier centuries, but men and women rarely saw and interacted physically with the "holy dead." It was by their presence or prayers, as opposed to their physical actions, that saints were able to perform miracles.

In part, this is a story of changing causality, which centers on a transformed understanding of how miracles worked and how to prove to others that they were real. In the twelfth century, everything that happened in a miracle was usually seen, and the saint's actions in bringing miraculous events to pass were understood. In the thirteenth and fourteenth centuries, saints continued to perform miracles, but the people understood, or at least described, the actions differently. It may be that people's perceptions changed as a result of the Church's drive to teach them that it was God, and not the saints, who worked miracles. Catechisms were strengthened on this point during this time period. Possibly it was the result of that impetus, not in the sense that the laity changed their belief in who worked miracles, but that clerical authors came to record the miracles in such a way that the saints were more intercessors than actors. In any case, the miracle narratives changed. An individual had a problem, prayed to a particular saint, and the problem was resolved. Saints in the thirteenth and fourteenth centuries could work miracles without ever being seen or felt by the petitioner and witnesses. Knowing and proving that it was the work of a specific saint no longer required witnesses to the saint's performance. Men and women had

developed new means of proving their testimonies, methods that involved the use of oaths, questions, witnesses, and notaries, among others.

This essay explores two changes in apparitions of the saints between the middle of the twelfth century and the early fourteenth century. In examining these changes, I hope to illustrate how society's ideas of itself and its relationship to the holy changed. The first change involves the knowledge of the holy dead. Whereas in the twelfth century the Catalan Oleguer knew more than his supplicants (warning them of approaching danger, for example), by the late thirteenth century, saints responded to situations presented to them; they no longer anticipated problems or demonstrated prior knowledge of them. The second change involves the actions of the saints. Later saints were much less physically involved in the world of the living. Even though continuing to work similar types of miracles as in earlier centuries (and in large numbers), thirteenth- and fourteenth-century saints, when they appeared, were frequently just there, not actually performing the miracle with their hands, bodies, or actions. Their presence, prayers, or intercession was enough.

Although the earliest copy of Oleguer's miracles is in a mid-fourteenth-century manuscript, Martin Aurell has convincingly argued for the text dating to between 1140 and 1160.[5] The collection contains twelve miracles and represents all of the twelfth-century miracles I have been able to locate for Cataluña. In these, Oleguer appears seven times. Although this is admittedly a small sample, their content replicates that found by other scholars, such as Pierre-André Sigal, elsewhere in Europe in the same years, including the

Bernardi ...,'" in *Arxiu Capitular de Vic* (Vic, 1244–1337). "ACV 36/2: 'Miracles de Sant Bernat Calbó,'" in *Arxiu Capitular de Vic* (Vic, 1245–1342). Ramon de Peñafort: "BUB Ms. 593: Vitae Sanctorum Thomae Aquinatis et Raymundi de Pennaforti," in *Biblioteca de la Universitat de Barcelona* (Barcelona, 1324–51); José Rius i Serra published a copy (housed in the Vatican) of this manuscript; "ASV, Congr. Riti, Processus 4153: Processus Antiquus Canonizationis Beati Raymundi de Penyaforti," in *Archivio Segreto Vaticano* (Vatican, 1577); Penyafort, *Diplomatario* (as in note 1). Maria de Cervelló: *Acta Sanctorum* [electronic resource] (1999–[cited 21

June 2007]) available from http://acta.chadwych.com, 25 September. Dalmau Moner: "AGOP (SS) MS XIV.23," in *Archivo General Ordinis Praedicatorum* (Rome, mid- fourteenth century), fols. 173ʳ–182ᵛ. Virgin of Montserrat—"AAM Llibre Vermell (Ms. 1)," in *Arxiu de l'Abadia de Montserrat* (Montserrat, 1399).

5. Aurell, "Prédication" (as in note 3). His excellent edition is of the text as found in a mid-fourteenth-century manuscript housed in the Barcelona cathedral. Voraigne, "ACB Codex 105" (as in note 3), fols. 81ʳ–7ᵛ.

level of interaction of the saints, their appearances, and their special knowledge.[6] The surviving twelfth-century accounts from Cataluña are extended with late-eleventh- and twelfth-century miracles from the shrines at Compostela and Silos.[7] The narratives of visions of Saints James of Compostela and Dominic of Silos accord with the accounts involving Oleguer in Barcelona, revealing that the conception Catalans had of saints and their interactions with them may have been part of a larger medieval, or at least Iberian, worldview.

The miracles for the thirteenth- and fourteenth-century saints survive in a variety of sources. I use miracle lists compiled at the tombs of Bernat Calbó and Ramon de Peñafort, as well as a similar list from Montserrat. Ramon de Peñafort's 1318 process of canonization has survived, as has a mid-fourteenth century *Vita et miraculae* for Dalmau Moner. Maria de Cervelló's miracles come from a *vita* composed in 1401.

Knowledge of the Saints: The Loss of Special Knowledge

In their miracle narratives, twelfth-century Catalans expected their saints to be able to see what was going on in the world of the living. The holy dead knew not only the present, but could also anticipate what would have an impact on the lives of their followers. Oleguer's miracle of a widow and her slave reveals this special knowledge.

A widow in Barcelona had a Saracen slave (*captivus*) who performed essential labor. One day, upon returning from the tomb of Saint Oleguer, the widow could not find the slave who had run away, and she anxiously looked everywhere. The widow returned to Oleguer's tomb where she fell asleep. While asleep, Oleguer came to her and said that she should go to a certain oven (*clibanum comitis*); there she would find the runaway, and there she found him, with another, hidden among the wood.[8]

The miracles of Oleguer, such as that for the Barcelona widow, show his extraordinary knowledge of the happenings of the world. The account of the Barcelona ship that Oleguer saved from pirates explains how it was that Oleguer knew to warn the Catalans. "Saint Oleguer, who was in the light of virtue, to whom everything was made clear in that splendid light, according to the grace and permission of God, saw the Moors who were attacking his Barcelonans."[9] From his place in heaven, in the splendid light of God, Oleguer could

6. Sigal studied miracle stories in eleventh- and twelfth-century France. Among the accounts of miracles connected to a specific sanctuary or saint (the *miracula* lists he examines), there are 167 visions from over 3,000 miracles and forty-two of those 167 are from a single source. Visions in *exempla* collections, however, make up over seventy percent of the miracles. Among the *vitae* there are 188 visions, including visions that occurred when the saint was alive. In total, Sigal examined 575 visions of the dead (15%), of demons (15%), and of the holy. Several individuals and groups make up the final category. Christ (10%), the Virgin (5.5%), angels and the blessed (12.6%), and the saints (41.9%) appeared. Pierre-André Sigal, *l'Homme et le miracle dans la France médiévale (XI^e–XII siècle)* (Paris, 1985), 283–6. Vauchez, in his monumental work on sanctity in the Middle Ages, claimed that apparitions of the saints (together with a cure) were the ideal ends of an incubation, a practice where an individual seeking a saint's assistance spent time (especially overnight) at the saint's tomb. André Vauchez, *Sainthood in the Later Middle Ages*, trans. by Jean Birrell (Cambridge, 1988), 445. Vauchez also claimed that pilgrims and Christians "believed that [relics'] therapeutic power acted most effectively during sleep." Vauchez, *Sainthood*, 444. For a discussion of this practice in thirteenth-century Italy, see Augustine Thompson, *Cities of God:*

The Religion of the Italian Communes, 1125–1325 (University Park, Pa., 2005), 211–13.

7. The *Liber Sancti Jacobi* is from a twelfth-century manuscript housed in the Compostela Cathedral Archives. This is the *Codex Calixtinus*. The text translated by Thomas Coffey, et al., dates to the first half of the twelfth century. Throughout this article, I use Coffey's translation of the miracles of Compostela. The miracles date to between 830 and 1135. Thomas F. Coffey, Linda Kay Davidson, and Maryjane Dunn, "Introduction," in *The Miracles of Saint James: Translations from the Liber Sancti Jacobi* (New York, 1996), xxxv–li. According to Lappin, the *terminus ante quem* of the Silos collection is around 1120. Anthony Lappin, *The Medieval Cult of Saint Dominic of Silos* (Leeds, 2002), 9. There is also a *La Vida de Santo Domingo* composed by the cleric Gonzalo de Berceo (ca. 1195 – ca. 1260) in which later miracles are found. Furthermore, manuscripts in Silos contains miracles from the fourteenth century.

8. Aurell, "Prédication" (as in note 3), 156.

9. *Sanctus autem Ollegarius, qui erat in luce virtutis cui omnia patent in ipso splendore lucis, secundum gratiam et permissionem Dei, vidit Mauros qui persequebantur suos Barchinonenses.* Aurell, "Prédication" (as in note 3), 150.

watch this world. Moreover, through God's grace, he was able to apply that knowledge. Then, "truly with the nod and permission of God," Oleguer went to the ship, appeared to the captain, and warned him of the approaching danger.[10]

The cult of Saint James of Compostela also reveals that saints were thought to have special knowledge. In 1080 James appeared to one of two men whom other pilgrims had left behind. The second man died and the first wanted to bury him, but feared the darkness and the "impious Basques." After asking for James' help, the saint appeared, "sitting on a horse like a soldier," and asked the living man what he was doing. When the man explained that he was unable to bury his companion, James told him to hand over the body and mount the horse; together they would ride to the burial place. They arrived near Compostela where James told the man to have the canons bury the dead pilgrim and then to meet up with his faithless companions. The pilgrim was to tell the others that their pilgrimages were in vain. Realizing then that the soldier was Saint James, the pilgrim "wanted to fall down at his feet, but the soldier of God no longer was visible to him."[11] The Apostle knew what the other pilgrims had done to their companions and, furthermore, where they would be in their travels; he communicated it all to his supplicant.

James' miracle involving a father and his children is even more explicit in its claim for the saint's special knowledge. In 1190 a man from Poitiers took his family to Compostela to avoid a plague then scourging his homeland. When his wife died in Pamplona, the innkeeper took the man's goods and the horse upon which his two children had been riding. Although "fettered by anxiety and in great distress," the man continued his pilgrimage, carrying his children in his arms. As he traveled, he met a man from Compostela who had a donkey that he offered to the father, upon condition that the latter return it upon reaching the city. Once in Compostela, the father prayed in a corner of the basil-ica. The Apostle, "wearing very bright clothing," appeared and asked the pilgrim if he knew him. When the pilgrim replied that he did not, the saint revealed that he had been the man who had lent him the donkey. The father was to continue using the donkey to return home. Furthermore, James informed him that the treacherous innkeeper was about to fall and die because of his evil deeds.[12]

Another example, from the conquest of Coimbra, Portugal, in 1064, illustrates that the Apostle James knew what was said about him and could predict and perform future events. A former bishop, Stephen, heard people calling James a soldier. Indignant, he called them foolish and the former bishop told them that it was better to call James a fisherman because Jesus had made him a fisher of men. The next day James appeared, "adorned in the whitest clothing, bearing military arms surpassing the rays of Titan, transformed into a soldier, and holding two keys in his hand." He told Stephen that he was a "fighter for God and his champion" and that he was then fighting with the Christians against the Saracens.[13] So that Stephen might believe him, the Apostle said that he would open the gates of Coimbra with the keys and hand the city over to Ferdinand I of Castile. James said it would happen at the third hour and it did, just as the saint predicted.[14]

A miracle from between 1088 and 1091 reveals that Dominic of Silos was also able to predict future events. After Saracens had captured a certain Pedro from Llantada (in the province of Palencia), Dominic appeared surrounded by a wonderful light. The saint castigated Pedro for being lazy and not leaving his prison. Pedro replied that he could not because of the chains that bound him, and he asked Dominic to free him. The saint replied with a plan for Pedro's escape. Within two days Pedro would be sent to work in the fields; from there he would be able to escape, and it came to pass just as Dominic had foretold.[15]

None of the thirteenth- or fourteenth-century saints

10. *vero secundum nutum et dispositionem Dei.* Aurell, "Prédication" (as in note 3), 150–1.

11. Thomas F. Coffey, *The Miracles of Saint James: Translations from the Liber Sancti Jacobi* (New York, 1996), 66–7.

12. Coffey, *The Miracles of Saint James* (as in note 11), 70–1.

13. *Ibid.,* 92. 14. *Ibid.,* 91–3.

15. Vitalino Valcarcel, *La 'Vita Dominici Siliensis' de Grimaldo: Estudio, edición crítica y traducción* (Logroño, 1982), 370–5.

display any such special knowledge or privileged view from the heavens. The sick, dying, injured, or otherwise troubled supplicants came to the holy dead *after* something had happened.[16] From over one hundred miracles of Ramon de Peñafort and the additional hundreds of miracles from the late-thirteenth and early-fourteenth centuries, only one supplicant sought something that was lost and that miracle did not involve a vision.[17] Berenguer Martini, a citizen and resident of Barcelona, lost a large amount of money out of carelessness (*propter incautelam*). He found it thanks to brother Ramon (*fratris Raymundi meritis adinvenit*).[18] In the case of Berenguer Martini, we know that he found his money, but the records do not include how he located it. In contrast to the cases of Oleguer, James, and Dominic, where the texts make it explicit that the saints informed their percipients what was going on, it was Ramon de Peñafort's merits that enabled Berenguer to "find" (*adinvenit*) the money. Ramon's participation, even though crucial in making the find miraculous, was not direct, and it was Berenguer who did the work. Ramon did not impart any special knowledge to the man.[19]

<p style="text-align:center">* * *</p>

Physical involvement of the saints

Around the middle of the twelfth century a weak man, crippled and without the use of his feet, heard of the virtues and miracles of Oleguer. His faith that he could become healthy through the merits of the deceased bishop of Barcelona lifted his spirits. As the crippled man spent a night in the cloister near the chapter house, an old man dressed in white, with a staff (*virga*) in hand, appeared to him and said "Get up, rise" (*surge, surge*). The cripple replied "I cannot get up" (*non possum sugere*), but after half an hour, the crippled man arose and walked upright.[20]

Oleguer spoke to, almost argued with, this cripple. In the case of a blind man cured by Oleguer at his tomb, Oleguer appeared, touched the man's eyes, and left.[21] Oleguer came to the rescue of three Christians held captive in Valencia. The men felt "the mercy of the divine power and of Saint Oleguer" and their heavy chains were removed.[22] They left the jail with Oleguer leading the way.[23] Oleguer led them down the roads they had to go until, commending them to God, he disappeared.[24] The men then saw a ship headed to Barcelona.[25] In each of these cases, Oleguer is presented as an active participant in the events. Not only does he bring about the miracle through his

16. There is evidence, particularly from Montserrat and Vic, of men and women placing themselves under the protection of a saint (in this case the Virgin of Montserrat or Bernat Calbó) before something happened and of giving thanks later. The individuals were embarking on a journey, going to war, or just invoking protection for goods and persons. For example, see the 1282 donation of Don Raymundo de Cabrera and his wife Doña Alamanda as found in Francesc Xavier Altés i Aguiló, ed., *Annals de Montserrat (1258–1485), Textos i estudis de cultura catalana (Vol. 52)* (Barcelona, 1997), 145–6.

17. Coll, in his eighteenth-century chronicle of the Franciscan Order of Catalunya, includes one miracle in which Francis of Assisi appeared to a merchant whose false companion had stolen his money and told him where the man could be found. Jaime Coll, *Crònica de la provincia franciscana de Cataluña*, 2 vols. (Madrid, [1981–87] 1738–64), Vol. 1, XI: 239. I have been unable to locate a medieval source for this account.

18. Penyafort, *Diplomatario* (as in note 1), 296.

19. It could be argued that this grammatical construction was the result of clerical influence. That is to say, that it was the clerics who determined that the miracle was through Ramon's merits

(and not his actions), thereby implying that God was the actor and Ramon merely the intercessor. The risk of this is minimal in this particular case. Berenguer Martini's miracle comes from the collection of Jaume Port. Jaume was a notary pubic of Barcelona, a secular man whose other writings are found in the Barcelona cathedral, as are the books of numerous other, secular notaries. I have found no evidence that Jaume Port belonged to any religious order or was a cleric. According to his introduction to the list, Jaume compiled the Dominican's miracles at the request of the bishop of Barcelona. Penyafort, *Diplomatario* (as in note 1), 286–7.

20. Aurell, "Prédication" (as in note 3), 156.

21. *Ibid.*, 153.

22. *Ille vero sentientes divine potentie clementiam et sancti Ollegari, gravitate cathenarum remoto.* Aurell, "Prédication" (as in note 3), 152.

23. *sancto Ollegario pro duce, exeunt de carcere.* Aurell, "Prédication" (as in note 3), 152.

24. *Sanctus autem Ollegarius docuit eos per quam viam ire deberent. Postea vero, commendans illos Deo, sanctus Ollegarius disparuit ab oculis eorum. Ibid.*, 152.

25. *Ibid.*, 152.

merits or *virtus*, but he also physically acts in and interacts with the world of the living.

The miracles by Saint James of Compostela also show a marked involvement in the physical world. Specifically, they reveal that he worked miracles by performing deeds, sometimes marvelous, sometimes mundane, but always in person. As mentioned earlier, in 1080 James came to a pilgrim of Lorraine who was hoping to bury his dead companion. "Saint James, sitting on a horse like a soldier," appeared to the pilgrim. When the man said that he could not bury his fellow pilgrim, the saint responded, "Hand me this dead man, and sit behind me on this horse until we come to the burial place … Thus it was done. The apostle held the dead man, facing him, carefully in his arms, and he had the living man sit behind him on the horse." James brought the men within reach of Compostela where he told the pilgrim to have the canons bury the body.[26] Several decades later (1103), James "appeared in human form … saying, 'Do not be afraid, my children…' to a group of men caught in a storm. He immediately loosened the cords of the sail, cast the anchor, stabilized the vessel, and controlled the storm."[27] In another example, James "appeared to the merchant in the jail, and he ordered the merchant to get up, and he led him to the top of the tower" from which he escaped.[28] Similarly, in 1100 James came to a man in Barcelona and "immediately broke his chains through the middle."[29] The most explicit example in which James physically acted to perform a miracle comes from the early twelfth century. A sick pilgrim recounted that, "Saint James entered [my room], holding in his left hand the woman's little sack, which I had borne on the road. In his right hand he was holding the beggar's staff, which I had carried while he had ridden my horse on the day when I took sick. He held the staff as a lance and the little sack as a weapon. He im-

mediately came toward me in a kind of indignant fury, raised the staff and tried to strike the demons who had held me. Terrified, they fled immediately and he followed them, forcing them to leave here through that corner."[30]

Dominic of Silos' manner of performing miracles was similar. As Anthony Lappin argued, "visions of Dominic convey a vibrant, vital conception of the saint's activity, violently engaged in the supplicants' search for health of mind or body."[31] Four of the eight visions of Dominic of Silos from the late-eleventh and early-twelfth century reveal the physicality of the abbot's miracles. Like James, Dominic broke the chains of captives. As he spoke to the captive Servandus around 1088, "he shattered all the obstacles that kept [the man] captive and, moreover, he broke all the bolts, bars, chains, and door bars of the jail" thus destroying all the defenses of the jail. Furthermore, Dominic broke the iron fetters that were holding Servandus.[32] When Dominic freed Martin of Burgos from the crippling illness that afflicted the man, he did so by beating a dog Martin saw attacking him. According to the account, one night, as he kept vigil at the abbot's tomb at Silos, Martin saw a huge, black dog violently attacking and biting his clothes. Then an old man appeared and, with the staff in his hand, beat the dog causing it to flee the church.[33] In a further example, Dominic woke up a mute boy at his tomb with a blow.[34] Finally, the boy Iustus saw Dominic gesture with his staff with which he struck a river.[35]

The miracles of Oleguer, James, and Dominic reveal activities in the physical world that are markedly different from the behavior of thirteenth- and fourteenth-century saints. Ramon de Peñafort's miraculous cure of Bernat Oliverii illustrates the difference. Bernat Oliverii had a fever for days and he lost his senses and became lethargic. Those around him thought he was

26. Coffey, *The Miracles of Saint James* (as in note 11), 66–7.

27. *Ibid.*, 75. 28. *Ibid.*, 79. 29. *Ibid.*, 95–6.

30. *Ibid.*, 83. My addition.

31. Lapin, *The Medieval Cult of Saint Dominic of Silos* (as in note 7), 203.

32. Valcarcel, *La 'Vita Dominici Siliensis' de Grimaldo* (as in note 15), 358.

33. *Ibid.*, 395.

34. Dominic *ei alapam dedit atque a somno illum excitavit. Ibid.*, 472.

35. *Ibid.*, 524. For a discussion about the symbolism of this account (and its parallels to the actions of Moses), see Lapin, *The Medieval Cult of Saint Dominic of Silos* (as in note 7), 202–3.

dying, until one day, Bernat prayed vehemently and constantly to Ramon de Peñafort. The same day he fell asleep and began to recover, when suddenly (*confestim*), Bernat was cured of the illness that had been afflicting him. When asked by the men investigating Ramon's case for canonization in 1318, Bernat told them about his vision. Bernat said that "in the same moment that [I] received [my] health, [I] saw brother Ramon de Peñafort, dressed in white, standing next [to me]. Immediately, [I] was cured."[36]

In Bernat's cure, as told by the recovered man himself, Ramon appeared beside him and, with his mere presence, healed him. Ramon neither said nor did anything; his physical interaction with the sick man was not crucial to his granting a cure. The miracle that began this essay—the cure of Maria the cripple—shows that Ramon could touch the living. Maria swore that Ramon "came to [me] and touched [me] and [my] hand."[37] The physical contact she had with the Dominican was important to Maria. Her account implies that it was through his touch that Ramon cured her, particularly as in both her description of her illness and of her cure, her hand was emblematic of her crippled body.[38] Yet, the contact was minimal, not like the in-

teractions Oleguer and James had with their supplicants. Other later miracle stories include the saints speaking or acting in the world of the living, but their interaction with that world is noticeably more limited than in cases from the eleventh and twelfth centuries.[39] Maria de Cervelló appeared above a ship and told her Mercedarian confreres to trust in the power of the Lord, and she then commanded the wind and sea to be calm.[40] She walked above the waves without a word in the vision of Arnau Liguer.[41] Dalmau Moner, on his way to heaven, spoke to the cleric Jaume de Castellario, fulfilling his promise, but offering no physical contact. "Lord Jaume, to God, to God, I go to heaven to take up the heavenly home [there] for me."[42]

Several miracles of the Virgin differ from this model for late-thirteenth and early-fourteenth-century Catalan miracles. Mary held the Mercedarian friar Pere Armengol in her hands when he was hanged in North Africa around 1266.[43] As the Virgin of Montserrat, she spoke to a Trinitarian friar whom she helped escape from captivity. She told him to go to the church at which he could pray to her, and he arrived at the Benedictine monastery of Montserrat in 1331.[44] The Virgin of Montserrat kept water from drowning a man

36. *quod eo momento quo dictam sanitatem recepit vidit fratrem Raymundum de Penyaforti predictum in indumentis albis qui stetit prope hunc testem et fuit incontinenti curatus.* Penyafort, *Diplomatario* (as in note 1), 252–3.

37. *veniret at hanc testem and tangeret eam et manus* [i.e., *manum*] *eius. Ibid.,* 258–60. My correction.

38. This is markedly similar to the manner in which Saint Margaret of Scotland appeared to and cured many of her supplicants between the end of the twelfth century and (probably) 1249. Robert Bartlett, ed., *The Miracles of Saint Aebbe of Coldingham and Saint Margaret of Scotland* (Oxford, 2003), 69–145. The miracles of Margaret, compiled ca. 1249, are atypical of thirteenth-century compilations, according to Bartlett (their editor) and based on my own readings of thirteenth-century sources. Margaret often identifies herself and behaves much as an earlier saint, that is, in the words of Gabor Klaniczay, as "basically ... a doctor" (when referring to tenth-century Latin saints). Moreover, her compilation has a decidedly political flavor to it. As Keene has interestingly argued, it would seem that the legitimating of the then-reigning Scottish royal family was an important motivator for the compilation. Gabor Klaniczay, "Dreams and Visions in Medieval Miracle Accounts" (paper presented at the "Ritual Healing in Antiquity and the Middle Ages," Warburg Institute, London, 17–18 Febru-

ary 2006). Katie Keene, "Envisioning a Saint: Visions in the Miracles of St. Margaret of Scotland" (paper presented at the 43rd International Congress on Medieval Studies, Kalamazoo, Mich., 2008). I should like to thank both Professor Klaniczay and Katie Keene for sharing these papers with me.

39. For another example, see the cure of Daurats, reported between the beginning of 1279 and late 1280. *Quidam, cui nomen Daurats, cum in maxilla dolore immanissimo torqueretur, se ipsum devote fratri Raymundo commendabat, cumque de eo cogitanti, quasi per imaginationem occurreret corporis ipsius fratris Raymundi statura, et dispositio, quem, dum adhuc viveret, facie noverat, vultuque quoque religiosus ac serenus, decens compositio habitus, et incessus, subito liberatus est a dolore quasi in tenuissima ferri scindentis acie sine dolore dolos ipse a carne abscinderetur, nullum sui vestigium derelinquens.* Penyafort, *Diplomatario* (as in note 1), 311–2.

41. *Acta Sanctorum* (as in note 4), 25 September, sect. 45, col. 0174E–0175A, pp. 174–5.

42. *Domine Iacobe, ad Deum, ad Deum, vado ad celestia accipere mihi sideream mansione* "AGOP (Santa SS) MS XIV.23" (as in note 4), fols. 173ʳ–182ᵛ.

43. *Acta Sanctorum* (as in note 4), 1 September, sec. 3–8, col. 0334A–C, pp. 333–5.

44. "AAM Llibre Vermell (Ms. 1)" (as in note 4), fol. 4ᵛ.

being tortured about a homicide some time between 1327 and 1336, although it is unclear how the she did so.[45] While these cases show Mary acting in the world, the majority of her extant miracles from Montserrat (the main source of Virgin miracles in medieval Cataluña) accord with the model described at the beginning of this article. When a person has a problem, he or she prays to a specific saint, sometimes trying different saints until an effective one is found, and the problem is resolved. Only rarely is the saint seen and, even more unusually, does the saint or the Virgin interact with the living.

Conclusion

The apparitions and actions of the saints discussed here reveal a shift in medieval Catalan conceptions of the "holy dead"—in particular, there was a change in the relationship between the dead and the living. In the eleventh and twelfth centuries, the saints came to the world of the living. They descended from their privileged place in the heavens and became physically involved in a person's life.[46] Oleguer removed chains and led Christians escaping from Muslims. He saw where things or people were hidden and told his supplicants. The deceased Barcelona bishop even conversed with one of his petitioners.[47] He physically appeared in seven of his twelve miracles. The miracles of Dominic of Silos and James of Compostela reveal similar behaviors and knowledge. They physically inter-

acted with their supplicants, hitting them or those attacking them, breaking chains, and even sailing ships. Furthermore, Dominic and James knew preternaturally what was going on in the world. Like Oleguer, they were "in the light of virtue ... everything was made clear in that splendid light" and, from that light, they watched over and intervened for their devotees.[48]

By the end of the thirteenth century the saints came much less frequently to an individual. Contained within the thirteenth- and fourteenth-century miracle collections where a saint appears at least once are a total of 372 miracles among which only fourteen involve visions or voices of the saints, just under four percent.[49] The holy dead continued to grant miracles in the later centuries but they became more removed from this world, even if they were from an order deeply involved in secular affairs, such as the Dominicans.[50]

There are several ways to interpret the significance of this change. It is possible that the changes I have argued for are only text deep—that they reflect a change in narrative style or miracle recording and not a change in reality. That in itself would be interesting. With this explanation, the transformation may lie in how miracles were *recorded* and not, necessarily, in how men and women believed that they occurred. This would suggest changing ideas of proof, story-telling, miracles, and even community. In a related vein, the significance of the change could be that it reflects a growing familiarity with the saints among medieval men and women,

45. "AAM Llibre Vermell (Ms. 1)" (as in note 4), fols. 1^{r-v}.

46. As Sigal pointed out, in many visions from the eleventh and twelfth centuries, saints offered instructions to the faithful that they might be cured (Sigal, *l'Homme et le miracle* [as in note 6], 145). Even though this is not the case in the miracles of Oleguer from the twelfth century or in the later thirteenth- and fourteenth-century miracles from Cataluña, it does hold true for the miracles of Dominic of Silos.

47. Aurell, "Prédication" (as in note 3), 156.

48. *Ibid.*, 150–1.

49. Oleguer (Bishop of Barcelona, d. 1137, Barcelona) worked twelve miracles in the middle of the twelfth century. Bernat Calbó (d. 1243, bishop of Vic) worked 116 miracles between his death and the middle of the fourteenth century. Ramon de Peñafort (O.P., d. 1275, Barcelona) performed 184 miracles. Maria de Cervelló (O. Merc., d. 1290, Barcelona) worked four miracles—two prior

to the Black Death and two others that date to between 1290 and 1401. Dalmau Moner (O.P., d. 1341, Gerona) performed twelve miracles between his death and 1356. The Virgin of Montserrat worked fifty-six miracles in the late-thirteenth and early-fourteenth centuries—forty-seven reported at Montserrat and an additional nine recorded in wills registered at the cathedral of Vic.

50. There are exceptions. Saints did continue to embrace and physically interact with the living as seen in the case of an Italian vision of Saint Dominic in 1290 discussed by Augustine Thompson, *Cities of God* (as in note 6), 344. Furthermore, the miracles of Saints Aebbe of Coldinghim and Margaret of Scotland show a marked physicality, Bartlett, *The Miracles of Saint Aebbe ... and Saint Margaret* (as in note 33). My argument concerns the extant Catalan stories and is meant as an overall survey of those narratives, not a comprehensive analysis of the way *all* saints worked *all* the time.

at least in Cataluña. The saints and their works had become so familiar, so much a part of daily life, that it was no longer necessary to see—or describe—them doing something to know that it was a miracle. It is also possible that there was a mystification of these saints through these centuries. The means by which the holy dead worked became less clear, more marvelous in a way and, therefore, indescribable, even invisible. Finally, as I suggested earlier, a richer catechism may have shaped what recipients expected. The saint was the vessel to point to—or was to be a conduit of prayers to—the true miracle worker, God.

If the significance of the change is clear enough, the proximate causes of the change remain uncertain. Perhaps the style of miracle narratives changed because of a transformation in the use of miracle stories. No longer needing to convert pagans, Christian preachers and clerics stressed the lives and virtues of saints and not their power over nature. Benedicta Ward argued that the power of miracles no longer lay in how they could show that the strength of the Christian God and His saints was greater than that of demons, but rather in the didactic power of the stories; they could turn a Christian to the proper life. Bernard of Clairvaux (d. 1153), when preaching about Saint Martin, spoke "not of [Martin's] miracles, posthumous or during his life, but of his obedience, his poverty, his charity. His *miracula* and *signa*, he [said], are to be wondered at, and his *merita* and *virtutes* are to be imitated."[51] Miracles, as signs of sanctity, were important, but it was the Christian life of the saint that was central to the accounts, not his or her supernatural power over nature; the latter was merely a sign of the former. From the twelfth

century, preachers, according to Ward, treated miracles as signs; they were "subservient to their end—to implant or strengthen faith."[52] "The aim in sermons …was to encourage men in the way of salvation."[53] This became increasingly the case with the rise of the mendicant orders in the thirteenth century.[54] With that end in mind, the importance of miracles lay in what had allowed a saint to be able to perform a miracle, not *how* he or she did so.[55] This change in interest on the part of preachers points to the possibility that miracle narratives changed to focus on the larger picture of the miracle (why the saint could perform a miracle) and not the details about how it was performed, at least in clerically produced or influenced works. According to this explanation, the saints were no longer portrayed as physically performing miracles because that was no longer the central part of the events. The performance of a miracle was significant as a sign of personal sanctity; the power of the saint did not need to be physically seen. It was through their merits, accrued by their virtuous lives, that saints could bring about miracles, not through their supernatural strength or abilities, even if God-given.[56]

The work of André Vauchez highlights a potential problem with this explanation.[57] From the twelfth through the early-fourteenth century Vauchez found a number of significant changes in the types of miracles recorded in canonization processes. If it was merely the didactic function of miracles that was of paramount importance, at least amongst the clergy, one might not expect to find these changes. Overall, the clergy who supervised canonization proceedings and recorded lists of miracles increasingly included

51. Benedicta Ward, *Miracles and the Medieval Mind: Theory, Record and Event, 1000–1215*, ed. by Edward Peters, *The Middle Ages* (Philadelphia, 1982), 175–6.

52. *Ibid.*, 24. 53. *Ibid.*, 28.

54. See also, Michael E. Goodich, *Miracles and Wonders: The Development of the Concept of Miracle, 1150–1350* (Bodmin, 2007), 17–8.

55. According to Ward, medieval intellectuals in the twelfth century were interested in the purpose of miracles, not in the process by which they occurred. Ward, *Miracles and the Medieval Mind* (as in note 51), 20–23.

56. Goodich argued, "The thirteenth century was characterized

by greater interest in the saint's life and less in his miracles. As Innocent III had said in the case of Homobonus of Cremona, reports of the saint's conduct, his good works and virtues are necessary, in addition to his miracles, before a candidate may be dubbed 'sanctus' by the Church Militant." Goodich believed that this increased focus on the life of the saint was part of the larger fight against heresy and the need to provide examples in the face of the good men and good women of Languedoc, whom he called the Cathars. Michael E. Goodich, *Vita Perfecta: The Ideal of Sainthood in the Thirteenth Century* (Stuttgart, 1982), 207.

57. Vauchez, *Sainthood* (as in note 6).

prodigious and marvelous miracles.[58] One example serves to illustrate the point. From the thirteenth to the fourteenth centuries there was a dramatic rise in the number of resurrections from the dead, which were "very rare, if non-existent, in the processes of the first half of the thirteenth century, [but] they account for 10 per cent of miracles in the fourteenth."[59] If the main purpose behind the composition of miracle accounts was to stress the virtuous life of the saint and to encourage its imitation, it does not necessarily follow that the miracles would become more spectacular or awe-inspiring. The life of the saint was to be imitated, not his or her miracles. Moreover, such astonishing miracles could easily be imagined as causing a saintly life to be thought of as being beyond the abilities of ordinary men and women. According to Vauchez, "From the years 1300–50, even in the non-Mediterranean countries, the saints began to be regarded as living beings who had acquired by their merits a power of intercession with God."[60] The laity, clergy, and intellectuals shared this belief, argued Vauchez. "All [clergy and laity] agreed that sainthood was the fruit of a devout, ascetic and virtuous life, assuring to those who led it the power to work miracles. Logically, this change of perspective ought to have made sainthood more commonplace. In practice, the opposite happened; the late medieval saints are far more extraordinary than those in the twelfth and thirteenth centuries."[61] The saints provided models for living, but how can the increase in the marvelous among their miracles be explained?

On the surface the increase appears to contradict the implications of Ward's argument—that it was the living of a good life that was important and not the supernatural powers of a saint. There was, according to Ward, an "insistence on miracles linked to virtues" from the papal court as "a check to credulous popular mistakes."[62] How would the ability to raise the dead, for instance, lead to a good Christian life? Vauchez and Ward, among others, point to an explanation. In the thirteenth century, but also somewhat before, the good Christian life came to be modeled more and more on the lives of the Apostles (the *vita apostolica*) and Christ (the *imitatio Christi*).[63] Clerical authors and intellectuals sought miracles that echoed Biblical accounts as a means of authenticating the events and of pointing to the importance and value of living a proper Christian life, that is, of imitating the lives of Christ and the Apostles.[64] In saints' lives, miracles mirroring Biblical events, particularly from the New Testament, "were intended to establish [the wonder workers] as Christian saints, powerful and holy according to the scriptural pattern."[65] Many of the cures wrought by saints reflect the list of miracles Jesus himself gave in Luke 7:22—"... the blind receive their sight, the lame walk, the lepers are cleansed, the deaf hear, the dead are raised, the poor have good news brought to them ..."[66]

58. Goodich, too, noticed the importance placed on the "element of astonishment" and awe in canonization records. According to Goodich, "The sense of wonder and surprise voiced by both those who experience and witness a miracle remained a *sine qua non* of a credible miracle and was to become the central feature of those miracles which were intended to convert the non-believers or strengthen the faith of penitent Christians." Goodich, *Miracles and Wonders* (as in note 54), 8.

59. Vauchez, *Sainthood* (as in note 6), 466–7.

60. *Ibid.*, 527. 61. *Ibid.*, 528.

62. Ward, *Miracles and the Medieval Mind* (as in note 51), 186.

63. Vauchez, *Sainthood* (as in note 6), 530–1. See also, André Vauchez, *The Laity in the Middle Ages: Religious Beliefs and Devotional Practices*, ed. by Daniel E. Bornstein, trans. by Margery J. Schneider (Notre Dame, 1993); Giles Constable, "The Ideal of the Imitation of Christ," in *Three Studies in Medieval Religious and Social Thought*, ed. by Giles Constable (Cambridge, 1995); M. H.

Vicaire, *l'Imitation de Apôtres: Moines, chanoines et mendicants IVᵉ–XIIIᵉ siècles* (Paris, 1962).

64. According to Ward, "The need to distinguish Christian miracles from pagan magic was a powerful incentive to find authentication in recognized patterns for the miracles of later saints." Gregory the Great, for example, described Saint Benedict "as a patriarch able, like Moses, to draw water out of the rock (Exodus 17:1–7) ..." Ward, *Miracles and the Medieval Mind* (as in note 51), 168. Goodich stated, "The medieval Christian vision demanded that every terrestrial phenomenon correspond to a transcendental, celestial prototype: the heavenly Jerusalem was reflected in the earthly; the celestial hierarchy in the ecclesiastical. The Catholic saint likewise corresponds to an archetype of the sacred which transcends time or place." Goodich, *Vita Perfecta* (as in note 51), 207.

65. Ward, *Miracles and the Medieval Mind* (as in note 51), 168.

66. *The New Oxford Annotated Bible: The New Revised Standard*

Tied to the increased focus on the *vita apostolica* and the *imitatio Christi*, the increase in the spectacular matches the use of miracle stories. Clerical miracle-recorders, and their largely lay witnesses, focused more on the types of miracles worked by Christ and his disciples, and the means by which they were wrought. For example, Christ and the Apostles raised the dead by their command, but their miracles did not involve great physical involvement on their part. The resurrection of Lazarus illustrates the means by which Christ brought the dead to life. Arriving near the home of Martha and Mary in Bethany, Jesus was told that their brother Lazarus was dead. Jesus went to the tomb, ordered the stone removed from the opening, and, praying to God, "cried with a loud voice, 'Lazarus, come out!' The dead man came out, his hands and feet bound with strips of cloth, and his face wrapped in a cloth." [67] Christ's prayers and command were sufficient to bring about the miracle; he did not physically do anything. [68] Thus, one possible explanation for the decreased involvement of the saints in the world of the living is a shift in the use of miracles by the clergy. The purpose of the miracles was to point to the lives of the holy dead, and to relate them to the lives of Jesus and the Apostles, not to saints' actions after death. The behavior of the saints after death, apart from their working miracles, was not important; the miracle merely pointed to the holy way in which they behaved while alive. Therefore, the change in physical involvement of the saints, according this explanation, may be only a change in narrative focus. The saints may well have continued physically working in the world of the liv-ing, but the living, or at least the clerics and other scribes, were no longer recording those corporeal actions.

The possible explanation for the change in the physical involvement and appearances of the saints points toward the influence of Biblical, particularly New Testament, models of sainthood. After his death, Christ did not regularly appear to his followers. The early Christians awaited his return at the end of time, which they saw as imminent, not his return to their daily lives. Even in life, Christ's miracles did not always involve physical actions. For example, Matthew recorded how Jesus healed a man's withered hand. "He [Jesus] left that place and entered their synagogue; and a man was there with a withered hand, and they asked him, 'Is it lawful to cure on the Sabbath?' ... Then he [Jesus] said to the man, 'Stretch out your hand.' He stretched it out, and it was restored, as sound as the other." [69] With his command, Jesus cured the man. Furthermore, the Apostles did not appear to their followers after death. The models on which saints' lives (and miracles) were increasingly based in the later Middle Ages did not involve apparitions of the holy dead, even though they did include the holy dead's involvement in the world through the working of miracles.

Another possible explanation for this change in the physical involvement of the saints is a tension concerning the idea of how the saints interceded and how miracles worked. According to Church theologians, God alone worked miracles. For example, Anselm of Canterbury (d. 1109) stated, "Now, those things which are done neither by created nature nor by the will of the

Version, ed. by Michael D. Coogan, 3rd ed. (Oxford, 2001), Luke 7:22, p. 109 (hereafter NRSV). "... *caeci vident, claudi ambulant, leprosi mundantur, surdi audiunt, mortui resurgunt, paupeers evangelizantur ...*" *Biblia Sacra: Iuxta Vulgatam Versionem* (Stuttgart, 1994), Luke 7:22, p. 1620.

67. NRSV (as in note 66), John 11:1–44, pp. 187–8. *Biblia Sacra* (as in note 66) John 11:1–44, pp. 1678–80.

68. Vauchez offers an additional explanation for the increased number of prodigious miracles included in canonization proceedings. "... the evolution of the processes of canonization is only one aspect of a much wider transformation. The emphasis on the most extraordinary aspects is less a product of a clerical reading of saint-hood than of the desire of the church to popularize a few 'stars' whose cult it wished to promote." Furthermore, as in the case of the miracles of Peter of Morrone (Celestine V, d. 1296), there was a "tendency, already visible in the fourteenth-century enquiries, to take account only of prodigies it was difficult to challenge, like the resurrections of dead children or the cures of sick people regarded as incurable by doctors," Vauchez, *Sainthood* (as in note 6), 532, 487.

69. *Biblia Sacra* (as in note 66), Matthew 12:9–13. p. 1543. NRSV (as in note 66), p. 25. Jesus did physically act in some cures, for example in Matthew 9:25 and 9:20, but his actions were limited to touch.

creature but by God alone, are miracles (*semper Miranda sint*)…"[70] In his *Dialogue on Miracles*, Caesarius of Heisterbach (d. 1240) wrote, "God is the author of all miracles."[71] In early miracle stories and saints' *vitae*, God granted a saint power to perform miracles based on the individual's suffering, which was at first physical suffering as martyrs and then spiritual suffering as confessors.[72] Michael Goodich has noted that, in the central and high Middle Ages, "theologians repeatedly warned against the misconception that angels, saints, demons and magicians can perform miracles by themselves, independent of a higher authority."[73] Repeated condemnation points to the possibility that there existed persistent or widespread belief at variance with the condemnation, that is, the belief that saints, among others, could perform miracles on their own. According to Vauchez, some later medieval clerics and intellectuals, and even some elite laity, believed that God no longer performed miracles *through* the saints, but rather *for* them, "that is, in consideration of [the saint's] own merits. From this perspective, it was as if the servants of God had acquired, through the sufferings they had endured during their lifetime, a means of putting pressure on God, in a sense obliging him to intervene on behalf of whoever had put themselves under their protection."[74] Other men and women, lay and clerical, including some medieval Catalans, believed that the saints themselves performed the miracles, even if they admitted that it was God working

through them.[75] The decreased physical involvement of the saints as seen in the Iberian visions examined here could have been the result of this tension. The clerics, after being educated about the official teaching concerning miracles, especially the Dominicans and Franciscans, may have ignored or omitted the physical actions of the saints in visions to make the miracles theologically acceptable. At the same time, the laity may have continued to believe that the saints physically executed the miracles, as seen in the example of Maria the cripple that began this essay. The inclination of clerics to make the accounts more acceptable would have been particularly strong in the thirteenth and fourteenth centuries as papal canonization itself became more difficult.[76]

A final possible explanation for the shift in the physical involvement of the saints may have been that the people continued to believe that the saints worked their miracles with their own hand, but these actions had become so familiar that it was no longer necessary to specify how they came about, only that they did. According to Vauchez, by the fourteenth century, the saints had become "fully integrated into the religious universe of the faithful; reverential fear had given way to a feeling of confidence, which was expressed in an affectionate familiarity."[77] As revealed in the surviving Catalan accounts as well as in Vauchez's sources, saints were invoked "more than in the past in all life's difficulties."[78] With such familiarity, it is possible that

70. As quoted in Ward, *Miracles and the Medieval Mind* (as in note 51), 4.

71. Caesarius of Heisterbach, *Dialogue of Miracles*, trans. by H. Von E. Scott and C. C. Swinton Bland, Vol. 2 (London, [1929] 1220–1235), 171.

72. See Vauchez, *Sainthood* (as in note 6), esp. Book 1, Part 1, Chapter 1 "Late Antiquity and the Early Middle Ages: 'Vox Populi' and Episcopal Power (Third to Tenth Centuries)," 13–21.

73. Goodich, *Miracles and Wonders* (as in note 54), 16. For a discussion of Thomas Aquinas' views on the performance of miracles, see Goodich, *Miracles and Wonders* (as in note 54), 19–21.

74. Vauchez, *Sainthood* (as in note 6), 461. An example of one elite man's idea of the intercessory role of the saints is found in William of Saint-Pathus' account of some words of Saint Louis IX of France. "It is the same with the saints in Paradise as with the counselors of kings … whoever has business with an earthly king

seeks, in effect, to know who he holds in high regard and who, having his ear, is able to approach him successfully. He then seeks out this favoured person and begs him to convey his request. It is the same with the saints in Paradise who, being the friends of Our Lord and his intimates, can invoke him in all confidence, since he cannot fail to listen to them." As quoted in, Vauchez, *Sainthood* (as in note 6), 461.

75. Vauchez, *Sainthood* (as in note 6), 461–3, esp. note 65, p. 462. "To most people, the saints were first and foremost beings who possessed power over nature and the elements." Vauchez, *Sainthood* (as in note 6), 463.

76. Vauchez, *Sainthood* (as in note 6), 27–32. Also, Goodich, *Vita Perfecta* (as in note 51), 47.

77. Vauchez, *Sainthood* (as in note 6), 459.

78. *Ibid.*, 470.

speakers assumed that listeners knew how the miracles occurred, and there was no need to specify a saint's actions and all that the audience was interested in was what the miracle was.

These explanations are not mutually exclusive and all, along with other possible ones, probably played a role in the shift in saints' apparitions examined in this article. Several explanations argue for a transformation in how miracles were *recorded* and not, necessarily, a shift in how men and women thought that they occurred. Yet changes in the character of the saints, particularly their knowledge of the world and physical interaction with it, also point to a shifting conception of the relationship between the human and the divine, at least among the recorders, lay and clerical, of Catalan miracle stories. These are just a few possible explanations for that new relationship.

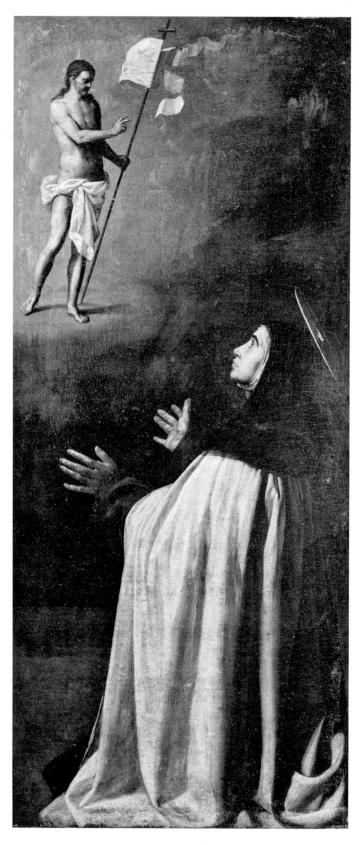

FIG. 1 The Vision of Saint Teresa of Ávila by Alonso Cano, 1629.
Private Collection.

LUIS R. CORTEGUERA

Visions and the Soul's Ascent to God
in Spanish Mysticism

The Vision of St. Teresa

IN his 1629 painting of *The Vision of St. Teresa of Ávila*, Alonso Cano depicts a crucial episode in the life of the great Spanish mystic (Fig. 1). On 25 January 1561, on the feast of St. Paul, the Carmelite nun witnessed a vision unlike any she had experienced before. As St. Teresa explains in her *Life*, during Mass:

> I saw a complete representation of this most sacred Humanity, just as in a picture of His resurrection body, in very great beauty and majesty.... Although this vision is imaginary, I never saw it, or any other vision, with the eyes of the body, but only with the eyes of the soul.... At certain times it really seemed to me that it was an image I was seeing; but on many other occasions I thought it was no image, but Christ Himself, such was the brightness with which he was pleased to reveal Himself to me. Sometimes, because of its indistinctness, I would think the vision was an image, though it was like no earthly painting, however perfect, and I have seen a great many good ones. It is ridiculous to think that the one thing is any more like the other than a living person is like his portrait: however well the portrait is done, it can never look completely natural: one sees, in fact, that it is a dead thing.[1]

For Teresa, the language of seeing is insufficient to describe the mystic's encounter with the living presence of God as manifested in the vision of Jesus Christ. The vision is like a painting, but unlike any painting. The visionary perceives a presence, but not with the eyes. The mystic's paradoxical statements respond to a subtle distinction between visual perception—that is

to say, the act of seeing—and what St. Teresa and her early modern contemporaries understood as the experience of seeing. That early modern understanding of the visual experience included, for example, assumptions about the influence an image could have over its viewer, as well as the role of a person in the act of seeing. As will become clearer in the course of this essay, according to St. Teresa, these notions of the visual experience came closest to describing the visionary experience to those who had not witnessed this indescribable event.

One way to grasp this early modern visual experience is to consider how painters appealed to it in order to convey the visionary's encounter with the divine. For example, in *The Vision of St. Teresa*, painter Alonso Cano appealed to the viewer's own experience of looking at his painting to convey Teresa's description of her mystical episode. Cano played on her paradoxical statement that "the vision was an image, though it was like no earthly painting" by rendering the vision of Jesus Christ as an unreal image suspended in midair. This image of the resurrected Jesus Christ, identified as such by the ensign of victory, might resemble a painting, except for its nebulous aura, which indicates that this is no "earthly painting." Cano also conveys the extraordinary effect of God's living presence on St. Teresa by depicting her, bathed in a strong light emanating from the vision, with tense open hands and an intense gaze to denote her state of rapture.

According to Victor Stoichita, the visual medium of painting gives the beholder some sense of the mystical

1. *The Life of Teresa of Jesus: The Autobiography of Teresa of Ávila* [henceforth *Life*], trans. and ed. E. A. Peers (New York, 1960, repr. 1991), 259, 261–62 (chap. 28). I am grateful to Mindy Nancarrow, Marta Vicente, Alison Weber, and Christopher Wilson for their suggestions and comments on this article.

experience because of a permanent communication "between mystical imaginary and artistic imaginary." In this dialogue, Stoichita explains, "There is a to-ing and fro-ing between vision and painting that can be found in the work of the great mystics as well as in popular mythology."[2] Mystics described "a mystical illusion" in their visions by comparing it to painting. Artists spoke of an "artistic illusion" by comparing it to the mystical experience. By combining non-verbal gestures, dramatic compositions, and visual effects, Golden Age Spanish art succeeds in recreating an experience that was "not so different from that to which the mystical experience itself has for a long time been witness."[3] That shared experience Stoichita sees as common to art and mystical vision is precisely a visual experience.

Understanding this early modern concept of the visual experience requires distinguishing among three different meanings of the word "vision." The three meanings overlap in the very title of Alonso Cano's painting: *The Vision of St. Teresa*. What is the vision in this painting? First, the vision is a "thing," namely, the theophany, or the manifestation of God, which in Cano's painting is the image of Christ floating before St. Teresa. This immaterial "thing" is what St. Teresa compares to a painting that looks like no earthly painting. But *The Vision of St. Teresa* is also an "event": that is to say, it is the moment when the theophany appears before the nun, and which produces her dramatic reaction. This vision as a spiritual event is what Stoichita calls the "visionary experience." Then there is a third "vision" at play in Cano's painting that constitutes an action: St. Teresa's apparent visual perception of Jesus Christ before her—apparent because, as she insists, she did not see with her bodily eyes. Taking these three meanings into account, Cano's *The Vision of St. Teresa* constitutes the painter's rendition of Teresa's visionary experience as a visual experience.

Painting worked as a medium to convey the vi-sionary experience because, for mystics like St. Teresa, their experiences approximated those of looking at an image. Precisely because a mystical vision was incomparably superior to the best "earthly painting," its perception constituted an intensified, otherworldly, version of the experience of looking at a painting. To borrow the theological terminology of St. Augustine of Hippo, for whom St. Teresa held a special devotion, seeing an image and perceiving a vision shared a certain "likeness," but they were not equal.[4]

What follows consists of three sections, each examining a different aspect of early modern notions of the visual experience that shaped St. Teresa's description of her mystical visions. The first section discusses the role of the sense of sight in her religious practices. For St. Teresa, the possibilities and limitations of visual perception allowed her to distinguish between what she experienced during her encounters with divinity and the effects produced on her by other religious practices. The second section discusses how early modern assumptions about the power of images to touch and affect the soul informed St. Teresa's description of the effects mystical visions had on her soul. The third and final section considers how early modern ideas about individual agency in the act of seeing provided an appropriate analogy for the soul's interactions with God.

Distilling Teresa of Ávila's mystical thought will invariably do her as much injustice as the attempt to capture her essence by drawing her physical features. The necessary reliance on English translations of her works only compounds that injustice. Considered one of the greatest Spanish writers of all times, St. Teresa aimed to write in an unadorned and direct style that often conveys the passion and energy that made her an enormously charismatic figure during her lifetime, and posthumously inspired countless men and women to follow in her path. Yet her plain language is an illusion. Teresa the writer resorted to common words and Spanish expressions that betray multiple,

2. V. I. Stoichita, *Visionary Experience in the Golden Age of Spanish Art*, trans. A. M. Glasheen (London, 1995), 48.

3. *Ibid.*, 77.

4. See St. Augustine, *Eighty-Three Different Questions*, trans. D. L. Mosher (Washington, D.C., 1982), 189–91 (Question 74), and *On the Literal Interpretation of Genesis*, in *Saint Augustine on Genesis*, trans. R. J. Teske (Washington, D.C., 1991), 182–88 (chap. 16). See Stoichita's discussion of Augustine's texts in *Visionary Experience* (as in note 2), 46, 48.

and often complex, readings. Whether in Spanish or in translation, Teresa's writings often prove as elusive as the incommunicable experiences she sought to communicate.

The Eyes of the Body

Since the times of the ancient church, Christian theology has long drawn on analogies of visual perception to describe spiritual phenomena.[5] Consequently, Teresa of Ávila described her visionary experiences drawing on a number of longstanding assumptions about the nature of visual perception. This is especially clear in the way she distinguishes between her bodily eyes and the eyes of the soul.

As Teresa insists in the passage quoted above describing her vision on St. Paul's day, she never had sensory, or corporal, visions; in other words, she never once experienced a vision with her own eyes.[6] The imaginary vision she had that day involved only the "eyes of the soul," which allowed her to perceive the divine presence, but which overwhelmed the senses and rendered them powerless, so that she could not see the vision of Jesus Christ with her own eyes.

St. Teresa may have persistently denied the role of the sense of sight in her visions in response to the widely held disdain for the physical senses.[7] Teresa's denials may have also sought to allay fears among the Catholic clergy about her visions, since theologians considered the active participation of the senses during visions as evidence of demonic influence.[8] With her characteristic self-deprecation and feigned ignorance,[9] Teresa writes: "Those who know better than I" say that imaginary visions are "nearer perfection ... than those which are seen with the eyes of the body," which are "more open to delusions from the devil." Yet at the time of her vision on the feast of St. Paul, Teresa confesses she was "not aware" of this distinction and in fact wished to see that vision with her bodily eyes so that "my confessor would not tell me I was imagining it."[10] But whenever she tried to see a vision, it vanished. It was impossible to see visions, she explains, because they only last an instant. More important, the intensity of divine visions overcharges the physical senses and renders them impotent. Even if the vision were longer, the mystic would be incapable of actually seeing, hearing, or even thinking.

To understand the visual nature of a mystical experience we must turn to Teresa of Ávila's account of another vision that did not involve the sense of sight. Teresa's first intellectual vision happened seven months before the vision on St. Paul's day described at the beginning of this essay. On June 29, 1560, on the feast of St. Peter, Teresa was praying when

> I saw Christ at my side—or to put it better, I was conscious of Him, for neither with the eyes of the body nor with those of the soul did I see anything. I thought He was quite close to me and I saw that it was He who, as I thought, was speaking to me. Being completely ignorant that visions of this kind could occur, I was at first very much afraid, and did nothing but weep.... All the time Jesus Christ seemed to be beside me, but, as this was not an imaginary vision, I could not see in what form: what I felt very clearly was that all the time He was at my right hand and a witness of everything that I was doing, and that, whenever I became slightly recollected or was not greatly distracted, I could not but be aware of His nearness to me.[11]

5. D. C. Lindberg, *Theories of Vision from Al-Kindi to Kepler* (Chicago, 1976), esp. 141–43.

6. For the distinction between corporal, imaginary, and intellectual visions, specifically in relation to St. Teresa's mystical experiences, see M. Martín del Blanco, "Los fenómenos extraordinarios en la mística de Santa Teresa de Jesús," *Teresianum* 33, nos. 1–2 (1982), 361–409, esp. 368–69, 386–92.

7. On the disdain for sensory vision, see J. M. Soskice, "Sight and Vision in Medieval Christian Thought," in T. Brennan and M. Jay, eds., *Vision in Context: Historical and Contemporary Perspectives on Sight* (New York, 1996), 31–43.

8. On St. Teresa's concerns to secure clerical support for her mystical experiences, see G. T. W. Ahlgren, *Teresa of Avila and the Politics of Sanctity* (Ithaca, 1996), esp. 98–104.

9. A. Weber, *Teresa of Avila and the Rhetoric of Femininity* (Princeton, 1990), 159.

10. *Life* (as in note 1), 259–60.

11. *Life*, 249 (chap. 27). Where Peers translates "I could not discern in what form," I have followed the original, which literally states: "I could not see in what form" (no vía en qué forma); see *Libro de la Vida* [henceforth *Vida*], ed. O. Steggink (Madrid, 1986), 349–50.

Against her wishes, St. Teresa describes in visual terms an experience she insists involved neither the eyes of her body nor the eyes of the soul. Instead, she clearly felt on the right side of her body the presence of Jesus Christ, although she could "not *see* in what form." "I *saw* near me, or felt, to say it better," St. Teresa corrects herself, as she struggles to describe her indescribable vision. She had faced the same difficulty when describing this vision to her confessor. When he asked her "in what form" she had seen Christ, she replied: "I had not *seen* Him at all." Then how did she know it was Christ? "I did not know how, but ... I could not help realizing that He was beside me...."— and in another slip of the pen, Teresa adds—"and I *saw* and felt this clearly" (in all of these quotations, the emphasis is mine).

As much as she searched for the right comparison, none fit her vision: "For, if I say that I do not see Him with the eyes either of the body or of the soul, because it is not an imaginary vision, how can I know and affirm that He is at my side, and this with greater certainty than if I were to see Him?"[12] She was not exactly like someone in the dark, or a blind person, unable to see a person standing near her. There was no darkness in her vision: "on the contrary, He presents Himself to the soul by a knowledge brighter than the sun. I do not mean that any sun is seen, or any brightness is perceived, but that there is a light which, though not seen, illumines the understanding...."

Later on, St. Teresa tries to clarify what she means by comparing the experience of praying to that of witnessing a vision. During prayer, "the soul recognizes the presence of God by the effects which ... He produces in the soul ... but in a vision, the soul distinctly sees that Jesus Christ, the Son of the Virgin, is present." In other words, according to St. Teresa, the soul and the eyes play opposite roles during a vision and during prayer. During a vision, the soul can "see" the presence of Jesus Christ, but during prayer, the soul can only feel the "effects" of the divine presence. In contrast, the eyes of the body do not see during a vision, although they often play an active part during prayer.

Visual images, such as paintings, sculptures, and engravings, were essential to St. Teresa's method of prayer, as they were to most Catholics at the time. She recounts in her *Life* that, after her mother's death, when Teresa was only a child, she turned to an image of the Virgin Mary pleading that she now become her mother.[13] As a young nun, Teresa liked having pictures of God "in a great many places" and got objects of devotion for her own oratory.[14] In her daily prayers, St. Teresa surrounded herself with visual images.[15] She kept inside her breviary images of the Samaritan woman (with whom Teresa identified as a woman-sinner), of the child Jesus, and of the Holy Spirit represented as a young man enveloped in flames. She kept in her oratory an iconostasis, a triptych-like screen, which had on it images of thirty saints, of angels, Church patriarchs, saints from her Carmelite order, and the Eleven Thousand Virgin Martyrs. She had a particular predilection for sculptures of the Child Jesus, which were known by their nicknames: "The Little Pilgrim," "The Little Messenger," and the "Little Talker," so named because St. Teresa conversed with it during her travels.

St. Teresa also owned and commissioned paintings for use during prayer and meditation.[16] In her *Life*, she describes several paintings of Christ's passion of special importance in her religious life. She commissioned for her first reformed convent of St. Joseph, in Ávila, a mural of the *Christ at the Column*, following her own specifications based on her vision of the same scene.[17]

Following Catholic religiosity of her time, St. Teresa relied on such sacred images for aid during prayer, as she describes in her *Life*:

12. *Life*, 250.

13. *Ibid.*, 67 (chap. 1). 14. *Ibid.*, 97 (chap. 7).

15. See T. Álvarez, ed., *Diccionario de Santa Teresa de Jesús* (Burgos, 2000), 512–14, 840–43; and M. Florisoone, "Estética de Santa Teresa," *Revista de Espiritualidad* 22 (1963): 482–88.

16. A. Cea Gutiérrez, "Modelos para una Santa: El necesario icono en la vida de Teresa de Ávila," *Revista de Dialectología y Tradiciones Populares* 61, no. 1 (Jan.–June, 2006), 7–42.

17. *Vida* (as in note 11), 528, n. 13.

My method of praying was this. As I could not reason with my mind, I would try to make pictures of Christ inwardly; and I used to think I felt better when I dwelt on those parts of His life when He was most often alone.[18]

More than an aid, Teresa found images absolutely necessary: "Of Christ as Man I could only think: however much I read about His beauty and however often I looked at pictures of Him, I could never form a picture of Him myself.... It was for this reason that I was so fond of pictures."[19]

Besides allowing her to visualize Christ, images had a second, far more significant, effect on Teresa. When she received communion, she explains: "I wanted to keep ever before my eyes a painting or image of Him since I was unable to keep Him as engraved in my soul as I desired."[20] Her choice of words is important. Throughout her *Life* and her other works, St. Teresa repeatedly uses the verb "to engrave" (*esculpir*), meaning "to form an effigy or image," as well as the verb "to imprint" (*imprimir*) to describe the mark left on her soul by an image or a vision.[21]

This notion that images entered through the bodily eyes and left their imprint, or impression, on the soul had ancient origins and shaped Christian medieval theology.[22] In the early modern period, this idea remained current in the general understanding of the workings of visual perception and cognition. More specifically, it provided a compelling explanation about the power of images to influence the soul, which in turn informed Catholic religious practice. Finally, the way images left their imprint on the soul provided an analogy to discuss the influence of God over the soul—an analogy favored by early modern theologians, religious authors, and mystics.

The Power of Images

In the sixteenth century, Spanish religious works often described the human soul as a battleground where pious and sinful images competed to leave their imprint and move the soul accordingly. This struggle of good and bad images inspired analogies to other spiritual struggles. For instance, in his best-selling treatise on prayer and meditation, the Dominican Fray Luis de Granada (1504–88) advised that he who wants to devote himself to God "should work to uproot from his heart" all "strange affections" and present his heart to God "as a raw material denude of all forms, so that God may imprint on it everything He desires without any resistance."[23] By "strange affections," Luis de Granada meant temptations that found their way to the soul, displacing God from His rightful place there. The example given of one such affection clearly indicates that Granada conceived of these temptations as having the same power as sinful images had to move the soul to commit sins. As Granada explains it, for the soul to remain devoted to God as in a "spiritual marriage," a Christian should not do as the husband who has "his eyes put on another woman besides his own." As stated in Matthew 5:28, even if that man does nothing else, by gazing lustfully at another woman he commits adultery. In other words, the sinful image of the second woman becomes engraved in the man's soul,

18. *Life* (as in note 1), 115 (chap. 9). On the use of visual aids in Carmelite meditation practices, see M. N. Taggard, "Picturing Intimacy in a Spanish Golden Age Convent," *Oxford Art Journal* 23, no. 1 (2000), 97–112.

19. *Life*, 116–17 (chap. 9). See also, B. Mujica, "Beyond Image: The Apophatic-Kataphatic Dialectic in Teresa de Avila," *Hispania* 84, no. 4 (Dec., 2001), 741–48; and also see, C. C. Wilson, "Teresa of Ávila vs. the Iconoclasts: Convent Art in Support of a Church in Crisis," in J. Roe, B. Bustillo, and C. C. Wilson, eds., *Imagery, Spirituality, and Ideology in Iberia and Latin America* (forthcoming 2010).

20. Teresa of Ávila, *The Book of Her Life*, trans. K. Kavanaugh and O. Rodríguez (Indianapolis, 2008), 140.

21. J. Poitrey, *Vocabulario de Santa Teresa* (Madrid, 1983), 303–4, 384–85; J. L. Astigarraga and A. Borrell, *Concordancias de los escritos de Santa Teresa de Jesús* (Rome, 2000), Vol. 1, 1348–49 (imprimir).

22. As Lindberg notes, St. Augustine's insistence about the spiritual, as opposed to the material, nature of the soul, meant that the "forms" seen through the eyes "are not themselves impressed on the soul, but trigger the creation of similar (but incorporeal) forms out of the soul's own inner resources"; *Theories of Vision* (as in note 5), 94. See also N. Caciola, *Discerning Spirits: Divine and Demonic Possession in the Middle Ages* (Ithaca, 2003), esp. 179–94.

23. L. de Granada, *Tratado de la oración y meditación*, in *Obras Castellanas* (Madrid, 1997), Vol. 2, 376.

displacing the wife's rightful place there. Allowing "strange affections" to take root in the soul is like taking on a second, and therefore false, god, which constitutes adultery against the one true God.[24]

Fray Juan de Santo Tomás, from the University of Alcalá, warned that the eyes are "thieves" that steal the heart, because "the representations that enter through them adhere to the imagination, and it requires great violence and labor to tear them away."[25] Children are especially susceptible to "lascivious and dishonest figures and paintings," wrote another Spanish theologian, because these images "are much imprinted on the fantasy." The danger of such nefarious images responded to the "infallible" power of images over the soul, which the theologian summarized as follows:

> What is put before the eyes, and is seen, is imprinted on the powers of the soul, according to the object [so that] seeing happy things makes one happy, and if they are sad, they sadden; and if painful, they cause pain; and if unsettling [descompuestas], they damage [descomponen] the soul, which is only one, and if lost, there is nothing more to lose.[26]

It was therefore essential for all devout Catholics to do as St. Teresa did and surround themselves with pious images to instill in the heart and in the soul devotion to God.[27]

It is precisely this power of images to influence the soul that comes closest to what St. Teresa experienced during her mystical visions. When her confessor asked Teresa how she knew the intellectual vision she had on the feast of St. Peter came from Jesus Christ, she replied that Jesus Christ told her "many times":

> But before ever He told me so, the fact was imprinted upon my understanding.... Though He remains unseen, so clear a knowledge is imprinted upon the soul that no doubt it seems quite impossible. The Lord is pleased that this knowledge should be so deeply engraven upon the understanding that one can no more doubt it than one can doubt the evidence of one's eyes....[28]

Although the visionary does not really see anything, a vision has a similar effect on the soul as seeing an image, in the sense that the vision also leaves an imprint on the soul. However, as St. Teresa explains, a vision "was like no earthly painting"; "If this was an image," she adds, "it is a living image" because God is present. This distinction has important implications about the nature of the visionary experience.

In the passage cited above regarding the dangers of indecent paintings, the theologian stated that "what is put before the eyes, and is seen, is imprinted on the powers of the soul, according to the object." By extension, the impression produced by the presence of God Himself during a vision must be infinitely beyond that of any material or imaginary image. The vision in fact stamps on the visionary's soul God's own seal, the *sigillum Dei*, which constitutes a "true portrait" of God by virtue of being an exact duplicate made from the original prototype.[29] This *imago Christi* left on the mystic's soul was akin to the physical imprint left by the face of Jesus Christ on the veil of St. Veronica.

There is yet another way in which the power of images informs the nature of the divine seal engraved on the visionary's soul, namely, the ability to represent. Just as images can make present someone absent, or invisible, so too does the indelible image of Christ on the mystic's soul provide a constant reminder of His divine presence. While living at her first, unreformed,

24. *Ibid.*, 375. In the King James Bible, Matthew 5:28 reads: "But I say unto you, that whosoever looketh on a woman to lust after her hath committed adultery with her already in his heart."

25. F. Cornejo et al., *Copia de los pareceres y censuras ... Sobre el abuso de las figuras, y pinturas lascivas y deshonestas ...* (Madrid, 1632), repr. in F. Calvo Serraller, ed., *La Teoría de la Pintura en el Siglo de Oro*, 2nd ed. (Madrid, 1991), 252.

26. "Presentación," in Cornejo et al., *Copia de los pareceres*, 244, 246.

27. C. Frugoni, "Female Mystics, Visions, and Iconography," in D. Bornstein and R. Rusconi, eds., *Women and Religion in Medieval and Renaissance Italy*, trans. M. J. Schneider (Chicago, 1996), 130–64.

28. *Life* (as in note 1), 250–51. The word "imprinted" reads "impressed" in Peers' translation.

29. For the notion of a "true portrait," see J. de Acuña del Adarve, *Discursos de las Effigies y verdaderos retratos non manufactos* (Villanueva de Andujar, Spain, 1637). On the concept of *sigillum Dei*, see Cea Gutiérrez, "Modelos para una santa" (as in note 16), 31.

Carmelite convent of La Encarnación, in her native Ávila, Teresa witnessed the following vision of Christ:

> I saw Him with the eyes of the soul more clearly than I could ever have seen Him with those of the body; and it made such an impression upon me that, although it is now more than twenty-six years ago, I seem to have Him present with me still.[30]

Just as a lover might carry near her heart a miniature of her loved one to assuage the sadness of their separation, Christ's imprint on Teresa's soul reminded her of His love during the "dry" spells when she had no visions.[31] Anecdotal evidence about this episode in Teresa's life reinforces the representative nature of the vision's imprint. The mystical vision just described inspired Teresa to commission for her first reformed convent of St. Joseph the painting of the *Christ at the Column*, discussed above.[32] According to a witness for Teresa's canonization process, Teresa made precise specifications to the painter she commissioned regarding how she wanted the portrait, describing in great detail the ropes tying Christ's hands, the bruises on the face, the hair, and in particular a scrape on the left arm near the elbow. The finished mural was in a hermitage especially built for it. When Teresa saw it, she stood in rapture. The *imago Christi* engraved on her soul inspired an actual painting with a similar power to recall His divine presence.

The Act of Seeing

The visual experiences also provided a compelling analogy for the interaction between the human soul and God. The ideas discussed thus far regarding the power of images over the soul and the role of seeing in Catholic religious practices were predicated on three basic assumptions: that the experience of seeing was direct, unmediated, and essentially passive. Because seeing was direct and unmediated, the wise and the ignorant could see in exactly the same way, since images simply entered through the windows of the soul and imprinted themselves on it. In addition, seeing required no effort, not even thinking, from the individual. Likewise, the visionary experience was direct, unmediated, and largely passive.[33] According to St. Teresa: "The Lord introduces into the inmost part of the soul what He wishes that soul to understand, and presents it, not by means of images or forms of words, but after the manner of this vision aforementioned." In other words, the soul can receive divine knowledge without the mediation of spoken words or images, and without requiring the visionary to make any effort other than being receptive to divine inspiration. It is, St. Teresa explains, "as if food were introduced into the stomach without our having eaten it or knowing how it got there." The person simply "finds all its food cooked and eaten: it has nothing to do but to enjoy it." Therefore, even the ignorant and the illiterate can receive divine knowledge at the blink of an eye. Despite the lack of any effort, such a person would understand so well "the mystery of the Most Holy Trinity, together with other lofty things," that no theologian would dare to challenge such learning.[34]

According to this interpretation, the visionary experience, like the act of seeing, requires nothing more than for the mystic to make herself receptive to the image or to the divine communication. St. Teresa repeatedly describes the state of rapture as one in which her physical and intellectual powers succumb to God's irresistible force. This is the version of the visionary experience represented in Gian Lorenzo Bernini's *The Ecstasy of St. Teresa*. Bernini's Teresa epitomizes the visionary as a passive agent.[35] Her own words would seem to confirm this interpretation beyond any doubt. During an ecstasy, Christ claims His lordship over

30. *Life* (as in note 1), 99–100 (chap. 7).

31. In the case of Clare of Montefalco (d. 1308), the imprint of Christ's vision was quite literal: a post-mortem autopsy revealed images of a crucifix and the passion implements engraved inside the nun's heart; see Caciola, *Discerning Spirits* (as in note 22), 176–78.

32. *Vida* (as in note 11), 146, n. 22. See also, Florisoone, "Estética de Santa Teresa" (as in note 15), 485.

33. On the degrees of passivity in St. Teresa's mystical experiences, see Martín del Blanco, "Los fenómenos extraordinarios" (as in note 6), 392–99.

34. *Life* (as in note 1), 251–52 (chap. 27).

35. S. Warma, "Ecstasy and Vision: Two Concepts Connected with Bernini's *Teresa*," *Art Bulletin* 66, no. 3 (Sept. 1984), 508–11.

the soul, and "The soul no longer wants to desire, nor would she want to have free will—and this is what she begs the Lord. She gives Him the keys of her will." [36]

Yet the mystic's complete surrender represents only a culminating moment in an arduous process that often requires what Teresa calls "the heroic deeds of true lovers of Christ." [37] Her own campaign to establish convents under the rule of her reformed Carmelite order required a whirlwind of activity that left her with little time to write and ended only upon her death. But even in her spiritual life, St. Teresa's soul hardly remained still. Her writings are full of military images. Her soul is both a castle and a fortress. She compares her spiritual struggles to fighting with a giant, to "a battle and conflict," and to "a troublesome war." [38] After offering resistance to God, she ultimately surrenders. Christ can then raise God's banner from the highest tower in the fortress of her soul. [39]

The passivity of the act of seeing would seem the opposite of this highly dynamic interaction between the soul and God, until we recall the notion of the soul as a battleground between pious and sinful images. The seemingly effortless disposition to open the eyes and allow in the image may sometimes involve considerable effort from the viewer. The theologians denouncing the dangers of lascivious images noted that children, women, and in general anyone without a strong will were easy prey for the spell of those images. [40] Yet whereas the devout Christian should surrender to God, she should resist with all her might the attraction of "dishonest figures."

In these parallels between the act of seeing and the visionary experience we find the struggle of Spanish mystics to explain the place of individual agency in the soul's ascent to God. On the one hand, that ascent could happen only once the soul surrendered its will to God. The highest expression of the mystical union of soul and God was the annihilation of human agency. On the other hand, Spanish mystics refused to deny the importance of free will in reaching that mystical union. The historian José Antonio Maravall applied the paradoxical term "active obedience" to describe the similar ideal among seventeenth-century Spanish political writers of a balance between the need for complete obedience to the king, but without denying the importance of subjects' liberty. [41]

This ideal of active obedience recalls as well the appeal of medieval and early modern mystics for the loving struggle between lovers in the Song of Songs. Artistic renditions of the biblical book reflect what Jeffrey Hamburger has described as "a sense of continuing and developing action." [42] The same is true of one of St. Teresa's poems, which seeks to convey this sense of action between the soul and God through imagery that fuses the visual and the visionary experiences. In the poem "Alma, buscarte has en Mí" (Soul, thou must seek thyself in Me), the Lover/God addresses the Beloved/Soul with the following declaration:

> De tal suerte, pudo amor,
> alma, en Mí te retratar,
> que ningún sabio pintor
> supiera con tal primor
> tal imagen estampar.
> Fuiste por amor criada
> hermosa, bella, y así
> en mis entrañas pintada,
> si te perdieres, mi amada,
> alma, buscarte has en Mí.

36. *Book of Her Life* (as in note 20), 130 (chap. 20, par. 22). Where the translators use "it" to refer to the soul, I have changed it to "she," as in the Spanish original.

37. *Ibid.*, 181 (chap. 27, par. 14).

38. *Ibid.*, 43 (chap. 8, par. 2: troublesome war; par. 3: battle and conflict), 121 (chap. 20, par. 4: giant).

39. *Ibid.*, 129 (chap. 20, par. 22).

40. Moreover, uneducated ordinary viewers were more susceptible to view even religious paintings "sensually" instead of with "purged eyes," without which they could not attain spiritual cogni-

tion; see P. M. Jones, "Art Theory as Ideology: Gabriele Paleotti's Hierarchical Notion of Painting's Universality and Reception," in C. Farago, ed., *Reframing the Renaissance: Visual Culture in Europe and Latin America, 1450–1650* (New Haven, 1995), 127–40, esp. 133–39.

41. J. A. Maravall, *Teoría del Estado en España en el siglo XVII*, 2nd ed. (Madrid, 1997), 323.

42. J. F. Hamburger, *The Visual and the Visionary: Art and Female Spirituality in Late Medieval Germany* (New York, 1998), 124.

Que yo sé que te hallarás
en mi pecho retratada,
y tan al vivo sacada,
que si te ves te holgarás
viéndote tan bien pintada.[43]

It was by love that thou wert made
Lovely and beautiful to be;
So, if perchance thou shouldst have stray'd,
Upon My heart thou art portray'd.
Soul, thou must seek thyself in Me.

[Such is the power of love's impress,
O soul, to engrave thee in My heart,
That any painter must confess
He ne'er could have the like success,
Howe'er superlative his art.

For well I know that thou wilt see
Thyself engraven on My breast—
An image vividly impressed—
And then thou wilt rejoice to be
So safely painted, so highly blest.][44]

43. "Alma, buscarte has en mí," in Santa Teresa de Jesús, *Obras Completas*, ed. L. Santullano, 11th ed., 6th repr. (1988), 717.

44. *The Complete Works of St. Teresa of Jesus*, trans. and ed. E. A. Peers, 11th impression (London, 1982), Vol. 3, 287. I have altered a few words in Peers' translation to provide a more literal sense of the Spanish.

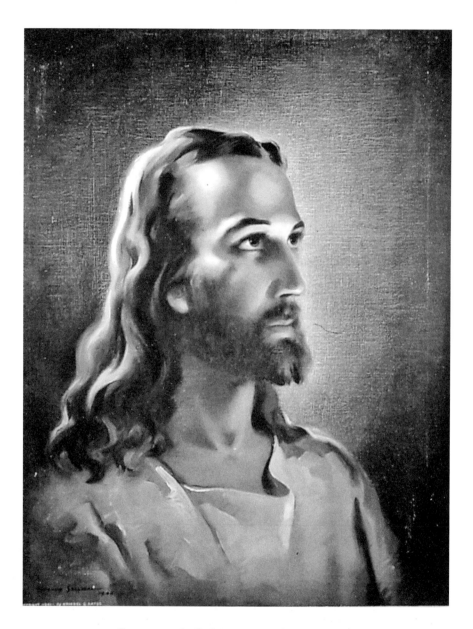

FIG. 1. Warner Sallman, *Head of Christ*, 1940, oil on canvas, 28¼ × 22⅛ inches (courtesy Warner Press, Anderson, Indiana).

DAVID MORGAN

Image, Art, and Inspiration in
Modern Apparitions

ARE THE MANY ACCOUNTS of miraculous images, visions, apparitions, and dreams that circulated during the Middle Ages comparable to what we encounter today on-line, on television, and on the covers of tabloids? Even though much of what one sees in the check-out line at grocery stores may be meant to be tongue-in-cheek, a great deal of material is published and received as true, such as a bleeding copy of Warner Sallman's *Head of Christ* (Fig. 1), which appeared in the *National Inquirer* in 1979, or a copy of the same image broadcast in 1993 on the television program "Miracles and Other Wonders," which miraculously exuded oil and healed a boy with terminal cancer.[1] As video stills from the program show (Fig. 2 & 3), the inexpensive copy of the *Head of Christ* was ritually installed as an icon in a Coptic church in a suburb of Houston, where the boy lived. The continuity between the treatment of a modern, mass-produced devotional image of Jesus and ancient icon veneration is striking. A comparable lineage was celebrated by the devout author of *Miraculous Images of Our Lord*, a volume which catalogued forty-two of what the subtitle states are "Famous Catholic Statues, Portraits, and Crucifixes," largely from Europe and Latin America, dating from the Middle Ages to the twentieth century, all of which have been documented as miracle-working by the Church.[2] To these kinds of Christian phenomena one may easily add UFO sightings, hauntings, premonitions and visions, wonders performed by angels, and fulfilled prophecies of Nostradamus as the tip of the supernatural iceberg in the modern world.

If the disenchantment of modern secularization actually happened anywhere outside of the academy, much of the world's population seems unaware of it. Secularization is perhaps better described as one cultural routine among others in modernity's repertoire. People turn out to be very good at juggling mutually contradictory propositions, making them work in spite of what purists (moral, aesthetic, or intellectual) hold to be inherently incongruous. Perhaps that is because epistemological impurity accommodates modernity far more than modernity's ideologues would care to allow. In *We Have Never Been Modern*, Bruno Latour described modernity's mercurial capacity to espouse at one and the same time a host of antinomies, e.g., atheism and theism, a remote God and an intimate one, materialism and spirituality.[3] For Latour, modernity is not the result of humanism or secularization or science and technology, but precisely this juggling act, a passel of opposites held in tension in the checks and balances of modernity's trope, constitutionalism. It is a useful insight because it allows us to recognize historical continuities rather than to fetishize the breaks that are so important to the ideology of the new. Modern but not Modernist, Latour's view of constitutionalism helps deliver us from a certain myopia and encourages us to recognize what is very old about the new. It is the way that moderns have their cake and eat it, too: they retain much of the religious past while enjoying a largely secular form of government. The First Amendment of the American Constitution cuts both ways to assure complementary liberties: it limits government but also protects it from religious prejudices; it removes religion from the state, but also safeguards

1. "Tiny Picture of Christ Weeps Tears of Blood," *National Enquirer*, 21 August 1979.
2. J. C. Cruz, *Miraculous Images of Our Lord: Famous Catholic Statues, Portraits, and Crucifixes* (Rock Island, 1995).
3. B. Latour, *We Have Never Been Modern*, trans. by C. Porter (Cambridge, Mass., 1993), 38–39.

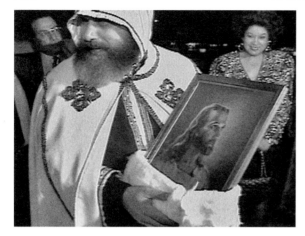 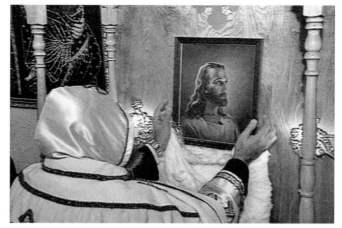

FIGS. 2 and 3. Coptic priest carrying a copy of Warner Sallman's *Head of Christ* and depositing it on a side altar in St. Mark's Coptic Church, from the television program "Miracles and Other Wonders," 1993 (courtesy of Grizzly Adams Productions ®, Inc.).

the liberty of citizens to practice any religion they may choose (or none at all). The result has been successful, or how else might we explain the flourishing of religion in one of the world's most technologically advanced nations? But it means the modern mind bears surprising appositions. A 2004 poll found that fifty-five percent of Americans believed that humans were not the product of evolution, but created in their present form by God.[4] In some matters of religious belief, a majority of Americans are perhaps better described as "medieval" rather than anything that might be consistently called Modernist, and in part they have their Constitution to thank for that fascinating paradox.

Art and Inspiration

The fact is that much of what used to be reported as happening many centuries ago still is. On the whole, apparitions and visions have not diminished, nor has the interest in hearing about them. Consider, for instance, the importance of the Byzantine and pre-Christian idea of the divine origin of sacred images, especially images of Mary and Jesus. A version of the idea persists in the modern world, used by artists and promoters of sacred art. A few examples will make the point that the modern world has not expunged the desire to celebrate images as revealed from above.[5] What has changed, although perhaps not dramatically, is the way of explaining the origin and operation of mental imagery.[6] The idea of artistic inspiration adapted to religious revelation enables artists to transform old imagery into new and forget the mundane visual source. This allows devout artists and admirers of their work to explain artistic inspiration as a miraculous or visionary operation, an act of visual revelation whose medium is the creative imagination. The divine enters the modern world through the individual psyche, where it arouses the imaginative vision of the artist. As we shall see, this subjective or psychological manifestation is also characteristic of the modern Marian apparitions.[7]

4. "Poll: Creationism Trumps Evolution," CBS News poll, conducted November 18–21, 2004. On-line at http://www.cbsnews.com/stories/2004/11/22/opinion/polls/main657083.shtml (accessed 19 March 2008).

5. On medieval treatments of *acheiropoietae*, or images made without human hands, see H. Belting, *Likeness and Presence: A History of the Image before the Era of Art*, trans. by E. Jephcott (Chicago, 1994), 62–9; and H. L. Kessler, *Spiritual Seeing: Picturing God's Invisibility in Medieval Art* (Philadelphia, 2000), 64–87.

6. Even the use of the dream, inspired by an image, is a motif to be found in the Middle Ages, see E. Kitzinger, "The Cult of Images in the Age before Iconoclasm," *Dumbarton Oaks Papers* 8 (1954), 108. Thanks to Cynthia Hahn for this reference. Hahn has written a very helpful overview of vision as concept and practice in the Middle Ages, "Vision," in C. Rudolph, ed., *A Companion to Medieval Art* (Oxford, 2006), 44–65.

7. I do not wish to sweep aside the many differences between modern and pre-modern eras, only to refute the typically Mod-

In 1797, the Romantic art enthusiast, Heinrich Wackenroder, told the story that Raphael was able to paint such beautiful images of the Madonna because "the picture had fallen into his soul like a heavenly beam of light." Wackenroder's persona in his tale was an art-loving monk who claimed to have found the account in the hand of the Renaissance architect, Bramante, squirreled away in a monastery. Bramante related what his friend, Raphael, had told him. In the midst of painting a picture of the Virgin, Raphael experienced a powerful dream:

Once, during the night, when he had prayed to the Virgin in a dream, as had often happened to him before, he had suddenly started out of his sleep, violently disturbed. In the dark night his eye was attracted by a bright light on the wall opposite his bed and, when he had looked closely, he had perceived that his picture of the Madonna, still uncompleted, had been hung upon the wall, illuminated by the gentlest light, and had become a perfect and truly living image. The divinity in this picture had so overpowered him that he had broken out into hot tears. It had looked at him with its eyes in an indescribably touching manner and, at each moment, had seemed as if it wanted to move; and it had seemed to him as

if it also really were moving ... The next morning he had arisen as if newly born; the vision had remained firmly stamped in his mind and his senses for eternity. And, thereupon, he had succeeded in portraying the Mother of God each time just as she had appeared to his soul.[8]

The important role of the heart in Wackenroder's account (he entitled his book "Herzensergiessungen eines kunstliebendes Klosterbruders," or Outpourings from the Heart of an Art-loving Friar) served as a transitional subjectivization of belief, inherited from the early modern era. Over the course of the eighteenth century the imagination came to be regarded as a mental faculty of creative feeling that participated in thought, art, taste, and moral sentiment. As a result, the imagination came to serve the artist as the interior where spirit and artistic invention intermingled. Given the importance of the heart in Pietism as well as Baroque Catholic spirituality (think of the development of the devotion to the Sacred Hearts of Jesus and Mary since the seventeenth century), it is not surprising that Wackenroder would identify heart, soul, and imagination as one in the same spiritual and creative faculty, and fix on the dream as the passionately felt medium of artistic revelation.[9]

ernist insistence on radical breaks. For example, William Christian concluded in his major early study of Catholicism in Spain over several centuries that two world views had come to co-exist: the older piety devoted to shrine imagery and the newer generalized devotionalism. The former focused on local intercessors who had power over nature; the latter, such as the modern apparitions of Mary, were intercessors between human and divine, see W. A. Christian, Jr., *Person and God in a Spanish Valley*, rev. ed. (Princeton, 1989), 182; also 44–78. An even more modern model, reflecting the perspective of the Second Vatican Council, was also insightfully described by Christian. Christian's view was affirmed by Victor and Edith L. B. Turner in their study of Marian apparitions and pilgrimages, *Image and Pilgrimage in Christian Culture: Anthropological Perspectives* (New York, 1978), 206–207.

8. W. H. Wackenroder, *Confessions and Fantasies*, trans. M. Hurst Schubert (University Park, Pa., 1971), 84. Wackenroder, *Herzensergiessungen eines kunstliebenden Klosterbruders*, in Wackenroder, *Sämmtliche Schriften*, ed. by C. Grützmacher and S. Claus (Berlin, 1968), 13–14:

Einst, in der Nacht, da er, wie es ihm schon oft geschehen sei, im Traume zur Jungfrau gebetet habe, sei er, heftig bedrängt, auf einmal aus dem Schlafe aufgefahren. In der finstern Nacht sei sein

Auge von einem hellen Schein an der Wand, seinem Lager gegenüber, angezogen worden, und da er recht zugesehen, so sei er gewahr geworden, daß sein Bild der Madonna, das, noch unvollendet, an der Wand gehangen, von dem mildesten Lichtstrahle, und ein ganz vollkommenes und wirklich legendiges Bild geworden sei. Die Göttlichkeit in diesem Bilde habe ihn so überwältigt, daßer in helle Tränen ausgebrochen sei. Es habe ihn mit den Augen auf eine unbeschreiblich rührende Weise angesehen, und habe in jedem Augenblick geschienen, als wolle es sich bewegen; un es habe ihn gedünkt, als bewege es sich auch wirklich.... Am anderen Morgen sei er wie neugeboren aufgestanden; die Erscheinung sei seinem Gemüt und seinen Sinnen auf ewig fest eingeprägt geblieben, und nun sei es ihm gelungen, die Mutter Gottes immer so, wie sie seiner Seele vorgeschwebt habe, abzubilden....

9. On Wackenroder's artistic spirituality, see M. Barasch, *Modern Theories of Art, 1: From Winckelmann to Baudelaire* (New York, 1990), 293–304; on Wackenroder, Pietism, and the heart, see Hurst Schubert, "Introduction," *Confessions and Fantasies*, 29–30, 44–52 (as in note 8); on the visual history of the Sacred Heart, D. Morgan, *The Sacred Heart of Jesus: The Visual Evolution of a Devotion*, Meertens Ethnology Cahier 4 (Amsterdam, 2008); a study of the heart as a theological and devotional motif in early modern

To his fictional narrative, which clearly recalls medieval accounts of miraculously moving images of the Virgin, Jesus, and the saints, may be added two that are closer to the present day.[10] First is the explanation of creative vision embraced by the French Catholic painter, James Tissot, who devoted two trips to Palestine in order to collect and process his impressions of the Holy Land for the preparation of his monumental two volume set, *The Life of Our Saviour Jesus Christ*, issued in France in 1896–97, in London in 1897–98, and in New York in 1899. In an article dedicated to the artist and his several hundred images for the project, the American writer Cleveland Moffett described Tissot's method for readers of *McClure's Magazine*. The artist, he said, gathered rough sketches on site, walking about Jerusalem and the countryside, but did not work up finished pictures during his two visits there. He returned to his studio in France for that purpose, where a mysterious kind of mental alchemy took place.

> But now a strange thing would happen, a rather uncanny thing, did we not know the many mysteries of the human brain. Scientists have called it "hyperaesthesia," a super-sensitiveness of the nerves having to do with vision. And this is it—and it happened over and over again, until it became an ordinary occurrence—M. Tissot, being now in a certain state of mind, and having some conception of what he wished to paint, would bend over the white paper with its smudged surface, and, looking intently at the oval marked for the head of Jesus or some holy person, would see the whole picture there before him, the colors, the garments, the faces, everything that he needed and had already half conceived. Then, closing his eyes in delight, he would murmur to himself: "How beautiful! How wonderful! Oh, that I may keep it! Oh, that I may not forget it!" Finally, put-

ting forth his strongest effort to retain the vision, he would take brush and color and set it all down from memory as well as he could.

According to Moffett, the "high degree of sensitiveness" possessed by many artists "gives them, literally, the power of beholding visions."[11] The vivid capturing of essential materials was understood as a selective process of memory that some contemporary French artists practiced as a way of sifting important from inessential aspects of their subjects.[12] Memory was part of the creative process, which it certainly was for the development of modern apparition imagery, which, as we shall see, remembered the visual features of the Virgin as rhyming with the iconographical tradition of her Assumption and Immaculate Conception.

A final instance of the visionary faculty of a pious artist of the modern world repeats the adaptation of the visionary origin of sacred images. As with the previous two examples, this one also displays the modern motif of regarding the artist as the vehicle of miraculous images. If medieval Western and Byzantine traditions could discover icons and holy pictures in trees, fallen from heaven, painted or completed by angels, or received as self-transporting images that traveled through the air or over the sea in search of a new shrine, modern artists locate the miracle in their imaginations, the site of divine inspiration, which their drawings and painting then serve to document.[13] As he told the story in the 1940s, Warner Sallman, a pious illustrator for the YMCA, the Salvation Army, and his own church body, the Swedish Evangelical Covenant, was faced with a publication deadline. One night in January 1924, unable to produce an illustration for a commercial assignment, he went to bed in frustration. "The clock was nearing two when suddenly and viv-

Europe is B. F. Scholz, "Religious Meditations on the Heart: Three Seventeenth Century Variants," in *The Arts and the Cultural Heritage of Martin Luther*, ed. by E. Østrem, J. Fleischer, and N. Holder Petersen (Copenhagen, 2003), 99–135.

10. Major studies are, of course, D. Freedberg, *The Power of Images: Studies in the History and Theory of Response* (Chicago, 1989); and W. A. Christian, Jr., *Apparitions in Late Medieval and Renaissance Spain* (Princeton, 1981), and *idem, Moving Crucifixes in Modern Spain* (Princeton, 1992).

11. C. Moffett, "J. J. Tissot and His Paintings of the Life of Christ," *McClure's Magazine* 7, No. 5 (March 1899), 394.

12. See P. ten-Doesschate Chu, "Lecoq de Boisbaudran and Memory Drawing: A Teaching Course between Idealism and Naturalism," in *The European Realist Tradition*, ed. by G. P. Weisberg (Bloomington, 1982), 242–89.

13. See Freedberg, *Power of Images* (as in note 10), 309–10, for discussion of self-transporting images.

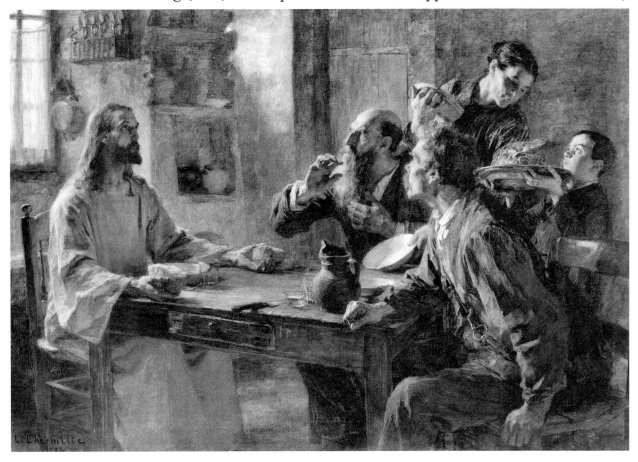

FIG. 4. Léon Lhermitte, *The Friend of the Humble*, 1892, oil on canvas, 61¼ × 87¾ inches (gift of
J. Randolph Coolidge, courtesy of Museum of Fine Arts, Boston).

idly there appeared to his mind's eye a picture. How clear it was! Impelled by this revelation he hastened out of bed, sat down at his board, and made a three-inch thumbnail sketch of what he had envisaged."[14] Convinced that "this revelation was from God, he fell into a deep and peaceful sleep." The next morning Sallman produced a larger and more finished version of the image (which he eventually produced as an oil painting—see Fig. 1). Years later he conceded that he had actually seen the reproduction of a painting of Christ by the French artist, Léon Lhermitte about a year earlier (Fig. 4).[15] It is helpful to remember that, for his part, Raphael owed no little debt to his teacher, Perugino, as the striking similarity of their Madonnas recalls. I point this out not to debunk the visions attributed to each image-maker, but to suggest the fundamental role that images continue to play in visions in the modern period. It seems that visions tend to occur when there is a significant visual density that bestows upon pictures a recognizability such that viewers

14. S. E. Peterson, *The Ministry of Christian Art: A Story of Artist Warner Sallman and his Famous Religious Pictures* (Indianapolis, 1947), 1. I have discussed numerous variations on Sallman's account in D. Morgan, "'Would Jesus Have Sat for a Portrait?' The Likeness of Christ in the Popular Reception of Sallman's Art," in *Icons of American Protestantism: The Art of Warner Sallman*, ed. by D. Morgan (New Haven, 1996), 184–87.

15. For Sallman's discussion of the image's source, Léon Lhermitte's *The Friend of the Humble*, 1892, which was reproduced in *Ladies' Home Journal* 39 (December 1922), 20, see M. Anderson, "His Subject Shaped His Life," *War Cry* (December 9, 1961), 7–8, 10. I have discussed the issue in "Warner Sallman and the Visual Culture of American Protestantism," in Morgan, *Icons of American Protestantism* (as in note 14), 30–31.

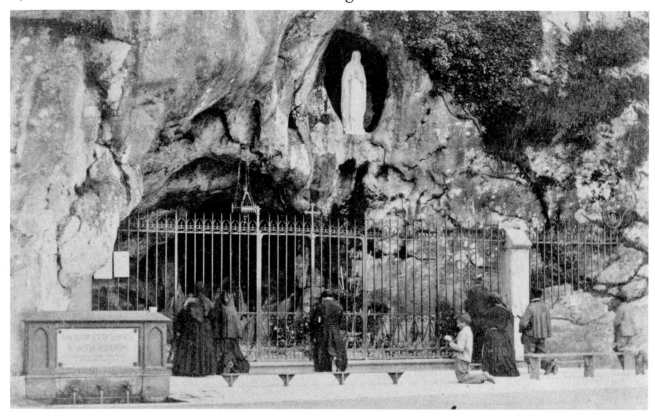

FIG. 5. Shrine at Lourdes, ca. 1870 (Art Resource).

experience a strange familiarity when they see them. Pictures of Mary or Jesus, or, of Elvis for that matter look right, as if they fit templates, which means that they feel authentic, filling the expectations that devout viewers bring to them.

These examples highlight the way in which images help make visions and apparitions work. The narratives assert that the image resulted from a mental vision of some sort, amounting to a material transposition from the interior of the mind, a copy of its cerebral or empyrean original. In fact, copies may be said to antedate their putative originals. This is not to pursue a Modernist, secular dismantling of spiritual visions, but to describe the visual construction of the sacred as a process that incorporates the history of images into the fixing of the apparition.

Not only are image-makers still producing miraculous images of a sort, popular religious practice affords dozens of examples of apparitions of angels, Jesus, and Mary that give the visual culturalist a welcome oppor-

tunity to understand more about the relationship between mental revelations and devotional imagery. As an example of how visibility takes shape within a religious culture, we may consider several of the modern portrayals of Our Lady (Figs. 5–8). It is surely noteworthy that in imagery that eventually issued from different forms of devotion to her, Mary appears as a small, doll-like figure, chastely dressed, hovering daintily in the air or perched on bushes or amidst flowers. She wears white drapery, gestures tenderly, and speaks only to one child or at most a few children. Why does she appear this way? Why does the Virgin look the way she does? What are the visual mechanics of apparitions?

We should begin by noting the historicity of Mary's visual form. The patterns of her appearance over the centuries in two streams of images are striking. In a long line of images of the Assumption and the Immaculate Conception by artists such as Velazquez, Zurburán, and Murillo (see Fig. 8) we find a clear iconogra-

FIG. 6. Our Lady of Lourdes, at the Grotto of Lourdes, 1896, Notre Dame University campus (photo: author).

FIG. 7. José Thedim, *International Pilgrim Statue of Our Lady of Fatima*, 1947, polychrome mahogany, ca. 40 inches high (photo: author).

phical tradition taking shape; and in images of the more recent apparitions (see Figs. 6 & 7) we see a clearly indebted way of visualizing Our Lady. The overarching pattern is pervasive and striking. There is a look to her, however much it has evolved and continued to change since the early modern era. She is almost never shown seated, but rather standing, even floating erect before the children and viewers of the image. Her hands are typically joined in some manner. Her face appears full and radiant, either gazing downward at the children or the earth of humankind below, or she looks heavenward. In any case, her gaze signals her role as mediator. She is dressed in a full-length gown and an outer mantle. She bears a halo of stars or light. The visual formulae establishing her appearance are unmistakable in spite of the many variations over time.

FIG. 8. Murillo, *Assumption of the Virgin*, 1670, oil on canvas. The Hermitage, St. Petersburg. (Art Resource.)

Misrecognizing Mary

But for all this tenacious pictorial recipe, it is remarkable that accounts of Mary's apparitions show that the children did not recognize her. As many scholars have noted, when she appeared at La Salette, Lourdes, and Fatima she was not immediately identified as the Virgin Mary.[16] Why, in view of this iconographical consistency, didn't the children recognize her at once? Apparently, these images are not what they saw. Recognition is a slower, more complicated process. Consideration of the formative first days of several apparitions will make this clear.

Mélanie Calvat described the appearance of "a most beautiful lady" on the mountain of La Salette in 1846. Over the course of several months as they recounted the event, Mélanie and her friend, Maximin, continued to puzzle over who the figure might have been. Both children had seen her only unclearly inside a bright light. Maximin reported that she was crying and that the seated figure had her faced buried in her hands. Upon her first appearance to Bernadette at Lourdes in 1858 and to the children at Fatima in the spring of 1917, the figure was also known only as a "lady." Bernadette called her "aquero," a vernacular pronoun meaning "that one." Bernadette did not know her name for several apparitions over a period of two weeks until the woman told her "I am the Immaculate Conception." A turn-of-the-century journalistic account summarizes the appearance on the first two days, conveying Bernadette's uncertainties for American readers of a mainstream magazine:

> Then she glanced toward the rocks, and was half blinded by a great light which gathered against the side of a cliff, where an aperture like a rude oval window sank into the crag … Bernadette fell to her knees in her fright, but kept her eyes on the niche above the cavern. Little by little in the light she discerned a white form, and she trembled lest this figure should be the devil….

The next day, after suffering her parents' disbelief in the event as "childish nonsense," she returned to the spot against their orders, impelled by townsfolk who urged her to go "armed with a bottle of holy water, to ascertain whether or no it was the devil she had to deal with."[17]

At Fatima, Lucia and Jacinta referred to the figure they saw as "a beautiful Lady," but did not know her name.[18] The lady had been preceded over a two year period by other apparitions: by "a person wrapped up in a sheet" in 1915 and in the following year by a young male figure, "whiter than snow, transparent as crystal when the sun shines through it," who identified himself as an angel.[19] And it is not as if the children were unfamiliar with devotional imagery of Mary doing miraculous things. Sister Lucia recalled many years later that about 1914 a statue of Our Lady of the Rosary on the altar of her parish church had appeared to smile at her.[20] The lady who appeared in the summer of 1917 did not tell the children her name until the third apparition, on 13 July. They had intended to keep the entire affair a secret from the first, which they might have done since the apparition was only visible or audible to the three of them (a feature common to virtually all modern Marian apparitions). Clearly, the identity was not a foregone conclusion from the beginning, but developed, gradually congealing in the larger matrix of the children's experience as the affair became more and more public and the difficulties for the children mounted into a significant crisis. The identity was adapted to appearances as the meaning became clear.

Likewise at Medjugorje, where on 24 June, 1981 six children saw what an official website narrative describes as "an incredibly beautiful young woman with a little child in her arms." The children were "surprised and frightened" and "afraid to come near," even though the text states that "they immediately thought her to be Our Lady." But they remained unsure. In the first days, the vision occasionally acted erratically,

16. See, for example, S. L. Zimdars-Swartz, *Encountering Mary: Visions of Mary from La Salette to Medjugorje* (New York, 1992), 47–51, 68–77; M. P. Carroll, *The Cult of the Virgin Mary: Psychological Origins* (Princeton, 1986), 173–81; and Turner and Turner, *Image and Pilgrimage in Christian Culture* (as in note 7), 214–26.

17. C. Johnson, "A Town of Modern Miracles," *The Outlook* 65 (July 7 1900), 564.

18. *Fatima in Lucia's Own Words*, ed. by Fr. L. Kondor, S.V.D., trans. by Dominican Nuns of Perpetual Rosary (Fatima, 1976), 28.

19. *Ibid.*, 59, 62. 20. *Ibid.*, 55.

suddenly leaving and then returning. After two more sequential days of seeing the apparition, they took the advice of some local women and, borrowing a page from the account of Bernadette, took holy water with them in order "to make sure that it was not Satan." After the figure appeared to them, one of the children, "took the water and splashed it in the direction of the vision, saying 'If you are Our Blessed Mother, please stay, and if you are not, go away from us.'" [21] When the figure confirmed to them who she was, the children were assured.

Misrecognition seems to be a fundamental feature, even a commonplace of modern Marian apparitions. But it did not begin there. The motif is found in biblical accounts where Christ's own disciples failed on much more famous occasions to recognize him. It is described as having occurred several times, both before Jesus' death, when he approached his disciples walking over the water in Galilee, and after, when he appeared to the Marys outside of his tomb, and when he walked along the road to Emmaus with two followers. The Gospel of Matthew relates that one windy night on the Sea of Galilee Jesus appeared to his disciples, "walking on the sea." When they saw him "they were terrified, saying, 'It is a ghost!' And they cried out of fear. But immediately he spoke to them, saying, 'Take heart, it is I; have no fear'" (Matthew 14:25–26). Tissot pictured Jesus aglow, emanating a spectral aura (Fig. 9), as if to account for the disciples' misrecognition. His radiance, frontal presentation, raised hands, and direct gaze recall the iconography of Marian apparitions. No doubt early members of the Jesus cult faced a situation comparable to promoters of new Marian cults: how to make the narrative self-authenticating? The incorporation of misrecognition may help demonstrate the certainty of the first devotees: they approached the mysterious event with a skepticism that resulted in a tested reassurance. They were not looking for Mary or Jesus to appear, but they did so entirely on their own. As with Jesus' disciples, the children's misrecognition of Mary at Fatima and elsewhere serves to underscore

FIG. 9. James Jacques Tissot, *Jesus Walking on the Sea*, published in Tissot, *The Life of Our Saviour Jesus Christ*, 2 vols., London: Sampson, Low, Marston, & Company, 1897–98, vol. 1, p. 177 (photo courtesy Brooklyn Museum).

21. "A Short History of Our Lady's apparitions in Medjugorje," at http://www.medjugorje.ws/en/apparitions/ (accessed 7 March 2008).

the unexpected nature, and therefore confirm the reliability, of the appearance.

As a topos, the disguise of the sacred person also serves to engage the reader-viewer in the mystery and revelation of sacred power. As onlookers, believers are taken back to the moment of mystery, the origin of the subsequent cult, and allowed to glimpse its elusive beginnings. And yet, it is striking that the popular literature on the Marian apparitions commonly glosses over or even eliminates the episodes of misrecognition. At some point in the life of the devotion, perhaps, certainty seeks a new register, one from which all doubt has been expelled. For the faithful who seek healings or other blessings from a long and officially recognized intercessory figure like Our Lady of Fatima, the precise details and the confirmatory function of the topos are simply no longer necessary. The misrecognition is forgotten and the image on devotional cards or the statuary placed in grottos becomes the way Mary appeared, clear as day.

The act of misrecognizing is not just a literary or rhetorical device. It has a visual career that is relevant here. It is part of a process of remembering that is also a kind of forgetting. As the children remembered the original apparition, it congealed into Our Lady, helped along eventually by images. The blurry image of a burst of light developed into a pretty, doll-like lady perched in clouds. In time, the devotion forgets that process and fixes entirely upon the devotional image. One is reminded of a similar act of forgetting in the inspiration of pious artists, who overlook the borrowing that constitutes the empirical basis of their visions. Thus, Sallman appears to have ignored or for-

gotten the source of his image of Jesus (cf. Figs. 1 & 4).[22] The two processes, forgetting and misrecognizing, are inversions of one another. Images seem to facilitate a transposition or metamorphosis that is basic to the forms of visual piety under discussion. In the first case, an image veils or forgets its source in order to produce a strangely compelling, revelatory, virtually iconic portrait; in the other, the apparition is not recognized, and is later replaced by an image that effectively cancels the misrecognition by becoming the faithful representation of the apparition. This identification of image and apparition is sealed when the image begins to work miracles, as in the case of The Pilgrim Statue of Our Lady of Fatima (see Fig. 7).[23] At that point it becomes important to cease to recite the original confusion.

But the visual construction of the sacred likeness is what interests the student of visual culture, so retracing the development of devotion to Fatima may serve as a case study. Scholars studying the modern apparitions have noted that, generally, the figure of Mary has only subsequently been identified by someone other than those who experienced the apparition, that is, someone who did *not* see her, but wants to secure her appearance and meaning in relation to the Church as institution and authority.[24] This suggests that the expectations and the setting under which the children first encountered their apparitions did not provide the interpretive cues that allowed them to see the Virgin Mary. It is not really clear what the children saw because the visibility of the apparition took time to be resolved. It took hectoring parents and priests and the intrusion of civil authorities. It required theological

22. Sallman's is by no means the only occasion on which a pious creator of an image of Jesus forgot the visual source of his vision and its pictorial representation. The same kind of apparently forgotten borrowing occurred when a young man named Mark Cannon, injured in an accident and fallen into despair, produced a drawing of Jesus that was clearly indebted to a well-known film still of Christ from Franco Zeffirelli's 1977 made-for-television film, *Jesus of Nazareth*. But the website offering copies of Cannon's drawing for sale makes no mention of the debt, constructing the following account of the drawing's divine origin instead: "Four hours of intense effort slipped by in a moment. He felt his heart open, when suddenly he was staring into the eyes of Jesus

Christ—eyes which he had drawn with his pencil, and which now drew him into their power of His love. It was as if He himself had guided his hand and allowed him to see with his own eyes, and feel with his heart, the true significance of His sacrifice." http://www .crownofthornsprints.com/testimony.htm.

23. I have discussed this statue in particular, D. Morgan, "Aura and the Inversion of Marian Pilgrimage: Fatima and Her Statues," in *Moved by Mary: Pilgrimage in the Modern World*, ed. by A. Hermkens, W. Jansen, and C. Notermans (Oxford, 2009), 49–65.

24. Zimdars-Swartz, *Encountering Mary*, 32 (as in note 16); Carroll, *Cult of the Virgin Mary* (as in note 16), 148–72.

paradigms, emergent ritual viewings, the fervent response of the local community, and the determinative intervention of sympathetic clergy for the visibility to take shape.[25] The children saw something, perhaps, but as the accounts themselves make clear, they did not see what we see when we look at the devotional imagery of each apparition. The firm visual bearings of an iconographical type, the easily recognizable, universally familiar formulae of devotional imagery, is a later arrival, only gradually developing as the community of belief sorts out a system of visual communication that will make the elusive, ineffable, and idiosyncratic features of an apparition into an available protocol of devotion. It is easy, indeed, quite tenable for believers to conflate image and apparition. Pious biographers of Sister Lucia, for example, take quite for granted that when she referred to the apparition as a "lady" in her early written and oral accounts, she meant nothing different than "Our Lady," which was what she said later. But critical analysis, whether it is the non-believing scholar or the church's skeptical investigator, must look beneath this conflation. The power of images to hide fault lines and evolving narratives and erase contradictory details must always remain in mind, not simply as a form of false consciousness, but as a creative form of thought and practice. Scholars need to see the cloaking or transformative effect of images not merely as a form of deception, but as the way visual piety works. The misrecognition of Mary, which is later forgotten, inverts the procedure observed in cases of artistic inspiration where artists veil a source, thus forgetting it.

Rather than dismiss such instances as disingenuous or nothing more than plagiarism, scholars who wish to understand apparitions as forms of visual culture should place them in a different interpretive register and recognize that religious vision is a form of imagination that relies on the transposition of images. The point is to enrich and deepen the understanding of the way images collaborate with the imagination and communities of viewers. The ritual and theological meaning of the apparition of the Virgin is not clear until an image helps clarify or solidify what the children saw because what the Virgin looks like is what she is like, that is, what her meaning and message will be. Likeness or visibility is a structure of relations, a way of seeing that is a way of knowing. Rather than direct portrayals of what the children saw, the images of the apparition are better understood as the devotion's codification or fixing of how to enter into and maintain a devotional relationship with Mary. What Lucia saw at Fatima evolved from the 1915 manifestation, to the angel of 1916, to the lady of May and June 1917, to Our Lady in July, and her development did not stop there. Indeed, Our Lady continued to evolve as Sister Lucia gradually disclosed through successive memoirs and visions beginning in 1925 and stretching until 1941. But the constancy of images served to stabilize the person beneath or behind or within these semantic shifts and embellishments. Images anchor a shifting meaning by appearing to come after the original event in just the way that a fragment of a circle is morphed by the human eye into a complete circle. In other words, seeing contributes to what is seen. Images of Our Lady take shape after the event of her appearance, which they appear to capture by making the apparition visually accessible. More accurate perhaps would be to say that apparitions or visions occur within the

25. The powerful role of authorities of different kinds in shaping the discourse and imagery of apparitions recalls in at least one way the powerful influence of police, prosecutors, and other legal authorities in shaping what eye witnesses report. This has been studied as a forensic phenomenon regarding visual evidence, for example, D. F. Hall, E. F. Loftus, and J. P. Tousignant, "Postevent Information and Changes in Recollection for a Natural Event," in *Eyewitness Testimony: Psychological Perspectives*, ed. by G. L. Wells and E. F. Loftus (Cambridge, 1984), 124–41. The coercive influence of authorities also has been argued to exert catastrophic effects in distorting and prompting the testimony of children in instances of alleged sexual abuse. See, for instance, L. Manning, "Nightmare at the Day Care: The Wee Care Case," *Crime Magazine: An Encyclopedia of Crime*, on-line at www.crimemagazine .com/daycare.htm (accessed 17 March 2008). Yet I do not wish to suggest a direct parallel to apparitional visual piety since doing so would incline us to read apparitions as examples of pathology. A more constructive approach will not ignore instances of delusion when they occur, but neither will it presume that religious visions are merely delusional or that adherence to them by devotees is no more than a form of deception.

FIGS. 10 & 11. Guss Wilder III, Appearance of Madonna image on the windowpanes of a corporate office building, Clearwater, Florida, 1996, and the gathering of a large crowd before the image (courtesy of Guss Wilder III and Gary Posner).

stream of images, which is already there, moving through the minds of viewers as the wherewithal for seeing what they want very much to see. And so Our Lady appears to them in the body of an image, a faithful event, surely, an act of visual piety. A good example of this is the statue (see Fig. 7) that travels around the world as the official Pilgrim Statue of Our Lady of Fatima, which was not carved until 1947, when it was pronounced by Sister Lucia to be the image that most resembles what she saw in 1917.

There is in addition to this kind of image-apparition relation another large category of visual appearance, a different mode of apparition, one that inverts the role of the image just outlined. On some occasions it is the image that comes first—as a picture of Jesus in a forkful of spaghetti, in the suds of a beer glass, or on a tortilla. Even if these are no more than mere stunts, the manner in which they match figure to picture makes my point. Each involves the resolution of "visual noise," that is, the interpretation of marking as a recognizable pattern. More seriously, the figure of the Virgin on buildings is what it is precisely because it evokes the image we already knew (Figs. 10 & 11). The difference between the two kinds of apparitions is that the second type is not a private revelation, an appearance limited to a single person—recall that at Fatima, in the presence of hundreds, even thousands, it was only Lucia and Jacinta who saw Our Lady and

Francisco who heard her. In the second kind of appa-rition, Our Lady manifests herself very publicly as an image in such common objects as a wall, a tree, or food. In these instances one recognizes the figure as Marian by discerning its similarity to one or more models in the lexicon of familiar images. The viewer must rec-ognize a match, a correspondence to a prevailing pro-totype, otherwise the apparition does not occur. It is a matter of discovery, of seeing what was not there, what others may still not see, what must be sought for and once recognized is unforgettable. Devout viewers do not resolve the likeness by gradually settling on a vi-sual type to represent it, but begin with the visual fact of the image and proceed to determine what it means by asking why the Virgin has appeared at this time, in this place? The response, if it is a religiously earnest one and not only an entertaining spectacle, involves a material appropriation of the image, a devotional re-contextualization of the site. As news about the appa-rition circulates, pilgrims begin to visit and transform the site (Fig. 11), surrounding and framing the images with candles, votive offerings, and other images. An improvised architecture of enshrinement emerges, at first perhaps composed principally of human bodies, which gather about the image and transform it into a spectacle by virtue of a concerted gaze as well as by the many things they deposit before the image. As a result, the developing gestalt of the apparition is fixed and its meaning ascertained by the testimonies and sharing of stories among pilgrims.

Another instance available on the Internet is the postmortem appearance of Pope John Paul II in a pho-tograph of a bonfire in Poland burning to mark the sec-ond anniversary of the pontiff's death in 2007.[26] The fiery image makes us keenly aware of the importance of visual media. The apparition could not exist with-out being a photograph. Who would have glimpsed the instantaneous effigy by staring at a bonfire? In fact,

the Polish man who snapped several photographs of the commemorative bonfire was quoted as saying, "It was only afterwards when I got home and looked at the pictures that I realized I had something."[27] John Paul II did not become visible in the actual and very narrow flicker of time that the shape of flame existed. Indeed, his apparition only came to exist in the photo-graph, which captured an instant seen from one angle and made it into an enduring gestalt with a meaning, a sign bearing an intention for faithful viewers. The photographer found warrants to bolster his percep-tion. The bonfire was intended, after all, as a remem-brance of the Holy Father by his countrymen. Further-more, when the photographer showed the picture to a local bishop (not all of the pictures he took—only the one with the image in it), the bishop told him that John Paul II had "made many pilgrimages during his life and he was still making them in his death." The devout recognize in the contour of the flame the resemblance of a familiar image. Press accounts of the apparition paired the bonfire flame with a photograph of the pon-tiff near the end of his life, seen from an angle that bore close resemblance to the effigy in flame. Once the two images are seen together, the second retrospectively tailors the bonfire snapshot until devout viewers can see nothing else.

The Matter of Vision

The role of the materiality of the medium is key to understanding the visual culture of apparitions. This has also been studied in the use of Polaroid photogra-phy in pilgrimages to Marian apparition sites (Figs. 12 & 13).[28] In the imagery that has emerged from visual practices using Polaroids at shrines and places where Mary continues to show herself, two uses of photo-graphs have become prominent: images that are un-derstood to document her appearance and images that

26. For the imagery, see http://images.google.com/images?hl=en&q=john+paul+II+in+fire+image&um=1&ie=UTF-8 (ac-cessed 2 March 2008)

27. See: http://www.dailymail.co.uk/pages/live/articles/news/worldnews.html?in_article_id=487764&in_page_id=1811 (ac-cessed 2 March 2008)

28. D. Wojcik, "'Polaroids from Heaven': Photography, Folk

Religion, and the Miraculous Image Tradition at a Marian Ap-parition Site," *Journal of American Folklore* 109, No. 432 (Spring 1996), 129–48. For images, messages, and the Flushing Meadows, Queens, New York apparition site's official web page, see http://ourladyoftheroses.org/images or http://www.tldm.org/photos/olbysky.htm (accessed 2 March 2008)

FIG. 12. Matt Gainer, color photograph. Followers of Maria Paula Acuña photograph the sky to document the Virgin's presence, 13 December 2007, Mojave Desert (courtesy of Matt Gainer).

FIG. 13. Matt Gainer, color photograph. Followers of Maria Paula Acuña share Polaroid photographs, 13 June 2006, Mojave Desert (courtesy of Matt Gainer).

serve as occasions for divination, registering her messages for the faithful in a visual code. In the first case, Mary's appearance is commonly associated with the sun, a brilliant burst of light that confirms her presence, not often by limning her figure, but announcing her appearance in a blaze of light. Such photographs allow the devout to see her glory and participate in the message preached by the visionaries who first glimpse her appearance and then continue to receive her messages and share them with the community that gathers at the site.[29]

In the other instance of apparition imagery, the visual medium is a system of coded disclosure, conveying sacred information revealed to those with the faith necessary to receive it. Auras, reflections, glints, and all the visual disturbance or noise produced by luminous or chemical effects in Polaroid photography are regarded by the faithful as forms of heavenly communication.[30] As in any divination practice, chance plays an irreducible role in this process. By removing human intentionality from the production of marks, the element of randomness opens the door to supernatural causation. Because disconfirmation is impossible, all that is required are belief and the need to find the hand of God at work in one's life. The specific intention of God is determined by interpreting the marks according to a flexible lexicon of symbols that read the marks as a hermetic code. The principle is not unlike the visual suggestion of Tarot cards.[31] Naturally, this code is all the more telling when applied by those motivated by the desire and propelled by the predisposition to tailor a message to their own situation, that is, to enter into personal communication with the divine.[32]

The Internet is very helpful as a medium because origins are quickly forgotten and a vast reservoir of images is easily accessible. The circulation of images and anecdotes facilitates new narratives. Fragments invite re-contextualization and the Internet provides an endless transmission of anecdotes. But this is only half of the process. The Internet not only circulates fragments, it creates new contexts for re-deploying them in narratives and practices as well as extended relationships among devotees. Chat rooms, list serves, and web sites operated by religious groups, such as those studied by Paolo Apolito in his study of Catholic visionary virtual communities, install imagery in the apparatus of apocalyptic or millennial beliefs, applying revelation and apparition to world events or moral crises, and in international campaigns to promote the cause of beatifying or canonizing new saints.[33]

The power of images to appear just about anywhere assures believers of their veracity. It happens all the time in a process that is traceable, for example, in several steps from the discovery of a cross buried in the wreckage at Ground Zero to its delineation and final installment as an enduring monument. Why find a cross buried in tons of wreckage? Finding the cross compensated for not finding any survivors, and its discovery was also motivated by the need to recover a religious framework in which to see the suffering and loss. This is why the cross appeared, why it became visible, and why its visibility underwent successive degrees of clarification as it was separated from rubble and mounted at different points, culminating in the erection of the cross on a concrete pedestal as a monument at Ground Zero (Fig. 14).[34] This was a process of formalization that directly parallels the formation of shrines at spontaneous apparition sites, rendering them less spontaneous by changing the mark into a non-ambivalent epiphany (cf. Figs. 10 & 11). With the

29. Historian Lisa Bitel and photographer Matt Gainer are studying the photographic response of pilgrims at an apparition site known as Virgin of the Rocks in the Mojave Desert. Maria Paula Acuña leads devout response to the ongoing apparitions on the 13th of each month. See Bitel and Gainer's contributions to this volume.

30. Wojcik, "Polaroids from Heaven" (as in note 28), 132–34.

31. I have discussed the visual operation of Tarot in D. Morgan, The Lure of Images: A History of Religion and Visual Media in America (London, 2007), 251–52.

32. Wojcik, "Polaroids from Heaven" (as in note 28), 133–35,

stresses divination in his study of a Marian group in New York. I have examined visual divination of symbols embedded in a popular picture of Jesus in D. Morgan, Visual Piety: A History and Theory of Popular Religious Images (Berkeley, 1998), 124–43.

33. P. Apolito, The Internet and the Madonna: Religious Visionary Experience on the Web, trans. by A. Shugaar (Chicago, 2005).

34. For images of the cross and discussion of its formation, discovery, and interpretation with multiple links see "World Trade Center Cross" at http://en.wikipedia.org/wiki/World_Trade_Center_Cross (accessed 2 April 2008).

FIG. 14. Steel Cross, Ground Zero, Manhattan (photo courtesy of Jolyon Mitchell).

Marian apparitions the images come later, sometimes decades later, to tailor the distant event to the devotion of the millions. In the case of image-apparitions, the visual miracle comes first, embodying the sacred event itself. Yet it is important to recognize the larger family resemblance of the two kinds of apparition: in both instances, the images create an interface with a sacred manifestation. In each case, the enduring function of imagery is to establish a form of address that is occasioned by a situation that requires interpretation, an opening that beseeches a response from the devout. The inquiry, in turn, is converted into a visual invitation for engagement.

Apparitions of both kinds—which may be called internal and external—occur where there is a confluence of need, desire, precedent, belief, and the accommodating visual noise of a medium. I do not propose to observe a strong distinction between internal and ex-

ternal apparitions, because whatever the triggering phenomenon may be—an involuntary muscular twitch around the eye, a blob of chemistry in a Polaroid, or the dazzling aura of Mary herself—it requires an apparatus of interpretive response to become visible. Of greater interest are the visual operations of these two modes of apparition: in the external case, the image is the very medium of an apparition, and invites an interpretation; and, in the opposite way, the image is the end point of a search for interpreting an original, internal experience. In the first instance, the image holds an interpretive lens on the present, moving the devout to ask why the image has appeared—what does Mary intend with her sudden visual appearance? In the latter case, an image punctuates a quest, lending it finality, capping the interpretative search with an abiding answer. In that case, once the devout possess the official image of Our Lady, they no longer search for the object of devotion: they have found it. So the image might be said to fulfill, but also in some sense to erase, the quest for meaning. The image stabilizes the original ambivalence of the apparition by helping to forget that it ever existed. It does this in the same way that the original accounts of the apparitions at Fatima, for example, have been re-remembered by the later memoirs, which have replaced the mysterious figure with Our Lady of Fatima. Accordingly, the popular tracts on Fatima include little or no indication that there was ever any doubt about the Virgin's identity.

Conclusion

We may return to Bruno Latour and the helpful way he punctures the proud balloon of Modernism. In addition to exhibiting the modern passion for mastery, purity, rational consistency, and maximum efficiency, human beings are at the same time creatures of very old habits and may be accurately understood as layer upon layer of historical sedimentation, growing over time, from one generation to the next, as stubborn junk collectors who refuse to throw anything away. Their cultures are those drawers in everyone's kitchen where all manner of stuff is gathered. Why discard what might be of use one day? Capitalism prefers newness, planned

obsolescence, the fickle wave of taste quickly tiring of last season's fashion, the energy of invention always looking for a better solution and a new piece of the market. But every kitchen equipped with the latest appliances has its junk drawer. Every garage enshrining the latest model of automobile stores years and years of boxed stuff too good to throw out. When Warner Sallman was asked in 1961, twenty years after his well-known painting *Head of Christ* (see Fig. 1) had appeared, if he had based it on Lhermitte's 1892 painting (see Fig. 4), he conceded that he had seen the French image before he first conceived of his picture in 1924, but would not admit to the charge of plagiarism that some critics had leveled: "I don't wonder that people say the L'Hermitte painting influenced my drawing," he commented. "Isn't everything we create a composite of what we have subconsciously stored through the years?"[35] Zeuxis and Raphael are both said to have explained their creation of ideal beauty as composite integrations of discrete images.[36] So why not Sallman? And if invoking the mechanism of unconscious influence can help, all the better. What makes his picture appear authentic to many people is the way it subsumes the centuries-old practice of portraying Jesus with a solemn expression, slender face, long brown hair, large blue-eyes, and a demeanor that is dutifully submissive to his father's will. Sallman updated this physiognomy for his contemporaries, who commonly responded to this image the way other Christians do to images of Mary and the saints, that is, by recognizing him. As one person put it, "there he is … in person."[37] Or as another person told me, he'll know the Lord when he arrives among the crowds of heaven because he's already seen his picture.

35. Anderson, "His Subject Shaped His Life" (as in note 15), 8.
36. Discussed in Morgan, *Visual Piety* (as in note 32), 40.
37. Quoted in Morgan, *Visual Piety* (as in note 32), 35. I discussed in this book what I called "the psychology of recognition" as a key aspect of popular visual piety, 34–50.

LISA M. BITEL

IMAGES BY MATT GAINER

Scenes from a Cult in the Making:
Lady of the Rock, 2008

Lady of the Rock, California City, California

IN 1989 the two-year-old daughter of Maria Paula Acuña—a Mexican-born mother of six, living in Pacoima, California—was diagnosed with leukemia. One night the ailing child saw a "beautiful lady" who said that her mother should go to nearby Lopez Canyon and surrender herself to God. That summer, Maria Paula knelt in the canyon and saw the same Lady, whom she identified as Mary, the Virgin Mother of Jesus. The Virgin suggested that they "form an army and ... work together." [1] Maria Paula began to visit the spot on the thirteenth of each month. She claimed not to know why she chose that particular day, although she may have been aware that the famous vision at Fátima, Portugal, first occurred on the thirteenth of May in 1917. [2] Growing crowds began to attend Maria Paula each month to watch her vision and to take photographs of possible signs of the Virgin's presence. In 1995, the Virgin ordered Maria Paula to change venues, coincidentally at a time when the owner of the original vision site at Lopez Canyon asked Maria Paula to do the same. The pair moved their monthly meetings to uninhabited lands outside California City in the Mojave desert about two hours' drive north of Los Angeles. The crowds who continue

to follow Maria Paula have named the new vision site The Lady of the Rock. [3]

The office of Archbishop (now Cardinal) Mahony of Los Angeles investigated Maria Paula when she was still located at Lopez Canyon (the Catholic Church lays responsibility for determining the authenticity of visions and other extraordinary religious events upon its bishops). Archbishop Mahony issued a statement in 1995 through his publicist, Fr. Gregory Coiro, declaring, "The church's official position is that there are no apparitions, and people are to be discouraged from going there." Coiro added that the event "was looked into and found to be wanting. It was found to be due to somebody's imagination—not anyone's bad will." The Bishop of the diocese of Fresno, which includes California City, also warned Catholics in 1997 against the visionary and her closest followers, who had begun calling themselves the Marian Movement of Southern California. Recently, the diocesan chancellor and archivist pronounced Maria Paula's experience to be a "non-event" and "not a historical event." [4]

In some sense, the clerics were right. Maria Paula's monthly visions are not yet historical events because they are ongoing. It usually takes a long time for local bishops and their ultimate supervisors at the Vatican to add a new name to the list of formally approved visionaries, or to verify a genuine appearance of the Mother

1. Gary Nougues, "Our Lady of Perpetual Apparitions," *Prism* (Fall 1997), http://www.journalism.sfsu.edu/www/pubs/prism/oct97/P1.lifestyle.html (last accessed 5–9–08).

2. Carla Hall and Paula Bryant Pratt, "Blessed Virgin Mary Sightings in Mojave Desert," *Los Angeles Times* (2–16–97); Sandra Zimdars-Swartz, *Encountering Mary: From La Salette to Medjugorje* (Princeton, 1991), 67–91.

3. Besides Leonardo da Vinci's famous painting, the Virgin or Lady of the Rock turns up elsewhere around the Catholic world: The sanctuary of Madonna del Sasso in Locarno/Orselina, Switzerland, was built after the Franciscan Bartolomeo d'Ivrea had a vision of the Virgin in August 1480; La Virgen de la Roca is also the title of monuments to the Virgin in Ecuador and Bayona, Galicia.

4. Telephone conversation with Deacon Jesse Avila, 5–2–08.

of God.[5] Still, precisely because Maria Paula's monthly experiences do not yet comprise an historical event, they offer historians the chance to observe something never disclosed by archival documents: a self-identified visionary interacting with her witnesses to create a cult-in-progress. Although Maria Paula may not see exactly the same things that earlier Christian visionaries claimed to see, and even though the events at Lady of the Rock may not directly resemble ancient or medieval vision events, nonetheless the monthly gatherings reveal the living drama that preceded every historically recorded religious vision. Every month, right before the eyes of anyone who watches, a visionary and her collaborators actively negotiate the meaning of her extraordinary experience and together decide whether and how to present the vision to the world.

At the same time, history—many centuries of it— helps explain the extraordinary events at Lady of the Rock. Maria Paula's inspirations and behavior, the activities of witnesses and pilgrims at the site, and even the location of the cult make sense only in the context of vision events that have occurred in Christian communities elsewhere. In fact, Lady of the Rock's place in Catholic visionary tradition is crucially important to Maria Paula and her witnesses, who are actively trying to insert themselves into the very history so jealously guarded by the bishops and the Vatican. The struggle is becoming more urgent given recent changes at Lady of the Rock. The visionary has revealed that her health is failing. Her death will surely change the function and meaning of the cult at Lady of the Rock. In the meantime, her followers are collecting donations to build a permanent shrine, which will further testify to visionary's authenticity. However, the witnesses' primary technology for proving the presence of divinity at the vision site is about to disappear. The crowd uses Polaroid film in instant cameras (for reasons explained below.) In December, 2008, the Polaroid Company announced that it would no longer manufacture the film, thus threatening an end to at least one important element in the ritual, iconography, and proof of this regular vision event.[6] (As of November, 2009, the company plans to relaunch an instant-print film camera sometime in 2010.) Finally, although the protocols of the monthly event have remained similar over the years, the liturgy and iconography of Lady of the Rock have been shifting subtly from month to month to accommodate these other changing circumstances. All of these shifts, both monumental and incremental, offer exactly the evidence that scholars need to transform the story of Maria Paul and Lady of the Rock into genuine history.

On the Thirteenth of the Month

To casual observers, Lady of the Rock might seem like nothing special on twenty-nine or thirty days of the month. No one drives the mile of gravel from the Randsburg-Mojave highway to the site of Maria Paula's visions. Nothing but scrub and the occasional insect or snake is visible for miles around, although a few new houses shimmer in the distance like mirages. Only hand-lettered placards on a telephone pole mark the turn off to the vision site. But on the thirteenth morning of each month, cars and trucks take that turn and rumble deeper into the desert to park in respectful rows. Amidst the cars, someone has always marked off a small circle of desert with bright yellow tape, like a crime scene, and a white picket fence, at the center of which is a small stage-cum-shed. Early on the morning of the thirteenth, someone opens its doors so that fiesta streamers can shoot through the air above the impromptu sanctuary. Buckets of flowers flow from the stage onto the dirt and familiar hymns rise up from a sound system or an impromptu band.

By ten o'clock someone is usually repeating the

5. For example, on 4 May 2008, the church announced its official sanction of apparitions that appeared to the teenaged Benoite Rencurel from 1664 to 1718 at Laus, France: "Church recognizes Virgin Mary appearances in France," AP, via the *Washington Post*, USA (5–4–08), at www.washingtonpost.com (last accessed 5–10–08).

6. Courtney Dentch, "Polaroid to Exit Instant Film as Demand Goes Digital (Update2)" (Bloomberg, 2–8–08), http://www .bloomberg.com/apps/news?pid=20601103&sid=apSoe2r9tJ7 M&refer=us# (last accessed 5–3–08); BusinessWire, "Polaroid Brand Users in the NEW with OLD," http://www.businesswire .com/news/home/20091013005988/en (last accessed 11–15–09).

rosary in Spanish and English over a portable loud-speaker. The most eager pilgrims come early to surround the sanctuary with lawn chairs, tent pavilions, and umbrellas. Many unpack coolers and small grills while they settle in for the day. They have come from Los Angeles, Fresno, Orange Country, Nevada, Mexico, and even Peru or the Philippines in order to watch a woman see the Virgin Mary. They have heard from friends or relatives, or perhaps from an anonymous internet friend, that a visionary is at work here. A few have come many times before, but many are first-timers learning what to do. Some mill between the sanctuary and parking lots, visiting booths that sell drinks and tamales or devotional paraphernalia. Some also scurry up to the stage just long enough to deposit cellophane wrapped bouquets, bottles of water, or other objects for blessing; when the Virgin appears today, these items will be specially blessed. Others line up to use the portable toilets, or else linger near a twenty-foot steel cross set in cement just behind the stage. Still others peer through the chain link fence that surrounds a building site about forty yards to the left of the stage. In 2006, the fence contained only a pile of cut marble or quartz boulders supposedly brought from Lopez Canyon, but by spring 2008 the rock pile attached itself to the foundations of a small shrine with an elaborately planned cement approach. There are indications of future fountains.

Sometime around 10:30 in the morning, as the able-bodied begin to drift back toward the junction of gravel and highway to await the last arrivals, the visionary Maria Paula Acuña and her retinue pull up in a white SUV. The vehicle ejects four or five small women dressed in snowy nuns' robes. On the bodice of each robe is an iron-on transfer depicting Our Lady—not a particular icon, but a typically white-skinned, brown-haired, blue-eyed Virgin draped in white and blue. Men in t-shirts bearing the same appliqué help to unload a statue of the Virgin, a large crucifix, or maybe a portrait of the Virgin of Guadalupe.

They lift the statue onto a litter to be carried by the *monjitas* (sisters) or some other enthusiastic helpers. Since late 2007, a group of traditional Mexican *matachine* dancers dressed in belled skirts and carrying little wooden bows have often led the monthly procession, followed by the litter, the women in white, and the rest of the crowd.[7]

As the throng wends its way to the sanctuary, Maria Paula usually drops once or more to her knees. From that position she begins to look skyward where her partner in dialogue hovers, unseen to others. Audiences hear only Maria Paula's half of the conversation. She pleads with the Virgin in a breathless, high-pitched singsong inflected with a Castilian lisp. Sometimes she breaks off to announce in a stage whisper to the crowd, "You can be taking the pictures NOW of the blessed mother." The audience aims Polaroids and, increasingly, also digital cameras, video recorders, and cell phones at the skies. Maria Paula speaks with the Virgin for five minutes or more, then rises to lead the procession as far as the stage. The crowd holds back at the yellow tape. Only Maria Paula's retinue, special supplicants, and possibly an aggressive photographer penetrate the inner sanctum. The visionary usually kneels for a final conversation with the Blessed Mother before rising to address the visible crowd through a cordless microphone. She strolls around the circle and gestures as she speaks in Spanish and English.

After what must be close to 250 sermonizing explications over almost twenty years, Maria Paula has passed on many different messages from the Mother of God. Sometimes she offers precise details of what she has seen that very day. "She looks like a big ray of light coming from the sky very slowly," she explained in 1997, "the light of the Blessed Mother looks like a crown and covers all the people here." She reported, too, that Mary "appears in front of me. She looks like a cloud. I see her very clearly. She's a very beautiful woman, very young. Maybe 18 years old. About 5´5˝.[8] Almost ten years later, in August of 2006, she told one

7. Deirdre Sklar, *Dancing with the Virgin: Body and Faith in the Fiesta of Tortugas, New Mexico* (Berkeley, Calif., 2001).
8. Hall and Pratt, "Blessed Virgin Mary Sightings" (as in note 2).

observer that the Virgin seemed to be about 25 years old or maybe 35 or 55 like herself, and that Our Lady dressed in robes like Maria Paula's.

On that same day in 2006, the Blessed Mother told Maria Paula, who passed the information on to witnesses, that the government was using technology to monitor what everyone does, what they watch on TV, and what they eat. Apparently, in Maria Paula's estimation, God and the national government are at cross purposes, an assumption shared by many right-wing Christian associations and a few other Marian visionaries.[9] God sees all our sins, Maria Paula reported on that sizzling August day, but the government is working to create a single anti-Catholic world system that will result, in four years, in total Armageddon. At that time, the world will no longer need priests or the Church (presumably because the Book of Revelation's forecast of Christ's return will turn out to be true). "Now I'm nothing but a piece of skin," she informed the audience, "but after I die I will begin to work for you." This was an arguably immodest suggestion since, according to Catholic doctrine, only officially recognized saints can act as intercessors between the living and their God.

During and after the sermons, Maria Paula often approaches the individuals circling her, asking questions. "Are you perfecting yourself for God every minute of every day?" she demanded of one. "Are you delving deep inside yourself to root out sins and errors? God knows everything inside you," she reminds her listeners, "God can see inside." She beams at her witnesses, reaching to embrace or bless them. She gives friendly greetings to locals, Angelenos, and visitors from farther off who have driven down from northern California or up from Mexico, and flown in from even farther away. She stretches a healing hand to those who request it. Maria Paula's handlers accompany her around the circle, making sure that no one responds inappropriately to her questions. These special followers shoo petitioners and photographers from her orbit, and fetch water to refresh her. In April of 2008, one handler cautioned pilgrims not to tell Maria Paula

their stories as she traveled the circle, but only to offer themselves for blessing; too many people needed to see the Mother, he explained, and some would be disappointed if others kept her chattering. The handlers also sell roses blessed by the dialogue between Maria Paul and Virgin. Witnesses at previous meetings with Maria Paula have reported that the scent of roses occasionally pervades the apparition site; one time, they claimed, a shower of rose petals fell to the ground then rose again into the clouds. A clipboard-carrying sister sticks close to Maria Paula's elbow, recording names and addresses of petitioners and potential donors.

Yet not everyone at Lady of the Rock focuses on Maria Paula. Even as she sermonizes, the crowd is busy. Some observers shift position, scan the skies, and snap photos. Some fall to the ground to pray or weep while others observe motionlessly. Still others raise their arms to the heavens. The audience of each vision event thus contributes by its own behavior to the performance of the visionary. But they also talk while she talks. They leave to eat or use the toilet and return to watch some more. They also conduct rituals of their own with cameras and rosaries. Witnesses have helped craft the monthly liturgy and constantly express their expectations. They respond to incidents throughout the event according to an unwritten but familiar script cued by the visionary and her helpers and by the shift of sun and clouds above.

Throughout the day, witnesses also wield their cameras to locate meaningful signs in the photographs that they take of the skies. Even though the visionary instructs witnesses when to use their cameras, most people shoot photos before and during the event. They move about to align their shots, seeking the right angle of light, or trying to include the visionary or the stage in the frame. Some witnesses come armed with scrapbooks full of Polaroids from previous visits, which they share with other regular pilgrims. Long-time followers of Maria Paula claim to have many such books at home, each holding page after page of similar shiny square proofs that the divine is present in the Mojave. Copies of the most impressive shots are also for sale

9. Daniel Wojcik, *The End of the World as We Know It: Faith, Fatalism, and Apocalypse in America* (New York, 1997), 60–96.

from the Marian Movement at a table near the sanctuary, along with reproductions of photos taken at other historic vision events.

The picture-taking is a ritual act. The images that result are evidence of the photographers' own encounters with divinity at the site, as well as testimony to Maria Paula's experience. The photos also serve as a handy teaching device for newcomers or non-believers. Most of the returning witnesses will gladly instruct others in how to take pictures or explicate the special iconography of the Polaroids. The messages of the photos are not obvious to the uninitiated, despite an established iconography that has become part of the world-wide culture of Marian apparitions.[10] At one monthly vision event, an old man raised his camera to shoot the sun shining over the stage long before Maria Paula appeared for her vision. As the Polaroid paper slid out of the camera, he caught it between thumb and forefinger and waved the filmy image to dry it. He had captured a ragged globe of blinding white light pierced by crossed diagonal lines on a field of deep blue-black. Showing off his work to the uninitiated, he ignored the cross to indicate a small, vaguely triangular shape at the bottom of the photo. This was the Virgin, he explained. But his listeners could not easily have read the image without his instruction. Although seasoned pilgrims instantly recognize meaning in a variety of abstract images, they also deliberate about nuances in single images and themes in collections of photos. While the Virgin Mary is the main symbol in these photographs, other motifs recur.[11] A ball of light indicates divine presence. A shining cross signifies Jesus' crucifixion and resurrection. A triangular shape is the veiled Virgin, sometimes holding her holy baby or embracing another figure. A rectangle with rounded top and bottom represents the Gate of Heaven. Other blurs of light symbolize angels, doves, or the face of Jesus, if held at the right angle. Sometimes pilgrims are able to capture these motifs in the same frame as Maria Paula or with family members and other witnesses. Those skilled with a camera can combine in a single photo both abstract signs and tangible religious objects, such as the large cross that looms behind the stage, thus creating a more complex visual statement.

The photographers never stray far from a well-defined range of techniques and set of familiar images, which most realize resemble photos taken at other Marian sites. The prints for sale at the Marian Movement's booth prove this. Witnesses compare their fresh shots to pictures taken at California City long ago, or to images from Fátima and Medjugorje. They know that they are participating in a well-established ritual of commemoration and publication of visionary experience and that the monthly photography session helps locate their event in global Catholic history. Pamphlets about earlier apparitions, also for sale, tell the story of Saint Bernadette, Saint Teresa of Avila, and Padre Pio. The witnesses see their work as crucial to Lady of the Rock because Maria Paula Acuña herself refuses to divulge her personal history to reporters or academic observers. She claims to be keeping a diary of her visions and one of her attendants videotapes every monthly event, but these are kept secret by the Marian Movement. The diocese of Fresno will not share its investigative report and has hinted that, in fact, the document might no longer exist. The photos, then, constitute major lasting proof that something extraordinarily meaningful occurs in this remote part of the California dessert. The photos do not show what Maria Paula sees, but rather demonstrate to the faithful that a meaningful sacred event occurs at Lady of the Rock only when the visionary and the Virgin come to the desert.

By their attendance at the monthly event and with their photos, Maria Paula's devotees have begun to address the ancient problem of substantiating a

10. Paolo Apolito, *Apparitions of the Madonna at Oliveto Citra: Local Visions and Cosmic Drama* (University Park, Pennsylvania, 1998), 10–106, 216–20, on the negotiation of what witnesses see with eyes and cameras. For the iconography of Bayside visions, see Roses from Heaven, "Photo Symbolism," http://www.rosesfromheaven.com/photoStory2.html (last accessed 5-9-08.)

11. Daniel Wojcik, "'Polaroids from Heaven': Photography, Folk Religion, and the Miraculous Image Tradition at a Marian Apparition Site," *Journal of American Folklore* 109 (1996), 129–48 at 135; Jessy C. Pagliaroli, "Kodak Catholicism: Miraculous Photography and its Significance at a Post-Conciliar Marian Apparition Site in Canada," *Historical Studies* 70 (2004), 71–93 at 89–91.

visionary's interior experience. However, the partici-pants at Lady of the Rock, led by the Marian Move-ment of Southern California, have taken the next step in historicizing the visions by constructing a perma-nent shrine and grotto at the site. Over the last two years they have raised enough money to lay founda-tions and start building. The unfinished structure al-ready resembles traditional Catholic churches with semi-circular apses and rectangular naves. No one knows yet how the existence of the shrine might alter the flexible liturgy of the thirteenth. Plans include a special chapel to house the statue of Mary carried in the monthly procession, which now sits largely unno-ticed on the stage during most of Maria Paula's visions and sermons, although sometimes it is replaced by a crucifix or a framed image of the Virgin. The statue has not previously been an object of devotion, as is the case at many other Marian shrines. Presumably in its new venue, the statue will draw devotional rites. Some of the chapel's décor will be stable, unlike the decora-tions of the current stage, which change each month depending equally on the liturgical calendar and the whim of volunteer decorators. The permanent lay-out and decoration of the new building may, in effect, help regularize Marian devotion at Lady of the Rock by drawing on iconographical traditions at other Mar-ian shrines.

What is more, even if the permanent shrine does not become part of the regular monthly event, it will still compete with the stage and temporary sanctuary as the spatial center of Lady of the Rocks. If Maria Paula moves inside for her conversations with the Virgin, it could lead to a segregation of her personal revelatory drama from the less formal sky-watching rites of her audience. Perhaps witnesses will move inside with the visionary, although not many of them would fit within the shrine as planned. It is unclear whether they would continue to take photographs and, if so, where they would aim their lenses. No one would consider pho-tographing the sky over an ordinary Catholic church during Sunday Mass or snap shots of the miracle of the eucharist taking place inside. The building's walls help contain and focus divine immanence in particular ges-tures and objects, such as the priest's raising of the eu-

charist behind his altar. Inside a Catholic church, con-tact with God occurs through a priest's mediation. The new shrine itself is not currently planned as a church to be staffed by an ordained priest. Yet its very existence will diminish the solitude of the desert site. At the same time, the shrine will become the best evidence of all for the reality and truth of Maria Paula's visions. Its con-struction marks the first step in the event's transforma-tion from lived religion to historical event.

It is also unclear what will happen when pilgrims lose their Polaroids. Instant photos have been the most trusted tools for proving the authenticity of religious apparitions and visions since Polaroid film was devel-oped and made widely available in the 1960s. Wit-nesses at vision events believe that Polaroid film pro-duces instant and tamper-proof images of supernatural presences invisible to human eyes. As the anthropolo-gist Paolo Apolito has found, observers use Polaroids not only to commemorate a visionary's experience and their own witnessing presence, but also to capture and contain the divine. At Lady of the Rock, Maria Paula and the Virgin together create a temporary sa-cred space outside church walls and beyond the con-trol of priests, which pious photographers then exploit for their own religious purposes. If Maria Paula did not come, the Virgin would not appear, and nothing would lurk unseen to be captured.

Although pilgrims to Lady of the Rock keep up with technology and already use other tools to commemo-rate the monthly event, many have expressed dismay at the demise of Polaroids. Witnesses are well aware that digital technologies can produce instant images, but they also know that anyone with a computer and the right software can alter digital images to fabricate the kinds the pictures that, for the previous four de-cades, have constituted proof of apparitions at sites around the world. No scrapbooks can be completely reliable once the Polaroids disappear. Several devout photographers have also announced that digital cam-eras can never produce coded images of the same qual-ity as Polaroids. The malleability of digital images coupled with the end of Polaroids threaten the rhetoric of authentication developed by witnesses during the later twentieth century and wielded not only at Lady

of the Rock but at apparitions in Conyers (Georgia), Bayside (New Jersey), and elsewhere. Even if Polaroid relaunches instant film cameras, the equipment is likely to be too expensive for many pilgrims. Witnesses will need to generate new discourses of proof for what they see in the heavens, and new kinds of social exchanges among themselves, in order to prove what goes on in the Mojave. But devotees to visionary cults have adapted successfully to new visual technologies before. In the early Middle Ages the best testimony to any kind of holy event was a bodily relic from the saintly performer at its center. Throughout the premodern period, objects blessed by a gesture or merely the presence of a visionary worked wonders that also substantiated the divine message transmitted by the seer. Most likely, witnesses will find other proofs of what they cannot see after the Polaroids are gone.

What Did You Go Out Into the Desert To See?

Despite the disapproval of church officials, shifts in the environment of the vision site and possibly its rituals, the declining health of Maria Paula Acuña, and the loss of their favorite medium for commemorating visions, multitudes continue to meet monthly at Lady of the Rock. Perhaps pilgrims are seeking the spiritual reassurance that mainstream congregations and rituals cannot bring them—although many of the witnesses also attend parish churches. Perhaps they are the willing prey of a religious charlatan seeking profits and power from the hopes of less educated, poorer members of modern American society.[12] But pilgrims to Lady of the Rock seem willing to ignore the visionary and feel free to negotiate their own codes of divine proof. Neither possibility explains why Maria Paula's witnesses believe that she actually sees and speaks with the Virgin Mary. Why, over the last nearly twenty years, have so many driven so far from home and church to watch

someone else look at what they cannot see? What do they expect? Jesus once demanded the same of the crowds following John the Baptist: "What did you go out into the desert to see?"[13]

Over two millennia, church leaders have looked for but found no better answers to these questions. Local bishops believe that Maria Paula and her companions in the desert are misguided. Civic officials of nearby towns have not bothered to justify or deter the crowds at Lady of the Rock, although they recently cautioned the Marian Movement about trash left behind on the mornings of the fourteenth. The few journalists who have noticed crowds at Lady of the Rock have treated the gatherings with wonder, ignorant of visionary tradition yet amused at another bizarre eruption of religion into normal life.[14] Meanwhile, scholars have not yet systematically investigated the events in the Mojave. Social scientists who have studied similar grassroots religious movements have pointed to demographic and cultural shifts in California's population, suggesting that the failure of Spanish-speaking immigrants to assimilate into American society probably propels many of them to seek identity and meaning in strange places. Many commentators have noted the increasing influence of religion, especially immigrant religions, on American politics. However, neither academics, news analysts, nor politicians have satisfactorily accounted for the great groundswell in public religiosity that has come to light in the last twenty years. No one has been able to explain why people continue to have faith in what they cannot see or prove.[15]

Historians of the Christian visionary tradition can suggest at least partial explanations because they know that this kind of thing has happened before. For most of the last two centuries, the Virgin Mary has appeared with increasing frequency to women, children, and other disenfranchised, ill educated, poor Catholics. Sightings of the Virgin began to multiply across Europe during the formation of modern secular states,

12. I. M. Lewis, *Ecstatic Religion: A Study of Shamanism and Spirit Possession*, 2nd ed. (London, 1989), esp. 15–31.

13. Matt. 11:7.

14. Besides Nougues and Hall & Pratt (as in notes 1 & 2), see also, for example, Jonathan Petre, "Vatican rejects woman's Virgin Mary

claim," *Daily Telegraph* (9-24-07) reprinted: ReligionNewsBlog .com, Item 19467 (last accessed: 5-9-08).

15. Anne Simpkinson, "Something About Mary," Beliefnet (http://www.beliefnet.com), (2004) (last accessed 5-9-08).

beginning in France at Paris (1830), La Salette (1846), and Lourdes (1858).[16] After World War II, Marian apparitions increased in eastern European countries and, soon after that, the number of American apparitions rose from less than 10% to almost 50% of all reported Marian sightings.[17] Professed Christians, skeptics, scientists, and the merely curious have gathered at these purported apparition and vision events to watch a person of no obvious importance or skill see the Virgin, Jesus, saints, or angels. Meanwhile, religious and political authorities have looked on from afar with dismayed disapproval.[18] The current pope is rumored to be planning an encyclical denouncing apparitions.

The history of Christian visionary experience is much older than La Salette and Lourdes, though. Every generation of Christians has had its visionaries. Since apostolic days, seers and the less-sighted have contended over the importance of individual visionary access to God, and argued about the relation between personal and collective revelation. The authors of the Gospels struggled to explain the circumstances under which some followers saw the resurrected Christ and to explain the nature of that visual encounter. He only appeared to a chosen few of those who had heard him preach or felt his healing touch. According to the Gospel of John, Mary Magdalen was the first to spot the risen savior outside his empty tomb; she mistook him for a gardener. The apostle Thomas doubted his comrades' claims that they had visually encountered the living Christ. Thomas would only believe once he had both seen and touched Jesus' wounds. The savior reprimanded him for needing such sensual proof: "Because you have seen me, you have believed," Jesus said, but "blessed are those who have not seen and yet have believed." [19]

The foundational texts of Christianity posited a faith revealed by a resurrected savior to a few who could see and to all who would believe. After the savior ascended into heaven, Jesus' followers claimed that direct revelation continued visually and by other means, but they could not determine a satisfactory method for authenticating the experience. The texts that became Christian scripture described individuals receiving direct *gnosis*, but also emphasized the collective revelation to be shared by all Christians at the end of time. The latter would eventually be easier to prove, presumably, than an individual's personal perception. Meanwhile, as church leaders established more reliable sources of religious authority, such as apostolic succession and scriptural exegesis, they began to distrust visionaries who claimed authority based on personal messages from God. Some of the earliest theological debates resulted from the presence of unruly prophets at Christian rituals.[20] Nonetheless, the prerogative of individual revelation, along with the problem of communicating and proving it, continued throughout the Christian centuries to the present day, as many saints' legends attest (some discussed in this volume)— although visions are not themselves proof of sanctity, according to the Vatican.

If personal revelation and the doctrinal issue of reliable proof date back to Gospel times, an equally ancient tradition lies behind the site chosen by Maria Paula and the Virgin. Christians have always sought both meditative solitude and contact with divinity in the desert. Jesus spoke to his Father there while testing himself against Satan. Christian monasticism was born under the desert sun of Egypt. Medieval and modern ascetics and pilgrims have looked for visionary solitude both permanent and occasional in wastelands both literal and conceptual. Thomas Merton, Trappist and darling theologian of twentieth-century liberal Catho-

16. Yves Chrion, *Enquête sur les apparitions de la Vierge* (Paris, 1995), 173–259.

17. Paolo Apolito, *Internet and the Madonna: Religious Visionary Experience on the Web* (Chicago, 1995), 22–36.

18. As just a few examples of scholarship on the topic: Ruth Harris, *Lourdes: Body and Spirit in the Secular Age* (New York, 1999); William A. Christian, Jr., *Apparitions in Late Medieval and Renaissance Spain* (Princeton, 1981); Christian, *Local Religion in Sixteenth-Century Spain* (Princeton, 1982); and Isabel Moreira, *Dreams, Visions, and Spiritual Authority in Merovingian Gaul* (Ithaca, N.Y., 2000).

19. John 20:14–29.

20. See Peter Kirby, "Didache," Early Christian Writings (http://www.earlychristianwritings.com), (last accessed 5-9-09); also Jaroslav Pelikan, *Emergence of the Catholic Tradition (100–600)* (Chicago, 1971), 105–108.

lics, was equally inspired by the fourth-century her-
mits of Scete and Zen Buddhist masters, whose lives
were devoted to lonely meditation in remote places.
What, Merton asked in his edition of early monastic
apothegms, echoing Jesus, were early Christians look-
ing for in the desert? "They sought a way to God that
was uncharted and freely chosen, not inherited from
others who had mapped it out beforehand." [21] Mer-
ton's personal identification with hermits of old rested
on the assumption that—despite the obviously pro-
found interference of human history—the potential for
direct access to God in the desert was as real for mod-
ern Catholics in the 1960s as it had been for Egyptians
in the 360s. Thus, if Maria Paula had chosen to meet
the Virgin in a less predictable setting—say, a shopping
mall or a college campus—she might not have drawn
such large crowds over the years.

If historians' ability to explain modern vision events
rests upon the assumption of continuities in vision-
ary praxis, scholars nonetheless remain sensibly wary
of universalizing assumptions about religious behav-
ior. The ancient deserts of the Sinai have little in com-
mon with the modern Mojave—not even the sand is
the same. Supposedly unchanging Gospel verses have
meant quite different things to readers from different
cultural and historical contexts, and even to readers
within single congregations.[22] Official Catholic doc-
trines regarding visions and prophecy have changed
over time, despite the inherent conservatism of reli-
gious institutions. Nonetheless, although Christian vi-
sionary heritage has been more volatile than believ-
ers (including Merton) admit, it has been based since
the second century on a fixed set of texts. Visionaries,
witnesses, and interpreters of visions are obliged—if
they identify as Christians—to experience and assess
visionary revelation in response to the message of the
New Testament.

In fact, the visionary and community of witnesses
at Lady of the Rock have acted with purposeful con-
sciousness of Biblical models and thus also of the long

history of co-religionists who have done so before.
The emerging legend of Maria Paula and her visions,
the visionary's descriptions of the Virgin and her mes-
sages, and the iconography of Lady of the Rock all
suggest the direct influence of previous vision events
on events in the Mojave. The vision takes place on the
thirteenth, as at Fátima. The procession mimics ortho-
dox liturgical processions held at churches on Mar-
ian feastdays. The dancers are typical of Mexican and
southwestern American religious festivals. The white
habits of the visionary and her sisters are plainly mod-
eled after nuns' costumes. Even Maria Paula's mes-
sages resemble those of other modern visionaries, and
her witnesses' photos look like shots taken elsewhere.
Lady of the Rock, like all Christian vision events, is
becoming part of Catholic visionary history through
its trans-historical links to other vision events.

Still, written history is not the best medium for com-
memorating religious visions. In believers' terms, the
most meaningful visions exist in the senses and the
soul, within human bodies but outside of human time,
just as ideas exist in human minds but do not occupy
historical time. Religious revelation does not enter
time and history until it moves from the individual
seer's soul to the ears or eyes of an audience. In earlier
times, visionaries sometimes wrote diaries or treatises
about their experiences or, in a few instances, made
pictures of them. More often witnesses and religious
investigators composed accounts of vision events, de-
scribed the contents of visions, and interpreted them
for non-visionaries. Artists re-imagined moments of
divine revelation in painting, sculpture, and archi-
tecture. Dramatic performances, including liturgy,
also commemorated and advertised historical vision
events. Nowadays, visionaries and witnesses both post
written accounts and pictures of vision events on the
World Wide Web. All of these sources usually focus
on an individual who claimed to see something, while
barely hinting at those who carried that experience
into Christian history by considering it, helping shape

21. Thomas Merton, *The Wisdom of the Desert: Sayings from the
Desert Fathers of the Fourth Century* (New York, 1960), 3–6.
22. John J. O'Keefe and Russell R. Reno, *Sanctified Vision: An*

Introduction to Early Christian Interpretation of the Bible (Baltimore,
2005).

it for others, and commemorating it in some enduring form—only after each witness had decided for him or herself that the vision was true. All witnesses to Christian visions across the centuries have faced the same difficult double task suggested in Gospels: visionaries must explain their personal messages from the divine to those who did not receive the bulletins, and those who cannot perceive signs must assess the visionary's ability to do so. Each Christian community has relied on the wisdom of other congregations and previous visionaries, as well as on their foundational texts, for help in understanding and justifying local vision events.

Likewise, scholars must assess vision events with a similar blend of historical and ahistorical methods, examining the dialectic of a putatively unchanging heritage of Christian visions with the historically specific activities of particular visionaries and witnesses in unique moments. It is not sufficient to study either the theology or doctrinal history of visions or the details of a single vision event. The story of an individual visionary, however odd or entertaining, yields no explanation for why visionary phenomena persuade and recur. We shall understand why hundreds of people follow Maria Paula Acuña to the Mojave desert only when we understand why these witnesses are both the same and different from those who followed three children to a field at Fátima in 1917, or why other men and women imitated Francis of Assisi, or why anyone listened when newly Christian Paul told the story of lightning and divine voices on the road to Damascus. We shall understand why pilgrims attend the Lady of the Rock when we can explicate the new testament of shiny Polaroid squares that they are collectively compiling in the desert.

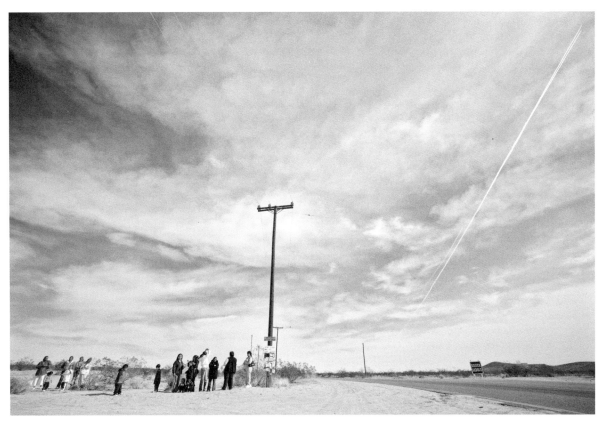

Followers of Maria Paula Acuña wait for her to arrive at the end of an unmarked road in the Mojave Desert as fighter jets from nearby Edwards Air-Force Base fly overhead. Ms. Acuña's visions happen on the thirteenth of each month—about 160 miles north of Los Angeles. December 2006.

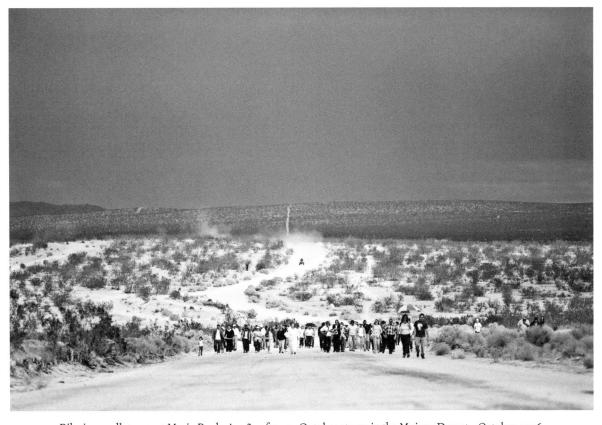

Pilgrims walk to greet Maria Paula Acuña after an October storm in the Mojave Desert. October 2006.

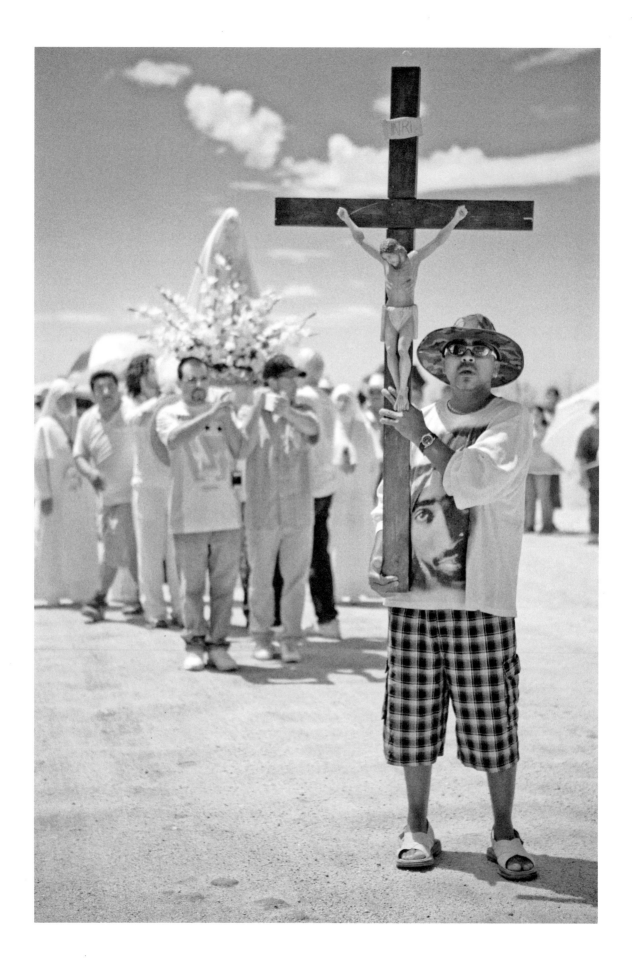

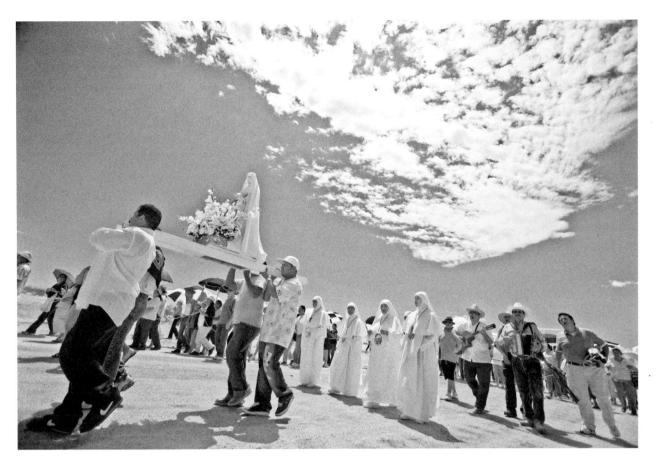

"Missionaries" lead followers down a long dirt road to a temporary shrine in the desert north of California City, California. July 2007.

(OPPOSITE) On the thirteenth day of every month, Maria Paula Acuña visits the same spot in the desert outside California City, California. At about 11 A.M. she kneels in prayer as the Virgin Mary appears to her and imparts a message to the world. Maria Paula then relates the Virgin's words to hundreds of pilgrims who attend the monthly event. She has been doing this since her toddler contracted leukemia almost twenty years ago. Meanwhile, pilgrims pray the rosary in hopes of sharing her vision. July 2007.

After leading a procession down a long dirt road, Maria Paula Acuña announces the Virgin Mary has arrived—and asks her followers to fall to their knees as she translates the Virgin's message. April 2008.

(OPPOSITE) The Virgin Mary's presence in the Mojave Desert is typically represented by abstract shapes in Polaroid photographs, and by Maria Paula's delivery of the Virgin's message. Occasionally pilgrims will report smelling roses, or interpret the shape of clouds as confirmation of the Holy Mother's presence. July 2007.

"Missionaries" or *monjas* carry a statue of the Virgin Mary on the last leg of a monthly procession. November 2006.

Crowds of witnesses take position around a barrier fence as Maria Paula shares the Virgin's message. Typical crowd size is in the hundreds, but can grow to well over a thousand on weekends or anniversaries. August 2006.

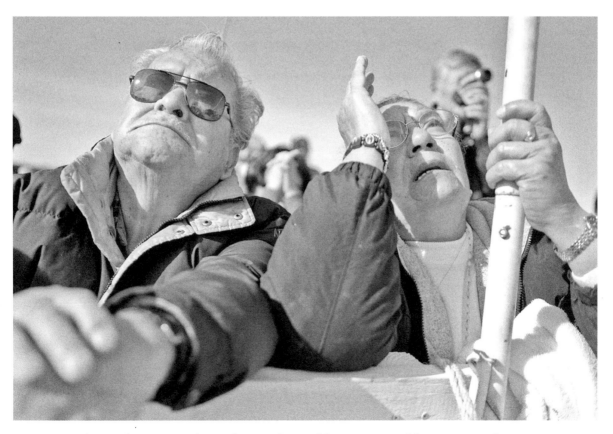

Pilgrims often gaze straight into the sun in hopes of sharing Maria Paula's vision. December 2006.

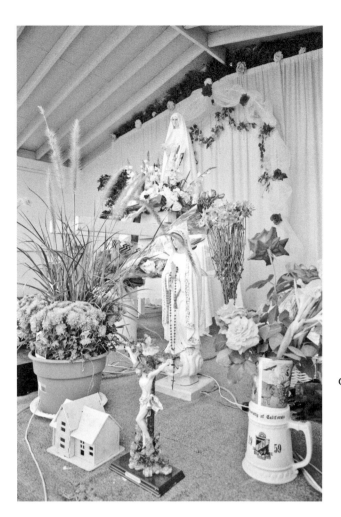

Witnesses follow Maria Paula to this makeshift sanctuary, marked by a small wooden fence and plastic tape and a small stage, where she will kneel to see the Virgin. Objects take on new meaning in this sacred space: Ordinary water, when blessed, may heal illness. Roses signify the Mother of Jesus.

The density of objects, arrangement, and visual complexity of the shrine change from month to month. Ordinary domestic objects share space with flowers, religious ephemera, and a small PA system. October 2006.

(OPPOSITE, TOP)
Language of solar symbols:
Ball of light = Divine presence.
Cross = Jesus' crucifixion and resurrection.
Rectangle with rounded top and bottom =
Gate of heaven.
Triangular shape = Virgin Mary to some,
Holy Trinity to others.
Other possible signs: Angels, doves, faces
of Jesus, Mary, or St. Peter.

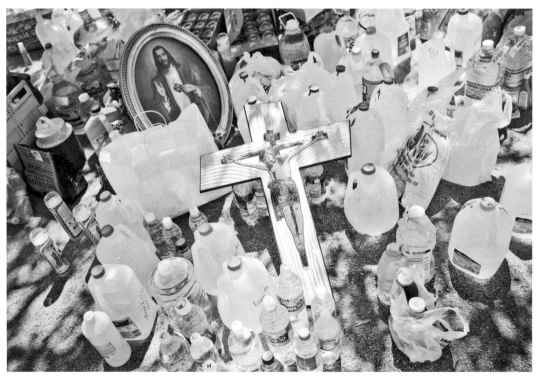

Pilgrims leave various objects and bottled water between a cross and the shrine. It is believed that if the objects are there when the Virgin appears, that they become blessed, and that the water becomes holy water. April 2008.

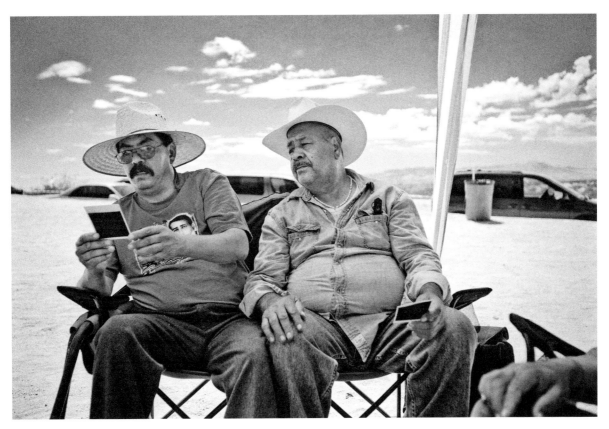

Before, during, and after Maria Paula's conversation with the Virgin, witnesses raise their cameras toward the sun and take pictures. Afterward, they show their photos and negotiate the meaning of the pictures. For them, this is evidence that a miracle has occurred in the desert that day. July 2007.

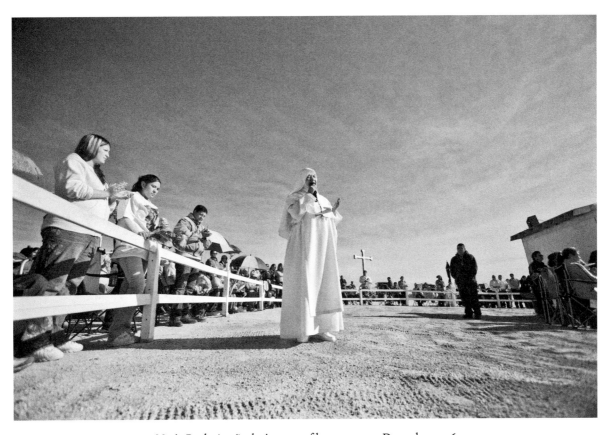

Maria Paula Acuña during one of her sermons. December 2006.

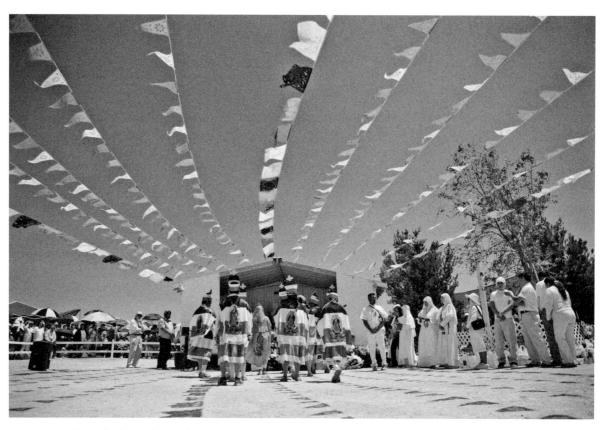

Streamers bring the desert sky to a human scale, and help define the space that separates Maria Paula from her followers—who remain outside of a barrier fence for the duration of the monthly vision. May 2007.

A pile of rocks marks the spot where Maria Paula's first vision in the Mojave occurred. June 2006.

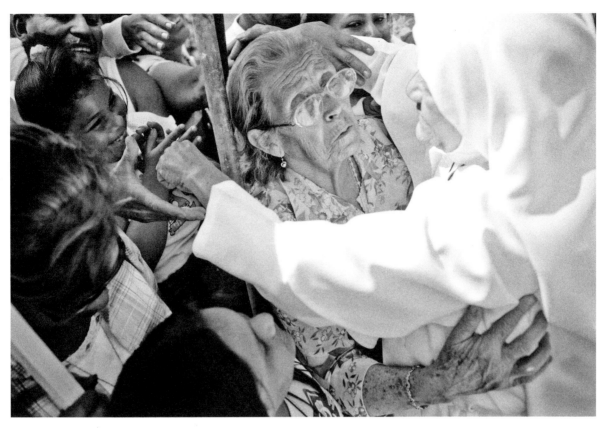

After conveying the Virgin's message, Maria Paula Acuña walks the perimeter fence surrounding the shrine and lays hands on pilgrims. Many of her followers credit her with healing serious medical problems, and return each month for ritual blessings. April 2008.

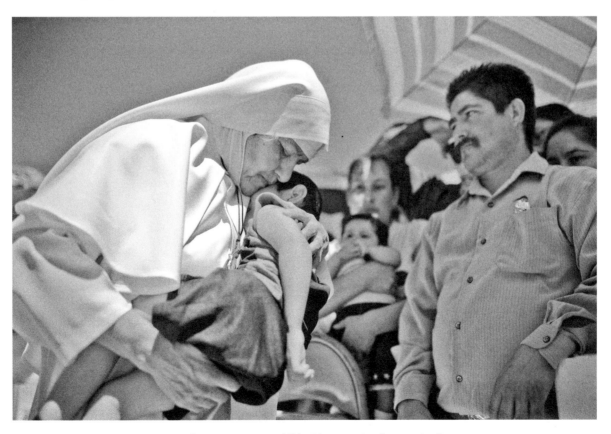

Maria Paula carries a young child with Down Syndrome. April 2008.

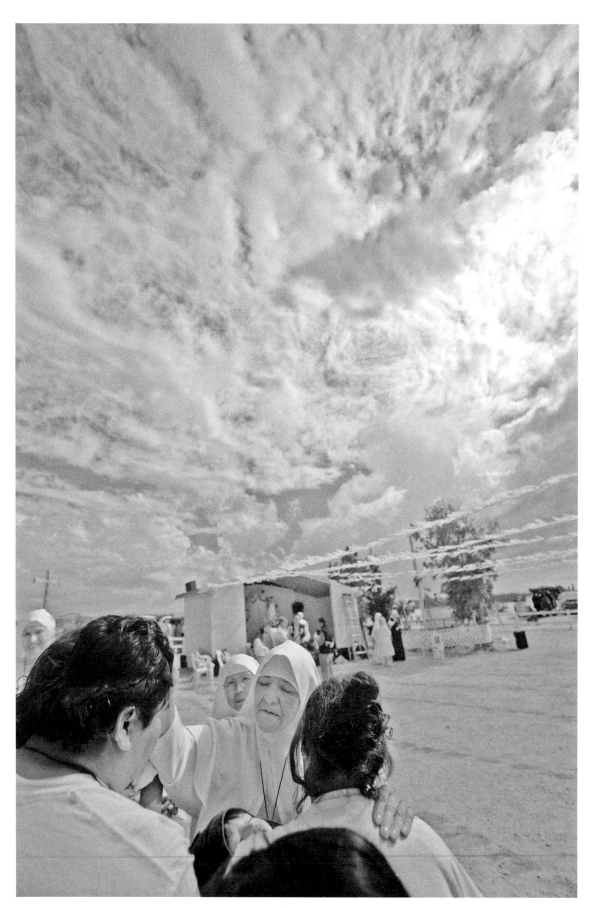

October 2006.

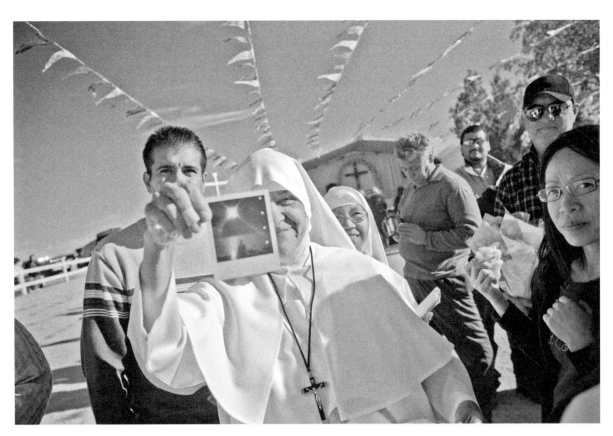

Maria Paula Acuña offers proof of divine visitation: a Polaroid photograph made minutes earlier which has an unusual lens flare. December 2007.

December 2007.

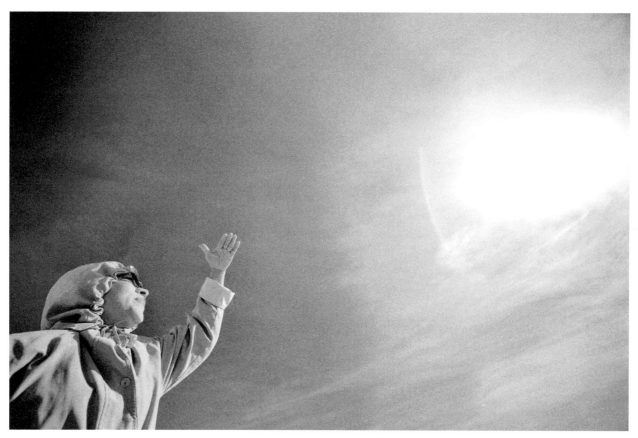

Ada Luz looks toward the sun. November 2006.

GENERAL INDEX

(italic numbers indicate text illustrations)

INDEX OF MANUSCRIPTS

(italic numbers indicate text illustrations)

PRINTED BY

CAPITAL OFFSET COMPANY, INC.

CONCORD, NEW HAMPSHIRE

BOUND BY THE

NEW HAMPSHIRE BINDERY, CONCORD

NEW HAMPSHIRE

DESIGNED AND COMPOSED

BY

MARK ARGETSINGER

ROCHESTER

NEW YORK